CAMBRIDGE STUDIES IN THE HISTORY OF ART

THE ORIENTAL
OBSESSION

CAMBRIDGE STUDIES IN THE HISTORY OF ART

Edited by FRANCIS HASKELL
Professor in the History of Art, University of Oxford

and NICHOLAS PENNY
Clore Keeper of Renaissance Art, National Gallery, London

Cambridge Studies in the History of Arts is a series of carefully selected original monographs and more general publications, aimed primarily at professional art historians, their students, and scholars in related subjects. The series embraces a broad range of topics from all branches of art history, and demonstrates a wide variety of approaches and methods.

Titles in the Series:
El Greco and his Patrons: Three Major Projects
RICHARD G. MANN

A Bibliography of Salon Criticism in Second Empire Paris
Compiled by CHRISTOPHER PARSONS and MARTHA WARD

Giotto and the Language of Gesture
MOSHE BARASCH

The Oriental Obsession: Islamis Inspiration in British and American Art and Architecture 1500–1920
JOHN SWEETMAN

Power and Display in the Seventeenth Century: the Arts and their Patrons in Modena and Ferrara
JANET SOUTHORN

Marcantonio Franceschini and the Liechtensteins: Prince Johann Adam Andreas and the Decoration of the Liechtenstein Garden Palace at Rossau–Vienna
DWIGHT C. MILLER

Pavel Kuznetsov: His Life and Art
PETER STUPPLES

Palma Vecchio
PHILIP RYLANDS

A Bibliography of Salon Criticism in Paris from the *Ancien Régime* to the Restoration, 1699–1827
Compiled by NEIL MCWILLIAM (editor), VERA SCHUSTER and RICHARD WRIGLEY, with the assistance of PASCALE MEKER

A Bibliography of Salon Criticism in Paris from the July monarchy to the Second Republic, 1831–1851
Compiled by NEIL MCWILLIAM

Pittoresco: Marco Boschini, ·his Critics, and their Critiques of Painterly Brushwork in Seventeenth- and Eighteenth-Century Italy
PHILIP SOHM

THE ORIENTAL OBSESSION

Islamic Inspiration in British and American Art and Architecture 1500–1920

JOHN SWEETMAN

University of Southampton

The right of the University of Cambridge to print and sell all manner of books was granted by Henry VIII in 1534. The University has printed and published continuously since 1584.

CAMBRIDGE UNIVERSITY PRESS

Cambridge
New York Port Chester
Melbourne Sydney

Published by the Press Syndicate of the University of Cambridge
The Pitt Building, Trumpington Street, Cambridge CB2 1RP
40 West 20th Street, New York, NY 10011–4211, USA
10 Stamford Road, Oakleigh, Melbourne 3166, Australia

First published 1988

First paperback edition 1991

Printed in Great Britain by BAS Printers, Over Wallop, Stockbridge, Hants.

British Library cataloguing in publication data

Sweetman, John
The oriental obsession: Islamic inspiration in British and American art and architecture
1500–1920 – (Cambridge studies in the history of art)
1. Art, English 2. Islam and art
I. Title
709'.42 N6761

Library of Congress cataloguing in publication data

Sweetman, John (John E.)
The Oriental obsession.
(Cambridge studies in the history of art)
Bibliography.
1. Art, British – Islamic influences.
2. Architecture – Great Britain – Islamic influences.
3. Art, American – Islamic influences.
4. Architecture – United States – Islamic influences.
I. Title. II. Series
N6764.S94 1987 709'.41 86–28383

ISBN 0 521 32982 5 hardback
ISBN 0 521 40725 7 paperback

CE

*I dedicate this book to
my mother,
my daughter Caroline,
my son Richard,
and to the memory of
my father*

The rising city, in confusion fair,
Magnificently form'd, irregular,
Where woods and palaces at once surprise,
Gardens on gardens, domes on domes arise,
And endless beauties tire the wand'ring eyes . . .

<div align="right">

Lady Mary Wortley Montagu, *Verses written in the*
Chiosk at Pera, overlooking Constantinople, 26 December 1718.

</div>

I tell my king, English love Persian very much.

<div align="right">

Mirza Abu'l Hasan, Persian Envoy to the Court of H.M. King George III, 1809.

</div>

L'Alhambra! l'Alhambra! palais que les Génies
Ont doré comme un rêve et rempli d'harmonies . . .

<div align="right">

Victor Hugo, 'Grenade', *Les Orientales*, 1829. Words printed at the
beginning of the folio *Plans . . . of The Alhambra*, by
Owen Jones (1842, 1845).

</div>

Contents

Illustrations

Preface

The impact of the civilisation of the Islamic East on Western observers has taken many forms. During the past century and a half, few who spent their early lives in Europe or America will have done so without responding in some measure to the 'sweetmeat childish oriental world' (the phrase is Meredith's) evoked by *The Arabian Nights*, the Baghdad of Harun al-Rashid and the resourceful Scheherazad. In the late twentieth-century age of rapid and easy travel, many will have gone to see Constantinople, Cairo and Moorish Granada for themselves and glimpsed the qualities that impressed the more privileged visitors of the past – the fair confusion that appealed to Lady Wortley Montagu or the gilded dreams and ample harmonies that were experienced so ardently by Hugo.

This book is concerned with the role of the visual arts in the relationship between the Islamic Orient and the West, particularly in regard to the English-speaking world and the period 1500–1920, when the appeal of the gilded dream was at its brightest. Mirza Abu'l Hasan speaks engagingly of finding a love for Persia at the Court of St James in the early nineteenth century. The wider Islamic world, however – indeed, aspects of 'the Orient' as such – had elicited degrees of devotion from Europeans, Englishmen included, for generations before this. If 'obsession' means having a passion of a sustained kind, it seems appropriate to use the word to describe the growing attention to Islamic art that was also part of this European feeling.

Hugo's words on the Alhambra are a reminder that we cannot ignore the French interpretation – so strong in the nineteenth century that the 1984 mixed nationality exhibition of orientalist painting at the Royal Academy in London (opened when this book was largely written) took the subtitle 'Delacroix to Matisse: European Painters in North Africa and the Near East'. Nor can the role of China in the obsession be overlooked. On the contrary, the attention it has received from students of chinoiserie is perhaps even more of a reason for attempting to distinguish between the specific appeal of Islamic art and that of the Far East, particularly as it affected certain British and American artists. These matters are taken up in more detail in the Introduction and the Conclusion.

After the Introduction, the plan of the book is chronological and, it is hoped, self-explanatory. The choice of illustrations calls for preliminary comment. Some are self-evidently pairs: Islamic works of art or architecture and works by British or American artists which relate more or less directly. The greater number, however, are works by Western artists which reflect unmistakable Islamic stimulus, without necessarily having a precise precedent. It is this type of work about which more needs to be said.

Three considerations have largely determined the selection. First, aesthetic merit rather than social reporting: the aim is to show works in which the artist or

architect has used Islamic ingredients or inspiration creatively to produce a self-sufficient work of art. A leavening of portraits and works of more documentary character are included but artistic merit has been the determining factor. There are a few portraits, of Muslim subjects, or of Britons who played a part in drawing attention in their own country to Muslim achievement. Portrayal in Turkish dress was a popular resort of British patrons, but there is little point in multiplying examples of the genre here. Lady Mary Wortley Montagu and Byron, despite such portraits (notably that of Byron in Albanian dress by Thomas Phillips), were never quite rewarded with portrayals which matched in insight or originality the remarkable sympathies of their subjects for the East. The portraits of Lady Mary and others *à la turque* are omitted in favour of more artistically venturesome and in certain cases little-known examples of other sitters by other artists. Nevertheless, William Finden's evocative steel engraving after the Phillips portrait of Byron is included.

The second criterion, following to some extent from the first, was that the artist's own choice of Islamic ingredients was more important than the demands of popular, 'ready-made' subject-matter. For example, the rich field of illustration by English artists of *The Arabian Nights* or *The Rubáiyát of Omar Khayyam* is omitted in favour of works which show Islamic motifs or modes of presentation as the unenforced choice of the artist. Thus the New York of Maxwell Armfield (Figure 126) displaces the Baghdad of Edmund Dulac, brilliant as Dulac was in the imaginative evocation of the *Nights*. In architecture, creative use of Islamic elements in new contexts such as Lee's Exchange Bank (Figure 143) is preferred to duplications of Turkish baths in Britain and America where the style has been used for its associations.

For the same reason, the extensive use made of mystical Middle Eastern themes, religious and philosophical, by late nineteenth-century Symbolist artists on both sides of the Atlantic is not treated. Such artists seldom used Islamic motifs for themselves but rather took subjects from Arabic or Persian literature as the means of externalising inner states of mind, which often remain obstinately grounded in European anxieties. The seismically sensitive stylist Aubrey Beardsley is an exception: discernible Islamic ingredients are to be found in his heady mixtures, and therefore find a place in this book.

The third consideration, as regards the applied arts, is that only works which show a distinguishable Islamic reference are included. We shall have occasion to note how the form of Muslim flowing ornament known as the arabesque is built into the classical tradition of European ornament to such a point that it hardly remains identifiable in its European context. It emerges clearly again, however, in nineteenth-century decoration, and this emergence is represented here. Similarly, at the end of the nineteenth century, Islamic calligraphic line – along with many other influences, for example, Celtic art – became part of a highly charged decorative language which led to Art Nouveau. Examples of Art Nouveau are included but kept to a minimum because of its hybrid origins.

These mergings with a style such as Art Nouveau mean that comprehensive coverage of the subject is hardly practicable. I am also aware that a number of artists of merit are omitted, including many topographical draughtsmen who drew India under the early Raj. Much excellent work on this latter subject has been done by W. G. and Mildred Archer, and the catalogue of the exhibition *India Observed* (1982), by Mildred Archer and Ronald Lightbown, treated it in detail. Dr Patrick Conner's exhibition and catalogue *The Inspiration of Egypt* (1983) and many publications of the Fine Art Society (see Bibliography) have been invaluable for the Near and Middle Eastern aspects. Instead, an attempt has been made to

explore the developments which were most creative for British artists, and to see the work of the major figures in this area of achievement – the painter J. F. Lewis, the designer Owen Jones and the potter William de Morgan – in the perspective of their times. I am particularly conscious of the quantity of material in America which has had to go unmentioned: the intention here is simply to discern and evaluate the nature of American engagement with the theme in relation to that of British artists.

The book was far advanced when the exhibition *The Islamic Perspective* was organised in 1983 for the World of Islam Festival Trust by Dr Michael Darby of the Victoria and Albert Museum. All students of the subject must have been grateful for the opportunity to see the riches of that museum in this area, and for Dr Darby's catalogue with its long-awaited information on Owen Jones. Visitors to the exhibition also saw loans from the superb collection of European painting and illustration of the Middle East by Mr Rodney Searight, on whose generosity exhibitions of orientalist art have relied for so many years. I am indebted to Dr Darby and Mr Searight for their help and encouragement, as well as to writers on other aspects of the subject such as Dr Patrick Conner, Dr Kenneth Bendiner and Major-General J. M. H. Lewis, CBE, great grand-nephew of John Frederick Lewis, R.A. The work of David Sylvester on the influence of the Islamic carpet in the West has also been most valuable.

I am particularly grateful to Dr Mildred Archer for reading earlier drafts of the material on British India, and to Dr May Beattie for reading the sections which deal with carpets. I am also very indebted to Dr Robert Hillenbrand who read the manuscript of an earlier version of the book and gave valuable advice about some aspects. I would like to acknowledge an abiding debt to my former teacher, Sir Ernst Gombrich, whose book *The Sense of Order* has wise comments on Islamic pattern, Owen Jones and J. F. Lewis. Specific debts incurred in preparing the present book over the last eight years have been legion, and some are acknowledged at particular places in the text. But I should like to mention with gratitude the kind permission of Mr Rollin van N. Hadley, Director of the Isabella Stewart Gardner Museum, Boston, to print here extracts from unpublished letters by J. S. Sargent in the possession of the Museum. I would also like to thank Larry Baume (of the Columbia Historical Society, Washington, D.C.), Chris Beetles, Annie Benge, Mary Bennett, Percy C. Birtchnell, Jane Brown, Judith Busby, J. Carter Brown (of the National Gallery of Art, Washington, D.C.), Jon Catleugh, Dr Rena Coen, Robert Copeland (of Spode), Dr Jill S. Cowen, Professor J. Mordaunt Crook, Dr James Stevens Curl, Professor Kerry Downes, J. K. des Fontaines, Stuart Durant, Sir Brinsley Ford, Godfrey Goodwin, Basil Gray, Richard Green, Dr Katherine Hall, John Harris, John Harvey, Professor Francis Haskell, Mr N. Higson (of the Brynmor Jones Library, University of Hull), Mrs M. L. van Hoeven, Dr Oliver Impey, Professor Lee Johnson, Mrs Mary Links, Dr Derek Linstrum, Sir Oliver Millar, Richard Ormond, Dr Aileen Ribeiro, Basil Robinson, Peter Rose, James Ryan (of Olana, New York), Professor James Sambrook, Colin Sorensen (of the London Museum), Kevin Stayton (of Brooklyn Museum), the Rev. Peter Stirk, Sir John Summerson, Margaret Swain, Glen Taylor, David Walker and Dr David Watkin. I also wish to thank the staff of Southampton University Library, especially Phil Wilkinson. The Fine Art Society, London, and especially Peyton Skipwith, have been most helpful, as have Dr Michael Rogers of the British Museum and the staffs of the Hispanic Society of America, New York, the India Office Library and Records, London, Leighton House, London, the British Architectural Library (Drawings Collection), the Ashmolean Museum, Oxford, the Fitzwilliam Museum, Cambridge and the Art Gallery, Southampton.

Many members of the Victoria and Albert Museum staff have patiently answered my questions, particularly Donald King, Michael Archer, Veronica Murphy, Linda Parry, Roger Pinkham, Nathalie Rothstein, Clive Wainwright and Oliver Watson: I am grateful to all of them. All errors that remain are, of course, mine.

Acknowledgements for most of the photographs are given in the captions. Illustrations for figures 4–6, 8, 9, 12–14, 18, 20, 21, 26, 28, 31, 40, 49, 50, 67–69, 71, 74, 95, 104, 105, 109, 110, 114, 125 and colour plates III and VII are reproduced by courtesy of the Board of Trustees of the Victoria and Albert Museum. I am grateful to Her Majesty The Queen for permission to reproduce the Hampton Court picture *A Woman in Persian Dress*, and the Wilkie portrait. I received kind help with illustrations from many people, including Briony Llewellyn, Dr Diane Chalmers Johnson, Professor Allen Staley and David Vyvyan-Robinson. The Royal Commission on the Historic Monuments of England (National Monuments Record) supplied photographs for figures 55, 117 and 119–23, and that of Wales for figure 118. Oxford University Press kindly gave permission for figures 7, 9, 11 and 104 to be reproduced.

I am most grateful to the British Academy for their generous grant. I would also wish to thank the Advanced Studies Committee of the University of Southampton for a grant towards the cost of illustrations, and my publishers and their advisors for their help and courtesy.

Finally I would like to thank Mrs Barbara Thomas and more recently Mrs Margaret Hague for their heroic typing of an unruly manuscript, and Mrs Christine Hardwick of Southampton University Library for compiling the Index.

28 August 1985 JOHN SWEETMAN

Introduction

This book has grown out of an interest in the English 'orientalist' painter, John Frederick Lewis, an unconventional and unmoralising Victorian, whose almost exclusive concern from early middle age was to paint the life of Cairo.

In recent years, the old-established term 'orientalist' has come to be applied to European artists, particularly those of the nineteenth century, who used Eastern themes as the starting-point for their work. Some did this in the imagination only, but a greater number – Lewis was among them – based their inventions on actual experience, turning their backs on their own artistic upbringing and an increasingly urbanised Europe to seek out the alien and mysterious qualities of Middle Eastern life and desert expanses. There were many orientalist artists, especially in France, and their work was popular, providing a welcome extension of the traditional subject areas of European painting and evoking a degree of fantasy in a period of growing materialism. We in the late twentieth century, when the Middle East has itself become caught up in the commercial and economic scramble of the shrinking world, can respond to the same urges, and clearly reflect them in our regard for the Arab paintings of Lewis, Delacroix and Gérôme, the book illustration of Dulac and Nielsen, and Art Nouveau letter forms with the elongations of Islamic calligraphy.

The unsympathetic may indeed view nineteenth-century orientalism in painting as a symptom of a Romantic cult of excess; as a flight into a world of superfluity and indulgence in which make-believe Chinese tea-pavilions are replaced by harems and Persian rose-gardens; as a kind of virulent chinoiserie run to seed. The vigorous classical tradition of the West has encouraged this assessment. This tradition has, of course, conducted a magnificent celebration of the nude human figure, often not without regard for the erotic. The light-filled distances of Claude's Roman landscapes and the elegiac scenes of Poussin (*Et in Arcadia Ego*) yielded a powerful imaginative release. But in its public, didactic role, concerned with the activity of man imposing order on his surroundings and the artist as a specially gifted and socially useful imposer of order and improver of virtue, the classical tradition has, in theory, tended to reject the idea of art as escape. To the classical purist (if he has survived the punishing twentieth century), the orientalist picture, concerned with alien traditions which the Western artist has approached, nomad-like, from outside, can easily appear frivolous, or at least no more than an eccentricity.

While it may be conceded that the harem subjects of the French classical artist Ingres are to some degree eccentric, even such a purist will agree that they are certainly not frivolous. One of the most enterprising small exhibitions to be seen in Britain in recent years, David Carritt's *The Classical Ideal* (1979), contained, alongside images of classicism extending from ancient Greek vase-painting to

Picasso, a gouache variant by Ingres of his harem scene, *Odalisque with a Slave* (1839, Fogg Art Museum, Cambridge, Mass.), which looked completely at home in the bracing company of a selection of works concerned with the human form.[1] The deep associations for Ingres of the female figure, in particular, enabled him to evoke the harem subject without going East: his pictures of reclining odalisques are explained today – no doubt rightly– as providing an opportunity for exercises in *volupté*, and placed in the tradition of Titian's paintings of Venus. Beside Ingres, much later orientalist painting, by artists who specialised in it, may look slight. But is the view of it as a kind of limp *fin de siècle* fad at the opposite pole from the clear-cut rigours of classicism – an agreeable frivolity bodied out of nothing more substantial than a desire to escape – really adequate? This book is written in the belief that it is not.

Such a view ignores the long exposure of Europe historically to widely varied visual ideas from Islam. The nature of this exposure and its strength in relation to Britain and America is our subject, though we shall constantly be aware of France also. The period under review extends from what was very much a time of expectation and new beginning – the onset, about 1500, of the challenge of the Renaissance to the French and English – to the twentieth century, taking in not only painting but also the applied or decorative arts of pottery, metalwork and textiles, and architecture, in which fields the Islamic or Muslim world had such important ideas to put forward. The countries involved are Turkey, Persia, Syria, Egypt, Moorish Spain and Morocco, and the areas of northern India (now largely represented by Pakistan) where Islam has flourished. Despite the recent interest in nineteenth-century painting of Middle Eastern subjects, the broader field has received little attention, far less than the related topic of chinoiserie. Neither Hugh Honour nor Oliver Impey in their books on European chinoiserie give more than passing reference to Islamic art as a source of inspiration; the book *Chinoiserie* by Madeleine Jarry keeps almost exclusively to the influence of China.

It is as well to make clear at the beginning where in fact our theme stands in relation to 'chinoiserie'. As a blanket term this refers to the Western imitation (more strictly emulation) of Eastern decorative art, mainly that of China but extending to embrace that of Islam also: firm distinctions about exact geographical origins were seldom made by the imitators. China, however, prevailed as an imaginative stimulus, and the study of chinoiserie, in rightly observing this, has tended to obscure the differences between the Chinese and Islamic traditions as sources of inspiration in the West, and the circumstances in which they were available in the Renaissance and post-Renaissance worlds. These differences are considerable and revealing.[2]

To see this we have to consider the images of China and Islam in Europe. Though traceable from the Middle Ages, the Western imitation of Chinese art was at its peak in the late seventeenth and mid eighteenth centuries, when immense quantities of articles from the Far East, especially the brilliant material called 'china' or porcelain, were being imported by the European East India Companies trading with China, India and the ports of South-East Asia.

The main period of chinoiserie, coinciding with the rococo style in decoration of about 1750, was in fact when many Europeans, tiring of the formalities of high classicism and baroque, were looking for a more unbuttoned, if not frankly informal art. The asymmetries and mobile line of Chinese porcelain painting readily combined with rococo ingredients – shells or rock-work, for example – to supply exactly what was needed, and there is undoubtedly much truth in the view that European work based on Chinese decorative ideas, and exemplified in such objects as German or English porcelain figurines in Chinese dress, stopped

tout court at the point of registering a sense of sheer gaiety and frivolity. This was not perhaps surprising: despite considerable attentiveness on the part of eighteenth-century Western philosophers to the accounts of travellers who had followed in Marco Polo's footsteps, and to those of Jesuit missionaries, understanding of Chinese ideas was inevitably limited at the time. In art the very remoteness of China encouraged free invention and a light-hearted acceptance of what little was accessible.

Chinoiserie, therefore, was propelled forward by an idea of what China was felt to be like: an idea made potent by distance. With the Islamic countries, however, we are literally and metaphorically on very different ground. Islam adjoined Europe and in the case of Moorish Spain (eighth to fifteenth centuries), Sicily (tenth to twelfth centuries) and the Turkish-occupied Balkan area and Greece (fifteenth to nineteenth centuries) was actually part of it. Christianity, which had taken root in Europe, had originated in the Near East, in a country where the Dome of the Rock nevertheless came to perpetuate Muslim belief. The builders of Rome, the heartland of European classicism before the intellectual rediscovery and reassessment of Greece in the eighteenth century, had also built extensively in the deserts of Asia Minor, Syria and North Africa. In Constantinople (Roman Byzantium), Roman power had had an Eastern counterpart. In 1453 the shock-waves of the capture of Constantinople by the Ottoman Turks spread over Europe to distant England, and a London chronicler recorded: 'Also in this yere . . . was the Citie of Constantyn the noble lost by Cristen men and wonne by the Prynce of Turkes called Mahomet.' The Grand Turk became for Europe the scourge of God. Yet Ottoman Turkey's military threat to Europe until the end of the seventeenth century was more than offset by the fascination of Constantinople as a city where Roman, Byzantine-Christian and Muslim architecture stood side by side.

There were other factors, less momentous but still important. There was the strategically placed presence of medieval and Renaissance Venice, continuously purveying Byzantine and Islamic design to the rest of Western Europe. There was the large number of Middle Eastern textile centres and markets which gave their names to European languages: in England we have only to think of damask (Damascus), muslin (Mosul), or fustian (Fustat). There were the ceramic insets (*bacini*) in the walls of medieval Italian churches and public buildings. There were Arab horses, admired the civilised world over: Stubbs's paintings of them in the eighteenth century – with their brilliantly observed attendants – show us why. In literature there was no serious Far Eastern rival to *The Arabian Nights*, known to the English in the eighteenth century in Galland's French version of 1704–07, and in the nineteenth in Lane's English translation of 1838–40 (also expurgated) and Richard Burton's English version of 1885–8. 'Aladdin, or the Wonderful Lamp' – one of the most popular of all stories – became a pantomime at London's Covent Garden in 1813. Fitzgerald's translation of *The Rubáiyát of Omar Khayyam* of 1859 in itself made an immense contribution to the European vision of Persia.

It is true that Persia itself and Arabia, which had given birth to Islam, remained relatively remote – though increasingly explored by the nineteenth century – and the oriental tastes of romantics like William Beckford were fed by an idea of what the East might be like rather than by actual knowledge. But by virtue of all the factors mentioned above, so various and in some cases so deep-running, we would expect Islam to make a more complex and insistent disturbance on the Western consciousness, on many levels, than China, powerful as the emanations from that country were. In Britain's case we also had British power being established in a heavily Islamicised Bengal in the late

eighteenth century, which brought about the close mutual acquaintance of Eastern and Western traditions.

In spite of this particularly British link with the Muslim world, it may be wondered whether Britain and America deserve special consideration in the context of Islamic influence in art. Surely Europe as a whole should be included? France, Holland, Portugal, Sweden and Denmark all had strong trading links with India in the eighteenth century: the English did not have the prerogative of patronage there, as the collecting activities of Swiss-French soldier Colonel Antoine Polier show. France, moreover, developed close relationships with Algeria and Morocco in the eighteenth and nineteenth centuries which powerfully fostered artistic contacts. Spain, virtually rediscovered by the post-Waterloo generation, had an ebullient Moorish culture within its borders and had been importing and making carpets with Islamic patterns for at least 700 years previously. Trade in Islamic carpets during the late Renaissance period had developed strongly in many other countries besides England. Distinguished imitations were made, notably in Flanders and Poland (many of these armorial, like those in England). The Isfahan carpets shown by Count Czartoryski at the 1878 Paris Exhibition were indeed wrongly taken to be of Polish manufacture. And Turkish art, like Turkish arms, was so intimately part of European experience that Alexandrine St Clair's useful work, *The Image of The Turk in Europe* (the catalogue of an exhibition held in New York in 1973) contained virtually no examples of work with English connections.

It might be further claimed, with some justice, that the French made more creative use of Islamic subject-material in painting than either Britain or America. Delacroix's visit to Morocco in 1832 was an unforgettable experience for him. And which English or American artist who visited Islamic lands can match the importance of Delacroix? Did not Ingres, who never visited Turkey, characterise the scented languors of the harem more memorably than any Englishman who did?

It is true that we shall not be concerned here with the process by which new material is transformed by first-rank European artists, achieving a deeply imaginative and affecting accommodation of that material to their own inherited traditions, in the way that an Arab horseman by Delacroix accommodates his first-hand experience of the original to his predilection for Rubens. But the absence in our context of front-rank artists by European standards is not the same as saying that no imaginative leaps were made: indeed the leaps of artists of narrower range may be more purposeful because less beset by the Hamlet-like distractions of added awareness.

On the (by these standards) less exalted levels of the applied arts, the activities of the English invite careful attention. The entrepreneurial roles of the English East India Company in the seventeenth and eighteenth centuries, and of Britain and America in the world of international exhibitions in the period from 1850 to 1920, have become clearer in recent years. The part played by the English-speaking countries in the rediscovery of the Alhambra at Granada in the 1830s has, however, never been evaluated: written about by the American Washington Irving in 1832 and by the English designer Owen Jones (outliving his French collaborator) 10 years later, the influence of this building on the reassessment of the qualities of Moorish pattern has its importance in the history of taste.[3]

The intention, therefore, is to explore these matters and to concentrate on developments in the English-speaking world from the end of the Middle Ages. Nevertheless it is important to take note of the many preceding centuries during which Islamic motifs were woven into the texture of European classicism and

Gothic, and thus become part of a common inheritance. These events have been admirably chronicled by Jairazbhoy.[4] Arabesque ornament is of crucial significance and will be discussed in chapter 1. Three aspects may be singled out briefly, however, for mention here: the contributions of the Islamic cultures of medieval Spain and of medieval Sicily; the immense significance of Islamic textiles in medieval Europe as articles of luxury as well as usefulness; and the matter of calligraphy.

The role of the Moors in Spain will occupy us in chapters 1 and 4. By the beginning of our period, this deeply artistic people had been officially expelled from Spain: the power of the Nasrid house was ended in 1492, but the Moorish influence – and presence – was to endure. That presence, established since the eighth century, had become inextricably intermeshed with that of the Spanish: the extent of the work done in Christian churches by Mudejars – Muslims working for Christian employers – is still obvious in such places as Seville, Saragossa and as far north as Burgos. Records speak of woven carpets being taken to England by Eleanor of Castile in 1255 on her marriage to the future Edward I. In 1289 a Spanish ship brought Moorish lustre pottery to the same queen, and in 1303 lustre pieces are recorded in Sandwich, Kent.[5] Lustre-making was continuing in Christian Spain 100 years after the official expulsion in 1492, and Moorish tin-glazes (and, to a notable though lesser extent, lustre) were to influence Italian maiolica within the period of this book.

Apart from events in Spain, the Muslim presence in Sicily (tenth to twelfth centuries) made the island a crucible for East–West artistic relations and in due course the subject of investigations by nineteenth-century designers and writers, as we shall see in chapter 5. Links in the twelfth century between King Roger II of Sicily and France included the Abbey of Cluny, where lived a grandson of William the Conqueror, as Boase records, who was to give an Islamic carpet to an English church.[6]

Besides these particular channels of supply, the import of Islamic textiles in general into medieval Europe created an incalculable sense of regard for them. This applied especially to carpets and silks. While the origins of carpet-making point back many centuries before Christ to the remote region of the Altai (in modern Siberia) and the knotted carpet long antedated Islam (the celebrated Pazyryk carpet now in the Hermitage, Leningrad, dates from the fifth to third centuries BC, and representations of carpets occur in the art of Achaemenid Persia), it was in Islamic Turkey and Persia that this form of artistic and functional expression found its most remarkable development. At some date still to be established, Islamic carpets began to be made on mainland Europe. According to the twelfth-century Arab geographer al-Idrīsī, woollen carpets were being made in his day at Chinchilla and in Murcia, both in Spain, and exported to 'all countries'. The *tapis Sarrasinois* was known in the France of Louis IX, and in 1277 there were trade privileges for it in Paris. In the fourteenth century woven Islamic hangings were prized in Arras. Silks too were by then a precious part of church treasuries: a cope from Mamluk Egypt inscribed in Arabic with the words 'the learned Sultan' was in St Mary's church, Danzig, early in the same century.[7]

While ceramics and textiles were to carry Islamic ideas across the breadth of medieval Europe, the specialised art of calligraphy, central and sovereign to the Muslim scribes of countless Korans, has also been shown to have aroused keen interest there in the period before 1500. In the forms of Arabic script – the angular Kufic and the cursive Nashki – a vehicle of rare rhythmic power had been created. As long ago as 1845 Longpérier drew attention to the use of Kufic forms in French manuscript border decoration and the carved wooden doors of Nôtre Dame de

Puy, and numerous art historians, including A. H. Christie, Joan Evans and Kurt Erdmann, have noted other medieval instances, the last-named pursuing the transformations of Islamic script into almost unrecognisable ornament.[8] The catalogue of the 1975 exhibition *Islam and the Medieval West* at Binghampton, New York, edited by Stanley Ferber and including articles by himself, Richard Ettinghausen and others, also examines the phenomenon. Recently Sylvia Auld has produced interesting arguments in favour of the use by the Italian painter Gentile da Fabriano of more than simply decorative Kuficizing forms (they occur in the haloes) in his 1423 *Adoration of the Magi*, painted for a Florentine patron, Palla Strozzi, at a time of active trade between Florence and Egypt.[9] Later in the century (1479–80), the Venetian artist Gentile Bellini visits Constantinople and includes calligraphy in his delightful gouache painting of a *Turkish Boy* (Isabella Stewart Gardner Museum, Boston).[10]

A writing tradition which employed rhythmic forms to express both meaning and ornament in large-scale contexts (notably in architecture) differed appreciably from that of Europe where calligraphy was far more restricted in its uses. But the long exposure of European eyes to Islamic script and inventions based on it by Muslims and Europeans alike, in metalwork, lustre pottery, textile borders, bookbindings and paintings, is a factor to reflect upon as we enter our period, and again later, when we meet explicit Koranic inscriptions in the nineteenth-century Arab Hall of Lord Leighton, a few years ahead of the galvanic spread of Art Nouveau across the whole spectrum of design in modern Europe.

We begin, therefore, at 1500. The following chapters focus on successive periods thereafter, including the two all-important phases 1750 to 1820 and 1820 to 1900. Near the end of the first phase comes the most familiar of Islamic-style buildings in Britain, the Royal Pavilion, Brighton. Delightfully frivolous perhaps, and a direct descendant of the eighteenth-century chinoiserie which had represented the recoil from Roman *gravitas*, but the dismissive charge of frivolity cannot explain later developments of the nineteenth century, such as John Frederick Lewis's deeply considered paintings of Cairo and Constantinople; Owen Jones's masterly exposition of the geometrical complexities of Moorish patterns: or William de Morgan's patient researches into Persian glazes. Nor can it explain the calm and fascinated interest of Christopher Wren, more than 100 years before the Royal Pavilion, in the relationship between the 'Saracenic' style of architecture and Gothic. It certainly cannot explain the prevalence and persistence, from a period nearly two centuries earlier still, of that form of flowing decoration known as the arabesque, which is absorbed into European Renaissance ornament in the sixteenth century, to emerge again distinctively in the nineteenth.

Christopher Wren lived for some years in London in a house which was called by the sign of the Saracen's Head. The fact is without importance for an understanding of Wren: but the penetration into English society of the iconography of the Saracen to a level that could hardly be more popular, that of the painting of house or inn-signs, is of more than passing interest. Samuel Chew in *The Crescent and the Rose* has shown how the depicting of a human face of exaggerated redness as the type for signs bearing this name was reflected in sixteenth-century literature.[11] The image of the Saracen as a figure of excess was a powerful conditioning factor in the period of our study. It was inherited from the Middle Ages and the time of the Crusades that began in 1095. The early twelfth century was a particularly formative phase. R. W. Southern has explained how a fictionalised image of Mahomet as Sorcerer and Antichrist grew up in Europe in this period, and was elaborated and exaggerated according to expectations as to

how such an enemy of Christendom might behave.[12] The associated vision of the Saracen as a figure of extremes – excessive in zeal, in cruelty, in sensuality – is one that we see enduring to the time of Dr Johnson and beyond.

But the image of the Saracen as a figure of excess is not the only one that is relevant to us. When we reach Dr Johnson's time in the later eighteenth century, we shall also find the classically educated critic Horace Walpole paying appreciative attention to Muslim weapons and other relics reputedly brought back from the Holy Land by a crusader ancestor. The gesture reminds us of the intimate relevance of the products of the Islamic world to the notion of chivalry that had grown up in Western Europe at the time of the Crusades. The code of chivalry represented an ideal of behaviour, a yardstick against which to measure personal conduct and by implication the baseness of infidel conduct (although medieval chroniclers and poets recognised that chivalrous actions could be performed by the Saracen).[13] In a classic study, Huizinga wrote of chivalry as the outcome of the need of warlike aristocracies for an 'ideal of manly perfection'.[14] There were two aspects of Western chivalry. One held up by the ideals of purity and asceticism: the other stressed combativeness and the pomp and pageantry of the tournament. In respect of military display (notably their splendid tents), the Turks enjoyed a high reputation. The idea of crusading against Islam still remained a challenge in the fifteenth century just before the start of our period: as the modern critic Cartellieri wrote of the Renaissance, 'the crusading fever left no rest to princes and people, to thinkers and poets'.[15]

Later in the seventeenth century, when Turkish arms ceased to threaten Europe, the religious challenge lost some of its urgency, but the continuing regard for the Holy Land meant it could not disappear from view. By the Romantic period of the early 1800s, when the ideal of the medieval hero forms the stimulus for so much creative work, Saracenic elements in the concept of chivalry play a role of some interest. In 1825 Sir Walter Scott produced his novel *The Talisman*, concerned with the Third Crusade of Richard I of England against Saladin (Salah-al-Din, 1137–93), the Arab ruler who in his own time had come to be admired by his Western enemies as much as by his own subjects. In this widely read work, Scott drew a sharp picture of how, for him, the attitudes of Christian and Saracen, of Kenneth, the Christian Knight of the Couching Leopard, and the Muslim warrior Sheerkohf, appeared to interrelate. Each represented a 'superiority', yet two different kinds of superiority:

the same feeling which dictated to the Christian knight a bold, blunt and somewhat careless bearing, as one too conscious of his own importance to be anxious about the opinions of others, appeared to prescribe to the Saracen a style of courtesy more studiously and formally observant of ceremony. Both were courteous; but the courtesy of the Christian seemed to flow rather from a good-humoured sense of what was due to others; that of the Moslem from a high feeling of what was to be expected from himself.[16]

The orders of medieval Islamic knighthood that are defined by the term *futawwa* preceded their Christian counterpart. *Futawwa* conveyed a notion of a spiritual path in a particularly intense and personal form, a durable symbol of which was the Muslim two-edged sword, bearing its Koranic inscriptions and tracing its origin back to that of 'Ali, the cousin and son-in-law of the Prophet himself.[17] Scott had no serious concern with the history of Islamic chivalry, but he was clearly at pains to distinguish his Saracen knight's conception of it. His description also suggests the appeal for him of an individual who saw courtesy as a function of his own self-respect.

Contending traditions of chivalry, then, will certainly have added a gloss – more attractive in the Romantic age when the old, stark antagonisms were less

clear-cut – to the fascination of Muslim military trophies which Crusaders had brought back with them. Another specifically European ideal of human conduct – that of the Renaissance 'complete man' – was also susceptible to the attractions of Islam, on grounds less of rivalry than of desire to be different. It is manifest most obviously in matters of dress. The recipe for the man of balanced accomplishments and polish given by the influential Baldassare Castiglione's *Il Cortegiano* (1528, translated into English as *The Book of the Courtier* by Sir Thomas Hoby in 1561) significantly notes the nonconformist presence of 'them also that will clothe themselves like Turkes'.[18] We need not linger over this now; but we shall be conscious as we go forward through our period of the many who feel the same urge. This will be most notable when we come to the eighteenth-century 'Age of Reason'. Lord Clark called it a 'winter of the imagination', but even without his metaphor we might suspect that the wearing of turbans could be a practical means of securing warmth for many of the century's nonconformists, and might remain so. At a deeper level too, the Rousseauist and Romantic vision of 'natural man' invites attention in the context of Islamic influences. How could the sophisticated cosmopolitan European of the late eighteenth century, aware of his past and of his culture, become the 'natural man' that Rousseau advocated? Could he be both sophisticated and natural if he followed other models – the Arab perhaps? For the moment we may merely note one very sophisticated rejecter of convention, Disraeli's Lord Alhambra, in *Vivian Grey* (1826–7). With his 'Mameluke' boots, he was a late example of the breed referred to by Castiglione. '"Why, Ernest Clay", said Mr Buckhurst Stanhope, "I thought Alhambra wore a turban; I am quite disappointed." "Not in the country, Stanhope; here he only sits cross-legged on an ottoman, and carves his venison with an ataghan".'[19]

Excess; a rival discipline; freedom from one's own discipline: the Muslim could evidently represent all of these to the European. And to the nineteenth-century Romantic passionately interested in the motives of the Hero, all these notions were important. The life of Delacroix is the story of his attempts to reconcile them. Byron – one of the pervading influences on Delacroix and himself well travelled in Muslim societies – hailed the contemporary Ali Pasha, in a letter, as a 'Mohammedan Buonaparte', cruel but mighty; Carlyle, in *Heroes and Hero-worship* (1841), dwelt deeply on the sincerity of the Prophet himself.

In a recent study, Edward Said has expounded a view of orientalism as an artificial creation formed as a buttress to Western self-esteem. Writing of the 'Suez Canal idea' of 1869, carried through by Europeans, Said sees this as

the logical conclusion of Orientalist thought and, more interesting, of Orientalist effort. To the West, Asia had once represented silent distance and alienation; Islam was militant hostility to European Christianity. To overcome such redoubtable constants the Orient needed first to be known, then invaded and possessed, then re-created by scholars, soldiers, and judges who disinterred forgotten languages, histories, races, and cultures in order to posit them – beyond the modern Oriental's ken – as the true classical Orient that could be used to judge and rule the modern Orient. The obscurity faded, to be replaced by hothouse entities; the Orient was a scholar's word, signifying what modern Europe had recently made of the still peculiar East.[20]

This is an interesting if debatable thesis which in the visual arts – an area of activity which Said does not treat – is especially worth pondering. Certainly we find in Europe in the period of the Renaissance and the great age of exploration an immense enhancement of the European's sense of personal esteem and self-possession: and this is clearly true of the European artist, especially the exponent of the 'fine' arts of painting and sculpture. The classical tradition, revitalised at that time, continues to maintain this sense of the status of the painter and

sculptor well into the early twentieth century. It simultaneously consolidates the authority of European man, his person, personality, achievement and potential, as the centre of the artist's attention: the spiritual universe which he feels bound to celebrate in his most serious work. The two factors make a formidable combination, which until late in this period assigns the decorative or applied arts of ceramics, metal and textile to a very much lower station.

On the face of it, an artistic tradition like that of Islam – manifesting to Western eyes a preoccupation with decorative effect in painting as well as in ceramics, metalwork and textiles – might seem to have little beyond the superficial to offer the European practitioners, except for a few maverick performers who were specially disenchanted with their own heritage.[21] Put in these terms the argument of the classical purist with whom we started begins to look plausible. But Western man's sense of superiority may not always have been so blinkered. Thomas Roe, English Ambassador to the Mughal court in 1616, may have been the first Englishman to feel a twinge of doubt when he was handed superlative copies, made with European chiaroscuro but by Mughal artists, of a miniature portrait of Isaac Oliver – a story to which we will return later. His overall verdict on the native tradition of Mughal painting was to be slighting, but if the Muslim could 'equal' the European on his own ground, might not the time come when he would tempt the European artist to step, unprejudiced and with genuine openness of heart, on to his own? Rembrandt never went East, but his copies of Mughal miniatures obtained on the Amsterdam market in the mid seventeenth century suggest the extent of his search for an experience that the art of his own continent could not give him. When we come to Delacroix we feel the same attentiveness, now accorded to the lives and colourful backgrounds of Muslims studied at first hand. By the late nineteenth century we have the fact that an ambitiously realised 'Arab Hall', decked with tiles collected in Damascus and matched with considerable effort by de Morgan at home, came to be built at the heart of the Holland Park home of the famous Lord Leighton, Eastern traveller but also central product in his time of the European figure-painting tradition and President of the Royal Academy from 1878 to 1896. In America, a new continent with related but distinctive artistic traditions, there is the phenomenon of Frederic Church's Olana: the 'Persian'-style residence built above the Hudson by a successful painter of American landscape in the same years as Leighton's Arab Hall. Clearly, in order to account for the appeal of Islamic design to these artists, the inter-relationships between the 'fine' and the 'decorative' arts in Britain and America in this period must be scrutinised, and that is one of the objects here.

We are concerned, therefore, with an exploration of the effects of the motifs of Islamic art, and the influence of the life and associations of Muslim peoples, on the art of the English-speaking world. Throughout the book, we shall constantly be concerned with classicism, as the parent mode of European art, fecund, ordering, yet liable to take discipline to extremes, and orientalism, at first sight so given to excess, but offering to those enquiring figures who took it up an alternative and fortifying classicism of its own.

1500 to 1600:
THE GROWING IMPETUS

I

In the late fifteenth century European curiosity about Asia was entering a new phase: the great age of exploration. In 1492 the Italian-born Columbus set out westwards on his first journey in search of the Cathay that Marco Polo had described 200 years before. In the winter of 1497–8 the Portuguese Vasco de Gama became the first to sail round the Cape of Good Hope: he reached India in the following April. But though the Portuguese achieved an early dominance in the increasing sea-trade with the Indies, in the next 100 years the Dutch and the English became serious rivals. Efforts to discover alternative routes to India and China continued, notably by way of the Northwest Passage. Throughout the sixteenth century European traders and trading companies were seeking to develop new links with Turkey and Persia. Furthermore, Portuguese (from 1523), Venetians, Dutchmen and Englishmen are all recorded using the overland route from the Levant to the Persian Gulf, which went via the great Syrian trading centre of Aleppo and along the line of the Euphrates to Basra. John Newberry in 1580 may have been the first Englishman to undertake this short-cut to India, which retained its popularity 200 years later, especially among the British whose power was increasing in the sub-continent. We shall notice some of Newberry's successors later in this chapter.[1]

While Europeans were pursuing their journeys by sea and land in search of the wealth of the Orient, Ottoman Turkey in the sixteenth century was looking southwards as well as westwards into Europe itself. This was the great age of its power and vitality. Originating as a tribe in central Asia but driven west by the Mongols in the thirteenth century, the Ottomans had settled in Anatolia and, under a succession of vigorous rulers from the time of Osman (1299–1326) onwards, had extended their power over the Balkan peninsula by 1389. Having overwhelmed Constantinople in 1453, they assailed the forces of the Mamluk Sultans of Syria and Egypt in 1512 and took possession of Cairo. Under Sultan Süleyman (1520–66), called by Europeans 'the Magnificent', the Turks pressed forward to Belgrade, established a presence on Hungarian soil and by 1529 stood outside Vienna.[2]

Contemporary with these events was another figure of some magnificence and military prowess, Francis I of France (reigned 1512–47), who had emerged at the opposite end of Europe. In 1535 he established special trading agreements with the Ottomans. ('Frank', the Muslim word for West Europeans (*ifranj*) at least since the early twelfth century, again enjoyed great vogue in Turkey through the French connection.) In the same years the word 'Turkey' was becoming familiar in Henry VIII's England through the importation of carpets.

We do not have to look long at Tudor portraits before becoming aware of the contribution made by Islamic carpets to their effectiveness. Western enjoyment of depicting these objects in painting is commemorated by the fact that we speak of 'Holbein' and 'Lotto' carpets, named after two of the foremost sixteenth-century portraitists whose sitters posed with Islamic rugs beneath their feet or draped over furniture. A magnificent example fills the centre of Holbein's double portrait, *The Ambassadors* (1533), in the National Gallery, London. The striking patterns of these carpets become so familiar to Europeans in the intervening 500 years that it is hard to imagine a time when they had the force of novelty. Dr Beattie notes that in England the history of the oriental carpet begins 'somewhat abruptly' in 1518 with a request for carpets from Venice by Cardinal Wolsey.[3] Islamic ideas of ornament had been transmitted in the textile arts through the Middle Ages: in the sixteenth century, however, there is a vast growth of awareness of the Eastern carpet due to increased trade, the demands of comfortable living and recognition of Muslim superiority in this area of production. What China was to be for the West in porcelain, Persia and Turkey were to be in carpets. Both products answered a taste for luxury and the modernity of luxury. The phenomenon of the Islamic carpet in this period, therefore, provides us with an obvious point of departure.

In the catalogue of the exhibition *The Eastern Carpet in the Western World* (Arts Council 1983), Donald King observes that although the late medieval and early Renaissance period found Europe frequently engaged in hostilities against the Near Eastern carpet-producing countries, fruitful diplomatic and trade exchanges nevertheless took place. There is abundant evidence of the presence of Islamic carpets in Europe in the fifteenth century, because they unmistakably appear in Italian paintings.[4] Early sixteenth-century European documents refer to *tapedi damaschini*, but Cairo rather than Damascus is now believed to be the place of origin for most of these. The manufacture of carpets in the fifteenth century for the Mamluk court in Cairo continued after the conquest of Egypt in 1517 by the Ottoman Turks, using Ottoman styles.[5] An export trade developed with Venice where documents speak of *tapedi ciaiarini* (carpets from Cairo). Other carpets, including rugs from more distant Persia, or from India, might enter Europe more cheaply through Portugal and Islamic Spain where Near Eastern textiles had been imported since medieval times. In sixteenth-century Europe, however, Turkish designs carrying traditional patterns of the previous century from Anatolia (especially the region of Ushak) and from Egypt evidently exerted a considerable power of attraction (Figures 1–3). Oriental carpets could be expensively bought in Venice, or acquired as diplomatic gifts. In England, leaving aside sporadic examples such as those noted in the Introduction, the despatch to Cardinal Wolsey in 1518 of seven, then in 1520 of 60 'Damascene' carpets from Venice provides the first firm evidence of the presence of oriental rugs.[6] The scarcity of these rugs[7] is suggested by the length of Wolsey's wait of two years for the larger consignment. Henry VIII, however, owned many: his inventories contain over 400 entries which refer to carpets of 'Turkey making'.[8]

Wolsey's rugs came overland via Antwerp, but Hakluyt records that English ships brought such rugs direct from the Levant. In 1579 the elder Richard Hakluyt laid down an instruction to the dyer Morgan Hubblethorne to go to Persia to study dyeing methods and bring back 'a singular good workman in the art of Turkish carpet making'.[9] There is no record that he managed to persuade one to come. At this time England was hoping to establish trade with Persia through Russia. Also in 1579, Anthony Jenkinson was bringing a consignment of goods along the Volga which included 'Turkie' carpets: the word, however, was applied

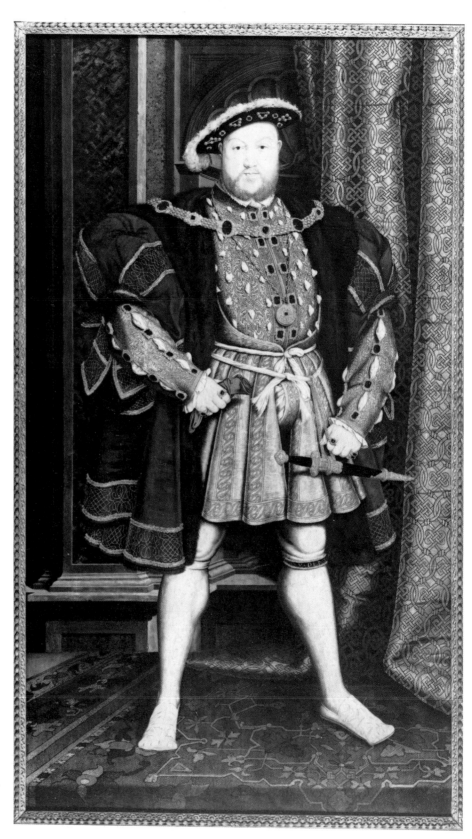

FIG. 1 Unknown artist, after Hans Holbein
(1497–1543), *Henry VIII*. Oil on panel,
239×134.5 cm. Courtesy of the Trustees of the
National Museums and Galleries on
Merseyside
Attributed recently to Hans Eworth, the portrait is
based on Holbein's original of 1537. Arabesque
coalesces with knots in bands along the borders of
the gown and there is Islamic interlacing band
pattern on the curtain to the right. The Star Ushak
rug has a floral border very like that in Figure 2.

to all Eastern rugs (and, often as 'Turkey work', to European imitations of them), and Jenkinson's carpets were probably Persian or Caucasian. Having suffered the loss of some of them near Astrakhan when 'Cossaks' took them as wrappings for their dead, he recovered them, but whether they reached England is not recorded.

Such carpets were placed on tables, chests and walls as display objects, though full-length portraits of the time show us that they were in fact put on floors (this became normal only in the eighteenth century).[10] Henry VIII's inventories include references to 'foot carpets'. Apart from the sense of luxury that they imparted, the two-dimensional patterns, bold stylizations and strong, glowing colours of Turkish rugs – notably the Star Ushaks in which eight-pointed indented star motifs alternate with indented lozenge-shapes – must have been a startling introduction for many to Eastern habits of design, far removed from the naturalism and three-dimensionalism which interested Englishmen were required to accept in the work of Italian Renaissance painters, sculptors and plasterers then working in England. Yet they must also have been much more congenial than Italian work to people whose attitudes were formed by the Gothic

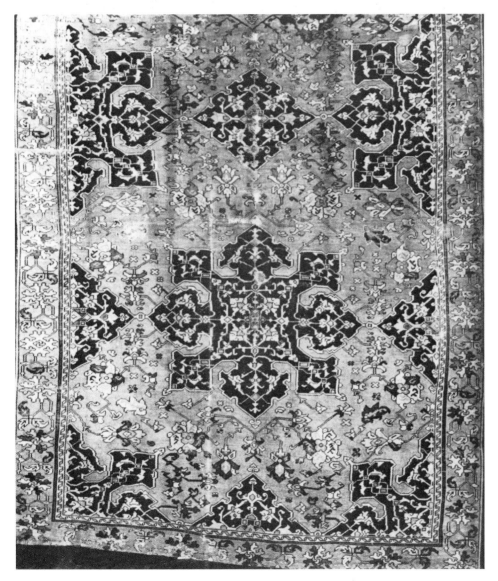

FIG. 2 Star Ushak carpet. L. 322 cm., W. 193 cm. Anatolia, late 16th or early 17th century. The National Trust, Hardwick Hall, Derbyshire. Photograph courtesy Dr May Beattie
A continuous pattern is made up of dark blue, eight-rayed stars alternating with smaller similarly coloured lozenges, on a red ground.

love of linear complexity and rich surface, as revealed for instance in fan-vaulting. Henry VIII had himself portrayed many times with his feet firmly planted on a Ushak rug (Figure 1) and his son Edward VI appears about 1550 standing on a Holbein (National Portrait Gallery).

In the sixteenth century, therefore, it is Turkish-inspired designs which become most familiar in carpets. Remote on its Derbyshire hill when built by Elizabeth of Shrewsbury (Bess of Hardwick) in the 1590s, the new Hardwick Hall became, with its gradually abandoned predecessor, an oasis for such rugs. Thirty-two Turkey carpets are recorded (19 in the main new Hall, 13 in the old) in the 1601 inventory attached to Bess's will.[11] Some of these may still be in the house, but such references as are given in the inventory make proof impossible. The strongest claimant, because of its size, is the great red-ground Medallion Ushak (381 by 782 cm, or 12 feet 6 inches by 25 feet 8 inches), though measurements of the rug and in the inventory do not match. It is possible that Henry Cavendish, Bess's eldest son, obtained it during his stay in Constantinople during the summer of 1589, but there is no mention of carpets in his diaries.[12] Nor is it provable that the Star Ushak at Hardwick (Figure 2) was acquired by Henry: all that can be said is that this type was evidently long in favour in England, as it corresponds closely with that shown in Henry VIII's portrait at Liverpool (Figure 1) and continues in the portraits of Larkin. In other respects the Hardwick archives are more helpful: Dr Beattie points to the book of accounts of William Cavendish (Bess's second son, who inherited Hardwick in 1608 and later became first Earl of Devonshire). This records (p. 145) the purchase in September 1610 of two 'Turkey carpetts' for £13 15s, and gives the price per square yard of 13s 4d. These were prestige possessions but also useful ones: the Hardwick Star Ushak bears inkstains, which prove its function as a table covering.

While Elizabeth I seems to have had less interest in carpets as objects for inclusion in portraits, her successor James I initiated a second major vogue for the practice: several portraits of him exist to prove it. The seven full-length portraits attributed to William Larkin, known as the Redlynch Long Gallery set (now at Ranger's House, Blackheath, London), are all of women. Dating from about 1615 and perhaps having a commemorative purpose (to celebrate the marriage of Elizabeth Cecil to Thomas Howard, first Earl of Berkshire) they constitute the most outstanding surviving series of portraits of the period. Nearly twice as high as they are wide, their verticality is accentuated by the looped curtains behind the gorgeously clad figures and offset by the horizontal borders of the Ushak carpets on which the figures stand. The colours of red, gold, blue-green, white and black which inform the pictures all occur in the carpet designs. Three of the series show the same carpet, which is found in other portraits associated with Larkin (reproduced in Roy Strong's book *The English Icon*, 1969) and which seems to have been a studio prop of the artist. The carpet borders are strictly parallel to the lower edge of the pictures. More than this, the painter of the Redlynch set makes the borders an element in the total design of each picture, which is worked out with the greatest deliberation. In five of the set the figures turn and extend an arm towards their right, in the other two they turn towards their left. In all the pictures we are invited to begin reading the carpet border design in the corner which the figure is turning away from. The design runs across and goes out, incomplete, in the opposite corner. In *Dorothy St John, Lady Cary* (Figure 3), two and a half repeats of the large hexagonal motif take the eye from left to right in the direction indicated by the sitter. The line of the carpet border contains the costumed figure even more tightly in its patterned world: yet from that world, as

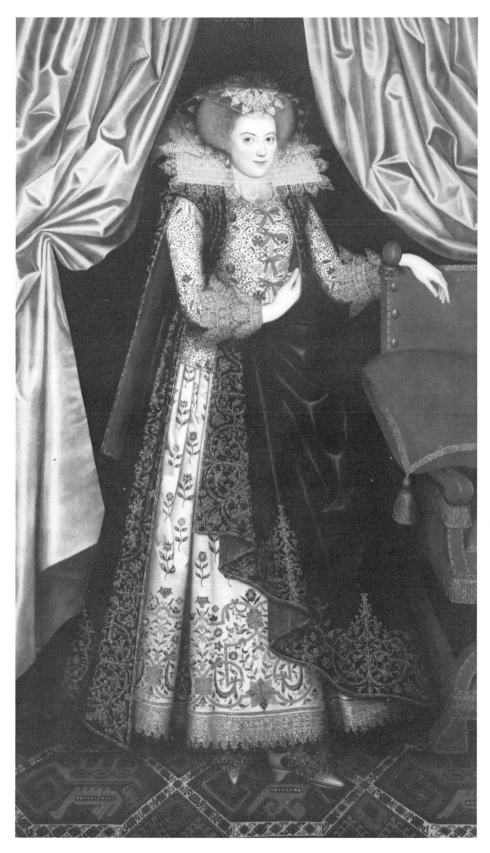

FIG. 3 Attributed to William Larkin. *Dorothy St John, Lady Cary*. Oil, 200.3×115 cm. About 1615. The Suffolk Collection, Ranger's House, Blackheath, London (English Heritage) 79/3343
The brilliant, bedizened figure shares a certain angularity with the sharp-edged pattern of the Ushak rug, the colours of which are also picked up elsewhere in the picture: see p. 14.

with all the portraits in this set, the face makes an unexpectedly individual contact with us. The pictures are a reminder of the double function of such 'long gallery' pieces. Contemporary accounts give evidence of their value in substituting for the real presence of friends. It is also clear that they had a role, in a space used for strolling and exercise, as a decorative enlivening of an inordinately extended wall. The contribution of the oriental carpet border, with its suggestion of endlessly continuing pattern, is positive in such a context.[13]

Before going on we must note three further developments. Two took place well before the end of the reign of Henry VIII's daughter Elizabeth (1603). First, imitations of Turkey carpets began to be made in Europe bearing the arms of English patrons. The Verulam carpet of 1570 at Gorhambury, with the arms of the Queen, may be the earliest, but the group of three matching carpets in the Duke of Buccleuch's collection at Boughton includes a large Star Ushak with the date 1584 and another dated 1585.[14] Secondly, the founding of the Levant Company in 1581 provided a firmer basis for increased trade in carpets from the Eastern Mediterranean. In 1588 five of the Company's ships, including the well-known *Hercules*, arrived in London from Syria with a large cargo that included '13 Turkey carpets'.[15]

Thirdly, after 1600, with the founding of the English East India Company, Indian carpets began to be imported from Agra and Lahore. Carpets 'like those of Turkey' had been in the cargo of the Spanish ship *Madre di Dios* captured by the English near the Azores in 1592, on her way from India. In 1612 an English factory was established at Surat near the coast 500 miles south-west of Agra: in 1619 we hear of 11 packs of Agra carpets being sent to Surat, whence the *Royal Anne* carried 46 carpets to England.[16] (In the same years imports begin through the Company, of Persian silks and Indian calicoes or chintzes, to which we will return later, p. 39).

The carpets of Turkey in particular presented stylisations of natural forms of a bold angularity that was accentuated by the nature of knotting. The element of flow and continuity of line, however, was one of the greatest strengths of Islamic pattern. Tudor portraiture abounds in evidence of this in the detail of costume and textile accessories: but designs of the period, for metal especially, reveal the presence of that flowing, most animatedly cursive element of Middle Eastern ornament, the arabesque.

The sixteenth century was a crucial period in the development of European ornament, in which a language of a multi-racial type was being put together. Muslims were supplying the Venetian market in the early years of the century with damascened brassware (Figure 4) which relayed the complexities of the arabesque in a pure and unequivocal form: a sequence of curving bands, ultimately plant stems, throwing off leaves (stylised Turkish arum leaves with beak-like flourishes) and flowers at intervals, but looping around and over each other to give the overall effect of an ordered mesh with infilling. The measure of the contribution of the arabesque to European ornament is easy to underestimate, as it could be assimilated so smoothly into the language of the Graeco-Roman grotesque, then enjoying enormous popularity in the interiors of buildings being designed in Rome by Raphael and his followers, and using decorative ideas discovered in the excavated palaces of the Emperors. The merging process was, in Peter Ward-Jackson's phrase, a marriage between cousins. Alois Riegl's challenging discovery (set out in his famous *Stilfragen* of 1893), that the arabesque developed from an Islamic adaptation of stem ornament of Greek origin, postulated a common ancestry for both European and Eastern systems. There are suggestive formal similarities, and indications of historical relationships: for

FIG. 4 Dish, damascened brass. D. 42 cm. Venetian-Saracenic, early 16th century. Victoria and Albert Museum 258–1894 Long developed in Byzantium and Sasanian Persia, metalwork enjoyed a flourishing tradition in Islamic countries, notably Mamluk Egypt in the fifteenth century. Mamluk brassware, sometimes signed in both Arabic and Roman script, helped to carry the arabesque across Europe to Tudor England (see Figures 12–14).

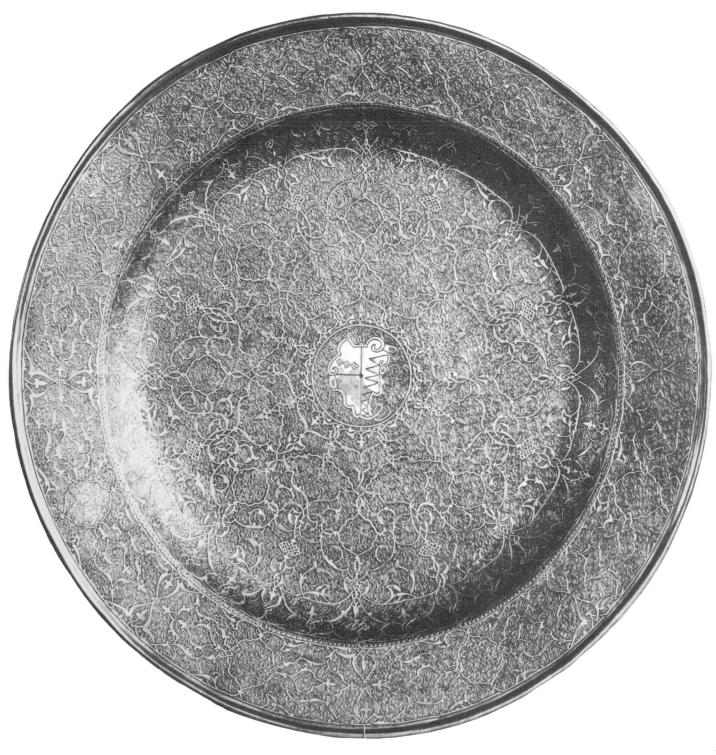

FIG. 5 Grotesque design by Jacques
Androuet Ducerceau (c.1510–85). About 1550.
Line engraving, 10.7×5.8 cm. Victoria and
Albert Museum FF2014
This is typical in its symmetry about a centre line,
diversified by a profusion of contrasting ingredients,
human, bird/animal, vegetable and geometrical. The
third dimension is suggested, but the overall effect is
of light, linear shapes set against a background
plane.

FIG. 6 Unknown Flemish artist. A
cartouche. Line engraving, 14×19 cm. Late
16th century. Victoria and Albert Museum
E2036 – 1899.
Strapwork decoration, deriving from grotesque, also
emphasises symmetry, but there is more
three-dimensional weight in the bandwork
supporting the individual elements: this bandwork
often suggests cut leather. Organic forms are
subordinate.

example, the Turkish term *rumi*, used to describe the interlacing arabesque, may point to an association with Romans (Rum) formerly inhabiting Anatolia. While etymology alone is a fallible guide in such matters, certain formal resemblances give strength to the idea. The coiling Roman foliate motif known as the rinceau is evidently related to the coiling arabesque, and the latter term is sometimes imprecisely used to describe it. But we must also note a vital difference: the rinceau is hardly ever interlaced, whereas the arabesque has interlacement as one of its fundamental characteristics.

The fertilising of European ornament by the arabesque in the sixteenth century, however – as Ward-Jackson has shown[17] – took place at a particularly vital moment. Both the classical grotesque and the type of decoration evolved by the Italians in the 1530s and known as strapwork, though abounding in lively and resourceful invention, indeed a teeming fancifulness, had a basically static character. The grotesque typically used the idea of a vertical stem with side elements leading away from it. The framework created of these verticals and lateral links across a wall surface made it popular in Renaissance Europe as architectural decoration (Figure 5). It could be filled with hybrid assemblies of human, animal, vegetable and man-made forms which provided resting places for the eye: centres of interest, an idea close to the spirit of Renaissance design. While the supporting structures of the grotesque were often light and attenuated, strapwork introduced a decided sense of weight with its broader forms imitating cut leather and giving the effect of a third dimension (Figure 6).

In the chapter 'The Challenge of Constraints', in his book *The Sense of Order*

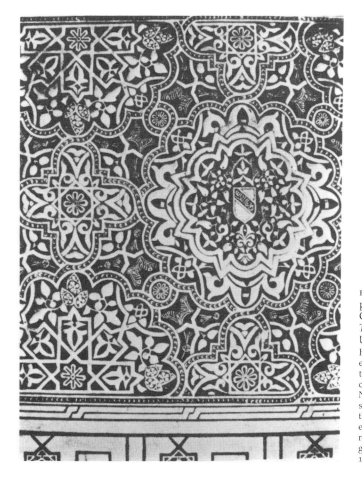

FIG. 7 Stucco decoration with cross-banded pattern of arabesque type, Alhambra, Granada. 14th century. (From A.H. Christie, *Traditional Methods of Pattern Designing*, Oxford University Press (1929), pl. LVI.)
Here many incidental symmetries are repeated in extended sequence. There is movement inwards, towards 'centres', and outwards to link with other centres, the whole pattern regulated by geometry. Natural forms are restricted to plants, and these are so simplified that they cease to be part of a three-dimensional world but become instead elements in an overall surface decoration. Christie's remarkable book, published in 1910 and 1929, was to give detailed attention to Islamic pattern (see pp. 21, 176).

(pp. 8of., 193), E. H. Gombrich describes the basic activities of the designer of ornament as 'framing, filling, linking'. All the great traditions of ornament, including that of Islam, are concerned with these. In dealing with Islamic ornament, however, we may also regard 'extending' as an associated function of decoration. If we compare Figures 5, 6 and 7 we can see that all these designs, two of them Italianate, the third Islamic, present the ideas of the framework and the symmetrical unit. The Islamic example alone has the effect both of relating ingredients in towards each other and of suggesting infinite extension. Into the frameworks and infillings of the Italianate types the arabesque could feed two of its salient excellences: mobility of line *across* a surface, and interlacing to create an illusion of slight depth. Both are vividly present in Figure 7. The process of framing 'centres of interest' in the design is not underplayed; the challenge of constraints is met in the sense that the pattern perfectly fills the total space available. But the activities of filling and linking receive an extraordinary imaginative release.

These concerns with mobility across a surface and with interlace are central to Islamic design. Though many of the interlacings give the illusion of different planes, and variations in colour and texture are made to define them, the patterns never disrupt the surfaces on which they are used: their finely calculated effects, whether employing interlace or not, impart with equal ease order to natural forms and life to geometrical shape.

The most popular early collection of arabesque patterns to appear in Europe was published with the title *La Fleur de la Science de Pourtraicture, Patrons de broderie, Facon arabicque et ytalique* (Paris 1530). This collection by Francesco Pellegrino, a Florentine in the service of Francis I, presented to the West a full range of woodcut reproductions of the flowing arabesque, including much interlace, and showed a considerable familiarity with Islamic procedures. Within

FIG. 8 Border of inlaid mosaic pavement, La Zisa, Palermo. Islamic, 12th century. Tracing by William Burges (1827–81) and signed with monogram. Victoria and Albert Museum
Against a background of lines at right angles and 45 degrees to each other, pale bands run in endless sequences, interlacing and forming stars. An interchange is set up between 'positive' bands and 'negative' background shapes which themselves become 'positive' when we read them as stars. Inexact as its pattern looks, this drawing well conveys the spirit of discovery with which the artist followed out the shapes.

a few years more than 100 similar pattern-books were to follow. Many came from Venice, a renowned centre of the book trade, where Giovanni Antonio Tagliente's *Essempi di recammi* (1527), an embroidery pattern-book containing arabesque designs, had appeared even before Pellegrino's.

Before pursuing the flowing arabesque in England, however, we must note a parallel but more extreme form of Islamic decoration, possessing the same properties of mobility of line and interlacing, but formed of overtly geometrical shapes and constructions. These patterns are overwhelmingly angular: frequently there are straight or near-straight bands which cross each other with exact periodicity to form stars and polygons internally (Figures 8 and 9). Without the reference to plant stems, leaves or other natural forms, we are left with effects in which the bands and the shapes they enclose equally hold our interest: what we might think are 'background' areas may indeed become as important visually as the superimposed bands. This optical counterpointing of geometrical forms, characteristically emphasising the diagonal and the acute angle, and incorporating interlace and overlap, was also a peculiarly intense Islamic concern. In general it was less easy than the flowing arabesque to accommodate to European thinking, which was conditioned to respond to the subordination by verticals and horizontals of the decorative elements between them, and inclined to look to natural forms to provide decorative ideas. Confident Western use of the angular type of Islamic pattern illustrated in Figure 9 could be made, however, as at Ballyfin much later (Figure 10). And it is worth noting that there had been common ancestry for this type of ornament also: for example, Roman tile pavements which included patterns formed from stars and other geometrical shapes. Christie, illustrating the Roman first-century mosaic pavement pattern shown in Figure 11, links it with the patterns that developed in Islamic times: though Creswell's analysis of window grilles (notably at Damascus) shows that Islamic patterns are uniquely set out in detail by means of equilateral triangles, the concealed use of them in this Roman example is also evident.[18]

The geometrical sophistication of these Islamic patterns has evoked numerous explanations, mathematical, philosophical, cosmological, which have been examined by Critchlow in his book *Islamic Pattern* (see Bibliography, p. 300). There is a strong likelihood that such a tradition of 'graded complication' (to use one of Gombrich's helpful phrases), based on the use of compass, ruler or strings held between points, was handed down over generations by means of workshop pattern-books. A collection of drawings owned by the nineteenth-century Persian decorator Mirza Akbar, in the Victoria and Albert Museum, contains sheets of such patterns wrapped in a leather scroll which could be carried round by the craftsman; and other pattern-books are known.[19]

Whether flowing or angular, these patterns, with their linear vitality and colour contrasts and yet essentially surface-respecting properties, formed a repository of ideas that remained very distinct from the three-dimensional and relatively static ornament of Roman tradition. The Islamic types were adaptable for every type of surface – architectural, ceramic, textile, leather, the printed page (the latter obviously of prime importance as a means of consolidating their familiarity). The band-like nature of arabesque also made it particularly suitable for metal and embroidery. Damascening on metal involved hammering on wire strips, while embroiderers used strip-like braids for appliqué. Benvenuto Cellini (1500–71) was inspired to emulate the damascened workmanship of a Turkish dagger and discusses the craft in his *Autobiography* (not published until 1730).

Venetian-Saracenic damascened brassware brilliantly combined the salient

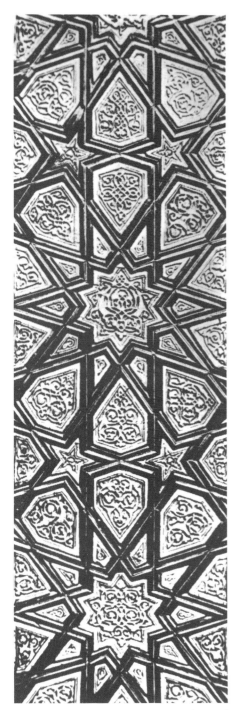

FIG. 9 Leaf of wooden door. Modern red wood beading in geometrical pattern, filled with original panels of darker woods carved with arabesques, in double relief, inlaid ivory and ebony border. H. of whole 266 cm., W. 117 cm. Cairo, 14th century. Victoria and Albert Museum 890–1884 (From A.H. Christie, *Traditional Methods of Pattern Designing*, Oxford University Press (1929), pl. XLVIII.)

In this pattern, bands composed of verticals and two diagonals create 10-pointed and five-pointed stars. The intervening panels are outlined with contrasting colours, ivory and black.

features of surface mobility and interlacement. It also presented that type of interlacing round a central point, the knot, at its most spectacular (Figure 4). The special appeal of this form for Renaissance artists is evident from the well-known 'knot' drawings of Leonardo da Vinci and Dürer.[20] The knot played a prominent part in Tagliente's arabesque designs of 1527, and is also prominent in the detail of Renaissance costume portraits of the period, including those of Henry VIII (Figure 1).

Besides metalwares, bookbinding was a long-established Arab craft which carried arabesque ornament and forms of gold tooling from Venice across the face of Europe during the late Renaissance. The catalogue of the Baltimore exhibition *The History of Bookbinding* (1957–8) produced considerable evidence of this, and in his review of the exhibition Ettinghausen discussed and reproduced certain fifteenth and sixteenth-century examples from Italy (Venice, Florence, Naples).[21] He also discussed France, where initiatives took place as central Italy recovered after the Sack of Rome in 1527, and England. The arabesque became one of a number of decorative possibilities used by the *doreur* or gilder of bookbindings and can be traced in work done for Jean Grolier, Vicomte d'Aguisy (1479–1565), the Treasurer-General of France from 1547 to 1565. Persian influence, filtered through Venice and France, occurs in English bookbindings of mid Tudor and Elizabethan date. A Koran printed at Basel in 1543 was finely bound about 1551–60 for Thomas Wotton (1527–87), using arabesque and geometrical interlace (Figure 12). The centre medallion and related quarter pieces characteristic of Persian bindings are also found. The Baltimore exhibition included an English black morocco binding (No. 352), c.1569, of the Bible for Matthew Parker, Archbishop of Canterbury (died 1575), with oval medallion and corner-pieces (now in the Houghton Library, Harvard University).

The interlacing arabesque continues to appear, often with a more three-dimensional forcefulness, in the grotesque decorations of innumerable European designers. By the late seventeenth century, in the work of the Frenchman Jean Berain (1640–1711), it has become entirely absorbed into a mixture of grotesque and strapwork; in the eighteenth, lightened again, in rococo ornament.[22] It was not until the nineteenth century, in the time of Owen Jones (1809–74) – who was very conscious of its idiomatic historical character – that it was to appear again in its original purity. But, once established in the sixteenth century, the flowing, interlacing arabesque had come to stay. We may surmise that to the stricter European classicist it appealed as an expression of disciplined intricacy: a complexity derived from basically simple ingredients; to the not-so-strict it appealed because of an effortless freedom of movement which European classical ornament could not match. The arabesque is present as a fermenting influence in England, as in Europe, through the entire period covered by this book.

II

The spread of the arabesque in Europe was chiefly through engravings, metal objects, pottery, textiles and bookbindings. Holbein, trained in Europe and living from 1532 in England, shows complete familiarity with it (Figure 13). Its transmission was helped specifically by books of ornament, and its adaptability to crafts of differing kinds is well indicated in the title of the first pattern-book to appear in England, a collection of 'moresque' designs[23] entitled *Morysse and Damaschin renewed and encreased, very profitable for Goldsmythes and Embroderars*, published in London by Thomas Geminus in 1548 (Figure 14).[24] Two years earlier Jean de Gourmont's *Livre de moresques* had been published in Paris, containing

designs for which Gourmont suggested appropriate uses: for example, on sleeves or collars or embroidered coverlets. Moresque decoration on English silver occurs widely by Elizabeth's time, and equally in the designs of men's and women's fashions. The accuracy of Geminus's claim to the profitableness of his designs was maintained in the reign of James I by Thomas Trevelyon's collection of embroidery patterns (1608), one of which is taken direct from a goldsmith's design in Geminus.[25]

More mysterious presentiments of the Islamic world were to be had, however, in Tudor England. The haunting 'melancholic' portrait *Woman in Persian Dress* (Figure 15) in which the figure crowns a weeping stag with a floral chaplet, includes Persian slippers and a headdress and long veil taken from an illustration of a Persian virgin in Boissard's *Habitus Variarum Orbis Gentium* (Mechlin 1581).[26] This 'fancy dress' portrait – which almost certainly commemorates a specific occasion – reminds us that however acclimatised to Western styles and the

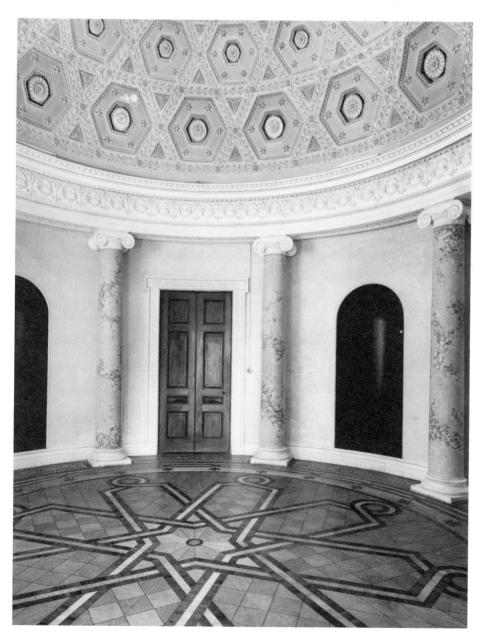

FIG. 10 Sir Richard Morrison (1767–1849). Floor of rotunda, Ballyfin, Eire. About 1820. Photograph courtesy of *Country Life*
The band-pattern used in the parquetry is closely similar to that in Figure 9. The way in which Islamic patterns led inward to centres and simultaneously outwards to the edges of a space made them adaptable to such favourite European building-shapes as rotundas.

withdrawing-rooms of embroidresses the arabesque may have become by 1600, it was natural to regard the East as a source for expressing extreme notions far removed from 'normal' experience.

A similar feeling was expressed in the early seventeenth century in the highly sophisticated and sensation-hungry world of the court masque. We know that Inigo Jones (1573–1652) designed exotic costumes for masque characters of un-European origin, including Asians. Eastern subjects occurred in Italian stage design of the day.[27] While no architectural stage-set of an Eastern kind by Jones appears to be on record, we find him in *The Temple of Love* of 1635 taking an idea for an Asian setting from the landscape inventions of a slightly earlier Italian designer, Giulio Parigi, whose set designs for the Florentine court entertainment *Il Giudizio di Parigi* (1608) he knew from engravings. Like the Italians, he can thus contrast the wildness of Asian associations with the sane, ordered world of classical Palladian architecture that appears later in the masque. Surviving drawings by Jones for the costume of Asian astrologers give only a generalised impression of what these figures must have looked like. They strike us as essentially fantastical inventions: but the absence of more detailed drawings makes it impossible to judge.[28] Jones could have consulted the old former ambassador to the Mughal court, Sir Thomas Roe, to document the appearance of such persons. Documentary accuracy concerning a remote people would certainly not have been expected, however, by his audiences at a time when Arabs, Turks, Egyptians and Indians were lumped together by Europeans into a vaguely defined category of 'orientals'. It might in any case not have accorded with the overwhelmingly Italianate focus of Jones's archaeological or antiquarian sympathies. Indeed this particular problem of the 'Asian astrologers' must surely

FIG. 11 Mosaic pavement pattern. Roman, 1st century AD. (From A.H. Christie, *Traditional Methods of Pattern Designing*, Oxford University Press (1929), fig. 278.) The scheme shows how basic hexagons are built outwards to form 12-sided figures which enclose squares and equilateral triangles, and overlap in all directions. Islamic designers were to develop such ideas with great facility.

have favoured fantasy: a deliberately inventive treatment for characters who, as representatives of licentiousness in the story, are banished from England by the Queen.

In Jones's day much information had already been gathered about Turkey and the Levant.[29] But first-hand knowledge of the Middle East and India was not easy to obtain. There was as yet little hard fact to set against the delights of fantasy. When Jones began work on the masque designs in 1605 few Englishmen had personally penetrated beyond the Levant. The seventeenth century, however, heralded a remarkable phase of fact-seeking about oriental countries by certain individuals. Curiosity and the unpopularity of Catholic Italy were to draw numbers of English gentlemen-travellers, some with a taste for drawing and all

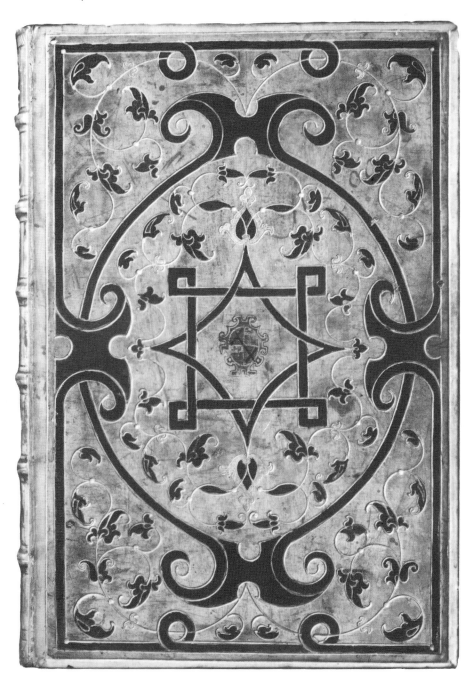

FIG. 12 Bookbinding. The *Koran* (Basel 1543). Brown calf: gold tooling with black painted decoration containing the arms of Thomas Wotton (1527–87). 28.9×18.4 cm. English, about 1551–60. Victoria and Albert Museum L 1593–1948. Bequeathed by H.J.B. Clements Esq.
The firm structural effect is obtained from straight and curved lines (the latter being segments of circles) which incorporate band-work of Islamic tradition on a light ground and are interspersed with beak-like leaves and florets also taken from that tradition.

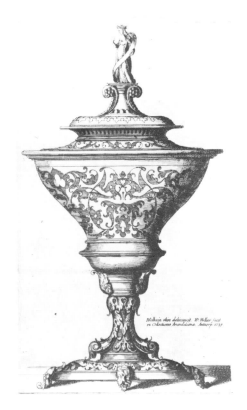

with a desire to write, to Turkey, and also to Egypt, the Holy Land, Persia and India. Some were concerned with attempts to extend English trade with Persia: a possibility viewed with disfavour by the Levant Company, fearful for its monopoly of the commerce with Persia's traditional foe, Turkey. Some went with diplomatic parties, about which we will have more to say. Some journeyed independently.[30]

The attractions and problems of travelling in places which could be unfriendly at this period are evoked in the title chosen to describe his journeys by the Scot William Lithgow (in the Levant in 1612): *Rare Adventures and Painfull Peregrinations* (1632). Fynes Moryson produced his *Itinerary* based on the Levant in 1617 (reprinted in four volumes, Glasgow 1907–8). Another voyager was Sir Henry Blount, in 1634. His *Voyage into the Levant* (1636) is, however, remarkable for its unprejudiced views: Blount tells us that he observed Turkey to discover if there might be there 'an other kind of civilitie, different from ours'. The Italian Pietro della Valle arrived in Constantinople in 1614 and reached Persia in 1617. His eventful travel account (*Viaggi*, Rome 1650) was translated into English by G. Havers in 1665.

Among the independent English travellers to the Near East in these years George Sandys (1577–1644), who published his *Relation of a Journey* (to Constantinople, Cairo and Jerusalem) in 1615, emerges as a particularly rewarding and acute observer. The title page of his enormous and closely printed book of travels indicates its scope: the 'History of the original present state of the Turkish Empire ... the Mahometan Religion and Ceremonies ... a description of Constantinople, the Grand Signior's Seraglio and his manner of living ... Greece ... Egypt ... Armenia, Grand Cairo, Rhodes, the Pyramides, Colossus ... a Description of the Holy-Land ...' Italy in fact comes last. The book had reached

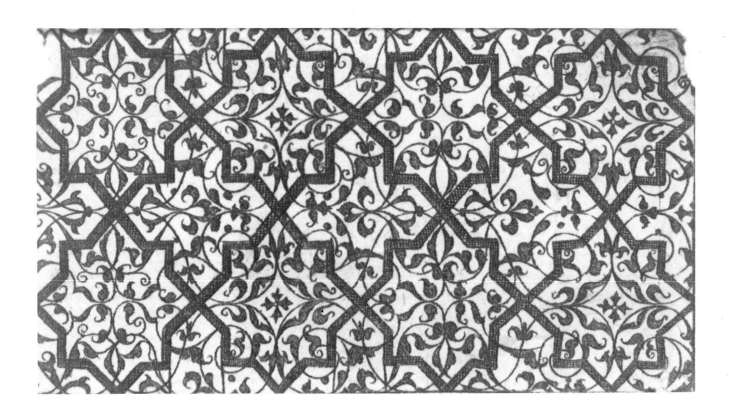

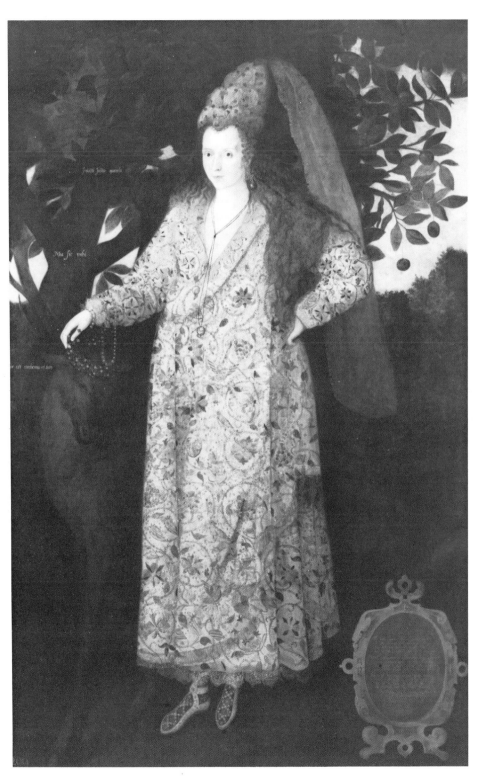

FIG. 13 (opposite above) Hans Holbein.
Design for silver cup, engraved with
arabesque. About 1537. Etched by W. Hollar,
1645. Victoria and Albert Museum 14112
The shape is European, but the design shows the
ease with which classical European ornament,
notably on the stem, where acanthus defines the
profile in sweeping three-dimensional curves, is
combined with two-dimensional Islamic arabesque
on the bowl and cover.

FIG. 14 (opposite below) Thomas Geminus
(fl. 1545–70). Arabesque ornament from
*Morysse and Damaschin renewed and
encreased . . .*, London, 1548. Line-engraving
(enl.), plate size 5×8.7 cm. Victoria and
Albert Museum 19009
This was the first known collection of arabesque
patterns published in England, and was used by
designers of silver plate and others into the
seventeenth century, see p. 23.

FIG. 15 Attributed to Marcus Gheeraedts the
Younger (fl. 1590). *A Woman in Persian Dress.*
Oil on panel, 217×135.3 cm. About 1600.
Hampton Court Palace. Reproduced by
gracious permission of H.M. The Queen
The figure, wearing Persian slippers and a dress
embroidered in green, salmon-pink and yellow with
birds, stems and flowers, is set against a dark,
vigorously leafing tree. The light rhythms and
two-dimensionality of the oriental patterns are to be
compared with the three-dimensional European
strapwork cartouche, lower right.

27

its seventh edition, illustrated with 50 maps and figures, by 1673. Sandys also has a lively and sensitive visual appreciation: 'There is hardly in nature a more delicate object', he writes of Constantinople, 'if beheld from the sea or adjoyning Mountains: the lofty and beautiful Cypress Trees so intermixed with the buildings that it seemeth to present a City in a Wood to the pleased beholders.'[31] We shall return to his descriptions of the mosques of the city in the context of Christopher Wren's interest in Islamic architecture.

One traveller who can on no account be overlooked is the Cornishman Peter Mundy (c.1596–1667). Here was a man with an itch for travelling which drove him not only across England and Wales and most of Europe (including, in 1621, Spain, on the 'pilchard business'), but also to Constantinople in 1618–20, to India in 1628–34 in the service of the East India Company, to India and Japan in 1635–8, and for a third time to India in 1655–6. In all, his travels cover more than half a century of activity. He compiled a vast manuscript account (now in the Bodleian Library), which was used to a limited extent by specialists in the nineteenth century. It was not published, however, until the Hakluyt Society edition in the early years of the twentieth century, and is now seen to have considerable value, not least for its avoidance of 'travellers' tales'.[32]

Another traveller-writer with a gift for characterisation – whose work, unlike Mundy's, was widely known in his own century – is Thomas Herbert (1606–82). He accompanied Sir Dodmore Cotton's ill-starred diplomatic expedition to Persia in 1627, stayed two years, and published his *Relation of some Years Travaile* (often referred to as his *Travels in Persia*) in 1634. This too, like Sandys's work, was in demand in later years: Herbert produced four editions, each revised and further enlarged, in his lifetime (1634, 1638, 1665 and 1677). The 1665 edition contained an engraving of Persepolis signed by the distinguished artist Wenceslaus Hollar (1606–77); Herbert himself contributed a number of drawings, mainly of animals and birds, but above all illuminating written accounts of the appearance of Persian cities, notably Shiraz (1928 ed., pp. 70–1): 'Fifteen mosques express their bravery there, which in shape are round . . .' These are tiled with a plaster made of burnt limestone, which looks like stone when dry, with 'azure stones resembling turquoises' used on top and outside as pargetting. The tops of the mosques, he says, are 'beautified by many double gilded crescents or spires, which reverberate the sun's yellow flames most delightfully'. He is moved by the capital Isfahan, with its Maydan planned by the great Shah 'Abbās (reigned 1587–1629) as a polo ground with elegant buildings around it. He goes on to detailed accounts of the royal parks, laid out by Shah 'Abbās, the *mahols* or summer-houses and broad-spreading *chenar* trees, the straight alleys of the Hazārjarīb garden 'from North to South . . . a thousand of my paces, from East to West seven hundred'.[33] He also visited 'Abbās's gardens on the Caspian, notably Ashrāf. On his return to England Herbert was painted in Persian dress; he lived out his last years after the Restoration with a baronetcy, domiciled in his home city of York and engaged in antiquarian study.[34]

Accompanying Cotton and Herbert on the journey to Persia of 1627 was the notorious Sir Robert Shirley (1581?–1628), who had been painted by Van Dyck in Rome in 1622 wearing Persian dress (Figure 16). Shirley wrote nothing of consequence, but was Shah 'Abbās's envoy to Britain and made unsuccessful efforts in 1611–13 and 1624–7 to interest the merchants of London in trading with Persia. His attempts were opposed both by the Turkish-orientated Levant Company and by the very determined East India Company, which began its own trade with Persia in 1616. James I and subsequently Charles I, however, became interested in the idea of developing trade independently of the Company, and

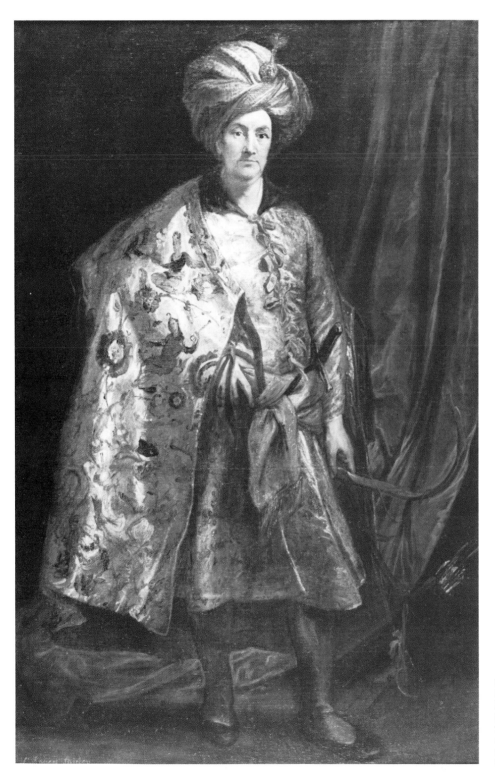

FIG. 16 Sir Anthony van Dyck (1599–1641).
Sir Robert Shirley. Oil, 200×133.4 cm. 1622.
H.M. Treasury and The National Trust,
Egremont Collection, Petworth House
The sitter wears a Persian cloak of pale gold,
opulently embroidered with figures and plants, the
rhythms of which, translated into the rich textures of
oil paint, pervade the whole portrait.

Cotton's embassy was despatched by Charles I to investigate the matter further.[35] With his brother Anthony, Robert Shirley was essentially an adventurer, filling his life with exploits, some dubious, in foreign climes, but living in Persia for considerable spells: between 1598 and 1608, 1613 and 1615 and from 1627 until his death at Qasvin. Whatever his faults, his portrait makes clear his excellent taste in Persian fabrics: his cloth-of-gold cloak has figures of youths which are echoed in the lines of plants flanking them.[36] Van Dyck's companion portrait of Shirley's Circassian wife (also at Petworth) depicts her with a Persian carpet: the flowing, naturalistic lines of which no doubt commended themselves to such a master of the Baroque. Larkin's outgoing idiom allied with Turkish Ushak seems far away.

Van Dyck's use of Persian carpets in his portraits (for example, that of Charles I's children in 1635, now at Windsor) must have given great satisfaction to a king who had shown so much interest in Persia, not only as a trading partner but as a source of aesthetic encounter. On 21 February 1634 Charles asked the East India Company to obtain for him Arabic and Persian manuscripts, a request which seems to have resulted in the sending of examples to England, even though doubt was expressed by President Methwold in memoranda to Company officials about the difficulty of reading the script.[37] His words reflect the literary bias of interest in such objects, in a period which also saw the collecting of Islamic manuscripts by Archbishop Laud, and the founding of chairs of Arabic at Cambridge (1632) and Oxford (1636).

In 1637, however, Charles I sent a certain Nicholas Wilford, painter, to Persia 'for seeing ye Antiquities of yt Country, and in procuring such as are fitt for us to be brought away'. Wilford died before he could do anything and Charles's presents to Shah Safi, which included, of course, pictures, were presented by a substitute agent, Thomas Merry, in 1638.[38] It is unfortunate that so little seems to have come of Charles's hopes for further acquaintance with Persian culture.

The carpet-historian Tattersall records (1934, pp. 46–7) the sale in 1645 by the Earl of Dorset of 27 'Turkey and Persian' carpets: another testimony to the growing interest in Persian carpets in England at this time. The reasons certainly include trade, but to find others we must look at what was happening in Persia itself.

The textile arts had been encouraged by many earlier rulers of Persia: silks had reached unparalleled technical perfection in the tenth century, and under the Seljuk dynasty (eleventh to thirteenth centuries) weaving traditions had been maintained. It is the sixteenth century, however, that marks the greatest productive phase of the Persian carpet, which from about 1600 is also being manufactured for the European trade.

In 1600 Persia was entering the second century of rule by the Safavid dynasty, established in 1502 by Shah Ismail and destined to survive until 1722. Under Shah Tahmāsp (reigned 1524–76), himself a calligrapher, the capital city of Tabriz – distinguished in the art of the miniature more than two centuries earlier, and the home of the great painter Bihzād (c.1440– after 1514) late in his career – had again become famous for its painting, and also for carpets. With the reign of Shah 'Abbās (1587–1629), another great phase unfolded. The capital moved to Isfahan in 1598. Shah 'Abbās's transformation of the city is described for English readers by successive generations of travellers, extending from the time of the Reverend John Cartwright (*The Preachers Travels*, 1611), through that of Herbert, to John Fryer's visit in the 1670s (*Nine Years' Travels*, 1698) and long afterwards (notably the account by the artist Sir Robert Ker Porter in his two-volume *Travels*, 1821). Beside the Maydan, so admired by Herbert, the tree-lined avenue of the Chahar Bagh (in the twentieth century edged with shops) evoked much comment, as did

the gardens arranged in a continuous sequence with buildings for various purposes disposed in each of them and reflected in axial watercourses. These stretches of water were intersected with irrigation canals alongside which the *chenars*, or oriental plane-trees, and poplars were planted; hedges of rose and other plants extended to the side-walls of the gardens. The sense of the lush Persian garden walled against the desert emerges strongly from the travel-writers.

On festival days, carpets – their designs incorporating in their firm borders the elements of canal, individual tree and flower-bed – would be brought out of the buildings and spread in the open. Many of the greater carpets had, of course, a strictly religious or palace context. The celebrated Ardabil carpet (which we will come back to in chapter 5) had been made in 946 A.H. (AD 1539–40), in the time of Shah Tahmāsp, for the Shrine of Shaikh Safi at Ardabil. Under 'Abbās, further rich examples were made for home use, however; and as trade with Europe accelerated around the turn of the century, the royal looms produced a succession of superb rugs for export, including many of the so-called Polonaise group, with silk pile supplemented by gold and silver thread, and incorporating the coats of arms of the Polish noble families who received them. Shah 'Abbās presented a carpet to the Doge of Venice (now in St Mark's) in 1603; others went to Rome and in 1639 to Copenhagen, where they still form part of the remarkable ensemble of seventeenth-century Persian furnishings at Rosenborg Castle.

Whereas Turkish carpets tend to a bold severity in the treatment of plant motifs, Persian examples are more naturalistic in the use of human and animal forms, and in their more flowing reference to landscape elements. The sumptuous colour of Turkish Ushak is in broad contrast to the more delicate interplay of reds and blues in Persian counterparts. Turkish designs often suggest the possibility of endless repetitions; those of Persia are typically organised round a central medallion. Persian carpet-designers, if not themselves miniature-painters, were greatly influenced by book design, as the characteristic pattern of centre medallion and quarter medallions at the corners clearly suggests. The Ardabil carpet (Figure 110) presents this layout on a grand scale that runs to 11.52 by 5.34 metres (37 feet 9 inches by 17 feet 6 inches) and incorporates 340 knots per square inch.[39] In the 'hunting' carpets the formality of such a structure is enlivened by the inclusion of animals and huntsmen in movement. In some instances the central unit appears to represent a pool from which trees radiate and around which leopards, gazelles or 'kilins' (Chinese *qilin*) run. The carpet with its firm borders became a realisation of a royal hunting-ground, or an enclosed 'paradise': the order that marked the disposition of the real world of the garden was rendered into two-dimensional curvilinear shapes and poetically juxtaposed colour.

Among the most influential Persian carpets, produced away from the key centres of Kashan and Isfahan, were those from the town of Herat in eastern Persia and its surrounding province of Khurasan: related pieces came from adjoining parts of Mughal India in which Persian workers settled. Some of those rugs included animals in their designs; others obtained movement from coiling plant stems and cloud-bands. They were evidently much exported to Europe, where they appear in the paintings of Rubens, Van Dyck, Velázquez and many Dutch artists (notably Vermeer) in the seventeenth century.[40] Baroque concern with fluid accentuation made much of them: for example, the well-known Van Dyck portrait mentioned earlier of the *Three Eldest Children of Charles I* (1635), at Windsor Castle, where the spreading brushstrokes perfectly translate their flickering chromatic effects into oil paint.

Trade, fashion and the appetite fed by European Baroque all help to account for the interest in Persian floral carpet tradition clearly reflected in seventeenth-century England. There is the further evidence provided by the carpets of Mughal India which relayed Persian ideas. Armorial floral carpets were ordered from here by Europeans, including the English: the Girdlers' Carpet (now in the Girdlers' Hall, London) was made for Robert Bell in 1634; and the Fremlin carpet (VAM 151–1936) was woven for William Fremlin about 1640. A Mughal-style floral carpet (National Museum of Antiquities, Edinburgh) appears to have been made in Britain for John Lyon, second Earl of Kinghorne, whose monogram it bears: the date was presumably that of either his first or second marriage, 1618 or (about) 1640.[41]

Besides its carpet-manufacture, the period of 'Abbās in Persia up to 1629 is well known for the emergence in painting of what David Talbot Rice (see Bibliography, p. 300; 1975, 236) has called 'that tender, delicate, even exquisite style of Persian art' characterized by portraiture, single figures and line drawing. English travellers of the time do not describe this kind of painting and it seems that no serious attempt was made to acquire miniatures past or present, either from Persia or from Mughal India, where the art was also prominent. In 1616 Thomas Roe, a man not without aesthetic sensibility, indicates approval of Mughal 'limninge' but, as we shall see, in contexts where it approximated to the realism of European miniature-painting. It is probable that this attitude was widely shared by his fellow-Englishmen, though not necessarily by all visitors. Charles I and Laud, as we noted, sought out Persian manuscripts in the 1630s. Towards mid century, aesthetic appreciation of such objects is clearly indicated. The Frenchman Monconys, for example, saw a book of Persian miniatures at Aleppo in 1647 and admired a Persian illuminated manuscript – 'très curieux et beau' – at Damascus.[42] His compatriot François de la Boullaye-le-Gouz was in Persia in 1648 and his *Voyages et Observations* of 1653 illustrated some of the first Persian miniatures to be reproduced in Europe.[43] In Europe itself, Rembrandt was collecting Eastern objects, including miniatures, costume and metalwork, some two decades, it seems, before copying, in the 1650s, original Mughal miniatures in his possession in Amsterdam. His work gives evidence that near-contemporary Mughal miniatures did find their way to Western markets and collections.[44]

In Constantinople, more accessible than Isfahan, there must have been a few native decorative painters, among the hundred or more who had workshops there by the mid seventeenth century, whose work caught the eye of English visitors: Peter Mundy owned a little book 'painted by the Turcks themselves in Anno 1618'.[45] Predictably, Turkish costume and Muslim dress in general continued in the seventeenth century to attract immense interest in the West. In 1587 an unknown European artist, perhaps inspired by the costume drawings published by Nicolas de Nicolay of 20 years before, produced a volume (now in Jerusalem) of watercolour drawings of Turkish, Moorish and Persian figures, which in turn provided the models copied by Rubens in his Costume Book in about 1600; it seems likely that more than one replica of the 1587 volume was made.[46]

If the figure-painting artists of Turkish origin aroused no great interest among English travellers, other Turkish arts certainly did. In the 1587 volume the costume drawings alternate with leaves of Turkish ornamented paper. Turkish methods of what later came to be called 'silhouetting' were much admired at this time both in Turkey and Europe. One technique, originally Chinese but also developed in the court libraries of Persia, required the cutting of ornamental and figurative shapes in paper; a parallel technique concerned calligraphic cut-outs.

Both methods appear in the Middle Ages, but the sixteenth century saw their main Turkish flowering in the work of Fahri of Bursa (died 1618) and others. Fahri was especially famous for his 'negative' calligraphy, which involved placing his cut-out shapes against coloured papers in order to make the writing readable. 'Positive' and 'negative' parts of a single piece of paper-cutting could both be used for effect against such backgrounds and the kinship is plain between results such as these and the effects of those counterpointing Islamic patterns already noted of the type of Figure 8. Among Europeans whose collections included Turkish paper-cuts was the Emperor Rudolf II; but among Englishmen was Peter Mundy again.[47] European artists in cut paper were active in the seventeenth century, notably in Germany (a famous exponent was Susanna Mayer at Augsburg), but no masterpieces to rank with those of Fahri resulted. Examples no doubt multiplied among the other specimens of ingenuity in the collectors' cabinets of the time. But as Otto Kurz recognises, this was above all an art of curiosity-value. The heraldic filigree cuts in paper and vellum that are made in England into modern times probably descend from German examples.[48]

Another enduring influence from Turkey was the art of 'marbling'. The practice of producing waved or 'marbled' effects with oil colours on water and transferring these to paper was increasingly pursued in many parts of Europe in the seventeenth century: in Spain, Holland, Germany, France and England. Francis Bacon took note of it,[49] but in 1610 it had earlier caught the attention of the sharp-eyed Sandys in Turkey: 'They curiously sleek their paper, which is thick; much of it being coloured and dappled like Chamblets; done by a trick they have in dipping it in the water.' That the Turks discovered the art is still open to debate, but their claim seems well substantiated.[50]

As well as Turkey and Persia, India also beckoned. Babur, the first of the Mughal line, had established his rule in north-west India in 1526. This dynasty, consolidated under Akbar the Great (1556–1605), would also last until the eighteenth century. Architecture, painting, the arts of the book, carpets, textiles, gold, silver, hardstones (including jade), glass and ceramics were to appear in a brilliant outpouring. The Mughal rulers had close contacts with Persia, and with Europe. The fascinating and highly detailed account by Sir Thomas Roe of his embassy of 1615–18 to the Mughal emperor Jahangir (1605–27) provides us with a full sense of the nuances of national pride combined with curiosity and goodwill that could be involved in the exchanging of diplomatic presents, particularly works of art. Roe explains in a delightful anecdote how his present of a miniature of a woman by the English artist Isaac Oliver in July 1616 was rapturously received by the art-loving Jahangir, who had his own artist make five copies. To Roe's intense surprise, viewing the results, he could tell only after great difficulty which was the original. Jahangir requested Roe to reward his artist, gave the ambassador a copy for himself, 'to showe in England we are not soe unskillfull as you esteeme us', and ordered a portrait of himself to be made for Roe.[51]

Embassies from Europe, to all three courts of the Turkish Sultan, the Shah or 'Sophy' of Persia and the 'Great Mogul', continually exchanged diplomatic gifts, bringing an added awareness of the qualities of Eastern artefacts westwards. As the Roe anecdote suggests, however, the influences were in both directions. Oriental monarchs were particularly interested in precious metals and jewellery from Europe. Sometimes European jewellers settled at their courts, and in the seventeenth century the French travellers Tavernier and Chardin were to negotiate sales of vast quantities of jewels to the Shahs.[52]

One of the most interesting and, to the casual eye, improbable of these channels of contact was that of clocks and watches. Already in the sixteenth

century we find the Ottoman Sultans looking to Europe to supply them with time-pieces: the French had presented Süleyman the Magnificent with a clock in 1547. As Kurz in his book *European Clocks and Watches in the Near East* (1975, p. 24) makes clear, the English were to play a prominent role in a process which lasted over 200 years. In 1583 the first English ambassador to Turkey, William Harborne, presented a clock set with jewels and valued at £500 to Sultan Murad III, together with silver vessels and several breeds of dog.[53] An extensive trade in clocks for Turkey built up under Elizabeth I. Sultan Mehmed III (1595–1603) was the recipient of highly elaborate automata-clocks from Augsburg and also England: Thomas Dallam's organ-clock was a tour-de-force with its mechanical trumpeters and song-birds. The Safavids of Persia appear to have been more interested in European pictures[54] than clocks, but it is plausible that the clocks given by Shah 'Abbās to the Mughal Emperor Jahangir in 1616 were European. Ogilby in 1673 credits a clockmaker named Festy with the clock in the Bazaar at Isfahan.[55]

The presence of Europeans working and trading in Constantinople, Isfahan or the Mughal capitals in these centuries is an elusive factor affecting the transmission of artistic ideas between Europe and the Orient. Rogers points to the taste for Chinese porcelains that flowed from Mamluk Egypt to Medici Florence in the sixteenth century, and suggests that European demand for Chinese celadons and blue and white stimulated the Ottomans and Safavids to collect these wares even more intensively.[56]

III

In the final section of this chapter, we turn from the exchanges of European automata and Islamic paper-cuts and the arts of overt virtuosity – a quality which readily crosses cultural divisions in any age – to consider ceramics and to return to textiles: areas in which Islam had a fundamentally distinctive contribution to make to Europe. Ceramics and textiles are two major fields of work in which the artists of the Orient excelled. In each, the Islamic genius for deploying colour and form against a contrasting ground colour finds full expression. The act of shaping clay vessels on the wheel accentuated the 'feel' both of continuous surface and of enclosed volume: such an apprehension must have given stimulus to countless Chinese potters and informed those standards which in China transformed the craft of pottery into a creative art. By contrast the Muslim potter explored volume far less (he used relatively few shapes): his powers of invention went into the creation of surface effects that were brilliant and subtle by turns, and often technically complex. As for textiles, the basic principles of design – contrast, repetition, alternation – could acquire an added grip on the imagination through being applied two-dimensionally across expanses controlled by the integration of warp and weft. The spontaneity of direct painting could be expressed here, as in ceramics, and in some of the painted calicoes of India evidence can be seen of the masterly interplay between brushed-on repeating or alternating motifs and background plane which is one of the supreme strengths of Muslim design.

We must first consider ceramics and in particular two wares which will be important in later chapters: the 'Hispano-Moresque' pottery of Spain and the Iznik pottery of Turkey. Both were to be extensively collected and studied in England in the later nineteenth century. The products of widely separated societies, the wares invite comparison. They share the interest common to Islamic countries in wall-tiles as well as in three-dimensional vessels. Both subscribe intimately to the Islamic designer's love for plant motifs applied to a surface. They greatly differ, however, in the way that these are presented. Hispano-

Moresque plant motifs (Figure 17) frequently become part of a dense, overall pattern – Arthur Lane's word 'ramifying' in his book *Style in Pottery*, is particularly apt – that may almost blot out any sense of 'background'; furthermore, as metallic lustre is extensively used, these designs typically reflect off the surfaces on which they lie. Iznik pottery, in its maturity (Figure 18), places a few freely painted plant motifs – endlessly varied sprays of roses, tulips, carnations or hyacinths – more openly, against a white or coloured ground to which they are always closely related. The springs of inspiration in Hispano-Moresque were in the medieval world: the flat abstractions of heraldry were well accommodated to it. Iznik partakes of the cultivation of whiteness in ceramics that was so powerfully reinforced for western Asia and post-medieval Europe by the blue and white porcelain of China. While Hispano-Moresque pottery decoration may be pictorial – such motifs as sailing-ships or rampant animals are not unusual – Iznik is habitually (though not always) so: the promptings of natural form are rarely far away. The tile sequences of Iznik wall decoration (following other Islamic precedents) were, indeed, to use floral motifs within framing 'arches', painted on the tile surfaces to suggest lunettes or windows opening on to gardens.

As the name suggests, Hispano-Moresque was a product of the westward extension of Islam and of a fusion of Moorish culture with that of Spain. The armies of Islam had moved across North Africa in the seventh century and by about 711 had spread into Spain to reach as far north as Toledo. A branch of the Umayyad family was established in power at Córdoba, which by the tenth century was being compared with Constantinople and Baghdad as a cultural centre. From the eighth century to 1492, when the Moors were officially 'expelled' from Spain, their art unfolded, often under the encouragement of Spanish Catholics. A strong, inventive architectural tradition produced the Great Mosque of Córdoba (785 onwards) and the legendary Alhambra at Granada (thirteenth–fourteenth centuries); the latter's delicate complexity of painted and tiled courtyards will occupy us in Chapter 4.

Though highly individual, Moorish decoration was closely connected with its eastern origins. In particular, Hispano-Moresque pottery, developing in the thirteenth century, was heir to the white tin-glaze and lustre traditions of the ancient Middle East. Tin-glaze had become firmly established in Mesopotamia four centuries previously. Although early methods of using this glaze were no doubt varied in matters of detail, a principle of the greatest value emerged for potters in search of a whitened body to rival Chinese porcelain.[57] When a pottery object had been biscuited (fired once), it was dipped in a slurry of lead-glaze made opaque by the addition of oxide (ashes) of tin. The glaze turned white when the piece received a second firing. The practice was to have widespread use in the maiolica of Renaissance Italy and the delftware of Holland and England.

In the lustre technique, tin-glaze which has been fired on to the biscuited body is painted over with metal oxide. The piece is then given a third firing at a lower temperature and in a reducing atmosphere: carbon in the oxygenless kiln 'reduces' the oxides to thin films of the basic metal. Copper sulphate gives a rich ruby-red, silver nitrate a yellowish-brown.

Lustre probably originated in pre-Islamic Egypt but, as with tin-glaze, appeared in the ninth century in Mesopotamia, and in Syria and Persia. It seems likely that it was in use in Spain before 1154, when al-Idrīsī says that lustreware was produced in Aragón and exported.[58] Known as 'golden pottery', it was made at Málaga, Andalucía, in the thirteenth century, and examples have been found in England (Sandwich) dating from 1303.[59] Competition by traders from Chris-

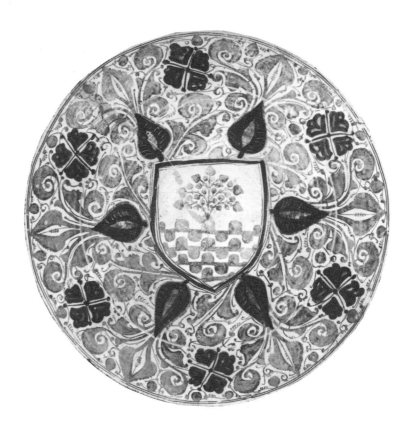

FIG. 17 Dish, earthenware with opaque white glaze, leaflets and four-petalled rosettes in cobalt, curving palmettes, shield with bouquet and crenellated wall in olive-violet lustre. Bull passant on reverse. D. 45 cm. Hispano-Moresque, Valencia, about 1450. British Museum G530 (Godman Collection). Courtesy of the Trustees

The richly proliferating design around the shield, allowing little background to show, and the metallic lustre, create an energetic surface pattern which is stabilised by the shield itself and the concentrically arranged leaves and rosettes in blue. The compendious collection of Islamic ceramics formed from the 1860s by F. du Cane Godman, and acquired in 1983 by the British Museum, will be noted on p. 289.

FIG. 18 Dish with flanged rim. White ware, painted in underglaze colours with roses and tulips growing from a leafy base; cusped line round rim. D. 31.8 cm. Turkish, Iznik, about 1540. Victoria and Albert Museum, Salting Bequest C1928–1910

Though most Iznik dishes of this form contain the plant sprays within the well, in some instances, as here, the sprays reach the rim. The design shows the vigour of the drawing against the brilliant white ground. George Salting's important collection is referred to on p. 289.

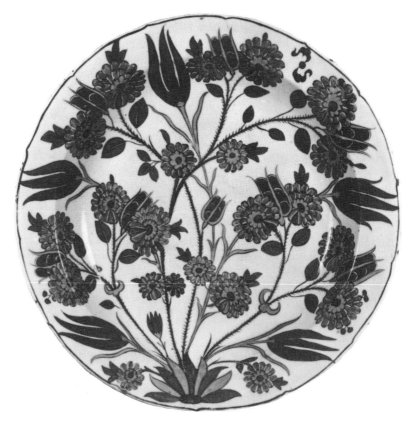

tian countries and by the motifs of Gothic art was to limit the foreign spread of Málaga lustre, though trade continued until later in the century. Output of lustre spread to Manises near Valencia, examples of which were also in England before 1400. The relative scarcity of it in England compared with France suggests that this was essentially a luxury trade: Hurst lists 22 Spanish lustre finds in Britain from the later fifteenth century as compared with 44 from the late thirteenth and early fourteenth centuries.[60] While some are container-vessels (albarelli or drug jars, amphorae and costrels), most are decorative bowls and dishes.

The decoration of some of the British finds, as Hurst comments, recalls simplified versions of that on the 'Alhambra vases' of Málaga. While these celebrated vessels had to wait until the modern age of museum collecting for their full appraisal, the type was already a legend in the sixteenth century: a travelling Englishman left a description of one of the vases in 1553, though he certainly did not know what he was looking at. Originating about 1400, the vases take their name from a specimen that has never left the Alhambra at Granada, others now survive in varying degrees of completeness in museums in Granada; the National Museum, Stockholm; the Hermitage, Leningrad; and the Freer Gallery, Washington (Figure 19).[61] Standing between three and four feet high these vases present a body which tapers to a narrow foot and is surmounted by a cylindrical neck and flat, wing-like handles. The surface is covered with lustre decoration of

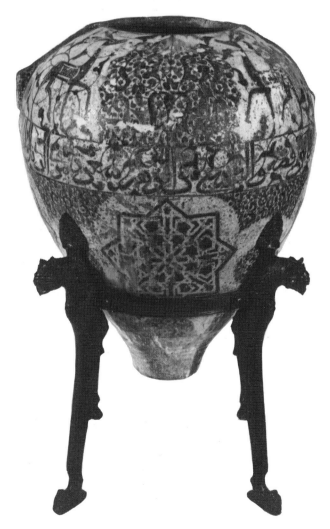

FIG. 19 Large vase (neck and handles missing). Earthenware with opaque white glaze, overglaze-painted in blue and golden lustre: some gilding. Twice-repeated design of two confronting gazelles flanking a large arabesque tree. Arabic poem at mid-point: four eight-pointed stars below alternately bearing geometric motifs and inscriptions. Stand with four lions designed by the former owner, Mariano Fortuny (1841–74), based on the Lion Court fountain of the Alhambra, Granada. H. 77.2 cm., D. 68.2 cm. Spain, Nasrid period, late 14th to early 15th century. Smithsonian Institution, Freer Gallery of Art, Washington, D.C. 03.206
One of the remarkable 'Alhambra' vases: the poem 'I seem to be made of silver and my clothing made of blossoms', records its celebrity. The vase stood for generations in a tub in the Albaicín at Granada. Charles Freer acquired it in 1903: see p. 290.

dense arabesque and other motifs with Kufic inscriptions. In the sixteenth century, as Kurz explains, the vases were venerated as the water jars which, it was believed, had been used at the Marriage of Cana.[62] The Englishman John Locke, visiting a 'Greek Church' in Cyprus in 1553 on a pilgrimage to the Holy Land, saw one in this light: 'the jarre is very ancient, but whether it be one of them or no, I know not'.[63] In 1571 Cyprus was occupied by the Turks who confiscated the contents of many Christian churches, as the Levant Company's Chaplain at Aleppo, Henry Maundrell, tells us (in his *Journey from Aleppo to Jerusalem at Easter AD 1697*, Oxford 1703). Kurz traces the Alhambra vase seen by Locke through the hands of Mustafa Pasha, the Turkish commander, to Vienna (after 1580) and thence to Stockholm.

Whatever their associations, the Alhambra vases could not fail to strike the imagination of those who saw them – not least because of the intricacy of their decoration. For Locke the jar that he saw was 'fairely wrought upon with drawen worke' – even though it is obvious that he did not associate it with anything Islamic. By the time that this encounter took place, however, another form of Islamic ceramic production had reached its creative peak. This was Turkish Iznik.

The high maturity of Iznik pottery comes in the post-medieval world, between 1520 and 1560: its origins at Iznik (ancient Nicaea, in north-western Anatolia) were, however, in the fifteenth century. The early years are notoriously difficult to chart but it seems likely that the typical Iznik white body-paste and the technique of underglaze painting, first noticeable in Turkey at Edirne in the first half of the fifteenth century, were taken over at Iznik towards the end of the century. The hard frit compound body replaced a reddish earthenware. Of the periods into which Iznik falls, the first, with much decoration of white on blue, lasts until about 1520. As we shall see in chapter 5, the second was later to be called 'Damascus', though this was never the place of manufacture. Blue on white effects are exploited, involving more open designs fluently drawn, and Chinese influence is as strong as it ever is at Iznik.[64] By the 1540s colours include cobalt and turquoise blue, sage and olive green and manganese purple. After 1550 – in the so-called 'Rhodian' period – the 'Armenian bole' red adds a warmth to the colour palette against the clear white background.

Iznik vessels reach a high point at mid century (Figure 18), both for naturalistic flower-drawing and for finely structured pattern: characteristics that are further exploited in the tile sequences of the great Ottoman mosques for which the period is famous. The outstanding architect Sinan designs the Süleymaniye mosque (1550–7) and others, and the Iznik potters, no doubt working in collaboration, provide multi-tile wall-designs that are both decorative and architectonic. (We shall find the inspiration of Iznik leading to fruitful collaborations between designer and architect when we discuss the work of the potter de Morgan and others in chapter 5.) The tile designs of the mosques, done to royal order, maintain the highest standards. The pottery vessels, relatively less prescribed, show an equal beauty that is nevertheless subject to an earlier decline. This had set in well before 1600. But by then Iznik was becoming widely known through exports.

The presence of European metal mounts on Iznik pieces in European collections points to its growing reputation in Europe, though documentation is extremely scarce. Between 1573 and 1578 David Ungnad, the Austrian ambassador to Turkey, had specimens shipped home via Venice.[65] The silver-gilt mount showing a London date-letter for 1597–8 on an Iznik jug (Figure 23) indicates that by then the ware had reached England. The more boldly splashed decoration of some Iznik pieces was, as we shall later discuss (p. 50), to find echoes in

seventeenth-century delftware and English Lambeth wares. An Iznik dish, broken but almost complete, has been found at Waltham Abbey in Essex: this bears freely painted tulips and carnations. The runny decoration of the piece relates in style to examples put by Lane after 1620: it is certainly datable on archaeological grounds to before 1669.[66] In the 1670s the English traveller Dr John Covell was to note the accessibility of Aleppo, Damascus and Smyrna from Iznik by road: a factor which no doubt helped the flow of the Turkish ware to foreign markets, including Nubia, Budapest and the Crimea.[67]

It is obvious that Italy, geographically placed between Islamic influences coming direct from the eastern Mediterranean and those coming from Moorish Spain to the west, would be the catalyst of a wealth of oriental motifs in its own ceramic production. Between the thirteenth and the sixteenth centuries the development in Italy of the tin-glazed earthenware called maiolica provides a major channel for the dispersion of Islamic motifs. The name maiolica (if not derived from Málaga, Arabic Maliqa) points to the influence of the trade with Valencia in Spain via Majorca. Hispano-Moresque patterns and techniques pervade the tradition to the extent that the word maiolica is even used with the meaning of a metallic lustre in the 1530s by the potter Giorgio of Gubbio, a master of lustre-painting: the usage is confirmed by the influential potter and writer the Cavaliere Cipriano Piccolpasso of Casteldurante, in his *Tre Libri dell'Arte del Vasaio* (*Three Books of the Potter's Art*) compiled about 1556–9.[68] The same writer, incidentally, gives prominence to arabesques, *rabeschi*, now on a high tide of popularity. While Islamic motifs and the use of tin-glaze, however, were to be passed to France in the *faience* of that country and to Holland and England in seventeenth-century delftware, European use of lustre was to decline after the 1550s. Potters did employ it in the eighteenth century, but the secrets of true Persian lustreware were to fall into disregard in Europe until their revival in the nineteenth century, in part by the firm of Carocci, also of Gubbio, and by William de Morgan in England.

While Islamic ideas could be conveyed by ceramics on many levels of sophistication and naivety, it was textiles which continued, most vividly perhaps, to reveal oriental mastery of colour and pattern to the English at home. Besides carpets, these merits were partly relayed by Turkish and Persian brocades (Figure 20), and velvets. And though Venice, Lucca and Florence had had their own silk-weaving for 300 years, Eastern silk still enjoyed the unique prestige that its Chinese origins had guaranteed it long before. As regards England, Persian silk – in the sixteenth and seventeenth centuries going through a period of splendour that was remarkable even in the long history of Islamic silk-weaving – became a staple commodity through the Levant trade and from the beginning of direct trade with Persia in 1616. In that year the Shah offered the English 3,000 bales on credit 'to give life to our trade's beginning'.[69] That life was to be vigorous and richly productive. Instructions of 4 February 1618 by Sir Thomas Roe to the factors in Persia discussed arrangements for purchasing Persian silk; Bengal raw silk, it may be noted, was also being traded in the same year. In 1619, the ship *Expedition* sailed from Persia to Surat with 11 bales of Persian silk which were then sent on to England in the *Royal Anne*. In 1620, having experienced harassment by the Portuguese, English ships at Jask in Persia loaded up 520 whole bales and six half bales of the material.[70]

At home James I, reigning between 1603 and 1625, was impressed by Eastern silk and seriously concerned to establish sericulture in both England and Virginia. He had mulberry trees planted in his gardens at Whitehall and on his country estates, and a Groom of the Chamber appears to have been employed at

times to carry silkworms about 'whithersoever his Majesty went'.[71] A batch of the creatures was lost at sea on the way to Virginia in 1609, but in 1621 Sir Edwin Sandys was expressing the hope that the Virginian colonists could subsist on trade in silk and iron, and that the silk of Persia would not excel that of Virginia. In fact the Virginian tobacco trade was to be markedly more successful than silk. But James I had instructed John Bonoeil, the French manager of the royal silk works, to compile a treatise on methods of silk production: this appeared in 1622 with a preface by the King.[72]

The same years saw rapid developments in the acquisition of Eastern silk. The foundation of the East India Company in 1600, one of Elizabeth's last innovations, had been a momentous factor in the new century, alerting Englishmen not only to the possibilities of direct trade with Persia, but also to the geographically

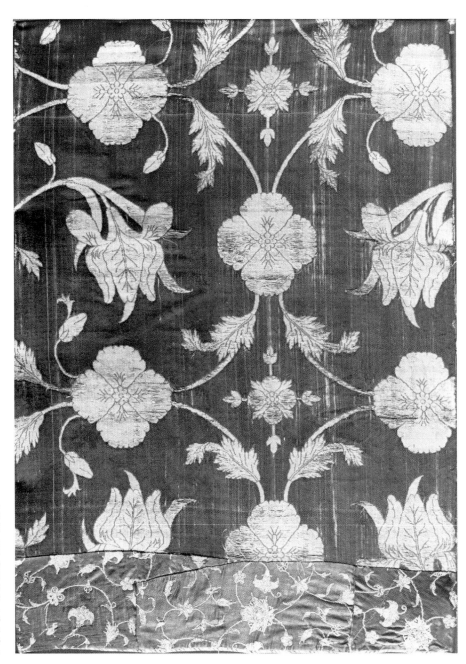

FIG. 20 Cover of crimson satin brocade. Woven in a repeating pattern of large four-petalled flowers and iris in blue and gold thread. Blue satin border. 96.5×89 cm. Persian, Safavid, 17th century. Victoria and Albert Museum 507–1889
The design effectively suggests both stability and movement. The main flowers take the eye upwards and sideways. They are joined by diagonals in the form of stems which fan out and give off leaves. Earlier examples of such structures in Islamic textiles had influenced those of Europe: the Persian design has a characteristic refinement. This cover was bought at the Paris International Exhibition of 1889.

still more remote attractions of China and India. The influence of Chinese silks had been deeply felt across immense tracts of the Middle East, including Persia, during the period of Mongol supremacy in the fourteenth century, when dated Chinese examples are recorded in Europe.[73] After 1600 direct trade developed between Britain and India; from the 1650s increasing quantities of genuine Chinese objects, including porcelain, lacquer, and curiosities of various kinds as well as silks, were appearing in 'China shops' in London. These would stimulate native craftsmen to supply their own versions of 'china work', or, as these would later be called, chinoiserie, compounded of a variety of motifs, some genuinely oriental, others Western in origin.[74]

'Great quantities' of silks, we are told, were being brought from China into England by 1639 and 'sold at very low rates'.[75] Despite the competition of Chinese stuffs, however, India – from whence Chinese objects were imported before the East India Company established direct trading at Canton in 1715 – could hardly be overshadowed. Indian painted cottons or calicoes, also called 'chintzes', were being imported into England by the Company before 1620: on December 1618 an English merchant in Agra notes the Company's decision 'to have ... more callicoes'.[76] By mid century these fabrics were establishing a reputation.

As the century went on, the English and the Dutch (through their own East India Company) built up considerable trading in Indian waters. Madras on the east coast of India was secured from the Mughal emperors in 1640 and by mid century had become the centre of the calico trade. Bombay was transferred from Portugal to England in 1661 as part of the dowry of Catherine of Braganza on her marriage to Charles II. From this period the reputation of Indian calicoes accelerated rapidly. Even by 1641, an English inventory refers to a whole room decorated with Indian chintzes (curtains, bed hangings, and 'carpetts', this last meaning coverlets).[77] Some of the 'pintadoes' or painted cloths were evidently of documentary value: John Evelyn records in his *Diary* on 30 October 1665, seeing some of these in a room 'hung with pintado' in Lady Mordaunt's house at Ashtead, 'full of figures greate and small, prettily representing sundry trades and occupations of the Indians, with their habits'.

Brilliant, colour-fast and the fruit of a long tradition, these calicoes were technically beyond the capabilities of English makers. They seem to have represented an exoticism that, despite attempts, was inimitable: any desire for compromise with taste at home was met, from the 1640s, by commissioning Indian manufacturers to produce designs in accordance with European ideas, and from the 1660s, by sending actual English patterns out to India for craftsmen there to make up in their own expert fashion. A cross-breeding process as regards motifs is traceable earlier, and admired oriental motifs such as the 'Indian Tree' may consort in the same design with English wild flowers or animals. Nevertheless a strong Islamic element may be quite explicit in those Indian export cottons which were less concerned with accommodating European tastes. The palampore illustrated here (Figure 21) shows how India had absorbed Islamic ideas, reflected in the all-over, flowing plant patterns, and in vases with flowers enclosed in pointed, leaf-shaped compartments. Naturalistic irises and carnations are combined with more fanciful flowers.

The success of these Eastern textiles had a notable sequel. Late in the century, woven, embroidered and painted fabrics from that quarter began to represent a serious economic challenge to manufacturers in both France and England. Complaints about the competition are heard after 1685 from the silkweavers of Spitalfields, their numbers swelled by the arrival of Huguenot refugees from

France.[78] Imports were restricted after 1700 but in 1719 conditions were sufficiently bad again for protests to be rife.[79] Whatever attempts might be made to limit exports, the message had by then been spelt out: the imported chintzes, carrying their charge of English, Chinese and native Indian elements – among which the two-dimensional elegance of Islamic running patterns provided an underlying coherence and legibility – were indeed to be the model for large numbers of the printed cottons of Europe, and also for wallpapers.[80]

This chapter began with the importing of rare and expensive Turkey carpets and must conclude with the incoming tide of expertly and cheaply produced Indian chintzes. The period between 1500 and 1660 was one of formative importance for the visual arts in England. To the monarchs of the houses of Tudor and Stuart, Italian Renaissance art was clearly that which befitted a modern nation aiming to play its part on the European stage. But Henry VIII's break with Rome in the 1530s made the central issues of modern Italian art less accessible in England than they were, for instance, in France. It was not until the early seventeenth century that a 'masculine and unaffected' classical architecture

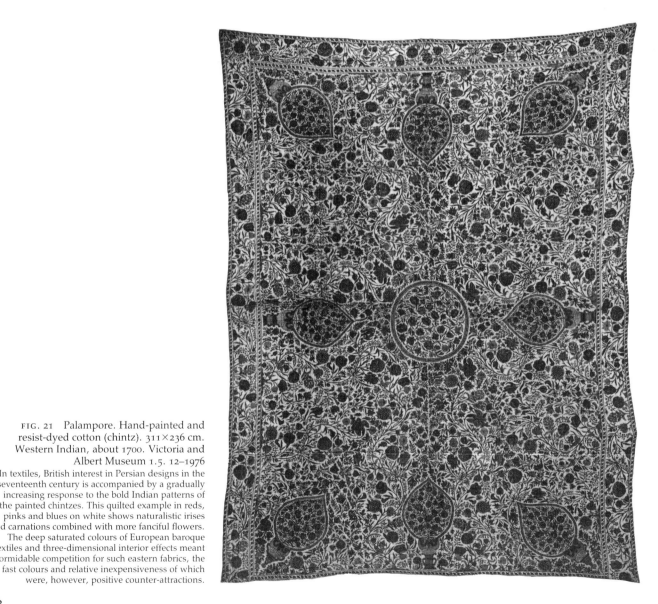

FIG. 21 Palampore. Hand-painted and resist-dyed cotton (chintz). 311×236 cm. Western Indian, about 1700. Victoria and Albert Museum I.5. 12–1976

In textiles, British interest in Persian designs in the seventeenth century is accompanied by a gradually increasing response to the bold Indian patterns of the painted chintzes. This quilted example in reds, pinks and blues on white shows naturalistic irises and carnations combined with more fanciful flowers. The deep saturated colours of European baroque textiles and three-dimensional interior effects meant formidable competition for such eastern fabrics, the fast colours and relative inexpensiveness of which were, however, positive counter-attractions.

(Inigo Jones's own words for the buildings that he admired) could arise in England. His energies pushed this achievement through: but in architecture only. Despite the example of certain great collections and the contributions of a few artists of genius whose imaginations moved easily within the classical tradition (notably the painters Rubens and Van Dyck), sculpture and painting in the country in 1660 remained groping for a serious modern identity. In these circumstances it could be said that the second most important visual stimulus of the period between 1600 and 1660 in England after that of Italian classicism was the growth of the East India trade, especially in ceramics and the variety of exotic textiles culminating in the silks and chintzes. The flowing, elegantly paced patterns on these textile objects of Persia and Mughal India gave evidence in line and colour of a different tradition, but one that answered modern requirements of comfort and ease of living as the measured masses of Italianate architecture answered those of human confidence and self-possession. The 90 years after 1660 were to see an appreciable extension of the creative uses to which both traditions could be put: and it is to that period that we now turn.

1660–1750:
THE CONNOISSEURS OF SPECTACLE

I

At a famous masked ball held at Versailles in 1745, to celebrate the marriage of the Dauphin to Maria Theresa of Spain, Louis XV is said to have cast his handkerchief before Madame d'Etioles, the future Madame de Pompadour, in a gesture understood to be that of the Sultan of Turkey in choosing his favourite. Whatever the truth of this episode, Charles-Nicolas Cochin's large engraving of the ball that took place in the Galerie des Glaces depicts numerous guests in Turkish dress, including many with gigantic Turkish headpieces consisting of face and turban and covering the heads and shoulders of the wearers (Figure 22). There could be no more vivid evidence of the fascination of the *turquerie*.

In this chapter, we shall be concerned with the 80 or 90 years leading to the period of Cochin's print. In the course of it we shall be constantly aware of the influence of France. Notwithstanding the lively intellectual life of Holland and

FIG. 22 Charles-Nicolas Cochin *père. The Masked Ball . . . in the Grand Gallery at Versailles.* Line-engraving, 47.7×76.8 cm, after C.-N. Cochin *fils.* British Museum, Dept of Prints and Drawings. Courtesy of the Trustees
The 'Turkish' party, with monstrous head-coverings, is prominent on the left.

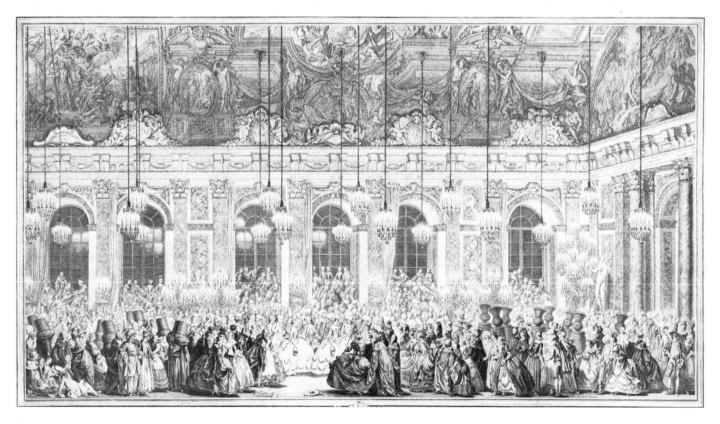

England in the seventeenth century, France from 1660 steadily becomes the focal centre, under its absolute monarchy, of the mental universe of large numbers of Europeans. The immense cultural authority of Italy is, of course, not diminished. Indeed the main phase of the Grand Tour of Italy, so richly turned to advantage by Englishmen, begins halfway through the period; and towards the end, in 1734, Rome's great Capitoline Museum receives its first visitors. But if Italy presided over the past, France in the 1660s was inescapably catching the eye of Europe in the present; and a gradual movement of fashionable ideas and appetites was taking the focus of new achievement in the visual arts away from the Rome of the Popes to the Versailles of Louis XIV. Versailles was to become synonymous with the *grand siècle* that lay ahead, and a byword for magnificence in Europe at large.

Through much of the seventeenth century the Baroque – bold, dynamic, emotionally charged, though grounded in classical values – had unfolded in Italy, most conspicuously in Rome in the work of the sculptor and architect Bernini. The final rejection by the French of Bernini's designs for the east front of the Louvre, in 1665, is usually taken as the most revealing indication of French self-confidence in the visual arts at that time. This was the first flush of the autonomous rule of Louis XIV, securely launched on a reign which was to last until 1715. At Versailles – the hunting-lodge which Louis was enlarging and transforming from 1668 onwards – his architects not surprisingly followed certain Italian leads in the Baroque style that was adopted. Significantly, however, while toning down the formal forcefulness of the Italian Baroque, they were skilfully adapting its brilliant potential as a vehicle of authority. The image of Louis sprang unavoidably and unequivocally to the visitor's eye from the stucco, marble and paint of the palace's adornments.

A time when the Renaissance cult of the prince was being converted so energetically into the terms of a French absolute monarch may seem unpropitious for the claims of Islamic art to have made themselves felt. Louis's foreign interests were considerable, but some estimates have made light of the extent to which he allowed himself to become seriously involved in matters originating outside Europe.[1] His diplomatic contacts with a country as far removed from the European orbit as Siam are well known: his envoy there, Chaumont, gathered material on Asian astronomy, mathematics and customs which he published in 1691. It is no surprise to find that the gravitational pull of the Far East, especially China, exerted itself on Louis as on other Europeans. By the late seventeenth century, among Eastern nations China was attracting unrivalled attention in Europe, both as Empire and as source of artistic ideas. Moreover, on a practical level, the economic appeal to Louis of elaborate but cheap Chinese lacquer furniture cannot be overlooked at a time when he was sacrificing his massively Baroque silver tables and chairs to the melting-pot to help pay the costs of his wars. As regards the Islamic world it seems clear that he took an interest in the reports of French travellers such as François de la Boullaye-le-Gouz and Jean Baptiste Tavernier.[2] In Laurent d'Arvieux and Antoine Galland, moreover, he had the services of two brilliant Arabic linguists, while French scholars were included in the retinue of French ambassadors to Turkey.

The subject of the elaborate embassies to and from the countries of the East during the *grand siècle* brings us to an aspect of the Islamic impact on Europe which held an obvious appeal for the many connoisseurs of spectacle of the Baroque age, among whom Louis had no rival. Here was a field in which the firework displays, processions and ceremonial tents of the Turks had proved their accomplishment.[3] Here, surely, were new applications of expansiveness

combined with teamwork that could not fail to attract the builder of Versailles. Embassies from Turkey in particular made dramatic appearances in Paris in his reign, tinging even that royal protocol with a degree of unpredictability and even perhaps redressing a little, in this way, one of the more grievous aspects of the visual arts under Louis, the State direction which made much of what was done so ultimately sterile.

The fullbloodedness of the idiom revealed in these encounters could provide authenticity for the theatrical entertainments that were a conspicuous part of the life of the French court: the Turkish scene requested by Louis in Molière's *Le Bourgeois Gentilhomme* (1670) is an obvious example to which we must return (p. 60). Besides the appreciation of authenticity there was also a frank enjoyment of the flamboyant and unusual which delighted Monsieur Jourdain in Molière's play. But it is important to recognise that the craze for *turqueries*, or Turkish-inspired presentations in various arts, which arises in this period rested in part on a firm foundation of informed interest. We can also best consider this later, together with its English counterpart, in the light of the extended first-hand contacts with Islamic countries, not only by travellers but by artists of some consequence, that begin to develop just before 1700.

The position in England after 1660 was similar to that in France and yet, in decisive respects, different. In Charles II the country had a vigorous upholder of the claims of the monarchy that had been restored in that year: but he also had an astringent Parliament to deal with. Court life blossomed, as all readers of Samuel Pepys know, in a pursuit of pleasures that had been frowned on during the Puritan Commonwealth; while music and the drama, which the Puritans had not undervalued, now flourished without inhibition. But Charles's spending on the visual arts was curbed by necessity to a far greater degree than that of his cousin Louis XIV. The most he could undertake in direct rivalry with Versailles was the initiation of a palace at Winchester and, also in the 1680s, of some Baroque interiors at Windsor Castle. Nevertheless these were not negligible in terms of display. As in France, the thriving state of the theatre could – as we shall see – offer opportunities for exotic ideas. And if England had no Molière, and the more extreme manifestations of ambassadorial ebullience were reserved for France, we should not forget the impression made on the fastidious John Evelyn by the person and suite of Ahmed Hadu, ambassador of Morocco, in 1682, together with his present to the King of two lions and 30 ostriches and his displays of virtuoso horsemanship in Hyde Park.[4]

Away from the glitter of public events, the amount of information about Islamic lands was building up prodigiously in both France and Britain during the last 40 years of the seventeenth century. In France Cardinal Mazarin's famous art collection had included Persian and Turkish objects; and Jean-Baptiste Colbert, the King's astute minister and administrator of the Cardinal's collection after Mazarin's death in 1661, later collected oriental books himself through the good offices of the orientalist Antoine Galland (1646–1715). Galland was in the Middle East in 1679, and built up a formidable knowledge which was to equip him as Professor of Arabic at the Collège de France 30 years later. In 1704–07 he was to bring out his translation of *The Arabian Nights*. This found a wide readership at a particularly significant moment when reading was becoming much more than an academic occupation or a gentleman's privilege. By then Barthélemy d'Herbelot's *Bibliothèque Orientale* (1697) was available, with a preface by Galland, constituting a rich alphabetically arranged conspectus of Eastern cultures and including entries on Islamic cities, customs, costume and history, though with little on art and architecture and no illustrations of examples.

In Britain there was as yet no rival to this single work, though as we saw, chairs of Arabic had been founded at the English universities in the 1630s. The interests of English Arabic scholars, such as the great Edward Pococke (protégé of Laud), appear to have remained literary rather than visual, though some beautiful manuscripts were collected by the Oxford orientalist Thomas Hyde (1636–1703) and a high-quality Jami was acquired by the Bodleian in about 1678 from the collection of the Deputy Professor of Arabic, Thomas Greaves. Several areas of Islamic life were under enquiry by individuals. John Ogilby, publisher and writer of compendious geographical works, had noted obscure customs, such as the medicinal use of jade by 'the Moors', in his *Asia* atlas of 1673. The concern for co-ordinating information as well as collecting it is reflected in the study of the plants of Turkey and Persia. William Sherard, consul of the Levant Company at Smyrna, made botanical and antiquarian forays in Asia Minor and later founded the chair of botany at Oxford.

The clerics John Covell between 1670 and 1677 and Sir George Wheler in 1675–6 also followed up botanical interests in Constantinople: we shall meet both of them again later (pp. 48, 50). In London the Royal Society for Natural Philosophy (newly formed in 1661) came to include amongst its members (from 1682) the eminent traveller and expert on Islamic matters, Sir John Chardin. Another member was the architect Sir Christopher Wren (1632–1723), possessor of one of the most gifted and questioning minds of the age. By the end of Wren's life Simon Ockley's *History of the Saracens* (1708–18) had appeared. Wren, however, was specifically curious about Saracen architecture and had interesting ideas on the subject (p. 53f.).

The curiosity of the men of the first generation of the Royal Society could be fed in three ways: by personal visits, by conversations with 'Turkey merchants' on their return from the trading-centres of Aleppo and Smyrna, and by perusal of the numerous accounts which were being published by serious travellers. Many of these travellers at this period were French, though their works tended to appear in English almost immediately following their French editions. Among these Jean-Baptiste Tavernier (1605–86) is conspicuous. In 1641 he was among the earliest Europeans to see the Taj Mahal at Agra in its still uncompleted surrounding complex beside the river Jumna. By the time that it was begun, in 1632, by the Mughal Emperor Shah Jahān in memory of his wife, this great building (Figure 90) and the identity of its designer was already the subject of speculation for the English traveller Peter Mundy, an even earlier observer of it.[5] For Englishmen at home – Wren for once is typical in this respect – Constantinople exerted more appeal: but Tavernier had seen Constantinople too, as well as the glories of Persia. His *Six Voyages*, published in Paris in 1676, was translated into English by the following year.[6]

François Bernier (1620–88) and Jean de Thevenot (1633–67), who also ranged as far afield as the Taj Majal, were other influential French travellers. Bernier visited England in 1685. Thevenot's *Voyages* appeared in Paris in 1684 and in London in 1687.[7] At the same time the Eastern travels of the tireless Jean Chardin (1643–1713), over the period 1664–76, were made partly available in both French and English in 1686, and the absorbing account of his experiences in Persia after leaving Isfahan followed in 1724.[8] But in any case Chardin was present in London as a resident from about 1680, was knighted as Sir John Chardin in 1681 and became a member of the Royal Society a year later.

Finally, the well-illustrated *Relation d'un Voyage de Constantinople* by Guillaume-Joseph Grelot, who had acted as draughtsman to Chardin, came out in France in 1680 – with a dedication to Louis XIV – and in English translation in 1683. Grelot's

'ingenuity, industry and diligence' are vouched for in a foreword by Dr John Covell, English cleric, botanist and collector of Turkish songs, who had known him in Constantinople.[9] The book illustrates Hagia Sophia and all the main mosques. It affords excellent insights into what an open-minded European observer could admire in Turkish life at this time, and what earned his disapproval. He likes the food, the 'pilaw, doulma, bourek, chorba, and other Eastern ragous' with which he was to regale friends on his return to Paris. But he is anti-Turk in matters of politics and religion, a reminder that the year of the English edition of his book was that of the unsuccessful siege of Vienna by the Ottoman army, and the turning of the tide of Turkish militarism in Europe. He regrets the deficiencies of this 'barbarous people' in painting and sculpture, and the lack of the 'ancient quaintness and ingenuity of the sedulous Egyptians, Arabians and Greeks', whose territories they now lord over'.[10] But he ungrudgingly praises the public buildings, the mosques, baths and bazaars.

In these years France, like Italy, was working for a neutralised Turkey, with the object of safeguarding the strategically vital city of Constantinople from any power with predatory eyes on the Mediterranean. Britain wanted a neutral Turkey also, in order to protect her route to India. The Levant Company received a new charter in 1661, so that Smyrna, and Aleppo in Syria, remained crucial trading centres for English merchants. The English East India Company was, however, as we have seen, to become increasingly active. Fort St George (Madras) was now the centre of the calico trade: Bombay was ceded to Charles II.

One of the more unusual figures to arrive in India in the period was Elihu Yale (1649–1721), most widely known for his benefactions late in life to the college in Connecticut which became the University that bears his name. Born in Boston of Welsh descent, he lived in England from the age of three. From 1672 to the end of the century he was in India: first in the service of the East India Company, then from 1687 to 1692 as Governor of Madras, and finally becoming a director of the Company. In India he collected Mughal miniatures: the six-part sale of his effects after his death included 23 Indian pieces in glass frames with 23 'Indian Pictures small' as well as a 'large India picture'.[11] The scale and gem-like clarity of figures in Mughal painting seem to be remotely reflected in some tapestries woven for Yale in what contemporaries called 'the Indian manner' at Soho (now at Yale University). A weaver called Van der Bank is known to have woven such tapestries.[12] But the 'Indian manner' is a concoction of mainly Chinese elements – fishermen, flowering trees, trabeated buildings – with no firmly recognisable Islamic character: 'Indian' means a generalised exoticism.

As Mildred Archer has remarked, the impact of East India Company merchants returning from India on society in Britain was negligible before 1750: 'Those who survived the life and the climate of India returned and quietly invested their money in land'.[13] One such merchant, however – still unidentified – may have placed some of his wealth differently, and commissioned the strange paintings carried out in 1696, in oil on wood, at 5 Botolph Lane, London (now at Sir John Cass's School, Aldgate, London) by the enterprising painter Robert Robinson. These present an extraordinary assembly of exotic figures in exotic landscapes, reflecting a variety of settings: a gilded Venice filled with chinoiserie buildings, a palmy jungle inhabited by Aztec-like figures. They combine a sense of theatre (and it is no surprise to find that Robinson worked as a scene-painter) with an attempt to be specific about the exotic in a period when it was usually vague and generalising: an attempt which carries a curious conviction in such matters as the feathered dresses of the primitive natives depicted.[14]

No English-born travellers at this time, in fact, did as much to improve

knowledge of Islamic lands as the Frenchmen Tavernier and Chardin, who published so voluminously and who were so moved by their experiences that they publicly wore, on their return to Europe, the Eastern dress that they had acquired at first hand. Louis XIV's interest in Persian travel also encouraged the issue of popular engravings of Persian subjects, which included details of costume and architecture.[15]

'Oriental dress' was usually a vaguely understood matter, however, among the great majority of Europeans who lacked specific experience of the East. Particularly in court circles, it was welcomed – as it had been for generations – as a break from formal conventions. At the fashion-conscious Restoration court of England some of its fascination may be ascribed to the influence of such men as Chardin. Some was undoubtedly also due to the 'fancy-dress' regard for such costume and the influence of the theatre. Diana de Marly has drawn attention to the presentation (recorded by Evelyn) of Lord Orrery's *Tragedy of Mustapha* at the very time – 18 October 1666 – that Charles II appeared in a vest of what Evelyn calls 'the Persian mode', which aroused the warm regard of both Evelyn and Pepys.[16] In fact (despite Evelyn's acquaintance with genuine Persian costume, which he had seen in Italy in 1645) it seems to have been a decidedly generalised oriental fashion, representing a reaction against French fashions at a time when the two countries were politically at odds, rather than a genuine regard for Eastern style.[17] Unfortunately Charles does not appear to have had himself portrayed wearing the 'Persian' vest: no doubt as the King he preferred more traditional, formal modes for such a commemorative purpose. Nevertheless portraits of actors exist which show the 'theatrical' vest being worn even before the King gave it a fashionable real-life cachet: and it is clear that even when the actor is depicted in a Muslim role there is no concern for fidelity to any particular oriental source.[18] In 1670, with the signing of the secret Treaty of Dover, France and England became allies again, and this particular 'oriental' mode died away at court in the face of fresh sympathy for French fashions.

In these late seventeenth-century years, when royal and aristocratic taste in England (Eastern fashions in dress apart) was centred on the formal Baroque vehemence of Versailles, more relaxing fashions were also flowing in from the Islamic East, some via France, others more directly. Foremost among these we may note the interest in coffee (which came from Mokah on the Red Sea, but had long been drunk in Turkey); in Turkish baths; and in Turkish flowers. All were concerns of a period when the Five Senses, so often depicted in Baroque art, appear to have increasingly sought gratifications from the East. Coffee, tea and chocolate were all commonly established in Europe by 1700 where they had been almost unknown a century earlier.[19] Coffee-houses in Marseilles and Venice fostered the habit and soon after 1650 one opened in St Michael's Alley, Cornhill, London. This was the 'Pasqua Rosee's Head', named after the servant whom a Turkey merchant had brought back with him to England.[20] By 1700 there were probably about 500 coffee-houses in London. A new need had arisen: in its coffee and chocolate-pots of ceramic and silver Europe was to pick up echoes of the long-spouted ewer-shapes developed long before in both China and Persia, but made so indissolubly part of Islamic metalware tradition in the thirteenth and fourteenth centuries.

Apart from contributing to the prevalence of the Persian spouted ewer-shape in Europe, the coffee-drinking habit has only incidental relevance to our theme. The late seventeenth-century fashions for oriental baths and Levantine flowers have an importance that is rather less oblique. In 1679 the 'Bagnio' or Turkish bath opened off Newgate Street, London (in the small street marked on

subsequent maps 'Bath Street').[21] The presence in the capital of a type of public bath which would become an institution is worth noting, even though we shall not find until the nineteenth century examples of the 'Turkish bath' with any serious regard for Muslim architectural style.

After 1679 the visitor to the Newgate Street Bagnio could nevertheless sweat surrounded by blue and white oriental-style tiles of Dutch manufacture, of a type then being made in tens of thousands at special factories at Delft, Rotterdam and Amsterdam as a distinct part of the great tradition of delftware. The Dutch tile-makers, striking out in a recently independent nation in novel directions, were using the ultimately Islamic technique (noticed in chapter 1) of painting in colour on tin-glaze to emulate Chinese blue and white porcelain.[22] The colour that they used, cobalt, was the most stable in the potter's repertory and had also been first employed, in all probability, by Islamic workers in Mesopotamia in the ninth century AD, antedating by several centuries the extended Chinese use of it as a means of decoration on white porcelain.[23] Tin-glaze had had a long development in Europe, where it occurs in Italy from the eleventh and twelfth centuries and where the ware that bears it is called maiolica: but in the 1600s as part of a new creative movement supplying ware for a public uninsistent on respected Italianate models, the Delft potters were adding their own initiatives. These included the use of a beautifully enriching, thin film of glaze called *kwaart* and a willingness to take in non-European ideas of decoration. These ideas, in a century when Chinese porcelain was at last becoming available in quantity in Europe for study and emulation, were Far Eastern rather than Near or Middle Eastern: between 1602 and 1657 over three million pieces of Chinese porcelain had been shipped to Europe by the Dutch East India Company.[24] Chinese motifs are therefore common on Dutch tiles, and their effect is very different from that of tiles in an Islamic interior: but the concern to cover wall-surfaces with brilliantly coloured, decorative ceramic objects was one for which Islamic precedent would clearly have many lessons.[25]

Ceramic decoration provides us with considerable evidence of seventeenth-century interest in Levantine flowers such as carnations or, most notably, tulips. Though most familiar to travellers who visited the Serail gardens at Constantinople, where it flourished, the tulip had Persian origins, as the derivation of its name – from the Persian *dulab* – indicates. Tulipomania, though much written about since, remains one of the more intriguing phenomena of the period.[26] The plant had arrived in Europe earlier: it was brought to Vienna by Count Ogier de Busbecq, ambassador to Süleyman the Magnificent, in 1554, and reached Holland about 1560. Numerous varieties were perfected there in the next 100 years. The interest was also shared by Italy: Francisco Caetani, Duke of Sermoneta, appears to have had the remarkable total of 15,147 tulips in his garden by the 1640s.[27] In France the Huguenots, a notably garden-conscious community, took the plant with them when driven to other countries by persecution, and helped to popularise it. In the 1680s it was among the flowers of the Serail when it caught the attention of the Englishman Sir George Wheler who, with other amateur botanists, brought home specimens.[28]

In painting, the tulip had been used most effectively in the sixteenth century by the Turks as a decorative device on their Iznik pottery, typically in a finely drawn form with elongated petals which flared outwards at the tips. Pieces of Iznik ware reached England, as we saw, before 1600 (Figure 23); and a Turkish pottery jug with late sixteenth-century Utrecht silver-gilt mounts (Victoria and Albert Museum 1561–1904) shows a freer handling of the motif. The wide occurrence of the broader-petalled tulip in Dutch paintings and prints undoubtedly helped to

make it popular. But Iznik pottery simply demonstrated the decorative potentialities of the plant, with its bold, vertical flower-head and pointed leaves. The tulip is indeed the flower *par excellence* that is recognisable in its profile view. Its qualities were not lost on Dutch or English designers later in the century: it appears in the decoration of English earthenwares (Figure 25), silver, bookbinding and samplers.

In the vigorously painted Lambeth earthenware 'chargers', the occurrence of the tulip is especially worth noticing. 'Charger' suggests a flat surface capable of bearing contents upon it, but the designs commonly have a vertical orientation for upright viewing and a flange for attachment to a wall. It has been suggested that the scarceness of flat ceramic wares in the late Middle Ages in Europe may have helped to form a taste in the Italian maiolica tradition for vertical designs orientated like those applied to ceramic plates from the East, rather than for designs conceived for horizontal viewing on a table-top.[29] It is possible that a subconscious prejudice might have been encouraged in this way: but it seems inherently more likely that the claims of classical symmetry and the classical pictorial conventions of the Renaissance played the decisive part in predisposing designers of ceramic plates in the seventeenth century to conceive ceramic wall-decorations and give them vertically orientated designs. The fact remains, nevertheless, that the designs of Islamic ceramic tradition, with some exceptions (for example, many Hispano-Moresque wares), favoured boldly painted upright motifs on dishes, and that Turkish Iznik stressed the vertical forms of, for example, trailing hyacinth stems, often forming a kind of bilateral symmetry, and particularly the vertical tulip flower. Now in the late seventeenth century – a

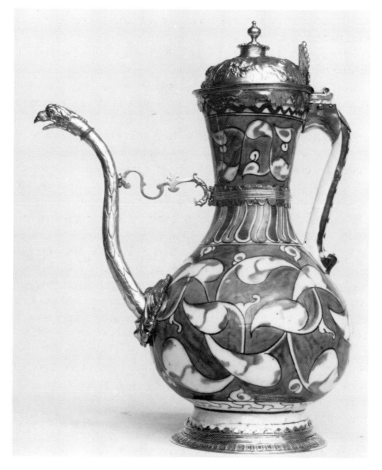

FIG. 23 Ewer, white ware, painted with leaf-scrolls drawn in black with bole-red details on a mottled blue-green ground. Turkish, Iznik, about 1580. Embossed and chased silver-gilt mounts with bridged spout producing a ewer-form. Foot bears London date-letter V for the year 1597–8. H. (overall) 31.5 cm., D. (base) 12.3 cm. British Museum, Dept of Medieval and Later Antiquities. Courtesy of the Trustees

The vessel was originally a jug. The flutings may derive from Venetian threaded glass. This is a commonly exported type, but was clearly rare in London for it to be given such elaborate mounts. Cf. p. 289, n.33.

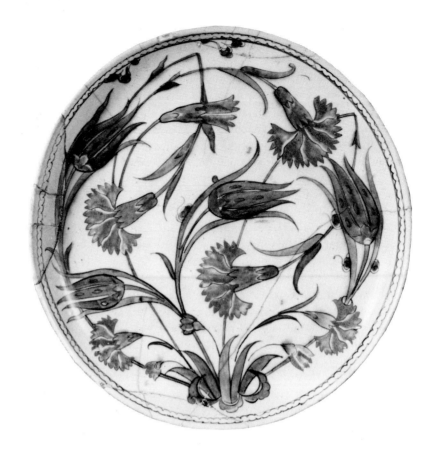

FIG. 24 Dish with flanged rim, white ware,
painted in polychrome with tulips and
carnations growing from a leafy base; double
zigzag lines inside rim: flowers in blue on
outside. D. 30.5 cm. Turkish, Iznik, second
half of 16th century. Private collection.
Photograph courtesy Faber and Faber
An extremely elegant design in which the two
flowers, the tulip long and pointed, the carnation
spreading and serrated, are used in a kind of
counterpoint.

FIG. 25 Charger, earthenware with
tin-glaze, painted in blue, manganese,
copper-green, yellow and orange, with tulips
and carnations in a globular lobed vase
flanked by inscription 16 68. Edge with blue
dashes. Back covered with buff lead glaze.
D. 39.7 cm., H. 7.8 cm. Lipski profile type D.
English, probably Lambeth, 1668. Fitzwilliam
Museum, Cambridge, Glaisher 1484–1928.
Courtesy of the Syndics
The decoration shows the exuberance and
spontaneity of touch characteristic of English
delftware. Both tulip and carnation motifs, however,
probably go back to Iznik (Figure 24).

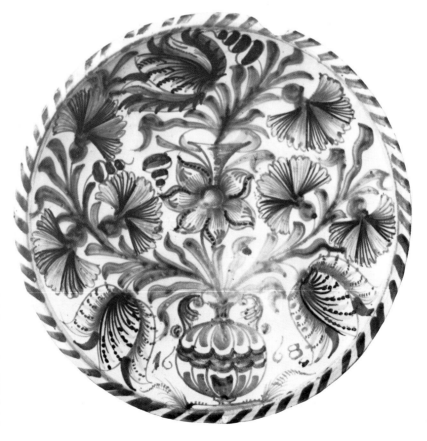

period of strong oriental stimulus in ceramics,[30] and in certain naively vigorous English pottery that was far from the sophisticated accomplishment of Iznik and which used very different colours – we witness the vertical designs of the 'tulip chargers', unclassical in all but their broadly handled symmetry. Besides the use of the tulip, there is here a basic expansiveness, not surprising in an age which produced the flower paintings of the Dutch or the lush wood carving of Grinling Gibbons, but which also recalls Iznik (Figure 24). Michael Archer in particular, in publications of 1977 and 1982, has noted possible links with the Ottoman wares.[31]

Among the other flowers of Turkey and Persia which provided motifs for Western ceramic decoration we must also recognise the carnation and the iris. In Iznik ware the carnation spreads fanwise as a foil to the tulip: in Figure 24 not only are the forms of the two flowers contrasted in shape and colour but the three main carnation blooms are skilfully presented next to three tulips which reverse their directions. Also characteristic is the way in which the serrations of the petal-edges of the profiled carnation become an important part of the effect. Several Lambeth chargers of the period 1660–1700 (Figure 25) show the tulip and carnation together in ways that exploit their profile characteristics.

In the iris we have another flower motif which is most recognisable in its profile view, like the tulip. Here, however, a form which is horizontal and rounded (the flower) can be contrasted with its vertical and spear-like leaves: the Safavid potters of the sixteenth and seventeenth centuries had seen this (for example, in Figure 26). The same relationship occurs in the English charger in the Victoria and Albert Museum (C79–1947), which has three irises and, using as it does a border pattern taken from early seventeenth-century Italian maiolica, has been dated (in Michael Archer 1982) to the same period. Mellor noted a probable influence from the Persian type of Figure 26 on Bristol delftware; a particularly suggestive example occurs in the Bristol dish in Figure 27.[32]

The attractions of cobalt against white as a ceramic effect had been shown to the world most signally by the Chinese, and Dutch and English ceramic achievements of this kind, together with their excursions into polychrome, have to be seen in the light of that example. But the contribution of Persian and Turkish flower motifs and the methods of presenting them is an individual one; and in the form of the upright Turkish tulip, given a degree of Baroque flamboyance in its European version, potters evidently found a decorative ingredient of admirable usefulness.

II

The tulip was not the only bold shape with Eastern connections which excited the men of the first generation of the Royal Society. The dome was another: and this was accompanied by a deeper curiosity about the visual arts of the Muslim world – especially architecture – which is evident in the writings of Christopher Wren. Evelyn records (30 August 1680) that he and Wren, one of the Royal Society's chief luminaries as well as the leading architect of England, met John Chardin, the French traveller, and questioned him about the East. Wren was also in touch with Dudley North, a Turkey merchant and an authority on Turkish life, about a technical point of Turkish dome-construction.[33] George Sandys's *Relation*, published over 60 years earlier but reaching its seventh edition in 1673, had possibly contributed to Wren's interest in Islamic buildings. The book had described (p. 24) the mosques of Constantinople as 'magnificent . . . all of white Marble, being finished on the top with guilded spires that reflect the beams they receive with marvellous splendor' and had proceeded to a detailed account of

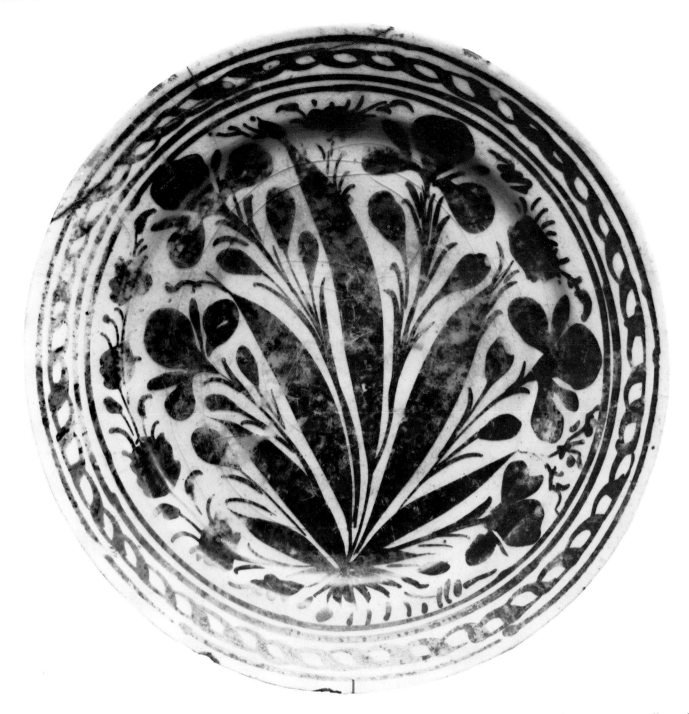

FIG. 26 Dish, earthenware with tin-glaze, painted in copper lustre with spray of iris. Cable-like surrounding motif within double and single lines. D. 22.5 cm. Persian, Safavid, 17th century. Victoria and Albert Museum 986–1883

The iris flower, a favourite Persian motif (cf. Figure 20) is here accompanied by its emphatic leafage. This dish was acquired for the Museum by Robert Murdoch-Smith, see p. 289.

Hagia Sophia. Wren's concern for spires as skyline features, as well as for domes, was one of the constants of his architectural thinking throughout his work on St Paul's and the City Churches that he redesigned after the Great Fire. We know Hagia Sophia – a pre-Islamic (in fact sixth-century Byzantine) building – was discussed in his circle, particularly so, we may imagine, after the appearance of Grelot's *Voyage to Constantinople* in 1680 (English version 1683). This carried illustrations of that church (flanked since the late fifteenth century by its minarets and functioning as a mosque) and also of the other main mosques of the city.[34] Wren does indeed briefly discuss the dome construction of Hagia Sophia (in the context of the Roman tradition) in his so-called second *Tract*

(probably written about 1693–4). In the same place, however, he shows that he has been considering the dome-type of the 'present seraglio' in relation to those of Rome. He could most readily have become acquainted with that building by consulting the *Description of the Grand Signour's Seraglio*, published in London in 1653.[35]

Wren's curiosity about Islamic architecture went much further than travellers' accounts. Of continual fascination to him were the similarities between Islamic and Gothic architecture: the style stigmatised by Renaissance classicists with the name of the barbarians who had sacked Rome. 'He was of Opinion', his son states in *Parentalia*, the record of the Wren family (1750), 'that what we now vulgarly call the *Gothick*, ought properly and truly to be named the Saracenick Architecture refined by the Christians.'[36] Wren was not alone in this speculation in the 1690s. It was simultaneously in the minds of the French sculptor and painter Florent le Comte, who wrote about it in 1699,[37] and of the churchman Fénelon.[38] The consideration of it by Wren, however, a practising architect, has a special interest.

This issue was a live one in Wren's circle. Despite a lifelong devotion to classical architecture, Wren responded positively to Gothic, as we know from his description of Salisbury Cathedral and his own creative use of Gothic ideas in St Paul's Cathedral and other buildings. John Evelyn (1620–1706), another thinking Englishman whose *Diary* leaves no doubt that he was moved by the power of Gothic cathedrals,[39] had also linked Gothic and Saracenic architecture, though in a context which led him to be bitingly disparaging about both: his translation of Fréart de Chambray's *Parallèle de l'Architecture Antique et de la Moderne* (Paris 1650). Evelyn's attitude to the 'Saracens' is much more predictable than Wren's,

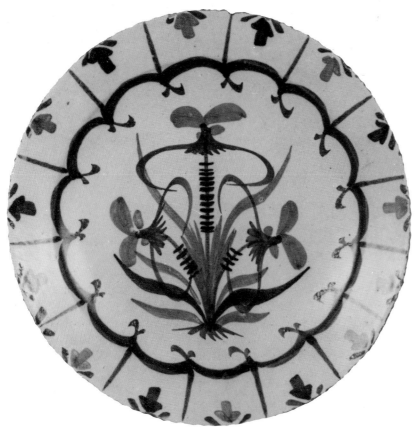

FIG. 27 Plate, earthenware with pale bluish tin-glaze, painted in blue, red and green with a spray of iris (lily?) and, on the rim, blue and green trefoils. D. 22.4 cm. Probably Bristol, about 1730. Bristol Museum and Art Gallery N5562 (gift of Miss E. Nesbitt, 1955)
The flower spray, though less bold, is related to Persian decoration (cf. Figure 26).

and the boldness of Wren's thought can best be seen against the background of Evelyn's arguments in this work.

In the original edition of his translation in 1664, Evelyn studiously puts over a basic Western humanist view, that good architecture responds to a human need for order and proportion: asymmetry, he says, and 'want of Decorum and Proportion in our houses' produce 'irregularity in our humours and affections'. The enlarged version of his 'Account of Architects and Architecture' – prefaced to the second edition of the *Parallel* (1707) with a dedication to Wren dated 21 February 1696/7 – underlines the accepted classicist opinion that 'Decorum and Proportion' are synonymous with Roman architecture. From here he goes on to attack Gothic for the absence of these qualities, and plunges into a tirade against Muslim building practice, 'those slender and misquine pillars or rather bundles of staves, and other incongruous props, to support incumbent weights and pondrous arched roofs, without entablature . . .' The Muslims' 'gaudy sculpture', he thinks, gluts the eye, and he parallels it with a Gothic example, Henry VII's Chapel at Westminster Abbey, 'sharp angles, jetties, narrow lights, lame statues, lace and other cut work and crinkle crankle . . .'[40]

When we think of the enjoyment of Gothic building that emerges from Evelyn's personal diary, the explanation of this engaging anti-Gothic diatribe must be that it is couched in the 'official' context of a standard work on Western classical architecture. We may be certain that in public Wren too would have upheld the same view, that Roman architecture was superior to Gothic. In a less exposed place, however – his 'Memorandum on Westminster Abbey' (1712) – we find him reflecting very differently. Speculating on the Western debt to Arabic scholarship, he sees Muslim architecture not as Evelyn's 'incongruous props', but as the result of different circumstances and building habits: 'their carriage was by camels, therefore their buildings were fitted for small stones, and columns of their own fancy, consisting of many pieces; and their arches were pointed without keystones, which they thought too heavy'.[41] Gothic and 'Saracenic' are related: Gothic grew up in England, he thinks, as a result of the Crusaders' contact with the Muslim East.

Wren's words highlight the candour of his approach to the question of 'Saracenic' and Gothic building. He is not concerned, here at any event, with the criteria of harmony, proportion and durability hallowed by Renaissance theorists and applied by Wren himself to classical architecture of the European past: he is impressed rather with the efficiency and economy of *means* of a very different tradition. Where Evelyn the non-architect saw meagreness and incongruity, Wren the architect recognised stability and the logic of geometry and sound structural principle. This had impressed him in Gothic. Accounting for the vaults of his own St Paul's Cathedral in *Tract II* he says he based them on medieval notions of economy and lightness, 'the least and lightest'. Wren will have known the astronomical tables – still a textbook at Oxford in 1667 – of Ulugh Beg, a successor of Tamerlane at Samarkand; would that he could have seen Ulugh Beg's elegant Islamic, brick architecture of the 1420s in that city.

This sense of a connection between Gothic and Muslim building method appears to have been in Wren's mind, if the 1693/4 date advanced in the Wren Society volumes for the second *Tract* is accepted, for at least 18 years before his Westminster Abbey Memorandum of 1712. It lies behind a puzzling reference in the same *Tract* to the differences between forms of vaulting 'as . . . used by the Ancients, or the Moderns, whether Free-masons, or Saracens'.[42] By 'Free-masons' here he evidently means the medieval builders, seen, however, as 'Moderns' as distinct from Ancients. At a time when the divisions between

'Ancient' architects, the exponents of classical tradition, and the Moderns were keenly felt and discussed, Wren here appears to apply a vivid turn to his own definition of a Modern: he instances the medieval builder as one possessed of insights transmitted from the Muslim East (by the Crusaders) and following ideas which might appear idiosyncratic, but which were long-evolved in terms of his own tradition and that of the Saracen.

It is interesting that Wren, in his private writing, in the course of seeking out antecedents for his own choices as a modern practitioner, came to link East and West in this way. Simultaneously, other speculations on the nature of building practice, would, in Frankl's phrase, extend the study of medieval culture. In particular, the modern freemasons were already concerned to trace the remoter origins of the mason's craft back to the work of Hiram, the master-mason of the building that was much discussed at this time, Solomon's Temple: Gothic, the Crusades and contacts with the Templars in the East were to be involved along the way.[43] The formation of numerous lodges of mason-initiates was, incidentally, to be a marked feature of the closing years of Wren's life.

Wren's own conclusions, so personally arrived at, are full of interest for two particular reasons. First it is rare before 1750 to find such receptiveness, in a Western writer who is also an exponent of Western classicism, to non-European architectural styles and practices. In the confused pre-Civil War years of Wren's youth the traveller Sir Henry Blount had been conspicuous for his fair-minded conjectures on the essential nature of the Turks who, as we saw earlier, might he thought be governed by 'an other kind of civilitie different from ours'.[44] After the Restoration, in Wren's early maturity, the 'Civilitie' of Roman architecture, thanks to Inigo Jones's example, had come to enjoy secure authority in Britain: the buildings being erected in contemporary Paris, visited by Wren in 1665, had confirmed his regard for classicism. During the last quarter of the century Wren was building prodigiously and meditating on the material contained in the Tracts. Louis XIV's France was simultaneously making its own authority more explicit: the King's minister Colbert, in particular, was indulging bold hopes. According to Charles Perrault (writing in 1688), he had advocated a scheme (unrealised) for designing suites of rooms in the Louvre, not only in the French classical style but in Turkish, Persian, Mongol and Chinese styles, apparently with the aim of encapsulating the known world in a single building.[45] The thinking of Wren, who never went east any more than Colbert did, is not of this dramatic cast: in his second *Tract*, though his imagination ranges beyond Europe, he is always the practical architect, working along the borderline between theory and practice, problem-solving as he goes.

The second point to reflect upon is Wren's generous view of Gothic. The Gothic style would eventually be a factor in the acceptance in Britain of Islamic architectural forms as worthy of serious attention. We can be certain that Wren discussed the idea of a link between Gothic and 'Saracenic' with his friend Evelyn. As a classicist, like Evelyn, he would certainly have put the 'true Latin' of architecture first: as an empirical scientist, however, he was clearly drawn to a candid evaluation of other traditions. We cannot conclude that as he placed Muslim architecture, which he acknowledged to be the work of people who 'wanted neither arts nore learning', in a line of development contributing to the medieval architecture of his own country, Wren was necessarily rejecting the polarisation still current in his day of classical (civilised) versus Gothic (barbarian). But at the very least he was taking a new look at it. He was not to be the last to speculate on a Near Eastern pedigree for the pointed Gothic arch. He was not the first to think of a link between 'Saracenic' and Gothic, but it was not to be

discussed in greater detail until the late eighteenth century, when 'exotic' styles were re-examined, as we shall see, in the light of the pronounced reactions of that period against the classical rules (p. 104).

That time, however, was still remote in 1700. In between, England had to go through a period when, in architecture, the classical rules became as firmly established as they ever did there. The more adventurous figures looked east. Wren's pupil Nicholas Hawksmoor (1661–1736) illustrates Henry Maundrell's *Journey from Aleppo to Jerusalem* (1703), basing his version of Baalbek, however, on that repository of Baroque architecture and decoration, the *Grand Marot*. He nonetheless also draws an early plan for the Radcliffe Library, Oxford, basing it on the Süleymaniye, Constantinople, which Grelot had illustrated.[46] But he used no Islamic detail from it. The Austrian architect of the Baroque, Johann Bernhard Fischer von Erlach (1656–1723), possibly encouraged by Wren, produced a remarkable history of architecture, *Entwurff einer historischen Architektur*, 1721 (another edition 1725; English version, *A Plan of Civil and Historical Architecture*, 1730; second edition 1737), for which he made considerable efforts to draw unfamiliar buildings in Eastern Europe or Asia as accurately as possible. The Third Book of this vast work is devoted to 'Some Arab and Turkish Buildings as well as Modern Persian, Siamese, Chinese and Japanese Architecture'. The Chinese buildings were truly eye-opening: the Great Wall, the Imperial Palace at

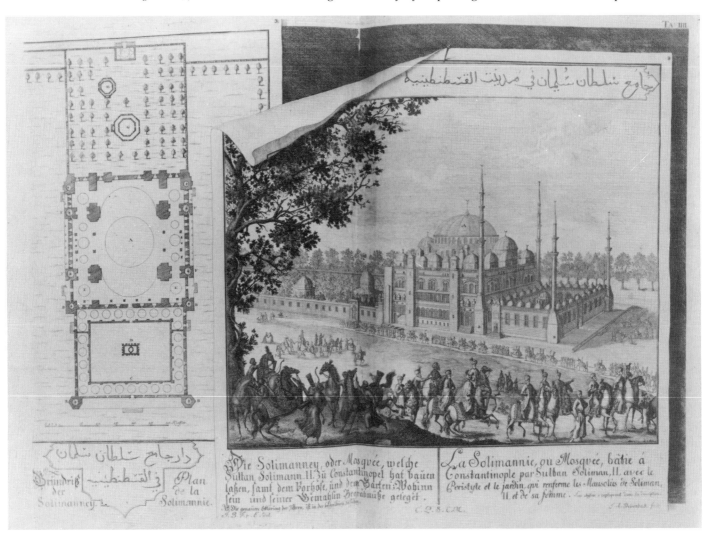

Peking, two suspension bridges: also included were views of buildings based on J. Nieuhoff's book *An Embassy . . . to the Emperor of China* of 1665 (translated into English 1669), such as the Porcelain Pagoda at Nanjing. Among other Islamic examples Fischer chose the dominating Süleymaniye at Constantinople (Figure 28), the Kaaba at Mecca, Muhammad's Tomb at Medina and the Maydan and great bridge at Isfahān. Some of those illustrated had, in terms of silhouette and mass, much to offer to architects of Baroque persuasions. The 'famous temple' Hagia Sophia was dramatically presented at an angle of 45 degrees and emerged re-created, with its minarets transformed into columns, in Fischer's own design for the Karlskirche, Vienna.[47]

Whatever eastward glances were being given by English architects in the first half of the century, however, any serious adaptations of Muslim architectural forms were restricted to garden buildings, many derived from the mosques illustrated by Fischer. So far as major buildings were concerned England rejected the Baroque for a renewed classicism based on the values of Rome and Palladio: the 'Palladian' movement was under way by 1715. Eastern ideas were to be reflected through the lighter decorative style being simultaneously developed in France and later to be called the 'rococo'.

III

The rococo style of the eighteenth century, which substituted light, linear rhythms and a concern for natural shapes like shells, corals and ammonites for the full-blooded formalities of the Baroque, was to be a ready vehicle of the exotic. It made easy alliances with the brilliant glaze effects and light, refined drawing against a white ground to be seen on the porcelains of China, then entering Europe as part of a vast import trade with the Far East. The discovery by Böttger at Dresden of the secret of making hard-paste porcelain in 1708 led to new and confident waves of chinoiserie in European ceramics which were to prevail until the French Revolution. All the arts reflected the excitements of this 'Chinese' rococo confected in France but carried to extremes of delicacy and insubstantiality in Central Europe, notably by such fanatics for the genre as Augustus the Strong, Elector of Saxony and King of Poland, the begetter in 1710 of the Meissen factory near Dresden. The most extreme of Augustus's chinoiseries, however, had a Mughal subject, *The Birthday of the Grand Mogul*, by Johann Melchior Dinglinger. This remarkable work (1702) presented 30 human figures and animals in a composition that occupied one square metre. The materials included gold, silver, enamels and precious stones, and the sources Indian, Chinese, Japanese and European as well as Islamic elements.[48]

The creation at a far remove from reality of a European version of the East, which is the essence of chinoiserie, could equally be a feature of the class of product known as *turqueries*. But *turqueries* was a broad term which conversely could also point to close acquaintance with, at any rate, the surface reality of Muslim life.[49] As understood in France in the later reign of Louis XIV (from, say, 1680 onwards), it covered works of painting and the applied arts, as well as literature and the drama, which had Turkish themes. Its borders were vaguely drawn, however, and could include art inspired by other Muslim cultures. The Sun King encouraged this form of work as avidly as he encouraged so many contacts with the East. Some examples were frankly fanciful, in the spirit of the court entertainments of Italy and England earlier in the seventeenth century. Berain's 'Indian costumes', with immense plumed turbans done for ballets at Versailles in the 1680s and 1690s, are good instances. Others, however, appear to

have been more concerned with accuracy. In 1670, on the occasion of the visit of a Turkish dignitary, Louis asked Molière to include an important Turkish sequence in his comedy *Le Bourgeois Gentilhomme*. Lully composed the music for this and the diplomat d'Arvieux, who was fluent in Turkish, helped with verisimilitude. The result added much to the burlesque qualities of the play; but the background presence of an informed advisor such as d'Arvieux was a significant pointer to the future.[50]

In the eighteenth century, with the onset of the exuberant rococo style and the type of painting known as the *fête galante* – given unforgettable authority as a genre by Watteau – together with the continuing popularity of the entertainments staged by the Italian *commedia dell'arte*, themes involving Turkish subjects enjoyed a ready vogue. Some were intimate, like Lancret's *Turc amoureux*, painted for the Salon of the Hôtel de Boullogne in the Plâce Vendôme, Paris. Others were grander, based perhaps on ambassadorial visits, like Coypel's large composition of *Mehemet Effendi giving audience* in 1721. The Persian embassy of Mehemet Riza Bey in 1715 had been opulent enough, and Watteau had made a number of studies of its members (Louvre; Victoria and Albert Museum; Teylers Museum, Haarlem etc.). The Turkish visit of 1721 was even more sumptuous and memorable: Charles Parrocel based two pictures on it, both of which were made into Gobelins tapestries. The famous Boucher, as we shall see, produced numerous paintings incorporating Turkish subjects and adapted from collections of costume prints. Boppe, the historian of the genre, detected some decline in rococo-type Turkish subjects after the 1750s, but their spirit endured in the seraglio scenes of Fragonard and such a work as Amedée Vanloo's *Fête Champêtre donnée par les Odalisques en présence du Sultan et de la Sultane*, shown at the Salon in 1775.[51]

With the upsurge of the French rococo, the rolling periods of the baroque indeed acquired the graces of a *lingua franca* that was exportable not only to other European countries but to Turkish Sultans with appropriate cultural leanings. Foremost among these was Ahmed III (1703–30) under whom the glass room of the Sofa Kiosk was built at the Topkapi Saray (Serail). This exhibits an extraordinary merging of oriental and occidental elements, among the latter being the gilded brazier designed by the elder Jean-Claude Duplessis and given to the Ottoman ambassador by Louis XV.[52] A taste for Western rococo was to become a passion with a number of Ahmed's successors. The interest went both ways: simultaneously through these years the tales of the comforts of Turkish living at the highest levels, expansive and untrammelled, were becoming realities in Europe through the importation of sofas and the amply upholstered seats known as ottomans.

This cultural interchange between Europe and Turkey is of some importance as it points to a lowering of barriers which had hitherto divided the two, and to ways in which rococo *petitesse* could also play a part in habituating aspects of Turkish exoticism to European living. Up to now oriental exoticism had been far removed from real life: at this point in the eighteenth century we see signs of it becoming part of living, without losing its essential *frisson*. The westward spread of the 'kiosk' and 'ottoman' provides incontrovertible evidence of this. Interest in such things not only linked Europe and Turkey: through them Turkey could be seen by Europeans to have something of value to offer Europe. Turkish Sultans had long built kiosks.[53] European monarchs of the eighteenth century were at last realising that moderate size and intimacy in surroundings were better for comfort, and perhaps more important considerations than outfacing rivals. This was not solely a stimulus from the East: the Petit Trianon at Versailles of 1762–9

betokens an initiative of the same kind that was conceived entirely in terms of European classicism. But the fact that Louis XV's father-in-law Stanislas of Lorraine built kiosks for himself, basing them on memories of his captivity in Turkey, is not without interest.[54]

Charles Perry, an English doctor, visited Turkey in the last 12 years of Ahmed's reign (1718–30) and provided graphic descriptions of some of the buildings. But he knew no Turkish, and the lack of opportunities for social contacts with the people points to a continuing difficulty in acquiring first-hand knowledge of Ottoman life.[55] Moreover, for religious reasons access by Europeans to such places as mosques was often denied. Nevertheless, through illustrated books and the work of artists, Europeans in the years 1700 to 1750 were in fact to have vastly enhanced resources of knowledge and awareness of actual Muslim life placed at their disposal. There were notable travel books, such as the accounts by Cornelis de Bruyn (1652–1726/7) of his Eastern journeys which provided a rich quantity of fact, background lore and illustration.[56] Artists had long first-hand experience of Islamic lands and were more accomplished than any to visit them since the days in the 1490s when the European painter of the Louvre *Reception* (see p. 259, n. 29), had accompanied a Venetian embassy to Syria. Some artists now stayed for many years in a centre such as Constantinople, gathering a formidable body of information.

One of these artists was the Fleming Jean-Baptiste Vanmour (1671–1737). He settled in Constantinople shortly before 1700 and spent the remainder of his life there. In 1725 he became *peintre ordinaire du Roi en Levant*, Sultan Ahmed III, and recorded the fêtes, receptions and hunting parties for which the reign was famous.[57] He was patronised both by Turks and Europeans: among the latter were the Dutch and French ambassadors and William Sherard, consul for the Levant Company at Smyrna between 1703 and 1716. The most important commission, by de Ferriol, the French ambassador, was in 1707, for a series of 100 paintings of Levantine costume which were engraved in an influential book, published by Jacques le Hay, the *Recueil de cent Estampes* (1713).[58] These were to

FIG. 29 William Hogarth (1697–1764). *The Seraglio*. Line-engraving from Aubry de la Motraye, *Travels* 3 vols., 1723–4. 25.4×35.3 cm.

Hogarth's vision of the harem is essentially based on the rococo, though he has heard about cusping, the use of star-patterns, and has probably seen the swaying figures on Persian velvets (cf. Figure 16).

provide source-material for countless artists. As Rodney Searight's unpublished researches have shown, over 40 were used by Aubry de la Motraye in the illustrations to his *Travels* (1723–4), some of which were by Hogarth (Figure 29).[59]

Shortly after Vanmour's death there came to Constantinople, in the suite of the English Earl of Bessborough, an artist of remarkable vision and ability, the Swiss Jean-Etienne Liotard (1702–89). He stayed five years, lived and dressed as a native, and helped to diffuse through Western Europe a renewed fashion for portraits in Turkish dress. His female portraits of sitters *en sultane*, often in pastel, are among the most individual works of the eighteenth century.[60]

Among lesser artists who play a role in the 'real life' *turquerie*, we should note Jacques André Joseph Aved, whose portrait of Said Pasha, ambassador of the Porte to France (1742, Versailles), documents the sitter's presence, the Turkey carpet and the *firman* on the table, with strict regard for accuracy.[61] There is also Antoine de Favray, Knight of Malta (1706–91), who painted portraits of the women of Constantinople as well as views of the Bosphorus, its shores now increasingly ornamented by small Baroque palaces and summer residences built by the Ottoman ruling classes.

Where did the English stand in the context of closer knowledge of the Turks at this time? Like the French, they continued to see the Muslim countries as a source of exoticism. Invention in England, too, is most stimulated by China and chinoiserie, and the vogue reaches a climax in the 1750s. The 'fancy-dress' character which we have seen in seventeenth-century portraits of sitters in Muslim costume is given in England, as in France and Italy, a particularly eighteenth-century fashionable impetus in the masquerade: a form of entertainment which endures throughout the century.[62] A factual background is traceable, however, even here. Many of the plates made from Vanmour's paintings of Turkish dress reappeared in the pages of Thomas Jeffery's masquerade pattern-book of 1757 and came to life in the routs and entertainments of Vauxhall and Renelagh. Hogarth's portrait of a Turk (Figure 30), though seemingly based on an encounter in Covent Garden Theatre, may well be of an actual Turk.[63]

In England, as in France, there is a concern for the portraiture of sitters dressed *à la turque* which sustains far more than a fancy-dress feeling. The portraiture associated with the remarkable figure of Lady Mary Wortley Montagu (1689–1762) is a case in point. With Lady Mary, Turkish dress was the expression of close sympathy with Turkish life. She was in Constantinople as the wife of the British ambassador in 1717–18 and became an unswerving admirer of the Turkish women's fashions (as well as the landscapes adjoining the Bosphorus, and Turkish practices such as inoculation for small-pox). Her letters stating her opinions were known to a wide circle even before their publication in 1763.[64]

In the England of Lady Mary and her friend Pope, the poet – an England passing through the Augustan age of devotion to Roman models – it is easy to see why Turkish dress held its attractions: the merits of informality and freedom of movement of the ensemble together with the advantages of the turban as a draught-excluder (as compared with the periwig) were obvious. The idea of escape through a back door to Constantinople was also understandably developing an added allure. The Society of Dilettanti, founded in London in 1732, conceived a concern with exploring the Hellenic world of the Eastern Mediterranean which, in less than two generations, would stimulate close interest in the present-day Turkish inhabitants of the classical sites.

Many responded to these beckonings from the East. A portrait at West Wycombe Park, Buckinghamshire, shows the owner, Sir Francis Dashwood, in

Turkish dress, commemorating his visit to Asia Minor about 1735: it bears on the back the words 'El Faquir Dashwood Pasha'. A portrait of 'Sultana Wortley Montagu' hangs near it. In 1737 Richard Pococke (1704–65) began three years' travelling in Egypt, Asia Minor, Palestine and Greece. The Dane Frederick Lewis Norden (1708–42) was also in Egypt in 1737. In the same year Thomas Shaw published his *Travels in Barbary and the Levant*, a work which did not discuss art and architecture but which paid considerable attention to the life of the Muslims in North Africa (he refers to the 'Bedoweens' as well as to the Moors). In 1738 the Earls of Bessborough and Sandwich made journeys to the Levant. In 1746 Lord Charlemont left England on an eight-year tour abroad, which included

FIG. 30 William Hogarth. *A Turk's Head*. Distemper on panel, 66.5×47.7 cm. About 1750–55. Collection Angus A. Browne Esq. (on loan to Tate Gallery)
This is not a mere 'comic Turk' or a conventional image, and indicates Hogarth's genuine curiosity about a representative of the Islamic world. It was painted originally on a box-lid, cut down and made up on all four sides.

Asia Minor and Egypt. In 1740 Sandwich became president of an 'Egyptian Society' in London with the title of 'Sheich': the membership included Norden, Pococke and the antiquary William Stukeley.[65] A 'Divan Club' was founded for those who had made the journey to Turkey. Pococke published the first volume of a much-applauded *Description of the East* in 1743 (volume II appeared in 1745), and Norden's *Travels through Egypt and Nubia* would appear in French in 1755 and in English in 1757.

But while the travel books and the projected expeditions to the eastern Mediterranean were to develop markedly more antiquarian links with the East, Roman classicism, spiced indoors by rococo modernities, retained a central appeal among the Whig leaders of taste in England. Unexpectedly, it is William Hogarth – albeit in the days before his fame and most obdurate individualism – who pinpoints the situation. In his illustrations of Turkish subjects in Aubry de la Motraye's *Travels* (Figure 29) there is an attempt to make the effect look Eastern, but the impression is of a slightly more regulated form of the European rococo that was then, by a nice irony, the vogue at the Turkish court of Ahmed III, as we noted earlier (p. 60). A decade later the French-born sculptor Louis François Roubiliac (1702/5–62), domiciled in England, combines bronze allegorical figures of Rome, Macedonia and Chaldea (on a clock for the Princess of Wales) with one of Persia holding a peacock, shown with a naturalism of pose that entirely subsumes it in the tradition of the French Baroque.[66]

By the 1750s the twin strands of influence we have been following from the seventeenth century – that of accurate reporting of Islamic life and that of fantasy – become yet more entangled. Each is strengthened by new contacts: accurate reporting due to fresh knowledge and experience, fantasy by the modish excitement of the rococo and its renewed associations with chinoiserie.

Extraordinarily large quantities of English chinoiserie were being produced in the eighteenth century. The number of surviving objects and satirical references to the Chinese taste, Hugh Honour remarks, 'combine to show that chinoiserie reached a height of popularity in England in the 1750s which it attained at no other time and in no other country'.[67] The plethora of objects and references may suggest an inordinately strong predisposition in England towards China: though ascription to a particular exotic source was commonly as vague as ever.[68] In fact notable examples of Muslim-type chinoisierie were also being produced, as in Europe. Indeed, English chinoiserie cannot be divorced from the wider taste for such objects in Europe: nor can its Muslim-inspired aspects be thought of as independent from the French-inspired taste for *turqueries*.

Chinoiserie, unmistakably a French word, is a term so comfortably assimilated into the English language that it does not need italics, unlike *turquerie*, a term used increasingly from the time of Molière onwards. The question has to be asked: why did the *turquerie* in art not find as distinctive a niche for itself in Europe as did chinoiserie? We cannot be sure: no contemporary seems to have written down the answer. One reason high on the list of possibilities is the paradoxical one that China and the Chinese were sufficiently far removed geographically to enable Europeans to impose a clear identity on them; the Turk, considerably nearer home, stood for many things.[69] He was representative of a faith that – vaguely for most Europeans in the early eighteenth century – stretched into Asia but which, through him, had stood out against Christianity for centuries on the battlefields of Europe. He represented an Empire that, early in the seventeenth century, Sir Thomas Roe, the British ambassador, had described as 'an old body, crazed through many vices that remain where youth and strength is decayed'.[70] But as that century progressed he was seen as more

and more representative of an ancient culture, 'a civilitie different from ours'. As such he could be of real value in about 1700 to the creative life of European intellectuals who were beginning to feel doubtful about the health of European society. For a wider public, the plates after Vanmour's paintings gave the Turkish people a reality and explored their variety more vividly than any previous collection of illustrations. Increased knowledge and familiarity could lead to interesting uses of the enhanced image that the Turk now represented. On a superficial level, Europeans could dress up and impersonate him to deceive their fellows, as Cléonte had deceived Monsieur Jourdain in *Le Bourgeois Gentilhomme*, and as many others were to do in the masquerades of the eighteenth century. On a deeper level, he could personate Europeans to themselves. At a time when the nature of European society was being questioned by Western writers, it is striking how many times the criticism is posed through the eyes and mind of an intelligent oriental, and how many times that oriental is Muslim; Montesquieu's *Lettres persanes* (1721) were the most celebrated of an already firmly established genre. In this context, England is also much involved: a famous critique of the court of Louis XIV, G. P. Marana's *Letters of a Turkish Spy* (1684), translated from the original Italian into French, and into English by 1686, reached its 22nd English edition by 1734.[71] Forty years later, in his *Decline and Fall of the Roman Empire*, Edward Gibbon was to compare what he saw as the obscurantism of medieval Catholicism in Europe with the rational simplicity of Muslim faith.[72]

The attitude of Europeans of this period to the Turks – that they were both of the European continent yet not of it – reflected both the accessibility and the strangeness of the Muslim world. Different considerations regulated European attitudes to the Chinese. Here were a people far removed from anything European: in history and in their way of life. To those European intellectuals looking for alternative canons of rational virtue by which people could conduct themselves, other than those of traditional religion, the code of Confucius had the appeal of unmuddied waters. Leibniz in 1697 would have welcomed Chinese missionaries to Europe. 'Admire and blush, but above all imitate', Voltaire was advising the princes of Europe, apropos of China, 60 years later.[73]

The admiration accorded to China as a kind of clear-cut, distant Utopia was condensed by the French economist Quesnay in 1767 into practical proposals for a state guided by Confucian principle. Such idealisation of the model pointed to an advantage enjoyed by China, in the eyes of Europeans, that no Muslim country – least of all a power like Ottoman Turkey which still occupied part of Europe – could emulate. Moreover, there was new information on China to reinforce the vision already held up by the seventeenth-century authorities Semedo and Nieuhoff: the massive folios of du Halde's encyclopedia of Chinese lore, the *Description géographique, historique . . . de l'Empire de la Chine* (1735), rich and detailed, yet taking none of China's prestige away.

The prestige was echoed in the forms of Chinese art – ceramics, enamelled wares, lacquers, ivories, wallpapers – now being imported by the East India Companies in vast quantity. It was particularly applied to porcelain. Always identified with China and teasing European ingenuity to produce a counterpart, its power of attraction could hardly be lessened in the eighteenth century when European potters succeeded in making it, consolidating the discovery that Meissen had implemented. For critics of European convention, the attractions were greater for being couched in terms far removed from those of traditional European classicism: instead of carefully modulated effects of light and shade, the tactile enamels of the newly evolved *famille rose* lay on the vitrified surfaces and gave as dazzling an experience of colour as was available anywhere in the

65

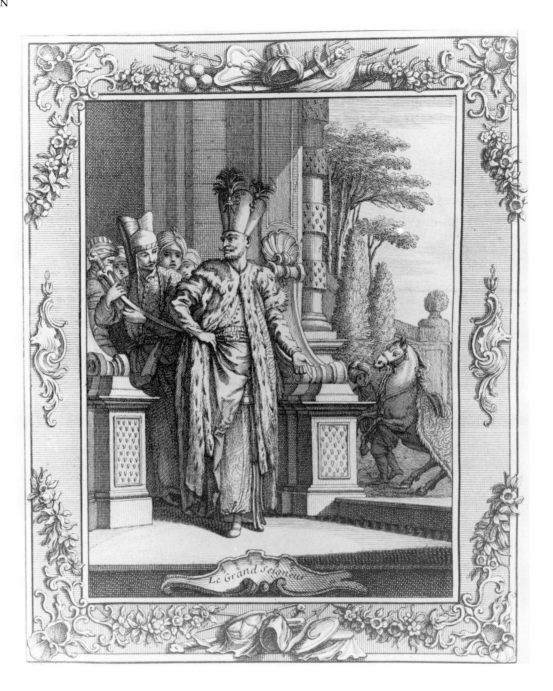

FIG. 31 'The Grand Seigneur'.
Line-engraving by C. Duflos after François
Boucher, from Jean-Antoine Guer, *Moeurs et
Usages des Turcs*, 2 vols., 1747 (vol. II, opposite
p. 9). Victoria and Albert Museum: Searight
Collection

Guer's book was in its time one of a number to carry
illustrations of oriental figures. Boucher's drawings
which Duflos engraved were themselves
paraphrases of figures in the famous *Recueil* of
Turkish costume by le Hay. The artifice of the
Boucher-Duflos result, however, shows the eastern
themes wholly absorbed into the language of rococo,
of which they became a popular element (see Figure
32).

range of man-made objects. Instead of symmetry, Chinese porcelain presented asymmetries of decoration which daringly extended even the asymmetries of the rococo. Instead of instructional allegories, it offered brightly clad figures with inconsequential fly-whisks and umbrellas, in painted landscapes which exhibited an enviably credible blend of reality and unreality, the latter predominating.

With such a combination of properties it is not surprising that Chinese-inspired chinoiserie notions infused and conditioned the Turkish confections made in the spirit of rococo by Europeans. But, when this is said, rococo porcelain *turqueries*, like the rare Worcester figures illustrated opposite (Figure 32), have a piquancy of their own: there is a sharp edge to the sweetness.

The porcelain figures of Turks made at the Meissen factory are well known.[74] These were a major influence on similar figures made at English factories. The

Meissen modellers J. J. Kaendler and P. Reinecke used le Hay's *Recueil* for source material, together with the German edition of 65 of the figures from that collection by Christoph Weigel.[75] Some figures come from other sources: the Meissen *Turk with Guitar* of 1774, for example, was derived from an engraving of Lancret's painting by G. F. Schmidt. The French origin of a large number of the source figures used by eighteenth-century porcelain modellers and the ramifications of the channels of influence involved were examined long ago by Braun.[76] He discussed the Turkish scenes on an enamelled box by Daniel Chodowiecki in the Kunstgewerbemuseum, Berlin, and found them to be more or less precise copies of engravings by Duflos after Boucher taken from the book by Jean Antoine Guer, *Moeurs et Usages des Turcs* (1747). The Boucher paintings were in turn free paraphrases of figures in le Hay's *Recueil*, and the process whereby engravings in le Hay, dry and lacking in charm, were transformed into personable genre pictures by Boucher alerts us to what can happen when a painter of genius is involved in the chain of contacts.

While it is no doubt the case that a number of the English porcelain figures of Turks represent modifications at a considerable remove from the originals, in some instances a direct link with an original in porcelain can be shown. An example is provided by two Turks in salt-glaze stoneware of an unknown factory but datable about 1760 (Victoria and Albert Museum): these have been traced back to Meissen models by Kaendler.[77] Other English figures came through Boucher: Joseph Willems at the Chelsea factory modelled figures of Levantine women from a rare set of engravings after Boucher by Simon-François Ravenet, probably done in France before Ravenet moved to England in about 1747.[78]

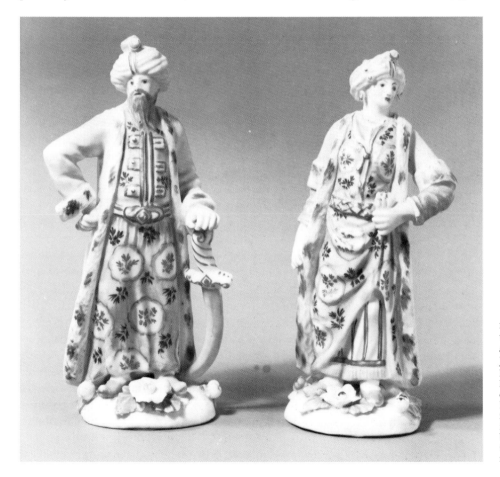

FIG. 32 *A Turk and his Companion*. Porcelain with enamel colours. H. 12 cm. Worcester, about 1770. Ashmolean Museum, Oxford, J 1141. Courtesy of the Visitors

Figurines of Turks in the fashionable rococo style are known from a number of English porcelain factories of the period: Chelsea (about 1750, modelled after Boucher), Bow, Derby and Longton Hall. It is noteworthy that two of the very few Worcester figurines should be Turks. With their visually bittersweet rose-pink and lemon yellow enamels, they epitomise the way in which a vision of the East reinforced the artifice of rococo. Cf. p. 68.

Variations on popular and particularly memorable poses account for other figures in the English canon: the masterful stance of the 'Grand Seigneur' by Duflos after Boucher in Guer's book (Fig. 31), with right hand on hip and swinging round to his right side, is indeed echoed in the Worcester *Turk* illustrated in Figure 32, who also, however, holds a scimitar. In any event the adaptation of oriental character to the European fashion of the moment leads to results of the utmost liveliness: the Worcester *Turk* and his female companion share the diminutive faces of European rococo; and the enamel decoration, varying between different versions, is entirely in the European style.[79]

Rococo, well suited to ceramic expression in the malleable material of clay, was not inherently an architectural language, but its rhythms could be expressed admirably in plaster-work and stucco. Architectural forms themselves, if sufficiently light and airy, could also be absorbed into its repertoire: we have noted how the Turkish kiosk is taken up at this period. Overwhelmingly, it is China which contributes the major exotic influence in Europe: this reaches epidemic proportions after mid century in the matter of garden buildings, for which the Chinese had been well known in Europe since the seventeenth century (notably since Nieuhoff's *Embassy . . . to the Emperor of China*, 1665).[80] The eighteenth century was to show a vast interest in the further evidence of Chinese ability in garden design provided by the engraved drawings done about 1713 by the Italian Jesuit Matteo Ripa, after first-hand experience of the palace gardens at Jehol, north-east of Peking. Further insights were provided by such works as du Halde's *Description of China* (1735), published the following year in translation as *The General History of China* (by R. Brookes) in four volumes. For exoticism of an architectural kind, however, Gothic was a ready intermediary, for Turkish effects no less than Chinese. Temples and gazebos sprouted in English landscaped parks and places of recreation. Vaguely conceived Muslim ingredients might be used as part of the fashionable rococo fantasy. There were the 'Temples' at Vauxhall Gardens, the popular recreation centre re-opened in 1732: a mélange of rococo and Gothic with a dash of Venetian-Saracenic cresting and decorative stars.[81] There were the Indian Temple designs of William Halfpenny (*Rural Architecture in the Chinese Taste*, 1750–2). There were the three varieties of mosque shown in William Wrighte's pattern-book *Grotesque Architecture or Rural Amusement* (1767). The role of such inventions as exuberant garden embellishments, flouting the cool and contained Palladianism of country houses, was to be a long one, extending through the 21 cahiers of Le Rouge's great work *Jardins anglo-chinois* (1773 onwards), down to a twentieth-century example like the Indian Temple at Acton Round, Shropshire.[82]

There were also Turkish tents. A building with this name was erected at Vauxhall Gardens by 1744: like many of the Vauxhall buildings it seems to have been couched in a kind of pageant Gothic style with a stress on fantasy and impermanence. A contemporary mentions 'Drapery, far beyond the Imaginations of the East',[83] and the Turkish name was no doubt simply part of the imaginative stimulus. It was both shelter and dining area, with no fewer than 14 tables.[84] The most famous Turkish tents in England were solitary, but located in two of the most influential landscaped gardens of the time, the Hon. Charles Hamilton's Painshill, Surrey, and Henry Colt Hoare's Stourhead, Wiltshire. Both probably dated from the mid or late 1750s. There is a watercolour drawing by Henry Keene of a Turkish tent (Victoria and Albert Museum, E 916–1921), which closely resembles the second of two drawings of the Painshill structure made by the Irishman John (later Sir John) Parnell on a visit there in 1769 (Figure 33).[85] Parnell (1744–1801) was great-grandfather of Charles Stuart Parnell. He visited

Painshill first in 1763: on each of his visits he commented upon and illustrated the tent. From the first description we learn that it was 'placed on the finest point for prospect in the whole improvement', and was 'elegantly finished'; the back was 'built and plastered', the top 'leaded and painted blue' and the whole was covered with sailcloth painted white with a blue fringe drawn up in festoons. In his 1769 account Parnell reveals that the lower parts were brick, the cornice papier-mâché and the overall dimensions 16 feet by 12. Both his drawings show an ogee-profiled dome, as does a further drawing of this celebrated structure done in 1779 by the Swede Frederik Piper (Swedish Academy of Art, Stockholm).[86] Another reference is provided by the French visitor J. de Cambry, who reclined on its cushions in 1787.[87] No trace of it now remains.

At Stourhead, Pococke was told in 1754 of 'a Mosque with a Minaret' that was intended for one of the islands in the lake;[88] this was unrealised, but the Turkish tent seems to have been built soon afterwards on the eastern shore. Mrs Lybbe Powys describes it hung with painted canvas,[89] and standing all the year round, though it seems likely that such tents were stored indoors in the winter months. At all events, the Stourhead tent was finally dismantled in the early 1790s by Henry Colt Hoare's classically minded grandson Richard.[90]

Another Turkish tent, built at Bellevue, Delgany, Wicklow, by the owner, the Dublin banker David La Touche, in the late eighteenth century, has also perished.[91] Constant folding and re-erection will have accounted as much as exposure to bad weather for the disappearance of such structures. A more recent example (c. 1910) with vaguely Turkish upswept roof, Chinese detailing and retractable latticework side panels, survives at Boughton, Northamptonshire.[92]

The 1750s produced the oriental buildings at Kew by William Chambers (1723–96). Chambers claimed that his Mosque there (Figure 34) possessed the 'principal peculiarities of the Turkish Architecture', but it is in fact derived from a free improvisation of Turkish buildings by J. B. Fischer von Erlach contained in his 1721 *Entwurff*. The Turkish prototypes included, it appears, the Imperial

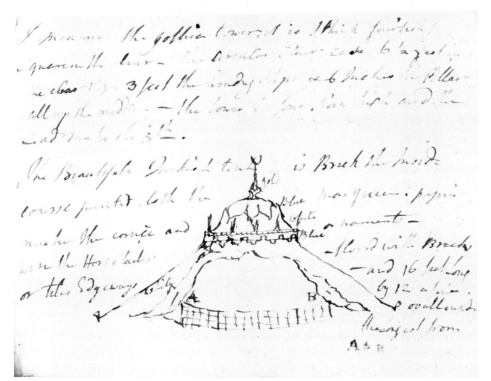

FIG. 33 The Turkish Tent, Painshill, Surrey, in 1769. Sheet of manuscript by John Parnell. Photograph courtesy of British Library of Political and Economic Science, London.
Parnell was an enthusiast for Gothic, and found the Turkish tent 'beautiful', no doubt in part because of the rococo/Gothick use of the ogee arch shape in the entrance and around the roof.

Baths at Buda and Sultan Ahmet's mosque, Constantinople. Chambers had visited China twice in the 1740s in the service of the Swedish East India Company and was to make convincing use of his first-hand knowledge of Chinese architecture in the course of his career, notably in the Kew Pagoda which stood near the now-vanished Mosque. His scanty knowledge of Islamic buildings forms, however, had been demonstrated in 1758 in his design for the Kew Alhambra (Figure 35) originally requested by Frederick, Prince of Wales – well known for his orientalist tastes – in 1750. This building has also disappeared. Unsure of the authentic idiom, Chambers was likewise content to relapse here into the rococo confections of the Vauxhall Gardens type – interestingly so, in the face of a marginally more authentic looking design for the same Alhambra (Figure 36), probably by a Swiss artist settled in England who had, however, been to Spain, Johann Heinrich Muntz (1727–98). Chambers certainly knew this design and appears himself to have sent it to the Prince.[93]

Chambers's Kew Mosque, by its celebrity, must have influenced the desire for fanciful mosques as garden buildings, which were duly planned at Hartwell

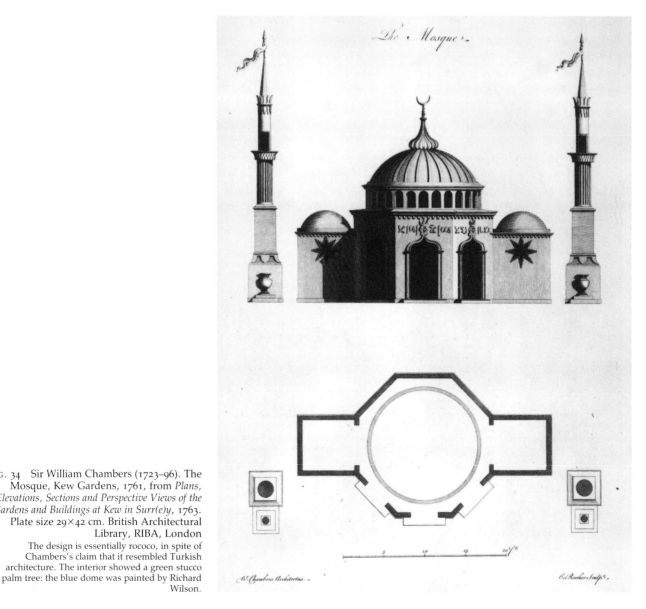

FIG. 34 Sir William Chambers (1723–96). The Mosque, Kew Gardens, 1761, from *Plans, Elevations, Sections and Perspective Views of the Gardens and Buildings at Kew in Surr(e)y*, 1763. Plate size 29×42 cm. British Architectural Library, RIBA, London
The design is essentially rococo, in spite of Chambers's claim that it resembled Turkish architecture. The interior showed a green stucco palm tree: the blue dome was painted by Richard Wilson.

House, Buckinghamshire and The Hoo, Hertfordshire. A mosque design (now in the Victoria and Albert Museum) may refer to Hartwell: it is by Henry Keene, who worked there.[94] But while Chambers's Eastern buildings at Kew belong to the rococo tradition, the whole Kew episode – involving the assembling together of building-types of different European and Asiatic styles, and of exotic trees with those indigenous to Britain – is a pointer to the compendiously ranging collecting instincts of the period which initiated the British Museum. Chambers, while ostensibly aiming for the peculiarities of the 'Turkish Architecture', in fact did not have the opportunity – or perhaps, with his deepening commitment to European classicism, the desire – to see genuine examples. Muntz, however, emerges as a shadowy pioneer, about 1748, of architectural studies at first hand in Islamic Europe by going to Spain. This quickening of first-hand study of historical styles, involving less dependence on established textbooks or past conventions, signalised an important change taking place in the mid eighteenth century, leading to a much-enhanced interest in Islamic architecture in the West. The Kew project of 1750 is a symptom of a wider movement that indicates a watershed for our subject: and that must be material for another chapter.

If we look back from here to 1660 at the fortunes of Islamic and Islamic-inspired art in France and England, we have an overwhelming impression of the importance of the decorative arts. The style had a part to play at the Baroque courts of Europe, even if only in the realm of supportive spectacle. In England, under the later Stuarts, as under the Tudors, the brilliance of Islamic textiles and the captivating intricacy of the arabesque found a happy correspondence with

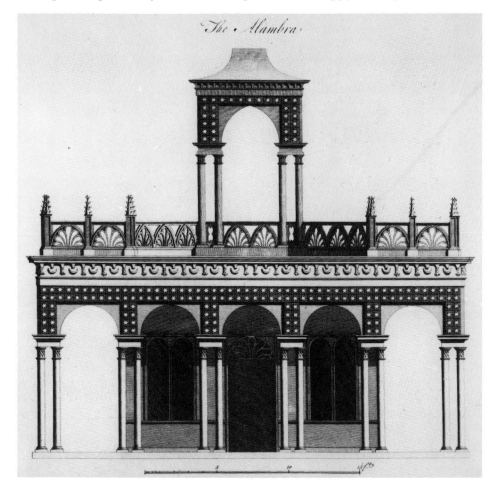

FIG. 35 Sir William Chambers. The Alhambra, Kew Gardens, 1758, from *Plans . . . 1763*. Plate size 29×42 cm. British Architectural Library, RIBA, London
Three buildings inspired by the East were placed in the southern area of the gardens: of these the Alhambra and the Mosque have gone, the Pagoda remains. In his Alhambra design, Chambers subscribes to the imaginary version of Islamic architecture accepted by the fashionable rococo Gothic taste – an elevation of a fundamentally classical horizontality is given a top dressing of stars, palmettes and Gothic crockets.

71

existing tastes and also made notable contributions to them. The rising influence of Italianate classicism throughout the period, culminating in Palladian England, subordinated decorative ideas of this kind to the forms and magniloquence of Roman architecture. This evoked reactions which drew their strength from China rather than Islam, though French *turquerie* – in strength at the Versailles ball of 1745 – represented an enduring vein of the rococo. The opposed ultimates of Rome and Peking made further appreciation of Islamic art difficult. After 1750 these obstacles to fuller acquaintance and understanding begin to be less important.

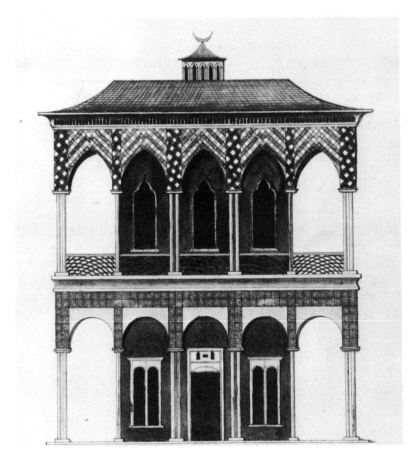

FIG. 36 Johann Heinrich Muntz (1727–98). Design for the Alhambra, Kew Gardens, 1750. Pen, grey wash and water colour, 27.3×33.5 cm. Drawings Collection, British Architectural Library, RIBA, London 1950.15

This design, by contrast to the foregoing, shows some familiarity with Moorish architecture, in its tall arcading, thin columns and use of polychrome (red, blue and gold).

1750 to 1820:
MODELS EAST OF ROME

I

On 13 November 1753, a group of prominent artists met in London to discuss the formation of a state academy for painting, sculpture and architecture in Britain. Two generations had elapsed since the third Earl of Shaftesbury had denounced what he termed the 'luscious colours and glossy paint' of 'Indian figures' and 'Japan-work' in his famous book *Characteristics of Men, Manners, Opinions, Times* (1711), and proposed, in his *Letter concerning Design*, an academy to take the visual arts in hand. In 1753 Shaftesbury, a stimulating and persuasive writer, was still widely read. It was doubtless by chance that the meeting-place of the academy-seekers of that year should have been a tavern in Greek Street, Soho, called the Turk's Head. The circumstance is not without a certain curiosity-interest, however. The English Royal Academy, in the succession of academies of painting founded in Italy in the sixteenth century and France in the seventeenth, was a little over 15 years away. By a paradox, the publication of archaeological work at classical sites over the same years was to focus attention on new architectural models many miles east of Rome. In the process, old attitudes to the Turks were to be revised. Even further east, Persia and India were to renew their power of attraction. Before 1790 British artists were to record with delight some of the architecture, both Muslim and Hindu, to be encountered in the distant hills and on the plains of India, as the Raj established its influence there. This phase of intensifying consciousness by Europeans of cultures beyond Europe – a consciousness both expanding and reflective – is the subject of the present chapter.

We have reached a crucial time of change. Roman art and architecture, as we have seen, stood in the 'Age of Reason' for the absolutes of excellence and example. 'China work', on the other hand, satisfied the desire for freedom from such absolutes. Both assessments fulfilled European needs of the moment, without necessarily involving the urge to study at first hand the societies whose art had nourished them. The pattern-book approach prevailed among the English Palladians: the first publication of the movement was significantly entitled *Vitruvius Britannicus* (vol. I, 1715). Eighteenth-century chinoiserie, the art that pre-digested for Europeans their vision of a generalised Orient, is clear evidence of the continuing desire to pre-digest it. By 1744, however, the third edition of the *Scienza Nuova* of Giambattista Vico (1668–1744) had appeared in Italy, a work concerned with the means whereby particular cultures arrived at particular modes of expressing themselves in language, art and thought. Each tradition, it was argued at length, develops its own vision, which no evaluation can afford to ignore. By proposing in detail such an approach to the study of other

societies removed in time and space, on their own terms, this complex work broke with the stereotypes of them that had long been cherished in Europe. These lived on; but Sir Isaiah Berlin, in his book *Against the Current* (1981, p. 104), has seen Vico's challenge as marking 'a genuine turning-point in the conception of history and society'. Vico was little read at first outside Italy and his direct influence does not concern us, but the relativism – of which his book is the most advanced sign in its time – certainly must.

By the mid eighteenth century, in fact, though French leadership in the visual arts was firmly established in Europe, a further shift of interest can be seen taking place in which England plays a vital part. This was the movement away from the self-contained, stable atmosphere of the Roman-based tradition towards a terrain blown by less predictable breezes from Turkish-occupied Greece, which would eventually include fresh air currents from the Orient. In England the squibs of the rococo continued to spark indoors and chinoiserie, some of it of a Muslim cast, has a lively part to play in the years ahead for those who wanted it. The English Palladian style in architecture was one of cool symmetries, capable of seemingly endless adaptability and subtlety within certain limits of proportion and calcula-tion. For all this flexibility it nevertheless relied heavily on the textbook precepts of Palladio and the Roman authority Vitruvius. By 1750 the first generation of Palladian architects was being succeeded by a second: but a new stimulus was at hand.

In the 1750s the Greek temples at Paestum in southern Italy were being measured by French architects, and the two Roman towns of Herculaneum (from 1738) and Pompeii (from 1748) were being retrieved from beneath the volcanic dust of Vesuvius which had buried them in AD 79. By the early fifties, archaeological digs in Italy and Greece, and exploration beyond Europe, were attracting the more adventurous British and French artists and architects to yet wider horizons and further visual experiences. Some architects closed their textbooks – without abandoning them – and sought the direct study of new sites of antiquity in the eastern Mediterranean and the Roman Orient. James Stuart and Nicholas Revett at Athens (1750–5) and Robert Adam at Spalato (Split) (1757) are representative British figures: but the Roman desert cities of Palmyra and Baalbek formed the subjects of widely studied publications by Robert Wood (1753 and 1757 respectively), based on his journey to the Near East in 1750 with James Dawkins; and in 1764–5 the antiquarian Richard Chandler explored Asia Minor with his accomplished artist William Pars.

The new sites afforded a variety of experiences and models for study, and those who addressed themselves to these have reasonably come to be known as 'neo-classicists'. Athens offered the finely calculated Doric temples of the fifth century BC, Paestum an earlier Greek Doric of primitive force. Herculaneum and Pompeii revealed Roman paintings of intimate elegance and sophistication; Baalbek and Palmyra the sculptural richness of late Roman provincial art. In different ways all provided alternatives to the rococo, which was to be rejected by the severer-minded of the new generation of classicists as a style of frivolity and inconsequence.

The exoticism that was an essential element in the rococo continued to thrive in its company beyond the mid point of the century, as we have seen. The decorative vignettes by the French illustrator Hubert Gravelot in the 1757 edition of Thomas Shaw's *Travels . . . in Barbary and the Levant* give lively testimony to this fact. Exoticism, however, had ways of being accommodated to neo-classical interests also. A look at the watercolours done by Pars during his stay in Asia Minor, or at the engravings made from some of them for Chandler's *Ionian*

Antiquities (1769), is instructive. Turbaned Turks smoke long pipes among the ruins of the Temple of Apollo Didymaeus (Figure 37). Others step with the European visitors on to the ferry to cross the Maeander en route for the Theatre of Miletus. The close observation by the artist of the inhabitants almost distracts attention from the classical remains that he is in fact in Asia Minor to document. Many paintings of ruined sites in the eastern Mediterranean done in the same period typically mingle orientals and Europeans among the broken columns in more or less self-conscious poses, which still recall rococo tradition. Paintings by another Frenchman, Charles-Louis Clérisseau, of an older generation than Pars, provide a range of examples. For Pars the accurate record of a foreign country clearly includes, as Wilton noted, its inhabitants, whom he makes into considerably more than decorative incidentals.[1]

The watercolour in which James Stuart, in many respects Pars's model, showed himself drawing the Erechtheion in Athens (Drawings coll., RIBA), had also given prominence to animated, pipe-smoking Turks, though the building, naturally, predominates. In his *Antiquities of Athens* (vol. I, 1762) Stuart was to stress his preference for 'Truth to every other consideration' in the delineation of his views which were all 'finished on the spot'.[2] While this pursuit of Truth was an initiative in which English artists were to play an important role, such curiosity was part of a much wider manifestation of the spirit of universal enquiry that characterised the European Enlightenment. The 1750s saw the appearance of the first volume of the vast *Encyclopédie* edited by Diderot and d'Alembert, detailing the state of knowledge but simultaneously pointing to teasing complexities on its fringes. Candid evaluation of the world and of history in a spirit which finely balanced scepticism with tolerance was to be one of the Enlightenment's driving concerns. The expeditions to classical sites populated by Turks in the eastern

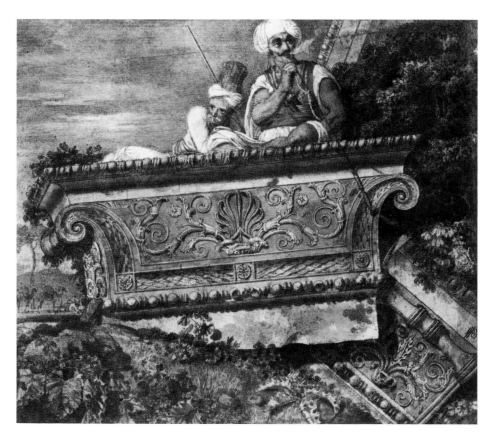

FIG. 37 William Pars (1742–82). *Capital of a Pilaster from the Temple of Apollo Didymaeus.* Watercolour and gouache, pen and grey ink, 18.1×21.1 cm. About 1764 (Engraved for R. Chandler, *Ionian Antiquities*, 1769.) Trustees of the British Museum, Dept of Prints and Drawings. Courtesy of the Trustees

Pars delineates in every detail the great classical wall-capital with its palmette, leaf-pattern and egg and-dart moulding. Above it, however, rise the figures of very characterful, pipe-smoking Turks. The white robes of the right-hand man isolate his blue and yellow coat and crimson waist-band – the primary colours which were to be so fascinating to Delacroix when he saw the Arab peoples of North Africa nearly 60 years later.

75

Mediterranean were now a symptom of a broad, international movement extending from Britain to Prussia, from Sweden to Italy: a movement which took artists, linguists and biologists deep into Asia (including, in 1761, the relatively unexplored deserts of Arabia).[3] From about 1750 India, indeed, would claim this kind of broadly based attention.

In what ways did this testing of received knowledge and the stress on fresh enquiry and first-hand experience affect European attitudes to the Islamic world? There are both obstacles and encouragements. First, the discussion of origins takes on a new dimension. The origin of the arts and artistic style had been debated ever since Antiquity.[4] We have already encountered a more recent branch of the discussion in regard to the derivation of Gothic architecture from that of the Saracens. The debate now flourishes again and this particular discussion is revived: on the other hand, it is placed in an altogether larger arena than ever before. The challenge of the east Mediterranean archaeological excavations to the authority of Roman classicism meant that it could no longer provide with the old certainty the points of reference from which artistic bearings in Europe had previously been taken. The urge was now to uncover at first hand the pure origins of classical art in Greece: the course of the 'true style'. But it was also to debate – in the light of the long historical perspectives that were opening – the origins of the arts as such: an ancient question indeed, but one which had never been discussed with such historical self-awareness as now. Many of the arguments were to be set in the context of the favourite eighteenth-century doctrine of progress. The evolutionary view of a progressive development proceeding from the 'simple' to the 'complex' clearly presented problems of compatibility with that which saw special sanction in the simplicity of origins.[5] The first art historian of modern times, the Abbé Winckelmann, saw 'noble simplicity' as characteristic of Greek art when it had progressed from the rude beginnings to a peak of perfection: for him this 'noble simplicity' and 'still greatness' made Greek sculpture the greatest human achievement. While Winckelmann did not assert that the Greeks invented art, there were many who made claims for other, non-European civilisations on the basis that they had been great initiators in one visual field or another. The Comte de Caylus, for example, saw the Egyptians as the inventors of architecture, arguing that Assyrians, Medes, Persians and even the Chinese had derived their architecture from Egypt. He had a general interest in the art of the East, including that of India, the other great civilisation which was attracting powerful partisans at this period. Among these supporters of India was G. J. le Gentil de la Galasière, an astronomer of the French academy of sciences who travelled in India between 1760 and 1768, and published in 1779 an account of his travels illustrated with splendid drawings of the Hindu *gopuras* or temple gate-towers.[6]

While much of the substance of these arguments resided in questions of antiquity, of prior claims to invention, they were concerned very largely with matters of architecture and sculpture of a monumental kind, of which the great early civilisations had left visible evidence. The adherents of the severer strains of neo-classicism – concerned as they were with mentally stripping away the surface decoration of buildings to the underlying essentials, and with ideals of functional brevity of greater or lesser sternness – found these matters highly congenial. On grounds both of the relative lateness, historically, of its arrival, and of its concern with surface elegance, the claims of Islamic art to serious attention in such a context might have seemed even slimmer than before. Moreover, as we noticed in the last chapter, the difficulties experienced by European visitors seeking access to Muslim religious buildings constituted a major problem.

Secondly, however, in this most complex of periods, forces were already at work which would effect a shift of sympathy away from these concerns with classical monumentality – the idea of truth enshrined in the formal properties of the ordered object – to a preoccupation with the feelings aroused by the visible world which would themselves become the subject of the work of art: a shift towards a set of concerns that, for convenience, we label Romantic.

Two powerful contributions to this fermenting process of change were the writings of Burke and Rousseau. In 1757, in his *Philosophical Inquiry into the Origin of our Ideas of the Sublime and Beautiful*, Edmund Burke's definition of the Sublime made the personal response of the observer the springboard of aesthetic satisfaction: a category of human response to experience which aroused the instinct for self-preservation in the face of the excitements of the unknown or unfamiliar. Burke's Sublime was overwhelmingly found in nature, but as a literary critic he cites instances of it in Virgil, Milton and other writers. Prominent among his examples are the Book of Job and Stonehenge, both of which were to become powerful influences on the Romantics, notably Coleridge and Blake. Indeed, Coleridge came to maintain that sublimity was 'Hebrew by birth', while Blake, as is well known, attributed the famous works of Greek and Roman art to the influence of 'greater works of the Asiatic Patriarchs'. The close interest taken in England in Hebrew origins was to be of some significance – as we shall see in the next two chapters – in directing attention to the Near East: while Coleridge's famous *Kubla Khan* (1798–9), with its orientalising imagery, indicates a parallel but distinct line leading the Romantic imagination in the same direction.[7]

The importance of Rousseau to incoming Romantic notions has frequently been stressed.[8] Apart from the autobiographical frankness of the *Confessions* (written in 1765–70 and published in 1781), it lay more generally in his advocacy of the spontaneous happiness of the 'natural man' in a state of simple savagery which, again from this crucial decade of the 1750s, was putting European sophistication in a still more questionable light than previously. Evidence for his views was soon to be amply forthcoming. The journeys of Bougainville (1768–9) and Cook (1768–71, 1772–5, and 1776–9) to the South Pacific brought Europeans into contact with the embodiment of 'natural man' in the persons of the inhabitants of the 'happy islands'. Omai, the prince from the South Seas, cut a striking figure at the court of St James in the mid 1770s.

We cannot pass Rousseau, however, without noting the special importance of the *Confessions*. In this revelatory book the author set down, as he says, an account of his personal identity in relation to that of other men: I 'may be no better, but at least I am different'. The complexities of Rousseau's sense of 'difference' led him personally to virtual persecution-mania; but there can be no doubt that the yearning for his island-home on the Lake of Bienne, and the sights of nature which he describes in such moving detail in the late stages of the book, is a symptom of a state of mind which was to take many Romantics to the deserts of the East – in search of their own independence or to rediscover themselves. The desert was to be specifically seen by Chateaubriand as the place where in loneliness the greatest passions could be released.[9] Rousseau's restless wandering took place in Europe: that of many Romantics after 1800 was to be increasingly close to the nomadic Bedouin.

We must note, then, three salient interests: first, in the origins of style; secondly, in the thrill of the unknown; and thirdly, in the seeking out of lessons for Europeans among remote people in remote places. All these by direct means would affect the climate of opinion in which Islamic ways of life and culture were viewed. In the case of all three there would be traditional obstacles,

but there would also be encouragements to new thinking. We may take these in turn.

As regards style, for the unbudging among classically minded artists and patrons there was the traditional, publicly voiced contempt of the Evelyn kind for the 'barbaric' style of Muslim building with its Gothic affinities. But with the wider search for the origins of artistic styles, the Gothic – a style with a tenacious tradition in Britain – was itself to become more respectable, and with it the linear diversifications of Muslim architecture.

For those who pursued the 'unknown' in the Levant or further east, in the light of Burke's account of the instinct for self-preservation, there was the memory of the Turkish threat to Europe, 'the greatest terrour of the world', as Richard Knolles had put it in his *General History of the Turkes* of 1603. After the Treaty of Karlowitz (1699), the Ottoman challenge to Europe was over: but Turkish histories, including Knolles, were still being read in the late eighteenth century, and with evident curiosity (as we shall see) by the young Byron (born in 1788).[10] After 1800 wild landscapes with Turks in them would make a marked appeal to the Romantics. In the second canto of *Childe Harold* (1812), Byron would recall his

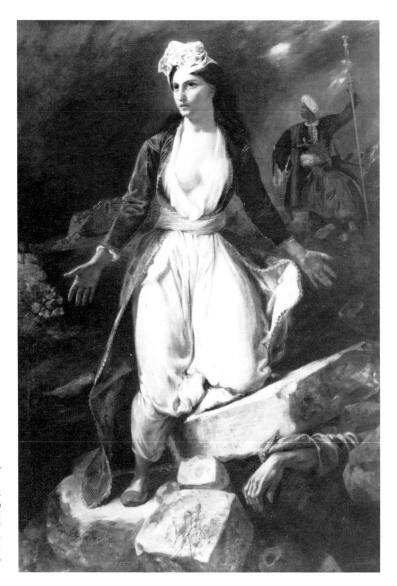

FIG. 38 Eugène Delacroix (1798–1863). *Greece on the Ruins of Missolonghi*. Oil, 209 × 147 cm. 1826. Musée des Beaux-Arts, Bordeaux Anc. 439

In this work Delacroix expresses some of the interest he had been building up, through the study of Islamic miniatures, in the real-life Orient. Greece rises as a semi-allegorical figure from the ruins but the oriental 'holds the eye', as he was to continue to do when Delacroix visited Morocco in 1832.

admiration for the Albanians and Suliotes in their 'native fastnesses'.[11] The turbaned oriental included by Delacroix in the background of his painting *Greece on the Ruins of Missolonghi* (1827, Figure 38) – commemorating a Turkish victory – indeed makes a figure of some splendour which almost eclipses that of the woman representing Greece, the central focus of sympathy. The fact that he is probably a Nubian in the service of the Turks makes no difference to the basic point.

Finally, for readers of Rousseau, speculations on the relationship between the savage and the sophisticated must have been particularly acute in contemplating the Muslim countries: were they to be admired more for their civilisation or for what had passed (by the standards of a European classical education) as their barbarity? While Chateaubriand, on his Middle Eastern journey of 1806–7, concluded that the Bedouin, though now decadent, were descendants of a great civilisation, the resolution of the general question was to take much time, and we shall see it being brought into sharp focus in the changing world of confused European artistic standards in the mid to late nineteenth century.[12]

II

The remainder of this chapter, therefore, is concerned with the evidence for these changes of attitude. In England, the extremes of contrasting approach to the Orient in the later eighteenth century are in fact well revealed by two readers of Turkish history. In 1751 Dr Johnson saw Knolles' *History of the Turkes* – available in its more up-to-date version of 1687 and 1700 by Paul Rycaut – as without rival in its field, though concerned with a subject of such 'remoteness and barbarity' that 'none desire to be informed'.[13] But Byron was excited by reading Turkish history as a child in about 1798, and believed it 'had much influence on my subsequent wishes to visit the Levant'.[14]

In the half century between the closed dogmatism voiced here by Johnson and the open curiosity of Byron we find a speculative admiration for the Islamic world taking shape in certain quarters. We shall consider in turn English attitudes to Turkey, Persia and India: but we may begin by looking at the favourable reactions to undifferentiated 'Arabs' as related by Robert Wood, who had known them at first hand during his expedition to the Roman Orient. The neo-classical painting by Gavin Hamilton of *Wood and Dawkins discovering Palmyra* (1785, on loan by the Dawkins family to the University of Glasgow, Figure 39) depicts the scholar-explorers as heroes but also gives prominence to their Arab escort.[15] In his well-known *Essay on the Informal Genius and Writings of Homer* (1769, new edition 1775 as *Essay on the Original Genius and Writings of Homer*), Wood declared his sense of the primitive, indeed Homeric, qualities of the Arabs. Palmyra may have relapsed into ruin, but the site 'has recovered its pristine inhabitants with their customs, manners, language, and what is most extraordinary, their traditions' (1775 edn, p. 148). The Arab is brave and hospitable, a moral being: even his 'ideas of plunder and rapine are perfectly conformable to those of the heroic and patriarchal times' (p. 151). Arab poetry displays a 'glowing imagination'. This kind of recognition in the living Arab of qualities now considered deficient if not defunct in the European forms the prelude to the identification of certain nineteenth-century Europeans themselves with the Arab, which we shall be concerned with in chapter 4.

While the 'Arab' was to advance steadily in the sympathies of travellers in these years of latent Romanticism, the Turk with his military record in Europe presented more of a problem. Prejudice died hard and so did his theatrical

stereotype: the second indeed owed a large part of its stereotype nature to the standard expectations engendered by the first. But there are notable indications of a desire for better understanding. It is to France that we must look first.

The Turk may have been of little concern to the more solid pillars of the English Enlightenment, but in France after 1760, under the influence of the dramatist Charles-Simon Favart, close attention was being paid to historical veracity in the presentation of Turkish themes. For his comic play *Les trois Sultanes*, first produced at the Théâtre Italien, Paris, on 9 April 1761, Favart had a sumptuous Turkish dress brought over from Constantinople for his wife to wear in the principal role of Roxolane, of which she made a great success.[16] It may be said of him that he reinforced, in respect of women's dresses in stage presentations of Turkish subjects, the process of authentication that had been upheld under the Chevalier d'Arvieux in respect of men's costumes a century before. In the meantime the residue of European Baroque stage conventions had delayed the process (Favart complains in a letter of stage Sultans 'in perukes').[17] Kurz, however, draws attention to the engraving of a scene from Favart's play, drawn

FIG. 39 Gavin Hamilton (1723–98). *Wood and Dawkins discovering Palmyra.* Oil, 312×387 cm. 1785. John Dawkins Esq., on loan to Hunterian Art Gallery, University of Glasgow AC 2319
The orientals are personalised and differentiated in physical type, though the Europeans occupy the centre and the vista leads to a Roman arch. Wood's interest in the inhabitants of the Arab world is reflected in his books, see p. 79.

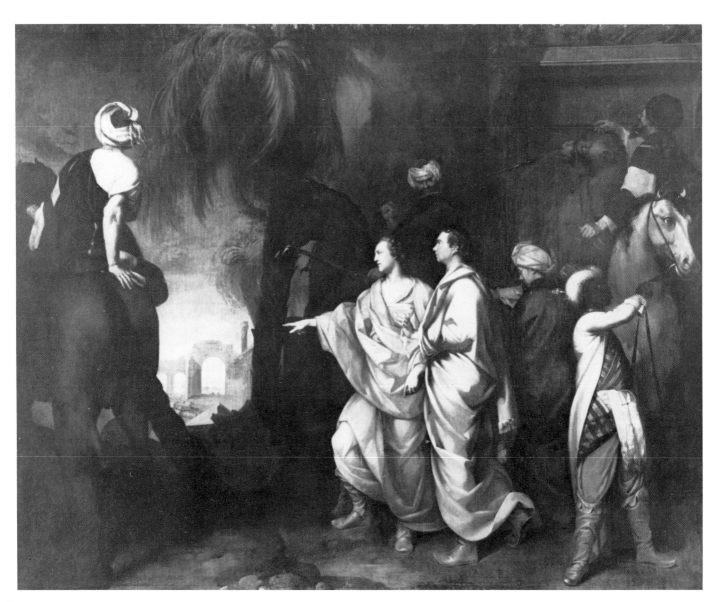

by the famous Gravelot, which shows musicians playing Turkish instruments such as the long-necked flute and cymbals.[18] Favart's *Les Trois Sultanes* found favour as a theme for opera, when in 1799 in Vienna F. X. Sussmayer, a pupil of Mozart, staged his version of it. By then Mozart's own operas had invested the Turkish fashion in music with deeper resonances: the magnanimity of the Pasha Selim in *Die Entführung aus dem Serail* (1782) being a well-known example.

While the atmosphere of a sympathetically regarded Seraglio was being induced in these years in the European theatre, further works on Turkish costume appeared which supplemented the famous *Recueil* by le Hay and which involved Englishmen. In 1763 Lord Baltimore made a journey to the Levant, taking with him the artist Francis Smith. Six years later Smith published 26 plates entitled *Eastern Costume*, which included several Turkish subjects, some of them repeated by Thomas Jefferys in the 1772 edition of his book on national dress (see Bibliography), and also by the Venetian editor Teodoro Viero in his costume collection of 1783–91.[19]

In the same years the phenomenon of the 'picturesque journey', to visit scenes which were felt to provide apt subjects for painters, was popularising the idea of publishing visual records of exotic places: we shall return to this in regard to India later (p. 101). A number of such 'tours' referred to Greece, Turkey and the Levant. In 1782 the Comte de Choiseul-Gouffier (1752–1817) – to be appointed ambassador at Constantinople two years later – published the first volume of a *Voyage pittoresque de la Grèce*. This had illustrations made at first hand by Jean-Baptiste Hilaire (1753–1822), whose work missed little of the Turkish life that he had observed. Also in 1782 the painter Anton Ignaz Melling (1763–1831) arrived in Constantinople from Italy and Egypt, and stayed for 18 years working for the Sultana Khadija. His own *Voyage pittoresque de Constantinople et des rives du Bosphore* came out between 1809 and 1819, containing 48 plates.

The British ambassador at the Sublime Porte from 1776 to 1792, Sir Robert Ainslie (c.1730–1812), was also active in sponsoring visual records of the Levantine world. The artist whom he patronised, Luigi Mayer (died 1803, Figure 40), ranged adventurously over a multitude of subjects, single figures, interiors and exterior views, which were engraved by Thomas Milton and published under three titles, *Views in Egypt* (1801), *Views in the Ottoman Empire*, (*chiefly in Caramania, a part of Asia Minor hitherto unexplored*) (1803), and *Views in Palestine* (1804). In the following years, while the Elgin Marbles were claiming new regard for Greek art in London, Mayer's plates were to supply oriental subjects, in particular for blue and white printed earthenwares by Spode and others.[20]

Besides the publications of views, the work must also be mentioned of a dedicated researcher with unique qualifications for the task that he set himself. This was Ignace Mouradega d'Ohsson (1740–1807). Of Armenian descent and son of the consul for Sweden at Smyrna, he grew up with an understanding of the Turkish language and for 26 years collected material for an accurate and complete account of Turkish civilisation. His *Tableau général de l'Empire Othoman* was published between 1787 and 1790 in two volumes containing 137 plates in the form of engravings after paintings, many of which were among the most beautiful as well as informative to deal with their subject: Hilaire was responsible for several.[21]

These assiduous researches into Turkish life were taking place at a time of intense Turkish interest in European life and art. Selim III (1798–1808) decorated his salon in the Topkapi Serail in a rococo idiom which far exceeded in richness the Western-style work of his predecessors, and contained more than a trace of effeteness.[22] Selim looked mainly to French art. Under him however, quantities

of English clocks and watches found their way into Turkey.[23] His successor Mahmud II (1808–39) was another Francophile who opened a medical school staffed by French doctors. It was he who instituted European clothes, including a frock coat and black trousers, for all officials, a move we shall find the colour-loving Victorian architect Burges execrating 50 years later.

While Mahmud was introducing European dress into Turkey, Europeans continued to dress themselves as Turks. As in the past, the reasons for doing so might be reaction against established Western attitudes, recourse to the sheer comfort and freedom that could be enjoyed, or a desire for safety while actually in Muslim countries (notably Syria). If reasons were not always clear in all cases, the attractions of Eastern dress had never been stronger. Byron, who supported the

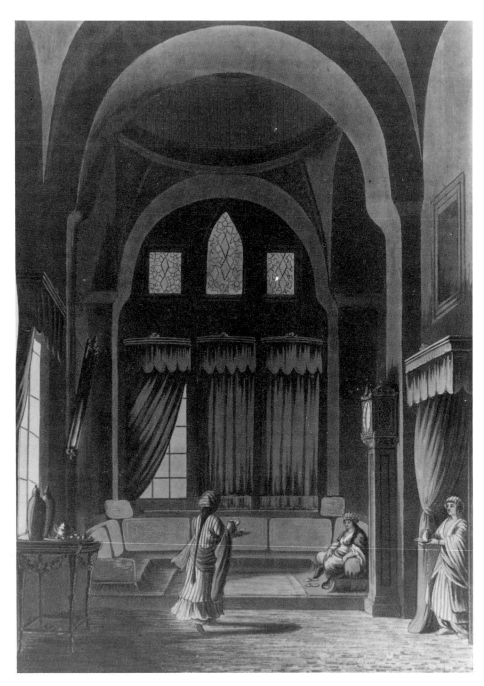

FIG. 40 Luigi Mayer (d. 1803). 'A Lady of Cairo', pl. 46 from *Views in Egypt*, 1801, Aquatint, 37×24 cm. Victoria and Albert Museum Searight Collection
Mayer is an obscure figure, but his prints of Near Eastern subjects based on first-hand contact are wide-ranging as well as being factual. Where, 40 years later, J. F. Lewis was to depict interiors which were uncompromisingly Islamic, Mayer shows the considerable degree of infiltration into Islamic settings of rococo French ingredients (the table and the clock) which could be seen in Ottoman interiors around 1800.

Greeks politically while admiring the non-European traditions of the eastern Mediterranean, was portrayed by Thomas Phillips in 1814 wearing Albanian costume. Those who had classical instincts might combine a journey to the new popular classical sites of Baalbek and Palmyra with a spell of 'going Turk': such was George Cumming, portrayed (Figure 64) by Andrew Geddes (1783–1844) (Royal Academy, 1817). But at Palmyra, Lady Hester Stanhope (1776–1839), niece of William Pitt and friend of emirs and sheiks, did more: she was crowned 'white queen of the desert' by the local populace in 1813. To Lamartine, visiting her in 1832, she confided the pronouncement that the East was her true homeland. By then, as we will see later, many Europeans were following the same line of thought.[24]

In England, meanwhile, the two major background figures of the period between 1790 and 1820 are William Beckford (1760–1844, Figure 41) and Thomas Hope (1769–1831, Figure 42). As men who were concerned to widen their own aesthetic awareness, they were both preoccupied with the Orient. But the vision of Islam provided each with different answers to his needs. Though he visited Spain, Beckford never went East, and the fantasy element in his conception of it remains uppermost. As a literary figure he cannot detain us here, but the shadow of Beckford the writer falls as long across the age as did that of his tower of Fonthill. The literary mirages of his oriental tale *Vathek* were indeed to outlast the tower (it collapsed in 1825), as was his reputation as a man of extravagance. His undoubted penchant for the extravagant gesture (the Fonthill Abbey sale of 1823 had 1,588 lots of 'Unique and Splendid Effects') has tended to distract attention from the solid scope of a remarkable collection of pictures and other objects formed by the exercise of a highly developed, fastidious taste. Characteristically, the sense of fantasy that he felt as a child from reading books about the East in his father's library led to a serious involvement with the subject. He read travel literature on Eastern countries and studied Arabic with a native speaker so that he could read *The Arabian Nights* in the original. His teacher of drawing, Alexander Cozens (c.1717–86), formerly drawing-master at Eton and known to Beckford as 'the Persian', told him about the Persian friends he had known in Russia and showed him oriental manuscripts. Beckford's official tutor Lettice on the other hand unwisely compelled him to burn oriental drawings as a precaution against corruption. In Spain in 1785 he had unforgettable first-hand encounters, seeing on one occasion figures in caftans and turbans in a Madrid palace doorway: 'My sparks of orientalism,' he wrote, 'instantly burst into a flame at such a sight'. The sparks of the travel diaries remained embers for the recluse at home: of necessity Beckford continued to develop his tastes for the East, collecting Mughal miniatures and keeping Cozens's letters in an Indo-Portuguese ebony cabinet. This was to be shown in the painting by Maddox of Beckford on his death-bed.[25]

Beckford's famous oriental fantasy, *Vathek: an Arabian Tale* (written 1782, published in French 1786), was an autobiographical account of an Eastern ruler, the Caliph Vathek who, after a life of self-gratification, is condemned to eternal torture in the satanic Hall of Eblis. *Vathek* went through many editions and had an immense literary progeny, including Byron's *The Giaour* (1813) and Thomas Hope's novel *Anastasius* (1819).

In spite of the fact that this vision of an oriental caliph was so personal to him – or perhaps because of it – Beckford did not surround himself with objects of Islamic art. Nor did he build in an Islamic style at his famous site of Fonthill, Wiltshire. Instead, in a letter of 2 February 1797 to Sir William Hamilton, he envisaged here 'a little pleasure-building in the shape of an abbey', containing

apartments 'in the most gorgeous Gothic style'. James Wyatt's plan for the octagonal Chapel appears to have recalled the particularly rich Gothic of the octagon of the monastery at Batalha, Portugal, which had impressed Beckford in 1794. The Gothic character of the final enlarged version of the building, which vied in height with Salisbury Cathedral, does not concern us here.

Nevertheless, an Islamic element cut through Beckford's imaginative life, and its manifestations must be noted. One of his early visual memories would have been the Egyptian Hall or 'Turkish Chamber' in Fonthill Splendens (completed 1768): the house of his father, the forthright Alderman. The Turkish masquerade which celebrated Beckford's 21st birthday in 1781 took place in the house.[26] Later in life Beckford included a 'Turkish Salon' in the autograph plan, dated 29 December 1793, for his own house at Lisbon.[27] In 1803, Lady Anne Hamilton, governess to Beckford's daughters, notes at Fonthill a bedroom in 'Turkish stile . . . like a tent'. Still later, in the 1820s, he built a Moorish summer-house behind his house at 20 Lansdown Crescent, Bath (Figure 41).

If we were to draw any conclusions from this sequence of events, we might conjecture that the Islamic idiom came to mean for Beckford a style for private rather than public occasions. Perhaps its presence in the opulent forms of Brighton Pavilion made it seem too redolent of the cynosure world of the Prince Regent: the world of social occasion from which personal circumstances had excluded Beckford. But although Beckford told Mr Lansdown that he was not greatly attracted by Moorish taste, there is in him evidence of a penchant for sumptuousness in silverware at least which linked him mentally to that public

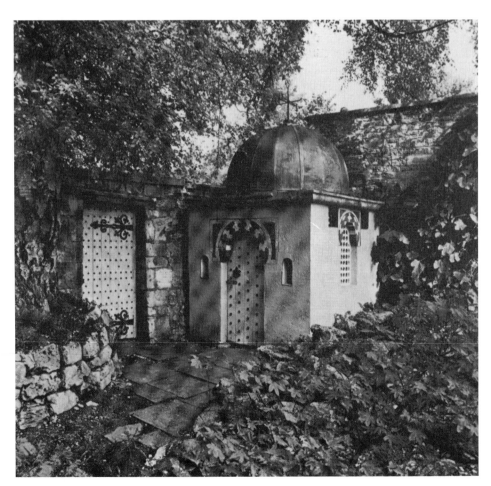

FIG. 41 William Beckford (1760–1844). Moorish summer-house, 20 Lansdown Crescent, Bath, mid 1820s
Beckford, the 'Caliph of Fonthill,' 'Sultan of Lansdown', built comparatively little in oriental styles for one so devoted to his own image of the Orient. The summer-house in the corner of his garden remains as a somewhat touching memorial to his orientalising taste, the more impressive for being so understated.

world: the superb cup with silver-gilt mounts and arabesque detailing, carried out for him by James Aldridge, is perhaps in part Beckford's design.[28]

Thomas Hope looked eastward for very different reasons. Beckford's East is in the imagination: he sees it as a source of literary fantasy, uncontained and even outrageous. Hope, a serious neo-classical artist who travelled extensively to the countries of his choice, looks more objectively for the salient qualities of style, though, as Watkin has shown (*Thomas Hope 1769–1831 and the Neo-classical Idea*, 1968), never with the eye of a pure archaeologist: he is not concerned to acquire his antiquities from the countries of their making, and some of his Egyptian sculptures appear to have been recovered from Roman sites. Beechey's imposing portrayal of him (1798, Figure 42) shows that despite the dry, neo-classical severity of the engravings in his *Household Furniture* (1807) he liked to rouse the

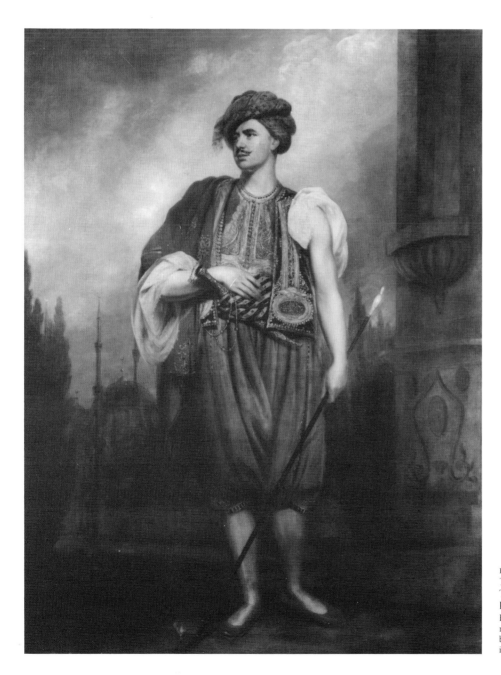

FIG. 42 Sir William Beechey (1753–1839). *Thomas Hope*. Oil, 221.5×168.7 cm. 1798. Trustees of the National Portrait Gallery, London 4574
Hope appears here as the Grand Tourist of the newer breed which put the eastern Mediterranean before Italy. He stands in sumptuous Turkish dress in front of a mosque.

imagination in his own portrait: he wears a golden turban and scarlet slippers, and stands against the dome and minarets of a Turkish mosque.[29] Turkey seized Hope's attention far more positively than Beckford's – but Hope, after all, actually saw it. Born in Amsterdam, he set out aged 18 on a Grand Tour extending over eight years (1787–95). He visited Turkey, Egypt, Syria, Greece, Sicily, Spain, Portugal, France, Germany and England, spending nearly a year in Constantinople. Anastasius, the hero of his part-autobiographical novel, is overwhelmed with the city, 'hardly retained power to breathe; and almost apprehended that in doing so, I might dispel the gorgeous vision, and find its whole vast fabric only a delusive dream'. (Anastasius, edn 1820, vol. I, p. 68). Nevertheless, despite the apprehension, Hope, an executant artist concerned with the decorative arts, thinks in firm visual terms, more so than Beckford. From 1799 he was converting the rooms of a mansion (now demolished) that he had bought in Duchess Street, off Portland Place, London, in a variety of 'extreme' styles. There was a Greek Doric Picture Gallery, an Egyptian or Black Room (which housed his Egyptian antiquities) and an Indian or Blue Room. This last (Figure 43), the main drawing-room in the house, was particularly created for paintings of Hindu and Islamic architecture commissioned from Thomas Daniell, the well-known artist who had been to India and whose great illustrated work *Oriental Scenery*, consisting of prints by him and his nephew William, was then in process of publication. Daniell's paintings for Hope, carried out in 1799–1800 for the Indian Room, have been identified by Shellim as (on the right as we look at the engraved view) an architectural capriccio, *Hindu and Muslim Architecture*, in which a distant Taj Mahal represents the latter; (on facing wall, left) the *Zinat ul Masjid, Darayaganj, Delhi*; and (facing wall, right) *The Manikarnika Ghat, Benares*.[30] Despite the Indian subjects of the paintings, however, the room as furnished took in many other Islamic sources. Hope describes its appearance: its ceiling canopy 'of trellis-work or reeds, tied together with ribbons' imitated from 'Turkish palaces', its peacock feathers (visible on the end wall), its Persian carpets, its low sofas

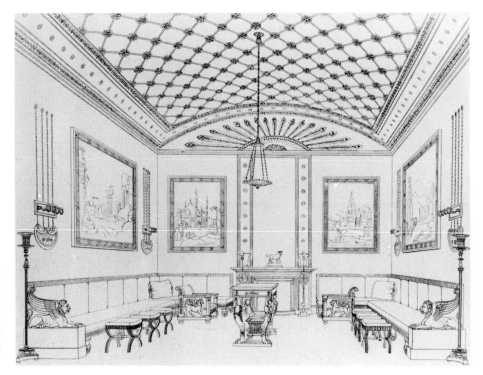

FIG. 43 Thomas Hope (1769–1831). Indian Room (drawing-room), about 1800, pl. VI from *Household Furniture and Interior Decoration*, 1807
This room, one of several in Hope's Duchess Street mansion made about 1800 and celebrating architectural styles that were relatively unfamiliar in modern Europe, incorporated four paintings of Indian subjects by Thomas Daniell. See above.

'after the eastern fashion' (*Household Furniture*, p. 30). As Hope explains, he could not avoid furnishing the room entirely without resort to European classical ingredients (e.g., the chairs with winged lions). Not the least interesting aspect of his Indian Room, however, is the conscious attempt to assimilate such elements into an 'oriental' interior effect.

When the Indian Room was opened to the public in 1804 it took its place among the other Duchess Street interiors in a sequence designed to present the civilisations of the ancient world. The idea looks forward far into the nineteenth-century period of museum endeavour. One of Hope's more surprising strokes was to place his interesting Daniell capriccio of *Hindu and Muslim Architecture* (Figure 44) opposite a view by Pannini of the ruined Roman Forum. The Taj is icily remote but preserved intact, a fact which had impressed Thomas Daniell: in his capriccio, the Hindu *mandapam* (a shelter for religious observances) is in use and a procession is approaching it. Was *passé* Roman achievement being 'put in its place', in the Indian Room, in the face of the living Indian one? It is possible. Perhaps a more important consideration for Hope, however, was to reflect on the links of the Indian buildings not so much with the present as with the past. He

FIG. 44 Thomas Daniell (1749–1840). *Composition, Hindu and Muslim Architecture.* Oil, 112×229 cm. 1799. Thyssen-Bornemisza Collection, Lugano, Switzerland
The painting was done for Hope's Indian Room (Figure 43) and reflects contemporary interest in comparing the architectural styles of India in the years when the Daniells' *Oriental Scenery* was being published.

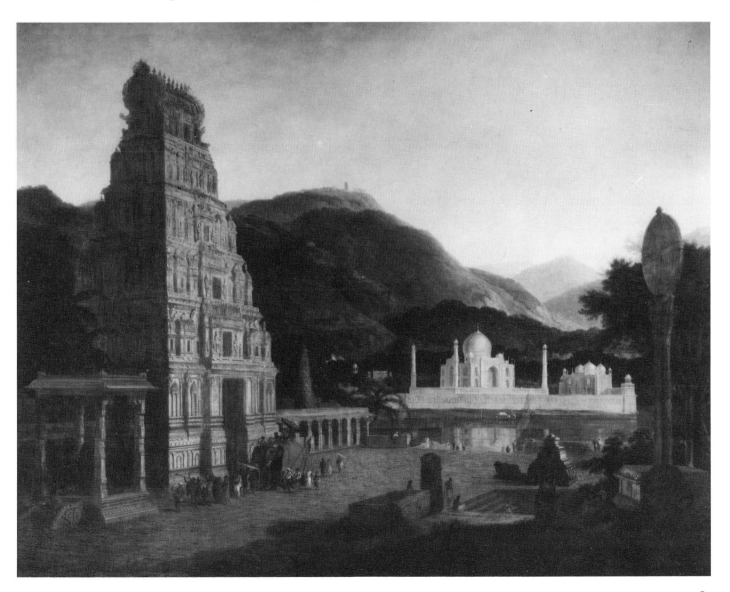

will certainly have seen these forms not only in the context of ancient civilisation but also in the still wider setting of natural origins. Fictitious mountains tower importantly over the Taj in Daniell's picture. The theory of natural origins is referred to in *Household Furniture*: thus Hope, in his 'Explanation' to that work (p. 18), likens the facetted forms on his title page (Figure 45), taken from a picture-frame seen, apparently, in Constantinople, to natural rock forms, 'congelations and stalactites'. The idea did not spring from nothing. The brand of eighteenth-century romantic speculation concerned with nature as a kind of index of primitive form, and with exotic architecture as a close derivation from it, will need comment later (p. 97). Hope was certainly responsive to it. Yet, when this is recognised, and in the presence of his own creative designing, we must conclude that his vision condenses, in the end, round the legacy of Greek classicism: his essentially generalised view of Islam is most interesting to him as a foil to the solid worth of that legacy.[31]

Persia was not included in Hope's long itinerary. Concern with that country and its arts was, however, developing simultaneously in Britain. Persia was remote and called for extra circumspection on the part of travellers, but in its favour it was without the record of the Ottoman Turks on the battle-stage of

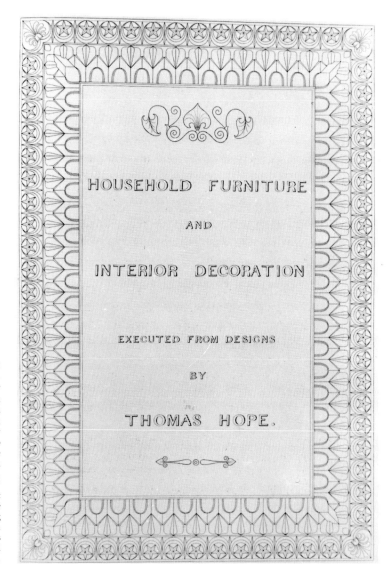

FIG. 45 Thomas Hope. Title page from *Household Furniture and Interior Decoration*, 1807

The palmette in the corner is Greek, but the circles inscribed in larger circles so as to create crescents is the Turkish *chintamani* motif, descended from Byzantine and Sasanian times, but particularly associated with Ottoman textiles. Hope was so captivated by this border design, taken from the frame of a picture, representing a 'Turkish personage', that he also illustrated its section (pl. L111). He was attracted by its 'multifarious angles' and 'numerous facets' and linked it, somewhat vaguely, with Islamic architecture throughout the world. The interest in sculptural facet – long subordinated in post-Renaissance Europe to a concern for volume – was to be developed by others as acquaintance with Islamic architecture deepened (see Figures 66, 118).

Europe. Chardin's *Journal du Voyage en Perse* (1686) had proclaimed the people of Safavid Persia the most civilised in the East. In the later eighteenth century, after Safavid power had collapsed, a sustained interest in Persian literature began to show itself in England. Sir William Jones (1746–94), the eminent linguist, praised the caliphs for their encouragement of the arts in his widely read *Persian Grammar* of 1771. 'Harmonious Jones' – the contemporary tribute was apt. It was Jones who, as Homer and Shakespeare loomed first among poets in European affections of the period, compared them with Firdausi and Hafiz, and went on to evaluate national and racial differences between European, Arab and Indian, while reconciling them in a broad view of human achievement. The sculptor Flaxman produced a reflective marble of him engaged on his encyclopedic survey of Islamic and Hindu law (University College, Oxford, 1798).[32]

The Persian connection was to flourish in the reign of Fath 'Ali Shāh (1798–1834), for whom Spode were to design a handsome cup with the Shah's coat of arms.[33] Fath 'Ali Shāh, the first ruler of the Qajar house, was himself to pursue a cosmopolitan policy, which included the encouragement of European styles and techniques of painting, especially oils, among his artists. But, more importantly, he and his immediate descendants were to give the country a stability which would stimulate a revival of Persia's own crafts, notably carpet-weaving.

Jones's authority as tireless propagandist of Persian language and letters was to have added practical relevance because Persian was the language of administration in Mughal India, where British trade and influence under the East India Company were rapidly growing. With the eventual collapse of the Mughals and the setting up of British rule in Bengal in successive stages from the 1760s onwards, a working acquaintance with Persian took on a major importance, particularly as more and more Englishmen turned to India to find fortune and adventure after the loss of the American colonies.[34] It was through the opportunities provided by living in India that some English collectors were to build up a knowledge of Persian miniature painting, along with that of the Mughals and the surviving courts of Northern India. Further incentive was given by the Asiatic Society of Bengal, founded in 1784 by Jones with Hastings's support to promote 'enquiry into the history and antiquities, the natural productions, arts, sciences and literature of *Asia*'. Jones expanded upon this intention in the first volume (1788) of the Society's Journal *Asiatick Researches*: acclaimed in the learned periodicals of London to such an extent that it was pirated.

Encounters with Islamic art and life through the British residence in India now took two main forms: visits by artists from Britain, and the collecting activities of Britons in India, sometimes involving the patronage of native Indian artists. Among visiting painters the most conspicuous were Tilly Kettle (1735–86) and Johan Zoffany (1733–1810). Both came looking for the portrait commissions which, in the face of competitors as able and determined as Reynolds and Gainsborough, were less forthcoming in England, especially in the case of an artist like Zoffany who had spent long years away from his fashionable London practice.

To Tilly Kettle and to Zoffany who followed must go the credit, as Mildred Archer has remarked, for bringing the native inhabitants of contemporary India alive for the British at home.[35] Tilly Kettle had news of opportunities in India from returning East India Company officials. He was there from 1769 to 1776, working in Madras and Calcutta and for the artistically active court of Oudh. His work was widely successful in India and in Britain. In Madras he painted the superb life-size, full-length portrait of Muhammad 'Ali Walaja, Nawab of the Carnatic (oil, 1770, Victoria and Albert Museum), using the European convention of

column and curtain to offset the figure, but treating visitors who saw it in the 1775 Society of Artists exhibition in London to a vivid display of Mughal state dress with long white muslin *jama* (gown) edged with gold tissue and pearls.

In the late eighteenth century, Oudh was one of a number of Indian courts which managed both to preserve their own traditions and to entertain a lively interest in Europe and European artefacts. That of Poona was another; there the British artist James Wales painted portraits of the Pashura and his ministers in the 1790s, and listed the European articles which had aroused the admiration of his hosts: these included not only the predictable gold watches but also prints after Van Dyck, silk stockings and pianos.[36]

But it was Oudh, under the rule of the sagacious Nawab Shuja-ud-Daula (1753–75), which offered most opportunities to Europeans. The Nawab employed French army officers to reform his army, while carefully maintaining his political independence from the British. In common with other Indian leaders he was concerned to demonstrate his status to the British through a medium respected

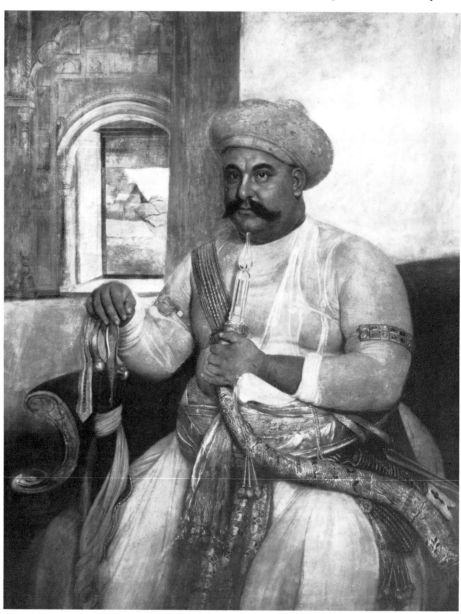

FIG. 46 Johan Zoffany (1733–1810). *Hasan Reza Khan*. Oil, 129.5×105.5 cm. 1784. The British Library, India Office Library and Records, London, Foster 108
The subject was minister of Asaf-ud-daula, Nawab of Oudh 1775–97. He is shown holding the mouthpiece of a *huqqa* (hookah), his right hand supported by his sword, against a background revealing more concern with Indian architecture than was usual with Zoffany.

by them: the portrait in oils. Tilly Kettle was painting for him in his capital Faizabad in 1772–3: many of his portraits of the court reached huge dimensions and included architectural backgrounds; others on a smaller scale depicted court scenes at close range.

Johan Zoffany was in India from 1783 to 1789. He travelled with an introduction from his friend Lord Macartney, Governor of Madras, to an influential attorney resident in Calcutta, William Dunkin. He quickly became known to Warren Hastings, the first British Governor-General of Bengal, who had a deep concern for the arts, and other patrons such as Sir Elijah Impey, the Chief Justice, who had earlier sat for Kettle. In 1784 he moved with Hastings to Lucknow, the capital since 1775 of Oudh, which was now under the rule of the vain and extravagant Nawab Asaf-ud-daula. Among his patrons here were the French soldier Claud Martin and the Swiss-French Colonel Antoine Polier. Zoffany took full advantage of a common interest in Indian life to paint Indian subjects, notably village landscapes; there are also many interesting portraits of Indian sitters (Figure 46).[37] His concern with indigenous culture is shown by his membership of the Bengal Asiatic Society.[38] An interest in oriental carpets might

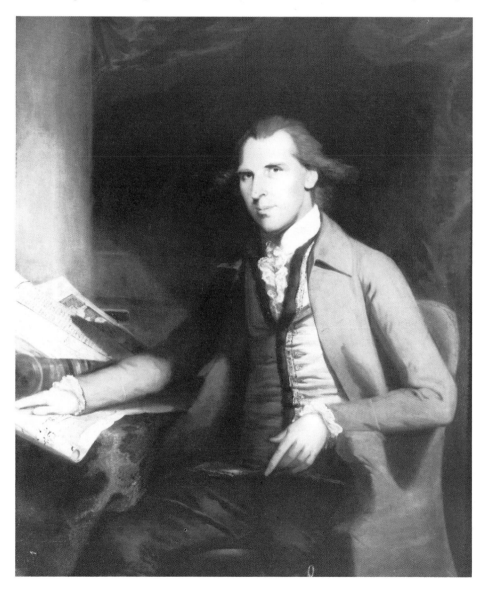

FIG. 47 Tilly Kettle (1735–86). *Nathaniel Middleton*. Oil, 125×105 cm. About 1773. Private collection. Photograph courtesy Hobhouse Ltd, London
Middleton, another East India Company official, became well-known for the large collections he formed in India of natural history drawings and also miniatures, one of which he holds in this painting.

be surmised before he went East because of their prevalence in some of his most important works: he includes a fine Mughal example in his portrait of 1783–4 of Warren Hastings' wife.[39]

Tilly Kettle painted a portrait of Nathaniel Middleton (Figure 47): one of the administrators of the East India Company who collected Persian and Mughal paintings. The Nawab of Oudh had presented the English soldier Clive with two albums of Mughal miniatures in 1765.[40] The younger administrators who followed, such as Middleton, became avid collectors. Warren Hastings set an important lead in his time in India from 1772 to 1785. On 30 March 1774, as recorded by Boswell, even Dr Johnson in a letter to Hastings was voicing hopes for what the Governor-General might reveal to his compatriots of the arts and sciences of the East. Inspired by Sir William Jones, Hastings indeed proved a remarkable patron of learning: he also built up a collection of Persian manuscripts that included the famous *Shāhnāma* or Book of Kings by Firdausi, and he acquired Mughal miniatures.[41] Richard Johnson (1753–1807) was in India from 1770 to 1790 as a Company official. Friend of Hastings, William Hickey (the diarist) and Jones, he amassed miniatures for their own qualities as artefacts. In the next generation, diplomats such as Sir John Malcolm, Governor of Bombay, and Sir Gore Ouseley (1770–1844) and his brother William (1767–1842) were conspicuous students of Persian art: Sir Gore, who was in India from 1787 to 1805 and subsequently ambassador to Persia (1810–14), was a founder member in 1823 of the Royal Asiatic Society. His brother listed 724 Persian manuscripts in his collection in 1831.[42]

Richard Johnson's responsibilities as Head Assistant to the East India Company's Resident in Lucknow, Resident at the court of the Nizam of Hyderabad and finally Judge Advocate-General at Calcutta, brought him into contact with miniatures from aristocratic Mughal collections which were being dispersed. Although he collected paintings, not simply manuscripts, his concern was not with the styles of painting, but rather with subject-matter, both Hindu and Muslim. His subjects ranged in time from the reign of Humayun (1530–55) to that of Aurangzeb (1658–1707) and represented the schools of the Deccan (especially Hyderabad) and the provincial centres of Lucknow and Murshidabad. Besides pictures of regional costume and Europeanised subjects, he was particularly interested in those which depicted the themes of Indian poetry and music (*ragamalas*). Johnson also acquired 68 examples of Persian painting, notably from Khurasan, Bukhara and Isfahan, including the work of Muhammadi and the most famous Persian artist of the sixteenth century, Rizā 'Abbāsī. Near the end of his life, in 1807, he sold 59 albums (*muraqqa*) to the East India Company, whose library had recently been founded. In 1858 this became the India Office Library, and there, together with Hastings' *Shāhnāma*, they still are.[43]

The founding of the East India Company Library in 1801 and the acquisition of Richard Johnson's great collection of miniatures were events of immense potential importance which unfortunately had little or no artistic impact in their time in England. In founding their Library, the Directors of the Company were concerned to establish a 'public Repository in this Country for Oriental Writings'. The wording of their announcement reflects the literary bias of those concerns. Sir Charles Wilkins, the famous Sanskritist – who had gone to India in the same year as Johnson, 1770 – became the first Librarian. For the next 100 years the interest of successive Librarians continued to be mainly historical, literary and linguistic. Little serious heed was given by them to the aesthetic qualities of Indian painting. Two Company surgeons who had worked in Bengal, John Fleming (1747–1829) and Francis Buchanan-Hamilton (1762–1829), presented

further paintings to the Company's Library, in 1814 and 1815 respectively: Fleming's were Hindu religious subjects; Buchanan-Hamilton's gift included an album of Mughal portrait miniatures which were probably part of an anonymous artist's working stock. Buchanan-Hamilton is known to have been interested in the economic conditions of artists.[44] After these donations, few miniatures of any significance entered the Library until after 1900.

Apart from artists' visits to India and the collecting of Indian painting by British residents, many of the East India Company's own officials depicted Islam-inspired subjects. Competence is variable and, as their work is hardly ever more than documentary, it does not concern us here. But sometimes a Company employee was also an artist with professional training and an interesting attitude to his subject: for example, Francis Swain Ward (c.1734–94). He deserves notice for the surprising view in oils of the Mausoleum of Sher Shah, Sasaram, Bihar (Figure 48), which he showed at the Society of Artists exhibition in London in 1770, six years after he had returned to England from a period of military service in India with the Company. This large work (81 by 129.5 cm) was presented by him to the Company when he rejoined in 1773. It was duly passed to the India Office Library, where it remains today. The painting presents the symmetrical main front of the mausoleum strictly parallel to the picture plane; Lightbown, illustrating it in the catalogue *India Observed* (p. 35), suggests that Ward meant to make British observers conscious of a regularity in Indian building which detractors usually denied. Ward's frontal view of the great structure, with its central dome rising above a horizontal mass punctuated with domed *chattris* and prefaced by flights of stairs, is indeed conceived with uncompromising severity,

FIG. 48 Francis Swain Ward (*c.* 1734–94). *Sher Shah's Mausoleum, Sasaram, Bihar*. Oil, 81×129.5 cm. About 1770. The British Library, India Office Library and Records, London, Foster 25
Ward was an East India Company official who developed a keen interest in the Muslim and Hindu architecture of India. See above.

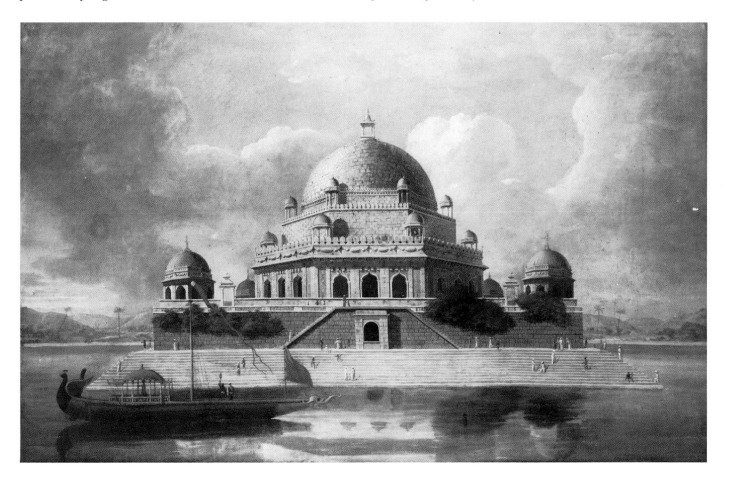

almost as though here was an Indian candidate for a kind of oriental Prix de Rome. Did the architect George Dance (to whom we shall return) see the painting, one wonders? It would surely have touched him; and possibly his young pupil, John Soane. William Hodges, later to go to India to see for himself, was to use the frontal view of Indian buildings to good effect (Figure 49).

We shall notice the Company's Museum, also established after 1800 with the Library, at East India House, Leadenhall Street, London, in a later chapter (p. 163). This was intended to preserve relics of Mughal India, and the new British administration in the sub-continent. Away from the fashionable West End and hard of access to a member of the general public unless provided with a warrant from the Director of the Company, it too made little popular impact in the early years, although the presence of the Man-Tiger-Organ 'Tipu's Tiger', from 1808, provided a draw. This distracting, wooden object – made at Seringapatam, Mysore, about 1790 (now VAM) and showing a tiger devouring a prostrate Englishman to the accompaniment of shrieks and groans when the 'organ' inside it was played – had been salvaged, with other items belonging to Tipu Sultan after the siege of Seringapatam in which Tipu died (as Mildred Archer has explained: see Bibliography).

In 1800 another object of attention, with the advantage of being in the West End, commemorated the campaign against the notorious Tipu. This was the vast painting by Robert Ker Porter of *The Taking of Seringapatam*, placed on view at the Lyceum in the Strand. The work was 120 feet long and romantically evocative of national effort and reward. We shall return to this also (p. 158), and the kind of experience that it offered, in the context of the panorama as a public spectacle.[45]

Compared with such attractions, genuine Persian or Mughal painting was little heeded in Britain outside the ranks of those serving in India, who often brought home pictures of Indian life commissioned from Indian artists. In spite of the amassing of originals by the East India Company Library and private collectors such as Beckford, few artists were likely to have seen miniatures in any numbers and the influence of these at home at this date was almost certainly negligible. But there are interesting pointers and at least one demonstrable case of such influence. Two widely differing artist-theorisers here occupy the stage from opposite sides: William Hodges (1744–97) and George Cumberland (c.1760–1848). Hodges had trained with Richard Wilson, but had not visited Italy. Instead, he accompanied Cook's second voyage in 1772–5, and became absorbed in the study of the light of the Pacific. In 1780 he travelled to India and remained until 1784, painting for Warren Hastings, Augustus Cleveland, Colonel Claud Martin and others, and collecting the visual evidence of Indian buildings which he exhibited in the form of paintings at the Royal Academy and published as 48 hand-coloured aquatints in his book, *Select Views in India* (1785–8). Hastings remained a close friend and patron after his own return to England in 1785; and it is likely that the low Mughal dome that rises over Hastings's home at Daylesford, Gloucestershire (1788–93) was adapted by his architect, Samuel Pepys Cockerell, from a drawing of an Indian building by Hodges.[46]

Hodges also studied Indian miniatures, and reproduced one which belonged to him in his second book, *Travels in India* (1793). As Mildred Archer and Nicholas Cooper have pointed out, this was used by the sculptor Thomas Banks in one of the chimneypiece reliefs with Indian subjects done for Warren Hastings in 1792 and still at Daylesford.[47] Cumberland, an artist whose biography is obscure, claims in an essay of 1827[48] that he recommended Banks to use 'Persian' sources for his relief: presumably he drew attention to Hodges' miniature (in fact Mughal rather than Persian). In 1793, the year of Hodges' *Travels*, Cumberland had

indeed written of painters and sculptors who 'of late . . . open their eyes to the latent beauties of Hindoo compositions'.[49] His interest in Persian and Mughal painting appears to have been lifelong: in the same essay we find him extolling the 'paintings of the ancient Persian masters; where natural grace and delicate expression are often found that might afford hints to the greatest of designers . . .'

No major artist of the period in fact seems to have taken any such hints to heart. Banks's relief at Daylesford, for all its sensitivity, shows a resolute neo-classicism which retains little of the spirit of the Islamic model. (Cumberland indeed admired it for what he termed its 'Grecianising' of the original.) The delicate attentuating of the human form in some of the drawings of John Flaxman (1755–1826), a known admirer of Eastern art, can be explained by other encounters: with Gothic sculpture, or Italian 'primitive' paintings on his European journey in 1787. Nevertheless, he clearly had seen Indian miniatures.[50] What William Blake (1757–1827) felt about Persian or Mughal painting must remain an open question. Blake knew Cumberland well and admired his outline drawings. We know from his notes on his *Two Spiritual Paintings of Nelson and Pitt* that he was moved by 'Apotheoses of Persian, Hindoo and Egyptian Antiquity, which are still preserved on rude monuments', but he in fact chose a Buddha figure on which to base the *Nelson*. The conscious 'grace and delicate expression' of the miniatures may well have been too far from the spirit of those early monuments to engage his sympathies.[51]

While few Englishmen were inclined to go so far as Cumberland in his somewhat theoretical advocacy of Eastern art, Hodges' first-hand knowledge had appreciable influence. For him there was to be no modern 'Grecianising' of the inspiringly different material he saw in India.

III

With the Indian journey of Hodges, and even more with that of the two artists who followed him in 1785, Thomas and William Daniell, we come within range of one of the more surprising episodes of British architectural history: the vogue of the 'Indian style' beginning around 1800 and lasting through the Regency until the 1820s. In this last part of the chapter we will be concerned entirely with architecture and landscape, and the developments which led to the building of the Royal Pavilion at Brighton.

Of the two major publications by Hodges, *Select Views in India*, a series of 48 aquatints, was issued in parts between 1785 and 1788 after drawings selected by the artist from 90 of his originals: first owned by Warren Hastings, bought in 1853 by Sir Thomas Phillips, and now at the Yale Center for British Art. The work abounds in examples of buildings remarkable for silhouette quality: bridges, Hindu temples, mosques. The plate size is large – $12\frac{1}{4}$ by $18\frac{1}{2}$ inches – and buildings are seen in a large way: detail is only cursorily indicated, but the effect of the whole on the artist is transmitted with directness and spirit. Some of the notes to the plates are straight descriptions; others are assessments, not always approving, or seeming to anticipate his readers' disapproval. 'It has great singularity' – Hodges is thinking aloud in front of the Mosque at Gazipoor (Ghazipur, pl. 31 in the book) – 'and I believe will hardly be considered by men of taste in Europe in any other light'. But he is absolutely convinced of the rightness of the Tomb of Akbar at Sikandra – this is 'one of the greatest monuments of Moorish grandeur'. 'Moorish' signifies here merely 'Mohammedan' (Portuguese *moros*), for Hodges as for others at this time. But with him there is also a genuine concern for historical style, and comment on this of a challengingly wide-ranging

kind. His remarks on the mosque of Chunar Gur (Figure 49), for instance, turn to the theory of the Muslim origin of Gothic, and the similarities 'between the architecture of India, brought there from Persia by the descendants of Timur, and that brought into Europe by the Moors seated in Spain, and which afterwards spread itself through all the Western parts of Europe, known by the name of Gothic architecture'.

The concern with Muslim style remained with Hodges. In 1787 he prepared *A Dissertation on the Prototypes of Architecture, Hindoo, Moorish and Gothic*, probably to introduce a series of large aquatint or stipple engravings, of which only two aquatints are known. In this he asked why these styles (he adds Egyptian) should be blamed 'because they are more various in their forms, and not reducible to the rules of the Greek hut, prototype and column?' By the time of his *Travels in India* (1793), which incorporates much of the material of the *Dissertation*, Hodges has arrived at an objective view, not only of Muslim architecture, but of the Hellenistic tradition from which he himself had sprung: 'that the Grecian architecture comprizes all that is excellent in the art I cannot help considering as a doctrine, which is in itself as erroneous and servile, as in its consequence it is destructive of every hope of improvement' (p. 64). The travelling artist should not judge non-Grecian architecture by Grecian rules: his task is to interpret the architectural idiom of each country he visits, and respond to the influences of climate, race and building materials that have determined the character of that country's buildings.[52] Hodges is inclined to attribute the common features he

FIG. 49 William Hodges (1744–97). 'A View of a Mosque at Chunar Gur', pl. 19 from *Select Views in India*, 1785–8, Sepia aquatint, 33×48 cm. Victoria and Albert Museum: National Art Library
The mosque is in Chunargarh fort above the Ganges, which was itself a major landmark from the river. In his note to the plate Hodges launches his belief in the common Muslim ancestry of Indian architecture of this kind and European Gothic.

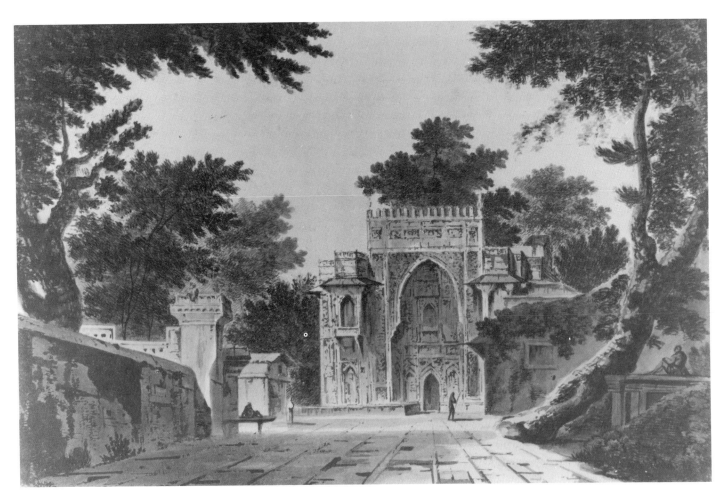

sees in Egyptian, Hindu, Moorish and Gothic architecture to a common visual memory of the stalactite and the rock formations of caves which early man inhabited: 'the pyramid, the obelisk, the spire steeple and minaret, are evidently bold stupendous imitations of the romantic forms of spiry, towering rocks' (pp. 75–6). The words suggest the extent of that hankering for the primitive and natural which was so palpable a feature of late eighteenth-century romantic feeling, and which had been given topical edge by the life and work of Rousseau. The passage must also be set against the background of speculation which had attending the finding of Fingal's Cave in 1772: Pennant records that Joseph Banks, its discoverer, had asked rhetorically in front of its stalactites and broken 'columns' if the Greeks had indeed added anything to architecture.[53] The relating by Hodges of the dramatic qualities of Islamic architecture to natural origins in rock-forms, however, directly prepares the ground for Thomas Hope's argument that the 'flicker of light and shade' of the Turkish border on the title page of *Household Furniture* is a development from natural 'congelations and stalactites'.[54] Humphry Repton, the landscape gardener, also reflects Hodges' thinking when he derives Indian arches from formations in 'subterranean caves or grottoes'.[55]

The *Travels in India* is full of lively and rewarding observations. Though it appeared nearly 10 years after Hodges had left the sub-continent, he is still responding with the feelings of a late eighteenth-century English landscape artist to sights and experiences of 'great singularity'. He is roused by the sublime in nature and the elegiac in human affairs. He is moved by scenes which, though new to him – isolated Hindu hermitages, or Muslim women tending their husbands' tombs after sunset – he can easily relate to as a European artist. But he also has a sensitive appreciation of the glittering Ganges plain, the horizontally spreading banyan tree and the ghats of Benares. He is conscious of being a visitor in a land where not only do flower gardens give off scents 'so strong . . . as to be offensive at first to the nerves of a European' but the 'glare of splendour' of the noonday sun can be so intense as to be 'almost beyond the imagination of an inhabitant of . . . northern climates to conceive' (p. 122). Reflecting afresh on the two visual traditions that confront him, Hindu and Mughal, he embarks on a comparison of them, acclaiming Mughal painting for its miniatures and its concentration on portraiture, and seeing it as superior to Hindu painting which, he thinks, is limited by its concern with idealised religious subject-matter. Mughal architecture he admires for its grand composition and Hindu for its mastery of the 'ornamental parts'.

Hodges reaches a position where he is so detached from the prejudices of his own European background that he can rate the Taj Mahal – admittedly a building with an already legendary reputation – as the most beautiful building he has ever seen: 'a most perfect pearl on an azure ground. The effect is such as, I confess, I never experienced from any work of art. The fine materials, the beautiful forms, and the symmetry of the whole, with the judicious choice of situation, far surpasses any thing I ever beheld'.

Hodges carried out a number of drawings of the Taj from the garden side – and at least one and possibly two paintings from the river side.[56] It is unfortunate that some of his versions have disappeared, but one drawing now at the Yale Center for British Art, of the view from the garden, shows that in the late eighteenth century trees had been allowed to grow up to form an avenue abutting on the centre of the entrance façade. This avenue is referred to in 1789 by Thomas Daniell, who rendered the same view. It is strange that *Select Views* only contains the Taj in the background of the general view of Agra; though the commentary proposes to feature the building in particular in a later number.

There was much in *Select Views*, nonetheless, to compel attention: Hodges is expert in using the three-quarter 'picturesque' view of a building to suggest its richness as a form in landscape; while the 'Chunar Gur' shows how successfully he could lead the eye along a 'prospect' to a building that is parallel to the picture plane.

Apart from his theories, the visual evidence of Hodges' *Select Views* made a swift impression in an unexpected place. Joshua Reynolds, in his 13th Royal Academy discourse of December 1786, revealed an appreciative scrutiny of Hodges' work in the clearest terms: 'The Barbaric Splendour of those Asiatic Buildings which are now publishing by a member of this Academy, may possibly . . . furnish an architect not with models to copy, but with hints of composition and general effect which would not otherwise have occurred.' Sir Joshua's forecast was well founded: Hodges' bold plate of the Jami Mosque at Jaunpur (Figure 50) was probably, as Conner notes, in the mind of one of the most radically minded architects of the time, George Dance the Younger (1741–1825), when preparing his design for the court (south) façade of the London Guildhall (Figure 51). There is a similar relationship of window to solid wall, though the lack of the central pointed arch in the Dance design makes for a very different overall effect: in any case Hodges provided little detail.[57] Humphry Repton (1752–1818), the landscape-designer who will appear later in this chapter (p. 101), was also to use *Select Views*. Hodges remains an impressive figure: a man of adventurous mind filled with a sense of the validity of forms un-European, and

FIG. 50 William Hodges. 'A View of a Musjd, i.e. Tomb at Jionpoor', pl. 13 from *Select Views in India*, 1785–8. Sepia aquatint 33×48 cm. Victoria and Albert Museum: National Art Library
The subject is the Jami Mosque at Jaunpur. Hodges' drawing for it was done in July 1783. The plate is one of the most forceful images in *Select Views*.

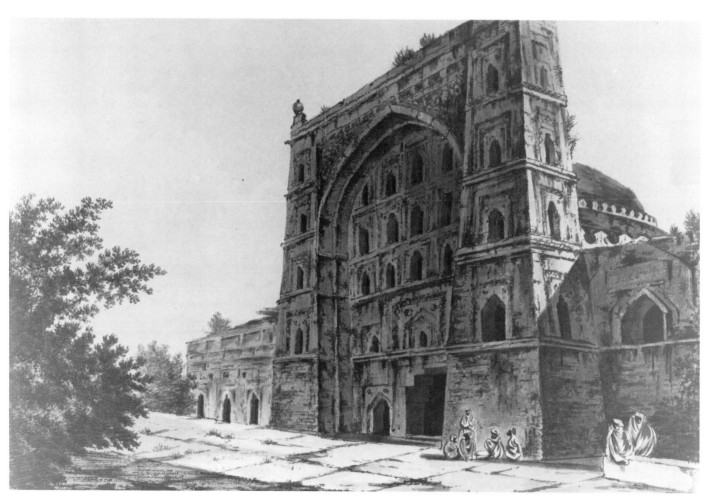

a prime mover in the direction which many in the still more archaeologically curious nineteenth century were to take. In *Asiatick Researches* William Jones suggested that others would build on Hodges' work and provide European architecture with 'new ideas of beauty and sublimity'.

In 1784, after Hodges' return from India, Thomas Daniell (1749–1840) and his nephew William (1769–1837) set out for the sub-continent. Thomas, an artist in oil and watercolour, had taken up aquatint engraving, in which William became even more proficient. They appear to have visited China first, but by late 1785

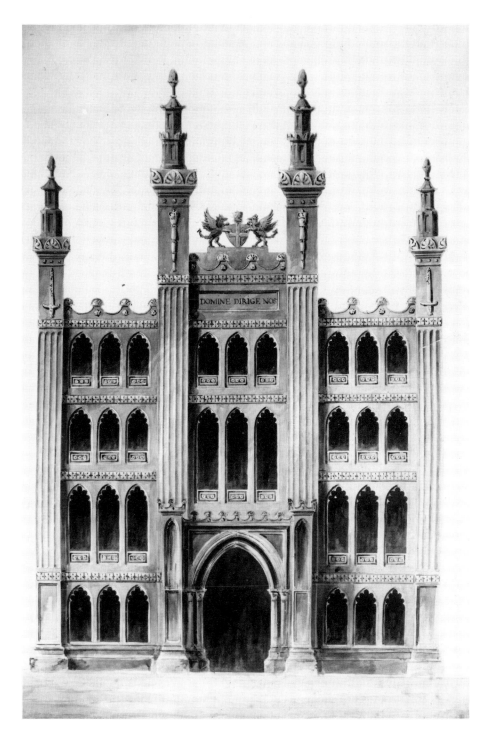

FIG. 51 George Dance (1741–1825). Design for the court (south) façade of Guildhall, London, 1788 (drawing about 1808 for John Soane). Soane Museum, London. 18.7.13
His thinking probably catalysed by Hodges's linking of Indian and Gothic architecture and perhaps by Joshua Reynolds (see p. 98), Dance replaced the Gothic design of the original building with a sharply vertical one incorporating triplets of cusped windows, minaret-pinnacles and swinging lines of cresting. The existing façade, very Gothic in character, was restored in 1969.

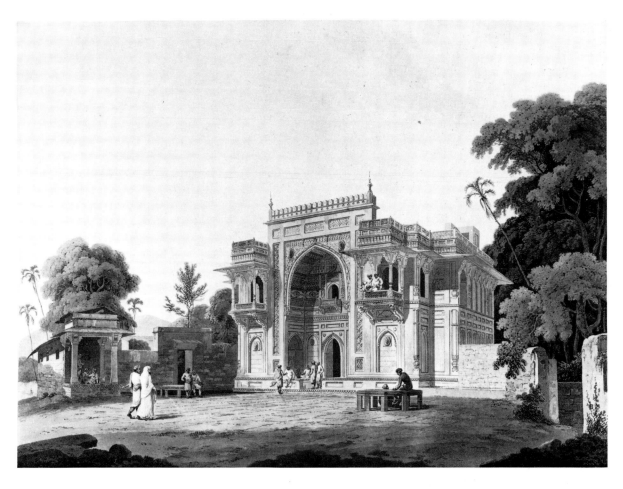

FIG. 52 Thomas Daniell (1749–1840) and
William Daniell (1769–1837). 'Gate leading to a
Musjed, at Chunar Ghur', from *Oriental
Scenery*, Part I, 24. Aquatint, 45×61 cm.
January 1797. The British Library, India Office
Library and Records, London
When they took subjects that Hodges had treated,
the Daniells often chose a different viewpoint, as
here. Cf. figure 49.

were in Calcutta. They settled to making and selling topographical engravings and some pictures in oils. Between 1788 and 1792 they undertook the immense journeys which provided them with materials for the monumental work for which they are best-known, *Oriental Scenery*.

The Daniells were fortunate enough to be in India during a period of peace. The first tour, along the Ganges and Jumna valleys, took them up country by boat and land to Delhi: from there they went into the Garhwal Hills, never previously penetrated by Europeans, to Srinagar, south of the Himalayas. Spending some time in Lucknow, they returned down the Ganges to Bhagalpur and back to Calcutta. It was on this tour that they saw and recorded the principal Islamic monuments, notably the royal mausolea of Humayun at Delhi, Akbar at Sikandra and Shah Jahān at Agra. The architectural content of the second tour of 1792, to South India, was mainly Hindu.

On 20 January 1789, six years after Hodges had stood there, the Daniells had pitched their tents on the bank of the Jumna opposite the Taj Mahal, and proceeded to draw the great building for most of the day. On the 22nd William's diary records that Thomas made a first drawing from the garden side, using a camera obscura. The artists were much impressed with this 'spectacle of the highest celebrity'. The two main views were published in 1801 with a separate booklet entitled *Views of the Taje Mahel at the City of Agra in Hindoostan taken in 1789*, perhaps to compensate for the fact that *Oriental Scenery* contained only one view of the Taj (Part I, 18) and that was from outside the gateway.[58]

Oriental Scenery was published in six folio-sized parts between 1795 and 1808,

Robert Bowyer undertaking Part One at the Historic Gallery, Pall Mall. For the remaining parts Thomas Daniell was his own publisher. The work falls into two basic divisions following the order of the original tours. The first four parts refer to the first tour, the last two to the second. Each part consists of 24 plates, constituting a total of 144 aquatints. Part Five comprised views taken by the Daniells' friend James Wales. The aquatinting in colour set a new standard, and the views brought to the British at home a sense of acquaintance with a new reality, 'too strange to be imagined'. They commanded an accuracy of observation, a sharpness of detail, combined with a breadth of tone and shadow and an essential luminosity in the best examples – those reproduced here (Figures 52 and 53) are cases in point – which gave them immense appeal as documentary records and pictures.

What was especially important, however, was the far-reaching and diverse nature of the work's influence. The East India Company bought 30 sets (at least of Part One, which was dedicated to them). Madras, as Joseph Farington records in his diary entry for 8 August 1799, ordered 40 sets of those then published. Mildred Archer and Maurice Shellim calculate, from the study of watermarks indicating reissues in 1816, 1836 and 1845, that 250 sets of the first two (most popular) series were produced. The whole work sold in 1808 for over £200: but for lesser pockets a smaller scale (quarto) edition was printed in 1812–16, which retailed at 18 guineas complete.[59] Many of the original sets were broken up over the years for separate framing. Moreover, further publications were based on the work.[60] A number of subjects were used either singly or in combination for the decoration of blue-printed earthenwares (Figure 54), and thus reached not only the study wall but also the dinner-table.[61] Even if the pictures on the wall were not the original aquatints, motifs from them might well appear on the wallpaper.[62] Finally, the prints were to be a vital ingredient as the 'Indian Gothic' phase of English architecture accelerated. They offered a rich quarry to partisans of the idiomatic exotic. William Hodges had splendidly rough-hewn an image of Indian architecture for home consumption: the Daniells (who felt that they had far surpassed their predecessor) had chiselled and polished it.

Apart from the quality of its results the enterprise of the Daniells could not fail to make a deep impression as a picturesque tour. The 1790s were a time, as we saw earlier, of considerable popularity of such activities. The term 'picturesque' had implied, earlier in the eighteenth century, the interpretation of landscape through reminiscences of landscape paintings, particularly those of Claude Lorrain with their classical and medieval ruins. In a remarkable letter of 11 June 1709, the architect Vanbrugh had not only mentioned this link between landscaping and landscape painting but stressed the idea that buildings in their landscape settings evoked a sense of time and of history in a way that was particularly vivid. The relationship between buildings and their settings had preoccupied English landscape designers throughout the century, and was to become an important element in the theory of the Picturesque which took shape in its closing years. The Reverend William Gilpin (1724–1804), in the accounts (published after 1782) of his tours of England and Wales, had given prominence to the notion that picturesqueness resided in natural scenes, unregulated by classical design, where the painter could, and should, discover it. Tintern Abbey in its far-flung valley was among his illustrations.

Humphry Repton – pivotal figure in the architectural episode after 1800 which brought together the Indian views of Hodges and the Daniells, and a partial realisation of their spirit in England in the forms of Brighton Pavilion – could himself, as the foremost landscape gardener in the kingdom, hardly remain

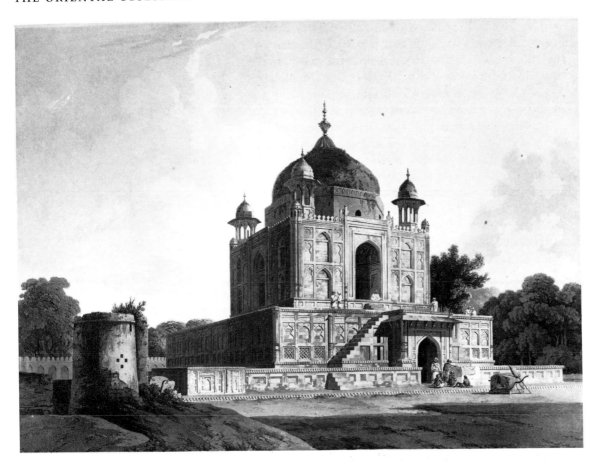

FIG. 53 Thomas and William Daniell. 'Mausoleum of Sultan Purveiz, near Allahabad', from *Oriental Scenery*, Part I, 22. Aquatint, 45×61 cm. November 1796. The British Library, India Office Library and Records, London
The oblique view embeds the building in its landscape, a fact which helped to make these prints so appealing to English 'Picturesque' taste, and to designers in other media (see Figure 54).

unaffected by the theory of the Picturesque. As a fashionable and pragmatic landscape designer he could not, however, go so far as its main apologists, Richard Payne Knight and Uvedale Price, in allowing the landscape to dictate terms. His occupation made him inevitably a pruner of Nature's tendency to rampage: but he had a keen eye for controlled diversification and the excitements of visual incident in landscape, greatly assisted by an interest in exotic shrubs. Desirable visual incident, to adherents of the Picturesque, included buildings of fanciful and unclassical contour. To Repton the Indian views of Hodges and the Daniells thus spoke directly and irresistibly: 'I cannot suppress my opinion', he wrote, 'that we are on the eve of some great future change in both these arts (gardening and architecture) in consequence of our having lately become acquainted with Scenery and Buildings in the interior provinces of India'.[63]

Thomas Daniell himself was closely involved in the Indian developments in England about 1800. He designed a small temple (1800, now destroyed) at Melchet Park, Hampshire, for a soldier who had served in India, Major John Osborne. This was Hindu in inspiration with its two Brahman bulls carved above the porch and the bust of Warren Hastings inside rising out of a sacred lotus.[64] Paintings of Islamic as well as of Hindu subjects were commissioned in 1799–1800 from Thomas Daniell by Hope, as we have seen, for the Indian Room at his Duchess Street mansion in London (Figure 43). In 1805 Humphry Repton was studying the Daniells' prints in the company of Sir Charles Cockerell, recently back from India and wishing to consult Repton on the design of his gardens at Sezincote, Gloucestershire. Cockerell had known the Daniells in India, and was interested also in having an Indian design for the house itself.

Sezincote as it eventually emerged (Figure 55), with its authentically Islamic-looking onion domes, pinnacles, cusped arches, corner pavilions (*chattris*) and deep cornices (*chujjas*), was the work of the owner's younger brother, the surveyor to the East India House (and friend of Hodges), Samuel Pepys Cockerell, with Thomas Daniell as consultant. Cockerell, as we saw, had previously added a Mughal dome to Warren Hastings's Daylesford. The result at Sezincote splendidly reflects, as Conner remarks, the closeness of the men who imagined it to its Mughal sources: no Hindu feature appears. The Daniells' 'View of the Lal Bagh, Faizabad' (Part III, 3), shows related details, notably the bracketted *chujja* with parapet above (as Conner indicates). The central dome rising clear from a square base and its relation to the corner *chattris* may be a reworking based on the 'Mausoleum of Sultan Purveiz, near Allahabad' (Figure 53), certainly to be used, as Mildred Archer points out, by Robert Lugar in his 1805 'Villa in the Eastern Style'. A decade later John Martin recorded the house and its landscape (Figure 56). Today, with its pale apricot masonry set in the green countryside, Sezincote remains an inspiriting sight. Cockerell also designed the farm buildings on the estate in the same style.[65]

The Royal Stables and Riding House at Brighton, commissioned by the Prince

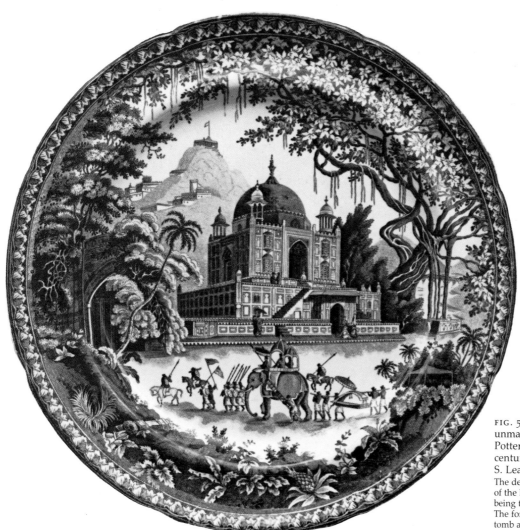

FIG. 54 Plate, earthenware, blue-printed, unmarked, attributed to the Herculaneum Pottery, Liverpool. D. 25.4 cm. Early 19th century. Private collection. Photograph S. Leahy

The design is principally made up from three prints of the Daniells' *Oriental Scenery*, the main motif being the Mausoleum of Sultan Purveiz (Figure 53). The foreground procession is from Part I, 1, and the tomb at the right from Part I, 15. The tree comes from 'View in the Fort of Tritchinopoly' (Part II, 21).

Regent about 1803, were the work of the now unfortunately obscure William Porden (c.1755–1822) and were finished in 1808. Porden had worked for S. P. Cockerell and an oriental strain in his work had emerged earlier: in 1797 he had shown at the Royal Academy 'a Design for a Place of Amusement in the style of the Mahometan Architecture of Hindostan'.[66] At Brighton Porden most effectively offset the great mass of the central rotunda with the sharp uprights of angle pavilions crowned by *chattris*. Inside the building two sequences of multifoil arches, one above the other, create a lively sense of movement which is extended into the dome with its wide and narrow ribs (Figure 57). Repton was highly impressed with the boldness and lightness of the effect.

In his *Enquiry into . . . Landscape Gardening and Architecture* (1806), Repton hails Indian architecture as a style with a character sufficiently distinctive to rise above the objections which traditionally minded Europeans, reared on 'Grecian or Gothic', will level against it. He is all for stressing its incomparabilities: which was to lead him to a close scrutiny of its Hindu element, the part that could least be accommodated to European conventions and prejudices. In his *Designs for the Pavillon* [sic] *at Brighton* (1808), Repton nevertheless sees Indian architecture as comparable to Gothic in richness of effect; and there is no doubt that the receptive attitude to Mughal architecture that is revealed in the work of Repton and Nash for the Brighton Pavilion was helped by the enhanced reputation being enjoyed by Gothic itself.

Between 1750 and 1820 a careful rehabilitation of medieval Gothic, much of it undertaken by local historians, was well under way in Western Europe. French theorists might emphasise the rational qualities of Gothic buildings: on the other hand their asymmetries and ancient textures made a powerful emotional appeal, especially in England. It was an appeal that could range widely and imaginatively in space and time. Not only could English patrons who were impatient of the classical style incline with unfeigned delight to Gothic as the national style of

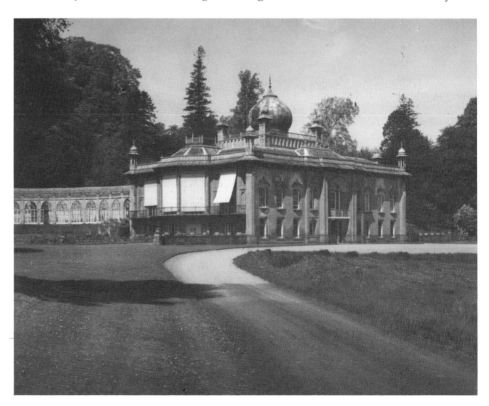

FIG. 55 Samuel Pepys Cockerell (1753–1827). Sezincote, Gloucestershire. About 1804–5. Photograph, National Monuments Record, London

This house, built for an English nabob, realised in England the ideas of Muslim architecture in India, as made available in the Daniells' prints. See p. 103.

their ancestors: classically educated ex-Grand Tourists with a lifelong respect for Italy could also indulge these feelings, and even find a place for Islam. The man who unites all this in the most specific terms is Horace Walpole, fourth Earl of Orford (1717–97), remodeller of Strawberry Hill at mid century in an archaeologically conscious medieval mode and simultaneously indulger of Gothic fancy: we find him declaring that 'imagination delights in whatever is remote and extraordinary' in his Gothic story, *The Castle of Otranto* (1764), and amassing in the Strawberry armoury a collection of Near Eastern spears and broadswords supposedly brought back by the crusader Sir Terry Robsart from the 'holy wars'.[67] The theory linking Gothic with the Saracens is still very much alive: Bishop Warburton has shaken the dust from it in his edition of Pope.[68] It is now immeasurably strengthened by the emotive lure of the Crusaders. Walpole firmly put his family crest, the Saracen's head, on the ceiling of his Library. He did not, however, turn Strawberry into a Saracen fort. He had flirted with the idea of 'Venetian or Mosque Gothic' and a drawing of a Turkish bathing-pool emerged.[69] His final choice of English Gothic for his interiors was a measure of his devotion to his ancestors, and his representation of Islam was confined to ceramics and silver: eight Islamic items are listed in the *Description of Strawberry Hill* of 1784, together with (emotive object) 'Henry 8th's dagger, of Turkish work; the blade . . . of steel damasked with gold . . .'[70]

Sadly we shall never know what Walpole would have said about the 'remote'

FIG. 56 John Martin (1789–1854). Double-spread (f.13) from 'Sezincot' sketchbook. 21×34 cm. 1817. Ashmolean Museum, Oxford. Courtesy of the Visitors
This double-spread shows clearly the 'Picturesque' connection between the Indian style of the house and its setting, planted by Repton. Other drawings show palms and exotic shrubs. Martin published 10 etchings of Sezincote in 1817.

and extraordinary' as presented to the eye by the Royal Pavilion, Brighton: he died just too early, in 1797. Indian outside, Chinese with some Indian motifs within, the Pavilion offers few concessions to the searcher for precise precedents. But as Mildred Archer has remarked, its builder John Nash (1752–1835), unlike Repton, was no purist. Compared with Cockerell's Sezincote, the exterior of the Royal Pavilion as built between 1815 and 1822 is 'Mughal' at a far remove, yet distilling certain basic qualities of the original style: the sharpness, the angularity, the buoyancy. As with Sezincote, the Pavilion's designers found the Daniells' *Oriental Scenery* an indispensable source of ideas. Nash is known to have borrowed four volumes of it from the Royal Library at Carlton House to help him prepare designs.[71] But the resulting building (Figure 58) is Nash's own, with its large central ogival dome offset by four similar subsidiary domes, arcading with unique, pierced walling above the arches, the roofs of the Music and Banqueting Rooms given an unswept concave profile (a form used in 1814, in the ballroom by Nash and Congreve for the Carlton House Victory Fête), and chimneys disguised as minarets.

Nash's own design: but that could never entirely be true, with a patron as

FIG. 57 William Porden (*c.* 1755–1822). Interior of the Stables, Royal Pavilion, Brighton, 1803–8. Pl. 26 from John Nash, *Views of the Royal Pavilion at Brighton*, 1827. Aquatint. Museums and Art Gallery, Brighton
Porden's Mughal-style exterior enclosed an interior in the same style below a glazed 80-foot dome. Though there are similarities to the Pantheon at Rome (circular plan with dome, arched openings in the depth of the wall) the overall effect is light and full of movement: the cusped ends to the dome lights in particular give great animation. The Prince of Wales acknowledged that his horses' accommodation was superior to his own and was receptive to Repton's scheme for designing a pavilion for him in the form of an Indian Palace.

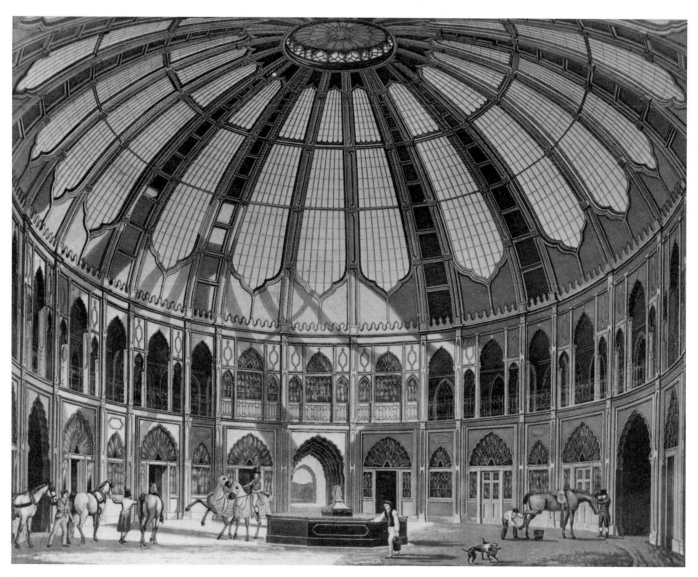

self-willed as the Prince Regent. The Pavilion's combination of lushness, elegance and unpredictability sums up much of the extraordinary vitality of the Prince – from 1820 King George IV – as debt-ridden owner and chief actor in the self-created drama of Pavilion life. Recent commentators (notably Conner and Dinkel, see Bibliography) have emphasised George's sense of the building as a symbol of monarchical continuity in the face of revolutionary social change. Parliament might fulminate; a Whig Member might express the hope in June 1816 that the House would 'hear no more of that squandrous and lavish profusion which . . . resembles more the pomp and magnificence of a Persian Satrap seated in all the splendours of oriental state than the sober dignity of a British Prince, seated in the bosom of his subjects'. To another contemporary, however, John Evans (*Excursion to Brighton*, 1822), the Pavilion represented an emblem of national greatness: 'England has been reproached by travellers for want of a palace on a scale commensurate with the grandeur of its Monarchy . . . The Pavilion is only a Winter residence, but in proportion to its extent it may be said to exceed any other of the palaces in the Kingdom.' Both observations have their truth. True legatee of the age of princely grandeur in the West, George responded energetically to the myth of empire; the conviction that his Pavilion should present to the world the style of the sub-continent of India seems in the light of this entirely explicable. So also does the fact that, thanks to his own transcendent capacity for self-projection as an Eastern potentate himself, his handling of that style was so idiosyncratic.

With such creative currents running through it the Pavilion was sure to be imitated. Its North Gate, with its repeating multifoil arches, may have stimulated J. B. Papworth to design an Islamic-style garden building at the Englefield family

FIG. 58 John Nash. East front of the Royal Pavilion, Brighton, pl. 5, from Nash's *Views*. Aquatint. Museums and Art Gallery, Brighton This shows the full ingenuity of Nash's garden façade with the domes offset by concave-sided roofs to Banqueting and Music Rooms, shapes evoking the ceremonial tents where a Sultan might take his ease and receive guests.

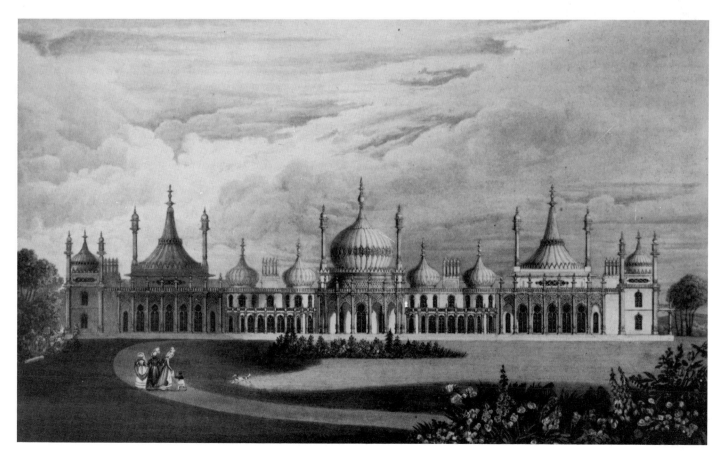

seat Whiteknights, Berkshire (between 1815 and 1819).[72] Within a few years the Pavilion certainly produced ebullient local variants in Brighton in the form of house-fronts by Amon Henry Wilds[73] and as late as c.1880 in the concave-roofed mausoleum built in Paston Place by Sir Albert Abdullah Sassoon.[74] The influence of the Pavilion quickly extended to Ireland[75] and, as we shall see in chapter 6, to America.

The Pavilion and its local progeny have been fully discussed in Patrick Conner's book.[76] This building, however, had a less precisely identifiable but still unquestionable contribution to make in another field of design which is intrinsically part of the nineteenth-century scene: the design of conservatories and other buildings in glass. To see this we have to go back to Repton and the genesis of the Pavilion before the arrival of Nash.

The remodelling of Henry Holland's Georgian house into the Royal Pavilion as we know it was a protracted matter. In 1801 Holland himself did a Chinese design; about 1805 Porden drew up a palace in the same style. In the same year the Prince was choosing Chinese furniture for the Pavilion rather than French to avoid the charge of Jacobinism according to Lady Bessborough. For the exterior, however, he appears already to have been inclining towards Indian ideas, and Humphry Repton, drawing on the Daniells' *Oriental Scenery*, produced a grand scheme on Mughal lines in 1806. Interestingly he included designs, also incorporating reminiscences of Indian buildings, for connecting the Pavilion to the Stables by a 'flower passage', consisting of corridors covered in with glass, and linking with an orangery that was convertible in summer into an open 'chiosk', and with hothouses, a greenhouse, an aviary and a pheasantry close at hand.

Glazed conservatories had developed in the period of 'Picturesque' planning as a link between houses and their surrounding gardens. As the nineteenth century advanced and as gardening became a popular pursuit, they were to become still more established: by 1864 they were seen as an integral part of living.[77] The stimulus of Indian architectural form in the design of 'glass-houses' was in part explained in terms of association: many of the plants that were imported for display in conservatories came from India. But the Indian – and particularly the Islamic – forms themselves were to show as much potential as Gothic for adaptation to the requirements of a skeletonic building (often with cast-iron frame) in which light was all-important. Sezincote had a conservatory under a small onion dome, and Repton's suggestions for the Royal Pavilion garden buildings also featured Indian motifs. As Conner points out, the aviary with its lightweight linear screens was adapted from the print in the first series of *Oriental Scenery* of the very solid-looking Hindoo Temples at Bindrabund (Thomas Daniell had shown a painting of the subject at the Royal Academy in 1797). If Hindu forms were thus adaptable, Islamic forms were plainly still more so: the upper part of Repton's pheasantry was adapted from the kiosks on the roof of the Palace in the Fort of Allahabad, also from the Daniells' first series.[78]

Other interests which would lead in the same direction were at work in the years around 1820. John Claudius Loudon (1783–1843), the horticulturalist on whom the mantle of Repton had largely fallen, had published a sheet of designs for glass-houses as early as 1817, which included domes with both pointed and ogee profiles. One of his designs in *An Encyclopaedia of Gardening* (1822) shows a Brighton Pavilion-like house with a sequence of conservatories in front of it; some have ogee domes which repeat the Mughal dome-shapes of the main building (Figure 59). Though Loudon's text makes it clear that the pointed dome-shape is suited to plant-houses for scientific reasons, the artistic connection of the

ogee-form is obvious.[79] Recognisably oriental profiles were featured in the glass-houses – lined up in a Royal Pavilion-like sequence – built about 1825 at Alton Towers, Staffordshire, by Robert Abraham for the 15th Earl of Shrewsbury, and illustrated by Loudon in the 1828 edition of his *Encyclopaedia of Gardening*.[80]

Examples multiply in the next few years and the Islamic note was again unmistakably sounded in the design of the iron and glass corridor which was constructed to lead into Sydney Smirke's Bazaar at the Pantheon, London, from the Great Malborough Street entrance, in 1834.[81] Bazaar – a palpably Arabic concept – conservatory, aviary: all could be buildings designed for a visiting public. The next important development would be the giant exhibition hall of the mid century, but the extent to which the designs of these became instilled with Islamic notions is material for the next chapter.

The display-sense of the Regency was also well rewarded by attention to the oriental tent-form: long esteemed in the West and now the object of much interest to Europeans who had lived in Mughal India.[82] At Vauxhall Gardens, when the visitor had contemplated the painted Indian views seen as if through verandah windows and doors, he entered the Rotunda and looked up at the tent-like roof, as Nathaniel Whittock describes it, 'now fitted up as a Persian pavilion . . . made to represent a magnificent tent, the sides drawn up, the roof of which is blue and yellow silk in alternate stripes: it seems to be supported by twenty pillars . . .' The Lyceum Theatre too, he tells us, had a saloon converted about 1820 into a 'Mameluke Pavilion' and Egyptian panorama, all in the form of a 'sumptuous tent'.[83]

The tent-form, both indoors and in the open, in fact enjoys a certain vogue again in these years. The Empress Josephine had had a Tent Room at Malmaison. In the last summer of his life George IV dined frequently in the Turkish tents that were erected on the shore of Virginia Water, not far from the royal Fishing Temple.[84] In Nash's fashionable Regent's Park the Marquess of Hertford, the 'Caliph', entertained about the same time in the Arabic Tent-room of St Dunstan's House, designed by Decimus Burton.[85] A good Regency tent-room survives at Cranbury Park, Hampshire: made about 1830, it was based on the example at Malmaison.

The books of villa-architecture had long offered designs in a variety of architectural styles, among which those of Islam were not forgotten. Robert Lugar in his *Architectural Sketches for Cottages, Rural Dwellings and Villas* (1805) had included some: so had Edmund Aikin in his *Designs for Villas and other Rural Buildings* (1808). Lugar's book includes a villa in an Eastern Style, based as we have noted, on a Daniells print in *Oriental Scenery* (Part I, 22). Aikin distinguishes Muslim style from Hindu and offers two designs with Islamic embellishments, a 'large Villa or Mansion' and somewhat smaller, 'a Villa of considerable magnitude'. Such works as these were to have considerable effects in both Britain and

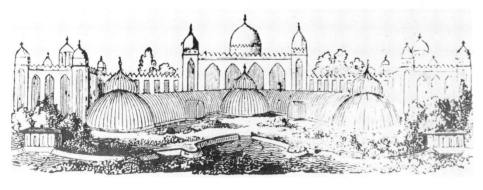

FIG. 59 John Claudius Loudon (1783–1843). Design for an Indian-style conservatory, *Encyclopaedia of Gardening*, 1822
While the English 'Picturesque' tradition was concerned with the marrying of building shapes with landscape, Loudon, as a designer-horticulturalist, shows an interesting variant of this: the linking of domestic building with garden building. Islamic forms were to be of great use to him and others.

America in the following half-century: a time of particularly active suburban expansion.

The propagation of Islamic styles in interior decoration and furniture proceeded apace in the Prince Regent's residence Carlton House, London, as well as in the Royal Pavilion. The half-Gothic, half-oriental fantasies conjured up by the designer Walsh Porter from 1806 at Carlton House amazed visitors in the brief heyday of the building before its demolition 20 years later.[86] They drew the satire of the Irish poet Thomas Moore in his *Twopenny Postbag* (1813):[87]

> The same long masquerade of rooms,
> Tricked in such different, quaint costumes,
> (These, Porter, are thy glorious works!)
> You'd swear Egyptians, Moors and Turks
> Bearing good taste some deadly malice,
> Had clubbed to raise a pic-nic palace.

This was four years before Moore made his own most important contribution to the oriental vogue in literature with his collection of verse-tales *Lalla Rookh*.

In the Pavilion interiors, a vivid eclecticism is pursued from 1802 to 1822 by the Prince and his two designers Frederick Crace (1779–1859) and Robert Jones, in which European Baroque, rococo, neo-classicism, and Chinese and Islamic elements all play parts.[88] These may even all occur in the same piece of furniture, for example, the white and gold cabinet designed by Jones for the Saloon (Figure 60). The Islamic cusped arch occurs here, as well as separately, in such places as the chimneypiece of the Music Room. The years dominated artistically by the man who became George IV – 1800–30 – are indeed the eclectic years, in crafts as well as architecture, and the attention accorded to Islamic forms and patterns

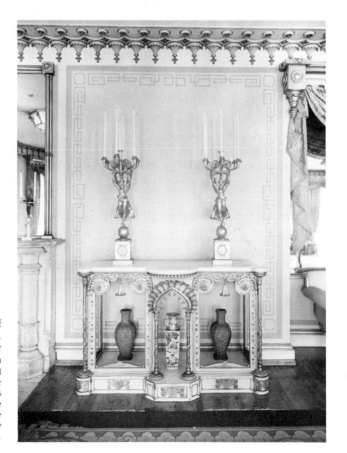

FIG. 60 Robert Jones. Open cabinet of giltwood and whitewood. 1822–3. The Saloon, Royal Pavilion, Brighton. Reproduced by gracious permission of H.M. The Queen
The Saloon, as the central room in the Pavilion, had some of the most sumptuous furniture designed for it – including these cabinets. The diverse ingredients – volutes, tree-bark, lotus leaves – suggest the vigour of Jones's eclecticism, within which the central Islamic multifoil arch plays literally the foremost role.

ranges from the studious 'presentation' of objects from various Islamic countries, as in Thomas Hope's Indian Room at Duchess Street, to the skilled assimilation of an Islamic interlacing floor-pattern and an Ionic pilaster order in unobtrusive harmony, in Richard Morrison's Ballyfin (Figure 10). The Royal Pavilion's oriental glamour was the reverse of unobtrusive. Conner notes the delightful Mr Soho, the 'first architectural upholsterer of the age' in Maria Edgeworth's novel *The Absentee* (1812), who tempts Lady Clonbrony, arrived in London from Ireland, with Turkish tent drapery, seraglio ottomans and 'Trebisond trellice paper'.[89] Ten years later 'moresque' was firmly entrenched among the furniture styles spread in front of the fashionable public by the designer Richard Brown.[90]

Indian Gothic on a truly large scale and on exteriors of permanent buildings of major importance was shortlived. This was for obvious reasons. The grafting of onion domes on to the English landscape or townscape, however picturesque and exhilarating, was an impertinence which could not be repeated often. Walpole, had he survived to see them, would no doubt have made the point unambiguously. The painter John Martin, having sketched Sezincote and its gardens and published 10 prints of the subject in 1817, moved on to re-creations of ancient Babylon. The move was paralleled in architecture by the taking up, in the incipient railway age, of the severer forms of ancient Egyptian architecture which Luigi Mayer had published (*Views in Egypt, Palestine and other Parts of the Ottoman Empire*, 1804): forms which designers of railway tunnels and termini, as Klingender was the first to observe, found useful. Even so, Moorish arches were used at railway entrances,[91] and it is interesting to see the engineer Robert Stevenson (1772–1850) giving the elegance of a Mughal minaret to his beautiful lighthouse at Girdleness, near Aberdeen (1833).[92]

With the Brighton Pavilion we arrive at an elegant summit at the end of a tumbled and fantastic skyline of peaks leading out of rococo. It is as though this brand of extravagance had now achieved real architectural quality through the flair of Nash and the surer knowledge of Islamic forms provided by Hodges and the Daniells. The placing of an Indian exterior round Chinese interiors showed unmistakably that the view of Eastern architecture as an exotic concoction was still alive. Hereafter the gaiety of this view of Islam evaporates as the gaiety of eighteenth-century chinoiserie evaporates. Civilised classicism still prevailed in the world of Jane Austen, but after 1815 other, more extreme tastes were gaining strength: the austerities of early Greek and Egyptian design were for the time being driving chinoiserie into the shades – the leafy recesses of such places as Vauxhall, where the *beau monde* were to return to relish its Chinese embellishments in preference to those inspired by India. In the real world, however, the Islamic countries had certain advantages over other contenders. Unlike the ancient Egyptian culture, that of Islam still existed and in fact was flourishing among the modern Egyptians. Unlike China, the Islamic East was close at hand and, so far as Britain was concerned, the shorter routes to India involved crossing it.

After 1820:
THE PAINTERS' VISION

I

The necessity of oriental subject-matter for the English Romantic poets is a factor that only partly accounts for the power of Islamic art as a stimulus in Europe in the nineteenth century, but it is important. In 1811 Lord Byron had returned from a two-year period of travel with profound impressions of Greece and the Levant. As we saw earlier, his original desire to visit the region had been fixed before 1800, probably by a childhood reading of Mignot's Turkish history. On his return from the Levant he published the first two cantos of *Childe Harold's Pilgrimage*, the poem which he had begun in Turkish Albania and which recounts the thoughts of a wanderer seeking to escape from his past life by travelling in foreign lands. In 1813 came *The Giaour*, which had a specifically Muslim theme (of considerable violence), and three years later *The Dream*, with its sultry evocation of Eastern repose.[1]

Byron's concern for the oriental world had more than one message for artists. On the one hand he lent new weight to old Western assumptions about Arab ferocity and indolence, both of them extreme qualities which could be revelled in by romantically minded young artists such as Richard Parkes Bonington (1801–28, Figure 61) and his friend Eugène Delacroix, already a keen student of

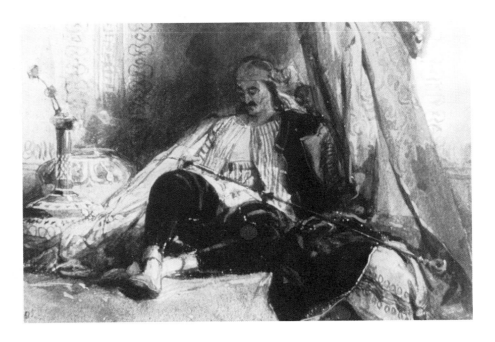

FIG. 61 Richard Parkes Bonington (1801–28). *A Turk Reposing*. Watercolour, 10.6×17.5 cm. 1826. Trustees of the Wallace Collection, London, P 750

Bonington painted several works with oriental themes. As a pupil of Gros (painter of the famous canvas *Napoleon in the Pesthouse at Jaffa*, 1804) he would have been aware of such sources, and he shared the interest with his friend Delacroix with whom he worked in Paris and England (compare Delacroix's *Seated Turk Smoking* of about 1825, Louvre). He lacked first-hand experience of the subject, but Byron's poetry had evoked a vision of the East which, supported by the work of earlier artists like Pars (Figure 37), gained a wide currency among the Romantics.

oriental subjects before his eventual visit to Morocco in 1832.[2] On the other hand Byron became, far more publicly than Beckford or any predecessors, an upholder of freedom from conventional Western restraints: by 1820 he was in fact the living embodiment of the restless hero-figures of his poems, finally exposing himself to new and dangerous experiences in the Greek war of independence against the Turks, and dying at Missolonghi. Byron the man of action was evidently reflected, at least for the first half of the century, in the portrait by Thomas Phillips (of 1813–14), showing him alone against a stormy sky and exotically attired in the costume of the Arnauots, a tribe of Turkish-occupied Albania: this likeness was made into a steel-engraving by William Finden and circulated widely, being used as the frontispiece to the 1841 edition of *Childe Harold* (Figure 62).

In the year that Byron had read his Turkish history, 1798, the poet Coleridge had probably begun his celebrated poem *Kubla Khan*; though he published it only in 1816 at the request of Byron. The vision of the 'stately pleasure-dome' in Xanadu within its gardens, 'twice five miles of fertile ground. With walls and towers . . . girdled round', had a hypnotic graphic clarity. The features of its landscape have been traced to many possible sources, westwards to Hafod and Wookey Hole, eastwards to the world of the oriental travel books and descriptions by Jesuits of Chinese gardens, notably that of the great palace of Yuan Ming Yuan near Peking. William Beckford's Fonthill of the same years, towered rather than domed but enclosed in an immense wooded park by a 12-foot high wall, was in many respects an English counterpart.[3] The road to Xanadu has been excellently charted.[4] Among English artists who took some steps along it was Thomas Cole (1801–48). His greater journey, however, was to America, where the fruits of his concern for Xanadu matured, as we shall notice later (p. 218).

The landscape of Kubla Khan is one archetypal Romantic image of oriental excess, related to travellers' tales and the eighteenth-century Sublime; another,

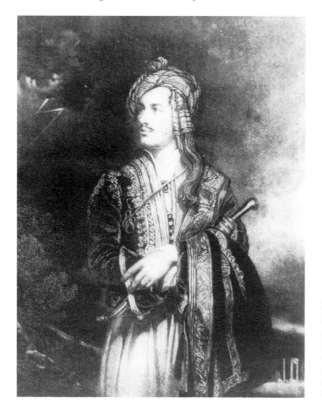

FIG. 62 William Finden (1787–1852). *Lord Byron*. Steel engraving after the painting by Thomas Phillips (1770–1845). About 1840, frontispiece to 1841 edn of *Childe Harolde's Pilgrimage*

The poet gazes away from the classical ruins towards a thundery sky. He wears the Arnauot dress of Turkish Albania which later passed to the Marquess of Lansdowne and is now at Bowood.

113

which was to grow in importance as the new century progressed, was the desert-landscape itself, not seen from without but experienced intensely by man at the centre of an apparent circle of it. Southey, who never went East, alludes in his poem *Thalaba the Destroyer* (1801) to 'the desert-circle' which spreads 'like the round ocean, girdled with the sky'. It is no coincidence that the Romantic age saw the flowering of the art of the Panorama, a form of circular painting put on in purpose-made rotundas. We shall come to this in due course (p. 158). For the moment it is enough to note the link between the art of panoramic paintings at home and the experience of real-life panoramas from remote places such as mountain-tops or deserts which becomes an intrinsic part of nineteenth-century exploration, geographical and mental.

The 'sublime' image of the writer who never experienced the East is very different from the precise image of one who had. In this chapter we approach the period of identification with the great deserts and their nomad inhabitants which produced Richard Burton's accounts of his pilgrimage to the 'forbidden' cities of Islam and Charles Doughty's *Arabia Deserta* (published 1888, based on travels made between 1876 and 1878).[5] Unmistakably of its time in the quality of the observation is a literary watercolour by Burton (1821–90), writing from repeated experience of the descent of night in the desert and accurately sensing the particular in the romantic surge of the general: 'Once more I saw the evening star hanging like a solitaire from the pure front of the western firmament.... Then would appear the woollen tents, low and black, of the true Badawin, mere dots in the boundless waste of lion-tawny clays and gazelle brown gravels, and the camp-fire dotting like a glow-worm the village centre'.[6] W. G. Palgrave, another visitor to Arabia, observes in his *Narrative of a Year's Journey* (1865) an affinity between Englishmen and Arabs. With Burton this included the very landscape.

This is the period when Islam becomes unprecedentedly 'real' for Western artists and indeed insistent for some. It is distinct from all that preceded it, in two ways. First, it is a time of far more intimate and extended contacts of the kind which the Burton passage suggests; secondly, besides Turkey and Persia, two hitherto relatively neglected elements – the society of Islamic Egypt and the cultural heritage of Moorish Spain – become powerful attractions.

In the years following the Napoleonic Wars, the Near and Middle East are important for Europe on many levels, diplomatic, social and cultural. Turkey, from 1821, becomes embattled with the Greeks as they make a bid for independence. The politicians of France, Russia and Britain angle for the goodwill of Persia in order to neutralise the Turks. Egypt, athwart routes to India and in the toils of modernisation, and feeling the need for Western technical help, is inevitably a prime focus of attention. Muhammad 'Alī, who ruled the country from 1805 to 1849, and energetically pursued contacts with the West, was to be portrayed both by David Wilkie and by J. F. Lewis.

It is with Egypt that we must begin. The French had already taken vital steps in the study of Ancient Egypt, an interest which (as we have seen) had become seriously established in the eighteenth century. Napoleon's expedition to Egypt of 1798 had been accompanied by the energetic Vivant Denon, archaeologist and future director of the Musée Napoléon. The 141 plates and detailed descriptions of his large folio book *Voyage dans la Basse et la Haute Egypt* (1802) revealed the country with a thoroughness that had not been possible for earlier Egyptophiles armed with Pococke or Norden's travel-books. They also carried a strong sense of local atmosphere. Forty years before, Pars had animated pictures of classical ruins with groups of attentively observed Turks. Now, with Denon, the architecture is no longer Greek or Roman, but the far more unfamiliar Egyptian. One of

the continuing preoccupations of the opening years of the century was the relationship of European classical art to the ancient and arcane culture of the pharaohs, the relics of which were to be found on the banks of the Nile. Denon's illustration in his book of the Temple of Edfu (Figure 63), with its colossal, half-buried columns dwarfing the huts of modern Arab dwellers, is memorable enough today: in the wake of its publication its message must have struck as deeply as any Piranesi print of Rome or Tivoli 50 years before. Having pointed to the contrast between the indestructible past and the vulnerable present in this way, Denon made it clearer by placing nine plates devoted to ordinary living Egyptians (plates 104–112 in his book) immediately before a long series concerned with antiquities.[7]

No Islamic buildings were represented in Denon's book, though silhouettes of the mosques had been featured, in an atmospheric way (oddly prophetic of Whistler working 80 years later in Venice), in a large pull-out panorama view. Many mosques remained difficult of access to Europeans wishing to conduct detailed study. In 1817, however, the French architect Pascal-Xavier Coste (1787–1879), was invited to Egypt by Muhammad ʿAlī to build a saltpetre factory. Staying on to advise on a number of urgent projects, including canal construction and telegraphic communications between Cairo and Alexandria, he obtained the Egyptian ruler's permission to measure and draw all the main buildings of Islamic Cairo, including those where Europeans were by tradition least welcome. The resulting drawings made between 1818 and 1826 are now in the Searight Collection. Coste used modifications of them for the superb folio book *Architecture Arabe ou Monuments du Kaire* that appeared in 1837–9. This gives plans, elevations and finely detailed perspective views together with a series of comparative elevations (plates 26–27 in the book) of the minarets of various mosques. Whether encountered in coloured or uncoloured form, the beauty and exactness of the large engravings in this work (each sheet is 44.5 by 30 centimetres) still make a strong effect.[8]

The panoramic plate of Cairo and the Nile by night was one of those to appear, on a much reduced scale to suit the pocket-size format, in the English edition of

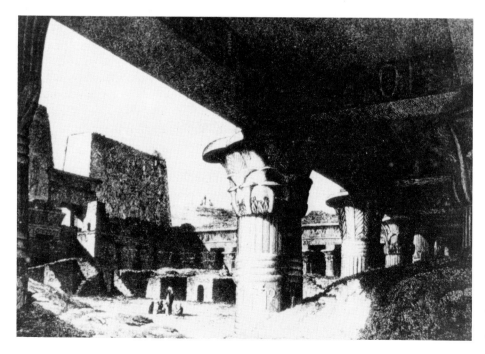

FIG. 63 'The Temple of Edfu', from Vivant Denon, *Voyage dans la Basse et la Haute Egypte*, 1802
This bold plate symbolised the double appeal of Egypt for Europeans at this time: its ancient civilisation and its present-day Muslim people.

115

Denon by Francis Blagdon, also of 1802. Outside Cairo the desert spread to the horizon and was to be observed in the large, robust plates by Henry Salt published in 1809.[9] It was a desert that many English visitors were experiencing for themselves. British interest in Egypt was being sharpened for a variety of reasons, among them the needs of trade and better communications with India as well as the promptings of archaeology and exploration. Trade, and the communications needed to ensure its efficient conduct, required a convenient means of access to India. Apart from the relatively little-used route round South Africa (a journey lasting half a year under wind-power and about three months in the early days of steam), passengers bound for India had to pass either via Egypt and down the Red Sea to Bombay, or across Syria to Basra and down the Persian Gulf. The first choice brought travellers to Alexandria, up the Nile to below Cairo and thence across the desert by coach, donkey-chair or other means to Suez and a waiting steamship. The introduction on this route of steam-power in the 1830s was to be a decided inducement to adopt it, and a notable contributory factor to acquaintance with Egypt itself (the Suez Canal opened as late as 1869). The famous second route down the Euphrates, though shorter in distance, was more dangerous to life and limb; and another route, across Persia via Tabriz, had less call upon it before developments in the oil industry in the early twentieth century.[10] Archaeology, collecting and the urge to document antiquities which drew British visitors to Egypt also enlisted their wider interest in the region. Thus Joseph John Scoles (1798–1863) immediately followed a journey up the Nile in 1823–4 with a stay in Jerusalem, where he prepared the plan of the city that was published in 1825. In London he then helped to found the Syro-Egyptian Society. One of the most ubiquitous pioneers of Egyptian studies in the field was Robert Hay, 'Laird of Linplum' (1799–1863), who was in Egypt between 1824–8 and 1829–34 as a leading organiser of archaeological expeditions. These included as members Francis Arundale, Frederick Catherwood and Joseph Bonomi the Younger whom we shall encounter later (p. 169). Drawings made for Hay by Owen Browne Carter and lithographed by J. C. Bourne were published in Hay's *Illustrations of Cairo*, 1840 (with text in 1841). A number of Islamic buildings appear in these. The fruits of Hay's expeditions comprised no less than 200 cases of antiquities and casts, and 49 volumes of drawings and manuscripts (British Museum).[11]

Interest in the ancient and modern buildings of Egypt was also brought to bear on the people who had produced the buildings. Evidence for this is provided by two publications of the Society for the Diffusion of Useful Knowledge: *Manners and Customs of the Ancient Egyptians* (1836) by John Gardiner Wilkinson, the distinguished Egyptologist who was later painted by J. F. Lewis, and *Manners and Customs of the Modern Egyptians* (1836) by Edward W. Lane (1801–76), a friend of Robert Hay's in Egypt and translator for his generation of *The Arabian Nights*. Lane's studies of modern Egyptians and the nature of Islamic life, the result of living as a native in the Arab quarter of Cairo, typify a rapidly growing preoccupation. The picturesque travellers of the years before 1800 were followed after Waterloo by Englishmen fired by an active desire not merely to escape from Europe and put on Turkish dress in front of Baalbek (though this continued as Andrew Geddes's portrait of George Cumming, exhibited in 1817, Figure 64, indicates), but also to spend long years studying the Islamic world and if possible identifying with its way of life.

A mark of the new generation of travellers – who could be social commentators, scholars or artists – was the desire to make their own record of the idioms of the Near and Middle East in written or drawn form, without recourse to Latin

authors or the classical ruins of Baalbek, Palmyra and the Romanised Orient, and at the same time to achieve a sense of greater personal identity. Lane's book, illustrated with engravings, showed how this could be done. It had reached its fifth edition by 1871. The avowed intention of Alexander William Kinglake (1809–91) in writing his book *Eothen* (1844) was close to this. His aim, he tells us, was not merely to recount his experiences in the Levant and Egypt in 1834–5, but to prove that travel in desert countries is important to 'moulding of your character – that is your very identity'. Edward Said, quoting this passage in his book *Orientalism* (p. 194), sees *Eothen* as a tiresome recital of English prejudices about the Orient: 'For all their vaunted individuality, Kinglake's views express a public and national will over the Orient; his ego is the instrument of this will's expression, not by any means its master.' Such a comment seems to undervalue the book's charm and take a somewhat severe view of its prevailing tone, which is insouciant rather than openly aggressive. Said is more accurate in his summing-up of that younger and more fiercely self-willed character Richard Burton. As Said remarks, Burton was to think of himself both as rebelling in the freedom of the East against Victorian moral authority and 'as a potential agent of authority in

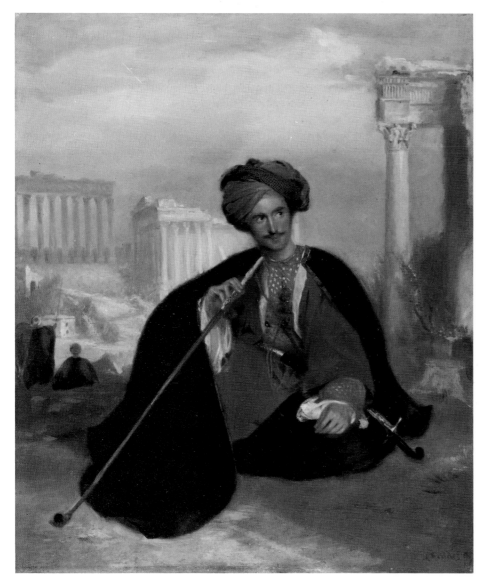

FIG. 64 Andrew Geddes (1783–1844). *George Cumming in Turkish Dress.* Oil on panel, 64.1 × 53.3 cm. 1817. Yale Center for British Art, New Haven, Conn.: Paul Mellon Fund B1979.4
The sitter is shown against the ruins of Baalbek. He looks up from his pipe and makes a strikingly unconventional silhouette, in scarlet, grey and black.

117

the East'. More a solitary than a rebel, John Frederick Lewis, living a self-imposed exile from Europe in Cairo for 10 years in the 1840s, and returning to England to paint Egypt for 25 years as if he had never left it, was to provide fascinating evidence of the ways in which a traditional European training and a freedom nurtured in the East could sustain striking new departures.

While an artist might become interested in the monumental forms of ancient architecture in the Middle East or in the shimmering patterns of Islamic effects, or in both, this was not necessarily the end of the matter. The idea of the continuity of racial character, linking early and modern times, also had its advocates in this period of close-up scrutiny. Moors, Persians, Egyptians: all invited study. The anonymous author of the two-volume *Summer in Andalucia* (1839) claims to see the lineal descendants of the old Moors in the modern Andalusian peasant: 'so much of the Saracen (is) in his character, manners, habits, costume and amusements' (p. 69). James Morier, author of the highly successful picaresque novel *The Adventures of Hajji Baba* (1824), makes the same point about the Persians, taking the perspective back before Islam: 'The numerous faces seen among the sculptures of Persepolis, so perfect as if chiselled but yesterday, were so many likenesses of modern Persians, more particularly of the natives of the province of Fars.'[12] Among painters, William Allan (1782–1850) was interested in such matters; and Wilkie and J. F. Lewis were to evoke age-old racial character in the faces of many of the contemporary male Arabs they portrayed (Figure 76).[13]

In this age of restless time as well as space-travelling, the desire for 'correctness', which could only be gained by first-hand experience of living in the East, easily combined, therefore, with the romantic pursuit of the vanished past of Eastern peoples. Previously, in eighteenth-century Europe, the memory of the Crusades had maintained a gulf between Europe and Islam, between Christian and 'infidel', which pre-Romantics like Horace Walpole could enjoy without seeking to bridge it. By 1820 the novels of Scott (who seems to have had no wish to visit the East) show that the stir of feeling induced by the exploits of the medieval Crusaders in the Holy Land was still working, but now not without regard for the positive qualities of their Muslim opponents. As we saw earlier, in *The Talisman* (1825) a careful differentiation is made between Saracen chivalry and that of the Christian knight. In *Ivanhoe* (1819), as Henderson has noted, Scott's Jewish heroine had sat on embroidered cushions in the manner of an Ingres odalisque.[14]

This concern for the past of Muslim cultures begins at this time to focus particularly on the Moors – in a precise sense, the people of Morocco and earlier of Spain – and their art. It is an interesting and influential phenomenon. It is not hard to see why Moorish achievement offered special attractions at a time of interest not only in the buildings of the past (which had so absorbed the eighteenth-century neo-classicists), but also in the people that produced them. Among Islamic peoples, the Moors – despite the traditionally vague uses of the description – were second only to the Turks in the European imagination. The long-established antipathetic associations that the ambivalent Turks were reviving (after the opening of war in Greece in 1821) applied in their case also: but the Moors were now emerging with distinct credentials. Had they introduced Gothic to Europe, as Hodges had speculated? They had clearly played a constructive role long ago on the European mainland. That role may have officially ended in 1492, but they had left a compelling visual legacy behind them to prove it. Moreover, that legacy was associated with that of a country of deep fascination to the Romantic mind, Spain.[15]

The conclusion of the Peninsular War in 1814 opened up Moorish Spain for

fresh scrutiny. Literature had already prepared the way with a sympathetic hearing for the Moors: Coleridge's *Osorio* (1797) presented them as a proud race abused by the Spaniards but totally unquenched in spirit. Morocco itself, by reason of French involvement in North Africa, was to be a particular resort of French artists, notably Delacroix, who was there in the early months of 1832, attached to a Government mission to the Sultan.[16] David Roberts and J. F. Lewis both visited Morocco shortly afterwards; most British artists, however, came to know Moorish art through travel in Spain, 'an unexplored territory, the very Timbuctoo of art', as David Wilkie, industriously sketching there in 1827–8, described it.[17]

If Wilkie was not entirely correct in suggesting that Spain was unexplored, he was accurate in sensing that a new phase of awareness and appreciation was under way: his reference to Timbuctoo suggests how keenly he felt the strangeness of the conjunction of Spanish and Moorish cultures which he found there. In particular, the new phase of awareness was to make the Moorish fortress of the Alhambra at Granada one of the most famous and closely studied buildings in Europe. This was an episode in which British and American visitors were to play key parts.

II

By the time of its high fame as a Moorish monument in Western Europe the Alhambra had overlooked Granada for nearly 600 years. It had been the fortress-palace of the Nasrid dynasty which ruled in Granada from 1237 until 1492. Much enlarged by Yusuf I (1333–54) and Muhammad V (1354–91) to provide residential quarters, mosques and baths, it was in this later period that many of the more remarkable interior effects had taken shape behind its massive outer walls. Prominent among these internal effects were the courtyards which gave access to elaborate reception rooms. In the famous Court of the Myrtles and the Court of the Lions, with its central lion fountain, light arches spring from slim supports round the edges of open pools: the overall effect is of spatial fluidity and shifting boundaries, in marked contrast to the firm containment of space in the courtyards of Renaissance Italy. Also contrasting with the sense of homogeneity of material proclaimed by the European tradition was the feeling of surfaces varied and interlinked by many colours, a feeling sustained in the reception rooms themselves with their *muqarnas* or stalactite domes. Everywhere coloured decoration in carved stucco and tile extends across surfaces, adding to the impression of movement.

The Alhambra, of course, had been known before 1814 to the Western book-reading public. The shadowy Irish antiquary James Cavanah Murphy had studied it, including its interior detail, on his Spanish journey of 1802–9, and even earlier, perhaps, around 1790.[18] But Murphy's immense book *The Arabian Antiquities of Spain* (1815) notwithstanding (and it contains many inaccuracies), the architectural riches of the Alhambra courts were ill-documented. The larger reputation of the building, understandably in the age of Picturesque Tours, was almost wholly based on its romantically suggestive exterior, high on its rock above the city. Eighteenth-century travellers had saluted this picturesque character, and Sir John Carr in his *Descriptive Travels in ... Parts of Spain* (1811) had even made a frontispiece illustration of it, silhouetted against the sunset. Chateaubriand, in a passing reference to it on its rocky site, had gone so far as to say that it had been for the Moors what the Parthenon had been for the Greeks.[19] For the age of Byron the Alhambra's role as romantic relic was obvious. Victor

Hugo, however, appears to proclaim its interior glories, though in phrases of high fantasy, in a poem on Granada included in his collection *Les Orientales* (1829):

> L'Alhambra! L'Alhambra! palais que les Génies
> Ont doré comme un rêve et rempli d'harmonies . . .

These lines were to appear on the title page of the first volume of Owen Jones's famous book *The Alhambra*, to which we will presently come (p. 125).

About 1830 a stream of travel books on Spain begin, which naturally feature the Alhambra: Caleb Cushing's *Reminiscences of Spain* (1833) is a typical example. At the same time specific interest in the building and its architecture are seen developing on both serious and popular levels. The serious level was reflected by Philibert Joseph Girault de Prangey (1804–93), who had undertaken considerable work recording the Moorish decoration at the Alhambra in 1832 and 1833 and was to publish this in the ensuing years.[20] The popular interest is seen in such works as Jennings's *Landscape Annuals of Travels in Spain*, of which a Granada volume appeared in 1835. By then the fashionable enthusiasm for the Alhambra was well advanced.

One immediate catalyst of this enthusiasm in the thirties was the appearance of the American Washington Irving's celebrated book *Legends of The Alhambra* in 1832.[21] As the title suggests, much of the book was a chronicle of the stories 'true and fabulous' that were connected with the fortress, but Irving pertinently saw a parallel between the veneration for the Alhambra that was felt by the historically and poetically minded traveller and that experienced for the shrine of the Kaaba at Mecca by the Muslim pilgrim. The dedication (omitted from late editions) of Irving's volume to his friend David Wilkie recalled 'the rambles we once took together about some of the old cities of Spain . . . and were more than once struck with scenes and incidents in the streets, which reminded us of

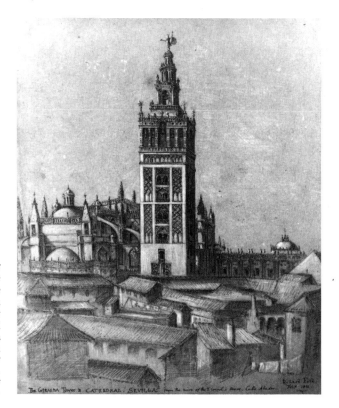

FIG. 65 Richard Ford (1796–1858). *The Giralda Tower and Cathedral, Seville*, from the mira of the Vice-Consul's House, Calle Abados. Pencil heightened with white on grey paper, 30×23.3 cm. 1831. Sir Brinsley Ford
This, one of Ford's earliest drawings in Spain, shows the famous Moorish tower or minaret built by Abu Jusuf Yacub *c.* 1196, and capped by a Gothic belfry of 1568 and the turning weather-vane *que gira*, 'which turns round', thus giving its name to the whole.

passages in the *Arabian Nights*'. Irving, a friend also of Walter Scott, had travelled widely in Europe, before becoming in 1826 a member of the American Legation in Madrid. His book, *The Conquest of Granada* (1829), affirmed his enthusiasm for Moorish Spain and was acclaimed as a masterpiece by Coleridge. He moved into quarters in the Alhambra in that year, staying four months before being called on to London. Memories of the confrontation of Spanish Gothic and the 'light, elegant and voluptuous character' of Moorish building never left him.

Two years later, a British visitor and artist, Richard Ford (1796–1858), was also quartered in the Alhambra in the course of a three-year stay in Spain (1830–3). This elicited from him over 500 drawings which comprised the most complete

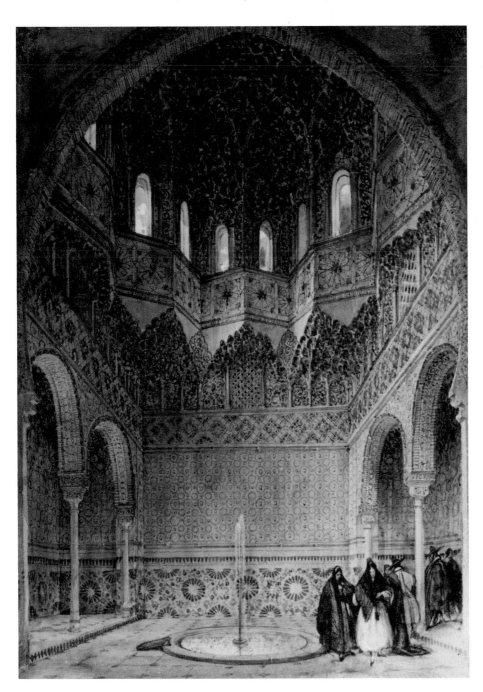

FIG. 66 David Roberts (1796–1864). *Hall of the Abencerrages, Alhambra, Granada*. Watercolour and body-colour, 33×23.5 cm. Signed and dated 1834. Laing Art Gallery, Newcastle-upon-Tyne (Tyne and Wear County Council Museums) 24.36.B-8041

With its angled windows and 'prismatic' dome, this subject was included by Owen Jones in his Alhambra Court at the Crystal Palace, omitting for space reasons the band of ornament above the arches. Roberts too has taken some liberties: he has simplified some of the intricate tile patterns, especially the lowest band. But this vivid work amply sustains the excitement of his experience.

record of Spanish monuments before photography (Figure 65). Wintering in Seville, Ford passed his two summers at Granada. The experience was indelible for him also and he seems to have modelled a Moorish tower built in 1838 at Heavitree House, his home near Exeter, on the Alhambra.[22] Ford was to write with feeling of Moorish building in his famous *Handbook for Travellers in Spain and Readers at Home* (1845): '*Lightness* was the aim of Moorish architects, as *massiveness* was of the ancient Egyptians. The real supports were concealed, and purposely kept unexpressed, so that the apparent supports, thin pillars, and gossamer perforated fabric, seemed fairy work: the object was to contradict the idea of weight, and let the masses appear to hang in air floating like summer clouds' (*Handbook*, 3rd edn, 1, p. 307). The passage might almost describe the Crystal

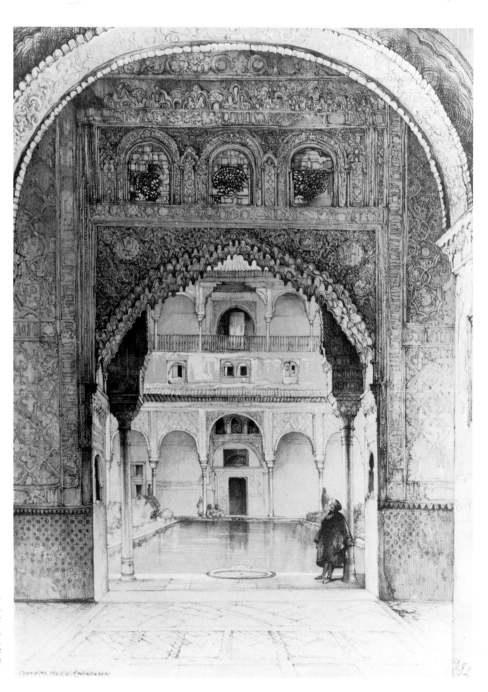

FIG. 67 John Frederick Lewis (1805–76). 'Door of the Hall of Ambassadors', pl. 12 from *Sketches . . . of the Alhambra* (1835). Victoria and Albert Museum: National Art Library
Lewis uses the simple line of the foreground arch and a basically three-tone scheme (light, medium and dark) to intensify the lightness and fragility of the stalactite vault and the arcade of the Court of the Myrtles.

Palace, its internal structure painted with delicately organised primary colours by one of the Alhambra's most effective advocates, Owen Jones.

The light rhythms and the colours of the Alhambra were also a major part of its attractiveness to artists. In 1832–3 Ford was visited, at both Seville and Granada, by J. F. Lewis. In February 1833 David Roberts arrived (after Lewis had left). Roberts appears to have been the first British artist to paint the detail of the Alhambra: he was to produce many views of it, abbreviating the patterns on its walls but suggesting an architecture of phantasmagoric brilliance (Figure 66). After his return to England, he illustrated the volume on Granada in the popular series of *Landscape Annuals* on Spain published by Jennings, and also published picturesque views, including Alhambra subjects, on his own account.[23] As for Lewis, his stay had given him his first encounter with the 'gossamer perforated fabric' of Islamic architecture, and the effect was revelatory. 'I regretted then', he wrote to Roberts from Seville, 'for the first time in my life, that I did not draw architecture, and almost intended to commence, but as you are there now, lucky man am I who let it alone.'[24] But Lewis had not let it alone: in the lithograph 'Hall of the Ambassadors' in his *Alhambra* series (published 1835, Figure 67) he squares confidently up to a succession of spaces seen parallel to the picture plane, and offsets the fretted profile of a central arch against the light behind and lower-toned wall patterns at the sides. Lewis seems to have tried to limit himself to three basic tones: an effective way of simplifying the daunting complexity of the subject.[25]

In 1834, a year after Lewis's work in the Alhambra, Owen Jones arrived and began the remarkable drawings which were to crystallise his delight in Moorish design and architectural polychromy (Figure 68), and were to lead to his monumental publication on the Alhambra in 1842–5.

With Owen Jones we come to a figure of central importance to our theme. As with J. F. Lewis and William de Morgan, Islamic inspiration in art was of crucial significance to him; if at first sight he appears a lesser artist in creative terms than either of these, the more he is studied the more clearly he emerges as an interpreter, theorist and practitioner of impressive range, whose enquiries have the kind of penetration that can be said to rank as creativeness.[26]

Trained as an architect, Jones began work at a time of confusion and indecision in many areas of design: a time of increasing breakdown between the supply of clear-headed creative purpose on the part of artists and architects on the one hand and the rampant demands of machine-production and urban expansion on the other. The eclecticism that had marked the Regency publications on villa-design had embraced interior design and furnishing: Gothic and exotic styles – including 'moresque' – vied with the classically based 'period' styles. The *House Decorator and Painter's Guide* (1840) produced by the Queen's furniture suppliers, the firm of Henry, William and Arthur Arrowsmith of St Martin's Lane, pointed the choices. While much decoration was still hand-wrought for the kinds of apartment owned by the Arrowsmiths' clientele, at other levels of the market mechanical methods of making ornament were drastically cheapening its character along with its cost, and opening up unprecedented possibilities of indiscriminate use. 'Gothic' was prominent among the Arrowsmiths' styles, but the year 1836 (after Jones's return from his first visit to Granada) had nevertheless seen the emergence of the formidable talents of Augustus Welby Northmore Pugin (1812–52): his plans for a new revival of Gothic had the fervour of a crusade.

In his famous book *Contrasts* (1836, 2nd edn enlarged and rewritten 1841), Pugin rejects Renaissance architectural style as one of structural dishonesty and

stuccoed sham. He also rejects the 'whim and caprice' of eclecticism, including in his brilliant invective the Brighton Pavilion, and the idea of 'a Turkish kremlin for a royal residence'. Above all, in his *True Principles of Pointed or Christian Architecture* (1841), Pugin was to propose a Gothic that would be articulated not only into the fabric of building but into the fibre of life itself. Pugin's militant Catholic Gothic embodied theoretical ideals of functional clarity: in planning, structure and the use of ornament. Decoration, he asserted, should grow out of the context in which it was set and the material of which it was part.

Jones was to agree with this bold thinking about the function of decoration but to reject the doctrinal and stylistic severity with which Pugin propounded his view of Gothic. Jones was not a revivalist if this meant re-creating to the letter a

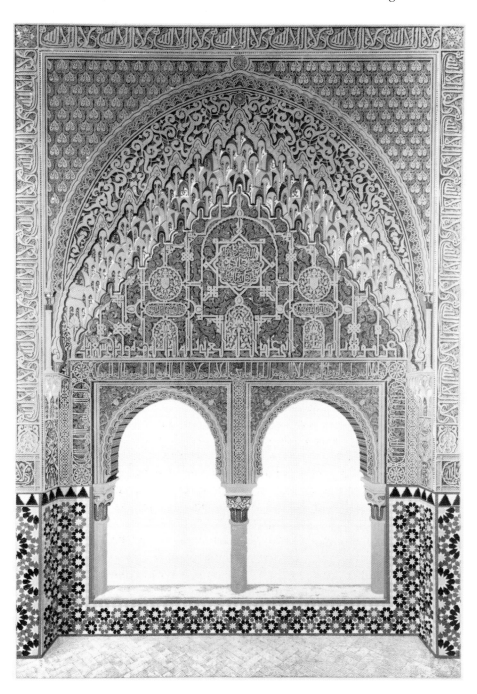

FIG. 68 Owen Jones (1809–74). Window in the alcove of the Hall of the Two Sisters, Alhambra, Granada, pl. XXI from vol. I of *Plans, Elevations, Sections and Details of the Alhambra*, 1842–5. Chromolithograph, 49×68 cm. Victoria and Albert Museum: National Art Library. Photograph courtesy World of Islam Festival Trust
Jones regarded this alcove (Arabic *al-qobba* vault) as a microcosm of the whole building in its blend of 'all the varieties of form and colour'. He also admired the inscriptions for 'the music of their composition'. He showed a painting of this subject at the R.A. in 1839.

style of the past. Twenty years after first seeing the Alhambra he did in fact re-create part of it at the Crystal Palace at Sydenham: his well-known 'Alhambra Court'. But this was done in the special context of a collection of interiors conceived in different styles. The measure of Jones's freedom from the revivalist creed is surely seen in his acceptance of the challenge of painting the interior of the most revolutionary-looking building of its age: the original Crystal Palace in Hyde Park. Did the experience of the Alhambra influence the decisions that Jones took at the Crystal Palace? We may find the answers to that interesting question if we look first at Jones's early concern with colour in building and then consider a combination of factors personal to him as a man of vision.

The circumstantial facts concerning Jones's early training and work on the Alhambra are soon stated. In 1824 he was articled to the architect Lewis Vulliamy who, though mainly a classicist, had drawn Turkish buildings in Constantinople in about 1818. In 1832–3 Jones travelled in Greece and Egypt, going up the Nile in company with Jules Goury (1803–34). Goury had been a pupil of the important German architect Gottfried Semper (1803–79): a student of polychromy in building to whom we shall have to return (see below). Together Jones and Goury made measured drawings and watercolours of a number of monuments, including Islamic subjects, which made a deep impression on Jones (examples are in the Searight Collection and the British Museum). Later in 1833 both men were working in Constantinople (drawings by Jones are in the Victoria and Albert Museum). A growing enthusiasm for Islamic art evidently took them to Granada in 1834, where they stayed six months drawing the Alhambra, and where in August Goury succumbed to cholera. In 1837 Jones was back in the fortress and made an exhaustive record of the decoration in drawings, paper impressions and casts. He set about retrieving evidence of the original colour by taking scrapings beneath the overpaint. Returning to England he exhibited in the Royal Academy of 1839 detailed drawings in colour which were hailed by the *Athenaeum* of 1 June (p. 418) as 'one of the most magnificent displays of gorgeous colour and elaborate tracing we ever saw'. From his chambers in the Adelphi, he was also preparing the elaborate colour illustrations (Figure 68) which were to make his book, *Plans, Elevations, Sections and Details of the Alhambra* (two volumes, published in 12 parts, 1836–42, 1845), visually so remarkable. Some of the chromolithographic plates involved the use of seven stones: all were printed under the supervision of Jones himself.[27]

Prefaced by the emotive quotation from Hugo's *Orientales*, this massive work brings the old shadowy world of Alhambra-worship into the clear light of scholarly investigation with passion and precision. It is still an unassailable part of bibliographies on Islamic art. Jones's book was by no means the first to concern itself with the decoration of the Alhambra, but it does represent new departures in its unremitting attempt to present faithfully the effect of the original colour. No previous book had paid such attention to Islamic decoration of such abundance and complexity, in a single building.

Jones's study of colour effects in architecture was part of a wide interest in the subject which had been established for more than a generation. Prominent architects such as Jacob Ignaz Hittorff and Gottfried Semper had been considering it for years in the context of European classical art, and Semper had studied buildings which included painted Islamic ornament.[28] Jones was to extend this concern and investigate Islamic architectural ornament more intensively than anyone.

The interest in polychromy in ancient art has also to be seen against the background of increasing preoccupation with colour in painting and as a natural

phenomenon. The Romantic artist's concern with personal experience empha-sised exposure to sensations of light and colour outside the studio: the very qualities of subjectivity and emotional suggestion which had made colour suspect to the classicist of the old academies were now its recommendation. Among the creative spirits, this stimulus is reflected by Goethe and Runge with their treatises on colour and Turner with his investigations of light in terms of colour and his paintings inspired by Goethe's colour theories. Others were attempting from a more technical standpoint to establish a science of colour which could be relevant to artists. George Field published his *Chromatography, or a Treatise on Colour and Pigments and of their Powers in Painting* in 1835 and Chevreul's *De la Loi du Contraste Simultane des Couleurs* appeared in 1839. Both were to be relevant to Owen Jones.[29]

The antiquarian preoccupation with the original colour of ancient buildings; the modern interest in the optical sensation of colour: Jones combines both sympathies. A third strand of concern, however, which marks him out, is the peculiar strength of the presentiment of order that he received from Islamic use of colour in pattern. Pugin, who never went East and relied for knowledge of Islamic design on encounters with such things as tiles and carpets, had inti-mations of this. In his *True Principles of Pointed or Christian Architecture* of 1841, published while Jones was working on his Alhambra plates, Pugin had written of the merits of Islamic flat pattern in which colour was the decisive agent of expression (p. 27). Having noted that ancient paving tiles showed pattern 'not by relief but by contrast of colour', he went on, 'Turkey carpets, which are by far the handsomest now manufactured, have no shadow in their pattern, but merely an intricate combination of coloured intersections'. Jones was able to express this same sense with the force of his experience of the Alhambra behind him.

In the Alhambra, Jones analysed the basic grids on which the repeating patterns were constructed (he was to include these in his *Grammar of Ornament*, see Figure 107 below). He was also fundamentally concerned with the colour: as he makes clear in his subsequent writings,[30] he had experienced bold patterns full of episodic interest in which the colours and the geometry nevertheless sustained each other in overall effects over large surfaces. He perceived the brilliant primary colours – reds, yellows and blues – on the upper levels, with the 'secondaries' of greens and oranges in the mosaic dadoes below merging at a distance to give the appearance of a reposeful baseline. He observed how different colours of distinct individual brilliance could be handled so as to present an effect of equal overall intensity. He was clearly fascinated by the problem of how the movement of lines of pattern and the flicker of bright colour at close range could be transformed at a distance into an overall effect of stability and repose: we will return to this interesting consideration when we look later at his *Grammar of Ornament*.

It is evident from Jones's later writings that he valued the quality of optical merging of colours into an effect of 'bloom' very highly. In a lecture delivered before a crowded audience on 16 December 1850 at the RIBA in defence of his controversial colour scheme for the interior of the Crystal Palace, he indicated both Islamic colour and the theories of the pigment-maker George Field as sources for his ideas.[31] Field had maintained that white light consisted of amounts of blue, red and yellow neutralising each other in the proportions of eight, five and three respectively. Jones had made these proportions the basis of his Crystal Palace scheme. Blue, as a retiring colour, was appropriate for concave surfaces; yellow, an advancing colour, for convex surfaces; red, the 'colour of the middle distance' for horizontal planes. In practice, light blue was to be used in

greater quantities on the main lines of the structure; yellow appeared on the horizontal cross-bracings; and red on the undersides of the girders. White lines separated the colours in accordance with Chevreul's theory for gaining colour distinctness.

In his work at the Crystal Palace, Jones was applying such modern ideas in the most modern, indeed revolutionary of buildings, which consisted almost entirely of straight lines of uprights and horizontals regularly repeated within an iron framework, and a vast quantity (900,000 square feet) of identical glass panes with no solid walling. Jones saw iron as a building material that was 'right' for the modern age, and primaries as colours that enhanced that rightness. He tells us, however, in the RIBA lecture that he first conceived interiors glowing with fragments of primary colour 'twenty years earlier in Egypt'.[32] The Alhambra was therefore not the initial catalyst: but we may surmise that the scale and quantifiability of the evidence there of both pattern and the use of colour provided the key experience of his life. Michael Darby is surely right in seeing Jones's wish, also voiced in his RIBA Lecture, to uphold the old principle of sustained repetition – what Jones calls 'repetition of simple forms (to) give . . . grandeur of effect' – as one that received vastly enhanced potential through the new knowledge of light and colour which was the outcome of his experience of Egyptian mosques and the courts of the Alhambra.[33]

The importance of Jones's *Alhambra* volumes is well summed up by the *Athenaeum*, which remarks that 'rarely, if ever' had there appeared 'a more magnificent work for the benefit of the architect or of the decorator', and in later years by the *Builder*, who saw its ideas on the union of form and colour as prophetic.[34] The *Athenaeum* also drew attention to the 'judicious admixture' and 'contrast' of bright colour which it claimed had been overlooked by many designers who adopted 'this gorgeous but difficult style'. Moreover, Jones's friend César Daly provided a strongly favourable series of review articles on Jones's publication.[35]

Such a prodigy of a book inevitably made Jones's name synonymous with Moorish design; he sustained the reputation in his own creative work as architect and designer. He designed tiles (and mosaics) in the 1840s to the point where the *Builder* thought he showed himself unable to 'throw off' the influence of the 'Moresco' idiom. Work in 1843 at 8 Kensington Palace Gardens for John Marriott Blashfield, a subscriber to Jones's *Alhambra* volumes, incorporated plasterwork and coloured tile dadoes based on the Alhambra. Drawings for tiles (now VAM) probably done about 1855, show him working on a geometrical grid-plan.

Jones clearly met with the kind of sales resistance that is often the lot of those who have acquired a label and who press their enthusiasm: his project for an Army and Navy Club in 1847 in the 'Alhambra style' was rejected (unhappily the drawings are lost), and designs in the same style for a house for a certain Alderman Moon, exhibited in 1849, called forth from the *Builder* (10 March 1849, p. 109) the austere comment 'clever but . . . unsuitable'. Such discouragements, however, did not deflect Jones from forming a mature style, notably after 1850 in the popular fields of textile design (his 'Alhambra', 'Arabesque' and 'Vine' done for the firm of Erskine Beveridge and shown at the Great Exhibition) and wallpaper design for John Trumble and Sons, Jeffery and Company and others (Figure 105).[36]

The basically Italianate façade of 24 Kensington Palace Gardens (1845, surviving), also designed by Jones for Blashfield, presents many Islamic features, including small domes at the angles; but Jones's drawings for this and the interior have not survived, making conclusions about his contribution difficult. In the

1850s however, he was feeding his Moorish predilections into his architectural work in decidedly successful ways. Six-pointed stars in glass crowned the vault of his Crystal Palace Bazaar in Oxford Street (1858). Also in 1858 Jones designed Osler's Gallery, Oxford Street (demolished 1926): the showroom of a firm which had made a much-admired candelabrum for Ibrahim Pasha 11 years previously. A pen and ink drawing in the Victoria and Albert Museum[37] shows Jones's idea for the ceiling (106 feet and eventually 14 bays long) in which stained glass segments were fitted into geometric panels of fibrous plaster. In the last decade of Jones's life there came the designs for interiors at 16 Carlton House Terrace, London, for the millionaire Alfred Morrison. These, superbly executed between 1865 and 1867 by Jackson and Graham in wood marquetry, involved band-like geometric patterns of Moorish origin. The results surely marked a high point in Jones's designing, one which, happily and unusually for him, survives (the house is now the Terrace Club).

It is obvious from the *Athenaeum*'s comments about 'this difficult style' that it was being used without sensitivity or discrimination by some designers, and this presumably helped to colour the attitudes of those who differed from Jones over the merit of re-employing Moorish ornament in contemporary building. The *Athenaeum* writer may have had in mind those responsible for the shopfronts in Regent Street and Oxford Street whom Ruskin noted as adding Alhambraic decoration in the 1840s.[38] Such additions no doubt added vitriol to the denunciations of the decoration of the Alhambra in the writings of Ruskin himself, who never saw the original, but who, like everyone else, regarded Owen Jones's volumes as providing the means of making a judgement.

On the matter of Alhambraic decoration as a debating point in Victorian England, Ruskin's strictures cannot be overlooked. Jones has been seen as a follower of Ruskin in the importance he attaches to architectural ornament,[39] but on the subject of the Alhambra the two men could hardly be further apart. Though conceding the traditionally admired picturesqueness of the building, Ruskin abominates its ornament, 'mere line and colour ... without natural form'.[40] Ruskin, in his *Seven Lamps* (1849), urges the artist to take nature as a guide, and use her clues – the colouring of a shell or a bird's feather – as indications of how to introduce colour in architecture, independent of structural lines.[41] Jones could never have accepted this – for him natural form should be conventionalised into a formal language in which the logic of structure and the emotional suggestion of colour were interlocked. In this respect all the essential lessons were contained in the Moorish interiors at Granada.

In 1850, then, Owen Jones was presented with the opportunity of applying his knowledge of colour to the building which became known as the Crystal Palace, erected to Joseph Paxton's design to house the Great Exhibition of the Works of Industry of All Nations. For the colour-scheme – much criticised in the early stages, in common with other aspects of the enterprise – he used, as we have seen, primary colours to create 'a neutralised bloom over the whole of the contents of the building'.[42] He also aimed to make the interior appear higher and longer and, by the effects of parallax glimpsed between the rows of columns, 'more solid'. In other words, the painting of the girders was intended to provide visual weight – a pertinent consideration in an overwhelmingly 'transparent' building. A drawing by William Simpson of his proposed scheme, preserved in the Victoria and Albert Museum (Figure 69) shows large expanses of textile carrying arabesque and coloured red, yellow and blue, rounding off the angles of the roof. Regrettably this idea was not accepted: in the event, having used red only on the shadowed undersurfaces of the ironwork and thus underplayed its

contribution to the balance of primaries envisaged by Field, Jones included what he called 'Turkey' red cloth at intervals on the gallery handrails – which must have produced quite brilliant notes of colour against the blueness of the distant perspectives. The whole setting, described by the *Illustrated London News* as the work of the 'genius of Owen Jones', nevertheless contrived an effect of brightness passing to hazy indistinctness 'which Turner alone can paint', and was much acclaimed.[43] 'The most potent apostle of colour that architectural England has had in these days': the words that open the obituary of Jones in the *Builder* in 1874 have the ring of truth.[44]

Why was the Alhambra so popular with artists in this period? There were probably two main reasons: first, the experience that it provided of colour, the life-blood of the Romantic; secondly, its richness as a storehouse of legible, classifiable and adaptable ornament. The second factor is best considered in the following chapter: in the present discussion we have concentrated on the matter of colour. The reference to Turner by the *Illustrated London News*, in its description of the interior of the Crystal Palace, is an *aperçu* of contemporary awareness of the values of space and light in terms of colour which, for more than 20 years previously, the dematerialised landscape of Turner's later style had been making familiar in painting, and which, less conspicuously but quite literally, glass

FIG. 69 William Simpson (1823–99). *Owen Jones's Scheme for the decoration of the Great Exhibition building.* Pen and ink and watercolour, 71×99 cm. (sight size). 1850. Victoria and Albert Museum 546–1897
The drawing provides a link between Jones's advocacy of the lessons of the Alhambra (arabesque and primary colours on the spandrels, eventually abandoned) and the final application of the primaries to the uprights and horizontals of the 'revolutionary' Crystal Palace building.

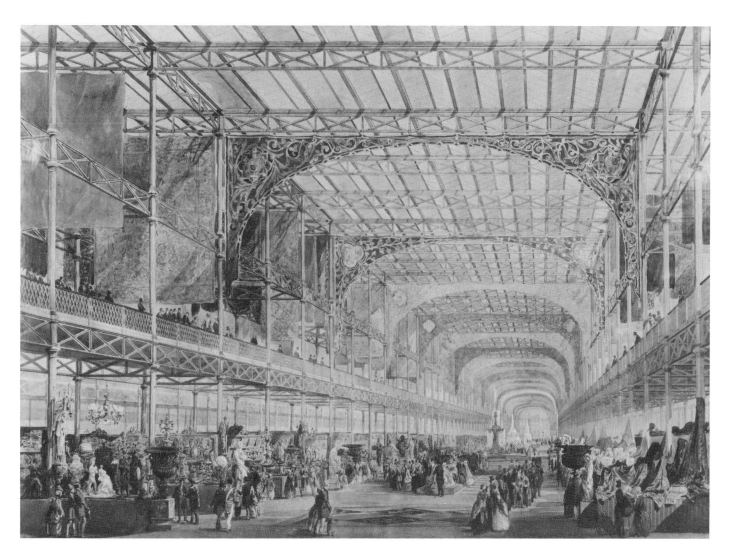

buildings had been opening up in architecture in the subordinate sphere of conservatories and plant-houses. The activity of Owen Jones was the means whereby the merits of the Alhambra in this climate of thinking were made manifest.

'One of the objects of decorating a building', said Jones in the same RIBA lecture of 1850, 'is to increase the effect of light and shade.' The painted decoration of the Alhambra had afforded unique scope for quantifying, as we have seen, the functions of the primary colours in relation to each other and in conditions of light and shadow. Jones's interest in these colours in an architectural context puts additional flesh on the theories of Field and Chevreul. It is at least likely that effects such as that of the Court of the Lions (Colour plate V), helped him also, and through him his contemporaries, to appreciate the spatial and colouristic qualities that could be achieved in rooms and courts unenclosed by solid bounding walls. The message of the spatial qualities is still being reflected in the more antiseptic years after 1918 by Philip Tilden at Port Lympne, Kent (Figure 70).

In the mid nineteenth century, therefore, through the devoted activity of artist-antiquarians – among whom Jones must stand pre-eminent – and despite the protestations of Ruskin, the Alhambra becomes celebrated as a repository of Moorish civilisation and decoration. In summing up the spell exerted by this building we should not overlook the fact of its location in Spain. The relationship between Spanish and Moorish culture was itself attracting unprecedented attention in the years that we have been considering. It is not perhaps difficult to see why. As a phenomenon in direct confrontation with Spanish culture and landscape, Moorish art had a character that was distant from anything else that Islamic countries had to offer, particularly Egypt, with which we began this chapter. While nineteenth-century Europeans certainly responded, as Jones had done, to the grand mosques of Cairo with their domes and minarets rising from

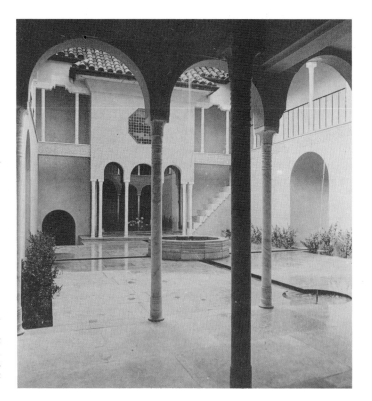

FIG. 70 Philip Tilden (1887–1956). Moorish Court, Port Lympne, Kent. 1918–21. Photograph courtesy of Howlett's and Port Lympne Estates Ltd
The design, for Sir Philip Sassoon, makes unmistakable reference to the Court of the Lions at Granada.

the living challenge of the great deserts (no empty cliché for them), the taste for picturesqueness and the fragility of the past – a gentler aspect of Romanticism – was now met not only by Constantinople but by the architecture and decoration of the Moors in Spain. Though these buildings were not on the uncompromising levels of the desert countries, but on the tree-covered slopes of Spanish hills, they stood for a combination of qualities which was no less compelling.[45]

III

The Alhambra and its decorative schemes represented a conspicuous strand of Islamic artistic influence in nineteenth-century Britain which, through the work of Owen Jones, helped to induce important shifts of attitude to decoration and ornament in the field of interior design. Before we come to a closer consideration of the 'decorative arts', however, we should trace some other lines of activity among painters. Among these was John Frederick Lewis who, with David Roberts, had responded so keenly to the spell of Granada. We must also look at British India, and pause again in front of that other Islamic building with so special a reputation, the Taj Mahal.

Having seen Moorish work in Spain, many British artists went on to investigate Constantinople and Cairo (reversing the sequence followed by Owen Jones). In 1838 Roberts sailed to Alexandria, exploring widely until June 1839, mainly in Egypt, though he also stayed in Petra and Jerusalem. He was delighted by Cairo, admired the mosques and successfully obtained a firman from the Governor to draw them; which he did despite some harassments.[46] David Wilkie was in Constantinople in 1840 before going on to Palestine and Egypt. He was to die at sea on the return journey. J. F. Lewis was also in Constantinople in 1840, and met Wilkie: Lewis then spent 10 years in Cairo, living as a native.[47] Wilkie was only briefly, and for special reasons, a student of Islamic subjects, and we can best consider him later.

Lewis is a very different proposition. As a painter who became a specialist in Near Eastern subjects for the rest of his life and who produced work of high originality in the genre, John Frederick Lewis (1805–76) deserves close attention. An element of smokescreen, partly induced, it appears, by the artist, prevents us from seeing him clearly as a man. Thackeray, visiting Lewis in his splendid Cairo home in the northern Esbekiya quarter of the city, in 1844, draws a picture of him living the opulent life of an Oriental nobleman.[48] The painter Richard Dadd had visited him two years before with his patron Sir Thomas Phillips, and Phillips had formed the impression that Lewis was not much employed as an artist.

The evidence, however, suggests that these interpretations do not entirely cover the facts. Lewis certainly lived imperiously and well, offering to Thackeray 'the pride of Oriental cuisine', but also, in conversation, allowing glimpses of himself contemplating the desert outside Cairo 'under the stars', as 'the camels were picketed, and the fires and the pipes were lighted'. But against the indications of a lotus-eater's life there remains abundant proof of concentrated work. Lewis's great grand-nephew, Major-General J. M. H. Lewis, estimates that almost 600 paintings and drawings were done in these Cairo years.[49] Of these, about half were figure-studies and about a quarter views of streets, bazaars and mosques, in which architecture played a greater part than had been apparent – apart from his Alhambra illustrations – in his Spanish period. A fifth was concerned with desert scenes and the life of the Bedouin, usually seen in bright sunlight (not, in practice, under the stars). In 1842 he went into Sinai; in 1844 he visited Suez; in 1850 he sailed up the Nile to Edfu. While the monuments and

people of these places provided a wealth of subjects, however, it was on interior spaces that he worked most surprisingly, noting the fall of light through lattices or into courtyards. This devotion to interior effects of the fall of light is not the only feature of his approach to subject and composition that reminds us of Vermeer: another is the repetition of elements that were part of his own house. In Lewis's case we meet repeatedly an arched doorway seen against the light. He inscribes a study of a large room for his picture *The Reception* (1873), 'Mendurah in my house at Cairo'. Looking at the strict elevation drawing of this by the architect James Wild – one of several done in Lewis's house by this devoted recorder of Old Cairo – we can see why this room, with its light filtered by elaborate windows and screens, captivated Lewis (Figure 71).

Lewis in fact brings together the typical Romantic role of wanderer with the rarer one of stay-at-home experimenter within the frameworks of classical design: it is in the way that he combines these, in his oriental composition, that a large part of his fascination lies. For classicism as he had experienced it in Europe – in Rome and Florence, which he visited in 1837, two years after publishing his Alhambra lithographs – was a very pervasive element in his art. Unpublished oil sketches by him, now in the Royal Scottish Academy, Edinburgh, reveal that he recorded parts of Early Renaissance compositions by Masaccio and Filippino Lippi in the Carmine church, and by Domenico Ghirlandaio in Santa Maria Novella (both at Florence), showing figures set against architectural backgrounds. The Edinburgh collection also shows that, already in 1834, he had copied the lower half of Velázquez's *Las Meninas* (Prado) and the two small views by the same artist of the gardens of the Villa Medici, Rome, with their strict frontal presentation of architecture and in one case a silhouetted figure. In Egypt he became obsessed with the same subject of figures seen against architecture, often silhouetted in doorways, but also set against the elaborate screen-lattices or *mashrabiyya*, and sometimes with the added effect of light stabbing through these on to the decorated surfaces of tile or drapery. For 11 years, as Ruskin comments – with some point – Lewis never saw a European picture. It became his daring – sometimes perilous – individuality to see the merit of Islamic mesh-lattices as a

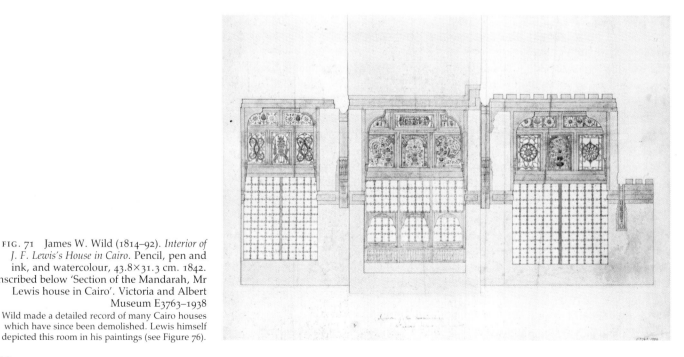

FIG. 71 James W. Wild (1814–92). *Interior of J. F. Lewis's House in Cairo*. Pencil, pen and ink, and watercolour, 43.8×31.3 cm. 1842. Inscribed below 'Section of the Mandarah, Mr Lewis house in Cairo'. Victoria and Albert Museum E3763–1938

Wild made a detailed record of many Cairo houses which have since been demolished. Lewis himself depicted this room in his paintings (see Figure 76).

means both of providing enclosing frameworks for figure compositions and of modifying the incidental forms contained within the frameworks through their own cast shadows. These lattices, splintering light as it passes through, in turn become its toy as it casts their patterns across walls, floors and figures alike.

We may aptly begin to consider Lewis by looking at three works: all interior scenes. The picture *Harem Life, Constantinople* (*c*.1857) illustrates the classical Lewis addressing a langorous romantic theme. One harem woman stands on the

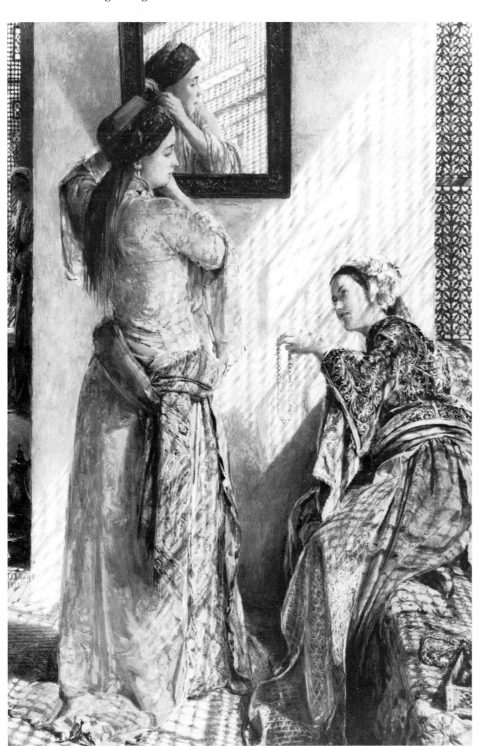

FIG. 72 John Frederick Lewis. *Indoor Gossip, Cairo, A Scene in a Hareem*. Oil on panel, 30.5×20.3 cm. Signed and dated 1873. Whitworth Art Gallery, University of Manchester 0.1.1961

In a number of works Lewis adds a further ingredient to his analysis of appearances: the pattern of light and shadow created by the *mashrabiyya* or screen lattice. This may or may not be outside the picture area but the effect is to bombard the solids with dematerialising cross-patterns, and to set up an interchange between vertical, horizontal and diagonal which lies at the very heart of Islamic pattern-making itself but which Lewis gives rein to in spatial terms.

133

right, her head reflected, along with the feet of another person outside the picture space, in a mirror behind her. We think of *Las Meninas*, of Dutch seventeenth-century painting, and of Ingres, Lewis's older contemporary, whose work he will certainly have been aware of after as well as before the Egyptian sojourn. The woman observes another reclining on the left, who gazes down at a cat, which in turn looks back at the right-hand figure. If we discount the mirror, only a narrow strip of distant landscape on the left-hand edge admits the outside world. What gives a small picture of a claustrophobic theme painted with painstaking detail such a strong sense of space, of expansiveness even? One factor is certainly the way in which Lewis has set the figures against a sequence of rectangles (mirror, line of wall-tiles, total picture shape) which are in ratio to each other. We are reminded once more of the European tradition from which Lewis came. Another device – we will find him using it again – is to clear the centre of the picture of figures. In this case the wall-plane that is revealed carries the vertical and horizontal lines of a tile-border, of four different recurring patterns. By the further device of linking each figure with the verticals that abut this space – of window, curtain and mirror – he can focus their separate identities. The result is a picture that, for all its scented atmosphere, sets up a structure of relationships and reciprocities which raises it high above anecdote.

A later work, *Indoor Gossip, Cairo* (1873, Figure 72), reflects other interests of Lewis: the exploration of colour complementaries and of light. Lewis shared with Delacroix and many other artists of his time a preoccupation with colours which are furthest apart in the colour circle (red-green, blue-orange, yellow-violet), but which enhance each other when juxtaposed and are thus 'complementary'. The Cairo bazaars were full of such effects and he extracts much brilliance from them. He was altogether exceptional, however, in sensing the possibilities of the screen-lattice and its effect on light. In *Indoor Gossip* there are again two women, though they are more intimately related than in *Hareem Life*. One figure holds up a rope of pearls to another. She leans away from us and is caught in light spilling

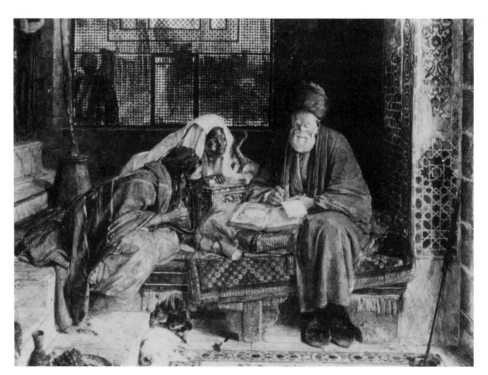

FIG. 73 John Frederick Lewis: *The Arab Scribe, Cairo*. Watercolour, 46.3×60.9 cm. 1852. Private collection
Lewis depicted many aspects of Cairo life, with documentary realism and careful observation of racial type.

downwards from the right: it softly follows the curve of her hand to become held itself as sharp highlights on the pearls. The second woman, crimson-clad, stands with upraised arms adjusting an earring and with her head reflected in a mirror. Both poses are Watteauesque; but the slant of light from the *mashrabiyya*, almost dissolving the leaning woman and varied in the mirror, is pure Lewis.

A third picture, *The Arab Scribe, Cairo* (1852, Figure 73), takes up a theme which Wilkie had painted in Constantinople. Lewis's picture, however, combines a classically balanced foreground group of the scribe and two girls with a background passage of extraordinary daring and technical interest. Here he paints figures indistinctly seen on the *far* side of a lattice, in tiny touches of broken colour. All three primary colours, red, blue and yellow, appear diluted side by side in the upper part of the *mashrabiyya*. We notice, incidentally, that the blue, golden-yellow and green colours in the foreground figures derive from those of the geometrically patterned tiles on the right-hand wall (a pattern found also in the Alhambra). The mixture of tight, classical economy and discipline on the one hand and virtuoso prodigality on the other is not unusual in this artist.

Lewis's Egyptian years, therefore – apart from his personal experiments with observing the intensity of light-fall on pieces of drapery in the courtyard of his Cairo house, as recorded by J. J. Jenkins of the Old Watercolour Society[50] – testify to an attentive response to the life that surrounded him and the interiors in which much of it was lived. These years provided him with enough material for the 25 years of his life that remained after his return to England. The watercolours exhibited by him in London immediately before his return (from 1850), beginning with the large *Hhareem* (divided, part now in Victoria and Albert Museum), created a sensation. 'Every gleam of colour is precious', Ruskin wrote of the watercolour *A Frank Encampment in the Desert of Mount Sinai* (private collection) in 1856; he gave it six out of 12 pages of his notice of the Old Watercolour Society's exhibition of that year.

Lewis's watercolours have a jewel-like clarity which put some critics of his time in mind of oriental painting. *The Times* reviewer of *The Hhareem*, shown in 1850 and cited by Bendiner, saw a Chinese flatness parallel to that of Western medieval painting: 'the Oriental treatment is in a sort of harmony with the Oriental subject'; while Théophile Gautier, seeing the same work in the Paris Exposition Universelle of 1855, was struck by a 'Chinese patience' and, more interestingly, by a 'Persian delicacy'.[51] The influence of Islamic miniature painting on Lewis is a matter for conjecture: no documentary evidence is known to exist on the subject. Lewis represents small Islamic painted texts in certain harem interiors and must have responded to them. He must have seen miniatures also. One work in particular points to similarities and differences. In *Life in the Harem, Cairo* (1858, Figure 74) – which includes a framed piece of Islamic calligraphy – he gives us a remarkable, empty expanse of wall in the centre framed by the verticals of window on the left and doorway on the right, and at the lower edge the horizontal end of the divan, the length of which separates the reclining figure from that entering through the door. As in *Hareem Life, Constantinople*, the figure itself is associated with the verticals of the window. This psychological separation of figures by background horizontals and verticals parallel to the picture plane has notable counterparts in Persian painting: for example, in the Herat School miniature of *Tahmina's Visit to Rustam* (Figure 75) from Firdausi's *Shāhnāma* – this also includes a reclining figure seen against a window-grille and two visitors on the right, one a negro, the other Tahmina in the doorway. Lewis's interior, however, has illusionistic devices such as the mirror reflection of the embroidered cover, which plainly reveals his European

starting-point. The length of Lewis's sojourn away from Europe no doubt disposed him towards un-European effects – Ruskin himself noted that there was something un-European about him. But though he flattens form into patterns and his compositions reflect a fondness for extreme lengths of horizontal and vertical line which are akin to Persian painting, in the end Lewis avoids pastiche and marries his jewel-like dabs of colour to European methods of space-presentation. The edge of the divan in *Life in the Harem* is shown in the mirror reflection clearly going into depth, though deliberately at odds with the perspective of the rest.

Lewis's oil *The Reception* (Figure 76), already mentioned as showing a room in his own house, treats a foreground room which leads to a space beyond. Velázquez has concerned himself with a double space in his *Fable of Arachne* (the *Hilanderas*, Prado), although his brightly lit further room does not show us the many windows of Lewis's, with daylight flooding through. Lewis's work is also

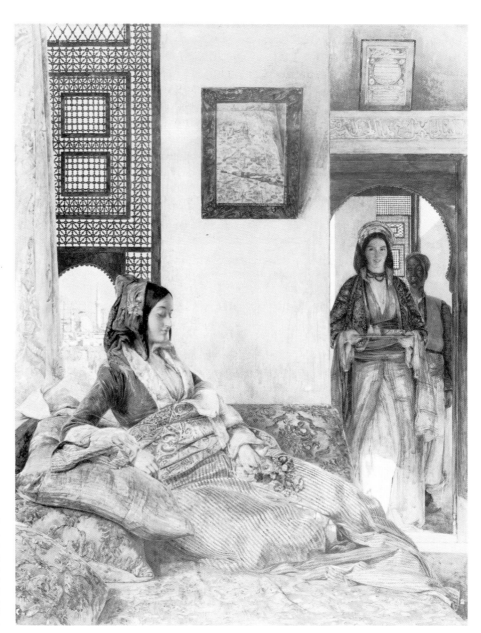

FIG. 74 John Frederick Lewis. *Life in the Harem, Cairo.* Watercolour and body-colour, 60.7×47.7 cm. Signed and dated 1858. Victoria and Albert Museum: 679–1893
One of Lewis's more experimental compositions, a variant of his favourite L-plan. A figure reclines parallel to the picture and wall-plane, and other figures approach on the axis of the spectator. A related effect is shown in the Persian miniature in Figure 75.

worth comparing with the Herat painting *Theologians disputing in a Mosque* (Figure 77). There is the same relationship of small figure-size to setting and the same concern with patterned architectural planes, at different depths, parallel to the picture plane, against which groups of figures can be placed on the diagonal, leading us into depth to a point where a background opening gives on to flowering trees beyond. The Persian painter, however, shows his scene from above: with Lewis, as with Velázquez in *Las Meninas*, we are firmly on ground level and perspective lines recede according to European ways of drawing them. Lewis's interest in surface is nevertheless almost as great as that of the Persian artist. The latter defines his foremost plane with a railing on the right, which stops immediately below the line of the opening into the second space behind: unconcerned with linear perspective he uses a vertical grid of floor-tiles to link the railing and the opening. Lewis introduces a fountain structure to define his foremost plane and places this at a point immediately below the edge of his second space beyond: in this way he too binds his composition and reinforces surface.

It is clear that Lewis preserves strong links with his European heritage. He habitually uses binocular perspective; moreover it is likely that he developed his technique, 'Persian delicacy' notwithstanding, out of a keen concern with watercolour method evolved earlier (which in fact employed body-colour only in half-tones and highlights). Even so, it is highly interesting to observe affinities with Persian practice in the way that he sets figures against a series of planes of different depths which are yet parallel to the picture surface. While he uses the planes in depth to achieve different ends – planar effect can accentuate the play of coloured light and cast shadows over his figures and furnishings – the overall results have a tautness and linearity in common with the Persian miniature.

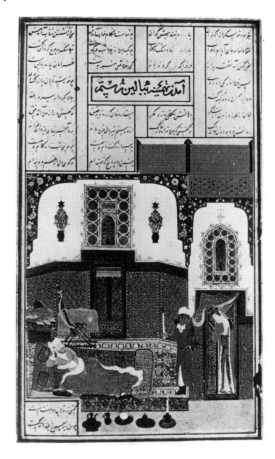

FIG. 75 Miniature. *Tahmina's Visit to Rustam* (Firdausi, *Shāhnāma*). 23×13.7 cm. Persian, Herat, about 1440 (844 A.H.). Royal Asiatic Society, London

By means of horizontals and the abstract shapes of architecture, the Persian artist isolates the two main characters of his story. J. F. Lewis in Figure 74 uses the same means to isolate his harem lady. The Persian artist, however, makes calligraphy an intrinsic part of his design: Lewis, constrained by his European 'realism', confines it within a picture frame at the top right.

137

Among the many remarkable performances that resulted from Lewis's Eastern sojourn, one needs special consideration on several counts. *A Frank Encampment* (Figure 78) may lack climax, but it remains a deeply impressive tour de force in the annals of watercolour. Even if it tempts Ruskin into hyperbole, it fully justifies his admiration for its strong characterisations and 'detail thus united into effective mass'. The virtue of unity is sometimes driven to breaking-point by Lewis in his pursuit of detailed analysis, but in the *Encampment* he posits his main figures in an effective if ambiguous relationship to one another which holds the spectator's attention in a fine state of balance. Upright, darkly pigmented Shaikh Hussain faces reclining Englishman, the latter identifiable as Lord Castlereagh, who made a journey to the East in 1841–2.[52] Castlereagh indicates in a letter to Lewis (10 May 1842) that he commissioned a group from him in Egypt; this work is probably lost, but Lewis's drawings made then no doubt served him well when he painted the picture in 1856. Precise personalities apart, for Ruskin the picture symbolised the encounter of the contemporary travelling Englishman with the immemorial ways

FIG. 76 John Frederick Lewis. *The Reception.* Oil on panel, 63.5×76.2 cm. Signed and dated 1873. Yale Center for British Art, New Haven, Conn.; Paul Mellon Collection. Photograph courtesy Major-General J. M. H. Lewis, CBE. Lewis places the figures in his own house (cf. Figure 71) against a background of verticals, horizontals and diagonals formed by receding perspective lines and the fall of cast shadows.

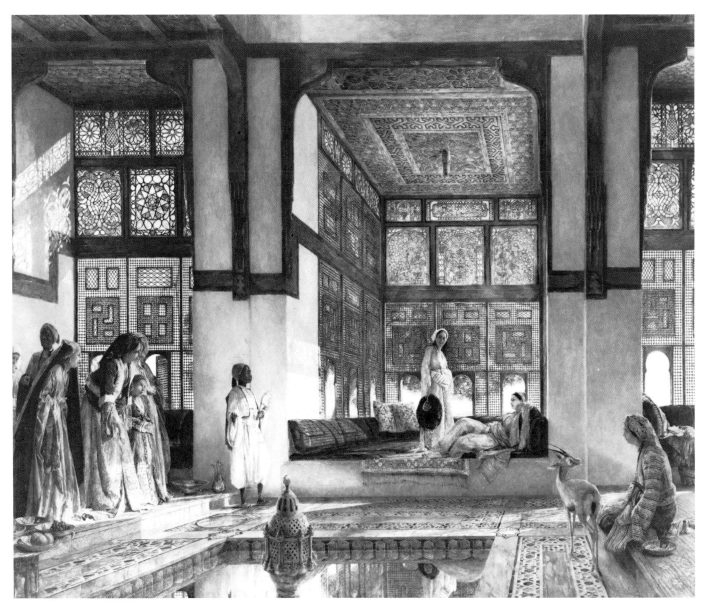

of desert life. The traveller points to a map of 'Syria, ancient and modern': the picture itself 'is a map of antiquity and modernism in the East – the Englishman encamped under Mount Sinai'. But Lewis also enlists our interest in the Shaikh, whose unaffected dignity contrasts with the supineness of the complexly accoutred Westerner. The presence of the Convent of St Catherine, both Christian church and Mosque at different stages of its history may, as Bendiner pointed out, suggest that a harmony between East and West is in the artist's mind. But if this is so, it is a harmony of the status quo, of wary mutual respect rather than of shared understanding.[53] Lewis takes things as he finds them, leaving us to make interpretations: he is no moraliser. The sun shines equally for Lewis's desert-watchers, Eastern or Western. Bendiner also has the interesting theory that Lewis saw the immutable desert as a kind of picnic-ground, in the manner of a Watteau *fête champêtre*.[54] This may be so here: a sterner aspect of desert life, however, is reflected in at least one other picture, the finely pointed *Arab Shaikh* (Fitzwilliam Museum, Cambridge).

Apart from the ambiguities of the subject, *A Frank Encampment* is interesting as a composition, especially in the way that it sets the weight of figures and animals against the delicacy of the vast tent-roof on the right, which is then extended by the spider's web of guy-ropes skimming across to the left-hand edge. The dividing up by these ropes of the space in which the Shaikh stands evokes Persian rather than European attitudes to space-representation: space is seen in terms of adjoining sectors rather than as a continuum defined by perspective. In the Tabriz school miniature, *Majnun brought in Chains to Laila's Tent* (Figure 79), we also find a figure isolated against the darting lines of tent-ropes which literally peg out the space in which he stands, albeit a captive, whereas Lewis's Shaikh is a free if subdued agent. There is no way of telling whether Lewis knew of this or a related painting.

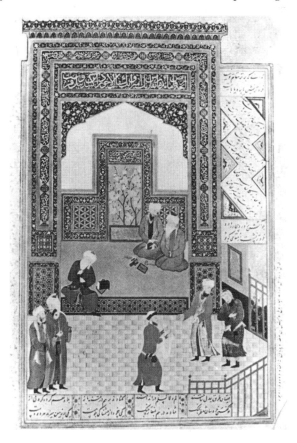

FIG. 77 Miniature: *Theologians disputing in a Mosque* (Sa'di, *Bustan*). 30.5×21.5 cm. Signed Bihzād. Persian, Khurasan (Herat), 1489 (894 A.H.). National Library, Cairo, Adab farsi 908 Working in a different convention from Lewis in Figure 76, the Persian painter ignores perspective; but both of them set their figures at key points in space where verticals, horizontals and diagonals join. The Persian's diagonals at the top right enclose calligraphy; those of Lewis (top left) the distorted lead-lines of stained glass. Cf. pp. 136–7.

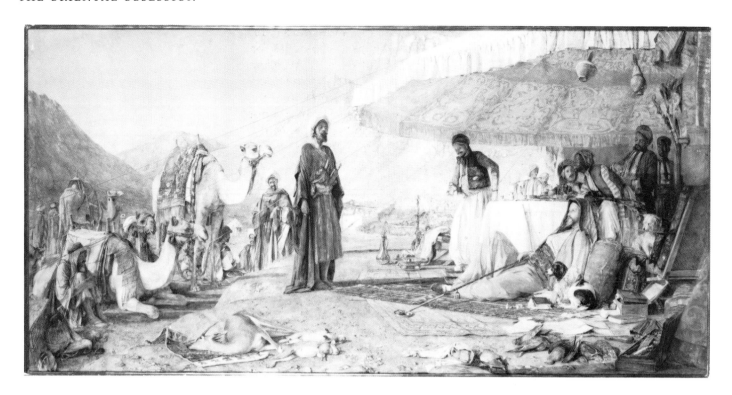

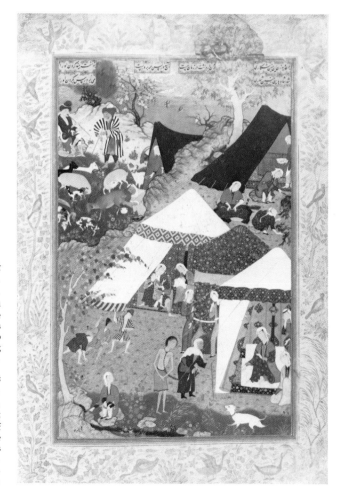

FIG. 78 John Frederick Lewis: *A Frank Encampment in the Desert of Mount Sinai*. Watercolour and body-colour, 64.8×134.3 cm. Signed and dated 1856. Private collection
A work in which Lewis obliges us to probe the feelings of the principal actors. The Arab Shaikh is one of his most impressive figures; he returned to the same relationship of standing and reclining figure in *The Reception* (Figure 76).

FIG. 79 Miniature. *Majnun brought in Chains to Laila's Tent* (Nizami, *Khamsa*). 32×18.2 cm. Persian, Tabriz, dated 1539–43 (946–49 A.H.). British Library, Or. 2265
The diagonals of the ropes crossing the lower half of this composition by Mir Sayyid 'Ali contain the figure of Majnun, much as the Shaikh is contained in Lewis's *Frank Encampment* (Figure 78). The Persian artist takes a high viewpoint however, whereas Lewis elevates his 'hero-figure'.

In *The Reception*, painted nearly 20 years later, Lewis brought the poses of his reclining Englishman and upright Shaikh into closer propinquity. This repetition of favourite poses, another element in his work that links him to Watteau, continues throughout his later life. In *An Intercepted Correspondence, Cairo* (1869, Figure 80) he repeats with minor alterations a whole group of figures from the *Hhareem* watercolour of 1849. But if figures are re-used, the later picture is put together in such a way as to make the whole seem a new invention – and there is indeed much new invention. The *Correspondence* is concerned with the intercepting of a message of love in the form of a bunch of flowers intended for one of the ladies of the harem. In the main, the picture shows us Lewis the European, using scientifically calculated space – L-shaped – to maximum effect. A strong vertical near the centre of the picture divides the two bars of the L, one light, the other dark, though with distant *mashrabiyya* at the end. The key figure of the intercepting woman to the right of this line proffers the flowers, which are placed below the central vertical. So far Lewis could have done all this from a study of Italian Renaissance painting from Piero della Francesca to Veronese. That object-lesson in the art of formal composition, Piero's *Baptism of Christ*, had, incidentally, entered the National Gallery in 1861. But Lewis's memories of Cairo interiors were never more vivid than in this picture. The heads of both the main figures – the intercepting woman and the Pasha on the left – are on the same level, our eye-level: the woman's head is inclined towards us, its nearness and roundness stressed by the patterned squares and flatness of the distant lattice. Besides being the object of the Pasha's attention, the woman's face gathers up the lines of perspective from the right of the composition: while her gaze delivers them to what is the vanishing-point for us, the onlookers, precisely at the centre of the

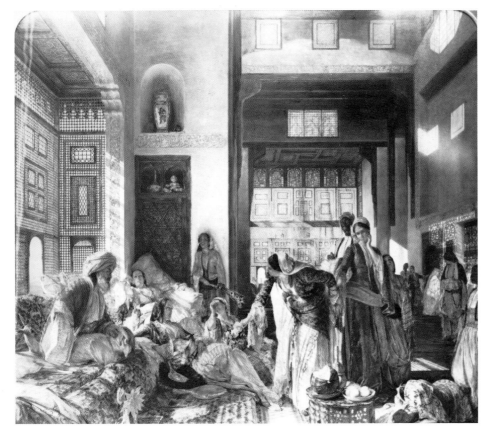

FIG. 80 John Frederick Lewis. *An Intercepted Correspondence, Cairo*. Oil on panel, 51.4×89 cm. Signed and dated 1869. Private collection
The left-hand group comes from Lewis's watercolour *The Hareem* of 1850: The central woman, the pivot of the composition – moving forwards and bending – is set against a complex *mashrabiyya* screen through which buildings are visible. The distant right-hand scene, with figures placed in shadow and in light, and the reflections of the stained glass from Lewis's own house, is one of his most dazzling virtuoso feats.

141

whole picture. Such 'doubling', in the interests of an overall lucidity, occurs not uncommonly in Piero's work and in Florentine painting of the late Quattrocento. Combined, as Lewis combines it, with a tapestry-like spread of painted oriental dress fabrics rioting across the entire foreground, and huge rectilinear spaces above, the effect is extraordinary.

In *A Mid-day Meal, Cairo* (1875, Figure 81), Lewis the European, seeking the unified perspectival effect, and Lewis the Oriental, fascinated by mosaics of colour, work together more uneasily. Here he employs the device used so effectively by Piero, but also by Florentine Quattrocento painters, of a central column leading back in steep perspective to another behind it, thus dividing the composition into two halves or sections. Ghirlandaio had used a colonnade, off-centre, in this way, in his *Birth of the Virgin* (Cappella Maggiore, S. Maria Novella, 1491), a painting which Lewis had studied in 1837; he had also introduced, like Lewis, a subsidiary scene on a different level, unifying the picture with his foreground group. Lewis, however, attempts a problem of near-insoluble difficulty, that of devoting each *half* to a different level, a balcony to the left and a distant courtyard to the right. He fails to unify his work, almost inevitably, but the beautifully deft little scene of figures and animals in the courtyard holds together unimpaired. This is the familiar courtyard of Lewis's Cairo house. His study of the fall of sunlight has enabled him to paint here largely in the upper half of the tonal register: different colours of the same tone denoting changes of subject – horse or turban – seen from above with the clarity and delicacy of a Tabriz miniature.

There remains a further consideration, a technical one. Both the *Correspondence* and *A Mid-day Meal* are oils. In 1857, a year after *A Frank Encampment*, Lewis had turned almost entirely to oil painting. He was to practise the technique, with the same finesse that he had developed for watercolour, for the rest of his life. An oil version of the *Encampment* was shown at the Royal Academy in 1863. Oil and watercolour versions of *The Reception* belong to the same year, 1873; the water-

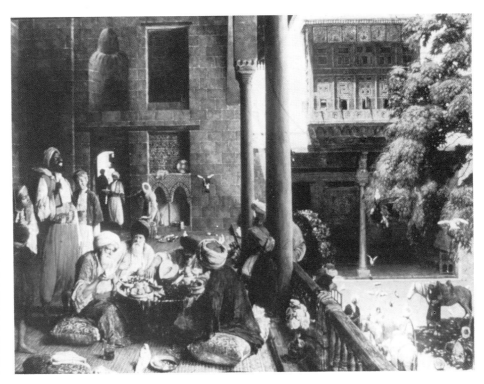

FIG. 81 John Frederick Lewis. *A Mid-day Meal, Cairo*. Oil, 87.6×115.6 cm. Signed and dated 1875. Private collection
Lewis was often attracted by the varying qualities of light as seen in the deep, balconied courtyards of Cairo houses. This composition is divided between shadowed upper level and brightly lit lower level by a line of columns, this last device adapted from Italian Quattrocento painting. The courtyard is that of Lewis's house, where he is recorded as studying the fall of light on pieces of drapery (see p. 135).

colour includes more figures on the left and differences of detail. There is no doubt that Lewis also developed a meticulous concern to make his oil paintings absolutely level surfaces, like the watercolours: soon after his return to England, indeed, he is recorded by Holman Hunt castigating Millais in the street for 'unseemly loading' of his canvas with paint.[55] This desire doubtless further nourished his liking both for compositions with flat or low relief wall-elevations parallel to the picture plane and for the patterns of Islamic art. After he began to concentrate on oils in 1857 it is likely that this was the inexhaustible challenge: to set these patterns against the corporeality of figures and render both as a totally integrated surface.

We cannot leave him without a look at his last major picture, *The Siesta* (1876, Figure 82; watercolour in Fitzwilliam Museum, Cambridge). Here, a woman – no doubt his wife Marian, who modelled so frequently for him – lies on a couch, above which a brilliant green curtain billows. In one respect the work is puzzling: it is clearly not 'finished' in Lewis's sense that it presents an absolutely level surface of continuous pigment – parts indeed (the forearm supporting the head, for example) are summarily indicated. Yet it is signed and dated. It shows Lewis's old loves, notably colour complementaries, which are superbly judged. The figure wears the red and green that had appeared so often before: on the right an orange-yellow table-cloth is offset by bluish-white Imari flower-vases, from which poppies flame against the edge of the green curtain. This last reveals all the artist's old daring. If by now we accept the inclusion of intricately patterned tiles of different colours modified by cross-shadows, what other artist in Victorian England would have set himself to paint a large work in which approximately one quarter of the surface, in the middle of the top half, is occupied by an oblong of green curtain which transmits the distorted shadows of lattices behind? Metrical order and the tremor of atmosphere are both present. The left-hand vase of the

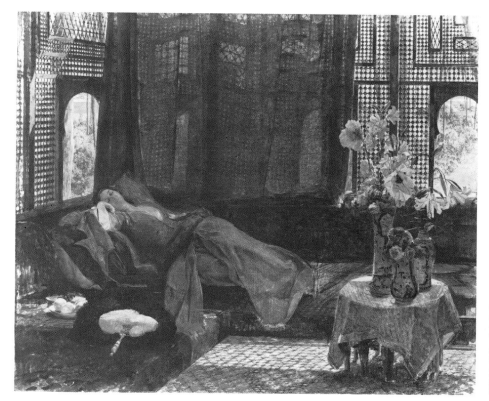

FIG. 82 John Frederick Lewis. *The Siesta*. Oil, 96.2×111.2 cm. Signed and dated 1876. Tate Gallery, London 3594
At the end of his life, with Cairo still shimmering outside the windows, Lewis introduces more movement in setting and accessories than is usual, perhaps to emphasise the stillness of the only figure. The billowing curtain, the slightly oblique drive into depth of both axes of the room, and the dynamics of the porcelain vases, all contribute to this. The picture is an essay largely in the complementaries, green and red, which Egyptian dress had so impressed on him.

143

group may have been a kind of module: not only is its bright edge the most important stabilising vertical in the picture, but its length goes four times into the picture's height and five times into its width. All this European proportionateness is, however, subordinate to the stirrings of strong colour and of direct and filtered light.

While Lewis's talent was a singular one, his passion for Egyptian subjects, however, was widely shared. In her essay 'The Victorian Vision of Egypt' in the catalogue of the Brighton Museum exhibition *The Inspiration of Egypt* (1983), Briony Llewellyn quotes the revealing remark of Lucie Duff Gordon (from her *Letters from Egypt 1862–1869*): 'This country is a palimpsest, in which the Bible is written over Herodotus, and the Koran over that.' Artists uncovered evidence of all three levels. Lewis remains the greatest of the immense number of British painters of desert, bazaar and harem subjects, and the monuments of the older Egypt, which were to appear regularly in exhibitions well into the twentieth century. Some of these works look pale beside his assured draughtsmanship; some swelter in sentimental anecdote (Frederick Goodall's *New Light in the Harem*, oil 1884, Walker Art Gallery, Liverpool, hardly avoids this). Other productions, however, show sturdy qualities of their own. Edward Lear (1812–88) and Thomas Seddon (1821–56) were in Egypt in 1853; within a week or so of each other, apparently, both drew Richard Burton, recently back from Mecca and Medina, in his Arab dress (Lear, Figure 83, perhaps copying Seddon's drawing, Fine Art Society, London). Seddon then went to Palestine with Holman Hunt. He revisited Egypt in 1856; and died the same year in Cairo. His fine sense of pictorial design in desert scenes must surely have been helped by a knowledge of Lewis's work. Another lamentably short-lived artist was the British-born William James Müller (1812–45), who was in Egypt in 1838 and again in 1844. His experience of

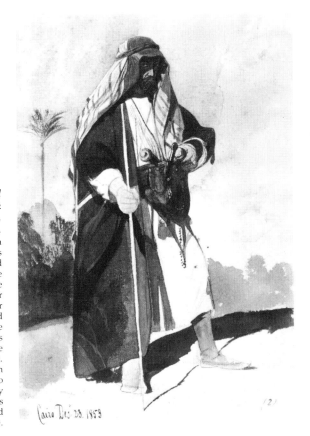

FIG. 83 Edward Lear (1812–88). *Richard Burton in Arab Dress*. Watercolour, 22.9×16.2 cm. Dated Decr. 23, 1853. Houghton Library, Harvard University, Cambridge, Mass. Lear visited Egypt first in 1849 and returned there in 1853. This bold drawing – one of Lear's few portraits – shows the famous explorer shortly after he had completed his journey to Mecca and Medina, the sacred cities of Islam. Burton appears in the same pose, but with a camel behind him, in a watercolour by Thomas Seddon, which Seddon tells us in a letter of 30 December 1853 (*Memoir*, 1858, 32) that he had just produced, having met Burton earlier in the month. He also painted an oil version of this portrait, which he left behind in Egypt. In the same letter, Seddon says that Lear has arrived in Cairo. Lear, however, makes no reference to his Burton portrait in his diaries and its relationship to Seddon's work remains unclear. Burton obviously liked the pose. Lear makes much of the elusiveness of Burton's character in the deeply shadowed treatment of the face.

the East, as with Roberts, drew out the best in him, and a marvellously dramatic best this is: he can deal effectively with the awnings and torn roofs of Arab street markets, infusing Rembrandtesque chiaroscuro with reverberant colour (Figure 84).[56] Müller's *Carpet Bazaar* is the extreme statement of the extremes implicit in the subject of long, dark perspectives interrupted by patches of brightness where light strikes downwards. One of Lewis's last works, *The Street and Mosque of Ghooreyah, Cairo* (1876), was to be concerned with the same effect.

One artist for whom Egypt evoked a multitude of memories was Richard Dadd (1817–83). He was there with his patron Sir Thomas Phillips in the winter of 1842–3, when the first signs of his madness became apparent. Later in life, from his confinement in Bethlem Hospital, he invented works which drew freely on his impressions of this visit.

Dadd and Phillips had reached the Near East after a tiring journey through Italy, Greece and on to Smyrna, Constantinople and Rhodes. They then travelled to Damascus – 'this emporium of artistic wealth', as Dadd described it in a letter to W. P. Frith – Jerusalem, Jericho and from Jaffa to Alexandria. In Cairo they made contact with Lepsius and Joseph Bonomi, who were studying the Pyramids and, as we noted, they met J. F. Lewis. Dadd spent much time wandering about the cities and observing the religious fervour of their inhabitants. He also studied ancient Egyptian religion; and returned home insane and imbued with the conviction that he was an instrument of the will of Osiris, a delusion which seems to have afflicted him for the rest of his life.[57]

The expanding shapes of ancient Egyptian papyrus and lotus capitals are combined with unusual ogee arches (in fact very un-Egyptian) and arabesque in the drawing inscribed 'Fantasie de l'Hareme Egyptienne' and dated October 1865, now in the Ashmolean Museum (Figure 85). In the foreground of this,

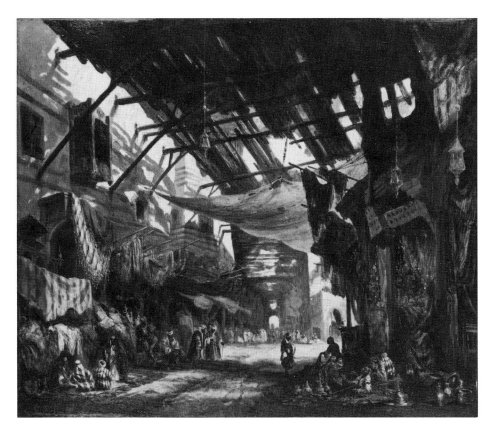

FIG. 84 William James Müller (1812–45). *The Carpet Bazaar at Cairo*. Oil on panel, 62.2×74.9 cm. Signed and dated 1843. City of Bristol Museum and Art Gallery K509
Müller travelled to Greece and Egypt in 1838. This work shows his quality as a transcriber of the blocks of strong colour and tone, with people absorbed into them, which characterised the bazaars. The approach reflects Rembrandt, as does the composition, but the colour has a sumptuous fullness which is Müller's own.

among fruit, flowers and musical instruments, we find a tense foregathering of figures, predominantly female, which occupy a field of force as potent as that surrounding the enigmatic 'débutantes' of Fuseli of 60 years before, or the formidable enchantresses with which Gustave Moreau was just about to confront Paris. The pent-up intensity of Dadd's group is, however, movingly emphasised by the contrast with the calm Nile riverscape in the background. Immediately behind the figures there hovers a series of bizarre arcades parallel to the picture plane. Did Dadd think back to Lewis's Alhambra courtyards where this effect of arches in depth is also presented (Figure 67)? But Dadd's arcades are the stuff of contradictions. All the arches are pointed in shape; but in the middle arcade,

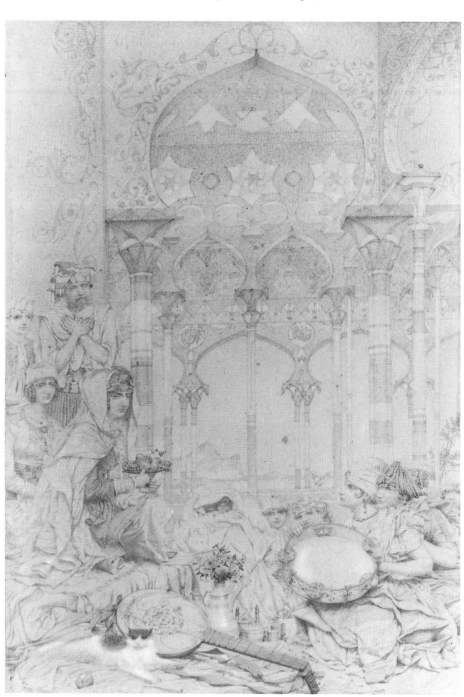

FIG. 85 Richard Dadd (1817–86). *Fantasy of the Egyptian Harem*. Watercolour, 25.7×17.9 cm. 1865. Ashmolean Museum, Oxford E346. Courtesy of the Visitors
This was one of the results of Dadd's never-forgotten visit to the Near East in 1842–3. A surviving sketchbook reveals something of the visual excitement of the trip, and letters convey the close study of Arab life that Dadd made. It was while he was in Egypt that he experienced the first symptoms of the mental illness which was later, after the murder of his father, to confine him to Bethlem Hospital, where he did this drawing.

two are placed in a bay-width required for only one in the furthest arcade, which, however, has double columns in contrast to the high single one of the middle arcade. Bulky stars and three-dimensional vegetable curves push restlessly into the space of the nearest arch, which is, by contrast, bordered with scrolling arabesques of the most tenuous delicacy.

Later artists and travellers who went independently to Egypt include Frank Dillon (1823–1909) and John Dibblee Crace (1838–1919). Dillon made several visits from 1854 into the seventies, and developed a Lewis-like interest in *mashrabiyya* lattices.[58] Crace, grandson of the decorator of Brighton Pavilion, was in Syria and Egypt (including Nubia) in 1868–9, and notes of interior ornament record his stay (Figure 86). The Sessional Papers of the Royal Institute of British Architects for 1870 contain his lecture of that year on 'The Ornamental Features of Arabic Architecture in Egypt and Syria' (p. 73), for which he used his own watercolours of Cairo houses and mosques – notably the house of the Chief Mufti and the Mosque of Qa'it-Ba'i – as illustrations.[59] The architect William Burges, who will concern us later, was an interested listener.

Among artists working after 1860 who based paintings of Arab subjects on first-hand experience of the Near East, we must also notice Frederick Goodall (1822–1904) and Carl Haag (1820–1915). (The latter was Bavarian-born but settled

FIG. 86 John Dibblee Crace (1838–1919). *Cairo, Private Houses*. Pencil and watercolour on three sheets, each 23.6×17.9 cm. Signed on mount, and inscribed on mount 'Ceiling Decoration – Cairo'; inscribed on drawings (top) 'House of the Sheikh of the Mufti'; (lower left) 'House of the Chief Mufti'; (lower right) 'Ceiling in House formerly Brit. Consulate Damascus'; and colour notes. Drawings Collection, British Architectural Library, RIBA, London
Crace visited Syria and Egypt in 1868–9. He made a number of drawings of the decoration in the Mosque of Qa'it-Ba'i and the house of the Chief Mufti (magistrate).

147

in England from 1847.) Goodall was in Cairo in 1858 when he met the newly arrived Haag. The two artists lived in the Coptic quarter; Haag made a watercolour of their shared studio, showing their works hanging on either side of a central *mashrabiyya* lattice (1859, Mathaf Gallery, London). Back in England Goodall specialised from 1860 in Near Eastern subjects; he was to revisit Egypt in 1870–1. After a period living with the Bedouin, Haag returned to England in 1860 and also exhibited Eastern subjects, especially at the Royal Watercolour Society. His *Interior of a Copt House* was in the Royal Academy of 1880. Both artists drew for documentation, like Lewis, on Arab dress and artefacts acquired in Egypt. Goodall had these in his home at 62 Avenue Road, Regent's Park, until his death, and *New Life in the Harem* (1884) no doubt incorporates some of them.[60] In 1867 Haag set a new studio in his Hampstead home as an oriental interior described in the *Art Journal* of 1883 as 'Cairo in London'.[61] He also made another visit to Egypt, in 1873, bearing this time an introduction from the Prince of Wales to the Khedive.

Five years earlier, the Prince had provided a similar introduction for Frederic Leighton, later Lord Leighton PRA (1830–96), who had sailed up the Nile in a steam-yacht placed at his disposal by the Egyptian ruler. On the same journey of 1868, the year before the opening of the Suez Canal, Leighton met the engineer responsible for it, Ferdinand de Lesseps. The British painter used the visit to enlarge the collection of Islamic tiles that will concern us again in the next chapter. A visit of 1873 to Damascus was also productive. Leighton then made studies of a *minbar* (pulpit) and a hanging lamp (among other details, contained in a notebook now in the Royal Academy, London). These provided detail for his picture *Interior of the Grand Mosque, Damascus* (1873–5, Figure 87), which effectively places the high *minbar* on a long vertical above the figures of two Arab children. Leighton was to take advantage of the popular appeal of Arab scenes with figures, and described his oriental subjects as 'fatal inevitable potboilers' with which he could cover expenses. Another picture, *Old Damascus: Jews' Quarter* (oil, 1873–4, private collection), shows lemon-pickers: but an arcade on the right-hand side displays exactly rendered Islamic star patterns on the soffits. Two slighter works, *Study: at a Reading Desk* (oil, 1877, Emma Holt Bequest, Sudley) and *Music Lesson* (oil, c.1877, Guildhall Art Gallery, London), give evidence of the collection of Arab objects acquired by Leighton during his Eastern journeys.[62]

Leighton's figures in these oriental works are European, as one would expect from a convinced Hellenist: but he was to take up the Eastern garden theme also. Lewis had dealt with this dazzlingly in two works, *In The Bey's Garden* (oil, 1865, Harris Museum and Art Gallery, Preston) and *The Lilium Auratum* (oil, 1871, shown at the Royal Academy of 1872, now Birmingham Museum and Art Gallery; watercolour, 1871, private collection). Leighton's lovely *Moorish Garden, or A Dream of Granada* (oil, 1874, College of Advanced Education, Armidale, New South Wales, Australia) incorporates the same idea of a woman in oriental dress among flowers. The work underlines the continuing attraction of Moorish Spain: the picture was based on the garden of the Generalife, visited on his way home from Damascus in 1873.

Besides Egypt and Spain, Palestine also became a goal for British artists, particularly those who, sharply different from Lewis, went East to gather material for biblical pictures. The revival of Christian fervour in Britain from the 1830s onwards was reflected by a growing demand for religious paintings and illustrations of the places associated with the life of Christ. Many of these would be engraved, published in books, periodicals and almanacs and reach a public

that could be reckoned in millions. Artistically outstanding in the field of illustration of Palestine but also having great documentary fascination were the drawings of David Roberts, done during his tour of 1838–9, lithographed by Louis Haghe and published as *The Holy Land, Syria, Idumea, Arabia, Egypt and Nubia* and (separately) *Egypt and Nubia* (1842–49), with historical descriptions by the Reverend George Croly and William Brockedon. The Queen, the two Archbishops and the Bishop of London subscribed and Roberts received £3,000 for the use of his drawings.[63] Turkey could also enlist the interest of Christian writers through its associations with the early Church: Thomas Allom (1804–72) had been sent to Constantinople in 1836 to produce views for *Constantinople and the Scenery of the Seven Churches of Asia Minor* (1838–40), with text by the chaplain at the British Embassy to the Porte, the Reverend Robert Walsh.[64] The Finden

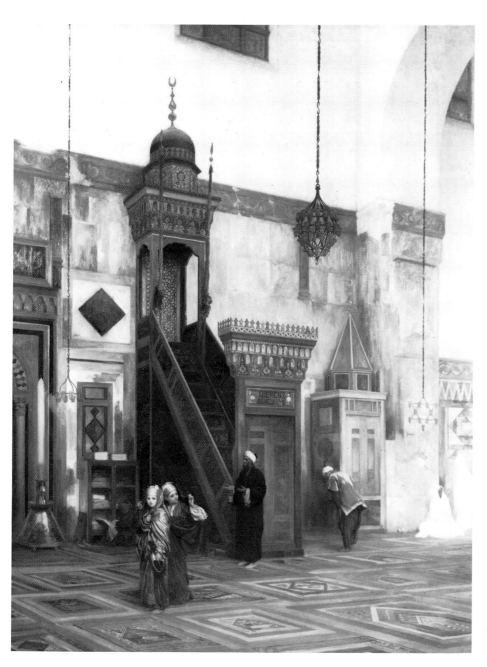

FIG. 87 Frederic, Lord Leighton (1830–96). *Interior of the Grand Mosque, Damascus*. Oil, 158×120 cm. 1873–5. Harris Museum and Art Gallery, Preston. 366
This atmospheric painting, with its prominent view of the *minbar* or pulpit and closely observed figures, also preserves the appearance of the mosque before the fire of 1893.

Brothers published *Landscape Illustrations of the Bible* in 1834–7, with descriptions by the Reverend Thomas Hartwell Horne. Dr John Carne's *Syria, the Holy Land, Asia Minor etc.* (3 vols., 1836–8) contained 107 plates, 94 of them by William Henry Bartlett (1809–54) and nine by Allom.[65] Bartlett was one of the most prolific of the topographical artists of the time to work in the East. As he recounts in his book *Forty Days in the Desert* (1849), he had even slept in a tomb at Petra. He made in all five trips, dying during his return from the last.

While most of the documenters of the Bible were simply talented topographical draughtsmen, others were figures of greater stature – knowing what they wanted, but ready to modify in front of the reality: fuelled by their own *idées fixes*, but themselves worked upon by their Eastern experiences.

David Wilkie (1785–1841) arrived in Constantinople in October 1840, and went on to the Holy Land in February of the next year. Wilkie essentially saw himself in the European figure-painting tradition of the Venetians and Rembrandt, and he was never, like J. F. Lewis (whom he met in Constantinople) to become seriously involved in the study of Islamic design. But he was by nature drawn to explore

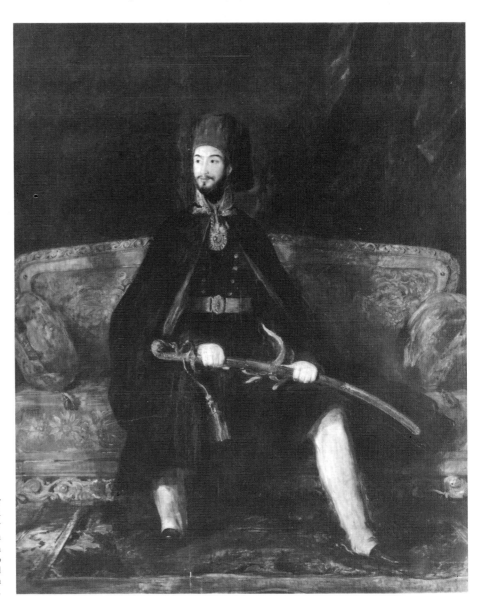

FIG. 88 Sir David Wilkie (1785–1841). *The Sultan Abd-ul Mejid*. Oil on panel, 80.7×58.4 cm. 1840. Buckingham Palace. Reproduced by gracious permission of H.M. The Queen
One of the most fascinating portraits to come from the brush of this detached but observant visitor to the eastern Mediterranean. Despite protracted sittings, the Sultan expressed much satisfaction with the final result.

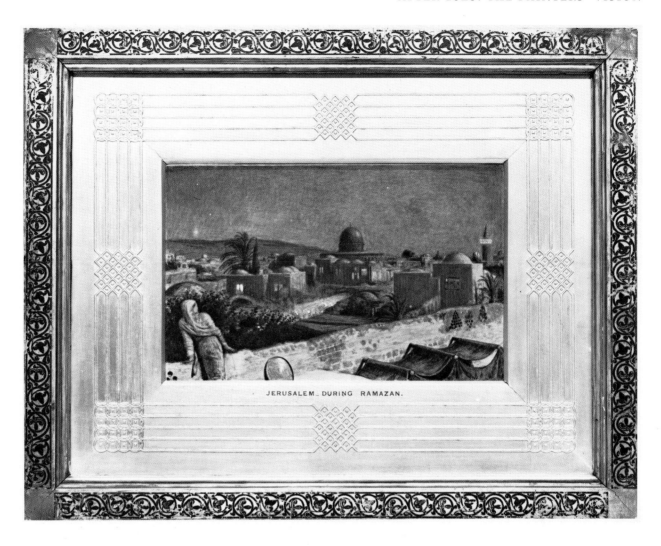

JERUSALEM_DURING RAMAZAN.

unfamiliar territory, and had earlier made a fruitful visit to Spain. In Constantin-
ople he busied himself with a number of portraits, which included Turkish and
other Muslim sitters. In late October he was working on his *Turkish Letter-writer*
(oil on panel, Aberdeen Art Gallery), carrying out drawings for the Prince Haliku
Mirza, and drawing Mustapha, the Albanian servant of the British Consul,
Cartwright. Many of the drawings, including those of Haliku Mirza (Aberdeen
Art Gallery) and of *Sotiri, Chief Albanian to Mr Colquhoun* (Ashmolean Museum,
Oxford), testify to Wilkie's alert response in the East to the primary colours in
dress and accessories. Many also translate attractively into lithographic form in
his posthumously published *Oriental Sketches*. The portrait of Abd-ul Mejid,
Sultan of Turkey (1840, Figure 88), in particular evoked a lively response in him:
legs splayed, the Sultan gazes edgily to the left, sword on lap; the lines of the
figure rise sharply to the tiny, intense head as the curves of sofa and sword drop
away. At Alexandria, on 4 May 1841, Wilkie began to record the likeness of
Muhammad 'Alī, ruler of Egypt. The resulting portrait (Tate Gallery) reasserts the
strength in his art, within weeks of his death, of the umbrageous chiaroscuro of
European tradition.

Curious and open-eyed to the end, however, Wilkie had come to Palestine – as
he writes to Sir Robert Peel in a letter of 18 March 1841 from Jerusalem[66] – to gain
material for his Christian subjects and to study peoples who had changed little

FIG. 89 William Holman Hunt (1827–1910).
*The Mosque As Sakreh, Jerusalem, during
Ramazan.* Watercolour heightened with
body-colour, 22.3×35.6 cm. 1854. Whitworth
Art Gallery, University of Manchester
D14.1937
Hunt drew the Dome of the Rock by moonlight from
the roof of his house in Jerusalem. In common with
most of his eastern scenes this has a high viewpoint.
The frame, designed by the artist, combines a
flowing arabesque (outside edge) with a simplified
version of geometrical cross-banding also developed
from Islamic ornament.

151

since Biblical times. The pale profile of Prince Haliku Mirza is presently transposed into the face of Christ for a planned *Ecce Homo*.

Another major figure with an ambivalent relationship to our theme is the Pre-Raphaelite William Holman Hunt (1827–1910), an artist of real originating power. In 1854, after three months in Egypt, Hunt undertook his famous journey to the Dead Sea to paint its landscape as the background for his *Scapegoat* (Royal Academy 1856). Hunt retained an overwhelmingly Bible-based interest in the Near East throughout his life, returning there in 1869, 1875 and 1892. But it is noticeable that from 1854 his concern for the topography of Jerusalem extended to Islamic architecture, and from thence to incorporating motifs in the picture-frames that he designed for works with both Islamic and Christian subject-matter. The watercolour *The Mosque As Sakreh* (Figure 89) shows both features. We shall meet him later (p. 162) studying in Owen Jones's Alhambra Court.[67]

An artist who became a celebrity for his biblical pictures, Frederick Goodall (1822–1904), tells us in his *Reminiscences* (1902) that he first visited Egypt in 1858–9 with the 'sole object' of painting scriptural subjects, but as we have seen he did not keep to it, and he does not seem to have felt the need to go on to the Holy Land. But many Old Testament subjects shaded easily into genre, and could accommodate an Egyptian setting. It is obvious that in the course of such Bible-centred expeditions much detail of Islamic life, architecture and decoration would be picked up. More important, the religious needs of the Victorians at home were steadily making it possible for Islamic motifs by direct association with the Holy Land to become familiar.[68]

As well as the picture galleries and Roberts's noble but expensive volumes, there were the photographic albums of Francis Frith (1822–98), which began to appear in 1858 with the title *Egypt and Palestine Photographed*. The importance of the new art of photography as a means of becoming informed about distant places cannot be overestimated.[69] But this was the great age of widely circulating periodicals (the *Illustrated London News* had begun publication in 1842), containing illustrations in them by down-to-earth engravers of facts recorded by draughtsmen. Millions who would never go East themselves desired clear-cut factual ideas of Islamic life from popular magazines. William Simpson (1823–99), an early war reporter-artist who was present at the Crimean campaigns, was in India from 1859 (after the Mutiny) until 1862 (returning via Egypt); and covered the Prince of Wales's tour of India in 1875–6.

The Prince of Wales's foreign tours are milestones in the history of British interest in the East. He visited Egypt in 1862 and 1889, and his journey to India in 1875–6, the year before Queen Victoria became Empress of the sub-continent, placed the seal on the long development of Anglo-Indian relations of which we have noticed the important eighteenth-century stages.[70] India manifestly offered uniquely intimate opportunities for Britons to become acquainted with Muslim life. Dozens of artists were active there in the period of supremacy of the British Raj, which began after the defeat of the Marathas and Gurkhas, and was being consolidated by 1820. By then, the East India Company was ceding its leading role in events to new investigators who were administrators and surveyors. William Jones's scholarship more than 20 years before had set the example for the serious collecting of fact which was put in hand as an essential ingredient of the business of efficient government. Hindu life and history continued to claim attention: Muslim India, especially from the 1830s, came under renewed scrutiny. On the levels of scholarship, monuments were listed and inscriptions deciphered; for more general consumption, topographical drawings of famous places were made and coloured illustrations of the different

peoples and castes of India were brought home as souvenirs by returning government officials.

Typical figures of the new age of British India were Colonel Robert Smith (1787–1873) and James Prinsep (1799–1840).[71] Smith was an officer in the Bengal Engineers who was responsible between 1822 and 1830 for the restoration of the major buildings of Delhi, notably the Jami' Masjid, the great work of Shah Jahān, and the famous tower, the Qutb Minar, which Smith controversially crowned with a replacement cupola (no longer surviving) of his own design. Smith's landscaping of the Qutb site, however, clearing away squatters' huts and providing for its maintenance, was successful. His watercolours show his competence as a draughtsman: a good example is *Aurangzeb's Mosque, Benares* (1830, in the India Office Library, London). After retirement in 1831 he built Indian-style houses (both surviving) for himself in Paignton (Redcliffe, 1853, said to be orientated towards Mecca) and Nice (Château Smith, 1858).

The civil servant and draughtsman James Prinsep arrived in India in 1819 and up to 1830 was mainly working at Benares, where he became Assay Master of the Mint and provided the city with new sewers. He then became increasingly concerned with scholarship, notably the decipherment of ancient inscriptions. His attractive draughtsmanship, however, is well shown in the three parts of his *Benares Illustrated* of 1831–4.

One type of book which could almost certainly guarantee success was that illustrating views associated with the wars, notably those in Mysore and with the Marathas. One of the finest was Robert Colebrooke's *Twelve Views in Mysore* (reissue of 1805, published by Edward Orme). Numerous books of Indian views were to appear in the Victorian period.[72]

By the 1820s, however, some unfavourable symptoms were disclosing themselves. Mildred Archer has described in the catalogue *India Observed* (1982) how the open-minded, intellectual curiosity about India that had marked the attitude of men like Warren Hastings was to a great extent to be superseded after 1820 by the money-making ethos of the merchant and planter on the one hand and the evangelising Protestant spirit, with its ingrained distrust of the arts, on the other. Her collaborator Ronald Lightbown, in the same catalogue, has drawn attention to the tendency of many who read certain writers – notably James Mill in his influential *History of British India* (1817) – to see India as basically a corrupt and moribund society in need of the benefits of British rule. Though Charles Wilkins's successor at the East India Company Library, Horace Hayman Wilson, countered Mill, the latter's arguments carried much conviction. In the absence of fresh objective encounters and the chance of relaxed social contacts between Britons at home and the Indians themselves, the romanticised imagery of India presented in Moore's *Lalla Rookh* (in its fifth edition within eight months of publication, also in 1817) could, and did, live on. The observer at home might increasingly wish to see the modern Turk, Moor and Egyptian with greater truth: with India there was the factor of distance; the relationship was between rulers and ruled; and the curiosity aroused by undocumented Spain and the Bible lands did not work so strongly.

Such considerations may help to explain the relative failure, in terms of popularity, of the same H. H. Wilson's *Oriental Portfolio*, a collection of illustrations of India, which ran for only two issues (1839–40). This was despite the fact that the *Portfolio* contained beautiful lithographed drawings by David Roberts (later to become famous for his book on the Holy Land), after original sketches by Thomas Bacon.

Even so, India did have its own irresistible attractions, notably splendid court

ceremonies and traditions, among which the durbar (*darbar*) or 'levée' took a high place. We shall come to the architectural versions of the 'Durbar Hall', or Hall of Audience, in the next chapter. The painter who did most to record the actual ceremonies was Frederick Christian Lewis (1813–75). Brother of John Frederick, his own Eastern sojourns were, after an early visit to Malta, Constantinople and Persia, spent in India, from 1839 to 1849, and in the years 1851–5, 1863–6 and 1874–5. His *darbar* (durbar) scenes (examples are in the India Office Library) are *tours de force* of documentation, complete with visiting envoys and servants bearing *morchals* or peacock feather fans.[73]

India also, of course, possessed one of the most remarkable buildings in the world, the Taj Mahal (Figure 90). To the American Bayard Taylor in the 1850s this was anthropomorphically speaking the 'perfect type', where the Alhambra recalled the 'scattered limbs, the torso'.[74] Nothing is more fascinating in the story of Western reactions to Islamic architecture in this period than to note the gulf of difference separating responses to the highly regarded and much-copied Alhambra and to the equally highly regarded but little-copied Taj. Whereas the Alhambra presented to the world a crumbling irregular exterior, settled on its rock, which made it an ideal example for exponents of 'Picturesqueness', the Taj

FIG. 90　The Taj Mahal, Agra. 1632–about 1650. Photograph courtesy of Tom Holder
The Taj Mahal, 'crown of the locality', was built by Shah Jahān as a burial place for his wife Mumtāz-i-Mahal: he is also buried here. The plan is a square with angled corners. Though each façade consists of the same basic elements arranged round a large central arch within a rectangular frame (the Muslim *pīshtāq*), different views present an immense range of variations in the relationships of the dome to the mass below, to the roof-top kiosks and to the four corner minarets. In its proportions, and its balance of unadorned whiteness with carved and inlaid decoration, the building marks the high point of Mughal architecture.

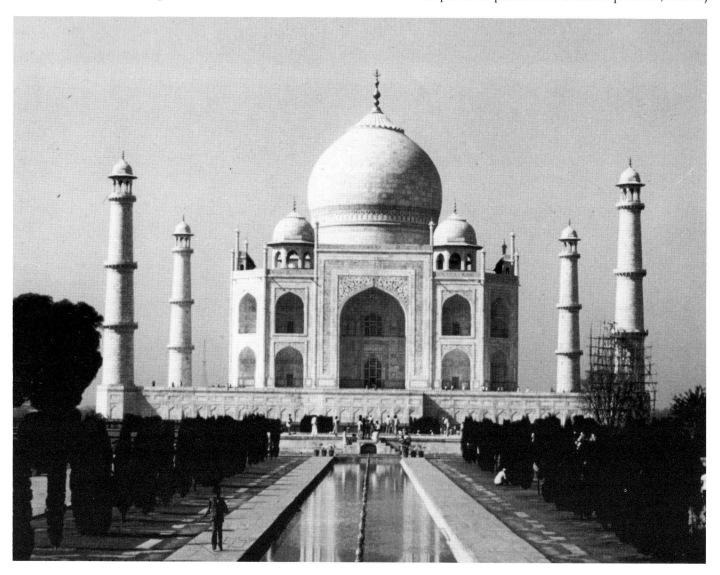

impressed everyone by its formal symmetry and perfection. Almost every visitor (including the 'Picturesque'-minded Thomas Daniell) seems to have commented on the need for repairs to maintain that completeness.

In the 1790s this quality of formal perfection had also impressed Thomas Twining of the Bengal Civil Service. He stayed in a pavilion at the corner of the grand terrace: 'I . . . rambled about every part of the Tage itself, enjoying a feast that seemed too great for me alone . . . Nothing in architecture can well exceed the beauty of this structure viewed from my pavilion'. Mrs Postans (wife of a Lieutenant who took a major role in transcribing rock inscriptions) visited the Taj in 1838, and saw it as an architectural gem which must be preserved. Major-General Sir W. H. Sleeman, administrator in the Bengal Army who had been to the Taj in 1836, published *Rambles and Recollections of an Indian Official* in 1844, and wrote that for him the building stood alone in architecture for its 'entire harmony of parts, a faultless congregation of architectural beauties, on which (the mind) could dwell for ever without fatigue'. (His wife wished for a similar burial place: 'I would die tomorrow to have such another over me.') Bayard Taylor keeps up the

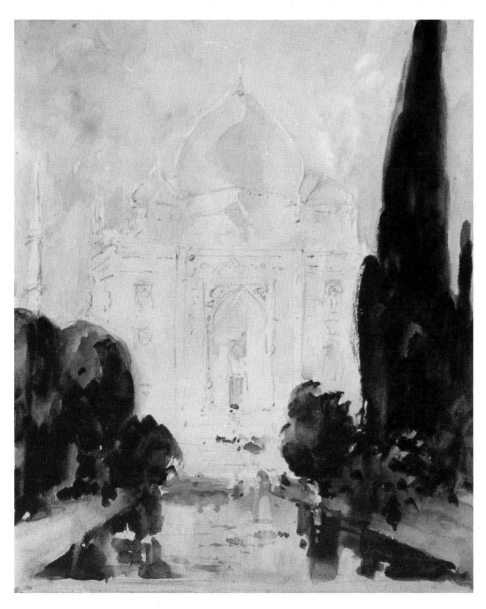

FIG. 91 Hercules Brabazon Brabazon (1821–1906). *The Taj Mahal*. Watercolour and body-colour, 31.8×21.4 cm. About 1875. Photograph courtesy of Chris Beetles Ltd
Brabazon made visits to the Near East in 1860 and 1868 and in the early 1870s, when he reached India. His command of swift wash and tonal accuracy made him a memorable interpreter of the luminosity of the Taj.

155

stress on perfection: 'the building is perfect in every part. Any delapidations it may have suffered are so well restored that all traces of them have disappeared'. The architectural historian James Fergusson praised the British for keeping the 'chef d'oeuvre of Shah Jehān's reign', with its gardens, 'in a perfect state of substantial repair'.[75]

One cause of the appeal of the Taj to Western observers was its unity, symbolised in its dome and its whiteness, qualities esteemed in religious buildings by such observers since the Italian Middle Ages. The dome of the Taj, however, surpassed for the American Taylor the finest European dome that he could think of, that of the Pisa Baptistery: its lightness of effect reminded him of a 'silvery bubble, about to burst in the sun'. The slightly expanding dome of the Taj, rising through more than a hemisphere to a point, seems in fact to have made it an object of doubt to Sleeman ('I at first thought the dome formed too large a portion of the whole building'), but continued scrutiny of every part and the '*tout ensemble* from all possible positions and in all possible lights' convinced him of its rightness. No Eastern building can have earned more devotion from its Western visitors than the Taj. For Europeans the pursuit of the harmonies central to Italian Renaissance architecture was also apparent here, so that the theory of it as the work of a European architect in Shah Jahān's service – bandied about since Tavernier in the seventeenth century – is accepted by Sleeman, though rejected by Taylor. There is surely no good reason for believing it.[76] While there is a broad consensus that the carved plant decoration of the marble friezes owes much to European herbals, few Europeans would now side with Sleeman on the point of overall authorship. Most would endorse, however, his sense of increasing awareness, with each visit, of the cumulative power of the Taj as a building: the observer, he wrote, 'leaves with a feeling of regret that he could not have it all his life within his reach'.

Such was the teasing marvel of the Taj, simultaneously and mysteriously aloof and alluring, that the English artist Edward Lear could not paint it. Confronted by the great building on his visit of 16 February 1874, he concentrates on the luxuriant gardens with their bright green parrots 'flitting across like live emeralds', and goes on: 'What can I do here? Certainly not the architecture, which I naturally shall not attempt, *except* perhaps in a slight sketch of one or two direct garden views'.[77] He mentally divides the human race into two categories: those

FIG. 92 David Roberts. *General View of Cairo.* Pencil and watercolour heightened with white, 52.2×300.4 cm. 1839. Private collection. Photograph courtesy of Fine Art Society, London
Views of Islamic cities with their domes contrasting with thin minarets, their dark cypresses with white walls, became a popular ingredient of Victorian panoramic shows. Robert Burford paid Roberts £50 for the copyright of this, which was used for the panorama shown at Leicester Square in 1847 and engraved in the *Illustrated London News* of 20 March of that year.

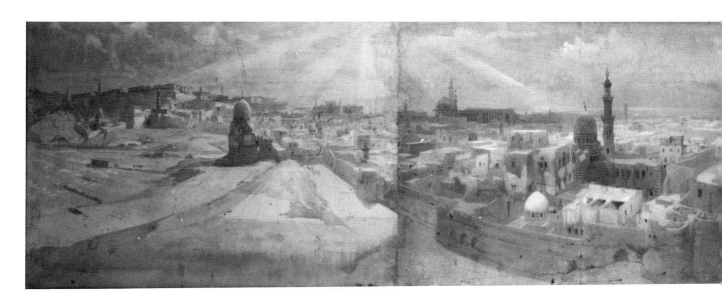

who have seen the Taj and those who have not. It is a matter for regret that Lear did not draw the Taj. When we consider the shimmer of insubstantiality with which J. M. W. Turner invested so solid a building as the Regensburg Walhalla in 1842, it is also sad that he did not even see the Taj. A measure of compensating incandescence is provided by the spectral Taj drawing of an artist who seems to have had no Lear-like inhibitions about his capacity to attempt the building, Hercules Brabazon Brabazon (Figure 91).[78]

The lonely plane of high achievement occupied by the Taj did not prevent some observers from finding a conflict between the coloured inlays of precious stones on its marble surfaces and the architectonic verities which it appeared to assert. The poet and educationist Sir Edwin Arnold (1832–1904) was troubled by this in his *India Revisited* (1886). The Mughals 'designed like giants, and finished like jewellers' (the remark was by Bishop Heber, 60 years before, in regard to what Heber considered 'Pathan' architecture). But if the integrity of the Taj presented to some a certain ambivalence, everyone agreed about the visual impact: Arnold praised the building, and for Kipling it was 'the ivory gate through which all dreams pass'.[79]

The enigma of the Taj apart, India had much that was accessible to those who were able to go there and even to those who were not. A certain Lieutenant Thomas Waghorn, of the Bengal naval service and later the Royal Navy, busied himself setting up a chain of hotels at suitable resting-places on the overland route from the Mediterranean to India, and cutting the travelling time from the three to four months needed for the journey round South Africa to less than a month. For those at home, his route was incorporated in a famous spectacle, *The Overland Route to India*, that was mounted in the new Gallery of Illustration at 14 Regent Street, London, at Easter 1850. This involved a sequence of painted realisations, both stationary and moving, by theatre scenery specialists and, again, by David Roberts, which took the visitor from Gibraltar to Malta and then (in a moving sequence) from Cairo to Suez, and finally to Ceylon and Calcutta. The *Illustrated London News* hailed it as the best show of its kind that had ever been seen in Britain: there were 900 showings in its first year and an estimated final attendance of a quarter of a million.[80]

The *Overland Route to India* show was in fact a particularly successful variant of a type of entertainment, the 'panorama', which had become a conspicuous part of

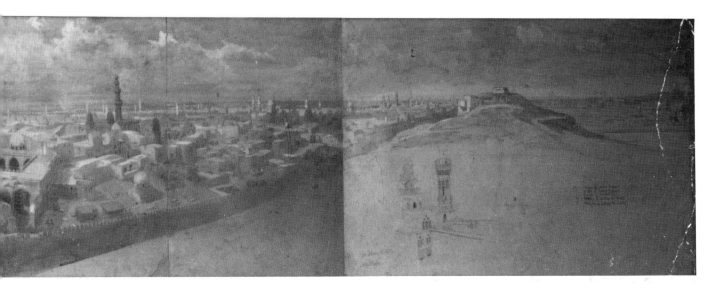

life in Europe, in London and the provinces of Britain, and in America, in the preceding years. As a vivid means of putting the visitor in direct touch with the marvels of nature and mankind in distant lands, not least those of Islam, it has a prime claim to our attention.

Panoramic paintings could be both informative (depicting the topography of a city) and imaginatively stimulating. The idea of entertainments involving light effects, moving figures and themes concerned with the fall of civilisations had been popularised long before in London by the Eidophusikon (1781) of Philippe Jacques de Loutherbourg (1740–1812). In the ensuing 50 years, an international interest grew in spectacles of this kind, and buildings were erected or adapted for them – frequently rotundas, such as that in Leicester Square opened by Robert Barker in 1794, in which more total illusions of space could be presented.[81] This was an interest which appealed in a period when the Romantics were emphasising personal experience as the quintessential quality of a work of art. This could amply be provided for in the full-circle panorama which presented a painting to the observer standing on a central viewing platform in carefully contrived conditions whereby everything that related to normal reality – doors or sources of illumination – was concealed. There were also subjects which the panorama could treat in a way which excited the Romantics: where neo-classic architects had found their inspiration in powerfully solid-looking temples – Paestum, Bassae, Karnak – Gothicists and the young J. M. W. Turner were imaginatively engaged by effects of confused light, space and void. Natural phenomena, epics and battles (Robert Ker Porter's famous portrayal of the *Taking of Seringapatam* was mounted in 1800) were particularly popular. Some panoramas were topographical, and in this category Eastern subjects such as Calcutta, 'city of palaces' (shown by Robert Burford in 1830), and particularly Constantinople, Cairo and Jerusalem came to occupy a prominent place. The skyline of Constantinople was featured at Leicester Square in 1799 by Henry Aston Barker. Barker, the son of Robert Barker, and one of the most gifted exponents of the art of the painted panorama, had recently returned from Turkey. Constantinople appears as a subject for public panoramas repeatedly afterwards. In 1851 Allom presented it at the Polyorama, Regent Street. It was highlighted again in 1854 by the Crimean War: in that year rival panoramas of the city were to be seen at Leicester Square and the Egyptian Hall, Piccadilly. As for Cairo, this was an obvious choice as interest in Egypt accelerated after 1800. David Roberts's general view was put on as a panorama in 1847 (Figure 92). The biblical fervour of the 1830s did much to make Jerusalem a popular subject. In 1835 Frederick Catherwood (1799–1854) returned from making detailed drawings of the Dome of the Rock to assist in the presentation by Burford in Leicester Square of a painted realisation of Jerusalem in which he and Joseph Bonomi, the architect and authority on Egypt, were included wearing oriental dress. In the forties, when the Middle East appears to have become more popular as a panorama subject than Rome or Pompeii, panoramas of Jerusalem were said to be acceptable to Nonconformists, whose religious scruples ruled out the ordinary theatre.[82]

Some public panoramas constituted complete static environments; other shows introduced movement. These were concerned with taking a seated audience on a journey by unrolling a continuous picture in front of them. Joseph Bonomi and Henry Warren worked on a 'grand Moving Panoramic Picture of the Nile' late in the 1840s. The *Art Journal* for 1854 (p. 90) describes the effect of Constantinople at the Egyptian Hall, Piccadilly, at which the presenter, William Beverley, 'directs your tour through the city, and is your pilot in the Bosphorus'. If the guiding at such shows was not done for the visitor in this way, he could

inform himself of the sights by consulting a sixpenny booklet obtainable at the door. At the climax of popularity of the public panorama it is clear that the architectural attractions of Islamic cities had their own idiosyncratic contribution to make.

This chapter has in the main been about the painter's world. Even the Alhambra courts, though their implications were not just for painters, made an immense impression through their spatial qualities and colour, constants of the painter's imagination. The panoramas of Islamic environments based on the paintings of artists like David Roberts, who had first-hand experience of the originals, bring us back to a point made at the beginning: that the panoramic experience was peculiarly intense for Romantic artists and it is no accident that a popular version of it was developed in this period across the Western world from St Petersburg to New York.

The wish of Byron's Childe Harold to make the desert his dwelling-place has its complement in the decision of artists to absorb Islamic cultural influence into their system at source. John Frederick Lewis becomes an unremitting student of the Cairo scene. The Alhambra exerts an almost hypnotic attraction. Here, it was discovered, was a universal mode of decoration and colour deployment. It was for an architect with a painter's eye, Owen Jones, to explore and analyse it. In the second half of the century, design in many fields was to benefit from Jones's work. It is this subject and the activities of other reformers in a more public arena that we must next consider.

After 1850:
THE DESIGN REFORMERS

5

I

The painted panoramas relied for their effect on total illusion: the visitor could go into one of the panorama buildings and imagine for a while that he was actually in Constantinople or Cairo. In this chapter we must look at other sources of Islamic artistic ideas in Britain in the second half of the nineteenth century. These lead away from the galleries specialising in orientalist pictures, away from the public panoramas, to places where illusion is replaced by direct encounter with Islamic objects, or to buildings which reflect Islamic style more or less faithfully: exhibitions, particularly the large international exhibitions which followed that of 1851; shops and emporia which specialised in oriental merchandise; the home itself, where in *objets d'art*, furnishings and sometimes whole interiors, oriental ideas could be deployed – all these are important. Then there were the books which dealt with or which drew attention to the subject, from manuals of ornament to the popular guides on household furnishing for which the period was well known. In the Regency period, as we saw in chapter 3, books on villa-architecture and furniture had included Islamic or 'moresque' among those styles available for use by designers. The reforming arguments of the 1850s and beyond were, however, to place a new emphasis on Islamic decorative ideas: this emphasis, and the creative thinking which accompanied it, were to infuse passive availability with active advocacy of qualities that these ideas were felt, often uniquely, to possess.

The year 1854 was an *annus mirabilis* for anyone in London with a taste for the Islamic. We have already noticed the panoramic shows concerned with Constantinople. In the same year the Islamic architectural style made its first appearance in a permanent London building at the Royal Panopticon, Leicester Square (Figures 93, 94) by Thomas Hayter Lewis (1818–98), opened for exhibitions of both the arts and the sciences. The glass ogee dome shown in the *Illustrated London News* of 31 January 1852 had been replaced in execution by a low cone with skylight, but two minarets set slightly back from the façade rose above its horseshoe arches and polychrome decoration. Inside was a rotunda with two upper levels, the higher topped by horseshoe arches enclosing windows. Occupying the middle, and connected to an artesian well, was a fountain 'worthy of the Alhambra itself', as the *Art Journal* for 1 April 1854 remarked. The palace at Granada was to give its very name to the Panopticon building in its later incarnation (from 1858 to 1882) as a music-hall. Also in 1854, after 10 June, it was possible to visit the reopened Crystal Palace, at Sydenham, and see Owen Jones's polychromatic Alhambra Court (Figure 95) reconstructing the Court of the Lions on a smaller site, but reproducing individual features to full scale. It was here, in

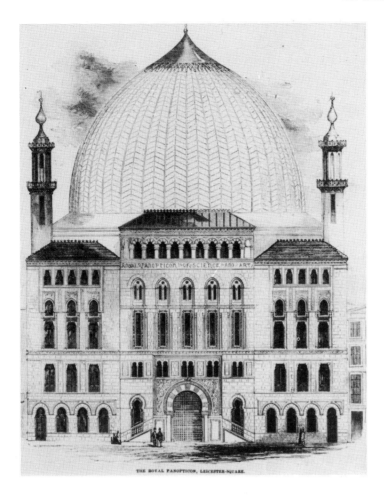

THE ROYAL PANOPTICON, LEICESTER-SQUARE.

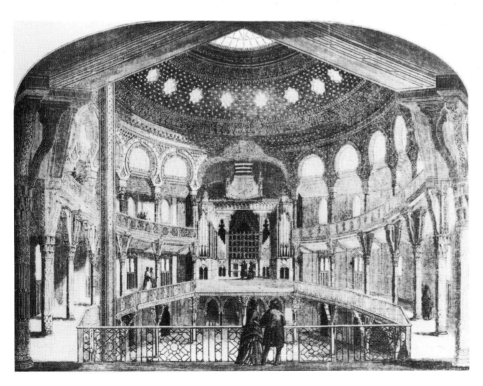

FIG. 93 Thomas Hayter Lewis (1818–98). The Royal Panopticon, Leicester Square, London. 1854. *Illustrated London News*, 31 Jan. 1852, 96
The opening of this building on 18 March, according to the *Art Journal* (1 April, p. 122), added 'another important feature to London, as well architecturally as scientifically'. Devoted to exhibitions of scientific machinery and demonstrations of crafts and trades, with painting and sculpture in the galleries and basement, the enterprise was the work of E. M. Clarke, the resident manager. Clarke chose the Moorish style, which was reflected outside in the polychrome Minton tiles and the two minarets: the glass ridge-and-furrow dome was simplified into a low cone in the actual building.

FIG. 94 Thomas Hayter Lewis. The Royal Panopticon, interior. *Builder*, 18 March 1854, 143
Apart from the central fountain, the interior presented Islamic detail based on Cairo mosques (it is unclear whether Lewis knew them yet at first hand). Decorations were in enamelled slate and glass mosaic, and there was a painted ceiling. Lewis travelled in the Near East in later life, lectured on Islamic architecture, and submitted drawings to the Khedive of Egypt for a building similar in style to the Panopticon (apparently not carried out).

161

December 1856, that Holman Hunt could be found working on his *Finding of the Saviour in the Temple*, as we learn from a letter by him to Edward Lear, 'painting the background from the Alhambra Court'.[1]

In the same year, 1854, as the Crimean campaign unfolded, an Oriental and Turkish Museum opened under the direction of two impresarios, C. Oscanyan and S. Asnavour, at the St George's Gallery, Hyde Park Corner. This gallery had been built in 1842 in the shape of a Chinese pagoda fronting a long exhibition hall 240 feet long, to house a collection of Chinese objects, but after two seasons was used for different purposes. In its time as a Turkish museum it was fitted up to show, according to the *Illustrated London News* of 17 June (which carried several illustrations),[2] 'the abolished institution of the far-famed janissaries, the renowned Militia of the Turkish empire, with their ancient uniforms and armour' and also aspects of contemporary Turkish life, from bazaars, coffee shops and baths to a harem and a smoking party. The wax figures in the display were commended by *The Times* for the 'actual drops of perspiration . . . on the brows of the porters'. Despite these attractions, the Museum does not appear to have maintained public interest, if we are to interpret correctly the directors' decision shortly afterwards to reduce the admission charge.

While this was an age of extravaganzas, illusions and nine-day wonders designed to entertain the common man, however, a deeper concern for information and the deployment of material in organised educational ways was becoming more insistent by the 1850s. On 29 November 1851, the *Athenaeum* printed a statement (pp. 1253–4) which compared the condition of the 'national collections' of Britain unfavourably with those in Denmark and Holland. The writer of the *Athenaeum* piece does not mention the British Museum (which in fact possessed considerable quantities of ethnological material, though it lacked the space to display it): but he usefully draws attention to the private museums

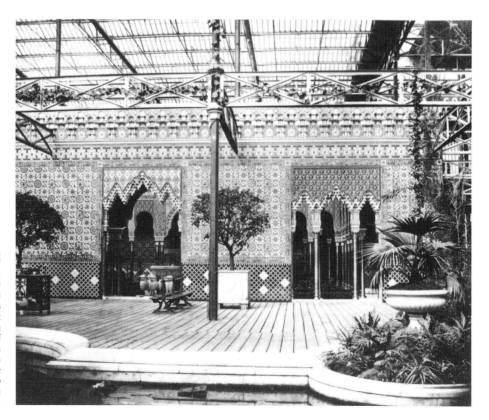

FIG. 95 The Alhambra Court at the Crystal Palace at Sydenham. 1854. Photograph, 28×23.1 cm. Victoria and Albert Museum 39–315
A number of architectural courts in period styles were created when the Crystal Palace was rebuilt at Sydenham. Owen Jones undertook the Alhambra Court, realising, with his unrivalled knowledge of the original Court of the Lions at Granada, a version that was somewhat smaller in area, although with individual features on the original scale. The photograph may be by P. H. Delamotte, who published views of the Sydenham Crystal Palace in 1853.

where oriental antiquities were to be seen, such as the collections run by the United Services Club and, notably, the East India Company. This latter collection had begun to be organised late in the eighteenth century when the Company's premises in Leadenhall Street had been enlarged. This 'Oriental Repository', administered by the Sanskrit scholar Charles Wilkins, offered only limited access to members of the public, as we have noted. But conditions became easier, and by 1830 Thomas Sopwith, Newcastle mining engineer and railway surveyor, records that he had seen the Eastern manuscripts in the collection and found them 'highly deserving the attention of the stranger'.[3]

From 1808, as we also saw, an object had been on view at Leadenhall Street which made East India House a focus of considerable popular interest. The Man-Tiger-Organ, plaything of Tipu Sultan, became one of the most famous exhibits in London and was reflected in countless Staffordshire pottery figures in Victorian times. By 1850 over 40,000 people were visiting East India House museum despite its ill-lit rooms and relative remoteness of location. In 1858 a new phase of its life opened: with the transfer of the East India Company's remaining administration privileges to the Secretary of State for India, the museum was moved to new quarters designed by Matthew Digby Wyatt in a tea auction room. The *Illustrated London News* for 6 March of that year shows the arcaded hall of the Company's building (Figure 96): Indian sculpture was displayed in this room, but the architecture was itself totally Islamic in character, reproducing 'the leading

FIG. 96 Sir Matthew Digby Wyatt (1820–77). Sculpture Hall, East India House Museum, London. *Illustrated London News*, 6 March 1858 This much-visited interior was based in part on the Diwan-i-Khas or audience hall in Agra Fort.

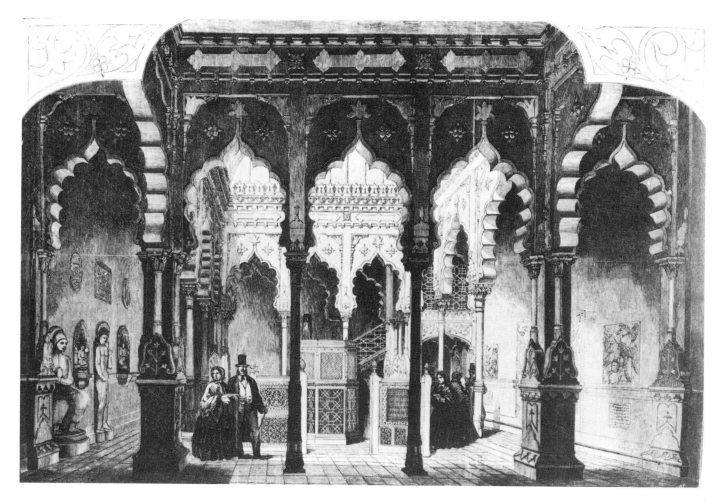

forms of a Mahometan musjid'. In fact Wyatt's arch design was based on the Diwan-i-Khas or audience hall in Agra Fort. In the next two years Wyatt's room, open five days a week from 10 to three o'clock, was seen by 175,000 people. With its straight borrowing of Islamic forms, here was the architectural idiom of an exotic culture, visually stimulating, having links with India, and yet highly adaptable to purposes at home through its capacity to deploy a traditional European form such as the arcaded courtyard or atrium to such strikingly different effect. The visitor could feel both relaxed and stimulated. He was learning, but learning agreeably.

While the exotic building forms of India were being presented educationally in England in this way, the same forms were also being marketed from here back to India or to the world at large. In 1867 a 'Moorish' iron structure with horseshoe arches, arabesque decoration, and tile and glass infilling, was erected at the Royal Horticultural Society's Garden at South Kensington. Designed by the engineer R. M. Ordish in collaboration with Owen Jones, it was made up into 'kits of parts' for assembly in Bombay.[4]

The Ordish design reminds us that we are in the age of the prefabricated cast-iron part, the possibilities of which had been so triumphantly indicated by Paxton at the Crystal Palace. Strong but light, cast iron was eminently suitable for packing and transporting, and by the 1880s many manufacturers were enjoying financial success making up sets of parts in a variety of styles, and exporting them as 'kits' to Egypt, India, South Africa and Singapore. One firm which was particularly active in both home and export markets was Walter Macfarlane's of

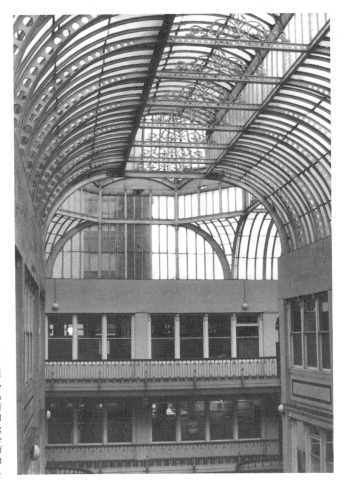

FIG. 97 The Barton Arcade, Deansgate, Manchester, detail of roof. About 1875. Photograph courtesy of Dr J. S. Curl
The adaptability of 'Islamic' arabesque filigree to the linear effects of cross-rib construction is well shown in such work as this, by the engineering firm of Corby, Raby and Sawyer. Functional line and decoration are here effectively combined. Following a principle of prefabrication made famous at the Crystal Palace of 1851, this arcade used a 'kit of parts' cast at Macfarlane's Saracen foundry at Glasgow.

Glasgow (later London) which ran a 'Saracen Foundry' from before 1850. Their beautiful catalogues give evidence of a wide range of crestings and terminals suitable for a variety of different purposes from arcades to smoking-rooms.[5] Despite the name of their foundry, direct Islamic inspiration is only occasionally seen in Macfarlane's designs, but the kit of Macfarlane parts used by the engineering firm Corby, Raby and Sawyer for the Barton Arcade, Manchester, about 1875 (Figure 97), combines Roman rinceau decoration with the thickened flourishes reminiscent of *rumi* ornament (see chapter 1). The cursive filigree effectively contrasts with the simple lines of the cross-rib construction: the thickenings in the rinceaux will also have strengthened the castings. G. R. Crickmay's Dorset County Museum of 1883 has unmistakable *rumi* ornament in the same material (Figure 98).

Externally the Barton Arcade has an octagonal dome that conforms to the type made famous by Brunelleschi's dome of Florence Cathedral (1420–36). The Islamic ogee dome-form, however, held other possibilities for the language of metal and glass infilling, as we saw in the last chapter. The age of the Crystal Palace brought a mature realisation of this by a few perceptive figures, notably Owen Jones. Just as the Exhibition of 1851, through being called 'Great', set a formidable precedent for subsequent 'universal' exhibitions, the Crystal Palace building itself, in its uncompromising modernity, cast its slim shadow far ahead of its successors. It observed no historical style. Jones's interior colour-scheme was equally bold, though, as we saw, Moorish polychromy was one of the ingredients in the fully evolved colour theory that he applied here. In certain details, such as the hand-rail that Jones designed to run round the building at balcony level, Moorish and Gothic affinities were more directly evident. But the interest that had existed since Regency times in having iron and glass green-

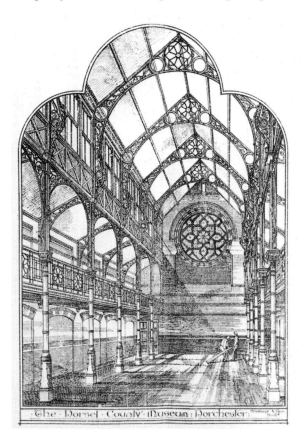

FIG. 98 G. R. Crickmay. Dorset County Museum, Dorchester. 1883. Dorset Natural History and Archaeological Society
The cast-iron hall incorporates horseshoe arches with arabesque (*rumi*) in the spandrels, and star patterns at the apex of each roof-arch, and in the large round window at the end. The architect's original colour scheme was not implemented until recently, after the rediscovery (in 1966) of his original drawings in the office of his architect grandsons. It is apparent that this scheme of blue, pink and ochre was based on the theories of Owen Jones. Crickmay, of Weymouth, was the architect to whom Thomas Hardy was articled.

houses and other structures capped by Islamic dome-shapes was not yet spent, as the design for the Enville Hall conservatory shows (Figure 99).[6] Indeed it had much to contribute to the designs of the large exhibition halls that were among the progeny of Paxton's Hyde Park building. For the New York Crystal Palace of 1853 (painted inside, incidentally, by Edward Garbett with Jones's ideas very much in mind), the architects Carstensen and Gildemeister included such a dome at the heart of the design, and unmistakably minaret-like towers at the angles (Figure 134).

Five years later and a year after his own barrel-vaulted iron and glass 'Crystal Palace' Bazaar opened in Central London, Jones himself prepared designs for an iron and glass 'People's Palace' at Muswell Hill (1858, not carried out, Figure 100). This was to be built on a wooded hill, above a large, specially constructed railway terminal which would have received 'visitors from the manufacturing areas of all Britain', come 'to participate in the instruction and amusement'. The core of the plan was an immense, circular, glass-topped Winter Garden, 200 feet across, with four high towers around it on the long nave-like axis, which extended 1,296 feet to reach four more towers, two at each end. The building was to be wholly covered with glass. Its debts in other respects were clearly to German and Italian Romanesque: in the clear-cut relationships between square, rectangle and circle and the punctuating of long horizontals by verticals. But the cupola and the styling of the detail were Islamic and indeed the way in which the whole complex would have risen shimmering out of a garden setting might not have been without distant echoes of a Persian 'paradise': though this would have been a paradise for working men and women.

A signed drawing by Jones, dated 1860 (Victoria and Albert Museum), presents a 'palais de Cristal' at Saint-Cloud, near Paris, again with Islamic-looking domes. A design for the same building-project by Paxton (Yale University) has similar domes: these (though not the positioning over circular pavilions rising from the ground against the main mass of the building) are pure Mughal, recalling in particular Khan-i Khanan's tomb at Delhi (c.1627).[7] Sadly neither design was carried out.

The glass domes projected by the Victorian exhibition-hall designers were

FIG. 99 Conservatory, Enville Hall, Staffs. About 1854. *Florist*, November 1855 This was put up for the Earl of Stamford and Warrington by the horticultural building firm of Gray and Ormson of Chelsea. The main front measured 150 feet. The density of the wood in proportion to the glass and the general decorativeness is to be contrasted with the simpler use of Islamic dome-shapes in glass (cf. Figure 100).

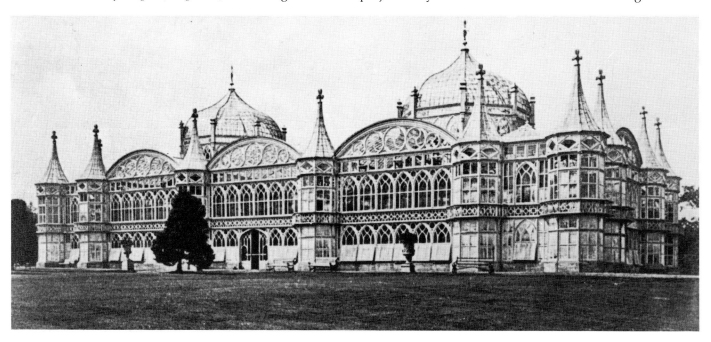

surely one of the most felicitous of the period's inventions to be informed by Islamic style. There were predictably many lesser instances of exhibition buildings which employed a more or less crudely adapted selection of Islamic ornamental motifs in a mélange with other styles: a conspicuous later example, by the impresario Imre Kiralfy, was that of the Franco-British Exhibition at the White City, London, opened in 1908.[8]

One of the most widely used motifs was inevitably the horseshoe arch or pointed variants of it. A particularly bold instance of this graced the entrance to the aviary (originally conservatory) opened in 1845 in one of the most popular of London entertainment centres of the mid century, the Colosseum in Regent's Park. This had arabesque in the spandrels and colonnettes with zig-zag ornament at the sides, together with strongly contrasting inlays on the jambs and soffit of the arch – in patterns of wilful eccentricity, to judge from the illustration in the *Illustrated London News* of 3 May.[9]

While Islamic architectural tradition gave opportunities in this way for unrestrained licence on the part of many Victorian and Edwardian designers, at no previous time had the chances of acquaintance with the disciplines of genuine Muslim artistic practice been greater. A number of different strands can be disentangled. First, the international exhibitions – Dublin (1853), New York (1854), Paris (1855), Manchester (1857), London (1862) and others – were to bring together quantities of authentic material on which serious writers, museum curators, and artists, could build both knowledge and enthusiasm. The Great Exhibition set the example by displaying fabrics from Egypt, Turkey, Tunis and India: Owen Jones was to use his knowledge of them to evaluate the merits of the different varieties of Muslim decoration that he was to write about at length in his *Grammar of Ornament*.

Secondly, there was the contribution of native craftsmen. While there was no counterpart in the field of Muslim architectural ornament of Ram Raj, the Indian writer on the aesthetics of Hindu architecture – whose authoritative book on the subject (1834)[10] was to be cited with approbation by Jones in the *Grammar* –

FIG. 100 Owen Jones. Palace of the People, Muswell Hill, London. 1858. Lithograph. Photograph courtesy of Guildhall Library, City of London
The view is from the north-east. There was to be a vast 200-foot Winter Garden under a dome at the centre. The proposed railway terminus is visible in the foreground. See p. 166. The scheme was abandoned by June 1860.

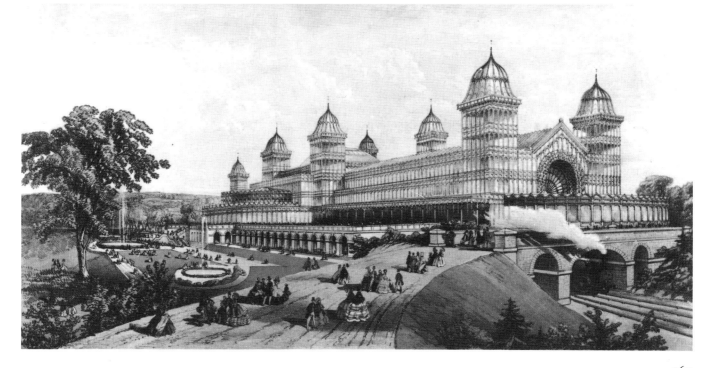

Muslim craftsmen were sometimes available for the carrying out of work. Alfred Morrison, who employed Owen Jones at 16 Carlton House Terrace, also engaged a Spanish metalworker, Placido Zuloaga. But after 1877, when the Queen had become Empress of India, ties with Muslim craftsmen were strengthened. For the Colonial and Indian Exhibition of 1886 at South Kensington, two Punjabi craftsmen, Muhammed Baksh and Muhammad Juma, provided a superbly detailed example of a Durbar Hall or audience chamber (Figure 101), in which the Prince of Wales held official receptions. Another Indian national, Bhai Ram Singh, worked on the grand Durbar Hall for the Queen at Osborne House (1890–1). In 1886 an advertisement in the second edition of Kelly's *Directory of Cabinet Furniture and Upholstery Trades* records a 'Studio of Arabian and Persian Art' in Notting Hill Gate, employing 'Asiatic Artists under the supervision of the late Chief Designer for the Decoration and Furnishing of palaces . . . to the late Sultan Abd-ul-Aziz'. In the field of Persian ceramics, the Qajar potter Ali Muhammad produced a technical account of his wares at the instigation of Robert Murdoch-Smith, adviser to the South Kensington Museum from the 1870s. This was to appear at Edinburgh in 1888 with the title *On the Manufacture of Modern Kashi Earthenware Tiles and Vases* – oddly there was no mention of lustre – and to be reprinted in W. J. Furnival's *Leadless Decorative Tiles, Faience and Mosaic* (Stone 1904, pp. 215–23). The contemporary contacts of the Armenian potter Ohanessian, a specialist in Iznik tiles, with British visitors such as Mark Sykes and C. R. Ashbee will be noted later in this chapter (p. 210).

Thirdly, a remarkable collection of Muslim ornament made by the architect James Wild (1814–92) formed the basis of the Cairene material in Jones's *Grammar*. Wild had first-hand experience of the Near East. He had joined the German expedition led by Lepsius to Egypt in 1842, and had stayed on to study the architecture and ornament of Cairo, only returning to England in 1848. Among the hundreds of drawings by him in the Victoria and Albert Museum are many of Cairene domestic interiors, including the house of J. F. Lewis. Wild's drawings of Cairene carved woodwork, in particular, were to provide invaluable documen-

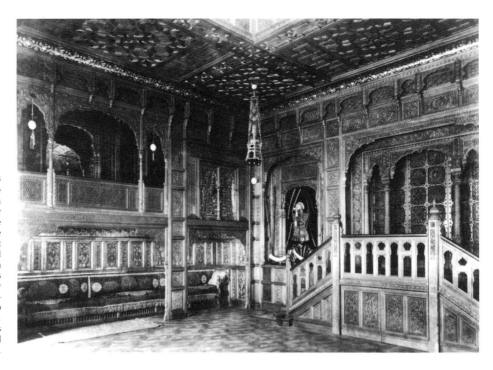

FIG. 101 Section of Durbar Hall. 1886. Museum and Art Gallery, Hastings

This was part of a reproduction by C. Purdon Clarke of an Indian palace made for the Colonial and Indian Exhibition at South Kensington in 1886. A columnar hall below supported the audience chamber where the Prince of Wales held receptions during the exhibition. The Hall was rebuilt (in somewhat altered form) at the Park Lane house of the first Lord Brassey to provide a smoking-room (below) and a gallery for his oriental collections: the structure was presented to Hastings in 1919. The lower storey reflects Islamic ideas, the upper has Indian motifs – but the superlative carving throughout was by two Punjabi craftsmen, Muhammad Baksh and Juma. The work well shows how Victorian exhibition-goers could have access to Islamic decoration of real quality and authenticity.

tation as the South Kensington Museum's collections developed.[11] Fourthly, there were the detailed studies of Islamic source-material published by Girault de Prangey (1804–93), already noticed, and those of another Frenchman, Charles Texier (1802–71). Both authors' works were on Owen Jones's shelves. The archaeological studies of Texier in Asia Minor, Armenia, Persia and Mesopotamia were much admired in Britain, and he was awarded the Gold Medal of the Royal Institute of British Architects in 1864.[12] Later comes the large folio by Jules Bourgoin, *Les Arts Arabes* (1873), with its detailed colour plates of architecture, furniture, ceilings and other features. The massive folio work *L'Art Arabe d'après les Monuments du Kaire* (1877) by Emile Prisse d'Avennes (1807–79) reviewed in detail religious, civil and military architecture and decoration, and presented 200 plates (152 in colour), including comparisons of domes (XL-XLII) and window grilles of the Qaisūn Mosque (XLVI).

Finally, beside the illustrated works that were specifically concerned with Islamic architecture, we should recognise the knowledge and appreciation of it which developed as a by-product of the study of the places where Christian and Islamic forms stood side by side, notably Constantinople and Jerusalem.[13] At Constantinople the great church of Hagia Sophia, built under Justinian in the sixth century, had been transformed into the most important mosque in the city. It became, as we shall notice later, a main focus of interest for English architects in the Victorian period. At Jerusalem the Dome of the Rock exerted an even greater attraction. Built on the traditional site of Solomon's Temple and reputedly incorporating some of its materials, it now represented the earliest surviving evidence of a major Islamic commemorative building (erected in AD 688–692). Joseph Bonomi (1796–1878), Frederick Catherwood (1799–1854) and Francis Arundale (1807–53) made the first comprehensive survey of it in 1833; James Fergusson (1808–86) wrote controversially about its possible origin as the site of Christ's tomb (in his *Essay on the Ancient Topography of Jerusalem*, 1847). As one who valued monumentality in architecture Fergusson could not see this quality in 'Saracenic', but even he, in his world-embracing history of architecture, acknowledges the supremacy of the decoration added by successive caliphs 'so sumptuous . . . as to render it one of the most beautiful buildings in the world'.[14]

Research and first-hand contacts were therefore providing abundant material for the reforming figures whose work we must now consider. For Owen Jones, Matthew Digby Wyatt, William Morris and a succession of others, Islamic design was to offer practical and teachable solutions to a host of problems that troubled or outraged them, notably the central question of how to produce goods in which decoration was reconciled to material and function. The catalyst of the situation, as is well known, was the Great Exhibition. There, the contrast was to be observed between the lucidity of two-dimensional pattern in the oriental fabrics and the overladen, puffed-up detail of their British and European counterparts. There was considerable detail in the Islamic designs – but the overall effect, which 'aroused general amazement' was of coherence, even simplicity. The quotation is from Gottfried Semper, the architect and student of architectural polychromy whom we encountered in chapter 4. He had been adviser on the Exhibition displays by Canada, Sweden, Denmark and also Egypt. What had particularly impressed Semper, however, was the broad adaptability of Islamic carpets to a variety of environments. He recognised such qualities in the arts of other Asian traditions (he mentions Indian ivory boxes), but the merits of Middle Eastern carpets plainly came across to him as an architect: 'Persian rugs suit a church as well as a boudoir.'[15] Owen Jones's main impression was of the enduring factor of unity in Islamic design. In European goods he saw proof of a restless and, in the

last resort, fruitless 'struggle after novelty, irrespective of fitness'.[16] Against such things the contributions of India stood out, together with the offerings from Tunis, Egypt and Turkey as a revelation of 'so much unity of design, so much skill and judgement in its application', with so much 'elegance and refinement in the execution'. Not all the British design was, however, indigestible: the eagle-eyed will have seen textiles designed by Jones (p. 127) on the principles of Alhambraic wall decoration.

After the Exhibition, the reformers – the remarkable Henry Cole, one of the leading organisers, Matthew Digby Wyatt the architect, Richard Redgrave the painter, and Jones – lost no time. They purchased (with a government grant of £5,000) some of the Eastern exhibits to form part of a museum of design examples. First housed in Marlborough House, after six years this would become the nucleus of the South Kensington Museum (in 1898 renamed the Victoria and Albert Museum). With the initial grant, £1,371 of metalwork alone was acquired, much of it Near Eastern and including 'Venetian-Saracenic' damascened brass-

FIG. 102 Sir Matthew Digby Wyatt. Iron decoration, Paddington Station, London. 1854. Photograph courtesy British Rail/OPC The metal and glass buildings of the mid nineteenth century highlighted the possibilities of the play of line and the dissolution of solids which gave scope to Islamic pattern in architecture (cf. Figure 96). Isambard Kingdom Brunel's Paddington Station sheds have open-work in the tympana at the ends which set flourishes reminiscent of Islamic brassware (cf. Figure 4) against a reticulated framework.

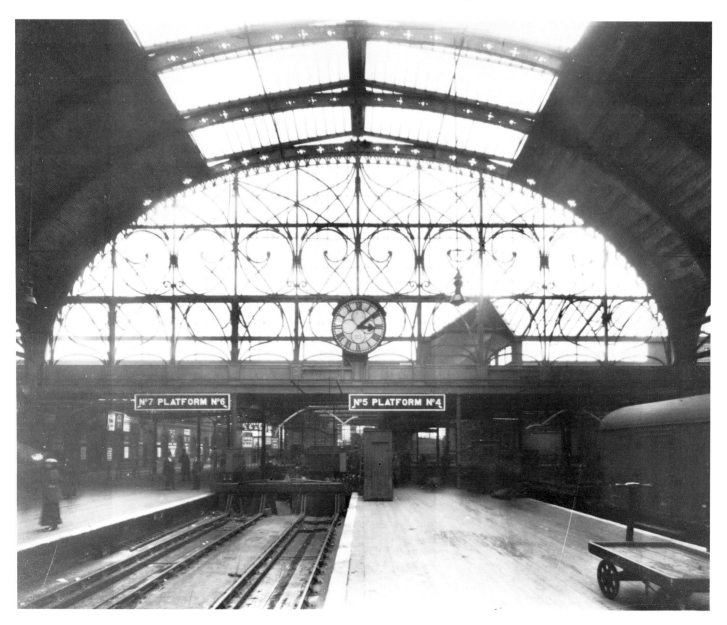

ware. Cole also set up the art school run by the Department of Practical Art ('of Science and Art' from 1853), whose students heard lectures from Jones, Wyatt and Semper.

The opportunities for reform were also pressed home in a variety of other publications. Henry Cole's *Journal of Design and Manufactures* (6 vols., 1849–51), however short-lived, had set a purposeful tone for the 1850s. It featured selected modern work; for example, that of the textile firm Daniel Keith and Company, who were to produce an 'Alhambresque' fabric. In 1852 Jones was already discussing his future *Grammar of Ornament* (1856) with Cole. Among the major reforming figures Matthew Digby Wyatt (1820–77) was architect and writer, at home with many architectural styles but also possessing a lively interest in industrial design. He was secretary of the 1851 Exhibition and from that year editor of an important publication, *Industrial Arts of the Nineteenth Century* (1851–3), which described the styles of particular fabrics that were shown in the Exhibition and discussed the processes and costs of production.

Wyatt was a figure of immense energy and influence. He was responsible for the overall planning of the various architectural courts at the Crystal Palace, Sydenham, for which Jones produced his faithful version of Alhambra decoration in 1854. In the following year Wyatt became surveyor to the East India Company, in which capacity he designed, as we have seen, their Museum in 1858, using an audience chamber in Agra Fort as prototype for his sculpture hall.

Wyatt could also be more inventive in his use of Eastern motifs. At Paddington Station he was called in as collaborator by the engineer Brunel, who laid down that the work should be unrelated to past styles, and specifically expressive of the iron and glass to be used. A series of effects was devised which has fascinated observers ever since. Along the ends of the three vast, parallel sheds of the station are lunettes with wrought-iron tracery of enigmatically Saracenic-looking type, as Hitchcock and others have noted (Figure 102).[17] The motifs here indeed appear to have no close prototype, but there are certain resemblances in the loops and reverse curves of damascened brassware (the type represented in Figure 4 makes an instructive comparison). Wyatt greatly admired this, as we know from his essay on metalware contributed to J. B. Waring's *Art Treasures of the United Kingdom* (1858).

The parallel sheds are separated by iron stanchions, the top stage of which is perforated. These stanchions support iron arches which carry glass infilling. Between stanchion-level and the upper spaces of each vault Wyatt introduced ornamental episodes of tracery on the lower parts of the arches (Figure 103). These take the form of a succession of leaf forms placed against the surface of each arch; these leaves become progressively smaller and finally quite angular, eventually dying away against the inner side. The largest leaves are each composed of two curving contours which meet at the top. What is so unexpected is the wedge-like shape next to the leaf, created by running a line from the apex to meet the leaf that is next above in the series, and to emerge on its farther side. It is possible to think of the resulting leaf-shape as a reworking, in the simpler terms of cast metal, of the 'bent leaf' form of Indo-Persian usage. This was a familiar enough sight in the mid nineteenth century: in his *Grammar* of 1856 Owen Jones was to illustrate an example taken from an Indian painted lacquer in India House (pl. LIV*, lower left) and another from a 'Persian Manufacturer's Pattern-Book' at the South Kensington Museum (pl. XLVII, lower centre). Many examples of the motif must have been seen among the Indian cottons that were shown at the major exhibitions of the day. The Paddington tracery is schematic, by comparison, but the techniques of casting metal would account for this. Whether or

not Wyatt was thinking consciously of the 'bent leaf', the fact remains that he has produced in this tracery motif an effect which implies both completeness and directional movement beyond itself – a feature of the 'bent leaf' and, as Gombrich suggests, a major factor in its popularity.[18] Such a combination was being seen at this period as one of the great lessons of Islamic ornamental design. In the context of the Paddington arch the merits of such a leaf-form may well have disposed Wyatt to evolve a cast-iron variation of it. It is further worth noting, in passing that the nineteenth-century Indian cotton-printer's block illustrated from Christie (Figure 104) presents a bent leaf with, at its heart, a sequence of simple, stopper-shaped palmette divisions which closely resemble those at the base of the tracery in the Paddington arches.

On the walls of the first departure platform, below these arches, there are cast-iron panels containing torrents of bandwork and scrolls against which X-shaped cross-bracing is severely imposed. We are reminded momentarily of Bishop Heber's comment on the language of giants and jewellers in distant India. The effect is surprisingly successful. But in the station-master's oriel and adjacent window-area, with its tracery, thin balustrading and pierced aprons below the

FIG. 103 Sir Matthew Digby Wyatt. Detail of main arch, Paddington Station. Photograph courtesy British Rail/OPC
The somewhat lace-like 'leaves', one of Wyatt's more novel effects, have no obvious prototypes. Both the Greek-derived palmette (a plant motif with stalk and fan of lobed shoots, see Figure 37, centre) and the Indian bent-leaf with Islamic associations (Figure 104) seem to lie behind them, but the language is that of cast iron, which Wyatt was bidden by Brunel to express.

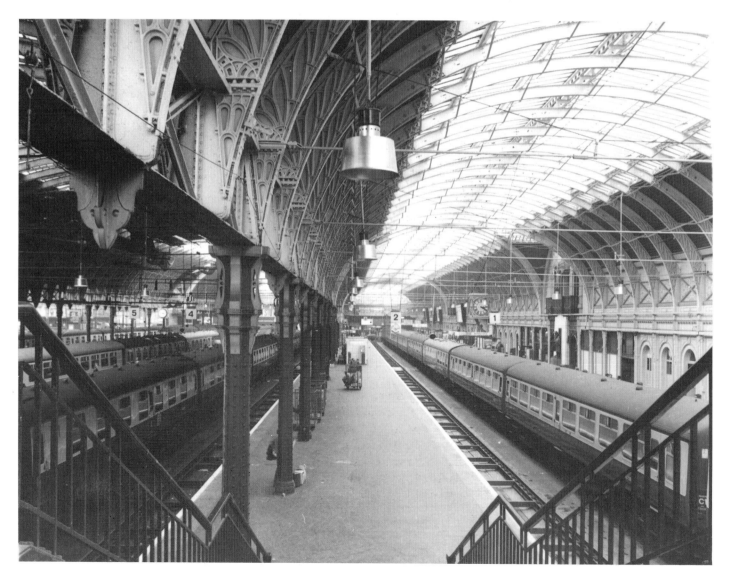

balconies, Wyatt the jeweller takes over. There are nods in the direction of fourteenth-century Tuscany in the main window shapes, but discernibly Islamic are the scalloped arches over the windows and the star patterns in the balustrades.

The display-consciousness of this set piece makes it look laboured. We turn again to the detailing of the roof arches and the end lunettes, and see how successfully Wyatt has followed Brunel's brief. The language is indeed that of metal, and free of historical ties. But the impression persists that in important ways the study of Islamic method helped him to form it.

In 1864 Wyatt created an Arab billiard room for the cotton magnate Alexander Collie at 12 Kensington Palace Gardens. This, like the East India Company's Museum, employed Islamic motifs explicitly. Michael Darby has pointed out that the immediate occasion for the style may have been the purchase of a fireplace by Collie (at the 1862 International Exhibition) which was set up in the billiard room. Designed by Wyatt and carried out by Maw and Company, the tile decoration of the chimneypiece was described by J. B. Waring as in the style of the Alhambra.[19]

In 1869 Wyatt travelled for the first time to Spain, including the Alhambra, and published his record of the journey in *An Architect's Note-Book in Spain Principally Illustrating the Domestic Architecture of that Country* (1872). This was affectionately dedicated to Jones. Six drawings which were used as illustrations are in the Victoria and Albert Museum.[20]

Wyatt's drawing of Moorish decoration has a racy quality of line and shimmering atmosphere that summarises rather than analyses the ornament. Yet he was a staunch upholder of the system of Islamic ornament that Jones had expounded and had applied to designs for many purposes from wallpapers (Figure 105) to books (Figure 106). Throughout the 1850s Wyatt worked indefatigably alongside Jones in advocating reforms in design standards and in particular the lessons of Alhambraic pattern and of Islamic textiles and metalwork. In 1857 the important Manchester Exhibition included an Indian Court and a large representation of oriental fabrics made available by the East India Company. Wyatt welcomed the opportunities provided by this display in his *Principles of Design applicable to Textile Art* (1858) and exhorted the 'artists of Lancashire and Yorkshire' to cultivate that sensibility of taste and eye which such pieces afforded. As for metalwork, we have noted his essay on the subject to J. B. Waring's book *Art Treasures of the United Kingdom* (1858), which also contained pieces on ceramics and textiles by J. C. Robinson and Owen Jones respectively. Wyatt singled out for favourable comment here a Turkish enamelled copper ewer bought by Edward Faulkner at Smyrna and a basin acquired at Constantinople – such things which had been examples to the sixteenth-century Venetians could be no less for modern firms, he asserted.

In the 1860s both Jones and Wyatt pressed their advocacy of Islamic design as a source of learnable principle which could be used by manufacturers. As Darby has shown, Jones was active as designer of products as diverse as bank-notes and biscuit-tin labels, which he conceived along lines suggested by Islamic pattern. Wyatt was equally aware of the great range of possible application. Both men accepted the notion of the suitability of a design system based on 'scientific' principle to an industrial scene in which the machine was to play an increasing part. In an essay 'Orientalism in European Industry' in 1870, Wyatt welcomed the growth of appreciation of Eastern influence 'in almost all departments of production', including carpets and tiles (*Macmillan's Magazine* 126, 1870, 551–6).

In the years after the opening of the South Kensington Museum in 1857 a wide and bewildering conspectus of style in the decorative arts was being made

FIG. 104 Leaf-shaped unit, from a cotton-printer's block. Indian, 19th century. Victoria and Albert Museum: Indian Section (From A. H. Christie, *Traditional Methods of Pattern Designing*, Oxford University Press (1929), Figure 147.)
This design is a good example of the way in which an Islamic-influenced design can move away from symmetry (the central motif and that at the base) to an overall asymmetry (the turn to the left to form the 'bent' leaf). The central form is a descendant of the Greek and Roman palmette (see Figure 37, centre), but it includes the idea of overlap so congenial to Islamic design – and suggested also in the 'leaf' motifs of Wyatt's Paddington arches (Figure 103).

available in the country. Islamic decoration was only one style among many. Jones and Wyatt were powerful champions, however, and throughout the 1860s the influence of Jones's great book *The Grammar of Ornament* (1856) was being consolidated.

This is the moment to consider this milestone of a book in some detail. J. B. Waring and Digby Wyatt contributed chapters and James Wild's Cairo drawings provided material for the illustrations of Arabian ornament. But the concept of the work with its 100 mainly coloured folio plates would have been impossible without the educationist fervour of Henry Cole and Owen Jones. The plates presented nearly 3,000 decorative motifs, beginning with those of 'Savage Tribes'. Classical and Renaissance were included, but European decoration after this latter period was omitted in favour of a detailed consideration of that of Asia. The contrast of this procedure with the Eurocentric habits of European writers comes over when we compare Jones's book with Henry Shaw's optimistically titled *Encyclopaedia of Ornament* (1842), which represented the entire Middle Eastern world by one plate of Cairene motifs. Jones drew extensively on the Marlborough House collection which he had helped to assemble. His pupil,

FIG. 105 Owen Jones (1809–74). Wallpaper for John Trumble and Sons, Leeds. Pen and ink and watercolour, 28.6×47 cm. March 1858. Victoria and Albert Museum
Jones worked extensively on wallpaper design, especially for Trumble (from 1858) and Jeffery and Co. (from 1865). In his Marlborough House lectures of 1852 he had demanded that such designs should avoid assertive treatment of natural objects, but rather present organised form and colour so that they read as flat patterns, following the 'Oriental rule'. The colours in the present example are red and blue.

FIG. 106 Owen Jones. Obverse of title page from T. Moore, *Paradise and the Peri*, Day and Son, 1860. Pen and ink and watercolour. Size of page 32.7×24 cm. Courtauld Institute of Art, London, Zarnecki Collection
The book contained 26 border designs by Jones, enclosing the text and illustrations by Henry Warren, together with the title page and other decorations, including this. Jones will certainly have observed the combination of boldness of shape and extreme refinement of detail from Persian manuscripts. Jones's interest in Persian sources was increasing in the early 1860s.

Albert Henry Warren – son of Henry – and others, prepared the drawings. Christopher Dresser, then studying at Marlborough House, contributed some drawings of leaves and flowers from nature (see p. 187 below).

Jones's chapters concerned with 'Mohammedan' design are valuable on a number of counts. In the first of them, on Arabian decoration, the multifarious origins of Muslim art are set against the speed of development of a style 'complete in itself', a fact that has continued to preoccupy modern historians of the subject. In the following chapters a serious attempt is made to differentiate and evaluate various national types: Turkish (3 plates), Moresque (8 plates), Persian (6 plates) and Indian (9 plates). In all, 454 Islamic motifs are illustrated in colour. In the all-important chapter on 'Moresque' ornament, the processes by which the Moors deploy a pattern on a surface are examined. Every ornament 'arises quietly and naturally from the surface decorated'; there is a balanced distribution of straight, inclined and curved elements; all lines flow from a parent stem; natural forms are never directly copied, but conventionalised into two-dimensional elements. Colours are used so as to be 'best seen in themselves, and add most to the general effect'. These points relate back to Jones's work on the Alhambra, from which all his Moorish examples are taken (see also Figure 68) and to the theories that we have seen him developing in practice and stating in lectures. Here in the *Grammar*, however, these principles are given triumphant assertion in the context of world ornament. 'Every principle which we can derive from the study of the ornamental art of any other people', he wrote here of the Alhambra (p. 66), 'is not only ever present here, but was by the Moors more universally and truly obeyed.'

Jones's *Grammar* is prefaced by the 37 'propositions' so derived by him from his Moorish studies, which form for him the essential grammar of ornamental design. Built into an axiom (proposition 5), the Puginesque idea that ornament should arise 'naturally from the surface decorated' could attain oracular blandness: 'Construction should be decorated. Decoration should never be purposely constructed'. But Pugin and Jones were read and acted upon. As John Steegman noted, Anthony Trollope's character Mrs Stanhope in *Barchester Towers* (published a year after the *Grammar*) carefully avoided 'constructing a decoration' in a dress pattern instead of 'decorating a construction'.[21]

Arabian to the Greek fret. The ornaments on Plate XXXIX. are constructed on two general principles: Nos. 1-12, 16-18, are constructed on one principle (Diagram No. 1), No. 14 on the other (Diagram No. 2). In the first series the lines are equidistant, diagonally crossed by horizontal and

Diagram No. 1 Diagram No. 2

perpendicular lines on each square. But by the system on which No. 14 is constructed, the perpendicular and horizontal lines are equidistant, and the diagonal lines cross only each alternate square. The number of patterns that can be produced by these two systems would appear to be infinite; and it will be seen, on reference to Plate XXXIX., that the variety may be still further increased by the mode of colouring the ground or the surface lines. Any one of these patterns which we have engraved might be made to change its aspect, by bringing into prominence different chains or other general masses.

FIG. 107 Owen Jones. Diagrams from *Grammar of Ornament*, 1856, 73
Jones here analyses Moorish ornament down to two basic geometrical grids, one with equidistant diagonal lines crossed by horizontal and perpendicular lines on each square, the other with horizontal and perpendicular equidistant lines with diagonal lines only on alternating squares.

175

Pursuing the matter of 'decorating a construction' Jones provided exemplary diagrams in his 'Moresque' chapter, showing two geometrical grids (Figure 107) according to which the 18 Moorish patterns illustrated in his plate 39 were built. Each grid shows a different system of combining horizontal and perpendicular lines with diagonals. But he does not stop with the mathematics: he is interested in the readability of effective pattern-making. In Moorish design the equilibrium is such that the tendency of the eye to run in any one direction is countered by lines going in another, so that 'wherever the eye strikes . . . it is inclined to dwell.' Jones's analysis of the way in which apparent movement in a pattern can convey an overall effect of repose – for him a cardinal quality of good ornament – makes his book relevant reading today. It has taken the late twentieth century to recognise his awareness of what we now call the 'psychology of perception', the link between the tracking motions of the eye as it moves across a pattern and our consequent sense of repose or agitation.[22]

Notwithstanding Jones's advanced thinking, the beauty and near-encyclopedic scope of his illustrations were immediately obvious. The *Grammar* was into its ninth edition by 1910 and has remained in print as an indispensable source-book. As a collection of motifs it also proved the progenitor of innumerable other books on historic ornament published up to the First World War. An example was the work translated into English by R. Phené Spiers from the German of H. Dolmetsch and called *The Historic Styles of Ornament*, which came out in 1898 and in a revised edition in 1912. Its Moresque designs (pl. 29) still come exclusively from the Alhambra. The analytical content of Jones's study of Moresque also bred much valuable new work, as may be seen by looking at A. H. Christie's *Traditional Methods of Pattern Designing* (1910), a work we have already noticed (Figures 7, 9, 11). In the 1929 edition of this, no less than 161 out of 419 illustrations are of Islamic examples and about 40 others depend ultimately on Islamic motifs.

As with all source-books which are also works of great intrinsic beauty, Jones's *Grammar* no doubt had a side-effect of inhibiting invention. The patterns that he advocated could be, and were, mechanically copied. But his book also opened many windows, in America, where Louis Sullivan saw it, as well as in Britain where some teacher-designers were stimulated to press enquiries in the Near East for themselves. The translator of Dolmetsch's book, for instance, Richard Phené Spiers (1838–1916), travelled there in 1865–6 and was concerned with investigating Islamic buildings over the next 40 years. Some of his lectures appeared in 1905 with the significant title *Architecture East and West*. Though this book makes it clear that Spiers preferred the Islamic buildings of Cairo and Constantinople to the Alhambra – which he came to regard as over-rich – it is also obvious that as Master of the Architectural School at the Royal Academy from 1870 to 1906 he enthused generations of students with his own interest in Islamic architecture. Among them was W. R. Lethaby, who will figure in this story later (p. 203).

II

In the late 1850s another reforming figure was ready to emerge. William Morris (1834–96), also reacting against the design standards of the British goods shown in 1851, was forming the ideas on pattern which were to be the foundation of his creative life. He was doing so with the help of Jones's *Grammar of Ornament*, which he is known to have possessed. From Jones certainly came a consciousness of geometrical structure as the basis of all successful pattern-making; from him,

possibly, an interest in conventionalising natural plant forms into continuous flowing sequences which respected the two-dimensional surface to which they were applied (Figure 108). Morris's concern with the application of ideas in practice was, however, to lead him to two basic convictions that were very personally held. The first was that good design depends on an understanding of a given material and process; the second, following from this, was that the artist must be a craftsman, a maker who expresses ideas through a medium whose properties he understands. Even in the specialised craft of stained glass, in which neither Morris nor his principal designer, Burne-Jones, were actual executants, Morris had a profound knowledge of method. In the process of assessing what wood, silk and clay could express – both as materials and in terms of the decoration that was appropriate to them – the study of Persian carpets, textiles and ceramics was to be a vital activity for Morris and for his followers in the Arts and Crafts movement.

Morris described himself as a 'pattern-designer', but this did not of itself predispose him to Islamic design. Just as the cast of his literary imagination was fundamentally northern, in visual matters he enjoyed Gothic and Elizabethan art and the English vernacular in architecture. He had no sympathy with architectural polychromy as such: the bright colours of Alhambraic wall-tiling probably held little appeal for him (though they were to fascinate his friend de Morgan). The tiles made by Morris's firm (founded in 1861 as Morris, Marshall, Faulkner and Company, but from 1875 to 1940 known as Morris and Company) bore delicate, brush-painted designs, but are only an important activity in the firm's early years. They were commonly made for fireplaces, though the six magnificently dark, vegetative and totally un-Islamic looking vertical panels designed

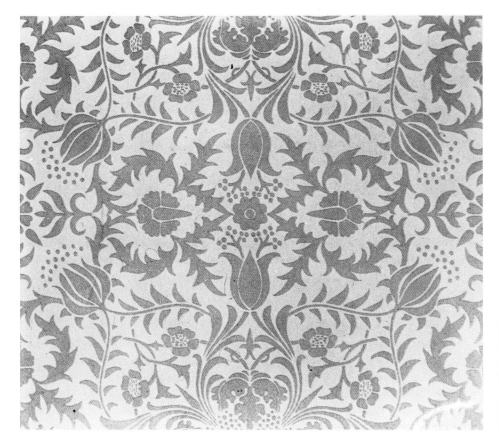

FIG. 108 William Morris (1834–96). Ceiling-paper, 'Persian'. Courtesy Arthur Sanderson and Sons Ltd.
This is an example, almost entirely in terms of curving elements, of Morris's gloss on the 'equilibrium' advocated by Owen Jones (compare Colour plate VII): a ceiling design should have no 'direction'. Morris counters the upward symmetry here with another at right angles to it, and the result is a highly successful flat pattern.

by Morris and carried out by de Morgan for Membland in 1876 (four of these in private ownership; one in the William Morris Art Gallery, Walthamstow; one in the Victoria and Albert Museum) were for a bathroom. The fascination of Morris himself with tapestries, after 1877, probably inclined him to look on walls – certainly those of living-rooms – as best decorated, if not by wallpapers, then with hangings, which absorbed light, rather than with tiles which reflected it. This would be consistent with his consideration of interiors that were *moderately* rather than brightly lit, in the lecture 'Making the Best of it' (written in or before 1879). Here he admires for their light-*reducing* properties Gothic window tracery and 'the lattice-work of a Cairo house' (Leighton's Arab Hall, to be discussed later in this chapter (pp. 190f.), had been designed in 1877).[23]

We have Morris's positive and repeated testimony, however, of his response to Persian carpets. Oriental rugs were the only floor coverings he could find worth putting down in 1860 at the Red House, his new home at Bexleyheath. He frequented sale-rooms and collections of Eastern rugs, especially those of the South Kensington Museum which were much extended in the 1870s.[24] He made contact with the archaeologist J. H. Middleton who was well versed in the subject. Persian carpets were now coming over to the West in large numbers through the activity of the merchants of Tabriz. On 13 April 1877 Morris wrote to Thomas Wardle: 'I saw yesterday a piece of ancient Persian, time of Shah 'Abbās (our Elizabeth's time) that fairly threw me on my back: I had no idea that such wonders could be done in carpets'.[25] Fired by this he decided in the following year to make his own carpet designs. By 1882 he was declaring 'To us pattern-designers, Persia has become a holy land, for there in the process of time our art was perfected'.[26] The beauty of colour, coherence of pattern and respect for surface shown by these designs provided Morris with essential examples from which he could create his own very individual works (Figure 109) in a spirit of emulation rather than imitation and using 'principles that underlie all architectural art' as he put it in a circular of May 1880 that announced his exhibition of rugs.[27]

Though they confidently vindicate his wish to create effects which looked 'the outcome of modern and Western ideas', Morris's Hammersmith rugs (produced from Kelmscott House, Hammersmith) have designs of plants silhouetted, without shading, against a ground colour, and clearly reflect his study of Chinese as well as Persian carpets. After moving to Merton Abbey the firm produced, in the decade 1885–95, large carpets with unmistakably Persian-inspired foliate and floral patterns. A stock of genuine Islamic rugs was also formed. After Morris's death the influence continued: in 1912 a Wilton carpet from his firm was based on a Turcoman pattern developed, it seems, from an antique Bokhara rug.[28]

While his own designs were very personal, however, Morris could throw his considerable energies into spreading awareness of genuine old Persian examples, and stimulating demand in the West for classical Persian patterns and the standards of weaving that should go with them. In 1893 he was writing strongly to support the acquisition for the South Kensington Museum of the most famous Persian carpet of all, that from the Shrine of Shaikh Safi at Ardabil, woven (probably) in Tabriz and dated 1539–40, 946 A.H. (Figure 110). To Morris, the Ardabil was 'of a singular perfection . . . logically and consistently beautiful', and, as it was dated, it represented 'a standard whereby one may test the excellence of the palmy days of Persian design'. Morris had contributed three sixteenth-century carpets of his own to the 1885 exhibition of the Burlington Fine Arts Club (p. 183); one of his carpets was eventually to hang with the Ardabil in the Victoria and Albert Museum.

Morris's imagination was nourished by many sources, notably the arts of medieval Europe about which he wrote so eloquently and which he sought to reinterpret in his generation. Later writers, bearing in mind the high cost of his hand-production, have criticised Morris's socialism for its failure to meet positively the challenge of the machine and the possibilities of machine-production as

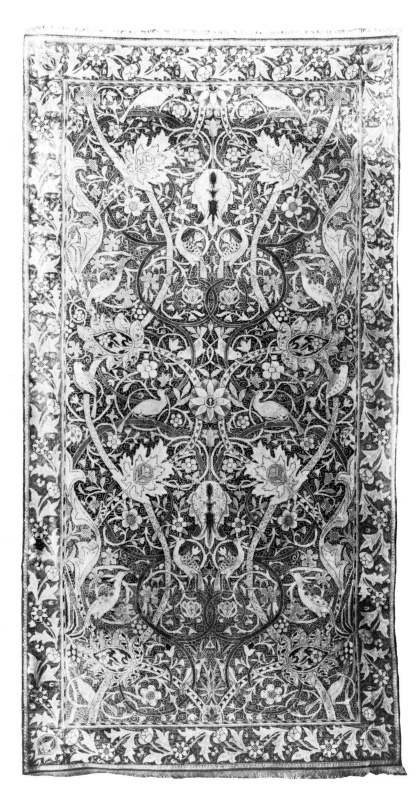

FIG. 109 William Morris. Carpet, 'Bullerswood'. Hand-knotted, wool on cotton warp, 755×410 cm. 1889. Victoria and Albert Museum, T31-1923

This famous design was for Sanderson's house of the same name in Chislehurst, Kent. Whereas in tapestry, recognising the qualities of Gothic examples, Morris was ready to turn the wall into a 'rose-hedge or deep forest', in regard to carpets, with his deep admiration of Persian designs, he agreed with the ideas of Henry Cole, and with Owen Jones and Christopher Dresser, that flatness must be observed. Even in as complex a design as 'Bullerswood' the motifs are strictly two-dimensional and the sense of an underlying surface is always present.

a means of placing good design within the reach not only of the wealthy but also of the modestly paid. The priority for Morris, however, was the artist and his well-being as worker. His phrase about Persia, 'there in the process of time our art was perfected' was a reminder to himself and others that labour and skill were two sides of a single coin and indispensable elements of material and spiritual worth. He was, moreover, aware that he was enunciating his ideas at a time when in the Middle East itself still-vital village traditions of carpet-weaving were being threatened by the debasing influence of synthetic dyes; and in India, Western commercial concerns were having a harmful effect on native artistic traditions.[29]

The lessons of Islamic carpet-making had gone over equally firmly with Charles Locke Eastlake (1836–1906), whose influential book *Hints on Household Taste* appeared in 1868, was in its fourth English edition by 1878 and its sixth

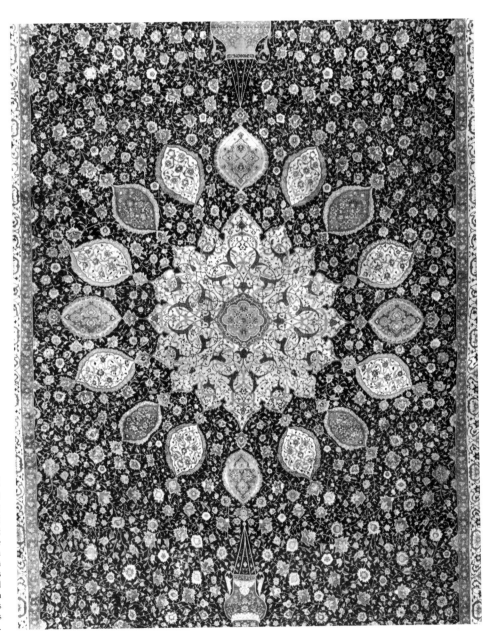

FIG. 110 The Ardabil Carpet (detail). Total size L. 1152 cm., W. 534 cm. Persian, 1539–40 (946 A.H.). Victoria and Albert Museum 272–1893
Unquestionably among the three or four greatest surviving Persian carpets, and made for the shrine of Sheikh Safi at Ardabil. At the heart of the design is the central medallion shown here, containing a green lotus pool with the most elegant of arabesques around it. Two mosque lamps 'hang' from this and 16 ogee shapes radiate outwards. These in turn open on to the dark blue ground of the field which is covered with vines and flowers. William Morris's advocacy was unhesitating: see p. 178.

American in 1881. This book did much to reinforce the influence of the Arts and Crafts movement in the wake of Morris. Where Owen Jones had stressed the geometrical logic of Islamic design, however, Eastlake emphasises its freedom from deadening regularity. The crucial fourth chapter, entitled 'The Floor and the Wall', starts from an analysis of the distinctive qualities of Islamic carpets – their colour; the irregularity (for Eastlake too often disregarded) of their patterns, conforming to a general symmetry but full of vagaries; 'hand-executed' and therefore free of what is to Eastlake the empty perfection of machine-production. 'Examine any old and good specimen of an Eastern carpet, and you will probably find a border on the right in which the stripes are twice as broad as those on the left ... At the north corner, near the window, that zigzag line ends in a little circle; at the south, in a square; at the east, in a dot; at the west, there is nothing at all. This is in the true spirit of good and noble design.' In Europe and in Britain, Eastlake goes on, imitations of oriental goods are often made with the idea that 'nothing can be quite beautiful of which the two opposite sides are not precisely alike'. The studiously accurate, mathematically correct copy loses entirely 'the vigour and independence of the original'; the writer continues: 'choose, then, the humblest type of Turkey carpet or the cheapest hearthrug from Scinde, and be sure they will afford you more lasting eye-pleasure than any English imitation' or European-based 'pictorial monstrosities which you see displayed in the windows of Oxford Street and Ludgate Hill ... only fit to cover the floor of Madame Tussaud's Chamber of Horrors' (Eastlake, edn 1969, p. 108). Eastlake makes the same comparison between modern European pottery and an 'Algerine or Moorish plate', which he illustrates (p. 222).

We must pause at the ambiguous term 'pictorial'. Eastlake uses it to denote what is to him a decadent and discordant European tradition of representing the natural world three-dimensionally, irrespective of suitability to the surface carrying the representation. Nevertheless it is plain that in the nineteenth century Islamic rugs were helping to open up a considerably enlarged awareness of what might be called 'pictorial': painters such as Delacroix and Sargent were even to suggest that as arrangements of shape and colour these rugs surpassed the finest paintings ever made.[30] Morris does not go so far as this. His lecture 'Hints on Pattern Designing' (1881) makes his position clear. To him reference to the natural world is necessary: as 'a Western man and a picture lover', he feels he 'must still insist on plenty of meaning in your patterns. I must have unmistakable suggestions of gardens and fields, and strange trees, boughs, tendrils, or I can't do with your pattern and must take the first piece of nonsense work a Kurdish shepherd has woven from tradition and memory' (1910–15, XXII, 195–6).

The Kurdish shepherd was to come into his own. Morris's sense of the long perspectives of oriental rug-making reflects another factor in the appraisal of such work in this period.[31] The comparison of Morris, the advocate of sophisticated handicraft, aware of the 'perfecting' process in Persian carpet design, and Eastlake with his recognition of primitive 'irregularity' in the 'humblest type of Turkey carpet' throws interesting cross-lights on ways in which these carpets could now be seen as objects which – whatever else they did – relayed the strong and continuous tradition of a society before the onset of machine-production and self-conscious 'reproduction'. A book by Vincent Robinson, *Eastern Carpets, Twelve Early Examples* (1882), goes further along the primitivist line. Robinson sees the rugs as the work of desert nomads, 'people whose primitive habits of life were at variance with those of civilised nations, and who needed no schools of art, nor expensive educational processes to stimulate their imagination'. With its aura of unease about contemporary Western art education, this text, as Sylvester has

noted, is of some importance. It shows attention being directed not only to the carpets but to the 'primitive' makers. The 'noble savage' of the South Seas had been the subject of distant admiration by enlightened Europeans 100 years before. The desert nomad nearer home, enjoying a prestige that three or four generations of close observation had made possible, is now recognised to have had ancestors who combined the virtues of a primitive life with the exercise of an imagination that was articulate enough for Europe to learn from it. As a dealer and collector of oriental carpets, Robinson is intent on holding up the glories of these 'splendid old examples', which were in his eyes inimitable. Sylvester draws attention to the passage in Robinson's second book of carpet examples, published in 1893, in which he notes with chagrin that his first book had been used for 'the purpose of manufacturing imitation carpets with the title of "Reproductions"'.[32]

Robinson was a prime mover in the important episode which saw the Ardabil carpet on public view in England in 1892. In 1843 the English traveller W. R. Holmes had seen the 'faded remains' of the carpet – as he describes them in his book *Sketches on the Shores of the Caspian*, 1845 – in the mosque of Shaikh Safi where it had lain since the sixteenth century. Forty years later the mosque was in need of repair and to raise the money the authorities resolved to sell some carpets. The Manchester firm of Zieglers (which had imported Persian carpets since 1883 and had some 2,500 looms there producing modern versions) conducted negotiations, and Vincent Robinson's firm bought the Ardabil carpet in 1888. Four years elapsed, before *The Times* was advertising 'an extraordinary carpet . . . on view in the afternoons' at Robinson's Wigmore Street galleries. Both *The Times* and the *Manchester Guardian* were in agreement that this was, in the *Guardian*'s words, 'the finest carpet known to modern times'. The Ardabil was sold to the South Kensington Museum for the sum of £2,500, then unheard of for a carpet but quickly raised as the result of a campaign led by Sir Augustus Franks and William Morris. Robinson's colleague Stebbing published an account in 1893, but other details have since come to light. Following common practice, the Ardabil had been woven with a companion carpet, which also came to Robinson, and was used to 'complete' the Ardabil (Erdmann, 1970, p. 32, provides a convenient summary). The second carpet, left as an intact middle section, subsequently entered the famous Yerkes Collection in America and is now in the Los Angeles County Museum.

Islamic carpets clearly provided thoughtful observers, in surprisingly various ways, with artistic lifelines which they grasped wholeheartedly. The rugs could convey a visual rightness which 'contained' irregularity: a primitive force which embraced sophistication. The same might be said of oriental ceramics with their ancient traditions of simple shape and investing glaze, and, in the case of so many Islamic types, surface qualities of pattern and metallic reflection. Morris's friend William de Morgan also frequented the South Kensington Museum, as it was enriched, along with the British Museum, with Near Eastern and Hispano-Moresque wares as well as Italian maiolica.

Turkish Iznik – in de Morgan's time known as 'Damascus' and 'Rhodian' ware – and Persian pottery, including lustre, were being acquired by private collectors and by the big London museums in impressive amounts in the period between 1860 and 1910. In 1862 the Loan Exhibition at South Kensington, with its catalogue introduced by John Charles Robinson, Curator of the Museum, presented a wide cross-section of Islamic wares, and in the 1870s and 1880s substantial quantities were arriving in Britain through the activities of museum agents and officials such as Robert Murdoch-Smith, Caspar Purdon Clarke and Augustus Wollaston Franks. The great exhibition of Persian and Arab Art at the

Burlington Fine Arts Club in 1885 showed 606 items representing textiles and painting, but gave by far the greatest attention to ceramics. The list of lenders given in the catalogue reads like a roll-call of almost all the adherents of Islamic art in Britain: here are George Aitchison, Edward Burne-Jones, Frank Dillon. C. D. E. Fortnum, Augustus W. Franks, F. du Cane Godman, Holman Hunt, Louis Huth, A. A. Ionides, Frederic Leighton, William Morris, Vincent Robinson, George Salting and Henry Wallis. John Henderson, whose Turkish wares had reached the British Museum in 1878, is one of the few major names that are absent. Godman and Salting were also prominent in the collecting of Hispano-Moresque. In 1855 the South Kensington Museum acquired five large dishes of this ware from the Bernal Collection: two were illustrated in colour in Fortnum's massive catalogue of the Museum's maiolica published in 1873: this also lists 31 other examples, apart from tiles.[33]

William de Morgan (1839–1917) was therefore reflecting very contemporary interests in his own creative work: his 'Persian' style, in fact using the colours of Turkish Iznik, begins in his Chelsea factory period, about 1875–6. He had come to ceramics, however, by an unusual route, starting somewhat uncertainly, with painting. He had then taken up stained glass-making: this involved him in a study of the chemistry of glazes, an interest which was to give continual momentum to his potting, taken up about 1869. He became an international authority on potting methods, and in 1893 was invited to Egypt to advise on the feasibility of setting up new kilns there. As a specialist in re-creating old pottery techniques, de Morgan had few rivals in his time and nowhere were his patience and ingenuity to be tested more than in the retrieval of lustre.

In 1869 the means of reproducing the lustre effect of early Persian earthenware was little known, though modern wares had been produced and shown at the 1862 London International Exhibition by the Ginori factory at Doccia (near Florence) and Carocci from that centre of sixteenth-century lustre, Gubbio. From 1873 de Morgan was devoting immense efforts to mastering the technique as his paper to the Society of Arts (delivered on 31 May 1892 and published in their *Journal* on 24 June) reveals. Here he presents himself as a dedicated chemist pursuing an investigation, even setting the roof on fire but developing his process and varying it with experiment. This picture of him accords well with that of his helper Reginald Blunt, who depicts him as a hyperactive inventor on many fronts, from aircraft and submarine work to refining a pneumatic speed change gear for bicycles.[34] De Morgan's lustre methods, he himself tells us, involved mixing the metal oxides with white slip, the proportion varying in accordance with the strength of colour required, and painting them on with water. Reduction might be achieved not with carbon, but by such experimental means as the use of ammonia, coal-gas, water-vapour or glycerine. From 1888 the most splendid period of lustre began at his Fulham factory, Sands End, with de Morgan making the designs which were then carried out by trained assistants: brilliant effects of red were obtained from copper oxide, together with the warm greys of silver oxide.

Besides three-dimensional lustre pieces de Morgan was interested in tiles as wall-decoration. De Morgan was producing tiles from the early 1870s, including designs for Morris's firm. In the decade 1872–82 he evolved more than 300 tile designs, at first painting Staffordshire blanks and then making his own.[35] Some of these tiles could be used singly or in groups; other made up units composing large pictorial motifs. Good examples of the latter can be seen in the 'Manchester pattern' from his Merton Abbey period (1882–8). In 1880 the Tabard Inn with its 600 de Morgan tiles opened in Norman Shaw's fashionable new London suburb

of Bedford Park. From the mid 1890s de Morgan was supplying tile decorations for six liners of the Peninsula and Oriental Steamship Company: for the S.S. *Arabia* he designed an 'Arabia Companion' frieze which included ogee arches and flowering plants. In 1905–7 he became involved with the decoration of the house at 8 Addison Road, designed for Sir Ernest Debenham by de Morgan's former partner, Halsey Ricardo, and now the home of the Richmond Fellowship. For the outside of this Doulton's provided tiles; but de Morgan was a firm advocate of tiles for exteriors, believing, with Ricardo, that washable surfaces as well as polychromy were desirable for building in large, smoky cities. Inside he was enabled to make reverberant multi-tile inventions in Iznik colours (Figure 111).

Throughout his career as a tile-maker, however, de Morgan was to meet no more testing challenge than in 1877, when he was invited to undertake the repair and matching of genuine old Iznik and Syrian tiles in Lord Leighton's Arab Hall at Holland Park. We will come back to this later when we consider the phenomenon of the Arab-style interior in private houses (p. 190).

Though de Morgan was by no means the only potter using Islamic motifs in his life-time[36] he was easily the most prominent. His large output was based on sedulous habit: he normally made his decorative designs on paper and then turned them over to others. His painters Charles and Fred Passenger, and James Hersey, worked up a confident expertise in handling the flower and leaf-forms of Iznik tradition. The Passengers formed a partnership with de Morgan and the kiln-firer Frank Iles which lasted at Sands End until 1907, though de Morgan had retired from practical work through ill-health two years before.

For practising potters de Morgan is often diminished for what they see as his lack of personal commitment to the true 'language' of ceramics. Leach made the point; Caiger-Smith, in his book *Tin-glaze Pottery* (p. 191), recognised de Morgan's high ideals, but concluded that he was 'primarily a draughtsman . . .

FIG. 111 William de Morgan. (1839–1817). Tile panel, earthenware, 90 × 162 cm. 1905–7, The Richmond Fellowship, London

Comprising 48 tiles, this panel presents the full range of de Morgan's 'Persian' colours – turquoise, dark blue, purple, sage green, pale green. In fact the colours and many of the motifs came from Turkish Iznik pottery (Figure 24). The brilliant counterpoint of the large peacocks against sprays of carnations and other plants is an instance of how de Morgan infused cool Islamic pattern-types with a nervous intensity that foreshadows Art Nouveau.

more a designer using ceramics than an artist, thinking in ceramic terms'. It is true that de Morgan is primarily the 'artist-designer'. Caiger-Smith also comments that he 'used ceramic techniques (i.e. lustre) which were too variable and uncertain to be used industrially'. This is also true: and in this regard, too, de Morgan, the friend of Morris, is the *artist*-craftsman. But it would be wrong to infer that he was just a facile painter-designer who automatically set hand-skill above technological process. Ceramic *processes* engrossed him. In the same Society of Arts lecture where he reviews the history of lustre from its Islamic origins, he seems in fact to be trying to adjust the balance between the claims of skill on the one hand and technological challenge on the other, a balance which he feels has been overweighted on the side of skill. He speculates on the reasons for the disappearance of lustre into obscurity after the Renaissance. He thinks that this happened because of the incompatibility of a method which carried a high failure rate with the development of a style of brushwork in Europe, at the Renaissance, which emphasised personal dexterity and total hand control. In other words, it is not only industrial methods that are in question: so also are the 'predictable' manipulative skills that had come from the heart of the European painting tradition itself. 'The greater an artist's success in manipulation, the less is he disposed to incur the risks of an uncertain firing.' For such flashes of provocation the lecture still makes worthwhile reading. How many in de Morgan's audience, one wonders, came away from this purposeful, unemotional account with an unfamiliar perception of the artist as one who not only uses manipulative skills but who also has to make difficult materials work for him – an obstetrician as well as a miracle-worker.

The development of 'art potteries', alongside that of de Morgan, produced a number of ceramic artists who became proficient in handling Near Eastern motifs. The term 'Art Manufactures' had been made widely known by the energetic Henry Cole in the 1840s as part of his plan to improve design by having articles produced by manufacturers to the specifications of artists. By the late 1860s the term 'Art pottery' came to be used to refer to ceramic objects so designed and executed. Art pottery might eschew the technical perfection of machine-production and emphasise personal expression: but its guiding tenets did not exclude those large enterprises where craftsman-skills were rated above machine-like slickness. The Art Studios, opened in 1871 by Doulton and Company with staff recruited from Lambeth School of Art, were among these. Besides Chinese ceramic shapes, vase and bottle-forms of the Near and Middle East appear. Women frequently painted the designs: among those who worked in the 'Persian' manner, adding foliate decoration of brilliant quality, were Minna L. Crawley (working in the late 1870s on the earthenware called Lambeth faience) and Louisa J. Davis (at Doultons from about 1873 to the mid 1890s).[37] Linthorpe Pottery, Middlesbrough (with which Dresser was associated) also reflects Persian bottle-forms: and in the 1890s the Burmantofts factory, Leeds, was producing large vases with de Morgan-like 'Persian' decoration.[38]

Lustre was taken up from the 1870s by George Maw and Company of Broseley, Shropshire, who contributed specimens to the 1878 Paris Exhibition in red (ruby) and yellow (*lustre d'or*). In 1905 the Pilkington Tile and Pottery Company of Clifton Hearsley near Manchester began to produce lustre as part of their Lancastrian range, which had been marketed in Greek, Persian and Chinese shapes for two years previously. A lustre-firing success rate of over 90 per cent was achieved and Walter Crane and Lewis F. Day designed for this popular ware.[39]

As for tiles, the important names beside de Morgan are Minton and again Maw

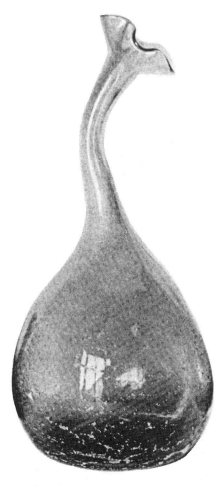

and Pilkington. Mintons, the first modern manufacturers of encaustic tiles, were also taking a lead in exploring Near and Middle Eastern ceramic shapes in the 1850s (the outcome being designs like Figure 112). But their director, Colin Minton Campbell, was collecting tiles in 1858 in Paris and Constantinople.[40] Maw were building up a large reputation in the 1860s for tiles of moulded maiolica. Many of the firm's tile-designs formed Islamic patterns composed of geometrical units, as may be seen in the illustrations of encaustic examples in Eastlake's *Hints* (1868). W. B. Simpson and Sons of the Strand, London, Maw's London agent (who described themselves as 'art tile painters'), executed such prestigious commissions as the floor and wall-tiles in William Burges's interiors for Lord Bute at Cardiff Castle, to which we will come later (pp. 192f.).[41]

Whereas de Morgan's fascination with ceramic surface led him to concentrate on glaze and decoration, we find in the work of Christopher Dresser (1834–1904) daring powers of invention directed towards overall shape in metal, ceramic and glass (Figure 113). Like Morris his visual interests were wide-ranging, but while Morris went back in time for inspiration, Dresser was an adventurous space-traveller, with a mental horizon stretching to Japan in the east and to Peru in the west. His experience of Japan was first hand, and decisive for him: he was,

FIG. 112 (right) Bottle, earthenware with green, blue and iron red enamels on white. H. 52.2 cm. Minton (unmarked), about 1875. Fine Art Society, London
This fine piece, circular at its mouth and foot but with a flattened oval body, reflects a shape long established in Sasanian metalwork and used in many parts of the East. There is a drawing for it in the Minton archives (illus. Minton exhibition catalogue, Victoria and Albert Museum, 1976, p. 6). The shape is a free variation of that of a Persian model, 991–1876, in the Victoria and Albert Museum.

FIG. 113 (above) Christopher Dresser (1834–1904). Vase, olive-yellow glass. About 1885. *Studio* XV, 1899, 105
Dresser worked inventively in many fields, including ceramics and glass. The 'natural' form expressing the ductility of glass had been paralleled in the glass of Persia (Figure 114). The *Studio* featured an article on Dresser in 1899.

however, as the spiritual heir of Owen Jones, drawn frequently to 'Moorish' prototypes of ornament; and he was obviously aware of Persian glass (Figure 114).

Dresser had been a pupil in 1847 at the School of Design in Somerset House which transferred to Marlborough House in 1853: he was therefore in early contact with the advanced thinking of the 'Cole group' which included Owen Jones.[42] A botanist, Dresser contributed to Jones's *Grammar of Ornament* a plate (XCVIII) concerned with the geometrical arrangement of flowers. His feeling for geometry and the calculated effect achieved by means of geometrical construction confirmed in him a high regard for Islamic design, as it had Jones. 'I know of no ornament', Dresser wrote, 'more intricately beautiful and mingled than the Persian – no geometrical strapwork or system of interlacing lines, so rich as those of the Moors (the Alhambraic).'[43] Also like Jones, however, he responded keenly to the more optical qualities of Islamic colour. Persian carpets were an object lesson in the handling of bright colour to produce an effect of overall 'neutrality': he had admired this in the London International Exhibition of 1862 and in the Paris Exhibition of 1867. The carpet, he felt, should be neutral in general effect as it is the background against which other objects are seen: but neutrality could include 'radiance' if small amounts of primary colours were used either alone or with secondaries or black and white. Persian carpets showed perfectly how this could be done.[44]

The author of seven books on art, 'he never tired', according to his obituary in the *Builder* (10 December 1904), 'of discussion on Art and the habits of the nations of the East, trying to trace their histories by their ornamental forms as a philologist does by their language'. Something of this philological concern, which goes back to Jones, is seen in Dresser's recommendation in his *Studies in Design* (1874–6) that the learner should 'notice carefully the resemblances and differences' between Alhambraic, Arabian and Turkish ornament 'and thus make himself master of the characteristic quality of each.' He included elaborate Islamic motifs in his illustrations for the *Studies*. Notwithstanding this concern with the philology of Islamic style his personal work shows unmistakable Muslim inspiration only occasionally. But he worked for many firms, including Minton, and he wrote – as he put it in *Principles of Decorative Design* (1873), based on articles first published in the *Technical Educator* – 'for the working man'. His importance in spreading awareness of Eastern models (such as the type used for the Minton bottle in Figure 112, which has been linked with his name) can therefore hardly be overrated.

The biggest practical part in achieving this spread of awareness of Eastern art for the public of the last quarter of the nineteenth century was nevertheless surely played by Arthur Lasenby Liberty (1843–1917), founder of the famous London firm.[45] He was at the heart of the orientalism of the time: Thomas Wardle printed 'oriental' style textiles for him, Dresser was a friend and de Morgan supplied him with tiles. He became interested in oriental art through the London International Exhibition of 1862, where Japanese objects were first shown on a large scale in Europe. Beginning at Farmer and Rogers's Oriental Warehouse in Regent Street, he opened his own shop 'East India House' on the opposite side of the street, in 1875, moving to Chesham House in 1880. From the 1870s Libertys was importing fabrics from the Middle and Far East – Cashmere woollens, Indian gauzes – creating in fact a demand which exceeded the supply. Standards were high: believing that some Eastern suppliers were making their colours crude to meet what was thought to be Western taste, Liberty encouraged British firms to perfect dyeing techniques which could obtain the subtle colour relationships of the older originals. Persian techniques were particularly studied. Plain Indian silks,

FIG. 114 Perfume-sprinkler, green glass. H. 35.7 cm. Persian, 18th to 19th century. Victoria and Albert Museum 921–1889 The South Kensington Museum had acquired a smoke-coloured glass Persian sprinkler in 1877: this handsome green glass example followed 12 years later.

shipped to Libertys, were dyed specially for the firm and hand-printed, using wood-blocks which reproduced old Indian designs.

Liberty, unlike Morris and Eastlake, had a high regard for the possibilities of machine-production in supplying inexpensive textiles of fine design, and catered for a large and varied public, not necessarily the wealthy.

In the 1880s Libertys opened a Near Eastern bazaar and an Arab Tea Room in their premises at Chesham House, Regent Street. The same decade saw the firm concentrating increasingly on wallpapers and on furniture (Koran-stands as well as sideboards and small tables imported from Near Eastern sources, especially Cairo), and designing their own furniture using Islamic motifs (Figure 115). If something more than a Moorish 'cosy corner' or 'Damascus niche' was required it was possible to have whole interiors in the style; notably smoking-rooms – created by Liberty design studio under Leonard F. Wyburd. In 1888 the studio carried out the influential contract of the Earl of Aberdeen's 'Indian' dining-room in his Grosvenor Square house: this had Moorish arches and old Persian tiles, and dinner guests sat at small separate tables according to the latest fashion.[46] In the years around 1900 the role of Libertys in providing a spotlight in London on Eastern goods was at the height of its influence: it was still to be appreciable 100 years after the firm's foundation.

Libertys were not alone in this market. In February 1886 the magazine *The Cabinet Maker*, which had illustrated moresque furniture by Liberty two years before, records similarly inspired furniture made in Cairo and imported by Rottmann, Strome and Company; the firm of H. and J. Cooper is said to be 'still leaders in the Cairene department' in 1885; the name of J. S. Henry is mentioned as another supplier in 1887.[47] A considerable demand is evident in these particular years.

FIG. 115 Table and chair, both mahogany. Table H. 80 cm., L. 90 cm., W. 37 cm. Chair H. 110 cm., W 57 cm. (at front). Liberty and Co., about 1890. Fine Art Society, London
The basic structure of both pieces, with square and turned sections contrasted, reflects a wider interest of the generation following William Morris: the rectilinearity has been softened here by Islamic cusping and the lattice effect of *mashrabiyya* screens (cf. Figure 117).

The firm of G. P. and J. Baker must also be mentioned here. Opened in 1884 in London by George Percival and James Baker, this concern became well-known for the oriental designs that it offered in the fields of wallpapers and textiles. The Eastern and in particular Islamic interests of Bakers' were partly the result of the activity of George Baker, father of the two founders of the firm. George Baker, a gardener, had been sent to Constantinople by the Government in 1848 and had combined extensive trade in plants with the collecting of Islamic textiles, which were sent back to Britain. George Percival and James were born in Turkey and, in 1871, at the age of 21, the elder brother travelled with his father in Persia. He began to act as his father's agent and to sell Turkish carpets to Britain. He came home with a collection of printed textile designs, some of which were adapted and printed by Swaisland and Co. at Crayford. This collection became the basis of the 3,000 examples which were amassed in Baker's own archives, and which have provided ideas for furnishing throughout the twentieth century. From 1893 the Bakers were producing their designs from Crayford themselves, with marked commercial success, and for a time set up looms from which hand-knotted rugs could be made from selected oriental models, using their own dyed wool. Charles Francis Annesley Voysey (1857–1941) designed Turkish-inspired textiles for them – for example, the block-printed linen 'Scutari' (designed about 1889–90, printed 1893). A roller-printed linen, 'Anatolia', adapted from a Turkish embroidery, was eventually sold (about 1905) through Libertys at 2s 11d a yard, and other Eastern designs were printed by Bakers for Heal and Sons.[48]

III

The 'Arab Room' is an arresting phenomenon of the last quarter of the nineteenth century and the opening years of the next. A case could be made for the Libertys smoking-room as the last major product of the old association of Islamic style with ideas of recreation and relaxation that had been made in the past. In the eighteenth-century English landscape, the piquancy of a Turkish tent or an Alhambra made an agreeable diversion. As the main house itself became part of the landscaped effect in Regency times, Islamic notions were often adapted in conservatories and garden rooms. The Victorian conservatory had maintained the connection. Now in the late part of the century the idea of the 'Arab Room' could be entertained indoors as part of the planning of the house and have its own special purposes.

Apart from Victorian tastes for the ornate and unexpected, this development had much to do with certain social trends that were strongly apparent in late Victorian society. At least two of these have to be taken into account. The first was the grudging attitude of many country house-owners to smoking, which led to the view that the habit could be tolerated if it were confined to a smoking-room.[49] To go from this position to the point of associating such rooms with the artistic style which obtained in the lands of the pipe-smoking Muslim and the hookah, required little imagination. The second factor was the process of separating the sexes in ways that were considered appropriate in well-conducted households of the larger kind. According to this, men should have gun rooms and smoking-rooms, women should have morning-rooms and boudoirs. Billiard rooms were largely a male preserve, but women might be admitted. Again it is not hard to see how the idea could arise of projecting the male prerogatives in terms of the architectural style of a part of the world where male dominance was taken for granted.

The most famous Arab interior of all, however, in Britain – the Arab Hall of

Frederic Lord Leighton (1830–96) – does not fit into this picture. Leighton chose to add it to his house out of an artist's delight in the style itself, 'for the sake of something beautiful to look at once in a while', as he put it.[50] Leighton is a remarkable instance of a painter with convinced classicist sympathies who responded intensely to Islamic pattern and colour. He had begun to collect Islamic pottery on a visit to Turkey in 1867, and had continued in Egypt in the following year. In 1871 his friend Richard Burton, the former explorer and then Consul at Damascus, promised to look out for houses which might be demolished with good tiles in them. Two years later Leighton visited Damascus: Burton left that year but introduced Leighton to a missionary, the Reverend William Wright, who knew useful kiln-sites. In 1876 Leighton was able to advise Caspar Purdon Clarke, visiting Damascus on behalf of the South Kensington Museum, where to look: Clarke brought him further tiles. The same year Burton secured for Leighton an important collection 'from the tomb of Sakhar, on the Indus'.

The following year Leighton set about providing a space to house his collection in the house, 2 (now 12) Holland Park Road, London, which his friend George Aitchison had designed for him in 1865. Aitchison was a skilful architect, particularly of interiors, and a committed advocate of polychromy. According to him and Walter Crane, the design was based on the reception hall of the part Muslim twelfth-century palace of la Zisa at Palermo. But the room is also an 'original'.[51] Aitchison's two beautiful drawings for it were shown at the Royal Academy of 1880 (Figure 116). The hall (Figure 117) is entered between double pillars from an ante-room containing de Morgan tiles: it is square with alcoves on the other three sides. The tiles are mainly seventeenth-century Syrian with some sixteenth-century Iznik examples: de Morgan restored those which were incomplete. A particularly splendid ingredient is provided by the 16-foot spread of tiles over the entrance bearing a Koranic verse in the original script. The translation of this runs

> In the name of the merciful, long-suffering God.
> The Merciful hath taught the Koran;
> He hath created man and taught him speech;
> He hath set the sun and the moon in their courses;
> The grass and the trees are subject unto him.

On the west wall is a wooden alcove with two inset star-shaped Persian tiles, brown-glazed and probably of the thirteenth century.

The prevailing blue tonality of the north and south walls presents a variety of flowering plants in overall patterns, and further panels with Koranic inscriptions. Marble columns surround the interior, some with capitals modelled by Sir Edgar Boehm to designs by Aitchison and Randolph Caldecott. Above is Walter Crane's mosaic frieze in brown, blue, white and gold. This has unexpectedly large-scale winding arabesque and includes confronted animals and peacocks with high coiling tails (recalling Persian textiles) which especially delighted Leighton.[52] The mosaic in the Arab Hall was done by Burke and Company. The black marble fountain was by White and Sons. To see the dome in its original gilding reflected in this must have been a notable experience. The *mashrabiyya* lattices in the windows below and in the oriel (of an imagined *zenana*) above, probably of the seventeenth century, came from Damascus. Stained glass for the dome windows appears to have come from there also, but only enough old glass is said to have survived the journey to fill one window.

The resulting interior presents these many elements, designed by different identities and produced by others, with a robustness that overrides criticism. Itself inspired by a hybrid interior, it unites objects and motifs from Sicily, Persia,

Syria and Turkey, together with inscriptions from the Koran in a secular setting, with total confidence. It both dips into history and underscores Victorian interest in the modern possibilities of Islamic planar polychromy in architecture. But for the contemporaries it was also an attractive reception room which managed to be both domestic in scale and the showpiece of one of the most fashionable homes of

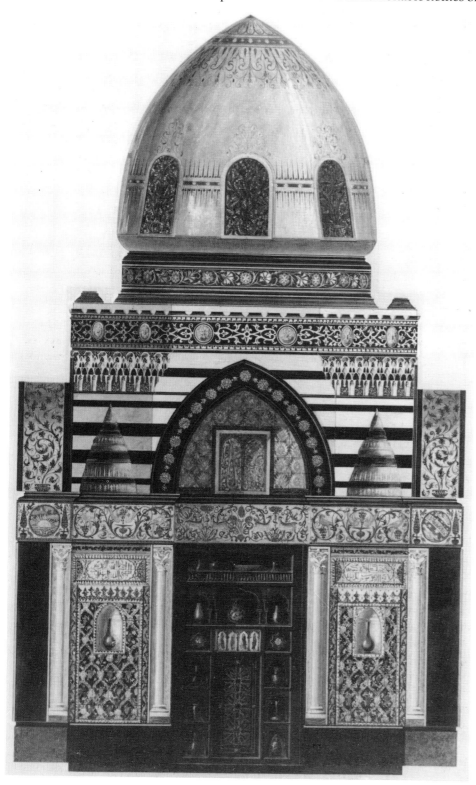

FIG. 116 George Aitchison (1825–1910). Design for the Arab Hall, Leighton House, Holland Park Road, Kensington, London. 1877–79. Watercolour and gold paint heightened with white. 63.4×43.7 cm. Signed on mount and dated March 1880. Inscribed 'Arab Hall, Kensington W. Sir F. Leighton Bart PRA.' Drawings Collection, British Architectural Library, RIBA, London
One of two drawings prepared by Aitchison of this interior which created an Arab environment for Leighton at the heart of his house. It shows the alcove in the west wall, and the dome above in gold.

London. In 1883 Maurice B. Adams drew the Hall's exterior, with its cut and moulded Iranian brickwork, for his book *Artists' Homes* (1883). Mrs Haweis (*Beautiful Houses* , 1882) called it a 'Moorish dream' and, also in 1883, Vernon Lee thought it 'quite the 8th wonder of the world' (the use of the Arabic numeral seems entirely justified).[53]

Not the least suggestive elements in the Arab Hall, it must however be said, are the calligraphic inscriptions. Upsweeping of line, these must surely take their place among the avatars of Art Nouveau: the style that was to be nurtured in Britain less than a decade later.

The Arab Hall was hardly built before another and very different 'Arab' interior was realised. About 1880–1 the architect William Burges (1827–81) was in the last stages of his extensive remodelling operations at Cardiff Castle for the third Marquess of Bute (Figure 118). These had been in progress since 1865. The association of this particular architect and patron, both united in a fervent regard for the architecture of the Middle Ages of Europe, had led to one of the most

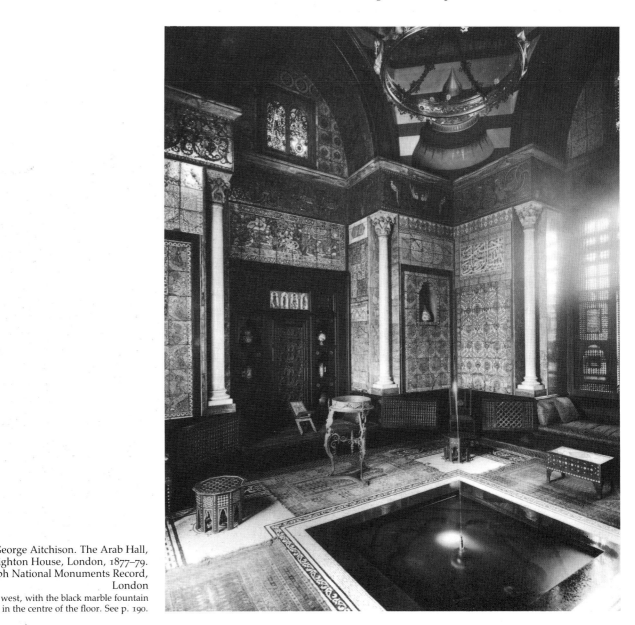

FIG. 117 George Aitchison. The Arab Hall,
Leighton House, London, 1877–79.
Photograph National Monuments Record,
London
The view to the west, with the black marble fountain
in the centre of the floor. See p. 190.

extraordinary sequences of interior effects, of any period, in Britain. The Banqueting Hall, Library, rooms in the Clock Tower (including the Winter and Summer Smoking-Rooms and the Bachelor Bedroom), the Chaucer Room at the top of the Beauchamp Tower, the Study and Arab Room in the Herbert Tower, have been described and analysed elsewhere.[54]

In the Arab Room the floor pattern sets out the Islamic eight-fold figure, which is developed with pyrotechnic virtuosity in the domical ceiling. High windows filled with stained glass break a dark horizontal, above which the ceiling rises in a startling series of angular and curving facets to a final simple restatement of the eight-pointed star. While the book by A. Prisse d'Avennes, *L'Art Arabe d'après les monuments du Kaire* (1877), and recent work by John Pollard Seddon at Rosdohan House, Ireland (as Darby points out in his discussion of the room in *The Islamic Perspective*), provided ideas for detail, the overall effect is completely individual.

The emphasis on facet in particular is typical of Burges, the possessor of a strongly sculptural imagination. Where Jones (Colour plate IX) thinks with the mind of a painter of coloured surfaces in extension, Burges is conscious of solid form with lit and shadowed sides. Where Jones is interested in diffused light,

FIG. 118 William Burges (1827–81). Ceiling, the Arab Room, Cardiff Castle. 1880–1. Photograph National Monuments Record for Wales
The ceiling is made up of four arm-like sections set at 45 degrees to the walls, and meeting at a central star. Its design incorporates echoes of the stalactite and honeycomb 'facetted' effects of Islamic domes, which Burges had studied in Prisse d'Avennes' book *L'Art Arabe* (1877).

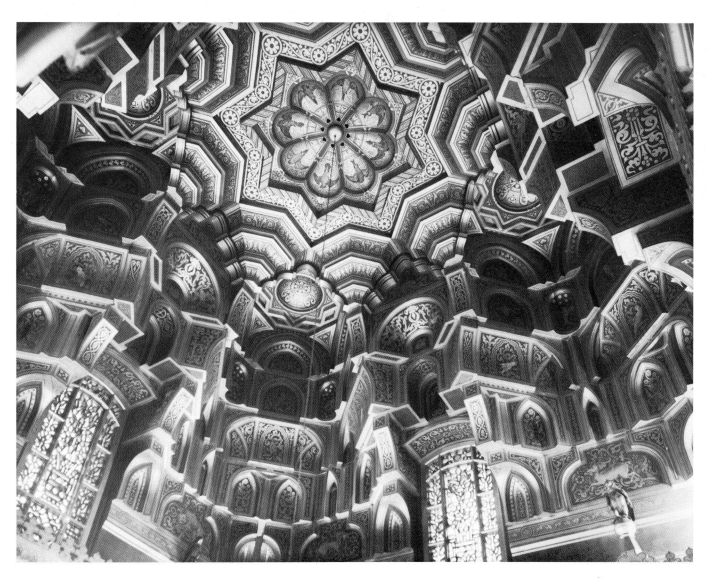

Burges wants to build up structural climax. We learn something of what Islamic style meant to Burges from two early articles he wrote for the *Builder* after his visit in the summer of 1857 to Constantinople.[55] 'Mosques teach us', he wrote, 'the importance of massing ornament in certain places', and not to distribute it 'over the whole surface', and thereby 'cut up all breadth of effect.' How different from Jones, who saw *his* breadth of effect in the very factors of repetition and overall distribution.

Burges's articles repay close attention. A reader of Grelot, whose seventeenth-century description of the Sultan's caiques (Bosphoran rowing boats) as 'all coloured and gilded, even to the oars' he quotes, Burges was disappointed by the loss in the centre of the city of so much architectural colour (apart from the mosques) and the greyness of the assumed European fashions in men's dress. He enjoyed the 'bright costume of the women' and speculated that the Turks' finest achievements in architectural decoration belonged to an age when the colour of dress and hangings was more intrinsically part of their lives. Back home he was to wear brightly coloured medieval dress on occasions: not, it seems, the ubiquitous Turkish dress of so many of his compatriots.[56]

Besides the bold carving of wooden shutters and superimposed layering of ceilings in the medieval houses, Burges also responded to the mystery of the lighting in the mosques. The gas lamps hung 'very low' from wire chains, giving an effect like 'walking under a sea of light', so very distinct he thought, from modern buildings at home which, if lighting was seriously considered, achieved it by 'flaring masses' of gas which blinded the spectator.[57]

Ceilings and the fantasy of ceiling-recesses where light is lost in shadow or from which colour might emerge into light fascinated Burges. Professor Crook has plausibly suggested that his painted ceilings in Cardiff's Bute Tower derive from the Moorish and Arabic strains of Islamic design as reflected in Sicily and Cairo respectively. In 1875 Axel Haig went to Palermo at Burges's bidding to draw the honeycomb ceilings there. Surely half the attraction of Sicily to Burges was the extraordinarily rich mixture of medieval styles with which Islamic ideas had conjoined: he knew of comparable mélanges through looking at his copy of Murphy's *Arabian Antiquities of Spain*. Henry Gally Knight in his *Normans in Sicily* (1838) had affirmed the stylistic richness in his illustrations of Siculo-Norman – a style Saracenic in its arches, Roman in its pillars and capitals, Byzantine in its cupolas and mosaics, Greek (i.e. Byzantine again) in its enrichments – and his restatement of the idea that the Saracens, through the Crusaders, were responsible for the pointed arch style of Continental Europe.[58]

Burges did not include Egypt in his travels: the vivid impressions gained on his visit to Turkey remained the only direct experience of an Islamic society. But throughout his life he developed an interest in Islamic art by reading and scholarly investigation. Besides the work of Prisse d'Avennes, he owned P-X. Coste's *Architecture Arabe ou Monuments du Kaire* (1837–9) and J. Bourgoin's *Les Arts Arabes* (1873). He studied the westward flow of Islamic influence, especially through textiles, and exercised a conviction that Muslim weavers had brought their own design traditions mingled with those of Byzantium to twelfth-century Sicily. Church vestments and other subjects in Western treasuries with oriental patterns fascinated him and he wrote papers on them to archaeological journals.[59] The articles on damascening and metalwork in Wyatt's *Industrial Arts of the Nineteenth Century* (1851–3) are attributed to him. What was missed by lack of further visits to Eastern countries could be in part supplied by time spent at international exhibitions. At one of these (1862) he was visited by the awesome thought of the continuity in Eastern countries of standards of vision and

craftsmanship which Europe had lost in the Middle Ages: 'Here in England we can get medieval objects manufactured for us with pain and difficulty, but in Egypt, Syria and in Japan you can buy them in the bazaars.'[60]

Burges's work embodies not only the physical fierceness of High Victorian 'muscular' Gothic, but also the search for escape from the problem that faced the mid-Victorian architect whose science urged him forward but whose art 'is ever bidding him to look ... back'.[61] It is clear that the ways in which Islamic art reconciled ornament with breadth of effect, 'the importance of massing ornament in certain places', helped him to focus his own powers of dramatic presentation of light, shadow and colour: those powers which took him into what Professor Mordaunt Crook has termed a dream-world. No one else in Britain handled the style with the sonorous éclat of Burges in the Arab Room at Cardiff Castle. If the final proof of a major style is affirmed by its capacity to inspire artists with fundamentally different ideas which they can develop, then we need look no further than the work of Jones and Burges for evidence.

The last years of the century produced remarkable variations of the Indian Durbar Hall or hall of audience. The most famous of these was constructed in 1890–1 for Queen Victoria at Osborne, Isle of Wight, by Bhai Ram Singh and John Lockwood Kipling (the father of Rudyard Kipling): although the choice of style was bound up with the Queen's rule over India, it falls outside the scope of a book concerned with spontaneous Islamic inspiration (see Appendix I). A much less well-known Indian hall at Elveden, Suffolk, nevertheless must be included. There are two chapters to the story of this remote house. In 1863 the Maharajah Duleep Singh, dispossessed by the British of his throne in the Punjab but enjoying the affection and support of the Queen, acquired the property and, with John Norton as architect, created Indian interiors with elaborate painting and plasterwork inside an Italianate exterior. In 1893 Lord Iveagh bought Elveden

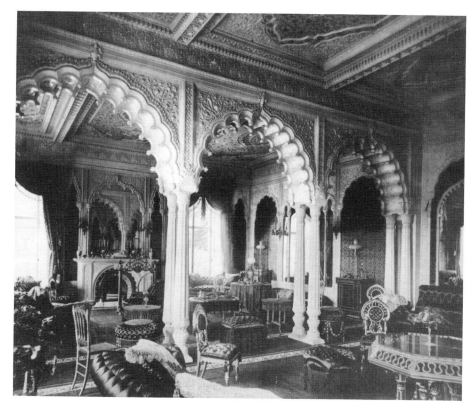

FIG. 119 John Norton. Drawing-room, Elveden Hall, Suffolk. 1871. Photograph by R. H. I. Jewell, National Monuments Record, London

Having designed an Italian Renaissance exterior for Duleep Singh, 'Queen Victoria's Maharajah', the architect was asked to provide 'pure Indian ornament' for the interior, which he did from 'careful models prepared by Messrs. Cubitt', the study of photographs by Bourne and watercolours provided by Duleep Singh.

from the prince's estate and proceeded to add a new wing and a magnificent Indian hall. The architect here was William Young, but Caspar Purdon Clarke of the South Kensington Museum advised on detail. Much of this derived from buildings photographed by Lord Iveagh when in India, notably the Diwan-i-Khas or hall of private audience in the mid-seventeenth-century citadel of Shah Jahān at Delhi. The marble that had attracted the Mughal Emperor attracted Iveagh also: he spent £70,000 on it at Elveden, contriving in his vast hall an interior which Lady Fingall called the coldest room in England.[62] With its giant cusped arches under the dome and elaborate low relief decoration it marks a summation in scale and authority of the many visions of imperial India that had been vouchsafed to visiting Englishmen: Norton's drawing-room (Figure 119) looks almost domestic in comparison.

After this most public of private audience halls, the physically smaller if hardly less atmospheric retreats of 'Arab' smoking-rooms and billiard rooms appear less overwhelming. These became a minor vogue in the later 1880s and 1890s: an outstanding specimen was the billiard room at Newhouse Park, Hertfordshire, recorded in 1897 by the photographer Lemere (Figure 120).[63] This had cross-beams painted with linked palmettes which were very far from anything Grecian: above these rose fretted and painted scrolls and sections of lattice. The walls were lined by compartments containing cushioned sofas and pierced at front and sides by horseshoe arches.

Examples of Islamic-inspired interiors which were added to houses in this generation and the next survive in the Alhambra room at Rhinefield, Hampshire; the work of Romaine Walker and Tanner in 1888–90 for Mabel Walker Munro; and the Turkish Room at Sledmere, Yorkshire, by Sir Mark Sykes and his architect Walter Brierley (1912–16). The Rhinefield room, originally a smoking-room, was remodelled after the Munros' visit to the Alhambra with dome above, stalactite half-domes in the angles, onyx columns, Koranic inscriptions and a mosaic floor.[64]

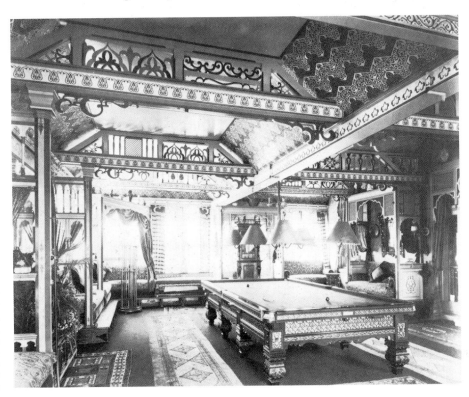

FIG. 120 Billiard room, Newhouse Park, St Albans, Hertfordshire. 1890s. Photograph by Bedford Lemere, National Monuments Record, London

This interior not only sums up the fashion for 'Moorish' billiard rooms in the nineties, but also the effects which the style high-lighted: flat patterns on textiles and wood, compartmentalised corners (alcoves) and 'transparent' cresting and infilling.

Sir Mark Sykes (1879–1919) was in the East on numerous occasions, notably in Turkey in 1902–3 and 1905–6. Though his prime interest was in politics and peoples (as his diplomatic career and main published writings, *Dar-ul-Islam: A Journey through Ten of the Asiatic Provinces of Turkey* (1904) and *The Caliph's Lost Heritage* (1915) show), he included architecture in his lectures in England. He contributed Islamic features to his family homes in Yorkshire at Eddelthorpe on the estate at Sledmere, and above all Sledmere itself. About 1908 parts of Eddelthorpe were enriched with Anatolian tiles and Kufic inscriptions, and at Sledmere Brierley built, to Sykes's instructions, a Turkish room connected to a plunge-bath.[65] The tile decoration, based on a room adjoining the Yeni Valide mosque in Istanbul, contains ceramic 'windows' framing garden trees, all in tiles by the Armenian David Ohanessian in the style of late sixteenth-century Iznik. The result is probably the finest equivalent in Britain of a characteristic effect of the Turkish pottery: an indication of space beyond the walls without sacrificing the stylisation of the wall-pattern. The tiled fireplace, faceted and spired above an

FIG. 121 S. J. Waring. Smoking-room, Berkeley Hotel, Piccadilly, London, 1897. Photograph National Monuments Record, London

The patterning shows how the Islamic style served Art Nouveau, at its height in the nineties. Pattern moves abruptly from small-scale (on the walls) to large-scale (in the frieze): the ceiling-pattern is directional (contrast the Morris pattern in Figure 108); and the horseshoe arch in the mirror is surrounded by 'squares' at 45 degrees to each other which recall the star-form.

ogee arch, is a particularly attractive feature. Half a century before, the *Building News* had gone out of its way to illustrate a fireplace from a private house in Mosul (now in Iraq, but formerly in the Ottoman empire), and thus 'supply a link, slight though it be, to the chain of architectural history'.[66] Against the flat walls with their two-dimensional patterns, the Sledmere Turkish fireplace makes the most of its architectural possibilities. So also do the simple, austere hexagons on the ceiling.

We have been concerned so far with domestic interiors created by private individuals who for one reason or another had developed a taste for Islamic art. A large number of Islamic-style interiors were, however, being created for public rooms in this period of the luxury hotel. Smoking-rooms, restaurants, tea rooms and the popular winter gardens gave ample scope. A particularly elegant effect was reached in the smoking-room of the Berkeley Hotel, Piccadilly, by S. J. Waring (1897, Figure 121). Here a dense but easily flowing commotion of arabesque on the walls was offset by a flat pattern of bands on the ceiling, enclosing octagons and a silhouetted adaptation of the ogee dome-shape.

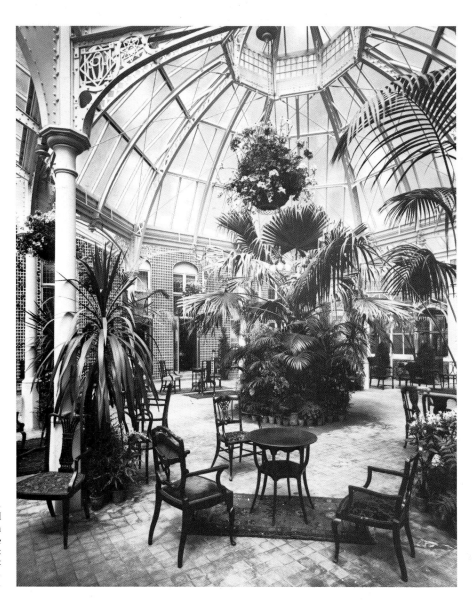

FIG. 122 Winter Garden, Hans Place Hotel, Exeter St, London, 1895. Photograph National Monuments Record, London
The elasticised-looking knots in the spandrels of the iron-work are clear derivations from Kufic: something of their galvanic power has almost entered the English traditional chair-forms below. Cf. Figure 19.

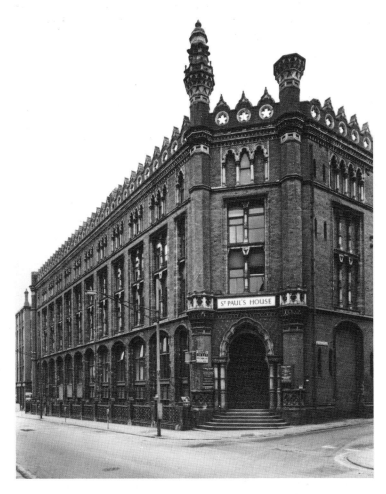

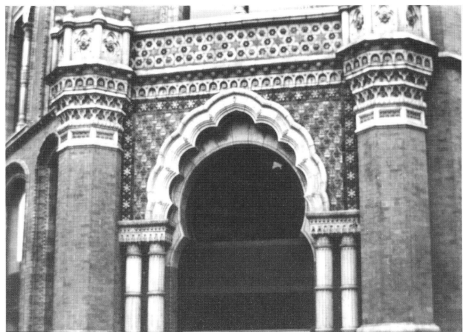

FIG. 123 Thomas Ambler (*c.* 1838–1920). St Paul's House, Leeds, West Yorkshire, 1878. Photograph National Monuments Record, London

This 'Venetian-Saracenic' brick and terracotta 'palace' was the product of an architect with marked sympathy for the style. Tiling was by Doultons and ironwork by Skidmore of Coventry.

FIG. 124 Thomas Ambler. St Paul's House, Leeds, detail of doorway. Photograph courtesy of Annie Benge

The building has been sympathetically restored (1976): this photograph was made after the restoration.

About two years earlier a visitor taking liqueur in the iron-framed, palm-bedizened Winter Garden of the Hans Place (later Hans Crescent) Hotel, London, by Read and Macdonald, could have noticed an Islamic star motif in the spandrel of the four-centred arches under the dome and, in the adjoining part of the spandrel, two squares laid at 45 degrees to each other to form another eight-pointed star, which enclosed an Art Nouveau stem and flower design worthy of Charles Rennie Mackintosh but betraying relationship to Kufic script (Figure 122). The contribution of Islamic shapes to Art Nouveau is a matter to be discussed in the next section of this chapter.

Late Victorian public buildings in Islamic styles tended to take up long-standing associations with fantasy and entertainment and are therefore relegated to the Appendix. A hybrid exoticism indeed, composed of many styles, is offered up in theatres, a field of design in which the Leicester Square Pan-opticon, from 1858 an Alhambra music-hall, helped to make Islamic or vaguely Islamic ornament a preferred choice. The generalised Islamic style of Imre Kiralfy's buildings for the Empire of India Exhibition of 1897, at Earl's Court, reinforced the message. To meet the more specialised pleasures of the Turkish bath, however, designs of an idiomatic kind were made. Three outstanding examples of this were built. In 1862 the *Building News* greeted the 'New Turkish Hammam' in Jermyn Street, St James's, as 'the one perfect Turkish Bath in London'. Its perfection lay not only in its functional efficiency as a building, or in the fact that its pipes and tobaccos all came direct from Constantinople: the *News* commends its authentic-looking fireplace and the coloured-glass Turkish lanterns that hung from the ceiling of its cooling-room. The architect was George Somers Clarke (1825–82). In 1866 the design for the Oriental Baths in Cookridge Street, Leeds, was completed by Cuthbert Brodrick (1822–1905): this effectively combined emphasis on a central domed area with long, extending lines of brick banded in red, blue and black. In 1882 the equally distinguished Drumsheugh Baths Club, Edinburgh, by Sir John James Burnet (1857–1938) opened: its arched main interior remains the most impressive 'Saracenic' example in Scotland.[67]

Apart from Brodrick's Baths, however, another Islamic episode of some note took place at Leeds in the shape of building work by the architect Thomas Ambler (c.1838–1920) in the St Paul's Square area in the late 1870s. Long after Nash, and with something of his flair, Ambler expressed what was evidently a personal enthusiasm in a major work in an oriental style – the Venetian-Saracenic St Paul's House (1878, Figures 123, 124), a warehouse for Sir John Barran, a clothing manufacturer – and added Islamic detailing to the exteriors of houses nearby. St Paul's House, with triple Moorish arches on the top floor, terracotta decoration and blue tiling, both by Doultons, and superb ironwork by Skidmore of Coventry, is a triumph and a genuinely creative adaptation of Islamic form to a building with a modern purpose.[68]

In general, however, the Islamic style was little resorted to in the 'public' form of exterior architecture as we approach 1900. If an exotic note was required, Byzantine was available. This enjoyed a vogue in the 1890s: it was favoured by Arts and Crafts figures, and church architects who wanted an alternative to Gothic found it had the attraction of being Christian.[69] The absorption of Islamic architectural shapes and idiom into the language of exhibition buildings no doubt emphasised their qualities of exciting visual immediacy – we find this particularly in America – and helped to confirm the Islamic style as one for occasions rather than permanence.

IV

In fact the style for occasions *par excellence* was rising into prominence in the decorative arts in these years, and Islamic influence was to contribute much to it. The closeness of Libertys to this decorative style of the 1890s, called Art Nouveau, is indicated by its Italian name, *stile Liberty*. The firm's injection of Islamic ideas into it is of unquestionable importance. Art Nouveau, a style of galvanic line so potently adumbrated in the calligraphy of Leighton's Arab Hall, had, however, mixed origins among which Islamic art was only one element. Blake and Burne-Jones apart, it had early roots in Mackmurdo's book design of the early 1880s, with its flaring plant-forms, and it is in the field of illustration, especially in works such as *The Arabian Nights* and *Omar Khayyam*, that it is deployed into the twentieth century with verve and facility by Edmund Dulac (1882–1953) and others.[70] Arab themes were to provide artists attracted to Art Nouveau with wide opportunities.

Although Art Nouveau rejects the historical styles of Europe, the formal fantasy of its line – which reaches a climax in the work of Aubrey Beardsley – is a direct product of the interest in extremes and excess for their own sake long nourished by Romanticism, but given fresh impetus by aesthetes and Symbolists in the last 20 years of the century. Blake's art, long before, had pursued line to convey a sense rather of dynamic liberation than of restraining contour. In the 1870s and 1880s Burne-Jones, earlier the exponent of a lush medievalism closely related to that of Rossetti and Rossetti's friend Burges, was exploring a realm of tensions and linear rhythms held within powerfully convulsive outlines. These muffled but insistent detonations from Burne-Jones's later dream-world carry no recognisable Islamic echo. As an admirer, however, of Persian poetry, he contributed illuminations to (and received into his own possession) William Morris's second *Rubáiyát* manuscript of 1872.[71] Japan, indeed, was the strongest oriental influence among the aesthetes (such as C. A. Howell) with whom Burne-Jones had contact. A vein of Muslim exoticism is nonetheless discernible in such a work as 'The Cave of Spleen' design by Beardsley in the 1890s (Figure 125), not just in its turbaned poet surrounded by his phantoms, but in its highly wrought linear sophistication. As usual with Beardsley, however, any precise stylistic sources are all but concealed in the hothouse sultriness, the ravelled atmospherics.

As the first modern European style to turn completely away from Renaissance restraints, Art Nouveau had a cauterising effect on European classicism. The impact of Japanese prints was comparable. By the end of the century the process of stepping outside the classical tradition to evaluate the arts of Asia on their own terms, which we have seen beginning seriously 100 years earlier with Hodges, was complete. When 1900 arrived, the scope of the enquiry, and the awareness of the enquirers, whether exponents of Art Nouveau or of Arts and Crafts or recorders of other barometric pressures, were world-wide.[72] The American glass-designer Tiffany, who has strong links with Paris and European Art Nouveau, transmutes a variety of sources, including Persian glass, into results which are sharply personal (his Favrile glass, patented in 1894). Islam becomes only one of a number of cultural areas which we find engaging the attention of Arts and Crafts advocates such as Walter Crane or W. R. Lethaby. An important periodical, the *Studio*, begins publication in 1893 and becomes a major disseminating agent of international information and illustration (Figure 113).

Walter Crane (1845–1915) is a designer with many sympathies. As a disciple of

Morris, however, he is a devotee of Persian carpets. He has interesting remarks on them in his book *Line and Form* (1900). We saw that Islamic carpets were valued as objects of luxury and distinction from the beginning of our period. Crane, writing against the background of the discussion on design within the Arts and Crafts movement, is able to offer precise analysis of the reasons for this continuing esteem. First, he is conscious of the effectiveness of a pattern that is produced not by shading, suggesting relief, but is due to 'the heraldic principle of relieving one tint or colour on another' (p. 238). The flat colour areas, juxtaposed without shading, contribute to an overall sense of surface. Secondly, as a student of the roles of different crafts in interior design, Crane is concerned to note how a

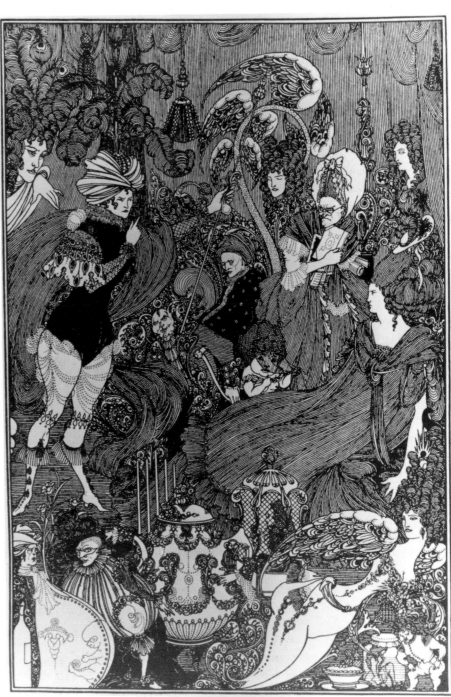

FIG. 125 Aubrey Beardsley (1872–98). 'The Cave of Spleen' from Alexander Pope, *The Rape of the Lock*, Leonard Smithers, 1897. Victoria and Albert Museum: National Art Library

The scene depicts the turbaned poet himself surrounded by his 'Strange Phantoms rising as the Mists arise'. The fires of Beardsley's genius transform his sources: with his illustration we are conscious again of rococo, but a rococo frenetically energised with close-packed sweeping lines, spirals and encrusted scrolls. Behind the brilliant eroticism, Art Nouveau has also fed deeply into the design: the use of rhythmic curve and deployment of nodal centres of interest link it with de Morgan's peacocks (Figure 111). In his title page for *Volpone*, Beardsley showed that he realised the power of the arabesque, and the assurance with which he passes in the 'Cave' from intricately wrought, large-scale forms to extremes of fine-drawn decoration – for example, from the wings of the figure in the lower right corner to the thin line of jewels down the front of her body – suggests attentive regard to Islamic-style decorations such as those of Owen Jones (Figure 106).

good Persian carpet emphasises the rectangularity of the room in which it is placed through its series of borders of different widths, bounded by straight lines, white and black. This explicit statement on the Islamic carpet as an integrating factor in an interior is of some interest. Even if it is not allowed to dominate a room in the West as it does in the countries of its origin, this carpet, however used, does perform a space-defining function superbly well. With Crane an important implication of William Morris's teaching has worked its way through: the Islamic carpet is seen to take its place as a unifying element in a total interior space.[73]

In his earlier book, *The Bases of Design* (1898), besides reproducing a Gustave Doré wood-engraving of the Alhambra (p. 187), Crane had devoted 10 pages to Persia (pp. 174ff). Here his purpose is two-fold: to discuss the Ardabil carpet and in particular the Persian garden as a walled enclosure or 'paradise'. It is no surprise that a man who was conscious of the space-defining function of the rectangular Persian carpet should also be responsive to the idea of the garden as a walled enclosure, which is reflected in many Eastern cultures but which has special connections with Persia.[74]

In 1894 William Richard Lethaby (1857–1931), whose ideas had also been greatly influenced by Morris, became the first Principal of the Central School of Arts and Crafts, London, which had well-equipped teaching workshops for crafts. As an Arts and Crafts man concerned to propagate standards of example and method across the whole field of design, Lethaby sensed to the full Europe's debt to the lands of 'Caliphs and Emirs, Mahomet, Arabs, Turks and Saracens'.[75] In his book *Architecture* (1912, p. 250) he summarises memorably the qualities that the 'Arab' style represents for him: 'elasticity, intricacy and glitter, a suggestion of fountain spray and singing birds'. Earlier in the same book, Lethaby had written of the influence of Eastern textiles, including *opere Saracenico*, on those of the West, and continued: 'For more than a thousand years these precious works of art have been like a vitalising pollen blown on our shores. If we would set seriously to work in reviving decorative design the best thing we could do would be to bring a hundred craftsmen from India to form a school of practice.'

In fact Liberty in 1885 had already achieved a smaller version of this. At the request of the Albert Palace Association the firm had organised the coming from India of 30 craftsmen – including silk spinners and carpet weavers – to work in an 'Indian village' in Battersea Park.[76] The appeal of the ideal village communities of India had been held up five years earlier as an antidote to the evils of Western industrialisation by Sir George Birdwood in his *Industrial Arts of India* (1880), a handbook to the Indian collection that had recently been transferred to South Kensington from the India Office Museum (the book was also based on the collection of Indian artefacts shown at the Paris International Exhibition of 1878).[77] Birdwood had ascribed the merit of Indian decorative arts to the social structure of Indian communities: Morris had warmly commended his views in the publication *Two Letters on the Industrial Arts of India* (1879). The ideal of the community of craftsmen drawn together by conceptual guidelines and a regard for traditional method was to be seriously taken up by the Arts and Crafts movement, notably by C. R. Ashbee in his Guild of Handicraft in 1888. Ashbee's own encounters with Islamic community art were to take a particularly interesting turn, as we shall see at the end of this chapter (p. 210), in Jerusalem.

The architect of the Indian Court at the 1878 Paris exhibition who received the Indian collection at South Kensington in 1880 was Caspar Purdon Clarke. The name of this intensely active architect turned museum director is inescapable in the context of interest in Islamic art in this period and more needs to be said of

him. Clarke (1840–1911) was in Teheran from 1874 to 1876 as superintendent of works for the consular buildings. In 1876 he undertook the purchasing tour for the South Kensington Museum in Turkey, Syria and Greece, on which we saw him collecting for Leighton. After a tour in Europe (including Spain) in 1879, he was in India in 1881–2. He became the first Keeper of the new Indian collection at South Kensington in 1883; and Director of the Museum in 1896. Six years later he was knighted. In 1905 he was appointed Director of the Metropolitan Museum, New York, then also becoming a major repository of Islamic material as we shall see in chapter 6 (p. 232). Ill-health forced him to resign this post in 1910. Despite his busy administrative life Clarke found time to publish a few writings on Islamic matters.[78]

Surely Clarke's most remarkable performance, however, was his Indian journey. Before the transference of the India Office material, the collection of Indian objects at South Kensington had been patchy, a fact not lost on Lieutenant Henry Cole, son of the Museum's founding figure and cataloguer of the Indian material in 1874. The Persian and Mughal miniatures of the India Office Museum had remained after the move of 1880, though some larger-scale Islamic painting came to South Kensington.[79] Clarke's efforts in India, however, produced a harvest of 3,400 objects for his Museum, including the majority of illustrations to the *Hamza Nama* epic, painted on prepared cotton fabric in the reign of Humayun, and discovered by Clarke in a shop in Srinagar. These are large (approximately 113 cm high) and have the story written in Persian on the backs. In 1896 the Museum was able to make an important acquisition of a Mughal painting: an *Akbar Nama* manuscript with 106 illustrations in gouache of the history of Akbar's reign, painted about 1590.[80]

In the 1880s, therefore, Islamic art and design could be encountered in Britain on many different levels. Apart from the London museums, there were the 'universal' exhibitions, Liberty's Oriental Bazaar, even such a bastion of Englishness as the Burlington Fine Arts Club, where the important exhibition of *Persian and Arab Art* took place in 1885: all could reach out in different ways to aesthete, artist-craftsman and layman alike. The concerted appeal of encounters which had novelty-value and yet could relay old – preferably medieval – associations is reflected in the continuing use of the term 'Saracenic'. This is evoked in the title and argument of an important book of the same years, Stanley Lane-Poole's *Art of the Saracens in Egypt* (1886). Lane-Poole was the son of Edward Stanley Poole, of the Science and Art Department, who had written an appendix to the fifth edition of Edward Lane's *Modern Egyptians*. Lane-Poole was also the nephew of Lane. In *Art of the Saracens* we meet the idea that 'the purest form of Saracenic art . . . is to be seen in Egypt'. Lane-Poole's preference for 'Saracenic' over the terms 'Arab' or 'Mohammedan' relates to the notion that it is the only word that implies 'the two ideas of Oriental and medieval'. For him it denotes an international style which in the Middle Ages showed its wide applicability to other traditions: 'the artists in this style were seldom Arabs, and many of them were Christians'.

Lane-Poole's book deals with architecture, ornament in stone and plaster, mosaic, woodwork, ivory, metalwork, glass, heraldry, pottery, textiles and 'illuminated manuscripts'. The chapter on woodwork is notable for its discussion and illustration of *mashrabiyya* lattices, based on examples in the South Kensington collection in which, the author tells us, there were then 40 specimens.[81]

While Lane-Poole was interested in identifying the pure essence of 'Saracenic' as seen (for him) in Cairo, the precise nature of Islamic style, studied in a light uncoloured by European assumptions, was to absorb other writers in the years

between 1875 and the First World War. By the early 1900s, for instance, the India referred to by Lethaby had come to look very different from the country which Hodges and the Daniells had wondered at over a century before. In 1800 England had comfortably assimilated the architecture of the Daniells' India into a home-based 'Picturesque'. By 1900 the evident evils of industrialisation at home were enforcing among idealists a regard for those parts of Indian culture which seemed as yet untainted by the materialism of Europe. At the same time Western consciousness of the East had reached the stage of close historical analysis of those qualities of different Asian cultures which were indigenous to them. In 1876 the archaeologist James Fergusson had added a volume on Asian building to his world history of architecture: in his famous *History of Indian and Eastern Architecture* he attempted a separation and classification of the styles of Indian architecture, including the Islamic phase of Mughal achievement. In America the lecturer Russell Sturgis conceived a *History of Architecture* (1906 etc.) which focused on the individual characteristics of different styles, including those of the Islamic countries.

In his monumental work *A History of Architecture on the Comparative Method* (1896, constantly reissued in the twentieth century), Banister Fletcher states his debt to Fergusson as 'the first to piece together the story of Eastern architecture', but nevertheless Fletcher remains the European-trained architect throughout: his 'tree of architecture' at the outset of his book places Greek, Roman and Romanesque on the main trunk and everything else, including 'Saracenic', is seen as side-branches.

Viewed against this background, the emergence in the 1890s of Ernest Binfield Havell (1861–1934), teacher and campaigner on behalf of Indian art, is all the more striking. Havell's starting-point was completely different from that of Fergusson. He was an artist who became Principal successively of colleges of art at Madras and Calcutta, and worked on Indian art for the rest of his life. In a series of publications up to the First World War, Havell established himself as the Western writer *par excellence* on the subject. At the beginning of his pioneering study, *Indian Sculpture and Painting* (1908), he tells us that his aim was to shake off his 'full equipment of European academic prejudices'. His *Handbook to Agra and the Taj* (Calcutta 1904), which went into a second edition (London 1912), rebutted the theory of Vincent Smith that the Taj was designed by an Italian. Above all, Havell wanted to release India from the deadening influence of the European art schools. Whatever might be argued about the advantages brought by Western methods in other spheres, he was in no doubt about the damaging effects of Western art as 'the unimaginative Anglo-Saxon succeeded the imaginative Mogul in the sovereignty of India'.

The full implications of Havell's work do not concern us because his chief purpose was to examine and assess Hindu and Buddhist art in India. He saw in both a spiritual force, beside which the courtly art of the Mughals seemed secondary.[82] Indeed in his arguments concerning architecture (notably the Appendix to the second edition of *Agra and the Taj*), he casts the Mughals in the role of tame inheritors of Hindu greatness (though elsewhere he recognises their skills as garden designers in the Persian manner).

In his combative way, however, Havell was to perform a signal service not only for the architecture of Hindu and Buddhist India, but also for the Indian Mughal painting, by helping to raise its status as an art form in Europe. In the late nineteenth century, this was not generally high in Britain, despite the existence of the Indian Section at the South Kensington Museum. The literary and ethnographic virtues of Richard Johnson's great collection of miniatures in the India Office

Library were known to specialists, but its artistic value was hardly recognised. Queen Victoria's assumption of the title of Empress of India in 1877 kindled a certain limited awareness, but this was essentially part of the generalised dream in which the Raj had the role of healer of the sickness of Mughal rule. While the applied arts of India, as we have seen, became the object of great interest in a period threatened by the Industrial Revolution, the 'fine art' of painting required a degree of immersion in a different tradition which few Westerners were inclined to give or saw any reason to give. It was not until the early years of the twentieth century, with the appointment in 1903 of Thomas Arnold, an Islamic scholar, to the post of Librarian of the India Office Library, that important new acquisitions of Mughal painting began to be made there, to complement the developments at the South Kensington Museum.

Outside the circles of specialists, Havell made the greatest impact after 1900. Readers of Sir William Foster's excellent edition (1899) of Sir Thomas Roe's embassy at the court of the Emperor Jahangir in 1615 will have been reminded of the typical European response to Mughal miniatures, which was to complain of what appeared to be lack of skill in naturalistic drawing. This had been characteristic throughout the eighteenth and nineteenth centuries. Before 1800, George Forster, who had travelled with Cook but whose taste in art was formed on the 'True Style' of neo-classicism, had seen in these paintings an ignorance of 'the rules of proportion and perspective'.[83] A hundred years later, in the context of disillusion with Western academic tradition, Havell was to take a quite different approach. Perspective for him was a matter to be used as oriental artists used it, in conformity to the 'laws of design' not, as in Western art schools, in conformity to the 'science of optics'. In *Indian Sculpture and Painting* (1908) – a book which received favourable review by Roger Fry (see Bibliography) – he made a vigorous plea for the merits of Mughal draughtsmanship which, he claimed, sought the essence not the likeness: 'To see with the mind, not merely with the eye; to bring out an essential quality, not the common appearance of things' (p. 223). Havell's scholarship was not to stand up to that of the later twentieth century, when Indian art was further investigated: but he had played an important proselytizing role.

Within a few years there were to be important exhibitions of Islamic miniature painting in Munich (1910) and Paris (Musée des Arts Décoratifs, 1912). Many French and German collectors were active in the field. The connoisseur F. R. Martin produced his pioneering book *The Miniature Painting and Painters of Persia, India and Turkey* (two volumes, 1912). In Britain, soon after 1900, the John Rylands Library, Manchester, came to join the British Museum, the Victoria and Albert Museum and the Bodleian Library among the major repositories of Persian manuscripts; and Alfred Chester Beatty began the famous collection that is now in Dublin.[84]

The possibilities of access to Persian painting were in any case to become attractive to European artists of the early twentieth century: Matisse is an example. In England Edmund Dulac (1882–1953), already susceptible to Art Nouveau, flattens his form in order to expose the movement of line more openly. His painting *Scheherazade* (1911, untraced) floats the figure against a background of vertical and horizontal lines and border decoration so as to give a curious sense of dislocated reality that is closer to Islamic painting than to Japanese prints.[85] The artist Maxwell Armfield (1881–1972) finds echoes of Persian miniatures in unexpected places. In America on a seven-year stay from 1915, he was reminded of them in Central Park, New York, with its groups of people sitting amongst rocky outcrops, and introduced the memory into the work that emerged in 1916 (Figure 126).[86]

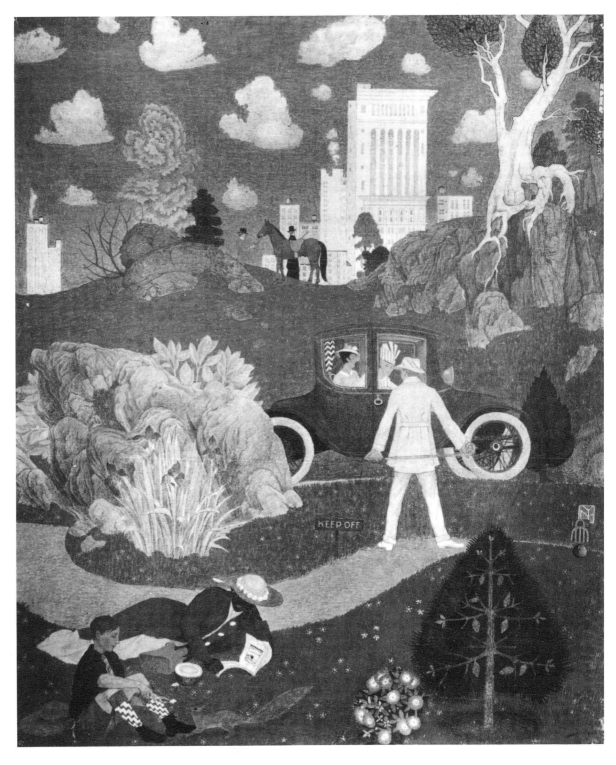

While in the 1880s and 1890s the pollen of Islam was indeed blowing strongly around the decorative arts, orientalist painting by Europeans – of the bazaars and oases of Egypt and Morocco – continued to be a popular if repetitive genre at the exhibitions of London and Paris. In London the Fine Art Society and the Leicester Galleries staged exhibitions by its specialists well into the twentieth century. A sense of the light and colour of the desert countries, which only a sojourn in them

FIG. 126 Maxwell Armfield (1881–1972). *Central Park, New York*. Tempera, marble and sand ground on canvas, 61.5×50.8 cm. 1916. Southampton Art Gallery and Museums, 42/1976
Armfield's interest in the 'hard-edge' properties of tempera and in Persian miniatures produces an unexpected conversion of the latter's language into twentieth-century terms. Cf. Figure 79.

207

could give, had been transmitted in different ways by the work of Delacroix and Lewis: now in the last years of the century the very emotional excitement afforded by the experience of these elements in the Islamic East became the subject of the brilliant impressionistic work of the painter Melville.

Arthur Melville (1855–1904) was a Scottish artist who had trained partly in Paris. There he had become interested in open-air light effects and began to develop a watercolour technique which involved applying the pigment on to a soaking wet surface, on which he sponged out lights and dropped colour splashes direct from the brush. He paid a long visit to the Middle East in 1880, reaching India in 1882, and returning via Turkey. *An Arab Interior* of 1881 (Figure 127), shows him observing with the devotion of J. F. Lewis, though concentrating on low tone.[87] Melville was in Algeria and Tangier in 1890 and 1893, and in Spain on a number of occasions. The brilliant light and colour of the Muslim countries, along with the influence of Spanish life, had a decisive effect on that blend of explosiveness and economy which became so personal to him. In a courtyard scene, *Waiting for the Pasha* (watercolour, 1882–7, Mr and Mrs Tim Rice) a rectangle of carpet squared up to the picture plane is set with calculated space defining intention against the light flagstones.

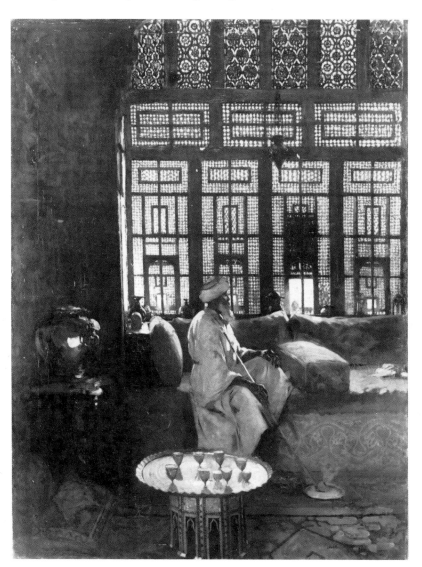

FIG. 127 Arthur Melville (1855–1904). *An Arab Interior*. Oil, 68.7×45.7 cm. Signed and dated 1881. National Galleries of Scotland, Edinburgh 4122
A low-toned work with accentuations (turban) in scarlet; in other respects the picture shows affinities with J. F. Lewis's work. The low Cairene table was a useful foreground ingredient in composition, as Lewis had demonstrated (Figure 80).

In 1892 Melville was accompanied in Spain by the young Frank Brangwyn (1867–1956): Brangwyn, already a seasoned oriental traveller, had been in Constantinople in 1889 and Tunis, Tripoli, Smyrna and Trebizond in 1891. A harvest of Arab subjects was the result of his trip to Morocco with Dudley Hardy in 1893. In Brangwyn we have a painter with direct experience of the decorative arts (he trained partly with Morris), and a lifelong regard for Islamic design, particularly ceramics. He was in fact capable of giving away most of his dining-room furniture for a dozen Persian pots, and once (though he afterwards regretted it) exchanged a Géricault sketch of *The Raft of the Medusa* for 'a modest collection of medieval Islamic pottery'.[88] Brangwyn responded deeply to the ways of life of the Islamic East (Figure 128) although, unlike Melville, he was by temperament drawn back to the central European tradition of Rubens and the human figure. He was nevertheless the owner of Mughal and Kangra drawings.

Few of the older artists who have played a part in this chapter and chapter 4 survived the watershed of 1914–18. The doyen of orientalist painters, Carl Haag, died in 1915, aged 95; Walter Crane also died in that year; Liberty and William de Morgan – who had long since given up pottery and become a novelist – in 1917. The First World War, in making an end to the old Europe, also put an end to the old European relationship with the Middle East. Some contacts, however, were still made. Mark Sykes, still planning his Turkish room at Sledmere, found release for the expenditure of new energy in the East and his efforts culminated in the Inter-Allied (Sykes-Picot) Agreement of 1916. Lutyens, having met five submarines in the Mediterranean, reached Egypt in November 1915 and declared 'The Cairo mosques . . . are remarkable – with qualities of real building and not that love of Dicky (shirt) front order so loved by the Indians (Moguls)'.[89] On a return visit in 1932 he was not so impressed: 'And mosques! After seeing half a dozen of them they became as tiresome as mosquitoes.'[90]

One post-war episode, however, not without its strangeness, brings together

FIG. 128 Sir Frank Brangwyn (1867–1956). *Study, Procession of the Holy Carpet, Cairo.* Oil, 26.8×52 cm. R.A. 1952. Fine Art Society, London
With its open-air theme, the picture provides a counter-balance to Figure 127. Eastern colour in a North African sun, which Delacroix had explored, remained a potent force for Brangwyn throughout his life.

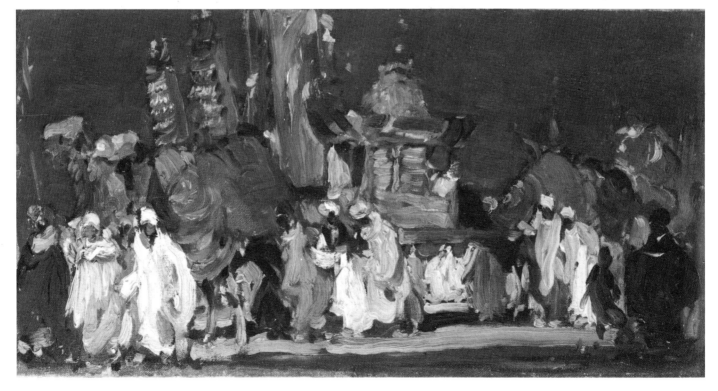

the names of Mark Sykes, C. R. Ashbee and David Ohanessian, the Armenian potter, and the idea of community art which has frequently been referred to in this chapter. In his unpublished *Memoirs* and the book *Jerusalem 1918–1920*, produced under his editorship, Ashbee retails the story of his time as 'Civic Advisor' in Jerusalem where he was the prime mover in a revival of the tradition of Islamic crafts of tile-making and (using the 'Jerusalem looms') textiles. In 1919 Sykes, who had ordered an elaborate tiled fireplace before the War from the Turkish potters of Kütahya (it was completed but not delivered owing to the hostilities), was largely responsible, it appears, for these potters coming to Jerusalem, during the British Mandate, to repair the tiles of the Dome of the Rock. Ohanessian was originally from Eskisehir in Turkey and secretary in the largest pottery in Kütahya. Ashbee records (*Memoirs* III, p. 120) how he sent for plans of de Morgan's kilns and for 30 crates of his ware, and the effect that this had on Ohanessian, who recognised and welcomed de Morgan's reconstruction of a kiln-type long abandoned at Kütahya. Ohanessian thereupon carried out repairs to the Dome of the Rock in two stages, the second – financially supported (in part) by the Pro-Jerusalem Society under the presidency of the Governor of Jerusalem, Sir Ronald Storrs – more successful than the first. (The Ohanessian Pottery also made tiles for a marble sideboard by Ashbee inlaid with Indian woods.) In repaying a debt to Islamic art which had so often inspired it, the Arts and Crafts community ethos seems to have had here a happy restatement, which would surely have pleased Morris.[91]

After the First World War, London staged Flecker's *Hassan* (1923). Sacheverell Sitwell made his first visit to Moorish Spain in 1919. The years before 1914 were nevertheless the last when the sense of release that the Islamic East had provided for so long could be felt with any completeness. T. E. Lawrence may have found it in the deserts again: and Bertram Thomas and Wilfrid Thesiger (the latter as late as the 1940s) were to draw deep satisfactions from their exploration of the 'Empty Quarter' of Arabia. The War, however, put appreciable limits to the isolation of the Islamic lands at the edge of Europe's familiar Mediterranean world, and there appears thereafter to have been a corresponding slackening in the power of the stimulus they undoubtedly exerted in the nineteenth century over British artists who went there. Some had gone as Christian pilgrims, half expecting what they were going to find, impelled by echoes in themselves of the Bible and crusading chivalry. Others went to identify with a new way of life or at least measure themselves against the unfamiliar. Whatever the need, access to a world which offered such a range of possibilities was a precious gain of the period we have been considering in the last two chapters. No other geographical area could offer so much to Europeans. Before we try to sum up the effects of this on British artists, however, we must look at America.

THE AMERICAN STORY

I

A number of diverse allusions to America have occurred in the foregoing pages: to Washington Irving's popular book *The Alhambra*; Charles Locke Eastlake's *Hints on Household Taste* and its numerous American editions; Louis Comfort Tiffany's links with Europe and awareness of Islamic glass; the promotion of universal exhibitions in Crystal Palace-like buildings, with the opportunities for study of oriental subjects that these made possible. These contacts and others across the Atlantic in the nineteenth and early twentieth centuries – however various in nature – deserve closer investigation, both for their effects in America and for the comparisons afforded with Britain and Europe. Such is the purpose of the present chapter.

There are appreciable obstacles to such a task. We have seen how Islamic art becomes in Europe (including England) one of a number of styles which vie for attention in the fluid conditions of well-informed awareness of world styles in the decades immediately before 1900. The question of isolating any contribution made then by Islamic art, problematic enough in the case of Europe, may well seem insoluble when we consider America, whose very cultural identity was being formed in the period that includes this phase, the closely packed and the quick-moving years between Independence in 1783 and 1920. The pace of assimilation and the particular character of American life and institutions will have to be in our minds constantly as we seek to take stock of the progress, on the west side of the Atlantic, of the patterns of influence that we have been following.

In order to gauge that pace and character, it is important to look, however briefly, at the earlier period, because this provides vital clues. From the time of the Elizabethan expeditions to Virginia in 1587 to the signing of American Independence in 1783, America and Britain shared a common background. But there were notable differences: the conspicuous consumption, the taste for luxury and the ability to indulge it, and the urge to travel that were behind the main contacts of the British with Muslim art leading to 1750 were not to apply to America until the end of that period. Against luxury and its indulgence in the sixteenth and seventeenth centuries, we have to balance the obvious need for the early settlers in America to fit themselves up with the necessities for life and survival. Turkey-work covers on chairs and damask linen were probably as close as anything came to reflecting the Islamic world in the early decades. The 'Connecticut sunflower', carved on chests and boxes, was face to face with painted tulips, distant cousins of those from the faraway Serail at Constantinople, on the cupboards and mirrors of the Dutch colonials. In the mid seven-

teenth century, a Puritan austerity will have given little encouragement to the Baroque and the qualities of display that went with it.[1]

As for the incitement to travel and exploration that led the Englishmen of Tudor and Stuart times eastwards, in the case of America it was that country itself which lay at the end of the sea-voyage: the destination became the land of adoption. Hakluyt had held up a vision of undreamed-of resources in the West, and Grenville and Raleigh had sought to realise it. Hopes of finding new routes to the wealth of the Indies may originally have initiated much of the westward travel, but the rigours of life in the new continent and the resistance of the 'Indian' inhabitants were speedy correctives to any over-indulgence in fantasy. In the seventeenth century the Puritan emigrants set out for America with objectives that were very different from those of the orient-loving Shirleys and Thomas Herbert.

It would be wrong to overestimate the severity of Puritan taste as a factor in the situation. At least by the 1650s the import of painted calicoes via England was taking place. A Massachusetts family inventory of 1656, for instance, lists '5 painted Callico Curtains and Valients'.[2] Indian ideas of design were congenial to taste in certain circles in the new continent, as in Europe. At what point did these encourage American colonists to produce chinoiserie or Eastern-style textiles themselves? The difficulties of ascribing American chinoiserie textiles to precise places of manufacture are notorious, and documents seldom help. It is evident that plain curtains with chinoiserie or other designs drawn on the fabric were sometimes acquired in England and worked in one of the American colonies. Boston Museum of Fine Arts has some seventeenth-century crewel-embroidered bed-hangings which are English Jacobean in style, with chinoiserie elements, but which are known to have been worked in New England in the early eighteenth century. Family records document their history. Captain Richard Fifield of Boston appears to have bought the fabric (fustian) in England; his wife and daughter Mary (born 1694) embroidered the hangings; Mary's great-granddaughters reworked them into quilted bed-covers in the early nineteenth century when bed-hangings were out of fashion.[3]

As for printed calicoes, England appears to have dominated the trade until the later eighteenth century when America's own textile industry began to develop. John Hewson, trained in English printworks, came to Philadelphia in 1773 and opened a similar business there, returning in 1810: his work closely resembles English chintzes of the period, though he may have been familiar with Indian 'tree of life' palampores with their large exotic flowers.[4] Until 1783 all such oriental goods would have come into America from Britain: it is only after that year that America enters the oriental trade directly.

As the eighteenth-century taste for decoration and the ability to pay for it developed, ornament tended to follow the leads prescribed by European rococo. By 1770 Philadelphia – the second-largest city in the British Empire – was the home of a vigorous tradition of cabinet-making, which included work based on Chippendale's *Director* of 1754, with its wide range of designs that mingled rococo, Gothic and oriental motifs. At least 29 copies of his book appear to have existed in the city before the Revolution.[5]

In the prestigious field of painting, Europe naturally beckoned. From the same city of Philadelphia in 1760 the painter Benjamin West (1738–1820) had left for Europe and ultimately England, where in 1792 he was to become President of the Royal Academy. The bonds linking English and American painting had, however, begun to be strengthened appreciably earlier when John Smibert (1688–1751) from England had settled in Newport near Boston. He came in 1728

to a society where painted images were uncommon, and produced over 200 portraits in 10 years. They reveal little which is relevant to our subject, but they sometimes include documentary evidence, and we will have cause to mention one of them later.

Besides the English colonists there were the French and the Spanish, the latter especially contributing a seething baroque in Arizona. Before 1700 the arabesque will certainly have wound its way deep into the New World along with the other elements in the repertory of European ornament. With the Spanish may also have come some of the *cuerda seca* ceramic tiles with interlaced Islamic decoration and geometrical star-patterns of the kind made in Seville and its neighbourhood in the sixteenth century, and by the early twentieth in the collection of the Hispanic Society of America.[6]

In the late seventeenth and early eighteenth centuries, immigrations of Germans and French Huguenots increased the cosmopolitan element in American society and brought further influences. The Germans, mainly from the Upper Rhine and the Palatinate, began arriving in 1683 in Pennsylvania, and together with many Swiss continued to cross from Europe for the next 40 years, especially in the decade 1717–27. Many of these were potters who brought with them knowledge of the Turkish tulip (established in Germany about 1559) as a decorative device. This flower, as we have seen, had been given in Europe a treatment that was more open and expansive compared with the finesse of the tulips drawn on Iznik pottery. However flamboyant it might have become in its European guise, it is interesting that the Germans in America continued to call the tulip motifs *Dulle banen*, a term based on *dulab*, the Persian word for tulip. Their bold dishes, in painted slip and sgraffito versions, continue to feature the motif throughout the eighteenth century: a particularly fine one in the Pennsylvania Museum was made by John Leidy in 1796.[7] The tulip also plays a prominent role on the impressive painted chests made by the Pennsylvania Germans.[8]

The development of American pottery in the eighteenth century and the analysis of the ethnic strains which fed it from Europe and the East still need further specialist elucidation, though revealing work has been done in particular instances. The achievement of the 'Moravian' potters of Northern Carolina, for example, has some relevance: some of these potters were moving to America from central Europe just before mid century. It is evident that they had their own strong preferences in matters of decoration and colour effect in their earthenwares, using light-coloured slips over dark brown, but they were also responsive to Chinese decoration and to 'modern' wares being made later in the century in England and Europe, such as Wedgwood's Queensware. They also made a tin-glazed maiolica. Any discernible Islamic contribution to what emerges from their kilns is as part of the European tradition of tin-glazed earthenware which had absorbed Islamic stimulus. Sometimes, however, an Islamic note is sounded more distinctively, if unconsciously.[9]

Chinese decorative effects predictably had much conscious appeal in America, as in Europe, not only through their transmission at second hand – for example, through the subjects of Dutch delftware – but through the import of Chinese objects from Europe. Some of this influence led to outstanding American work reflecting Chinese shapes: for example, the distinguished silverware in the form of Chinese porcelain bowls made at New York about 1740 by Simeon Soumain. But it was chinoiserie, the European reworking of oriental ideas, which had the greatest appeal, especially, as we have seen, in textiles such as crewel-work fabrics and calicoes.

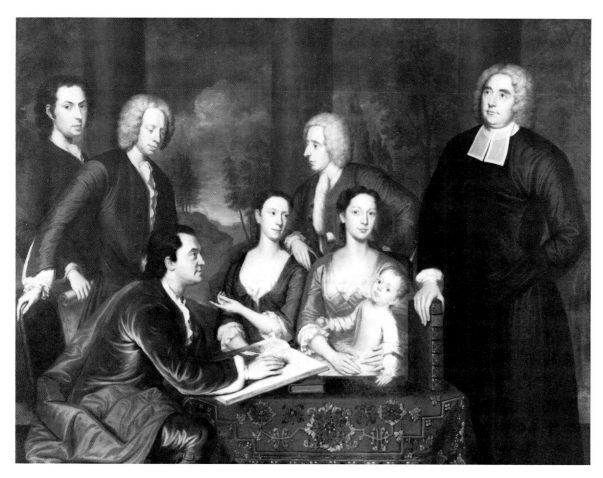

FIG. 129 John Smibert (1688–1751). The
Bermuda Group (*Dean Berkeley and Family*).
Oil, 176.6×236.2 cm. 1729–30 Yale University
Art Gallery 1808.1, gift of Isaac Lothrop
This impressive group portrait gives evidence of the
presence of carpets with oriental motifs in early
eighteenth-century America. It is unfortunate that
the evidence is not more conclusive on the origin of
the carpet so proudly displayed: its pattern has
elements of Ushak angularity but most unidiomatic
leaf-forms and curious stepped borders to the field.
The conclusion seems inescapable that this is
Turkey-work perhaps made up in Western Europe.

So far, one art form which was prominent from the beginning of our account of England has been absent from that of America: the Turkish and Persian carpet. As in Europe, evidence of the command of wealth and status is epitomised by the inclusion of such carpets in portraits. A well-known example is the group-portrait by Smibert of *Dean Berkeley and Family*, the so-called 'Bermuda Group', of 1729–30 (Figure 129). This shows a Turkey-work carpet prominently in use as a table covering in a way hallowed by Holbein's *Ambassadors*. Wilmerding has noted how recent cleaning has revealed the subtle colour scheme of the picture taken from the three primary colours which appear in the carpet.[10] The device of the oriental carpet was taken up by the American-born painter Robert Feke in his group portrait of *Isaac Royall and Family* of 1741 (Figure 130). It would be impossible without documentary evidence to say when the Turkish 'Transylvanian' rug shown here came over from Europe – the carpet in the Smibert was presumably acquired there by Berkeley himself, since Smibert had come to America with him – but at least such luxurious items, seen in America in the preceding century, were now being put on show in portraiture as opportunities opened up.[11]

The brightest talents among American painters who were born about the middle of the century, Benjamin West, John Singleton Copley and Gilbert Stuart, emigrated to Europe (though Stuart returned later). Some of Copley's portraits painted in New England before his departure in 1773 for Europe give evidence in the dress and accessories of the opulence imported from thence; others reflect the sobriety of outlook which kept exoticism at bay. Stuart's *Lansdowne* portrait of George Washington (1796, Pennsylvania Academy of Fine Arts) nevertheless

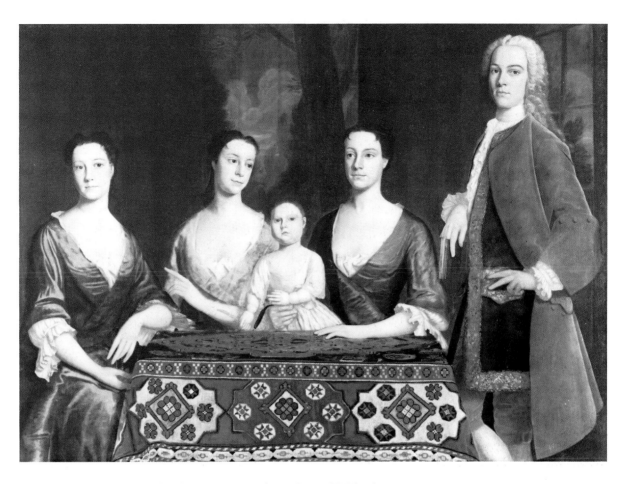

shows the famous leader of the new Republic electing to stand, as Henry VIII had chosen two and a half centuries before, on an Ushak rug.

But this is to overtake crucial happenings. There is a certain irony in the fact that in the 1770s, after decades of English domination of America in the arts, and just as Englishmen were establishing their rule in India and the tightening of links with the Islamic world was beginning to take real effect, a major event severed America from England politically: the War of Independence.

With the emergence of an independent America the cultural situation underwent profound modifications. On the one hand, direct trade with the East developed. Hitherto the colonists had followed the artistic fashions of England and Europe – though by no means slavishly – with varying degrees of time-lag (slight in the case of the Moravian potters). The Treaty of Paris of 1783, however, which ended the War of Independence, gave American merchantmen from the eastern seaboard the legal right to trade directly with the East. In December 1783, the 55-ton American sloop *Harriet* set out from New York for Canton via the Cape of Good Hope. For the next hundred years, despite competition from the British, America's trade with the Far East – though not the Near or Middle East – flourished and a large quantity of surviving Chinese export porcelain bearing the monograms of American families testifies to this.[12]

On the other hand, with independence, America made its first conscious choice of style as a nation. If rococo conveyed to Europeans the idea of freedom from the dictates of reason in the Age of Reason, how much more must it have represented irrationality to the Founding Fathers of the new Republic. The moment demanded the confidence afforded by the rational certainties of

FIG. 130 Robert Feke. *Isaac Royall and Family.* Oil, 142.6×197.6 cm. 1741. Harvard Law School Art Collection H 159, given to Harvard College, Cambridge, Mass., in 1979 by Dr George Stevens Jones
The picture unmistakably shows a 'Transylvanian' carpet pattern, based on a type of seventeenth-century Turkish rug much found in south-eastern Europe, but probably made in Anatolia. The cartouches in the border and rosettes in the inner guard-stripe are characteristic.

classicism. America turned to the 'True Style' of the neo-classicists. Even Palladio was not always pure – or we may suspect modern – enough for the national mood. If not Greek austerity then Adamesque elegance was preferred: each was doubly attractive by being compounded of precedent and contemporaneity. A New York ferry took the name of Troy, a Mississippi village that of Herculaneum. Thomas Jefferson's design for his University of Virginia at Charlottesville, built between 1817 and 1825, maintained the spirit of classical French and English town-planning far into the new century. But, as Patrick Conner has noted, Chinese-type railings made their appearance even here above Jefferson's colonnades.[13] Ideological revolution may mark new beginnings, but art, design, fashion and fancy show a seamless continuity.[14] At all events the stern virtues of the new Republic had not killed the appeal of European chinoiserie.

There was hardly more opportunity, however, after the Revolution than there had been before it, for Islamic artistic ideas to make real headway. The sea-trade of the clippers did not make direct links with Persia or Turkey. Nor does the American version of the Picturesque effect in architecture, which so attracted English designers and created the atmosphere in which a Georgian house at Brighton could turn itself into a large-scale 'Hindoo'-style pavilion, immediately lead to similar results. For this there was a good reason, to do with the particular character of American democratic life. Jefferson had an eye for bold Versailles-type building-layouts and considered the idea of a 'monumental' effect at the University of Virginia. In the end, he domesticated it with smaller human-scale units linked by low colonnades. Jefferson also responded warmly to land-scapings of the Versailles kind. But neither were these to be carried out at Charlottesville. J. C. Loudon, in his *Encyclopedia of Gardening*, perceptively remarked that landscape parks of the European type would be improbable in America: 'in a country where all men have equal rights, and where every man, however humble, has a house and garden of his own, it is not likely that there should be many large parks'.[15] In the early decades of the nineteenth century this was true. There was therefore little opportunity for Kew-like Alhambras or Mosques in the American scene (though a version of Chambers's Kew pagoda was put up by William Strickland in 1823 at Philadelphia).

However, there were ample opportunities for incorporating Islamic detail in cottage-sized 'rural residences' for the moderately rich. Pattern-books compiled by English designers and writers of the Regency provided ready models. For example, Muslim-inspired examples in the *Designs for Villas* (1808) by the Englishman Edmund Aikin influenced the American Henry Austin in a number of compositions such as the Wallis Bristol House, New Haven (before 1848).[16] The repertoire of the American designer Alexander J. Davis (1809–92) ranged from Log Cabin through Suburban Greek to 'Oriental' and 'Moorish'. Davis's collaborator Andrew Jackson Downing (1815–52), in his *Landscape Gardening* (1841), illustrated a house (by John Notman of Philadelphia) for Nathan Dunn at Mount Holly, New Jersey, which had vaguely oriental crestings, but belonged essentially to the cottage tradition.[17]

An interesting divergence of views is to be found around mid century. We find Downing asserting that 'the Saracenic, or Moorish, style, rich in fanciful decoration, is striking and picturesque in its detail, and is worthy of the attention of the wealthy amateur'.[18] For America, as for European clients, intricacy of detailing was clearly one of the main recommendations of the Eastern architectural styles. A cautionary view, and even an indication of the reverse side of the coin is, however, offered by the architect Calvert Vaux in his book *Villas and Cottages* (1857). Charming as the effects might be, he notes that the hard facts of

economics in a democratic country might make them unrealisable even in a cottage.

Styles like the Chinese or Moorish assist us but little, though each exhibits isolated features that deserve careful examination. The Moorish, for example, shows what magical effects may be produced by light, recessed arcades, and gives some good suggestions for verandas. The Chinese again, with its trellises and balconies, is interesting in detail; but neither of these phases of architectural taste is of comprehensive value. They are very deficient in compactness and completeness of plan, and in artistic design they depend too much for their effect on delicate and elaborate ornamentation; such decorations as paneling, carving, painting and gilding, may be readily enough obtained where a clever, industrious, efficient pair of hands can be hired for a few spoonfuls of rice 'per diem', but not so easily in a country where every one is as good as his neighbor 'and better', and where ordinary mechanics ask and get two or three dollars for a day's work.[19]

Nevertheless Vaux included oriental designs in his book, and was to assist Frederic Church in building the 'Persian'-inspired mansion Olana, to which we will come later.

In the case of buildings which were intended to woo the public, Moorish style could, as in Britain, combine with Gothic or other detail in effects of unbridled fantasy. Sometimes the Islamic association might be expressed in the name, as in the remarkable Bazaar of Mrs Frances Trollope at Cincinnati (1828) with its fusion of Gothic, Moorish, Venetian and classical detail.[20] A fanciful Turkish sofa featured in Robert Conner's *Cabinet Maker's Assistant* (1842) marks the extension of the style to furniture.

The absence of a Prince Regent (or a Nash) who could translate the numerous small-scale indulgences in the exotic into the dimensions of a palace did not, of course, deter the éclat of the Brighton Pavilion from reaching America. It was illustrated in an American journal as early as 1831.[21] A kind of transatlantic answer to it was eventually to appear at Barnum's large villa Iranistan, in 1846–8. This, however, is best included in the next section: before reaching it we should pause to summarise the factors which inhibit a substantial regard for Islamic style in America until after the first quarter of the nineteenth century. These were in essence fourfold: first, remoteness from Islamic contacts at first hand, and the stronger tug, as in Europe, of the applied arts of China; secondly, the close links with European and especially English classicism as a source-style; thirdly, the setting up of the processes of self-reliant democracy in the first flush of the new Republic when it came; and fourthly, a latent or explicit Puritanism. By 1825, with the emergence of a more truly American culture – in literature, painting, the applied arts – a more appraising, selective relationship with artistic develop-ments in Europe – including European orientalism – was ready to develop.

II

We saw earlier how a new wave of travel literature swept over Europe in the decades after Waterloo, culminating in one of the most widely read books of the century: *The Alhambra* (1832) by Washington Irving. This understandably went through numerous editions in the land of its author: from the time of the welcoming review in the *New York Mirror* in June of the year of publication its success was assured.[22] It is of some significance that Mrs L. C. Tuthill in her *History of Architecture from the Earliest Times* (Philadelphia 1848) has, as Gerald Bernstein noted, five pages on 'Arabian Architecture' of which three consist of direct quotations from Irving's book.[23] This may suggest a relative scarcity in America of Owen Jones's book on the Alhambra which, the New World apart,

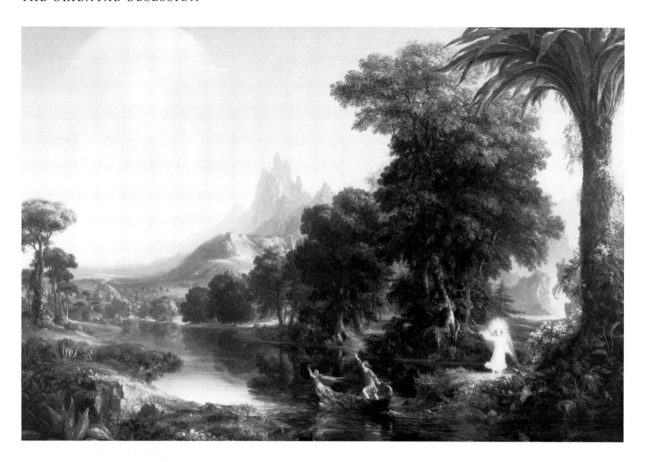

FIG. 131 Thomas Cole (1801–48). *Youth* (*The Voyage of Life*, 1840–2). Oil, 133.3×199.5 cm. 1840. Munson-Williams-Proctor Institute, Museum of Art, Utica, New York 55–106
The release of the Romantic imagination into landscape, symbolised by the theme of a journey, is continued into the sky, where a kind of etherealised palace of Kubla Khan appears.

was circulating badly enough in Britain, no doubt in part because of its bulk. But then Irving's volume, lacking in visual analysis yet replete with romantic narrative, scored heavily on a number of counts: small size, comparative cheapness, and human content.

About 1830 Americans could indeed be found welcoming, on their shores, the waves of Romanticism that had been breaking in Europe. There was a fresh factor west of the Atlantic: if the Romantic stood for the freedom to choose from his experience those mingled qualities that made up its uniqueness, without regard for rule or precedent, the American Romantic had an extraordinary subject, the largely undelineated landscape of his own continent. The degree to which concern for this personal Xanadu would foster a hankering for a distant Xanadu in the ancient East is a matter which will concern us later. The Coleridgean Xanadu could certainly attract the artist in America. He could turn from the rococo and Picturesque oddities of Frances Trollope's Bazaar at Cincinnati to visionary themes in which a solitary observer is confronted in one *coup d'oeil* by a panorama of classical temples, Gothic churches and Egyptian pyramids. This is precisely what Thomas Cole did in his painting *The Architect's Dream* painted in 1840. Here the dreamer reclines on cushions from a high vantage-point near the spectator and contemplates, like a visitor to one of the public 'Panoramas' of the age, an infinity of buildings set around him.

The emphasis in Cole's painting on the 'fixed observation' point from which the view can be seen is not, in fact, surprising at a time when the Panorama vogue had struck America as well as Europe. An important figure who helped in the process of developing the American panorama industry (which had originated, as in Europe, in the years around 1800) was Frederick Catherwood, whose

painted appearance in a Jerusalem panorama of 1835 in London we have noticed. Catherwood had come to New York in 1836, and his famous Holy Land panorama was put on in his rotunda in New York two years later. Catherwood's role in familiarising the New York public with a famous Eastern townscape in this way has its importance.[24]

Cole is an interesting case of an artist with English roots and European training who painted vast 'sublime' landscapes in and of America in a manner reminiscent of John Martin, whose Sezincote sketch-book we have also noted. A poet also, Cole responded keenly to the inspiration of poetry, including *Kubla Khan* (1798, published 1816). The idea of the dome-shape, so fundamental in the poem, certainly fascinated him. Cole's painting *Youth* from the second *Voyage of Life* series of 1840–2 (Figure 131) includes an ethereal building with a dome of Islamic contour and minarets, and a drawing by Cole exists which shows a dome of bulbous form together with a minaret.[25]

Later in the same decade a notable step towards the realisation of a Kubla Khan-like palace on American soil was taken by the showman P. T. Barnum, with the building of his house Iranistan at Bridgport, near the railroad from New York to New Haven. This was completed in 1848. Much detailing here – especially that of the central dome – was close to that of Brighton Pavilion.[26] And yet, though there were stables and outbuildings at Iranistan in the same Mughal style as the main house, the main impression given is of a frail verticality, very

FIG. 132 Leopold Eidlitz (1823–1908). Iranistan, Bridgport, Connecticut. 1846–8. Lithograph by Sarony and Major, 1855. Photograph Library of Congress, Washington, D.C.
The house was constructed for the showman P. T. Barnum as a response to the Brighton Pavilion. It was taller and less various in its skyline and also shorter-lived: it was burned down in 1857.

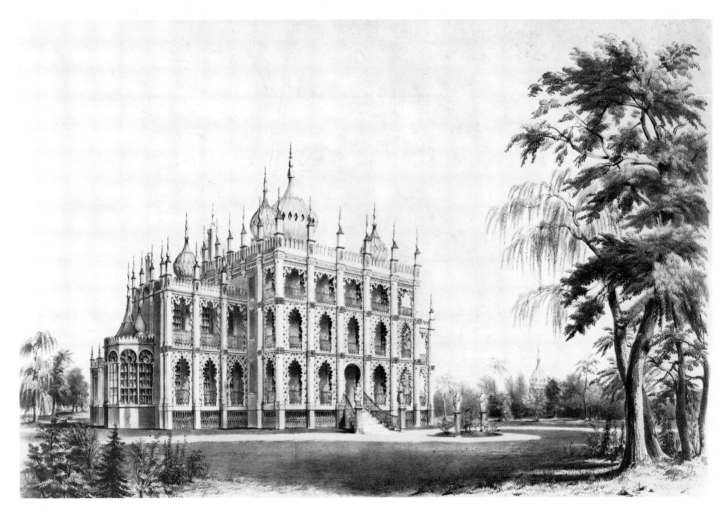

different from the Brighton building. At Iranistan there were three tiers of arches in the central block and a forest of pinnacles. The house burned down in 1857, but probably always lacked the look of permanence: something of the air of the eighteenth-century folly clung to it, if we may judge from the Sarony and Major lithograph (Figure 132). Calvert Vaux's desideratum of that year, 'comprehensive value', seems to have eluded it.

More architectonic in feeling than Iranistan, and confidently avoiding any suggestion of a folly, is the mansion Longwood near Natchez on the Mississippi, designed by Samuel Sloan for the cotton-planter Dr Haller Nutt (Figure 133).[27] This is one of a highly interesting group of verandah-clad octagonal houses in America which have no counterpart in Britain. The inspiration of the phrenologist and social reformer Orson S. Fowler has to be taken into consideration in accounting for them: Fowler rejected the fancifulness of the *cottage orné* and prescribed the simple octagon for its space-saving properties and avoidance of dark right-angled corners.[28] In his book *The Model Architect* (pl. lxiii, vol. II, 1852), however, Sloan had illustrated a 'Design for an Oriental Villa' that was octagonal with a central onion dome, three storeys and horseshoe arches above the main windows: this led to the commission for Longwood. Another octagonal house at Irvington-on-Hudson, New York (1860) has four storeys with a verandah: its larger dome, however, recalls Italy or France rather than Mughal India. The octagon form was also used by George Carstensen and Charles Gildemeister in their design for the New York Crystal Palace for the World's Fair of 1853–4 (Figure 134). This building, as Conner notes, has affinities with Porden's Stables at Brighton in its dome-shape and in respect of its minarets at the junctions of the façades. The stimulus of the octagon shape and of obtusely angled façades at this date to American architects with an interest in Islamic forms is a fascinating phenomenon. Perhaps it is partly explained by a combination of Fowler's concern for making the most of light (which the incidence of glass buildings must

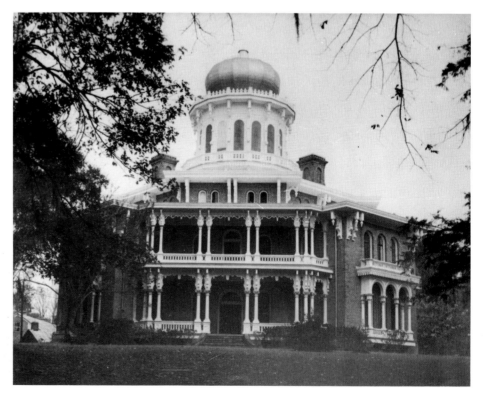

FIG. 133 Samuel Sloan (fl. 1850–65). Longwood, Natchez, Mississippi. Late 1850s–64. Photograph courtesy of Natchez Pilgrimage Garden Club, Mississippi Longwood was built for Dr Haller Nutt, a cotton-planter who had been to Egypt: it was left incomplete when the Civil War broke out in 1864, but what was built survives as a National Historic Landmark. Octagonal in plan, it is surmounted by an ogival dome which is seen as a subordinate element to a high drum. The Islamic arch appears above European classical columns and balustrades in the verandahs which link the outer rooms.

220

certainly have stressed for many at this period), together with the popularity of Indian-type verandahs with their light-affording slim supports.[29]

At Longwood the effect of verticality implicit in the onion dome above and clearly stated in the slim uprights of the verandahs below is powerfully reinforced by the massive piers at the angles of the octagon. A memorable contrast between the upward movement of the Islamic dome form and the horizontal pull of a building conceived on European classical lines below is made in the Armory building built in the 1850s at Hartford, Connecticut, for Samuel Colt, the creator of the famous revolver. Below roof-level this has a wholly European look, with Wren-style ranges divided by pedimented centre-pieces: above, however, on a broad octagon, rises a colonnade capped by a bulbous dome of the sheerest austerity. Colt's house, Armsmear, also at Hartford, had further Islamic touches in its conservatory.[30]

By mid century, then, hybrid effects in which European and Mughal forms are successfully combined without damage to overall architectonic integrity are being achieved. By this time, however, travel books such as the Reverend Jesse Ames Spencer's work *The East: Sketches of Travels in Egypt and the Holy Land* (1850, published in London, printed in New York) were providing greater chances of idiomatic familiarity with Islamic countries. The novelist Bayard Taylor published *Lands of the Saracen* and *A Visit to India, China and Japan* (1859).[31] More important, artists were to go to see more for themselves. Already in 1834 John Lowell Jr of Boston had journeyed to Egypt, taking with him the French artist Charles Gleyre (1806–74), who executed for him a vast number of drawings that documented the life, architecture and landscape. In November 1835 Lowell sent 158 of these back

FIG. 134 George J. B. Carstensen and Charles Gildemeister. 'Crystal Palace' for World Fair, New York, 1853–4. From Carstensen and Gildemeister's *New York Crystal Palace*, 1854. Photograph Library of Congress, Washington, D.C.
This great building of iron, timber and glass stood east of Sixth Avenue on the site now occupied by Bryant Park. The Islamic-inspired elements of dome and 'minarets', and detailing in common with that of the Brighton Royal Pavilion, are clearly evident in this view.

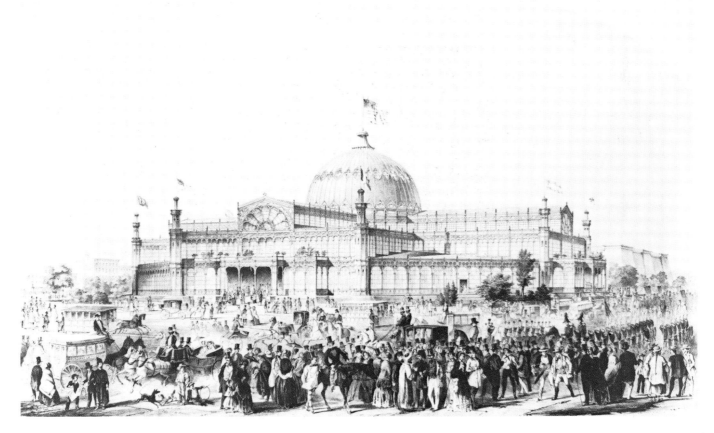

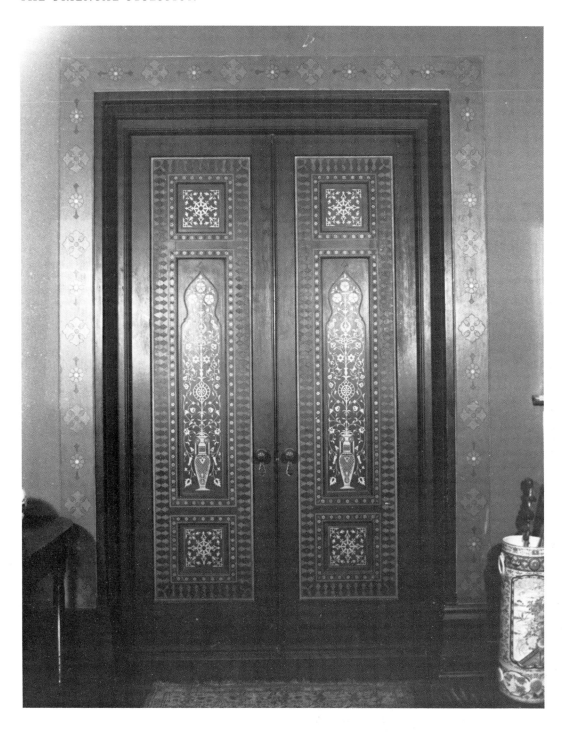

FIG. 135 Frederic Church and Calvert Vaux.
Double-leaf doors leading from vestibule to
the picture gallery, Olana. Photograph New
York State Office of Parks, Recreation and
Historic Preservation. Bureau of Historic
Sites, Olana State Historic Site
The doors have elegant stencilled designs showing
plants (including, at the top, carnation flowers seen
from above) in vases. Compare Figure 136.

to his family in Boston. These became part of the collection of the Lowell Institute
there, though most of them are now on loan to the city's Museum of Fine Arts.
Lowell died at Bombay at a later stage of the same journey: Gleyre returned
through Syria and arrived back in Paris in 1838. The copies that the artist had
made for himself are now mainly in the Musée Cantonal des Beaux Arts, Lau-
sanne. Besides numerous figure studies, one particularly fine architectural study
commissioned by Lowell, and now at Boston, stands out: this is a view in water-
colour of the drawing-room of a Copt house in Cairo, looking towards the slightly
raised *liwan* space, with carved woodwork and divans against three walls.[32]

Lowell's interest in Islamic life was confined to documentation. The most seriously considered American example of Islamic inspiration in actual architecture, extending to ceramic decoration and furnishing, comes with Olana, the 'provincialised Persian' villa built by Thomas Cole's pupil, the painter Frederic E. Church (1826–1900), at Greendale-on-Hudson, New York, after a visit to the East in 1868. Church toured Europe, Palestine and Syria, and became enthused with Eastern tiling, as had Leighton. A number of drawings of Islamic subjects were included in a large gift made by his son in 1917 to the Cooper Hewitt Museum, New York. Olana – the name comes from the Arabic *'alānā* meaning 'our place on high' – was largely Frederic Church's design, but he had as consulting architect

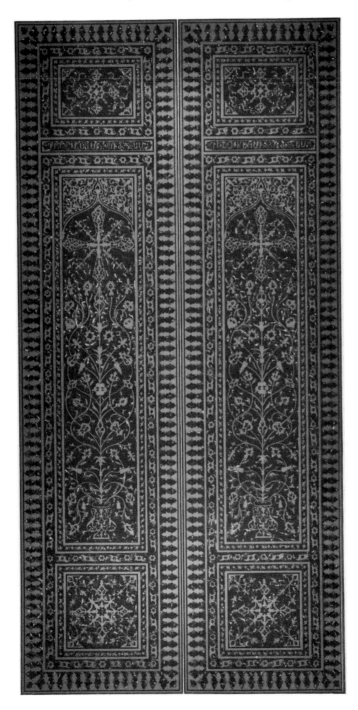

FIG. 136 Jules Bourgoin. Pl. 27 from *Les Arts Arabes*, 1873. Doors from the Church of St James of the Armenians, Jerusalem. Photograph New York State Office of Parks, Recreation and Historic Preservation, Bureau of Historic Sites, Olana State Historic Site
This plate from a well-known book provided the basis of the designs in Figure 135.

Calvert Vaux, who included oriental designs, as we saw, in his book *Villas and Cottages* (1857). Though Olana dates from 1870–2, much detail was added during the next 10 years.[33] This grandly wilful building, with its picturesque outline, includes a studio wing of 1888–9 which has Alhambra motifs as well as simplified Hindu detail. There are fireplaces with carved wood surrounds by Lockwood de Forest, Mrs Church's cousin, who had a design workshop in Ahmedabad in India. In other places Church or Vaux used printed sources: some of the doors in the house (Figure 135) are decorated with Indo-Persian stencil patterns, one of them based closely on an illustration (Figure 136) from Bourgoin's book *Les Arabes* (Paris 1873), Church's copy of which is still at Olana. Pascal Coste's *Monuments modernes de la Perse* (Paris 1867) was also in Church's library. Plate XXI from it provided motifs on which the stencils in the court hall arches were based: plate XXXIII gave ideas for the piazza columns.

Throughout the house Church's multifarious collections are spread, ranging from Etruscan to Pre-Columbian sculpture and ceramics but having much that is Islamic: Turkish carpets, Persian tiles, 'Saracenic' brass. The effect is of a romantically ebullient counterpart to Sir John Soane's London house (in Lincoln's Inn Fields), a collection of more than half a century earlier. Soane's romanticism, however, has for us today a bottled-up intensity through being confined in a town house and behind an austere neo-classic façade: Church's is extended extravagantly and prodigally through a hill-top, laterally spreading house with many large windows, some commanding a 40-mile view to the Catskills. The spirit of the place is caught in the bold originality of the tiled roof above the tower: this has an angular pattern akin to the pseudo-Kufic border design of a Turkey rug.

After this one might expect Church as a professional painter to have followed Eastern themes with the devotion of a J. F. Lewis. But this is not so. He paints a picture *El Khasne, Petra*, in 1874 to accompany the fireplace with Muslim-style ornament in the parlour: but by the time of his Eastern journey his reputation had

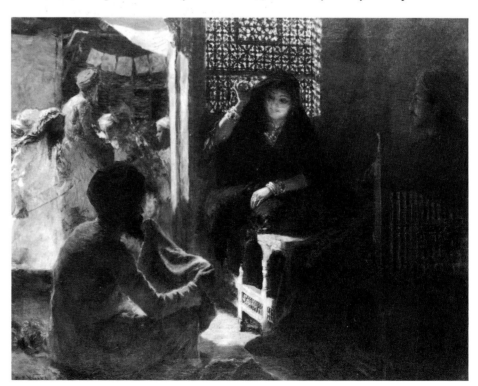

FIG. 137 Edwin Lord Weeks (1849–1903). *An Indian Cloth Merchant*. Oil, 50.9×61.5 cm. Photograph courtesy Whitford and Hughes, London

Weeks was widely travelled in the Orient (see p. 226) and evokes his first-hand knowledge in the unforced – indeed very intimate – view shown here.

been built on paintings of the Americas, of Niagara and the same Catskill Mountains beyond the Hudson, of the High Andes or Cotopaxi: 'sublime' subjects, in fact, of a kind that his teacher Cole might have chosen, or in fact chose, years before. 'The painter of American scenery has, indeed, privileges superior to any other', Cole had written. 'All nature here is new to art.'[34] Even if the artist in America in fact accommodated his visions to the European 'sublime', the simple fact of this newness still remained: he had no need to go to the deserts of the Middle East or the plains of India, and if he did, it was not primarily for the landscape. As one who had read Alexander von Humboldt's *Kosmos* (1845–58), Church found imaginative satisfaction in the landscapes of his own continent. An Islamic arch frames the view of the Hudson from Olana, a dramatic opening up of the new world from the old. Turning to the sitting-room, surrounded by grey

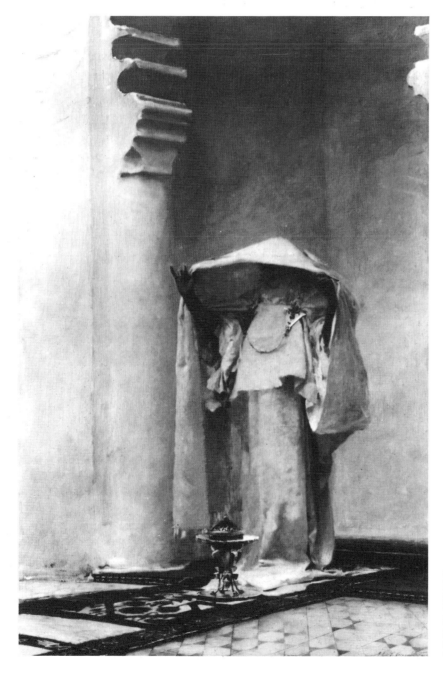

FIG. 138 John Singer Sargent (1856–1925). *La Fumée d'Ambre Gris*. Oil, 139.4×93 cm. 1880. Sterling and Francine Clark Art Institute, Williamstown, Mass. inv. 15
Sargent contrasts the abstractions of floor-tiling, prayer-rug and archway with the erect but palpitating figure set deep within the space they define.

walls with pink stencilled Arabic script, he perhaps sensed an ideal combination of freedom with order.

Few American artists in fact devote themselves with any seriousness to the Islamic scene as such. Frank Duveneck painted Turkish interiors, but cannot be seen as a committed orientalist. Sanford Gifford followed Church to the Middle East in 1868 but preferred to paint Alaska thereafter. An experience of European training might tilt the balance, as in the case of Edwin Lord Weeks (1849–1903). A Bostonian, Weeks studied in Paris under Gérôme and Léon Bonnart. He travelled to Morocco, Algeria, Egypt, Palestine, Persia and India, and wrote about his journey in *From the Black Sea through Persia and India* (New York 1895, London 1896). He was a prolific exhibitor in America and Europe, and the way in which he treats sunlight across an Eastern interior invites comparison with J. F. Lewis (Figure 137).[35]

Weeks was a contributor to the magazines *Scribner's Monthly* and *Harper's*, which often reflected the interest of the period in Spain and Moorish art. In 1887 an article appeared in *Harper's* by Henry James, on the young but already prestigious painter John Singer Sargent (1856–1925).[36] Sargent had been born in Florence to American parents, but all his working life he was a cosmopolitan. There were two elements in his nature which drew him to exotic subjects: a taste for the theatrical and a genuine interest in Islamic building and townscapes which had grown out of his visit in 1879–80 to Spain (including the Alhambra) and Morocco. He had then painted the houses, streets and courtyards of Tangier: several panels survive in the Metropolitan Museum, New York. Sketches made on this journey also led to full dress paintings such as *Fumée d'Ambre Gris* (Figure 138) and the famous *El Jaleo* (Isabella Stewart Gardner Museum, Boston). The first showed an Arab woman inhaling incense under a Moorish arch; the second was the Spanish cabaret scene that made a big impression at the Paris Salon of 1882.[37]

While some of the large works became public exhibition pieces, many of the smaller pictures inspired by Muslim themes testify to the immediacy of Sargent's response to the real-life experience. We find him returning to Eastern subjects at intervals. The year 1891 marks the beginning of his project for mural decorations in the Boston Public Library, with subjects based on the Bible. Like so many English Victorians before him he visited Egypt and Turkey to gather material, and the result was a series of portraits of Arabs, including several Bedouin.[38]

At a later stage of the Boston murals Sargent became heavily involved with decorative detail and turned to books on Islamic buildings. In 1903 he fills sketch-books with decorative borders, geometrical and running motifs and drawings of tile designs at the Alhambra. Two years later he decides to return to the East. There he looks for more architectural material, fails to find it and ends up painting the desert nomads, then the desert itself, in oil and water-colour.[39]

This sequence of events perhaps affords clues to understanding Sargent's relationship to Islamic inspiration in art, which is worth comparing with that of Brangwyn. Both artists belonged intimately to the old European tradition of figurative painting, and the modern cosmopolitan world of Western exhibitions. Both found the stimulus of first-hand contacts outside those traditions of immense importance for their large-scale decorative work. Both responded to the vitality of the East. Both had a deep regard for Islamic carpets: Brangwyn's went back to his time with William Morris, Sargent's probably grew with his mature style of painting. Here we reach a difference. Brangwyn, as heir of Morris, was to become closely involved with designing for the decorative arts and the search for the finality of form that is implicit in the designing process. Sargent was not an

Arts and Crafts figure: his response remained fundamentally that of a painter of colour, light and the intangibles of atmosphere.

Even so there is evidence that Persian carpets interested Sargent for their pattern as well as for the challenge they offered to the painter. This evidence is provided by letters written by Sargent from Tite Street, Chelsea, in 1894, to Mrs Isabella Stewart Gardner, and now in the Art Museum at Boston that bears her name. In an undated letter he writes of a Persian rug he has seen (also in the Museum, Figure 139) 'of the finest design and period, worth all the pictures ever painted': he secures it for her from the Turkish dealer for £350 and she allows him to retain it for a while in his studio, where on 18 August he writes that he is doing a study of it. A further letter on the 27th reveals that the picture that he had in mind 'never came off. Whenever I put my model on it, she covered up something infinitely more beautiful than herself, so I gave it up and merely did a sort of map of the carpet for the pattern'. Sargent was still studying rugs in 1917, and attempting to work out the basic principles of their designs.[40]

By 1920, five years before Sargent's death, the period of close engagement with Islamic inspiration in American painting was over. By then, too, the wave of Art Nouveau had spent itself, leaving traces, however, which we cannot overlook.

FIG. 139 Carpet (detail). Woollen pile on cotton foundation, 121 knots per square inch. Total size L. 742 cm., W. 365 cm. Persian (Herat) or Indian, 17th century. Isabella Stewart Gardner Museum, Boston, Mass. T26C1
This carpet was bought from Benguiat Brothers, London, in 1894 through John Singer Sargent, who responded keenly to it (see this page).

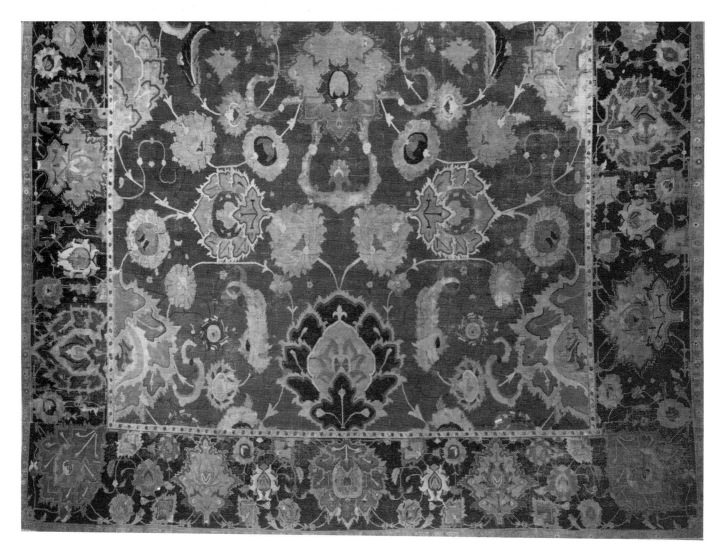

227

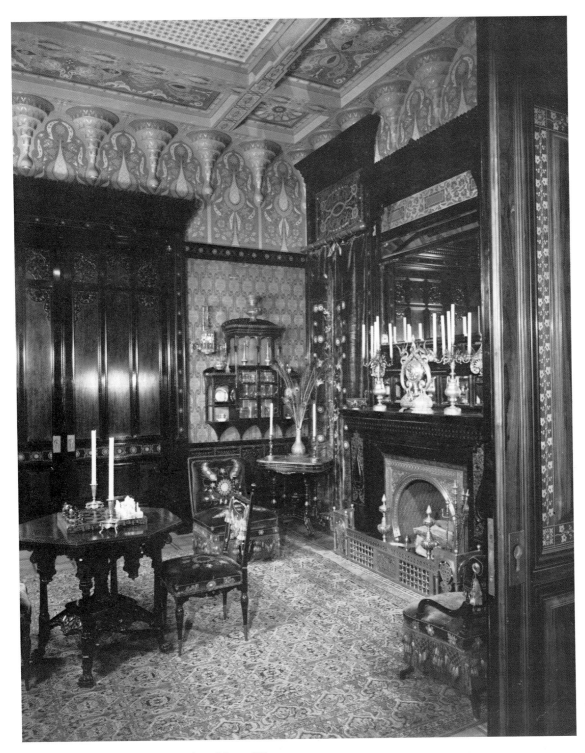

FIG. 140 Moorish smoking-room from John
D. Rockefeller House, 4 West 54th Street,
New York. 1884. The Brooklyn Museum,
46.43 MN, gift of John D. Rockefeller, Jr
This room, created by Mrs A. Yarrington Worsham
in the house later owned by Rockefeller, is one of
the most complete of its kind to survive. The New
York firm of Pottier and Stymus were involved. The
furniture in Moorish taste reflects the domination of
the upholsterer, with its fringes and tassels. See
p. 229.

III

The Souvenir published for the opening day of the North Central and South
American Exposition at New Orleans in 1885–6 shows how firmly America had
been gripped by the idea of the grand exhibition. Though this claimed to be the
largest yet held, it came a decade after the Philadelphia Centennial of 1876, which
had a unique importance among American exhibitions of the time. The Phila-
delphia show was a landmark in time as well as in space, commemorating a

hundred years of independence. It was also of the highest interest for the number of Islamic-style buildings that were to be seen in it.

With the Centennial the choice of Islamic style for exhibition buildings on a variety of scales was truly established. The largest was Hermann Schwarzmann's Horticultural Hall, 373 feet long and 193 feet wide, with its kiosks and sequence of horseshoe arches (demolished only in 1955). The preliminary design of this had been compared in the *Art Journal* of London to the legendary Alhambra. Souvenirs of it in the form of a birdcage could be bought at the exhibition. Inside the Main Building of the exhibition site could be seen Frank Furness's crested and cusped Brazilian Pavilion. There were six Islamic-style entertainment pavilions, including a Tunisian bazaar and a Turkish cafe. The style was also conspicuous among the exhibits in the three-bay cabinet by Parvis of Cairo, who had made a speciality of 'Arabian Cabinets'.[41]

Over the last quarter of the century the great exhibitions were clearly crucial, in America as in Britain, for their part in familiarising the public with Islamic forms, both original and in Western versions. Again as in Europe, various other factors were also to emphasise exoticism, not least Art Nouveau.

It would be as mistaken to try to disentangle the Muslim contribution to Art Nouveau in America in the 1890s as it was in the case of Britain or Europe. Nonetheless we noticed earlier how its progress in Britain was linked to the marketing flair of large firms such as Libertys of London whose interest was primarily in oriental art: and it is no coincidence that Louis Comfort Tiffany in New York and Samuel Bing in Paris, the two other proponents of Art Nouveau who were most influential commercially, also based their taste on oriental art, which they collected[42] and which was featured in the famous shops associated with them.

Custom was readily available: the last 20 years of the century were years of unprecedented affluence for a number of American families. This was the age of the Vanderbilts and the Carnegies and of family Ducal Palaces and Alhambras along Fifth Avenue and in the country. The attractions of Moorish forms were no less marked than they had been for Church 20 years earlier, and were pursued with avidity. Potter Palmer's house by Cobb and Frost at Chicago was only the most expensive of many to secrete within picturesque medieval exteriors elaborate sunken pools or fountains on Moorish lines. In Florida, J. A. Wood built for the rail tycoon H. B. Plant the Tampa Bay Hotel (1891) as a kind of Moorish palace for those who could not yet afford one of their own: this had 13 minaret-like towers.

One of the most remarkable of the wealthy experimenters with Islamic style of the day was Mrs Arabella Yarrington Worsham, who in 1884 married Collis P. Huntington, the railroad millionaire. The ceremony took place in a house in New York, 4 West 54th Street, which she owned for years and where she had recently created the Moorish sitting or smoking-room now in the Brooklyn Museum (Figure 140). After her marriage she sold the house to John D. Rockefeller and this room is often wrongly called after him. The actual creation of the room, however, was done during Mrs Worsham's ownership, probably just before her marriage to Huntington. The New York firm of Pottier and Stymus were involved and records also refer to George Schastey, who claimed to have designed the room but who also is known to have worked for Pottier and Stymus early in his career.[43]

A further line of development to be noticed in the last quarter of the century and after 1900 is the serious interest being taken by a number of wealthy Americans in Islamic art as such, and the simultaneous collecting of such material

being done by museums. The first indeed was greatly to benefit the second, as in Europe. The number of important Islamic collections in American art museums that were being formed at this period is indeed remarkable: Richard Ettinghausen has stressed the factor of the availability of oriental objects at a time when most American museums were beginning to collect; but the public-spiritedness of wealthy American businessmen in making benefactions of Islamic art objects to the cities where they were born or lived was an especially crucial element in the American story: Henry Walters of Baltimore and Charles L. Freer of Washington were conspicuous representatives of a class of men whose munificent gifts made work of the highest quality publicly accessible in museums throughout the country.[44]

Besides the influence of the great exhibitions we have therefore two further major considerations: the use of Islamic ideas of decoration by the entrepreneurs of Art Nouveau, and by the newly rich; and the dedicated collecting by individuals of Islamic objects which would eventually benefit public museums. A fourth pervasive factor is the effect on American artists of the Arts and Crafts movement. In the last quarter of the century we find among the furniture, textiles and ceramics produced in America a number of objects which are decidedly exotic, although their spiritual progenitor was William Morris. Tiffany indeed in his early years had visited London, where a branch of his father's design firm was established in 1868, and had met Morris and Ruskin. Morris's ideas of expressing the qualities of materials honestly in everyday objects and organising the arts and crafts in communities of workers whose thinking was so motivated had considerable effect in America, as might be expected in a country with a long history of democratic group effort. There were many links between America and the thinking associated with Morris and progressive British designers, in the years up to and after 1900. Eastlake's *Hints*, as we have seen, was in its sixth American edition by 1881 (though American use of it often departed a long way from the original, particularly in furniture). Christopher Dresser had passed across America in 1876 on his way to San Francisco and embarkation for Japan. Morris glass was extensively exhibited with a long explanatory handout at the Boston Foreign Fair in 1883,[45] by which time his chintzes were famous.[46] Walter Crane lectured in Chicago in 1891–2 and helped to organise the exhibition of his work in the Art Institute there.[47] C. R. Ashbee, founder in Britain of the Guild of Handicraft in 1888, was in Chicago in 1896 and 1900–1. The New York periodical *The Craftsman*, dedicated to Morris's ideals, ran from 1902 to 1916. Chicago held an exhibition of Morris fabrics in 1902. The William Morris Society was founded there by an Englishman, Joseph Turyman, in 1903.

This British 'craft' influence therefore joined that of oriental art from the mid 1870s through the medium of the great exhibitions: indeed between the Philadelphia Centennial Exposition of 1876 and the World Fair at Chicago in 1893 the 'tastes for things British and oriental', it has been said, 'were . . . the decisive influence'.[48] Besides carpets, the Philadelphia show featured a large display of oriental pottery which was much noticed, particularly by potters from Cincinnati, where American 'art' pottery had recently begun to be made. In 1888 Samuel Bing opened a New York showroom at 220 Fifth Avenue where John Getz, his American agent, held sales of oriental art.

Where did the appeal of orientalism lie in these years in America, when ideals of visual honesty and simplicity, on the one hand, and display and sophistication on the other, were being pursued by the exhibition-going craftsmen and public? Walter Crane, Morris's most important ambassador in America, leads us to a possible answer. 'The great advantage and charm of the Morrisian method,' he

later wrote, 'is that it lends itself to either simplicity or splendour. You might be almost plain enough to please Thoreau, with a rush-bottomed chair, piece of matting, and oaken trestle-table, or you might have gold and lustre (the choice ware of William de Morgan) gleaming from the side-board, and jewelled light in your windows, and walls hung with rich arras tapestry'.[49]

While separate effects of simplicity or splendour were alike among the aims of designers working in the spirit of Morris, another relationship was also implied by the Arts and Crafts movement between the simplicity of basic materials and the overall splendour of what could happen when they were combined.[50] It is hard not to conclude that the thought of such a relationship lay behind the creation in 1881 of the vase (Figure 141) that was shown at the Chicago Fair of 1893. This striking piece was the work of a Mrs C. A. Plimpton, one of the distinguished number working at this period in Cincinnati, the first home of American 'art pottery'. The potter here took pride in producing a dramatically complex and sophisticated object from coloured inlaid clays that were all from Ohio, with one exception that was nevertheless still American. Such a pot as this, made in the United States but in an oriental taste, could suggest sophistication with unique power in a context which reflected the sturdy virtues of the maker's vernacular materials. The result is a long way from the simplicity advocated by

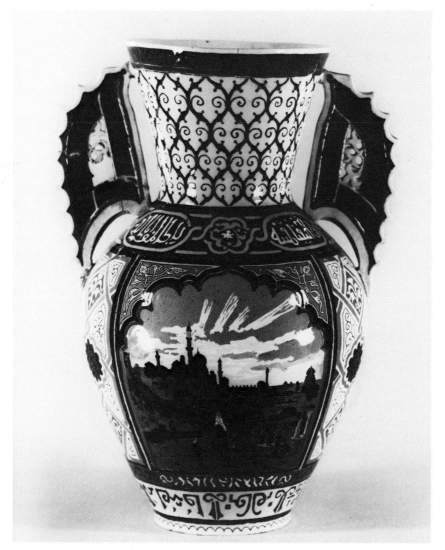

FIG. 141 Vase, earthenware with pierced wing-handles, inlaid with coloured clays in cream, terra-cotta, brown and black. H. 42 cm. 1881. Cincinnati Art Museum, Cincinnati, Ohio, 1881–61, gift of Women's Art Museum Association

This vase was designed by L. F. Plimpton and carried out by Mrs C. A. Plimpton, a leading member of the Cincinnati Pottery Club. It unites a strong silhouette reminiscent of the 'Alhambra' type wing-handled vase with dramatic detailing that uses imitation Kufic script, abstract pattern and a naturalistic view of an Islamic city. The similarities between the cloud forms and the script above cannot be accidental: both reinforce the sense of surface that is recommended in Arts and Crafts thinking. Cf. Figure 19.

Thoreau (1817–62), the Harvard-educated ascetic. However, the art of allowing materials to speak for themselves, which Islamic examples demonstrated in the eyes of the design reformers of Britain, takes on a special force in such a craft-object as this, made from the very earths of the new continent. It is no surprise to learn that this vase made a considerable effect at the Chicago Exhibition of 1893.[51]

At such a time of growing wealth, and activity by American writers on the role and purpose of art, Islamic artistic ideas could be laid in front of the public in the numerous profusely illustrated books and articles on house interiors which were being published almost yearly. George Sheldon's *Artistic Houses* in two volumes (1882–4, which repeatedly cites Owen Jones's principles) has many examples. Earlier, the magazine *Scribner's Monthly* presented a series by the art lecturer and journalist Clarence Cook (1828–1900) which were reprinted to form his successful handbook *The House Beautiful* (1878). This was illustrated with woodcuts of many objects, some close to Morris (whom Cook much admired), others remote from him. Asian art was well represented, ranging from Chinese bamboo furniture to Cairene inlaid mother-of-pearl stools and Moorish gunracks.[52]

Also in 1878 there appeared the influential book *Art Decoration applied to Furniture* by Mrs Harriet P. Spofford (1835–1921). The word 'applied' suggests a view of decoration that was far from Morris's sense of ornament growing out of material. But the book included a chapter on Oriental Styles, amongst which 'Moorish' was prominent. It was not a style, Mrs Spofford conceded, for those with restricted incomes: but she thought that even in small houses one room at least might be devoted to it. She recommended 'sumptuous gold-threaded material' for upholstery: fringes should reach the floor concealing all woodwork in true Moorish style. Preoccupation with accumulating Eastern ornament was to endure after 1900: in the 1890s the 'cosy corner' with sofa, cushions and tent-like canopy was to become a minor rage.

While this process of immersion in Eastern ornament was working itself through, a man of genius, Louis C. Tiffany, was taking his own decisions. Influence from another oriental quarter was pressing. As in Europe, the effect of Japanese art was decisive in America in these years, especially (after the Paris Exposition of 1878) in pottery. By 1880 Tiffany had an extensive collection of Japanese arms and armour, and Bing was deeply involved in collecting and selling Japanese objects. But both were in close touch with the well-known collector of Islamic art, Edward C. Moore (1827–91). Besides creating a major assemblage of Islamic artefacts Moore ran a shop which was absorbed by Tiffany and Company, the New York firm founded in 1837 by Charles Lewis Tiffany, the father of Louis Comfort. Moore was also a silversmith, receiving a Gold Medal at Paris in 1878 and designing ware to which he gave the name 'Saracenic'. By the 1880s Moore was chief designer and partner in Tiffany's firm. After his death his extraordinary collection of enamelled glass, textiles, tooled leather and metal-wares entered the Metropolitan Museum, New York.[53]

While the elder Tiffany was primarily a businessman, the younger was above all an artist. In 1867 important developments took place for them both in Paris. First, the Tiffany firm won international fame at the International Exposition. Secondly, while in Paris Louis Comfort met an American artist Samuel Colman, with whom he began to study painting, and with whom he travelled in Spain and North Africa. It was this visit that laid the foundations of Tiffany's lifelong concern with Islamic and particularly Moorish style. But he was not to remain purely a painter. He made, as we saw, a visit to England and met Morris. The gospel of Morris linking the 'fine' arts with the crafts and with everyday living

was being put into effect by E. C. Moore and for that matter by Tiffany's own firm. Encouraged by Moore, it was a natural progression, as the historian of Tiffany and Company, Joseph Purtell, has remarked, 'for the son of the firm's president to turn toward decorating the whole interior of a house'.[54]

After the Philadelphia Centennial Exposition of 1876 Tiffany became involved in teaching pottery under the auspices of the New York Society for the Decorative Arts, founded by Candace Wheeler. Dissatisfaction led him, in 1878, to form with Colman and Miss Wheeler a company known as Louis C. Tiffany and Associated Artists. The ensuing years saw the carrying out by the company of a number of prestigious commissions for large houses. The half-tone plates of Tiffany interiors in Sheldon's *Artistic Houses* reveal the extent of his involvement in his Moorish style, notably in the panelled wall surfaces with tiles and perforated partitions: a good example is the entrance hall of George Kemp's house on Fifth Avenue (1879). The disciplined convolutions of the arabesque animate the decoration round the fireplace of the Veterans' Room, Seventh Regiment Armory, Park Avenue at 67th Street, New York, of the following year.[55] A further much discussed Tiffany interior was that of Mr Ottendorfer's Pavilion, New York: in his description of this, Sheldon cites the principles of Owen Jones, 'the leading authority on Moresque decoration' and quotes extensively from Washington Irving's *Alhambra*.

In the field of artefacts, Tiffany's firm was already alive to Islamic forms early in the 1870s: in 1874 the firm made a coffee set in silver with niello inlay in Islamic style, which had a superbly proportioned ewer.[56] In the 1880s the firm produced a number of designs with Islamic elements, notably the teapot which is probably by Moore: some were suggested by Tiffany's friend and associate (and relative of Frederic Church) Lockwood de Forest, who set up a shop in Ahmedabad, India, to produce ornament for Tiffany's exotic furniture.[57] But Roman, Etruscan, Byzantine and European medieval art all contribute ideas to his metal, glass and enamels. In the 1890s Tiffany's preoccupation with glass leads to the creation of his celebrated 'Favrile' glass, made at a factory at Corona, Long Island. Patented in 1894 and first shown publicly two years later, this material combines fantasy of shape and iridescent colour, with results that are intensely personal. The 'Peacock Vase' incorporates a favourite motif of this period.[58] Any alien stylistic origins are usually obscured by the self-sufficiency of Favrile glass objects, though references to plant form may be apparent.

After the death of his father in 1902, Tiffany's regard for Islamic exoticism nevertheless remained clearly discernible. Now head of the firm, he bought 980 acres of land on Long Island and built Laurelton Hall for himself (1905; gutted 1953 and demolished). While this property, designed in three storeys below a hill-top, asserted an Art Nouveau freedom from precise precedent, there were Islamic elements in its architecture (notably its minaret-like smokestack)[59] and it had a dining-room which conspicuously featured Middle Eastern pottery.

Tiffany emerges, therefore, as a major purveyor of oriental style, occupying a place in commerce as powerful as that of Liberty, but injecting into Art Nouveau his predilections for Islamic art with greater creative force. Other firms designed Moorish interiors, such as Pottier and Stymus. Other artists reflected the interest in iridescent colour, like Jacques Sicard in his versions of Hispano-Moresque lustreware.[60] Tiffany alone unites magical sensitivity in his best work to a larger-than-life personal legend. One of the most memorable photographic portraits of him shows him attired as a Middle Eastern ruler wearing turban and pearls, for a grand ball in New York in 1913 (Figure 142). The long procession of

ghosts of 'them . . . that will clothe themselves like Turkes' will have appreciated it.

IV

Finally in this chapter, we turn to architecture. As we have seen, buildings with Islamic allusions that were of real architectonic effectiveness were appearing in America in the 1850s. One of the most successful of these was the Farmers' and Exchange Bank at Charleston, South Carolina (Figure 143) designed by the little-known architect Francis D. Lee, in 1853.[61] Here the horseshoe arch, far from its true home in North Africa and Spain, plays a major role in a façade design of engaging originality: the arches enclose round windows in the middle of a

FIG. 142 Louis Comfort Tiffany (1848–1932). Photograph Tiffany and Co. The famous entrepreneur-artist is shown in the dress worn at the ball at the firm's studios, 345 Madison, New York, in 1913.

cliff-like expanse of stone topped by a cornice in a manner recalling a fifteenth-century Florentine palazzo.[62]

Conspicuous among protagonists of Islamic style in New York was Owen Jones's pupil Jacob Wrey Mould (1825–86). He proposed numerous designs with Islamic – especially Moorish – ingredients, notably a polychrome bandstand (1859–86) for the New York Parks Department (Figure 144).[63]

As the second half of the century advanced, debate on the merits of the various historical styles that were available to Western architects flourished in America no less than in Europe. In 1890, eight years after Franklyn Webster Smith had designed his own house, the Villa Zorayda, at St Augustine, Florida, using concrete covered with Alhambra-style stucco decoration, he emerged into some prominence with his scheme for a National Gallery of History and Art at Washington, D.C. Smith's proposal envisaged a series of parts of the Alhambra, the Great Mosque at Córdoba and a Mughal Court containing a Taj Mahal. In his book on the subject in 1891 he asserted that 'the interior of the Alhambra at Granada is generally admitted to be the most fascinatingly beautiful in the world'.[64]

Apart from the urge to collect, deploy and compare the styles of architecture in this way, such matters as the status and nature of ornament and of colour in building were being discussed by practitioners and theorists on both sides of the Atlantic. Those were issues on which Islamic styles had much to contribute: they also fundamentally concerned the great American architect who was both practitioner and theorist, Louis Sullivan. We must consider his reactions in detail later.

Awareness of Islamic skills in the use of colour in building was unequivocally reflected by a very different and considerably older architect and writer who has been called the 'principal populariser of architectural knowledge in America'.

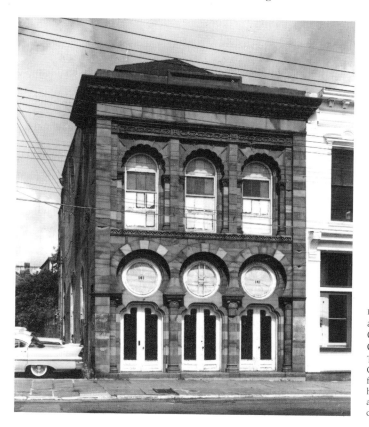

FIG. 143 Francis D. Lee (1826–85), Farmers' and Exchange Bank, Charleston, South Carolina, 1853–4. Photograph Library of Congress, Washington, D.C.
The architect, who worked extensively in Charleston, develops here a Florentine palazzo-type façade with major Islamic ingredients, notably the horseshoe arches below and cusped arches above, and the bi-coloured banded stonework which in this context recalls Cairo more than Siena.

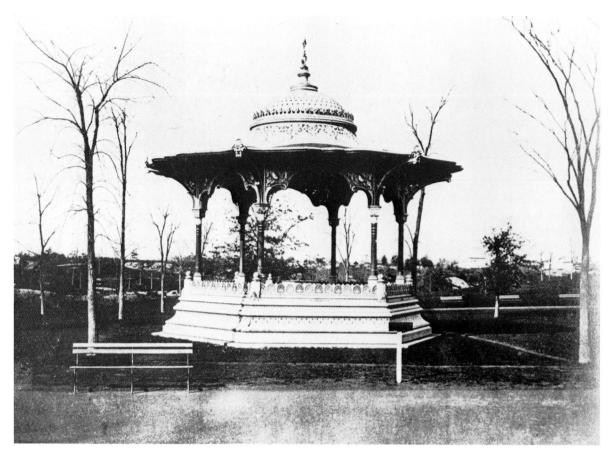

This was Russell Sturgis (1836–1909), a neo-Gothicist who devoted most of the last three decades of his life to writing and lecturing. Among his works of this period was a *History of Architecture* (1906 onwards), planned in four volumes, of which only two were completed at his death. The second of these concerned 'Mohammedan' architecture. This constituted the most important pioneering account by an American writer of the subject and contained lively responses to it, particularly on Persian polychromy: 'It is the glory of the Persian designer of the Middle Ages that he knew where to stop and where to emphasize, how to combine by contrast and by harmonious gradation, and, in short, how to produce colour decoration on a scale and with a faultless good taste which the other nations of the earth have never approached.'[65]

Muslim concern with colour in decoration had, long before this date, become evident in America, through Owen Jones's publications, through exhibitions, through buildings which included Islamic forms and effects, even if only in combination with other styles. Among these last were the synagogues which were going up widely west of the Atlantic. We shall note (p. 252) how Moorish architectural forms had become identified with these as the Jews sought to give expression to their sense of alienation in Europe. The first Moorish-style synagogue in America was the Temple B'nai Yashurun, the Plum Street Temple, Cincinnati, by James Keys Wilson, completed in 1866. This appears to have conjured up the inevitable vague echoes of the Alhambra, but it has mixed ancestry: the synagogue has Gothic portals, with, however, two minarets rising simply from the high central section of the main façade in a manner which recalls the Friday mosque at Isfahan.[66] The mixed ancestry was seen also in other buildings. The Emanu-El synagogue at New York by Leopold Eidlitz, finished in

1868, consolidated the Moorish style in America for synagogues, though its main front was a compromise with the European twin-tower façaded-type.[67]

The wide use of Islamic forms in synagogue architecture in America makes their absence in the Kehilath Anshe Maariv Synagogue in Indiana Avenue, Chicago, designed in 1890–1 by the famous partnership of Dankmar Adler and Louis H. Sullivan, a matter of some note. Here there is no Islamic-style dome, or indeed any dome at all: while the main façade is unemphasised. The exception is all the more striking inasmuch as Sullivan had already picked up Islamic ideas positively in earlier work,[68] and was to do so on numerous occasions in the future.

Louis Sullivan (1856–1924) has notoriously proved one of the most difficult artists of the last hundred years to evaluate. A glance at the ornament on his buildings, described by Pevsner as 'these curious tangles of tendrils, cabbagey, scalloped leaves and coral reef growths',[69] unwinding across surfaces according to a hectic discipline of their own, is like an encounter with an artistic language from another planet. He was clearly an originator, both in the creation of this ornament and the application of it to the surfaces of the steel-framed buildings that followed his early 'skyscraper', the Wainwright Building in St Louis (1890–1). In terms of the aesthetic of the steel-framed building and what America then went on to give to the world, Sullivan is a pioneer. But in the wider context of Western architecture as a whole there is much in Peter Collins's contention that it is as the culmination of nineteenth-century concern with ornament that his achievement is 'most solidly founded'.[70] Collins cites the remark of Sullivan's famous pupil, Frank Lloyd Wright, in *Genius and Mobocracy*, that Sullivan had no structural sense of the nature of materials, which were valued by him for the ornamental possibilities of their surfaces. Sullivan appears from this standpoint as an inheritor of values that had found expression among progressive thinkers

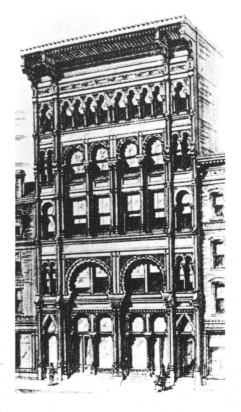

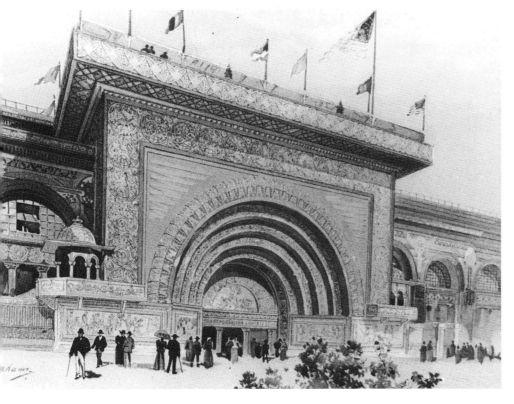

FIG. 145 Richard Morris Hunt (1827–95). Tweedy Store, New York, 1871–2. Photograph
This cast-iron façade in Lower Manhattan included a variety of Islamic arch-shapes above bay-widths which doubled – from one to two to four – in the higher storeys. The effect is therefore of large, spacious openings below and brisker repetitions above.

FIG. 146 Louis Sullivan (1856–1924). The "Golden Gate", Transportation Building, Chicago World Fair, 1893. Watercolour by C. Graham from the series *Watercolours of the Fair 1893*. Photograph courtesy Dr Diane Chalmers Johnson
This design sets a series of concentrically arranged 'Romanesque' arches within a wide rectangular frame which contains a dense form of winding stem and leaf ornament. This is basically linear and recalls Islamic practice (notably Iznik tiling) but there is an Art Nouveau indiscipline also. The two kiosks to left and right below are clear quotations from Mughal architecture.

and designers who were in many respects essentially Victorian. While we shall not explain the complexity of Sullivan entirely from this direction, this aspect of him is one that we clearly should examine in the light of what we have found respecting the relevance of Islamic art for say, Owen Jones, a man not without influence in Sullivan's formative years.

What did Sullivan know of Islamic design? He never toured the Near East: nor did he see Moorish buildings at first hand. But in his immediate background a number of interestingly suggestive facts may be gathered. His early influences in the 1870s were from architects who themselves used Islamic notions. In 1870–1 George Wattson Hewitt and Frank Furness were building the Rodeph Shalom Synagogue in Philadelphia in an idiom which combined Romanesque with conspicuously Moorish ideas (including an onion dome) on the outside, and a horseshoe arch over the organ inside.[71] In 1871–2 the influential Richard Morris Hunt chose the Moorish style for the façade of his Tweedy Store, New York (Figure 145), which was acclaimed not only at home but in Europe.[72] In 1872–5 Frank Furness, Hunt's former pupil as well as Hewitt's partner, built the Pennsylvania Academy of Fine Arts, Philadelphia, in a Venetian-Saracenic mode.[73] In 1872 Sullivan had been recommended by Hunt to join Furness and Hewitt's Philadelphia firm, and a year later Hewitt found him working late tracing Moorish ornament from a former design of Hewitt's.[74] Finally we must note Sullivan's move to Chicago where he found work in the office of William le Baron Jenney, and met John Edelmann who greatly influenced his philosophical life: Edelmann was to use Islamic ornament on his own buildings (the Decker Building, New York, 1891, is an example).

Furness, in fact, had a pronounced penchant for the Islamic styles and went on to indulge it in the Brazilian Pavilion in the Philadelphia Centennial Exposition in 1876. The employment of Islamic forms in exhibition halls was to be accompanied in the United States, as in England, by a parallel use in theatres, such as Kimball's Casino Theatre, New York, of 1880.[75] Sullivan was to reflect the connections in buildings of both types.

Sullivan's drawing of Moorish ornament in 1873 is an interesting pointer to an influence which, Sullivan's biographer Connely suggests, lay in his mind for many years. In 1880 an American edition of Owen Jones's *Grammar of Ornament* appeared, an event which will hardly have escaped Sullivan. It is also known that he collected Islamic art objects: in 1893 Frank Lloyd Wright was obtaining Persian rugs as well as Chinese ceramics and Indian statuettes for Sullivan at auction.[76]

It was in 1893 that the Chicago Fair opened with its spread of eclectically inspired buildings ranging from that for Administration by Hunt, using Ecole de Beaux-Arts Baroque, to that for Fisheries by Cobb, using Tuscan Romanesque, and to the celebrated Transportation Building by Sullivan himself.

The Transportation Building made Sullivan famous. It was not in a Revival style and looked original and American: Andre Bouilhet, Commissioner of the Union Centrale des Arts Decoratifs, said that it recalled no European building, and Banister Fletcher, the British historian of architecture, welcomed it as 'the first rose of summer to the jaded European'.[77] Certain antecedents do have points in common, however, with the 'Golden Gate' of the entrance façade (Figure 146). In particular the rectangular frame round the central opening is clearly related to the similar feature on Islamic gateways and façades (*pīshtāq*). Dimitri Tselos cites as prototypes a form of Poitou church portal and Islamic monuments of North Africa such as the Aguenaou Gate, Marrakesh (twelfth century) which he reproduces.[78] Instead of the Koranic inscriptions that were frequently set within the rectangular band in Islamic buildings Sullivan has placed his intricate

vegetable ornament. The colours applied to the façade included orange, red and yellow, and gold (in the form of gold leaf). Sullivan's address on 'Polychromatic Treatment of Architecture', given at the time to the World's Congress of Architects, stressed his regard for colour on exteriors. In the colour and vegetable plasterwork of the Transportation Building Sullivan brought out qualities of immediacy of effect that were all the more potent for being deployed on a temporary structure for an important occasion.

The development of his vegetable ornament (and the use of colour) pre-occupied Sullivan for the rest of his career. In his later years Sullivan produced a theoretical work *A System of Architectural Ornament*, the illustrations of which enable us to see how intensely personal to himself, how far from Islamic, or indeed any precise artistic style of the past, his plant ornament was. The differences are worth examining. Both Sullivan and the Muslim designer look for ways of stylising plant form so that, while maintaining its natural origins, it becomes abstracted into art. Both, as Chalmers Johnson notes in her discussion (1979, 146f.), are concerned with rhythmic multiplicity within unity. But the Muslim makes effects which are light and linear in terms of an essentially two-dimensional surface – tile or plaster – and reduces all the elements to the play of line that is imbued with the sense of movement across that surface. Sullivan differs in three ways. First, he thinks in terms of *three-dimensional* light and shade. The superb drawings of 1922–3 for his book are conceived in these terms and understandable in no other: Sullivan models the forms of his plants with the soft, supporting tones of his chalk. Secondly, he is concerned with the sense of the *unit*, often achieved through the use of symmetry: of the 20 plates in the *System*, 13 are of symmetrical designs.[79] He is not interested in suggesting the possibility of infinite pattern even in the asymmetrical examples. Thirdly – and most important – while the Muslim designer is concerned to suggest life through the

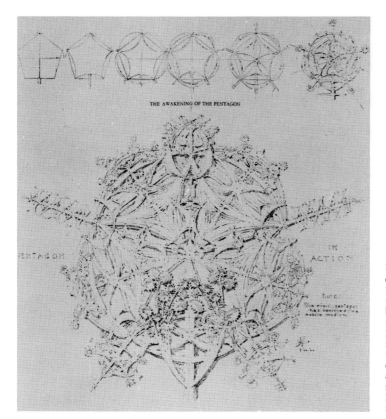

THE AWAKENING OF THE PENTAGON

FIG. 147 Louis Sullivan. Pl. 4 from *A System of Architectural Ornament*, New York, 1924. Beginning with a geometrical shape – here a pentagon – Sullivan has drawn plant-like motifs out beyond it, with an effect of fibrous three-dimensional growth that is very different from Muslim ornament, itself concerned with abstracting from natural form without, however, losing contact with the geometrical basis. Art Nouveau and his own metaphysical speculations have led Sullivan to a highly personal language: but the peculiarly seething ornamental sequences with recognisably Islamic content in his work of the 1890s (Figure 146) need to be recalled as an earlier contributing factor.

239

mobility of line, Sullivan prefers *growth*, of organic into inorganic, of inorganic into organic. Where the Muslim designer thinks of a seed-pod as a linear unit in a larger pattern that is art based on nature, Sullivan sees it as the repository of a life-force; the *leitmotif* indeed of his *System* is the seed with two cotyledons that he draws on a page at the beginning: this is, he tells us, 'the Germ' which has a 'will to power'. Plate 15 of the book shows an ornament consisting of a stalk dividing into eight specialised leaf forms which then themselves differentiate. But Sullivan is also interested in the activating of geometry itself by the vital impulses of the artist, and this brings him nearer to the Islamic designer. Plate 4 (Figure 147) illustrates the development from a simple pentagon through successive stages to a large, elaborate drawing which fuses Gothic tracery with Art Nouveau: a note in the margin says 'The rigid pentagon has vanished in a mobile medium'.

Sullivan's view of ornament therefore moves into very personal realms, and his drawings bear witness to its complexities. It will be noticed, however, that in the three respects that have been mentioned – the pursuit of three-dimensional reality, of symmetry or at least the sense of the unit, of growth from simple to complex, he shares the analysing, rationalising preoccupations of Western man and Western classical art. The uniquely intense reduction of the real world by the Islamic pattern-maker to pure rhythm and interval he leaves aside.

Nonetheless, Sullivan's response to Islamic artistic stimulus in the relating of ornament to overall form is unmistakable in certain works. In a discussion of Sullivan's use of Eastern sources, Narciso Menocal suggests that Sullivan's reliance for his knowledge of Moorish buildings on prints and black and white photographs ensured his disregard of the Muslim capacity for producing homogeneous decoration where no motif is allowed to dominate.[80] This is probably true: nonetheless, when we look at particular buildings by Sullivan, we sense the same relationship between the austerity of the large forms and the disciplined intricacy of the low relief ornamental passages that we see in buildings of Islamic origin. Neither European classical nor Gothic styles could provide the same combination. Besides the Transportation Building, the affinity with Islamic precedent is especially true of the Getty tomb, Graceland Cemetery, Chicago of

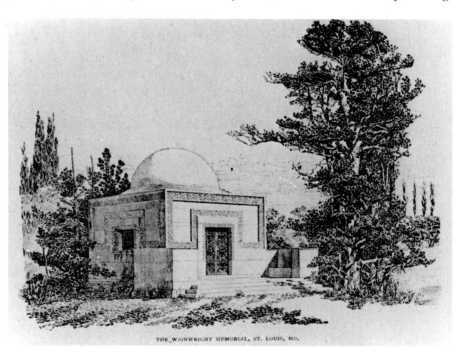

THE WAINWRIGHT MEMORIAL, ST. LOUIS, MO.

FIG. 148 Louis Sullivan. Wainwright Tomb, St Louis, Missouri, 1892. *Engineering Magazine* 3 (1892)
Sullivan has turned here to the tradition – made accessible by paintings and prints by European artists in India – of concentrated, block-like tomb designs entered within an ornamented rectangular frame and with a dome above.

1890, and the Wainwright tomb of St Louis of 1893 (Figure 148). In later work the influence is much less discernible. Recognizably Byzantine arches contribute to one of his later masterpieces, the Farmers' National Bank (now the Security Bank and Trust Company) at Owatonna, Minnesota, of 1907–8. This last mingles brick walls on a sandstone base with an exoticism that is palpable but unspecific: bands of bronze-green with mosaic in blue and flicks of green, white and gold, the sleekness of which is emphasized by the large, Sullivanesque foliate panels in relief high on the façades.[81]

Sullivan's creative response to Islamic design helps us to take overall account of American reaction to Islamic inspiration in art. Before him the degree to which American artists responded to Islamic stimulus, though intense in certain individuals, was evidently more limited than in Europe. In the early days (before 1825) the fact that such stimulus operated at a vast distance from its origins greatly reduced the urge to make direct contact. The degree of difference is also accountable in terms of what America and Europe were seeking and where each was seeking it. In the later eighteenth century Europeans, tiring of Roman classicism, were finding new points of reference in the alien mysteries of Turkish-occupied Greece and beyond. Geographical proximity to Islamic lands and the cultural and commercial encounters made possible by this meant that those mysteries were brought to them alive and analysable. Americans, however, creating a nation in a land which had alien mysteries of its own, were looking for models to link it to Europe. Their classicism was to be firmly European throughout: in the crucial period of 1776–1825, after Independence, there was no similar urge to study alternatives outside Europe.

The situation changed appreciably after 1825. Americans of the nineteenth century, like their European counterparts, shared in the opening up of the Western imagination to the historical styles of Asian countries as well as those of other continents. Some American artists – again rather few, compared to those in Europe – were drawn to visit the source-lands of Islam. Others absorbed ideas indirectly through the international exhibitions and auctions. And we have seen that the response to Islamic stimulus at home from such sources could be intense: Louis C. Tiffany and Sullivan are only the most outstanding artists who felt it.

The part played by Britain in the clearing operation which swept away nineteenth-century art revivals and initiated Art Nouveau has often been recounted. The contribution of Islamic art to this process has been less noticed. As Gerald Bernstein perceptively remarked, however, Islamic art was not sufficiently documented, as was, for example, Gothic, to sustain a text-book type historical revival.[82] The deficiency offered other advantages. Owen Jones had been the main catalyst of Islamic style, discerning its principles of colour distribution and surface treatment and the possibility of modern applications of them. It was left to Tiffany and Sullivan, artists working in a society that was itself evolving its own cultural identity, to turn what was relevant from this to creative ends. Sullivan was, as Pevsner said long ago, an original in matters of ornament, but his startling work reminds us that he was also the first major architect (Richardson notwithstanding) to come to maturity in an America that had fully reached its own maturity, a culture in which Greek and Roman classicism could never, despite the previous efforts of Jefferson's generation, have the authority that it had enjoyed in Europe. As Samuel Bing remarked, the brain of America was 'not haunted by the phantom of memory'. In the freer atmosphere of the new continent, Islamic art – one genus among many but combining strong distinctiveness with surprising adaptability – could and did connect positively with particular needs. But this raises matters which properly belong to a concluding chapter.

Conclusion

At the outset it was suggested that geographical closeness and a partially shared background made the influence of Islam on Europe less easy to define than that of China, with its utterly remote civilization. A case in point is the Muslim contribution to eighteenth-century rococo. Like part of a binary star, its glow is outshone by that of China; *turqueries*, representing an Islam both real and imagined, became for this period an enduring but less distinctive alternative to the allure of chinoiserie. But it is an alternative which includes the portraiture of real people and the landscape of real places, and which therefore has more density to its substance than chinoiserie: we must return to this aspect later.

We saw that in the sixteenth and seventeenth centuries Muslim pottery, metalwork and, above all, textiles were coming into Europe, and that Turkey merchants and travellers brought home Turkish dress and formed the enduring habit of wearing it for their portraits. After 1700, if the Turk's role is no longer as a military enemy, but sometimes as a literary spy criticising European institutions, he and his fellow Muslims are welcomed as exotic visitors in embassies and impersonated at masquerades. Muslim style becomes part of a tissue – part-Chinese, part-Gothic – of rococo fantasy in reaction to the rules of classicism. China, however, because of its remoteness and utopian reputation, becomes the philosophical lodestone.

Between the Kew Alhambra in the 1750s and the Brighton Pavilion in about 1820, the rococo fantasy continues. Simultaneously, rococo is itself being undermined by a neo-classicism associated with an increasing historical awareness of the past which is regarded as the repository of origins, many of them at variance with the traditional tenets of Roman antiquity and many leading beyond Europe. There then takes place a process of reassessing non-European cultures, each of which is now seen to have its own evolution. Together with this philosophical relativism are new political factors. Any lingering opprobrium which clings to the Turks takes second place to a more candid appraisal of Turkish culture. The study of Persian letters accelerates as the British links with India provide a formidable network of relationships across Islamic Asia. William Hodges propounds strong arguments for the intrinsic qualities of Indian architecture, Mughal as well as Hindu, and the Daniells produce a range of brilliant documentary prints. The Taj Mahal becomes a symbol of perfection for generations of European and especially British artists.

Spanning the entire period from the sixteenth to the twentieth centuries, linking the most unlikely of compatriots – Hakluyt the elder sending for a Persian weaver in 1579 with Lethaby hoping for a school of Indian craftsmen to be settled in 1912 – there is the popularity of Islamic art as the *fons et origo* of endlessly fascinating patterns. Whatever the reactions to Riegl's arguments, near the end

of the period, about the origin of the arabesque in Greco-Roman ornament, the essential visual distinctiveness of the Islamic language of ornament remained unimpaired by his speculations and could hardly be otherwise. Here Muslim designers had presented Renaissance and post-Renaissance Europe with a motif which curiously managed to combine the apparently spontaneous with the inevitable in a way matched by no Roman ornament. The arabesque can extend across a surface lightly, metrically and infinitely, in the most beguiling way: one never becomes bored with it. It can make Roman foliate ornament, for all its fluency, look fleshy. And yet its effects can be both stimulating to the imagination and, for those who wish to pursue its intricacies and analyse its system into its component parts, as intellectual as any mathematical or constructional diagram by a Renaissance architect. The attractions of freedom with order are brilliantly offered up. Britain found Islamic patterns of this kind an inspiration when it needed them – in the sixteenth century with classicism thinly established and Gothic modes (so often allied with those of Muslim art) still vigorous; so too by the 1830s, when the Gothic Revival was edging an advantage over the Italians. So also as the century wore on, although there was competition: Japanese prints, coming to Europe out of the unknown as they did, from the later 1850s, were undoubtedly a more arresting revelation of the merits of flat pattern and bold shape-making. Beside the abrupt leaps in scale of these, the elegance and sense of the proprieties of the Persian and Mughal miniatures could look tame. Moreover, the repetitions and symmetries of Muslim geometrical ornament complied relatively easily with European ways of thinking and, as we have seen, the arabesque was closely assimilated to it, if never to the point of innocuousness. Even the non-foliate, straight-banded type of pattern could be accommodated. Muslim ornament could never have the force of total revelation – but revelations fade. The remarkable merits of Muslim ornament lay not only in the controlled dynamics of its band-patterns, but also in the language of mark, interval and emphasis which could be applied with equal success to the side of a building as to the cover of a book. The advantage of this was not negligible in a period when, under the influence of Morris, the visual arts were drawing together as a family of crafts, or when, as Owen Jones saw, the need for high standards in industrial design and for a visual language to communicate with was so great. The extent of the demand made on Jones by manufacturers proves that others saw the merits of his ideas also.

Writing of architectural theorists of the nineteenth century, Pevsner remarked that Owen Jones's praise (in the *Grammar of Ornament*) of the mosques of Cairo as amongst the most beautiful in the world 'does not treat them as architecture at all' but as examples of the application of ornament.[1] Jones was undeniably more of an ornamentalist than an architect, and it was the Alhambra with its sequences of patterned spaces that he chose to make into a book, not a building of strong unitary character such as the Great Mosque of Córdoba. But the word 'ornamentalist' is not necessarily so restrictive: communicated in a period when the relation of form, colour and decoration in architecture was ill-understood, Jones's concentration on a sequence of interior spaces which linked them so successfully was both imaginative and salutary. Moreover, the optical lessons of the Alhambra walls, with their deft deployment of the primary colours to produce what would now be termed environmental effects, constituted an architectural usage: that muted but still vital bloom, he clearly concluded, was equally as desirable on a distant interior wall as on a chintz viewed near at hand. On the basis of such thinking it might be argued not only that Islamic style for Jones did not come down to the use of ornament in any trivial sense that the twentieth century has

given to the word, but also that with him Islamic use of ornament was raised to the condition of a style, with all the integrity, density, broad applicability and indeed absoluteness of meaning, implied by that term.

Ornament was one of the obsessions of Victorian art to a degree that we in our relatively austere age can never fully understand. This was so, even across a spectrum of opinion which had at one extreme Ruskin who regarded ornamentation as 'the principal part of architecture' and at the other the most blatant *arriviste* who might wish to use it to define his status in society. Apart from Jones's important realisation of the possibilities of Islamic ornament when applied in industrial design, there were two related issues on which it had something to say to anyone willing to listen and look. One was to do with the much-debated antithesis of the nineteenth-century's making, the question of handwork versus machine-production. The other was concerned with the much older antithesis of the merits of simplicity versus sophistication.

The coming of the machine had not killed hand-made ornament in architecture, which continued to be hand-carved or cast. But Eastlake who, as we have noticed, was mindful of the contrast between the irregularity of hand-made oriental carpets and what to him was the sterile respect for exact symmetry in European imitations of them, had evidently seen that one of the side-effects of machine-production was not just to diminish the human element but to substitute false ideals of elaboration and 'finish'. 'Although', he remarks, 'it would be undesirable, and indeed impossible, to reject in manufacture the appliances of modern science, we should be cautious of attaching too much importance in decorative art to those qualities of mere elaboration and finish which are independent of thought and manual labour.'[2] For Eastlake and for many advocates of 'Art Manufactures' the inspiration of hand-made Eastern artefacts was the chief antidote to this temptation.

As for the ancient debate on the contrast between the insight of the primitive and the purblindness of the sophisticate, rapid social change had highlighted it, as we saw, for Vincent Robinson, as he reflected on the nomads who wove the most sublime of carpet designs. Owen Jones, however, had seen a single wavelength connecting primitive insight and sophistication. Writing of the 'Ornament of Savage Tribes' in his *Grammar*, he said of a cloth from Tonga in the Friendly Islands that it showed 'principles of the highest ornamental art', the ability to produce 'a broad general effect by the repetition of a few simple elements': a capacity shared by 'the most complicated patterns of the Byzantine, Arabian and Moresque mosaics'. Looking at Islamic design, Jones saw an art in which the impulsions of natural instinct had been carried forward to a high degree of expressiveness and maturity.

The New World, at a very different stage of evolution, will certainly have been conscious of these preoccupations of the Old. It could hardly escape the attention of thoughtful observers that the nineteenth century, the period of the most rapid social change that Western man had ever experienced, presented difficult choices for artists who were discontented with design standards. Owen Jones and de Morgan made enterprising choices. So, in America, did Tiffany and Sullivan, artists in any case of major creative power but who were far less in a situation of recoil against the accumulated weight of the past than their European counterparts and who were correspondingly more free to make use of whatever new stimulus would help them. That of Islamic art, as we have seen, was important.

It is not surprising to find that the age of this full recognition of the merits of Islamic design is also that of serious orientalist painting. Geographical proximity in the nineteenth century could now lead to a depth of reaction in Europe which

the factor of distance, geographical and mental, had always prevented in the case of China. We cannot imagine Delacroix, had he gone to Peking in 1832 instead of Morocco, seeing the Chinese as representatives of a living classicism such as he saw embodied in the life of the Arabs. Through the long domination of Roman classicism in Europe, the pull of the lands beyond its influence, and especially of what Raymond Dawson called the 'Chinese chameleon', had been considerable. But the stimulus of Chinese art in the West produced only a confected imitation, chinoiserie, visually scintillating but hardly ever more than decorative and incapable of serious utterance in painting.

There are two developments relevant to us in regard to painting after 1750, in which the British contribution is significant. First came the orientalising tendencies of the English Romantics. With them, following Burke's lead, the focus of impatience with classicism came nearer home to the edge of Europe, and for Coleridge, as we saw, the Sublime became 'Hebrew by birth'. A new binary was then ready to condense, of Hebrew and Islamic components: the poet of *Kubla Khan* reflects them both. For many painters what chinoiserie could not provide in substance and self-sufficiency was afforded in abundance by this new star and especially, in the years after 1800, by the arts of the Near and Middle East.

Secondly and more fundamentally, there is the first-hand discovery of Islamic ways of life as a serious and positive alternative to European society and European prejudices, and as a source from which to develop artistic initiatives. A painting such as Delacroix's *Massacre of Chios* (1824, Louvre), showing prostrate Greeks resigned to the actions of Turkish horsemen, might superficially indicate a return to the old divisions between European and Saracen that had come down from the Crusades. His *Greece on the Ruins* (1827) makes a hero of the Turk as well. Edward Said, in his controversial book *Orientalism*, has perceptively traced the movement of ideas that led from the travel, historical confrontations and Romantic promptings of the late eighteenth century to the age of Byron and Thomas Moore and beyond; and which substituted a passionate curiosity and openmindedness for retirement behind the defensive prejudices of the past: 'A selective identification with regions and cultures not one's own wore down the obduracy of self and identity, which had been polarized into a community of embattled believers facing barbarian hordes.' He shows also how the ways of thinking about foreign cultures were multiplied 'as the possibilities of designation and derivation were refined beyond the categories of what Vico called gentile and sacred nations; race, colour, origin, temperament, character, and types overwhelmed the distinction between Christians and everyone else'.[3]

It was not part of Said's concern to evaluate the opportunities for painters that were helped into being by such changes, specifically in relation to Islamic subjects. In painting, the citadels of European preference for classically orientated subjects of the traditional kind were in any case under attack, as we have seen. The old classification and hierarchy of genres of the Academies were no longer inviolable. The generation of artists whose careers opened after Waterloo, the fall of Napoleon and the death of Byron (1824) was the first since the Renaissance in which the history picture, dominated by the identifiable hero-figure, classical or Christian, had not been regarded as the uncontested pinnacle of painting. Delacroix's *Chios* reflects the 'contemporary history' piece in the anonymity and multiplicity of its human types. The 'reposing Turk' subjects of Bonington and Delacroix of the 1820s also adumbrate the opportunities for experience afforded by a theatre of life which, if not exactly new to Europeans, was now to be seen as offering not merely new subjects, but new models. These models were not Turkish: they were eventually to confront Delacroix, in all their

grandeur, in Morocco and Algeria. Here he saw art and life conjoined in a relationship which, from the icon-like solemnity of a white-clad Berber Arab to the real-life enactment of a Rubens lion-hunt, was constantly to refresh his imagination. 'These people own nothing but a coverlet in which they walk, sleep and are buried and yet they seem to be as satisfied with this as Cicero must have been with his magistrate's chair . . . All of them in white, like Roman senators or the Athenian people in the Panathenaic procession.'[4] Delacroix's sense of the classical basis of what he saw was particularly intense in an artist who concluded that art was 'pure reason, embellished by genius, but following a set course and bound by higher laws'.[5] The fullness of Moroccan life, at once concentrated yet superabundant, was in fact to provide Delacroix with the real-life experience of the qualities of warmth and enthusiasm that he had seen in the painting of Rubens.

Among the Islam-inspired successors of Delacroix, Alexandre-Gabriel Decamps won a deserved reputation for his desert scenes with horsemen; Eugène Fromentin made memorable compositions out of windswept oases; and Jean-Léon Gérôme presented desert, mosque and Eastern courtyard subjects with a dazzling competence. Between Delacroix and Renoir, however, the lesser French orientalists appear to rest largely content with illustration and anecdote. The orientalist picture – a genre which, as many have observed, cut across national European schools, and employed numerous French, German and Italian representatives – gave frequent expression to a sensuality and eroticism which the harem or 'entertainment' subject could easily make explicit, free of the inhibitions that easily attached to such subjects in Europe. The argument that such pictures were done to satisfy European appetites and sidetrack European guilt-feelings – as a kind of artistic counterpart to the exploitation of the Islamic Orient of which Said accuses the West in his book – has been presented by Linda Nochlin in two articles on 'The Imaginary Orient' (see Bibliography). But the rich chemistry – which had appealed to Delacroix – of an alien way of life combined with a close relationship to the source-lands where classical and Christian learning had placed the springs of Western civilisation had a considerable effect also, and particularly on English artists. We find in Britain too the flight into a world of anecdote, languor and sensuality (made suitably anodyne for Victorian susceptibilities). But we find more. The work of John Frederick Lewis may lack the scope and authority of Delacroix: but the encounter with the world of Islam was no less decisive for him, and in a certain respect more originating than that of any other artist in the field. With Lewis we might couple Arthur Melville at a particular phase of his work.

We must approach Lewis by looking first at the varying interests that Delacroix and his rival Ingres brought to orientalist painting. The 'higher laws' referred to by Delacroix certainly involved the study of colour. At this period colour was revealing a dual fascination. The first consideration was its power as emotional stimulus. If for the eighteenth-century *philosophe*, line had satisfied the whole mind and colour one sense only, the visual appeal of colour was now its very justification. Delacroix would have agreed with this, and whatever Ingres might say about the supremacy of drawing, the sensuous attractions of Ingres's colour too are very real. The second consideration was the scientific interest in colour as a phenomenon with its own 'higher laws'. Colour might be subjectively enjoyed, but the experience of, for example, the interplay of colour-complementaries involved a kind of objective truth: everyone with normal vision who gazed at a red spot on a white wall saw a green after-image. The hue-content of colour was now in the process of becoming a factor of absorbing interest in its own right:

independent, as Jean Clay has demonstrated in his book *Romanticism*, of the subject-content of pictures. For Delacroix, passionately concerned with expressing colour, Islamic flat patterns offered a positive experience of hue-relationships: the degree of positive colour content in the low-toned background of the famous *Femmes d'Alger* (1834), depicting the languors of the harem, reflects this.

Although Delacroix noticed that juxtaposed colour complementaries could produce an overall grey 'colour atmosphere' that was more alive than a ready-mixed grey, and he responded to the way that Islamic patterns evoked this effect, the impact of Islamic *planar* colour was far stronger, it might confidently be said, on Lewis, who was much concerned with line. Delacroix and Goya were impatient of line: Turner was even to eliminate it completely where his coloured light suffused his views of the interiors at Petworth. But Lewis was highly conscious of line and contour as organising elements in composition: here he was closer to Ingres, whose play with furniture, furnishings, mirror-frames and mirror-images – if not his torpid nude odalisques – affords many interesting relationships with Lewis's work. In his book, Jean Clay draws attention to the colour emphasis in the carefully articulated linear compositions of Ingres, and cites the version of the *Odalisque with Slave* in the Walters Art Gallery, Baltimore (1842) as an example of the way that the artist flattened space by bringing out colour from distant objects in the interests of preserving a sense of the picture surface. It is also interesting that contemporary critics were reminded in Ingres's work of 'coloured drawings that sometimes decorate arabic or Indian manuscripts' (a remark recorded by Ingres's pupil Amaury-Duval in his memoirs of 1878, cited by Clay).

We earlier noticed Gautier's recognition of echoes of oriental miniature painting ('Persian delicacy') in Lewis's work, and suggested that Lewis's interest in architectural forms parallel to the picture plane was related to his concern for the picture surface. But Lewis's great contribution to orientalist painting, one that was distinct from the 'colour-atmosphere' of Delacroix and the articulations of line and colour of Ingres, was his exploration of light in Islamic interiors, particularly the direct apprehension of light through lattices, and the effects of cast shadows.

Lewis was a basically classical artist, as his small masterpiece *Harem Life, Constantinople* (Colour plate VI) clearly shows. We have noted the structural deliberations of its lines and colours, so totally at one, as in Vermeer, with the mood of contemplation that it distils. In it, contours and planes are precisely accentuated by line. Looking at Islamic interiors, Lewis noticed many things. Flat patterns led the eye in every direction in straight lines. Square tiles were simultaneously units of self-containment and parts of a repeating sequence. Above all the mesh-patterns of the *mashrabiyya* lattices were vehicles both of structural order and disintegrating light: backgrounds could be meted out in terms of horizontals and verticals and light made to strike diagonally across foregrounds, with kaleidoscopic results.

Lewis in particular, then, among orientalist painters – to a greater extent than Delacroix – may be said to have used the given facts of Islamic interior detail to feed his imagination at its deepest level. The encounter revitalised the outlook that he had formed in Europe, and gave him the freedom he needed without the sacrifice of discipline. Arthur Melville responded to similar impulses in his *Arab Interior*, but chose to move away into impressionistic evocations of light and atmosphere. He was arguably beyond the constraints of classicism anyway, as an artist of a much later generation than Lewis: momentarily, however, in that single painting, Melville approached the earlier artist.

Lewis's Eastern interiors, marrying as they do European perspective and even European figure-types (notably his famous Victorian-looking denizens of the harem) to Islamic settings searchingly studied over so long a period, constitute a contribution to Western orientalism that was perhaps inimitable. Neither Goodall nor Haag, Dillon nor Weeks, look so far into this material. We have had occasion repeatedly to notice how frequently in the nineteenth century circumstances self-generated in the Western world could be imaginatively charged by Islamic design. The interest of Loudon in globular glass domes with acuminated tops for plant-houses could point up the attractions of the ogee dome-shape which Islam had made so effective. The Jews could encourage architects to use the same form for synagogues. The curiosity of European artists about the primary colours could be nourished by the patterns of the Alhambra, so brilliantly made available by Owen Jones. Painters looking for the experience of pure colour could find it in the patterns of Islamic carpets. With Lewis's chequered interior scenes we find the edge of Islamic inspiration exposed at its brightest by an artist who lived with it for 10 years, and re-created it for a further 25. Looking at them we are reminded of Pugin's phrase apropos of Turkish carpets, 'an intricate combination of coloured intersections', or of fishing-nets, as it were, laden with captured facets of light.

We therefore see in the period between Waterloo and the First World War a situation in which the character and scope of Islamic art became an important source of strength to Europeans, designers, architects and not least painters separated from the assurances of their own classicism and feeling the need for new but related assurances. The merit of radical difference but not very serious challenge which had recommended Chinese art in the previous century was no longer appropriate. If the religious *mores* of Islam were resistant even to men like Burton, its art was ready not only to be assimilated but to assimilate, a fact which made for a unique blend of appeal in the nineteenth century. Even David Roberts, whose antipathy to the religion of Islam was profound, could not fail to produce some of his best work in front of Islamic subjects, notably the halls of the Alhambra. The style of architecture which had held picturesque appeal for Hodges and the Daniells before 1800 becomes irresistible raw material for painters intent on its presentations of colour with disciplined pattern. Even Holman Hunt, including Islamic detail in his paintings in the interests of achieving verisimilitude for Christian subjects in biblical settings, felt its intrinsic attractions.

One final point remains about the English involvement and we must return to the Alhambra to make it. Hugo had pointed to the dream aspect of the building: Prangey and other Frenchmen were to draw its patterns more temperately. But to the English particularly fell the interpretation of the reality. English readers of the popular annuals of the 1830s might well have imagined the fortress courtyards as 'fancy-formed as a fabric of the Genii': the words are those of Richard Ford, in what looks very like a direct allusion to Hugo's poem quoted at the beginning of this book. But for all Ford's romanticism – as Denys Sutton noted in his essay in the Wildenstein catalogue of the Ford exhibition of 1974 – the Alhambra was no castle of illusion for him. 'To understand the Alhambra, it must be lived in', Ford announced near the beginning of his great description, in his *Hand-book for Travellers in Spain and Readers at Home*, of the fortress and its 'saloons' with their 'misty undefined magnitude' by moonlight. Washington Irving and he had done so. For both of them the place became a living verification of a cultural presence that had been active and creative in Europe but whose origins and post-medieval history lay beyond: in Ford's phrase, the Alhambra was the 'lost home' of the Moor. In their drawings and paintings of the 1830s Ford, Roberts and Lewis

became possessed of that reality, while Jones was to build on memories and detailed records of the decoration, and become absorbed at the Crystal Palace with the counterpoint of the primary colours in the spatial conditions of a large building without strong defining walls.

The 'escapist' description as applied to English orientalist artists, with which we began, evidently needs careful qualification. In the mid nineteenth century, escape to a 'simpler' oriental world undoubtedly took on a new piquancy as a result of that urban-based, earthbound prosperity and materialism in Western society which depressed Delacroix. In her book *Realism*, however, Linda Nochlin has shown that attention to the facts of the materialistic age was related to that regard for the *concret*, the 'presentation of real and existing things' as the painter Courbet expressed it.[6] If we look at a Gérôme painting of an oriental scene, its factual veracity has more in common with that of Courbet than with that of a 'classical' Poussin or David, though its exoticism makes it look different from both. In this pursuit of documentation the English had a substantial role to perform as fact-presenters. The Frenchman Hippolyte Taine – a trenchant observer of the English scene between 1859 and 1870, and one who had notable reservations about the concerted fact-gathering of the Pre-Raphaelites – maintained that 'the inside of an Englishman's head can be very fairly compared to a Murray's Guide: a great many facts, but few ideas . . . a collection of good, reliable documents, a convenient body of memoranda to get a man through his journey without help'.[7] There is more than a grain of truth in this apostrophe of the Victorian fact-collector, and the diligence of the 'escapist' English artist in the Middle East in the 1830s gives early evidence of it. But when, *pace* Taine, we look at the bonus of ideas that Lewis in his painting, de Morgan in his ceramics and Jones in the field of design produced from their stockpiled knowledge, we cannot accuse them of seeking an easy way out.

Along with the qualification of this 'escapism', the strictures of Edward Said quoted in the Introduction also seem, in relation to the orientalising work of British artists, in need of careful narrowing down. As he investigated the exacting process of lustre pottery-making, de Morgan was spurred on by no glib imperatives of European superiority. As for Jones and Lewis, theirs was no myth of a glamorised, symbolised or 'false' Orient, created out of the wish to impose, exploit or gain confidence. On the contrary, their art was based on the visual facts, long examined and weighed, but surviving with the immediacy of the artists' Near Eastern experiences intact.

We may therefore question whether the charge of 'escapism', though in part accurate, is really a very serious one to level at the British or American painter of Islamic themes in the late nineteenth century. What of the other label 'eclectic', that tends to stick to him and even more to the architect of the time? Eclecticism, since chronicled in regard to mid-nineteenth-century France by Albert Boime, was unquestionably a hallmark of that brilliant period of the cosmopolitan rich of Europe and America, as described by Jean Cassou: the artists' studios stuffed with the bric-à-brac of all cultures, the opera scenarios extended into real life, the Chicago World Exposition of 1893 with its 'colonnades, cupolas, minarets, obelisks and gondolas'.[8] We have long ceased to feel necessarily uneasy about eclecticism in the arts. Whatever the eclectic lacks in central focus, he makes up for in the precious attribute of liberty, the capacity to range freely and make fresh juxtapositions: that the power to make them was immensely strengthened by the adaptable systems of Islamic design seems a matter for rejoicing rather than cavil.

Alfred Waterhouse, the Victorian architect and, according to Sir Charles Eastlake, a 'self-confessed eclectic' (if innocent of Islamic inspiration), described

his habit of designing: 'Wherever I thought that the particular object in view could not be best obtained by a strict obedience to precedent, I took the liberty of departing from it.' This is exactly the strength of that creative eclecticism to which the arts of Islam could make such a contribution and which could lead to the adventurous window-treatment of Lee's Exchange Bank at Charleston, South Carolina, or to the exploration of planar polychromy in architecture in Aitchison's Arab Hall for Leighton. And it is the creative use of Islamic inspiration that has, throughout, been our theme.

Artists of the nineteenth century, many living in the Islamic world for years as Arabs or Bedouins, rose to the excitement of saturating themselves in its light and atmosphere. Among them were many compatriots of Burton, experiencing the affinity which Palgrave observed. America's special position in looking outwards to Europe and inwards to her own insistent national identity made the Islamic world seem as remote as China seemed to Europe. Once experienced, however, once seen beyond the Bosphorus and Pompey's Pillar, the character of that world, to British and American artists alike, could be all-demanding. 'If you want something really Persian and passionate, with red wine and bulbuls in it' mused Saki's Reginald, in search of inspiration for his personal Rubáiyát. At a time when the bloodstream of European classicism was growing thin, between 1815 and 1900, it is evident that the transfusion provided by the Islamic East to painters from Britain and America who sought it was plentifully endowed with red cells.

Buildings with Islamic associations in Britain and America

We have noticed that from the time of that historical awareness of style which was being strongly generated in the mid eighteenth century, Islamic architecture was the subject of discriminating study in the West. Muntz in Spain is the herald of a tendency for which William Chambers had sympathy though, as we saw, in Chambers's Kew Alhambra a rococo mixture of forms gave a very unidiomatic result. With the nineteenth century, this vague exoticism is succeeded by more specific knowledge and associations.

As this book has been primarily concerned with Islamic inspiration as the unenforced choice of the artist, serving in the creating of his own personal works, only incidental reference has been made to the large quantity of specialised work – architectural work in particular – which uses Islamic visual ideas but as the outcome of Islamic associations which, as it were, predetermined the choice. Sezincote was a case in point; the outcome, as there, can be inventive, and at least two works of the later twentieth century in London have shown how such associations can sometimes lead to results of considerable novelty: these are the Casson-Conder Partnership's Ismaili Centre, Cromwell Road (1979–82), with its geometrically patterned tiles designed by Jay Bonner of the Royal College of Art; and Frederick Gibberd's Regent's Park Mosque (1976), of which, despite the lateness of its date for the present enquiry, we shall have to say more later (p. 254).

In this Appendix, however, we are primarily concerned with ways in which Islamic architectural style has been used in Western contexts to satisfy particular requirements which carry Muslim associations. Sometimes the associations are (i) personal or national: here the Indian connection was predominant. Examples include buildings put up for or sponsored by Muslims with British links, or by British families with Indian or other Muslim links. Sometimes the associations are more with (ii) building types: the use of Islamic forms for Jewish synagogues or for secular buildings such as theatres or cinemas. We will consider each of these in turn.

(i) Buildings with personal or national associations

Links with East India Company servants or soldiers who had served in India have been noted in the main text, e.g., Daylesford House, Glos., for Warren Hastings ('Mughal' dome by S. P. Cockerell c.1793); Sezincote, Glos., for Sir Charles Cockerell (returned from India; by S. P. Cockerell, c.1804–5); Stratton Park, Hampshire, for Sir Francis Baring (East India Company official: a classical house but with 'Indian' turret caps, by George Dance the Younger, c. 1806).

In the nineteenth century, the associations become more varied and many buildings reflect memories of India. A complete list would be impossible, but the following deserve mention:

(a) Stevenson Mausoleum, Kilbride, County Antrim (c.1840). Based on a Mughal tomb-type (illus. J. S. Curl, *A Celebration of Death*, 1980, 175. A number of Mughal-style tombs of British families at Calcutta are also illustrated there. I am grateful to Dr Curl for information).

(b) East India Company Museum, London, work by M. Digby Wyatt (1858, see p. 163).

(c) Oriental Well, Stoke Row, Oxon (1863). Built with funds given by the Maharajah of Benares to E. A. Reade, who had carried through a scheme for supplying water in

Benares. Designed by Reade, the structure has a bandstand-like form with an ogee dome on eight cast-iron columns (illus. Lucinda Lambton, *Vanishing Victoriana*, 1976, figure 36).

(d) Elveden Hall, Suffolk, Mughal interior (1869, 1912, see p. 195).

(e) Sway Tower, Hampshire (1879, reputed date). Folly built at Sway by A. T. T. Peterson, a former High Court judge at Calcutta. Thin and campanile-like, 218 feet high, with domed stage on top. An early sample of the use of pre-cast concrete blocks, it is in a vaguely Indian Gothic style (see *CL*, CXI, 1952, p. 611 with illus.).

(f) Mausoleum, Paston Place, Brighton, E. Sussex (about 1880) for Sir Albert Abdullah Sassoon (see Conner, 1979, pp. 152–53, with illus.).

(g) Billiard room, Bagshot Park, Surrey (1884), for Duke and Duchess of Connaught by Ram Singh (of Lahore) and John Lockwood Kipling. See R. Head, *The Indian Style* 1986, 111f., with illus.

(h) Durbar Hall, Osborne House, Isle of Wight (1890–1). Built for Queen Victoria by Ram Singh and John Lockwood Kipling.

Lutyens's famous New Delhi design (1912 onwards) belongs here also, and the Viceroy's Staff quarters there with their numerous domes and towers must be mentioned. By 1912 Lutyens's very individual style was long formed, the outcome in part of innumerable experiences of other styles, in particular those of European classicism and English vernacular. It was informed by strong awareness of geometric shape as well as considerable adeptness in allying stylistic references so as to create the sense of new origins. This transforming gift is put to powerful use at New Delhi: Italianate classicism is overwhelmingly in evidence but it is given a characteristic acerbity by the use of bare surface. For excellent illustrations see Robert Grant Irving, *Indian Summer: Lutyens, Baker and Imperial Delhi*, New Haven and London 1981. Lutyens shared with Wren an enthusiasm for the possibilities of the dome as a skyline feature. He creates perhaps the most memorable domes of the twentieth century, and the Mughal *chattri* lends itself to being translated successfully into his terms in this most Mughal of settings. Although, as suggested elsewhere (p. 293, n. 74), ideas from Persian gardens may have been employed by him through his partnership with Gertrude Jekyll, no work by Lutyens other than that of the predictable New Delhi site makes unmistakable use, it seems, of Islamic motifs.

(ii) Associations with building types

Among instances of buildings with enforced or predictable Islamic associations, mosques of the faith erected in Western Europe eliminate themselves from the present enquiry, though their role in increasing awareness among Europeans of Islamic architecture must, of course, be recognised. The Jewish synagogues in Europe and America, however, which took up these forms, are particularly notable in this context and something must be said about them. We will look at these first, and finally refer to the wider nineteenth-century habit of associating particular styles with particular types of building or function: Islamic architecture answered a number of needs under this head.

For centuries the Jews had been depicted as 'Orientals' in Western painting: the most familiar are Rembrandt's many portraits of the turbaned members of the Jewish community that he knew in Amsterdam. In the early nineteenth century, however, the attention of the Jewish populations scattered through Europe was being focused increasingly on Palestine itself and the traditional forms of the Islamic mosque. The Damascus Affair (1840), in which certain Jews were accused of ritual murder, caused a defensive banding together of prominent European Jews (such as Sir Moses Montefiore and Baron James de Rothschild) and the idea of restoring Palestine to the Jewish people was much discussed. Rahel Wischnitzer-Bernstein, tracing these developments in her book *Architecture of the European Synagogue* (1964), also points to symptoms which helped to link the religion of the Jews with Near Eastern or specifically Palestinian settings. Disraeli's novel *The Wondrous Tale of Alroy* (1833), inspired by the author's trip to Palestine, painted a warm and colourful picture of the Orient. We have already encountered the Jewish girl in Scott's *Ivanhoe* (1819) who acted like an Ingres odalisque. Delacroix's painting *The Jewish Wedding* (1841) showed the subject in an Arabic setting, as did Holman Hunt's *Finding of the Saviour in the Temple* (1856–60). Jewish interest in the Orient led to a number of synagogue designs across Europe and the United States which had Moorish detailing or included larger

elements such as minarets. Semper's Dresden Synagogue (1839–40) is the turning-point (according to Rudolf Hallo), and synagogues at Leipzig, Cologne and Berlin also had Moorish detail. Leipzig is important as a centre of trade fairs which attracted Jews from many parts of the world, including Britain and America. In Britain the influence from this quarter is not strong, but was to be seen (until destruction in the Second World War) in N. S. Josephs' Central Synagogue, Great Portland Street, London, 1870 (illus. Wischnitzer-Bernstein, *European Synagogue*, p. 210). The line of influence in America is greater (see p. 236). Wherever it goes in Europe and across the Atlantic, however, it provides interesting evidence of an alien style – usually described as 'Moorish' – meeting an emotional need of the Jews who, in adopting it, took pride in emphasising their non-European origins.

This instance of 'adoption by association' is peculiar to itself by virtue of the particular position of the Jewish people vis-à-vis the Western World and Palestine. As another means of habituating the West to Islamic architectural and ornamental forms, however, it has a place in our enquiry. On this level it can be linked with the secular examples of 'adoption by association' which were consciously established in Europe after 1815 in the modern world of historicist awareness. This is more than the casual 'display of wares' made by books on cottage architecture before and after 1800, of which Robert Lugar's *Architectural Sketches for Cottages, Rural Dwellings and Villas in the Grecian, Gothic, and Fancy Styles* (1805) may stand as a specimen. The enormous expansion of cities after 1815 helped to identify established styles with public building-types, some of which answered new purposes. Furthermore, knowledge of the associations of different styles was greater. In the 1840s we find the Italian architect Pietro Selvatico (1809³–80) arguing that churches should be Early Christian or Gothic, cemeteries Byzantine or Gothic (in fact, following French neo-classic opinion of the 1780s, Egyptian was often considered appropriate), houses should be in a Renaissance style – and cafés should be 'Arabian'. The old-established image of the Muslim taking his ease and his comforts had presumably ensured the association with the last-mentioned institution (though Piranesi with his exotic – in fact Egyptian – designs of 1760 for the Caffe degli Inglesi in Rome may have had a hand in it). C. V. L. Meeks, who discusses related matters in his book *The Railway Station, an Architectural History* (1957, pp. 11ff.) aptly calls this type of thinking 'symbolic eclecticism': the style is chosen because of its symbolic associations.

The association of Islamic forms with the architecture of relaxation – above all relaxation from conformity – can be traced back much earlier, at least to the incidence of the Turkish kiosk in eighteenth-century Europe, as noted in chapter 2. But in the nineteenth century these associations ramify more, in precise directions: Islam is associated literally with non-conformity in John Foulston's Mount Zion Baptist Chapel at Devonport (1823–4, which is combined with an Egyptian-style library and a 'primitive Doric' Town Hall). If, as the century wears on, 'Arabic' is singled out as a style suitable to accompany the now widespread habit of drinking in cafés, a plethora of Romantic pictures of Orientals smoking makes an Islamic style the obvious choice for men's smoking-rooms; while it continues an older association with the idea of public baths. Examples of smoking-rooms and public baths were cited in chapter 5: there was a particularly good tea room with Arabic decoration at York Station about 1900 (illustrated in the *Railway Magazine* for December 1908: I am grateful to T. J. Edgington of the National Railway Museum, York, for this reference).

Few of the grander seaside hotels built in the period escaped the stylistic eclecticism which introduced Islamic motifs cheek-by-jowl with 'classical', rococo or Gothic ones. A prime example was the still-surviving Metropole, Folkestone (1897) for Gordon Hotels (architect Thomas Cutler, furnishing by Smee and Cobay; reference supplied by Simone Joyce).

The growing habit of relaxing by the sea further advances the use of Islamic building shapes in iron. Swelling roof-forms in pier-architecture, topped by *chattris* (most famously in Brighton's West Pier, by Eusebius Birch 1863–6) and other entertainment buildings in holiday resorts (notably bandstands in public parks) are familiar instances. As Conner comments (see Bibliography), referring to Brighton's West Pier and the Palace Pier by R. St George Moore of 1891–9, the orientalism is vague, though unmistakable, and many piers of later years reflect it (see S. H. Adamson, *Seaside Piers*, 1977, for examples).

The association of Islamic architecture with exhibition buildings has also been noted in

chapter 5. The Islamic-style Royal Panopticon, Leicester Square, opened as such a building in 1856, became an Alhambra Theatre two years later. Other buildings specifically designed as theatres consolidated the connection. In Britain the main phase of this is from 1850 to the 1920s, and runs through the activity of the theatre-designer Frank Matcham (Empire Theatre, Nicolson St, Edinburgh, 1892; onion domes of the Empire Palace Music Hall, Leeds, c.1897) to that of the architect Cogswell in Portsmouth (The Palace, Commercial Road, with onion domes and *chattris*, 1921).

In America, New York offers examples over the same period: from Kimball and Wisedell's Casino Theatre, 39th Street and Broadway, (1880–2, demolished 1930) which had Alhambresque capitals and horseshoe arches in its entrance-way, to H. P. Knowles's City Centre of Music and Drama (originally Masonic Mecca Temple, 135 W. 55th St (1923–4), which offers a tile-arched Moorish façade and plaster Mamluk domes with *muqarnas* (see Joy Kestenbaum and Jill Cowen, 'Notable New York Buildings with Islamic influence', *Middle East Studies Association Bulletin*, XIV, no. 2, Dec. 1980, pp. 30–1).

Perhaps the most elaborate version of Islamic-style theatre architecture in the States was the Fox Theatre and Cinema, Atlanta, Georgia, by Marye, Alger and Vinour (1929). Oliver J. Vinour was a Beaux Arts-trained Frenchman who reputedly turned here for inspiration to picture-books on Nubia and the Holy Land and quantities of picture postcards brought back by a friend from a tour of the Middle East. The walls of the two main street elevations are banded with alternating courses of cream and buff brick, like the Cairo mosques; the horseshoe-headed window recalls the mosque of Qa'it-Ba'i (for details and colour illustrations, see Marcus Binney, 'Greatest Surviving Atmospheric, Restoration of the Atlanta Fox Cinema, Georgia', *CL*, 25 March 1982, pp. 796–8).

The appeal of Islamic architectural and decorative style in the West to what might be called the 'architecture of occasions' – restaurants, railway stations, exhibition halls – was therefore infectious in the period up to the 1920s. In the sharper air of mid-twentieth-century Modernism, its traditions and associations have caused it to be looked at with reserve by architects, as well as laymen. The sprouting of Islamic domes on the cinemas of this very different post-1918 world evoked, not surprisingly, a suspicion of ostentation that is well described in Graham Greene's autobiography *A Sort of Life* (1971), where he writes (1972 edn, p. 11) of the dignity of Berkhamsted's High Street after the First World War 'abused . . . by the New Cinema under a green Moorish dome, tiny enough but it seemed to us then the height of pretentious luxury and dubious taste'. This was the Court Theatre opened in 1917; the dome was replaced, and the whole demolished after a fire in 1969 (I am grateful to Mr Percy Birtchnell of Berkhamsted for information).

More recently, however, it has been suggested that the style has retained its appeal with the public, and we may end with the building that focused this conclusion, the Regent's Park Mosque (1976). Here Islamic style is matched to its own most important, indigenous building type in an impressive essay by an English architect, Sir Frederick Gibberd. The *Architectural Review*, in an article (vol. 162, 1977, p. 145) on the Mosque, saw Islamic building as too contained within its traditional forms to be convertible into Modern Architecture: 'it is not the fact that it (the London Mosque) is decorated that upsets us, or even that it is recognisably traditional in appearance, but the fact that there is no internal logic which ties the decor to the structure behind it. This makes it (at least for architects) a frivolous building'. Sir Frederick himself sums up lay response to his building: 'Everybody likes it, except other architects.' Even the *Review*, quoting this, concludes by hailing the London Mosque as a 'sober, Festival-of-Britain counterpart to the Prince Regent's Brighton Pavilion. There is no good reason why architects should try and upset the good opinion the layman has of it.' No good reason indeed: used as Gibberd has used them, in a way that gives space for their individualistic, instantly recognisable outlines to make their effect, his dome and minaret give renewed evidence of the enduring appeal of these forms as such, however inescapable their association. In the Post-Modernist phase of architecture in the 1980s, other lessons (not least that of Islamic polychromy) retain their relevance.

Note on collections

The basic research material for the book has, of course, been the work of artists, whether creative or documentary. In both areas, the collections of the Victoria and Albert Museum are unbeatable. Among the creative works, the extensive holdings of drawings by William de Morgan (1,248 sheets, including kiln-plans) and especially Owen Jones (10 volumes of wallpaper designs containing 1,345 examples, and drawings for tiles based on geometrical grids) are of first importance. Four casts taken by Owen Jones from original ornament in the Alhambra survive in the Museum. Among the documentary collections the sketch-books and drawings of Cairo made by James William Wild in the 1840s are as valuable today as they already were to his contemporaries.

As indicated in the text, the collection of watercolours and drawings assembled in the twentieth century by Rodney Searight, and now at the Victoria and Albert Museum, is of fundamental value for its documentation of Islamic life in the eighteenth and nineteenth centuries by travellers and other visitors (notably scholars and engineers) as well as by artists. The collection includes important illustrated books, such as le Hay's *Recueil* and Mayer's *Views of the Ottoman Empire*.

De Morgan items may be seen by appointment at Old Battersea House, 30 Vicarage Crescent, London SW11, formerly the home of Mrs A. M. W. Stirling (née Wilhelmina Pickering, sister of de Morgan's wife Evelyn). There is also a substantial collection of de Morgan's work (tiles and pottery) on view at Cardiff Castle.

Oriental influences in William Morris's textiles and textile designs can also be studied excellently at the Victoria and Albert, and at the William Morris Gallery, Water House, Lloyd Park, Walthamstow, London.

In the United States the archives of the Hispanic Society of America, 613 West 155th Street, New York, the E. C. Moore material at the Metropolitan Museum and the Lockwood de Forest woodwork at the Cooper-Hewitt Museum, New York, have particular relevance in this field.

Notes

ABBREVIATIONS

(a) General

ARTS C Arts Council of Great Britain
BFAC Burlington Fine Arts Club
BM British Museum, London
MMA Metropolitan Museum of Art, New York
NMR National Monuments Record, London
NPG National Portrait Gallery, London
RA Royal Academy of Arts, London
RIBA Royal Institute of British Architects, London
VAM Victoria and Albert Museum, London

(b) Periodical titles

AARP *Art and Archaeology Research Papers*
AH *Art History*
AI *Ars Islamica* (from 1954 *Ars Orientalis*)
AO *Ars Orientalis*
AR *Architectural Review*
Art Bull. *Art Bulletin*
Art J. *Art Journal (Art-Union Monthly Journal)*
BMQ *British Museum Quarterly*
Burl. Mag. *Burlington Magazine*
Conn. *Connoisseur*
CL *Country Life*
Eng. Hist. Rev. *English Historical Review*
Gaz. BA *Gazette des Beaux Arts*
Iran *Iran, Journal of the British Institute of Persian Studies*
Isl. Qu. *Islamic Quarterly*
JCWI *Journal of the Courtauld and Warburg Institutes*
(JWI) *(Journal of the Warburg Institute)*
JRSA *Journal of the Royal Society of Arts*
JSoc.AH (UK) *Journal of the Society of Architectural Historians* (London)
JSoc.AH (USA) *Journal of the Society of Architectural Historians* (Philadelphia)
JSoc.IS *Journal of the Society for Iranian Studies*
JWalp. Soc. *Journal of the Walpole Society*
LAC *Leeds Arts Calendar*
OA *Oriental Art*
Proc. Soc. Antiq. *Proceedings of the Society of Antiquaries* (London)
TrECC *Transactions of the English Ceramic Circle*
TrOCS *Transactions of the Oriental Ceramic Society*
VAM Bull. *Bulletin of the Victoria and Albert Museum*

INTRODUCTION

1 See exh. cat., *The Classical Ideal* (David Carritt 1979), 28.

2 In attempting to make the distinction we must observe, of course, the existence of Islamic imitations of Chinese art in various forms, notably ceramics. See ch. 2, n. 24 below.

3 Oleg Grabar, *The Alhambra* (Cambridge, Mass. 1978), has some discussion of the relationship of the building to European as well as to Islamic architectural tradition.

4 R. A. Jairazbhoy, *Oriental Influences in Western Art* (Bombay 1965).

5 Cf. Jairazbhoy, *ibid.*, 43; and ch. 1, n. 59 below.

6 T. S. R. Boase, *English Art 1100–1216* (1953), 170.

7 Jairazbhoy (1965), 35.

8 A. de Longpérier, 'De l'emploi des caractères Arabes dans l'ornementation chez les peuples Chrétiens de l'Occident', *Revue Archéologique* (1845); A. H. Christie, 'Development of ornament from Arabic script', *Burl. Mag.* XLI (1922), 287–8; Joan Evans, *Pattern: A study of ornament in Western Europe from 1180 to 1900*, I (1975); K. Erdmann, 'Arabische Schriftzeichen als Ornaments in der abendländischen Kunst des Mittelalters', *Abhandlungen der geistes- und sozial wissenschaftlichen Klassen*, Nr. 9 (1953).

9 Sylvia J. Auld, 'Kuficising inscriptions in the work of Gentile da Fabriano', *OA* XXXII (1986), 246–65.

10 James Byam Shaw, 'Gentile Bellini and Constantinople', *Apollo* (1984), 56–58. Cf. ch. 1, n. 29 below.

11 Samuel Chew, *The Crescent and the Rose* (New York 1974), 145–6.

12 R. W. Southern, *Western Views of Islam in the Middle Ages* (Cambridge, Mass. 1962), 31f.

13 For a discussion of the 'Saracen Preux Chevalier' within the influential conventions of the medieval *chansons de geste*, see Norman Daniel, *Heroes and Saracens* (Edinburgh University Press 1984), 38f.

14 Johan Huizinga, *The Waning of the Middle Ages* (1924), ch. v.

15 Otto Cartellieri, *The Court of Burgundy* (1929), 12. See also Robert Schwoebel, *Shadow of the Crescent* (Nieuwkoop 1967), ch. IV, 'The Chivalric Ideal', 83.

16 Walter Scott, *The Talisman* (1825, edn 1906), 25.

17 Titus Burckhardt, *Art of Islam, Language and Meaning* (1976), 115.

18 Baldassare Castiglione, *The Book of the Courtier . . . done into English by Sir Thomas Hoby* (1561, edn 1900), 133.

19 Benjamin Disraeli, *Vivian Grey* (1826–7, edn 1926), 62–3.

20 Edward W. Said, *Orientalism* (1978), 91–2.

21 The theory of Muslim avoidance of the human figure in art, on religious grounds, may be discounted as a further factor alienating Western regard for Islamic painting. It would have been plain to anyone who looked at Muslim painting (other than religious subjects) how closely that tradition relied on the human figure.

1 1500 TO 1660: THE GROWING IMPETUS

1 The volumes of the Hakluyt Society are indispensable for the background of travel in the East in this period. Richard Hakluyt the Younger's own monumental collection of travel information *The Principall Navigations, Voiages and Discoveries of the English Nation* (London 1589) has three sections: the first two are on Asia. An enlarged three-volume edition came out in 1598–1600. The edition used in the present book is that of the Society in 12 volumes, Glasgow 1903–5. Especially notable among the Society's publications is Douglas Carruthers (ed.), *The Desert Route to India* (1929). On the background to the explorations, see B. Penrose, *Travel and Discovery in the Renaissance 1420–1620* (1952). For the books that influenced contemporary opinion, see Richard B. Reed, 'A Bibliography of Discovery', in Theodore Bowie, *East–West in Art, Patterns of Cultural and Aesthetic Relationships* (Indiana University Press, Bloomington and London 1966), 136ff.

2 On the Ottoman background, see Schwoebel, *Shadow of the Crescent* (1967). A. St Clair, *The Image of the Turk in Europe* (1973) and S. Searight, *The British in the Middle East* (1979), provide convenient shorter summaries and useful illustrations.

3 May Beattie, 'Britain and the Oriental Carpet', *LAC* 55 (1964), 4; John Mills, 'The

Coming of the Carpet to the West', in ARTS C cat., *The Eastern Carpet in the Western World* (1983) 18f.

4 For examples see ARTS C, *ibid.*, illus., on front endpapers of Carpaccio, *St Ursula* cycle, c.1495, and on p. 13; and Mills's discussion (1983), 13–14.

5 For a useful summary of Egypt's role, see Kurt Erdmann, *Seven Hundred Years of Oriental Carpets* (Berkeley, Calif. and London 1970), 97f.

6 A. F. Kendrick and C. E. C. Tattersall, *Handwoven Carpets, Oriental and European*, vol. 1 (1922); C. E. C. Tattersall, *A History of British Carpets* (Benfleet, Essex 1934); Beattie (1964).

7 Mills (1983), 18.

8 An inventory of Henry VIII's carpets is in the BM, Harl. MS 1419 B. See Donald King, 'The Inventories of the Carpets of King Henry VIII', *Hali* 5 (1983), 287–96. James V of Scotland's Inventory lists in 1539 'four grete peces of tapis of Turque . . . one is of silk'. See Tattersall (1934): also, for the wider background, Susan H. Anderson, 'Hand Made Carpets in the British Isles: Migration of a Tradition', *Hali* III (1980), 196–206.

9 Hakluyt (1903–5), III, 249.

10 Even so as a 'floor object' the carpet in the West was never allowed to dominate a room as it did in the East, where it became both *objet de luxe* and multi-purpose furnishing.

11 May H. Beattie, 'Antique Rugs at Hardwick Hall', *OA* v (1959), 52–61. Dr Beattie notes here that the inventory (the product of Bess's sharp mind) appears to distinguish between Turkey carpets and those of 'Turkey work', i.e. woven on the loom (in the West) and knotted as Turkey carpets. Tattersall (1934) first established that Turkey work was made on the loom, not necessarily (as had been supposed) with the needle. Cf. n. 41 below.

12 A. C. Wood, ed., 'Mr Harrie Cavendish in His Journey to and from Constantinople 1589. By Fox, his Servant.' Camden *Misc.*, XVII (1940).

13 For William Larkin and illustrations of all seven canvases in the Redlynch set see Roy Strong, *The English Icon: Elizabethan and Jacobean Portraiture* (1969), 313–36.

14 The suggestion that copies were made in England is very much a matter of speculation. Wolsey's Records of Household Goods at Hampton Court list several woollen 'table carpets of English making' but it is certain that throughout the Tudor period the costs of labour (apart from skill) meant that English craftsmen could not compete with Oriental weavers on a big scale of production. See Kendrick and Tattersall (1922), vol. 1, 78. The Boughton carpets are accurate versions of Star Ushak designs except for slight elongations of certain motifs, some differences of colour, and significant technical variations, notably the use of hemp or flax in the warp, and silk in the weft, instead of wool as in Anatolia, which establishes a non-Asian origin. Cf. Tattersall (1934), 36f., 83f. There is evidence that Turkey carpets were produced in England at this date: the inventory of the Earl of Leicester's effects drawn up in 1588 mentions 'a Turquoy carpet of Norwich work, in length ij yards, in breadth j yard quarter' (Tattersall, 1934, 38): but no record of Norwich carpet weavers has emerged. See also Anderson (1980). Beattie (1964) cites Guicciardini's *Description of the Trade of Antwerp* (1560), and stresses that city as a centre where Turkey carpets were made and from which they were ordered by English families. There is a serious possibility that at least some of those which have been called English were made in Flanders. For recent evidence, on the other hand, of an apparently British copy of a Mughal carpet datable somewhat later see n. 41 below.

15 T. S. Willan, 'English Trade with the Levant in the Sixteenth Century', *Eng. Hist. Rev.*, LXX (1955), 399–410.

16 Sir William Foster, *The English Factories in India 1618–1621* (Oxford 1906), 61, 73, 167–8.

17 Peter Ward-Jackson, 'Some Mainstreams and Tributaries in European Ornament', *VAM Bull* (1967), part II: on the Arabesque. In part I he illustrates many examples of the grotesque.

18 A. H. Christie, *Pattern Designing* (1929), figs. 278 and 280. See also Creswell, next note.

19 K. A. C. Creswell, *Early Muslim Architecture* (Oxford 1932–40), vol. 1, 139–41, analyses the methods of Islamic designers. See also E. H. Hankin, 'Some Discoveries in the Methods of Design employed in Mohammedan Art', *JRSA* LIII (1905), 461–77.

20 Christie (1929) discusses the relationship of Leonardo's knot drawings to Muslim tradition, and speculates on the possible application of these designs to silverware. Leonardo's knots have been connected with the idea of the labyrinth, e.g. in Marcel

Brion, 'Les Noeuds de Léonard de Vinci et leur signification', *L'art et la pensée de Léonard de Vinci, Etudes d'Art* 8–10 (1953/4), but the notion of interlacement seems intrinsically distinct from the iconography of the maze, where no line should be seen to cross another.

21 See Walters Art Gallery, *The History of Bookbinding*, compiled by Dorothy E. Miner (Baltimore, Md 1957); Richard Ettinghausen, 'Near Eastern book covers and their influence on European bindings', *AO* III (1959), 113–31.

22 Apart from the evidence of ornament by Berain and others, the assimilation of the term 'arabesque' into the context of European ornament is further suggested by the Italian sixteenth-century use of the word 'rabeschi' to denote classical ornament on, for example, pilasters, and by the French seventeenth-century use of *arabesque* to refer to Raphaelesque grotesque. Cf. Fiske Kimball, *The Creation of the Rococo* (Philadelphia 1943), 28. The 'irrational' combining of varied elements that is characteristic of grotesque probably assisted this assimilation. By the second half of the eighteenth century Europeans use 'arabesque' habitually to denote grotesque.

23 The word 'moreschi' is interchangeable with 'rabeschi' in G. A. Tagliente's *Essempi di recammi* (embroidery designs, 1527). 'Moresque' is not, it seems, like 'arabesque', confused later with European grotesque. See also Kimball *ibid.*, 29.

24 Geminus was a Flemish surgeon, engraver and instrument-maker settled in Black-friars: see Campbell Dodgson, *Proc. Soc. Antiq.* XXIX (1917), 210.

25 See J. L. Nevinson, 'The Embroidery Patterns of Thomas Trevelyon', *JWalp. Soc* XLI (1966–8), 1–38 (no. 197 in the collection). The drawings are in the Folger Shakespeare Library, Washington, D.C.

26 See Frances Yates, 'Boissard's Costume-book and Two Portraits', *JWCI* XXII (1959), 365–5 (reprod. of Boissard's *Virgo Persica*, pl. 37d).

27 Jones must have known, for example, Callot's engravings of scenes from Prospero Bonarelli's tragedy *Il Solimano* (second edn 1632). These feature Turkish costume, though the setting of Aleppo with classical buildings and nude statues is totally European.

28 Jones provided detailed notes for the costumes on the drawings in question (Chats-worth Settlement Collection). One figure wears a fantastic hat, called a 'Persian Mitter' (mitre). The set for 'An Indian Shore', based on Giulio Parigi's 'The Fleet of Amerigo Vespucci' in *Il Giudizio di Parigi* (1608), comprised rocks and palm trees. See Stephen Orgel and Roy Strong, *Inigo Jones, the Theatre of the Stuart Court* (London and the University of California 1973), vol. 11, figs. 295 (pp. 612–13), 297 (p. 615) and 299 (pp. 616–17).

29 This information had been growing for 200 years. Italian fifteenth-century paintings give ample proof of the interest aroused in Renaissance Italy by oriental costume, and though much information was derivative and inaccurate, some was undoubtedly due to first-hand contact. Mehmed II, 'The Conqueror', who took Constantinople in 1453, employed Italian artists at his court, among them the painter Gentile Bellini and the painter and medallist Constanzo da Ferrara, who both made portraits of him. Gentile Bellini was in fact there for just over a year (1479–81: see James Byam Shaw, 'Gentile Bellini and Constantinople', *Apollo* CXX, 1984, 56–8). Venetian painters naturally included oriental figures in their work, against the background of Venice: but a beautiful painting by a European hand, *Reception of the Ambassadors* (Louvre), is unique in showing a Venetian embassy with Muslims in an entirely Muslim setting. J. Raby, *Venice, Dürer and the Oriental Mode* (1982), 55ff., marshals the evidence for seeing this as the depiction of a Mamluk ceremony in Damascus not, as had commonly been thought, an Ottoman ceremony in Cairo: he also postulates a date for the painting of between 1495 and 1499. The authorship of the work remains obscure. Conspicuous for documentary value among prints of the period were the woodcuts of Levantine costume and life by Erhard Reuwich for Bernard von Breydenbach's *Sanctae Pere-grinationes* (Mainz 1486). The sixteenth century added considerably to knowledge of costume, particularly that of Turkey. Pieter Coecke van Aelst (1502–50) was in Constantinople in 1533–4, and his woodcuts illustrated *Moeurs et Fachons de faire de Turcs* (Antwerp? 1553). Melchior Lorichs (*c.*1527–83) of Flensburg, was in Constantin-ople in 1557–9 and made numerous woodcuts of people, costumes and buildings (published in book form in 1626). In 1567 the *Quatre premiers livres des navigations et*

peregrinations orientales of Nicolas de Nicolay, published at Lyons, brought together an influential group of drawings of Turkish figures. It is likely that a number of European draughtsmen, now unknown, were in Turkey at this period. cf. n. 46 below. Of artists who did not themselves visit Turkey, Jacques Callot (*c*.1592–1635) knew Turkish costume as we have seen (n. 27 above). He had a strong interest in ceremonial presentations, as had the Florentine Stefano della Bella (1610–64), who worked on ballets for the Grand Duke of Tuscany and designed Turkish dress for stage events. The spectacles of the Turkish court clearly attracted artists, and collections of drawings proliferate in the early 1600s: a good example is *Costumes de la Cour du Grand Seigneur* (1630), 172 drawings, seemingly of Venetian origin, of Turks and neighbouring nationalities (Bibl. Nat., Paris). Cf. Ch. 4, n. 2 below.

30 See Robin Fedden, *English Travellers in the Near East* (Writers and their Work 97, Longmans 1958): Searight (1979); (on Persia) Sir Roger Stevens, 'European Visitors to the Safavid Court', 'Studies on Isfahan', *J. Soc IS* VII (1974), II 422f.

31 George Sandys, *Relation* (edn 1673), 23f.

32 See *Travels of Peter Mundy* (1907), introduction by Sir Richard Carnac Temple.

33 Thomas Herbert, *Travels in Persia* (edn 1928), 133. *Paradaeza* in Persian meant 'game park'; and gardens were extensively developed as 'paradises' in Islamic lands. For their influence in literature see Elisabeth B. MacDougall and Richard Ettinghausen, *The Islamic Garden*, Dumbarton Oaks, Colloquium on the History of Landscape Architecture, Harvard University Press, 1976. See also Arthur Upham Pope, *Survey of Persian Art* (edn 1964–5), vol. III; Elizabeth B. Moynihan, *Paradise as a Garden* (1981). For a good range of photographs see Jonas Lehrman, *The Earthly Paradise* (1980). Cf. ch. 5, n. 74 below.

34 Herbert was presented with a cloth-of-gold tunic by the Shah. His portrait, re-identified in 1926, is now in a private collection in Yorkshire: see *CL*, 29 November 1962. A good reproduction hangs in the Merchant Adventurers' Hall, York.

35 See Sir Roger Stevens, 'Robert Shirley: The Unanswered Questions', *Iran* XVII (1979), 115–25, and the same author's article 'European Visitors to the Safavid Court', 'Studies on Isfahan', *JSocIS* VII (1974), II, 422f.

36 There are drawings for Shirley's portrait in Van Dyck's 'Italian Sketchbook' of 1622 (BM): one is reprod. in Christopher Brown, *Van Dyck* (1982), 65. The costume is also recorded in an unattributable full-length portrait at Berkeley Castle, Glos.: see O. Millar, *Van Dyck in England*, exh. cat. (NPG 1982), 45.

37 See R. W. Ferrier, 'Charles I and the Antiquities of Persia: The Mission of Nicholas Wilford', *Iran* VIII (1970), 51–56. The MS sources are in the India Office Records, B.21, 21 February 1634, and E/3/15/1543B, 19 January 1634–5. Charles's correspondence with the Sultan of Morocco in the 1630s, and despatch of John Harrison as his envoy there, were concerned with trade problems, but it is hard to think that the calligraphy of the Sultan's reply escaped his notice: see *Isl.Qu* (1973; illus).

38 Ferrier (1970), 54–5. A list of items in Wilford's possession in Persia includes 'A booke of flowers stampd' and 'A booke of perspectives', which indicates the kind of European art that was entering Persia at this time. Cf. n. 54 below.

39 For further discussion of the Ardabil carpet and its impact in the West see ch. 5, p. 182 below.

40 See Mills (1983), for illus. of Dutch examples; also Donald King's remarks in same catalogue, 29.

41 See *Hali* II, no. 4 (1980), 346–7. The carpet, discovered at Glamis Castle, is known as the Strathmore carpet: it is Turkey work (cf. n. 11 above) which, though made on a loom, may reflect English needlework designs. The Strathmore is nevertheless overwhelmingly Mughal in inspiration, and English (Norwich?) in actual manufacture. I am grateful to Margaret Swain for help.

42 *Voyages* (Lyons 1665), II, 120; 94. Balthasar Monconys (1614–65) travelled in Portugal and also in Italy, Egypt, Palestine, Syria, Anatolia and Constantinople, returning to France in 1649. *The Voyages de M. de Monconys* was eventually published by his son (3 vols.).

43 On la Boullaye, see B. Naderzad, 'Louis XIV, La Boullaye et l'Exotisme Persan', *Gaz. BA* LXXIX (1972), 32f.

44 The whole subject of Rembrandt's interest in the East, including his use of Eastern

elements to give veracity to his Biblical subjects, is discussed in L. Slatkes, *Rembrandt and Persia* (New York 1983).

45 Mundy, *Travels*, 1634–8 (1907), 27. The painted book, containing many fine 'cut-outs', is now British Museum (Oriental Antiquities) 1974-6-17-013.

46 On Nicolas de Nicolay, see n. 29. The anonymous volume of 1587 is now in the L. A. Mayer Memorial in Jerusalem; a replica is in the Veste Koburg; see Hilda and Otto Kurz, 'The Turkish Dresses in the Costume-Book of Rubens', *Nederlands Kunsthistorisch Jaarboek* XXIII (1972), 275–90, reprinted Kurz, *Decorative Arts of Europe and the Islamic East* (1977) sect. xv. Rubens depicts 41 Eastern figures on the last eight leaves of his Costume Book (now BM). The Kurzes make it clear that Turkish costumes in Rubens's time meant not only those worn by the Turks but also picturesque garments worn by minorities in the Turkish Empire, e.g. Greek Christians, Persians, Arabs, and Jews. See also Kristin Lohse Belkin, *Rubens's Costume Book* (London and Philadelphia 1978), where all Rubens's drawings are illustrated (pl. 180f). Pl. 192 is especially interesting: it shows two Arabs, a man and a woman (models not known to Belkin) and a Turkish woman in street clothes.

47 The 1631 inventory of Rudolf II's collection lists a small book 'von turkhischen pappir darinnen allerlei geschnittene kunststuch', see *Jahrbuch der kunsthistorischen Sammlungen*, xxv (1905), liv. The Turkish and Indian items in the Collection are listed in J. Moravek, *Nove objeveny inventar rudolfinskych sbirek na Hrade prazshem* (Prague 1937), 19ff. For Mundy see n. 45 above.

48 Such is the view of Kurz in a conveniently available article, 'Libri cum characteribus ex nulla materia compositis' (English text), originally in *Israel Oriental Studies* (1972), 240–47, but included in Kurz (1977), sect. xxi. He there cites other European collectors and gives extensive bibliographical references. See also J. M. (Michael) Rogers, *Islamic Art and Design 1500–1700*, BM (1983), 18–23 (illus.), The silhouette 'shadow' portrait of the later eighteenth century, named after Etienne de Silhouette, is only indirectly related to the Turkish paper-cut.

49 Bacon, *Sylva Sylvarum* (1627), item 741.

50 Sandys (6th edn 1670), 56–7. The word 'chamblets' refers to *camlet*, a costly Eastern fabric originally made of silk and camel's hair, then to an imitation of this of varying nature. Sandys's testimony is particularly important as evidence of the probable Turkish origins of the craft of marbling. W. H. James Weale records finding marbled papers of Turkish origin in an album dated 1616, and refers to another oriental binding of the late fifteenth century with marbled end-papers. See his *Bookbindings and Rubbings, an Introduction* (1898, r.p. 1962), xx. For a more recent discussion, see A. Haemmerle, *Buntpapier* (1961), 41ff.

51 Sir Thomas Roe, *The Embassy of Sir Thomas Roe to India 1615–19*, ed. Sir William Foster (1926), 189, 199f.

52 André Daulier des Landes, *Les Beautés de la Perse* (Paris 1673) – writing as one who had accompanied the famous traveller Jean-Baptiste Tavernier on one of his Eastern journeys – says Tavernier sold the Shah 60,000 crowns' worth of jewels. The even more famous Jean Chardin was seeking jewels in Paris for the Shah in 1670.

53 Otto Kurz, *European Clocks and Watches in the Near East* (1975), 42; Chew (1974), 155.

54 They are alleged to have sent their painters to Europe to study painting; but evidence is, so far, almost non-existent. What is obvious is that the Persian court was much interested in oil-painting, and the 'fresco' cycle in the Chihil Sutun palace in Isfahan, datable *c*.1642–66, not only shows figures in European dress (including a man holding that very un-Persian vegetable, a turnip) but is carried out in an oil medium on plaster. The evidence here points to an unknown Persian artist as author of the paintings. See Eleanor Sims in Colnaghi exh. cat., *Persian and Mughal Art* (1976), 231f: she reproduces and discusses (nos. 137–41) five life-size full-lengths in oil in a mixed Perso-European style and relating to the poses of certain figures in the Chihil Sutun frescoes. Three have faces close in style to those of Godfrey Kneller, in England and Principal Painter to the King in the late seventeenth century: the Persian paintings therefore appear to be in the 1680s. Other comparable 'European' paintings by Persians are known from this period, e.g. two from Bassett Down, Wilts, in the 1931 Persian Exh. in London and on the London market in 1974. Though it is certain that Persian painters had English paintings around them in the seventeenth century (diplomatic visits will have seen to this),

precisely what they saw is hard to prove. References to a European artist in Persia known by the travellers Herbert and Della Valle may refer to a single identity who was Dutch: see Carswell (1972) and Ferrier (1977). Sims (1976) traces three major channels of European artistic influence in Persia at this time: (a) Mughal India, where European paintings had been known since the late sixteenth century when Portuguese Jesuits also presented them in Persia to 'Abbas the Great; (b) trade in Europe by Persian-based Armenians, which brought to Persia paintings as well as fabrics, clocks and other items; (c) direct European contacts. Prominent among Persian (or apparently Persian) artists who work in a European manner are (i) Muhammad Zamān, who has long been held to have studied in Rome: but see A. A. Ivanov, 'The Life of Muhammad Zamān, A Reconsideration', *Iran* XVII (1979), 65–70, where the theory of a Roman sojourn is discounted in favour of European influence reaching Zamān through Flemish engravings; (ii) 'Ali Quli Jabbadar, who worked at the Safavid court in 1666–94 and, as he is described as *farangi* ('Frank'), may have been a European; (iii) Shaikh 'Abbasi, whose works date from 1652. These artists are discussed in Sims (1976). A further figure of interest is Engelbert Kaempfer (1651–1716), physician with the Swedish Embassy to Isfahan in the 1680s. An album of pen drawings of Persian cities, including Isfahan and in a European hand, and figure drawings probably by a Persian artist, was obtained from Kaempfer's family *c.*1723–5 by Hans Sloane and is now in the BM (see Sims, 247).

55 John Ogilby, *Asia, The First Part . . .* (1673), 15.

56 J. M. Rogers, 'Cross-currents in Islamic Art', *British Museum Soc. Bull.* 44 (Nov. 1983), 15.

57 The bodies and glazes of the early Islamic white pieces varied considerably; a useful summary is in Henry Hodges, 'The Technical Problems of copying Chinese Porcelains in Tin Glaze', in *The Westward Influence of the Chinese Arts from the 14th to the 18th Century*, Percival David Foundation, University of London, Colloquy No. 3 (1972), 79f. For Islamic tin-glaze and lustre see Arthur Lane, *Early Islamic Pottery* (1947) and *Later Islamic Pottery* (1957, 2nd edn 1971); Alan Caiger-Smith, *Tin-glaze Pottery* (1973), chs. 1–3, and *Lustre Pottery* (1985).

58 For the early history see Alice W. Frothingham, *Lustreware of Spain* (New York 1951), 1–6.

59 J. G. Hurst, 'Spanish Pottery imported into Medieval Britain', *Medieval Archaeology* XXI (1977), 68–105, esp. 71.

60 Hurst (1977), 74–5.

61 For list and locations see A. van de Put, 'On a Missing Alhambra Vase and the Ornament of the Vase Series', *Archaeologia* XCII (1947), 43–77; Frothingham (1951), 53–5.

62 Otto Kurz, 'The Strange History of an Alhambra Vase' in Kurz (1977), sect. XVII, 206.

63 Kurz (1977), prints the story: it was originally in Hakluyt (1903–5), v, 96, and reprinted in C. D. Cobham, *Excerpta Cypria, Materials for a History of Cyprus* (Cambridge 1908), 70.

64 Julian Raby and Ünsal Yücel, 'Blue-and-white, Celadon and Whitewares: Iznik's Debt to China', *OA* ns XXIX (1983), 38–48. See also John Carswell, 'Ceramics' in Y. Petsopoulos (ed.), *Tulips, Arabesques and Turbans* (1982), 79f.

65 Lane (1971), 59; also Carswell (1982), 86.

66 P. J. Huggins, 'Excavations at Sewardstone Street, Waltham Abbey, Essex, 1966', *Post-Medieval Archaeology* III (1969), 47–99, esp. 81 (illus. pl. Ij. Cf. Lane (1971).

67 Julian Raby, 'A Seventeenth-century Description of Iznik-Nicaea', *Deutsches Archäologisches Institut Abteilung Istanbul, Istanbuler Mitteilungen*, Band 26 (1976).

68 R. J. Charleston (ed.), *World Ceramics* (1968), 155. See also *ibid.*, fig. 434, for a *rabeschi* design from Piccolpasso (drawing, VAM).

69 Foster (1906), xxv.

70 Foster (1906), 2, 77, 181, 229.

71 David Harris Willson, *King James VI and I* (1956), 331.

72 Brian Dietz, 'Colonial Developments in the Reign of James I', in Alan G. R. Smith (ed.), *The Reign of James VI and I* (1973), 135.

73 A number of examples survive in Europe from this period, in cathedral treasuries, of Chinese silks made up into dalmatics, chasubles, etc. The earliest-known datable Chinese silk brocade in Europe is the dalmatic with small lotus flower pattern found in Perugia, Italy, among the funeral vestments of Pope Benedict XI (died 1304). By the

mid-fourteenth century the weavers of Lucca in Tuscany were imitating Chinese designs: on this point see Hugh Honour, *Chinoiserie* (1961), 35f.

74 In fact many of these 'China-work' objects showed Turkish influence mingled with that of China. The well-known Hulton embroidered cushion-cover (VAM) is an example, see J. C. Irwin and K. Brett, *Origins of Chintz* (1970), 19. The floral section of the book of drawings by Thomas Trevelyon, dated 1608, contains designs which freely mix elements of diverse origins (see n. 25).

75 *State Papers, Domestic 1639–40*, 35; quoted in Margaret Jourdain and R. Soame Jenyns, *Chinese Expert Art in the Eighteenth Century* (1950), 61.

76 Indian painted cottons ('pintadoes') were being used as furnishing fabrics in France in the 1570s and 80s and in England probably soon after the East India Company began operations in 1600. A palampore – a coverlet with a chintz panel within a border – is mentioned in Company records in 1614: see Irwin and Brett (1970), 23f.

77 At Tait Hall, the property of the Countess of Arundel: see *Burl. Mag.* xx (1911–12), 235; Irwin and Brett (1970), 25.

78 It must be noted that exoticism still contrived to exert an influence on some of the weavers. The taste for splendour inherent in Baroque art combined with exoticism in the period 1695–1720 to produce an extraordinary phase of inventive silk design that was remarkable more for fantasy than for coherence. The curious 'bizarre silks', manufactured in France and other European countries, were first distinguished as a group by Vilhelm Slomann in his book *Bizarre Designs in Silk* (1953); they were further described by Peter Thornton (*Baroque and Rococo Silks*, 1965). The patterns are marked by extravagant plant-motifs set against large abstract shapes, and are sometimes arranged in vertical repeats of up to three feet that accorded with the extreme length of women's dresses (Thornton, p. 97, n. 2). In England the Spitalfields weaver James Leman, who came of Huguenot stock, produced striking designs which included the leaf with serrated edges seen in Indian cottons (cf. Cecil Lubell, *Textile Collections of the World*, vol. II (1976), pls. 88–9). At a time when Spitalfields weavers had succeeded in having the sale and use of oriental fabrics forbidden in England, however ineffectively, precise oriental derivations are, predictably, not obvious; but, as Thornton notes (1965, 100), Indian, Persian and perhaps Turkish motifs appear to have been resorted to in the bizarre silks, along with those of China. By 1720 the taste for them had died down. For Leman, see P. K. Thornton and N. K. A. Rothstein, 'The Importance of the Huguenots in the London Silk Industry', *Procs. of the Huguenot Society of London* xx, no. 1 (1960).

79 A series of pamphlets of the years around 1695–1700 (BM) debates the question on both sides. The writer of one (BM 816. M. 13/139) says, uncompromisingly, 'to carry patterns of our Fashions into the Indies, where silks are made cheaper than they can be in Europe, as these Gentlemen (the East India Company) have done, shows them Enemies to the Nation'. An Act prohibiting sales of Indian chintz for the English market – but without imposing penalties for actually wearing it or using it as furnishing – was passed in 1700. A second Act of 1720 instituted these penalties, and was more effective than the first, though unsuccessful in obtaining full prohibition: see Irwin and Brett (1970), 5–6. The prohibition of 1700 extended to Persian and Chinese fabrics, and there were parallel laws in France. These styles continued to be fashionable, however, and Eastern objects – lacquers and porcelains especially, but also silks – will have entered England after 1700 through the Levant Company for re-export, quite legally, as well as among the personal possessions of visitors to the East, and traders.

80 Oriental influence in wallpaper design was to be dominated by China, however: see C. C. Oman and Jean Hamilton, *Wallpapers, A History and Illustrated Catalogue of the Collection of the Victoria and Albert Museum*, edn 1982, which has no instances of unmixed Islamic influence before the nineteenth-century examples by Owen Jones for John Trumble and others.

2 1660 TO 1750: THE CONNOISSEURS OF SPECTACLE

1 Pierre Goubert, *Louis XIV and Twenty Million Frenchmen* (1969, English translation of 1966 text) finds Louis a figure whose concerns were largely confined to Europe: 'The court, the Kingdom and the collection of princes which, for Louis, constituted the chief of the old continent, these were the accustomed limits of his royal horizon' (p. 313).

Against this view must be set a quantity of evidence assembled by B. Naderzad, 'Louis XIV, La Boullaye et l'Exotisme Persan', in *Gaz. B.A.* LXXIX (1972), 32ff.

2 Naderzad, *ibid*, recounts how la Boullaye was bidden to court in 1652 wearing his Persian dress and how Louis XIV helped the publication of his *Voyages et Observations* in 1653.

3 Michael Levey, *The World of Ottoman Art* (1975), 55f.

4 Evelyn, *Diary*, 11 January 1682 (edn 1955), vol. IV, 265–6, 268–9. Evelyn refers to the 'rich symeters' and 'large calico-sleev'd shirts' of the Moroccans and tells us he drank 'jacolatte' at an entertainment for the Ambassador at the Duchess of Portsmouth's Whitehall apartment on 24 January. The Ambassador's horsemanship was commemorated in a portrait by Kneller (Chiswick House).

5 See Mundy's *Travels*, vol. II (1914), 65, 225. Tavernier's account of the Taj in his *Travels* of 1676 (edn 1925, I, 91) implies that he saw the building going up, but Persian histories and three dated epigraphs on the fabric suggest completion about 1636 – five to six years before Tavernier's visit – though the surrounding complex was probably not finished until 1647 or even later. See Wayne E. Begley, 'The Myth of the Taj Mahal and a New Theory of its Symbolic Meaning', *Art Bull.* LXI (1979), 7–37.

6 Translated by John Phillips, the nephew of Milton. A folio English edition of Tavernier's text (or, as seems likely, the text compiled from Tavernier's accounts) appeared in 1678, and an amplified edition in 1684 (a 'Description of the Seraglio', first published in Paris in 1675, is added: it is almost entirely about life and ritual). Tavernier was still being read by Gibbon in the eighteenth century, and by William Ouseley in the early nineteenth.

7 François Bernier travelled in the East between 1656 and 1668: he saw the Taj in 1659. See his *Travels in the Moghul Empire* (trans. by Archibald Constable, 1891, r.p. 1969, 293–9). Jean de Thevenot, the nephew of Melchisedek Thevenot, the 'French Hakluyt', saw the Taj in 1666.

8 Chardin's published writings came out in incomplete English editions before the 10-volume text of 1811, but the important account of the journey to Persia was contained in the 1686 English edition of vol. 1, which also carried engraved views of Tiflis, Qum and a number of Persian buildings. For elucidation of the bibliographical perplexities which beset Chardin's published works, see *Sir John Chardin's Travels in Persia*, intro. by Sir Percy Sykes, preface by N. M. Penzer (1927).

9 The English version of Grelot's book, *A Late Voyage to Constantinople*, was also by John Phillips (see n. 6 above). John Covell, Covel or Colvill (1638–1722) was chaplain to the Levant Company 1669/70–6: he left Constantinople in 1677. His manuscript journals of his travels, illustrated with lively drawings which include buildings, are in the BM, Add. MSS 22910–14. He later became Master of Christ's College, Cambridge. Covell has interesting observations on Iznik pottery and its materials: see John Carswell, 'Ceramics' in *Tulips, Arabesques and Turbans*, ed. Y. Petsopoulos (1982), 80.

10 Grelot, 242.

11 The Indian pictures are mentioned (respectively) in 'A Catalogue of Divers Rich and Valuable Effects being a Collection of Elihu Yale Esq.', London, 14 December (1721?), 10, item 165 and 'A Fourth Sale of Elihu Yale Esq.', London, 15 November (1722), 26, item 467.

12 Examples of the tapestries are discussed and illustrated in Madeleine Jarry, *Chinoiserie* (Fribourg 1981), 34f.

13 Mildred Archer, *India and British Portraiture, 1770–1825* (1979), 39.

14 Robinson is discussed in Edward Croft-Murray, *Decorative Painting in England* (1962), vol. 1, 46.

15 E.g. the popular engraving *Le Roi de Perse*, with 'Shah Hussein' on horseback and a panorama of Isfahan behind, issued in Paris *c.*1666; reproduced by Naderzad (1972), fig. 3.

16 Diana de Marly, 'King Charles II's own Fashion: the Theatrical Origins of the English Vest', *JWCI* XXXVII (1974), 378ff.

17 The point is demonstrated in the article to which Diana de Marly's is a sequel, by E. S. de Beer, 'King Charles II's own Fashion: an Episode in Anglo-French Relations 1666–70', *JWI* II (1938), 105–15.

18 John Greenhill's portrait of Thomas Betterton as Bajazet (National Trust, Kingston

Lacy) shows the theatrical version of the 'oriental' vest in 1663: reproduced de Marly (1974).

19 However pleasurable coffee might be as an exotic beverage, its early associations in the West were medicinal: a two-page pamphlet by 'An Arabian Phisitian' (Dr Edward Pococke) appeared in Oxford in 1659. See Chew (1974), 184–5. In 1671 the Lyons physician Joseph Spon published (anonymously) a short treatise *L'Usage du Caphe, du The et du Chocolat* (1685). Spon was later to travel in the Levant with the English botanist George Wheler. The Muslim associations of coffee were held up at the end of the century by the French orientalist Antoine Galland in his short treatise *De L'Origine et du Progrez du Cafe (sur un Manuscrit Arabe de la Bibliothèque du Roy)* (Caen and Paris 1699). See also Edward Robinson, *The Early History of Coffee Houses* (1893, r.p. 1972), especially ch. II.

20 In 1652, according to the memory of John Aubrey, 'Life of Sir Henry Blount', *Brief Lives* (edn 1949), 26. Coffee does not appear, however, in the sale lists at East India House until 1660: see Chew (1974), 184.

21 As recorded by Aubrey, *ibid.* He says it was 'built by Turkish merchants'.

22 Cf. Henry Hodges, 'The Technical Problems of copying Chinese Porcelains in Tin Glaze', in *The Westward Influence of the Chinese Arts from the 14th to the 18th Century*, Percival David Foundation, University of London, Colloquy no. 3 (1972), 79f. See also Caiger Smith (1973), chs. 1–3, especially on frit-paste bodies, 43–5.

23 The Chinese had used cobalt as a glaze colourant on earthenware in the Tang dynasty (AD 618–906), probably importing it from the Near East in the form of glass cabochons: see M. Medley, *The Chinese Potter* (1976), 77. It was not (so far as is known) until the Yuan period (1280–1368), however, that cobalt was used to create underglaze patterns against white. Persian cobalt (from Kulrān or Kirmān) was then again used (the Chinese called it Mohammedan blue) and there is a possibility that the idea of underglaze painting came from older or contemporary Persian wares (perhaps from Kashān), although the Chinese development of it on their true porcelain body was clearly their own.

24 See T. Volker, *Porcelain and the Dutch East India Company 1602–82* (Leiden 1954), 227. From 1657 the pirate Coxinga was playing havoc with the Chinese and the Dutch in the South China Seas and an embargo interrupted the European trade, including that in porcelain. The Dutch sought alternative sources for blue and white in Japan, Vietnam and, it is to be noted, Persia. Besides the many examples of Persian 'Chinese' in the VAM, see also a Persian blue and white pottery bowl in 'Ming' style, diam. 37 cm, late seventeenth century, in J. B. da Silva, 'Transition Wares: An Historical Perspective', *OA* xxxi, 1 (1985), 47, fig. 9. It is unclear from contemporary records how much of this type of ware was reaching Britain.

25 Caiger-Smith (1973), 137, draws the contrast between an expanse of hand-width Dutch tiles (each 12–14 cm across) in blue on white and the richly polychrome and often architecturally large-scale effects of Islamic (notably Ottoman Iznik) tile schemes with their multi-tile 'pictures'. The effects were indeed vastly different, the Dutch mellow though light-reflecting, those of Iznik colour-saturated. Some multi-tile schemes of Dutch manufacture remain, however, which build up pictorial compositions, e.g. that in the kitchen of the Amalienburg, Munich, 1734–9, illustrated in colour in R. J. Charleston (ed.) (1968), pl. 35.

26 Tulipomania reached a climax in Holland in the 1630s; see Wilfrid Blunt, *Tulipomania* (King Penguin, 1950). But it was equally potent in Turkey itself, as late as the reign of Sultan Ahmed III (1703–30): he imported 1,220 different bulbs, cultivated in Europe, for the Serail gardens, and held tulip fêtes there, in which, according to Lady Mary Wortley Montagu, his gardeners dressed themselves in the colours of tulips and in the distance 'appeared like a parterre'. The most outstanding European botanist to study Levantine plants in this period was J. Pilton de Tournefort, whose journey was in 1700–2: his *Relation d'un Voyage au Levant* came out in 1717. See Wilfrid Blunt, *The Art of Botanical Illustration* (1950), 113f.

27 Georgina Masson, 'Italian Flower Collectors' Gardens', in *The Italian Garden*, Dumbarton Oaks (Washington, D.C., 1972), 77.

28 Robert W. Ramsay, 'Sir George Wheeler 1650–1724 and his Travels in Greece' in *Trans. Royal Soc. of Literature of the U.K.*, n.s. xix (1942), 1–38.

29 Hodges (1972), 84.

30 The readiness to accept oriental stimulus is detectable in the warrant made in London for John Dwight, ecclesiastical lawyer turned potter (at Fulham) in 1672: in this year he is granted a patent for 'The Mistery of Invencon of Transparent Earthen Ware comonly knowne by the names of Porcelane or China and Persian Ware as also the Mistery and Invention of makeing the Stone Ware vulgarly called Collogne Ware'. The reference to Persian ware is as vague and inaccurate as the description *decor persan* that is applied to Nevers faience of the seventeenth century (or of Charles II's 'own fashion', already discussed): but cf. n. 24 above. Chinese models were inevitably to dominate the ceramic field in porcelain; while in the years round 1700 the red stoneware Yixing teapots were to be imitated by the Elers brothers of Fulham and Bradwell Hall, Staffordshire.

31 M. Archer and B. Morgan, *Fair as China Dishes*, International Exhibitions Foundation, Washington, D.C. (1977), cat. 21; M. Archer, 'The Dating of Delftware Chargers', *TrECC* XI (1982), 118.

32 Sir Gilbert Mellor, 'Bristol Delftware', *TrECC* II (1934), 23, pl. X: b, c and d. Mellor also illustrated an English eighteenth-century polychrome bowl and plausibly suggested a Persian textile origin for the carnation-like flower on it.

33 Roger North, *Lives of Francis North, Baron Guildford and Sir Dudley North* (1826 edn), III, 42.

34 Wren's friend Robert Hooke discussed Hagia Sophia in 1677: see Kerry Downes, *Hawksmoor* (1959), 29. Wren knew Chardin in 1680 and evidently saw his artist's drawings of Persian cities before the meeting on 30 August of that year recorded by Evelyn: on 9 August Wren wrote (to a person now unknown: see Sotheby sale 25 Jan. 1955, lot 493), of his disappointment at having 'received noe other instruction' from the views 'but that they (the Persians) build as the Turkes doe, the Cypresses overtop the low Houses, the cupples of the Mosques the Cypresses'. This letter provides valuable evidence of Wren's curiosity about the idiomatic forms of Muslim architecture, as distinct from the Roman/Byzantine elements of such a building as Hagia Sophia.

35 The *Description* came out in 1650 and 1653, the latter edition ascribed to John Greaves. The text is now known to have been written before 1622 by Ottaviano Bon: see N. M. Penzer, *The Harem*, 1965 (1936), 36. Wren's actual words are 'I question not but those (domes) at Constantinople had it (the dome-form) from the Greeks before them, it is so natural, and is yet found in the present Seraglio, which was the episcopal Palace of old; the imperial Palace, whose Ruins still appear, being further eastward'. (*Wren Society* XIX, 132).

36 *Parentalia* (1750), 306. P. Frankl, *The Gothic* (1960), 346ff., discusses the theory of the Saracenic origin of Gothic and gives Wren precedence in holding it, 376. J. Rykwert, *The First Moderns* (1980), 222, notes that it occurs earlier, in a history of the Hieronymite order by Jose de Siguenza (Madrid 1600), but, as he says, Wren is unlikely to have known this.

37 Florent le Comte, *Cabinet des Singularitez d'Architecture* (Paris, 1699–1700), beginning (no pagination). Le Comte distinguishes two kinds of Gothic: 'le manière de bâtir des sarrazins ou Arabes' e.g. in Granada, Seville, Toledo, in Spain; and a mixture of 'goût Antique' and 'goût Arabesque' in a building like St Mark's, Venice. See Frankl (1960), 346.

38 Fénelon (1651–1715), *Dialogue sur l'Eloquence*, written late in life (1706, published 1718). The work praises simplicity and condemns excessive ornament. Greek architecture is compared favourably with Gothic, which 'came down to us from the Arabs', a people whose intelligence, 'very lively and unrestrained by rules or culture, could not do otherwise than plunge into false subtleties'. See Frankl (1960), 376. Fénelon, Archbishop of Cambrai, possibly knew of Wren's ideas (though these were not published until *Parentalia* appeared in 1750) through an intermediary: Rykwert (1980), 222, suggests Andrew Michael ('Chevalier') Ramsay, Fénelon's secretary in 1709–10; see n. 43 below.

39 See Evelyn's *Diary* for 1654, with its praise of Gloucester, Worcester and York Cathedrals as well as Christ Church, Oxford and King's College Chapel, Cambridge. Frankl (1960), 375ff., seems to make too little of Evelyn's regard for Gothic: for a more just estimate, see Kerry Downes, 'John Evelyn and Architecture: An Enquiry' in

Concerning Architecture: Essays on Architectural Writers and Writing presented to Nikolaus Pevsner, ed. John Summerson (1968), esp. 34–5.

40 Evelyn, *Parallel* (1664, 4th edn 1723), 10. 'Misquine' means 'slender' (Fr. *mesquin*).

41 *Parentalia*, 297.

42 *Wren Society* XIX, 131.

43 The theory of the Near Eastern associations of Gothic, and the Crusaders' contribution by bringing it to Europe, was to be helped by masonic speculations, even though these hardly favoured the Saracens as such. The first-known treatment linking the Crusaders, the Templars and the origins of masonry is that of the mason Chevalier Andrew Michael Ramsay, a lecture probably first delivered on 26 December, 1736: it is regarded as the 'foundation text of higher grade masonry in Europe', as Rykwert (1980), 228, puts it. See also J. M. Roberts, *The Mythology of the Secret Societies* (1972), 36–8, 98–100. Another figure, William Stukeley (1687–1765), who became a mason (in 1720) and will come into our story later, had an interest in the Orient as well as in the origins of Gothic: see Frankl (1960), 374. Said (1978), 118, notes an intermingling by Mozart, another Freemason, of masonic codes with 'visions of a benign Orient' in *The Magic Flute*, 1791.

44 Blount's *Voyage into the Levant* (1636) reached its eighth edition by 1671: see p. 4. Tolerance towards the Turks was to increase by the 1680s in certain quarters in England: see Halifax's letter to Trumbull quoted by C. J. Heywood, 'Sir Paul Rycaut, a seventeenth-century observer of the Ottoman State', in E. Kural Shaw and C. J. Heywood, *English and Continental Views of the Ottoman Empire 1500–1800* (1972), 50.

45 Charles Perrault, *Parallèle des Anciens et des Modernes* (1688), IV, 121 (published after Colbert's death).

46 In the Gibbs Collection, Ashmolean Museum, Oxford: see Downes (1959), 29. Hawksmoor repeats the idea that Gothic develops from Saracenic in a letter of about 1733–5, undated (Letter 147 in Downes, *ibid.*, 255f.).

47 On Fischer's interest in Asian monuments see Frankl (1960), 377–8. For the genesis of all architecture of merit from the Temple of Solomon (even the architecture of Islam and China) see H. Aurenhammer, *J. B. Fischer von Erlach* (1973), 153. For the relation of the Karlskirche design to Hagia Sophia see Rykwert (1980), 73.

48 The group included figures from a variety of authors, from Nieuhoff to Stefano della Bella. See Erna von Watzdorf, *Johann Melchior Dinglinger, Der Goldschmied des deutschen Barocks*, 2 vols. (Berlin 1962), illus., and Oliver Impey, *Chinoiserie* (Oxford 1977), 177, illus.

49 The word *turquerie* was used with the meaning of 'Turkishness' in 1668 by Molière, in *L'Avare* II, 5: 'Il est Turc là-dessus, mais d'une turquerie à désespérer tout le monde', E. Littré, *Dictionnaire de la Langue Française*, 4. 'Turquesque' occurs a century earlier: in 1578 Henri Estienne complains that courtiers have begun to dress '*à la turquesque*' (*Deux Dialogues du nouveau langage françois italianizé* I: Paris edn 1885, 277). I am grateful to Dr K. M. Hall for this reference.

50 Laurent d'Arvieux, on a diplomatic visit for Louis XIV to the Near East, travelled in Arabia in 1660. His book *Voyage dans la Palestine* (1717) was the first to give a detailed account of the life of the desert nomads. It is noticed in the *Gentleman's Magazine* III (Feb. 1733), 107 (I am grateful for this reference to Glen Taylor). George Sale relied heavily on d'Arvieux in a chapter 'Of the Arabs before Mohammed', in the 'Preliminary Discourse' to his translation of the Koran (1734). Sale's Arabic learning in turn impressed another Frenchman, Voltaire.

51 For Turkish-inspired French painting of the period two pioneer studies are still important: Auguste Boppe, *Les Peintres du Bosphore au XVIIIe Siècle* (Paris 1911); Jean-Louis Vaudoyer, 'L'Orientalisme en Europe au XVIIIe Siècle', *Gaz. BA* (1911), 89–101.

52 Illustrated in Levey (1975), 115.

53 The term *kiosk* is first recorded in English, according to the O.E.D., in 1625 by the traveller Samuel Purchas (*Pilgrims* II, ix). Lady Mary Wortley Montagu, in a letter of 1 April 1717 to Anne Thistlethwayte, mentions a *chiosk* 'rais'd 9 or 10 steps and enclos'd with Gilded Lattices'. See Robert Halsband (ed.), *Complete Letters* I (Oxford 1965), 343.

54 Stanislas Lezczynski, King of Poland, created Duc de Lorraine in 1738, had the architect Emmanuel Héré build him at Lunéville, in the same year, what Héré's book

Recueil des Plans . . . des Châteaux Jardins (1753) calls a 'Kiosque, ou Bâtiment à la Turque'. See Conner, *Oriental Architecture in the West* (1979), fig. 10.

55 For Perry, see Kural Shaw (1972), 13f.

56 Cornelis de Bruyn published the account of his journey to the Levant in 1698 (200 pls., French edn Delft 1700, English edn *A Voyage to the Levant*, London 1702). That of his later journeys appeared in Amsterdam in 1711 (300 pls.): This was published in England as *Travels in Muscovy, Persia and the East Indies* (1737).

57 For Vanmour, see Boppe (1911), 2–55: a *Turkish Hunting Party* by this artist is reproduced in colour in *Eastern Encounters*, exh. cat., Fine Art Society, London (1978): see also *ibid.*, 37.

58 *Recueil de cent Estampes représentant différentes Nations du Levant, tirées sur les Tableaux peints d'après Nature en 1707 et 1708, par les Ordres de M. de Ferriol, Ambassadeur de Roi à la Porte. Et gravées en 1712 et 1713 par les soins de Mr Le Hay* (1713). The *Recueil* quickly went through two more editions, in 1714 and (with colour) in 1715. A German edition came out with engravings by C. Weigel (copied and thus reversed in printing, 2 vols., Nuremberg 1719–23). Le Hay's publication remained influential throughout the century (Italian edition 1783). For a discussion of the 'gravure dressé' in relation to the *Recueil* – the eighteenth-century practice of 'dressing' costume engravings in actual fabrics – see Jeremy I. Smith, 'An Eighteenth-century Turkish Delight', *Conn.* CLVI (1964), 215–19.

59 I am grateful to Mr Searight for help and for generously making available his unpublished researches on this matter.

60 Aileen Ribeiro, 'Turquerie', *Conn.* CCI (1979), 16f.

61 Philippe Jullian, *The Orientalists* (1977), reproduces this, fig. 22.

62 A Turkish masquerade staged by student *pensionnaires* of the French Academy in Rome in 1748 is recorded by Boppe (1911), 131, 134ff. Its theme was *Le Caravane du Sultan à la Masque*.

63 The picture is painted in scene-painter's distemper (on panel) and a label on the back by an unknown writer reads 'This sketch (in size) I saw when a boy, made by Hogarth, in a fit of pleasantry, one evening in the Painting Room at Covent Garden Theatre . . .'.

This room was the meeting-place of the Beef Steak Club to which Hogarth belonged. For further information see L. Gowing in *Hogarth*, exh. cat., Tate Gallery, London 1972, 77.

64 For Lady Mary's 52 Turkish Embassy letters, see Halsband (1965), I, xiv–xvii; on women's fashions in Turkey, 350, 381–2; on the appearance of Turkish houses and gardens, 342–3; on Lady Mary's favourite theory that subjection of Islamic women gave them greater freedom than women in the West, 308, 328. For portraits of Lady Mary in Turkish dress see Ribeiro (1979) (illus.). For Lady Mary's evidence on the presence of English glass in the windows of the Grand Vizier's house in Constantinople, see R. J. Charleston, 'The Import of Western Glass into Turkey', *Conn.* CLXII (1966), 18–26. Byron was to profit from Lady Mary's Turkish letters: see *Don Juan*, vol. 3. Ingres used her description of the women's bath at Adrianople for his famous picture *Le Bain Turc* (1862). His 'Cahier IX' cites passages from the letters on fol. 34 and fol. 37, quoted in full in *Le Bain Turc d'Ingres* (Musée du Louvre 1971), 12–13.

65 Stuart Piggott, *William Stukeley, an Eighteenth-century Antiquary* (1950), 143–4.

66 Of the four figures, only *Rome* and *Persia* appear to survive, and are in the Royal Collection. *Persia* is illus. in *Rococo: Art and Design in Hogarth's England*, exh. cat., VAM (1984), 289.

67 Hugh Honour, *Chinoiserie* (1961), 132. The references often continue to be to 'Indian' objects, the term commonly used to denote Chinese items imported by East India Company ships plying from Indian ports.

68 The binding in England *c.*1765 of a *Khamsa* by Nizami (dated 1540, now St John's College, Cambridge) illustrates this vagueness. Captured as part of the loot resulting from the Battle of Buscar in 1764, the manuscript was bought by an East India merchant, Richard Bate, and sent to England. It was bound by his brother James (of Cornhill) using a variety of decorative motifs – rococo scrolls, a shepherd and shepherdess, Chinese figures, a make-believe Chinese pavilion – in what was called the 'tawdry Mahometan taste' by their father, the Reverend James Bate, who paid for the work. See Honour (1961), 265 and pl. 97.

69 See A. St Clair, 'The Image of the Turk in Europe (MMA 1973), *passim*. For background before Louis XIV, see especially C. D. Rouillard, *The Turk in French History, Thought and Literature 1520–1660* (Paris, n.d.).

70 The Turk's association with license, of course, continued. The stereotype of the Turk's head still appeared on inn-signs, indeed with particular frequency, according to Chew, in this period. The Turk's Head bagnio was the setting of the Countess's assignation in Hogarth's *Marriage à la Mode* (1743–5).

71 C. L. van Roosbroeck, *Persian Letters before Montesquieu* (New York 1932), 39f. B. Sprague Allen, *Tides in English Taste* (Cambridge, Mass. 1937), II, 14f., has much on this, e.g. Lord Lyttelton's *Letters from a Persian in England* (1735), in which the Persian, Selim, is made to write from London about English society and politics to a friend in Isfahan.

72 See David Kopf, *British Orientalism and the Bengal Renaissance* (Berkeley and Los Angeles 1969), 25–6. Discussing Gibbon's orientalist tendencies he quotes the passage from *Decline and Fall* (written between 1776 and 1788) where the historian hails the 'religion of Mahomet' as seemingly 'less inconsistent with reason than the creed of mystery and superstition' of seventh-century Catholicism in Europe.

73 The famous suggestion by Leibniz in *Novissima Sinica* (1697), that Europe needed Chinese missionaries, is quoted in context in R. Dawson, *The Chinese Chameleon, An Analysis of European Conceptions of Chinese Civilisation* (1967), 190–1. Voltaire's eulogy of China is from his play *Orphelin de la Chine* (1755).

74 C. Berling, *Meissner Porzellan und seine Geschichte* (Berlin 1900); W. B. Honey, *Dresden China* (1934), 114f. The Muslim subjects from Meissen do not necessarily look insipid beside their Chinese counterparts as is sometimes claimed: on the contrary they can be outstanding in pose and colouring, e.g. the *Moor with Spanish Horse* by Kaendler, illus. O. von Falke, *Deutsche Porzellanfiguren* (1919), pl. 9; or the *Persian* by Kaendler, c.1748, illus. O. Walche, *Meissner Porzellan* (Dresden 1975), fig. 122.

75 See n. 58 above.

76 Edmund W. Braun, 'Die Vorbilde einiger "Türkischer" Darstellungen im deutschen Kunstgewerbe des XVIII Jahrhunderts', *Jahrbuch der Königlichen Preussischen Kunstsammlungen* XXIX (1908), 252f.

77 The Kaendler originals are illustrated in Berling (1900), fig. 82.

78 Arthur Lane, *English Porcelain Figures of the Eighteenth Century* (1961), 52 and pl. 5.

79 Another version of the Ashmolean *Turk and his Companion* (fig. 32) is illustrated by Wallace Elliott in a paper 'Worcester Porcelain Figures', *TrECC* II (1934), 29–40, pl. XIII. Mrs Philip Lybbe Powys, visiting the Worcester factory on 27 August 1771 (letter to her cousin, Mrs Wheatley, day following: see *Passages from the Diaries of Mrs Philip Lybbe Powys*, ed. E. J. Climenson, 1899, 126), saw ornamental figures being moulded, but does not specify their subjects. In his paper Wallace Elliott illustrates a watercolour drawing by E. F. and T. F. Burney, 1784 (ex coll. Dyson Perrins), which shows a Worcester porcelain *Turk* among other products characteristic of the county of Worcester, and which was to be an additional illustration (finally omitted) to Dr T. Nash's *Collections for the History of Worcestershire* (vol. I, 1781; II, 1782; 2nd edn, both vols., 1799). The inclusion of the Turk suggests that it was sufficiently familiar at the time to 'represent' the Worcester figurines, rare though these have since become.

80 For the Chinese influence, see Conner (1979), chs. 3, 4 and 5.

81 See David Coke, section 'Vauxhall' in *Rococo: Art and Design in Hogarth's England*, exh. cat., VAM (1984), 75–81, and further illus. of views of the gardens esp. p. 90: also Lawrence Gowing, 'Hogarth, Hayman and the Vauxhall Decorations', *Burl. Mag.* XCV (1953), 4–19.

82 Le Rouge includes Vauxhall in Cahier 4. A 'Pavillon Moresque' (not identified) appears there as illus. 7 and designs for mosques with corner minarets are also shown. A Bagnio at Steinforten, Westphalia, appears in Cahiers 17 and 18. Contemporary with Le Rouge, Islamic-style buildings were put up in many celebrated European gardens, e.g. the Turkish minaret in Carmontelle's Parc Monceau, Paris (Duc de Chartres, 1773 onwards) and, outstandingly, Nicolas de Pigage's mosque, 1778–95, at Schwetzingen, Mannheim (Elector Palatine). On garden buildings see also p. 102f. A later Moorish Temple was that at Elvaston Castle, Derbyshire (c.1855–60, still extant). For the temple

at Acton Round designed by the owner, Huw Kennedy, see Gervase Jackson-Stops in *CL* CLXIII (1978), 617 (illus).

83 Quoted by Coke (1984), 88.

84 *Gentleman's Magazine* (1765), 354.

85 For a full account of the Painshill tent with reproductions of Parnell's drawings see James Sambrook, 'Painshill Park in the 1760s', *Garden History* VIII, 1 (Spring 1980), 91–106.

86 Piper went on to design tents in Sweden, notably the large metal *corps de garde* at Drottningholm (1780).

87 J. de Cambry, *De Londres et ses Environs* (1788), 134, 141.

88 Richard Pococke, *Travels through England* (Camden Soc. 1889), vol. II, 43.

89 Mrs C. Lybbe Powys, *Passages from the Diaries* 1899, 170, entry for events of 5 August, 1776.

90 Kenneth Woodbridge, *The Stourhead Landscape, Wiltshire* (National Trust, 1982), 31.

91 See John Ferrar, *A View of Ancient and Modern Dublin, to which is added a tour to Bellevue in the County of Wicklow* (1796), 109, 111; also Mark Bence-Jones, *Burke's Guide to Country Houses: Vol. I, Ireland* (1978), 38. See also ch. 3, n. 82.

92 Conner (1979), pl. 44.

93 John Harris, *William Chambers, Knight of the Polar Star* (1970), 37. Muntz is a figure of some interest who appears to have worked with Chambers several times and who settled in London in 1760. Support for Harris's attribution of the RIBA drawing of the Alhambra to Muntz is provided by Muntz's statement (Proposals for a 'Course of Gothic Architecture', issued 1760) that in 1748 he drew 'some remarkable fine and curious Remains of Moresque Fabrics, still existing in the Kingdoms of Murcia, Valentia and the City of Saragossa in Spain', together with his declared intention to publish 'a Temple for a Garden in the Moresque style, of the Author's composition, and which is going to be executed at a Nobleman's Country Seat'. Muntz thus appears to have anticipated first-hand study by artists of monuments of Moorish Spain by half a century or more.

94 See Michael Darby, *The Islamic Perspective* (1983), 13 and Fig. 2.

3 1750 TO 1820: MODELS EAST OF ROME

1 On Pars's use of Turkish figures for their own sake, see A. Wilton, ed. of *Travels in Asia Minor 1764–5* by Richard Chandler, British Museum (1971), xxviii.

2 Preface to vol. 1 (1762), viii.

3 For Arabia, see Kathryn Tidrick, *Heart-Beguiling Araby* (1981), and the chapter 'Sons of the Enlightenment' in Peter Brent, *Far Arabia* (1977). The elder Niebuhr was a notable traveller there. For India, see Partha Mitter, *Much Maligned Monsters, A History of European Reactions to Indian Art* (Oxford 1977), especially ch. iii.

4 The Renaissance initiated much discussion on the question of the invention of arts and sciences by the 'oldest nation'. The particularly notable work by Polydore Vergil, *De Inventoribus Rerum* (1499), was translated into English in 1603 as *The Works of the Famous Antiquary, Polydore Vergil*.

5 On primitivism and the simplicity of origins, E. H. Gombrich, 'The Debate on Primitivism in Ancient Rhetoric', *JWCI* XXIX (1966), 24f, is of particular note; also his four articles, 'The Primitive and its Value in Art', *The Listener*, 15, 22 February, 1, 8 March 1979.

6 Caylus's views on India are conveniently summarised by Mitter (1977), 193f, and those of Le Gentil in the same work, 113f.

7 The relationship of Burke's view of the Sublime to Blake is succinctly suggested in Anthony Blunt, *The Art of William Blake* (1959), 15–16. As Blunt points out, Blake did not agree with that view in every respect: his belief in the necessity of clear line in imaginative art would have caused him to reject Burke's insistence on vagueness as a quality of the Sublime. For Coleridge see his *Table Talk*, edn Oxford 1917, 191 (entry of 25 July, 1832).

8 J. B. Cohen indeed claimed that Rousseau 'contributed more than any other man to the growth of the Romantic movement' (intro. to Penguin edn of *The Confessions*, 1953, 10).

9 Chateaubriand's account of his Eastern travels of 1806 and 1807 (*Itinéraire de Paris à Jérusalem*, 1811) was translated into English by Frederic Shoberl (two volumes 1812). The writer's feelings for the desert in Judaea, where 'mute with terror', it passed from 'solitude to solitude' (1812, 1, 409), were further excited by those of Egypt 'which open to the imagination the field of immensity' (II, 215). The association of isolation with independence made by Benjamin Constant in *Adolphe* (1816) is noted in a discussion of the Romantic cult of loneliness by Hugh Honour, *Romanticism* (1979), 135. The sense of isolation is necessary for the Romantics; and the contribution of the desert-experience to forming a favourable view of Islamic life that was independent of Europe will become important in the nineteenth century, see ch. 4, n. 53 below.

10 The Turkish threat to Western Europe, though a thing of the past by the late eighteenth century, was too embedded in literature to be forgotten. Anyone returning to Milton's description of Pandemonium in *Paradise Lost*, perhaps after seeing the depiction of it in de Loutherbourg's famous stage entertainment, the Eidophusikon (1781), would have been reminded of it in the poet's compelling image of the horns of the Turkish crescent closing like pincers on the retreating Persians (*Paradise Lost* x, 434).

11 Aware of Gibbon's remark that the landscape of Albania, though 'within sight of Italy, is less well known than the interior of America', Byron was proud to have penetrated its borders in 1809. See Peter L. Thorslev, Jr, 'The Wild Man's Revenge', in E. Dudley and M. E. Novak, eds, *The Wild Man Within, An Image in Western Thought from the Renaissance to Romanticism*, Pittsburgh (University of Pittsburgh Press, 1972), 295.

12 Chateaubriand is again relevant. He looks back to the greatness of Arab civilisation and contrasts it with present savagery in an interesting comparison with the North American Indian: 'As with the American every thing proclaims the savage, who has not yet arrived at a state of civilisation; in the Arab, every thing indicates the civilised man who has returned to the savage state' (1812, 1, 430; '... Tout annonce chez l'Americain le Sauvage qui n'est point encore parvenu à l'état de civilisation: tout indique chez l'Arabe l'homme civilisé retombé dans l'état sauvage', *Itinéraire*, edn Paris 1963, 220). The discrimination of different *types* of savagery is interesting in this period after the emergence of the Tahitian into greater focus and further assessment of the American Indian in Europe in the 1770s. Earlier, detractors of the Muslim had vilified him as a barbarian; others had invoked him to comment, as 'natural' man, on European society. Dryden, in his *Conquest of Granada* (1694), had even introduced a Noble Savage hero, Almanzor, who becomes reconciled to the civilised society of the Moors. A century later Chateaubriand, writing in the light of deeper acquaintance with 'natural' man, recognises a specific blend of primitivism and civility in the Arab. This was a condition which was evidently to have much interest for nineteenth-century Europeans; it is clearly implied for instance in such a painting as J. F. Lewis's *Frank Encampment*, see ch. 4, n. 53 below.

13 *The Rambler*, 122 (1751).

14 *Narrative of Lord Byron's Last Journey to Greece* (1825, pub. posthumously), 149. Shortly before his death in Greece Byron told Count Gamba that 'the Turkish history was one of the first books that gave me pleasure when a child' and acknowledged its likely role in giving 'the oriental colouring which is observed in my poetry'. See also Harold S. L. Wiener, 'Byron and the East; Literary Sources of the "Turkish Tales"', *Nineteenth-century Studies* (Cornell University Press 1940), 89–129. From Byron's note in the third edn of Isaac Disraeli's *Literary Characters* (1822), 101–2, it is evident that he is referring to Vincent Mignot's *History of the Turkish or Ottoman Empire*, trans. into English by A. Hawkins (4 vols, Exeter 1787). In 1807 Byron stated that he had read Knolles, as noted in Thomas Moore's *Letters and Journals of Lord Byron* (1830): see W. A. Borst, *Lord Byron's First Pilgrimage* (New Haven 1948), xviii.

15 For a full discussion of Hamilton's painting, see Claire Pace, 'Gavin Hamilton's "Wood and Dawkins discovering Palmyra": the dilettante as hero', *AH*, vol. 4, no. 3 (1981), 271·90 (illus.). This also lists (289–90) 28 paintings with Arab and Turkish themes shown at the Royal Academy between 1769 and 1830.

16 On Favart, see Otto Kurz, 'Pictorial Records of Favart's comedy "Les trois Sultanes"' (1975), reprinted in Kurz (1977), xvi, especially p. 313. The engraving of Simonet's portrait of Madame Favart as Roxelane and wearing her Turkish dress is reproduced at fig. 201. Her success in the play led to paintings by Fragonard, see Boppe (1911),

139–40. In the context of Roxelane we should note Sir Joshua Reynolds's portrait of Mrs Abington in the part (RA 1784, priv. coll., London): she wears Turkish dress and is shown informally parting curtains (see E. K. Waterhouse, *Reynolds*, 1973, pl. 97).

17 Favart to Count Durazzo, dated 24 Jan., 1760. See Kurz (1977), 313. Favart also criticises stage seraglios 'meublés à la française'.

18 Kurz (1977), fig. 198. The cymbals were then unfamiliar enough in Paris for Favart to write a long, explanatory note, quoted by Kurz, 316. A Turkish band had been given to Augustus III of Poland by the Sultan before 1735.

19 Boppe (1911), 230. In 1770 Smith showed a panoramic view of Constantinople and its environs at the Royal Academy. Boppe provides background detail on the life of Europeans in Constantinople in these years, especially ch. iv, 145f. In Britain George, Prince Regent, was to stimulate interest in Turkish history. In 1815 his engraver John Young (1755–1825) published 'A Series of Portraits of the Emperors of Turkey, from the Foundation of the Monarchy to the year 1815', a large folio of colour mezzotints, with hand-finishing, engraved from pictures painted by Turkish artists in Constantinople. Begun under the auspices of Selim III, it was completed by command of Mahmud II. The portraits are oval, lettered in French from the Ier to Trentième Empereur Othoman, and accompanied by biographies. The work was dedicated to the Prince Regent. I am grateful to Sotheby's. See R. V. Tooley, *English Books with Coloured Plates* (1978), 516.

20 For scenes based by Spode on Mayer's illustrations of Turkish life see S. B. Williams, *Antique Blue and White Spode* (3rd edn 1949), figs.44, 46 and 49. Spode's blue-printed 'Caramanian' pattern, to which these refer, was introduced in 1809, and took its subjects from Mayer's three volumes (which were combined into a single volume in 1804). A later series known as 'Ottoman Empire', by an unknown maker, also took its views from Mayer, all of them except one being contained in his *Views on the Ottoman Dominions, in Europe, in Asia, and some of the Mediterranean Islands, from the Original Drawings, taken for Sir Robert Ainslie, by Luigi Mayer, F.A.S. with Descriptions, Historical and Illustrative* (1810), published by R. Bowyer of 80 Pall Mall, London. These include the 'Mosque of Sultan Achmet' (Ahmed I) and 'Mosque in Latachia' (port in Syria); for full list, see A. W. Coysh and R. K. Henrywood, *The Dictionary of Blue and White Printed Pottery 1780–1880* (1982), 270. See also n. 61 below.

21 Mouradgea's wish was to give Europe a complete and accurate account of Turkish civilisation: see *Biographie Universelle* xxix (n.d.), 471.

22 Levey (1975), 127, has aptly seen Selim as a real-life Pasha Selim, the character in Mozart's *Die Entführung*, who welcomes the hero Belmonte as an architect from Europe in Act I.

23 Turkish or Arabic numerals identify these objects. Among those who supplied the Turkish market were Isaac Rogers and Edward Prior: for examples (Rogers 1780, Prior *c*.1800), see Cecil Clutton and George Daniels, *Catalogue of the Collection of the Worshipful Company of Clockmakers*, Guildhall, London (1975).

24 Paul Henry-Bordeaux, *Lady Stanhope en Orient* (1924), I, 177f.

25 For the Madrid experience, see letter VIII (14 Dec. 1785) in *Travel Diaries of William Beckford of Fonthill*, ed. Guy Chapman (1928), II, 200. For Cozens, see A. P. Oppé, *Alexander and John Robert Cozens* (1952). Beckford owned several albums of Mughal miniatures: 13 random compilations that were once in his library passed to his younger daughter, the Duchess of Hamilton, then were sold by the twelfth Duke in 1882 and are now in the Islamic collections of the Staatliche Museen, Berlin. Before Beckford had them, seven albums had belonged to Colonel Antoine Louis Henri de Polier (1741–95), the Swiss-French soldier who was in India in 1757–88 serving under Warren Hastings and various Indian princes. Beckford had them from Polier's widow when he was in Lausanne in 1796 to acquire Gibbon's library: he is recorded as paying £800 to Mme Polier for paintings (see Boyd Alexander, *Life at Fonthill 1807–1822*, 1957, 200). In a letter of 2 April 1817 (printed in Alexander, *ibid.*), Beckford says he is selling 'Polier's *Natural History*'. In his sale at Sotheby's that year lots 208–20 were described as 'original Chinese and Hindu drawings (of Natural History) from the collections of Van Braan, Bradshaw and Polier', without specifying more precisely. On Beckford's interest in Indo-Portuguese furniture, see Clive Wainwright, 'William Beckford's Furniture', *Conn.* cxci (1976), 290–7.

26 Beckford decorated the house with richly coloured hangings for the event. He was also

portrayed in oriental dress by Richard Cosway (formerly Coll. Mme Stadler-Errera, sold Sotheby's, 19 Nov. 1969, lot 38): see Boyd Alexander, 'Fonthill and Portraits of William Beckford', *Register of the Museum of Art, University of Kansas* (Laurence, Kansas), III (1967).

27 The plan of the Salon is illustrated in James Lees-Milne, *William Beckford* (Tisbury 1976).

28 See Michael Snodin and Malcolm Baker, 'William Beckford's Silver', *Burl. Mag.* CXXII (1980), 735–48, 820–34. The Cup illus. in pl. III, described as 'Persian' in Christie's Beckford sale, 7–15 Sept. 1822, appears to be the subject of a bill (Beckford Papers, Messrs B. H. Blackwell) by Beckford's friend and factotum Gregorio Franchi of Rome (4 May 1818): *Coulson pelle Coppa Persana £32.0.0*, with sketch resembling the cup (Snodin and Baker, 747). Franchi owned a number of Venetian-Saracenic and Near Eastern metalwork pieces, 'Moorish basons', listed in his sale, Christie's, 16–17 May 1827 (Snodin and Baker, 822). Aldridge was a jeweller and smallworker who made up silver designs for Beckford (*ibid.*, 820–1). Another recipient of Beckford's patronage was the silversmith J. J. Boileau (resident in England since 1788), who seems to have made tripods 'à la Turque' (untraced) for Fonthill (Phillips sale, 19–22 Aug. 1801). Beckford owned a number of Mughal hardstone cups and plates (sale 1822, lots 1/59, 6/75), as well as the jade hookah of Tipu Sultan, now lost (sale 1823, lot 154). He also owned at least one Venetian-Saracenic brassware sideboard dish and ewer (sale 1822, lots 6/77, 78, 1 Sale 1823, lots 831, 832, 'a curious antique-shaped ewer of or-moulu made at Granada, elaborately engraved in the Moorish style' and 'an ancient and very curious metal dish of the same workmanship'). Seven Islamic metalware items were in the Beckford sale of 1844 (listed Snodin and Baker, 833–4). The attractions of Islamic damascened metal were not lost on Horace Walpole either (cf. p. 105 below). A Venetian-Saracenic ewer and basin entered the Royal Collection in 1827 (Garrard and Co., *Descriptive Inventory* III, 1914, no. 731, pl. ccxl). Such items relayed the arabesque in unequivocally oriental form forward to the collecting, by Henry Cole and his circle, of metalwork examples of it for public exhibition (cf. ch. 5, n. 19).

29 The portrait, life-size, hung in the staircase hall of Hope's house in Duchess Street, London: see David Watkin, *Thomas Hope 1769–1831 and the Neo-classical Idea* (1968), 232.

30 See Maurice Shellim, *India and the Daniells* (1979), 54–5 (illus.). The capriccio is privately owned; the other two pictures are now in the National Gallery of Modern Art, New Delhi.

31 See Watkin (1968), 234f., on Hope's oriental interests and their context. He links Hope's generalising orientalism to the imprecise kind which Beckford's Turkish Room at Fonthill Splendens had also represented: and quotes the account of a Moorish masquerade given in T. S. Surr's novel *A Winter in London* (1806) and apparently based on a Duchess Street event. This reinforces impressions of the 'fancy dress' nature of Hope's orientalism.

32 The knowledge of Persia built up by Europeans through reading Tavernier and others was extended in the eighteenth century, as we have seen, by Cornelis de Bruyn, who published engraved views of Isfahan and other cities. But the period from 1760 marks a vast increase in knowledge: ancient texts were now studied by French and English scholars for the first time systematically. Sir William Jones's major contribution to understanding with his *Persian Grammar* was to introduce Edward Fitzgerald to Persian 80 years later. For Jones, see S. N. Mukherjee, *Sir William Jones* (Cambridge 1968); R. M. Hewitt, 'Harmonious Jones', *Essays and Studies by members of the English Association* (Oxford 1943), vol. XXVIII (1942); John D. Yohannan, *Persian Poetry in England and America* (New York 1977), ch. 1. As regards India, Col. Alexander Dow published his translation (from the Persian) of Ferishta's history of the Deccan in 1768. Students in India of Sanskrit included, besides Jones, Nathaniel Halhed, Charles Wilkins and Henry Colebrooke: see R. Lightbown in *India Observed* (Bibliography under London: Victoria and Albert Museum), 16f. Halhed's *Grammar of The Bengali Language* (1778) is the earliest-known work printed with Bengali types. Following its success Charles Wilkins, writer with the East India Company, cast a fount of Persian *nasta'liq* type in 1780 and printed Francis Gladwin's *A Compendious Vocabulary English and Persian*. Calcutta became the centre for important typographical productions, notably the magnificent edition of F. B. Solvyns's *Collection of two hundred and fifty coloured etchings* on Hindu customs (1799).

33 See L. Whiter, *Spode, A History of the Family, Factory and Wares from 1733 to 1833* (1970), 73. I am grateful to Robert Copeland of Spode Ltd for information. The firm developed a flourishing trade with Persia and India under Josiah Spode II (1755–1827): see Whiter, *ibid.*, 72.

34 The importance of Middle Eastern languages for the English was further confirmed by 1806, when William Wilkins designed the East India College for the East India Company (the building is now part of Haileybury College, Herts.). Here, until 1858, students of the Company received linguistic education and career training. As future civil servants liable to be called on to advise on building projects, surveying and public works they were also taught topographical drawing and watercolour (as were officer-cadets at Woolwich and other military colleges).

35 For India and the British the essential authority is Mildred Archer. For Kettle, see her book *India and British Portraiture 1770–1825* (1979), 67f. The catalogue *India Observed* by Mrs Archer and Ronald Lightbown (1982) is also invaluable; Kopf (1969) is helpful on the background.

36 Mildred Archer (1979), 346; Veronica Murphy, 'The European Vogue', in *The Indian Heritage*, exh. cat., VAM (1982), 17–19.

37 Mildred Archer (1979), 156–7. Zoffany was so impressed by the Taj Mahal that he wanted it protected from the 'impression of the air', *ibid.*, 157.

38 Zoffany's sale of effects in 1811 included 'Oriental Dresses and Superb Hookers', turbans, *jamas*, *paijamas*, a peacock feather fan and a Koran: see Archer, *ibid.*, 177.

39 Victoria Memorial Hall, Calcutta, repr. Mildred Archer, *ibid.*, pl. 82. The continuing attraction of oriental carpets in England in the later eighteenth century is attested by various pieces of evidence: an allusion by Beckford in his *Biographical Memoirs of Extraordinary Painters* (1780), describing a painting that contains a Turkey carpet (p. 131); and Zoffany's repeated use of them in his pictures, e.g. the *Family of Richard Dalton*, c.1765–8 (Tate Gallery), *The Archduke Francis*, 1775 (Kunsthistorisches Museum, Vienna) and, most familiar of all, in *Charles Towneley's Library in Park Street*, 1781–3 (Towneley Hall Art Gallery, Burnley). The presence of such a carpet in this most classical of settings may well be due to Zoffany and not represent fact: J. T. Smith, who had been employed as a draughtsman by Towneley, tells us that the best of the sculpture collection was assembled from various parts of the house by the artist and made up a 'picturesque composition according to his own taste' (*Nollekens and his Times*, ed. W. Whitten, I, 1920, 213). The carpet might alternatively have been in Towneley's library; we know that Towneley's interests extended beyond Europe to embrace Indian sculpture: see Mitter (1977), 91f. Not surprisingly, Turkey carpets represented a standard of excellence in carpet-making in this period as previously, but there was no lack of the competition of classical European designs which Zoffany or Towneley could have chosen to accompany the Greek and Roman art depicted in the painting. About 1750 two Frenchmen from the Savonnerie at Chaillot moved to London and set up a carpet factory in Westminster, which survived until 1755 in different locations (Paddington and Fulham). Their products appear to have included imitations of Turkey carpets, but evidence is inconclusive. A year later two premiums of £30 and £20 were offered by the Society of Arts for making carpets 'in one breadth, after the manner of Turkey Carpets in Colour, Pattern and Workmanship; to be at least 15 foot by 12 foot' (Minutes of the Society, 7 April 1756). The premium money was in fact divided equally between Thomas Moore of Chiswell Street, Moorfields, whose carpet was 'the finest in Pattern and Colour', and Thomas Whitty of Axminster, Devon whose carpet, also a Turkey design 'came nearest in Staple'. The Moorfields factory became particularly associated with neo-classical carpet designs. The Axminster looms moved to Wilton in 1836: Axminster also produced designs in European traditions but undertook many versions of traditional oriental patterns until 1957. Prominent among these were the three large carpets made for the fifth Earl of Bristol and still at Ickworth, Suffolk (now National Trust). All three were oriental: that for the Library has a Hamadan-like central medallion on beige brown; the Drawing Room carpet has a wide formal Persian border on green; both these carpets date from 1827–8. The carpet in the Eating Room dates soon after the move to Wilton; it has Herati-style flower sprays and a blue ground. See Bertram Jacobs, *Axminster Carpets, hand-made, 1755–1957* (Leigh-on-Sea 1970), 58–9.

40 One of the albums is now in the VAM (IS 133–1964, painted at Isfahan c.1620–30 and

possibly by Afzal al-Husayn). The collection of objects made by Clive (1725–74) in India, including metalwares, and a painting of *A Lion Hunt*, by Mir Kalan Khan, is at Powis Castle (National Trust). Clive's son and especially his daughter-in-law, Lady Powis, also collected Indian art objects.

41 Hastings's collection of Mughal miniatures was later with him at Daylesford. Some were sold to the East India Company before his death in 1818; others were in the Daylesford sale of 1853; some were sold by his descendants at Bonham's, 29 March 1985.

42 Many of Gore Ouseley's manuscripts were bought by J. B. Elliot of Patna, who presented them to the Bodleian Library. See B. W. Robinson, 'Persian miniature painting from collections in the British Isles', exh. cat., VAM (1967), 20, illus. The Royal Asiatic Society also had its own particular links with Persia. A large hand-coloured aquatint by Robert Havell, *The Court of Persia*, dated 4 April 1834 (BM), from a painting in the collection of Thomas Alcock of Kingswood, is dedicated to the Society. It depicts the Court of Fath 'Ali Shah and six Europeans: three Britons, Sir Gore Ouseley, Sir Harford Jones, and Sir John Malcolm, and three Frenchmen, General Gardane, M. Jouannin and M. Jaubert. Malcolm collected Persian manuscripts and produced *Sketches of Persia*, a detailed account of travel with anecdote, in 1828 (two volumes). Sir William Ouseley published *Travels in Various Countries of the East* in 1819 (2 vols.). He illustrates a design from a Hafiz manuscript of 956 Hegira (AD 1549), in his collection, in vol. I, pl. xxii.

43 See Mildred Archer and Toby Falk, *Indian Miniatures in the India Office Library* (1981): this contains a full account of Richard Johnson and his collection, 14f. For the Persian miniatures, see B. W. Robinson, *Persian Paintings in the India Office Library* (1976).

44 Archer and Falk, *ibid.*, 29.

45 The stipple engraving made of Ker Porter's painting (which is now destroyed) is illustrated in Mildred Archer (1979), pls. 338, 339 and 341.

46 On Hodges' contacts with Hastings, see Isobel Combs Stuebe, *The Life and Works of William Hodges* (New York and London, 1979), 44f. and her article 'William Hodges and Warren Hastings, a Study in Eighteenth-century Patronage', *Burl. Mag.* CXV (1973), 659–66.

47 *Apollo* XCII (1970), 128–9.

48 George Cumberland, *Essay on the Utility of Collecting the Best works of the Ancient Engravers of the Italian School* (1827), 19.

49 George Cumberland, 'Plan for the Improvement of the Arts in England', prefaced to his book on Bonasone, *Some Anecdotes of the Life of Julio Bonasoni* (1793).

50 Flaxman made a number of drawings of Indian subjects: see the album in the Fitzwilliam Museum, Cambridge, presented by G. Fairfax Murray in 1916: page reproduced as pl. 154 in David Irwin, *John Flaxman, Sculptor, Illustrator, Designer 1755–1826* (1979). It is possible, as Irwin suggests (p. 212), that Flaxman saw Richard Johnson's collection of Mughal miniatures bought by the East India Company Library, London, in 1807. Flaxman's fantastic poem *The Casket* (1812) probably derives some of its oriental flavour from literary sources: Irwin plausibly suggests Southey's *Curse of Kehama* (1810).

51 Blake's friend Thomas Stothard illustrated Moore's *Lalla Rookh* (1835 edn.) and scenes from the *Arabian Nights* provided him with many subjects: see Mrs Anna Bray, *Life of Thomas Stothard* (1851), 236, 241. A picture by Stothard entitled *Arabian Nights* was in the Royal Academy of 1828. None of these works, insofar as they are traced, show any serious concern with authentic setting or style.

52 Theoretical reassessment of Gothic had long been under way, e.g. Richard Hurd, *Letters on Chivalry and Romance* (1762), had maintained that Gothic architecture must be judged by Gothic rules, Grecian architecture by Grecian (1911 edn, 118). See Frankl (1960), 392–3. Warren Hastings prefaced Charles Wilkins's English translation of the *Bhagavad-gita*, published by the East India Company in 1785, with a plea that the original be judged on its own merits, not by the standards of Europe.

53 See Thomas Pennant, *A Tour in Scotland and a Voyage to the Hebrides, 1772* (1774–6). Geoffrey Grigson, 'Fingal's Cave', *AR* CIV (1948), 51–4, usefully summarises the importance of this place for writers, artists and musicians of the Romantic period. John Miller, the draughtsman with Banks at the cave, made a drawing of it which William

Daniell, the traveller to India, engraved in aquatint (*Illustrations of the Island of Staffa*, 1818). The popularity during the Regency of the clustered basalt shafts of the cave and of Gothic and Muslim architecture (the 'bundles of staves' and 'incongruous props' of which Evelyn had disapproved) is evidently no coincidence.

54 Watkin (1968), 234. Hodges' argument forms part of a wider interest in comparative architecture and in the natural origins of styles, which has been much discussed. Outside Watkin's book the part played by sympathisers with Islamic style – Hodges, Hope, Repton – still lacks due recognition. In Britain the broader interest was reflected by the architect John Soane (1753–1837) and his architect-draughtsman friend Joseph Michael Gandy (1771–1843): the latter's drawing *Architecture: its Natural Model* (RA 1838; Soane Museum, London; illus. *Joseph Michael Gandy*, exh. cat. Architectural Association, London, 1982, 45), with its compendium of 'architectural' rock-shapes in nature, is a famous example.

55 'Of Indian Construction', in *Designs for the Pavillon at Brighton* (1808), 27.

56 Stuebe (1979), 198–201, records two painted views (made from the river side) in the National Gallery of Modern Art, Jaipur House, New Delhi; a painting shown at the RA in 1787 and another in 1794 (both now untraced); and various drawings, e.g. three sold in the Fonthill Abbey sale in 1807 (all now untraced).

57 Dorothy Stroud, *CL* cxxxv (1964), 771, and *George Dance, Architect 1741–1825* (1971), 170, also proposes a direct link between Hodges' *Select Views* and Dance: she cites the 'Chunar Gur' plate (no. 19). Dance's awareness of Mughal architecture is also evident in the turret-caps at Coleorton, Leics. (1804–6 for Sir George Beaumont); in similar caps and in the proportions of his gateway at Stratton Park, Hampshire (*c*.1806), for Sir Frances Baring, Director of the East India Company; also in this same personal 'Indianised Gothic' turret as seen at Ashburnham, Sussex (1807) and Norman Court, Dorset (1810). For illus., see Nicholas Cooper, 'Indian Architecture in England 1780–1830', *Apollo* xcii (1970), 123–33; also Conner (1979), 116.

58 Mildred Archer, *Early Views of India: The Picturesque Journeys of Thomas and William Daniell 1786–1794* (1980), illustrates the views conveniently, following the course of the tours. See also Shellim (1979) for a detailed account and catalogue of the oil paintings, also (20f.), for the patronage that the Daniells enjoyed. Thomas painted Mughal subjects for (among others) Thomas Hope, Richard Colt Hoare and the third Earl of Egremont. Oil paintings by both artists are in the Victoria Memorial, Calcutta (ex. coll. George Lyell). For the Taj Mahal prints, see Archer (1980), pl. IV (colour), pls. 28, 29.

59 For full bibliographical details, see Abbey (1956), II, cat. 420, 432; also Shellim (1979), 20.

60 These are listed in full in Archer (1980), Appendix II. They include *The View of Hindoostan*, 2 vols., by Thomas Pennant; *Twenty four Views in Hindustan* by William Orme, 1805; *Monuments Anciens et Modernes de l'Hindoustan*, Paris 1821; and *The Oriental Annual or Scenes in India*, 7 vols., 1834–40, 132 steel engravings after William Daniell: commentary by the Rev. John Hobart Caunter BD, based on that of William Daniell, with his own experiences added. Indian views were popular in the 1830s: J. M. W. Turner admired the Daniells' *Oriental Scenery*; and the seven drawings by him engraved for G. F. White's *Views in India, Chiefly among the Himalaya Mountains* (1836–8) – based on sketches by White himself – included one of the 'Ghaut at Hurdwar' (watercolour, Leeds Art Gallery).

61 Potters known to have been involved in illustrating Islamic subjects from India are John and George Rogers of Longport (*c*.1784–1842), and J. and R. Riley of Burslem (*c*.1802–28). See Michael Archer, 'Indian Themes in English Pottery', in *Apollo* xcii (1970), 115–16, where a Riley plate (coll. Mrs J. Busby) is reproduced which combines elements from two of the Daniells' prints: 'View on Chitpore Road, Calcutta' (Part II, 2) and 'The Sacred Tree of the Hindoos at Gyah, Bahar' (Part I, 15). The Daniells' exploitation of the 'three-quarter view' of Indian buildings so as to show brightly lit and shadowed sides and vertical skyline elements made their designs particularly useful for illustration by 'Picturesque' designers in the medium of blue decoration on white earthenware. Sezincote and the Brighton Pavilion also had their influence in this field: John Davenport of Longport produced *c*.1820 a blue-printed design showing a mosque in an English-looking landscape; see A. W. Coysh, *Blue and White Transfer Ware*

1780–1840 (1970), 30, fig. 42. Hindu architecture in India as recorded in other source-books could also be used: a plate (coll. Mrs J. Busby) made for King's Warehouse, Dundee *c.*1825–30, carried a view of Sursaya Ghaut, Khanpore, from C. R. Forrest, *A Picturesque Tour along the River Ganges and Jumna in India* (1824): for illus. see Michael Archer (1970), 116. But the prime importance of the Daniells' work as a source is beyond question. Motifs – buildings, figures, landscape elements – were often selected and recombined in new formats. Accuracy took second place – as was appropriate enough in the context of domestic earthenwares – to overall decorative effect. Mrs Archer (1980), 228, reproduces a blue-printed jug (Staffordshire, *c.*1815, maker unknown), the decoration of which includes the 'Mausoleum of Makhdam Daulat at Maner' (Part I, 12) and reverses the steps and gateway from the 'View in the Fort, Madura' (Part II, 14). In such works enough of the idiom of the original buildings survived, however, to convey their character. Other designs were more or less representations of single Daniell subjects, though many made common use in backgrounds of the decorative possibilities of the tree in the 'View in the Fort of Tritchinopoly' (Part II, 21). Besides Rogers, Riley and Davenport, the Herculaneum Pottery of Liverpool (fl. *c.*1793–1841) and T. and J. Bevington and Co. of Swansea (fl. 1817–24) also used the Daniell prints. The Herculaneum 'India' series is of striking interest: five designs are known, all based on the prints of the Daniells, and all having the same background based on Part II, 21. Three of these designs bear the Herculaneum mark: 'Gate of a Mosque built by Hafiz Ramut, Pillibeat' (Part III, 10); 'Mausoleum of Nawaub Assoph Khan, Rajemahal' (Part III, 24); and 'View in the Fort, Madura' (Part II, 14). Two are unmarked: 'The Chalees Satoon in the Fort of Allahabad on the River Jumna' (Part I, 6) and 'Mausoleum of Sultan Purveiz near Allahabad' (Part I, 22). See Coysh and Henrywood (1982), 187 and references under the above subjects. Another Staffordshire firm which should be mentioned was John Hall and Sons (fl. *c.*1814–32), who produced a series of 'Oriental Scenery' using scenes from a source (at present untraced) which combined Muslim and Hindu subjects: for list see Coysh and Henrywood (1982), 267. A later series with the same title by an unknown maker is also listed there. After 1842 the Copyright Act reduced the number of picturesque views derived from the engravings that were protected by the Act, which encouraged a cult of more or less imaginary landscapes or townscapes. However, a series 'Indian Scenery' was produced by Thomas and Benjamin Godwin around mid century: this provided views of 'Delhi'; 'Surseya Ghaut, Khanpore'; the 'Tomb of Shere Shah'; and 'Tombs near Etaya on the Jumna River'. The copper-plates were, it appears, acquired and used for a further series by Cork, Edge and Malkin (of Newport Pottery, Burslem, fl. 1860–71: later renamed Edge, Malkin and Co., of Middleport and Newport Potteries, Burslem, Staffs., fl. 1871–1903).

62 As for wallpapers, the Daniells' view of Madura Fort also figured in the examples produced by the firm of Joseph Dufour of Macon. Mrs Archer (1980) illustrates examples of derivations from Hodges' *Select Views* by Jean Zuber of Rixheim (near Mulhouse, Haut Rhin) and from the Daniells' *Oriental Scenery* by Dufour (coll. Whitworth Art Gallery, University of Manchester). Zuber produced a panoramic wallpaper in 1806 with the title *L'Indoustan*: in this the designer Pierre-Antoine Mongin placed buildings from the Daniells' work and Indian flora and fauna in park-like settings. Dufour followed with *Paysage Indien* and *Paysage Turc*, both of 1815. Parts of the former survive at Laxton Hall, Northants, where George Dance had designed the markedly French-looking neo-classical staircase hall about 1812, and where Humphry and John Adey Repton had previously worked in 1805–11. See David Watkin, 'Some Dufour Wallpapers: a neo-classical venture into the Picturesque', *Apollo* LXXXV (1967), 432–5 (illus.). Zuber of Rixheim have more recently supplied designs for wallpapers and fabrics, a number of which have subjects from the Islamic world ('Samarcande', 'Mogador' etc.) to Cole and Son (Wallpapers) London (patternbooks of 1977 and 1979, VAM, London; see C. C. Oman and J. Hamilton, *Wallpapers*, edn 1982, 268). For Dufour and Zuber's early 'Eastern' papers, see also Françoise Teynac, Pierre Nolot and Jean-Denis Vivien, *Wallpaper: A History* (1983), 108, 122.

63 *Enquiry into the Changes of Taste in Landscape Gardening and Architecture* (1806), 41.

64 William Daniell's aquatint of the exterior of this (1802) is reproduced in Archer (1980), 230, where the work is also discussed.

65 Conner illustrates these buildings (1979), 124, and also cottages at Lower Swell, nearby, which have multifoil arched 'Islamic' windows, 125.

66 R.A., 1797, item 1136 (p. 30). Porden also made a design in 1804 for Eaton Hall, Cheshire, in a Gothic style with small, faintly Islamic domes above projecting columns: Joseph Farington called it 'Morisco Gothic' (*Farington Diary*, ed. J. Greig, 1922–8, III, 7, entry for 30 Sept. 1804). See Conner (1979), 131 (illus), 185.

67 Walpole's letter to Horace Mann, 12 June 1753, in *Letters of Horace Walpole*, selected by W. S. Lewis (1951), 73. George Henderson, *Gothic* (1967), 190, discusses the eighteenth-century association of Gothic with dreams and the exotic, and its attraction as 'an interesting oriental infection caught by Europeans in the course of their muddled wars and diplomacy in the Holy Land'. Walter Scott in *Ivanhoe* (1819) sees medieval civilisation as split between the 'Saxon' and the 'Saracenic' cultures.

68 See Warburton's edn of *Works of Alexander Pope* (1753), III, 290–3. The theory is destroyed by Dr John Milner in an essay 'On the Rise and Progress of the Pointed Arch', published in *Essays on Gothic Architecture by the Rev. T. Warton, Rev. J. Bentham, Captain Grose and the Rev. J. Milner* (1800).

69 At Farmington, Conn. See W. S. Lewis, *Horace Walpole* (1960), 102.

70 *Description of Strawberry Hill* (1784), 63. Some items are arms, but Walpole also owned Turkish and other Islamic pottery objects (12, 14).

71 Clifford Musgrave, *Royal Pavilion* (1959), 158.

72 Illus. in David Jaques, *Regency Gardens, The Reign of Nature* (1983), 154. See also Mrs Hofland, *Descriptive Account . . . of Whiteknights* (1819).

73 Wilds was another student of the Daniells' prints. He designed Indian-style houses in Sillwood Place and Western Terrace, Brighton, and (probably) the Mughal-style Clifton Baths, Gravesend (1835, demolished). For these see Conner (1979), 149–50, 154 (illus.).

74 Conner (1979), pl. 117.

75 The gateway and lodge beside the River Finisk at Dromana, Co. Waterford (col. illus. in Brian de Breffny and Rosemary Ffolliott, *The Houses of Ireland*, 1975, 158). The design has an elongated ogee dome above a central pointed arch; there are minarets and ogee-arched windows at sides. Built in papier mâché for the homecoming of Henry Villiers-Stuart and his Viennese bride in 1826, the building was made permanent in the 1840s and restored by the Irish Georgian Society in 1967. George IV had visited Ireland in 1821.

76 Conner (1979), also discusses one other large house in Britain, besides Sezincote, which employed Islamic style: Hope End, Herefordshire. About 35 miles from Sezincote, this was reconstructed for Edward Barrett Moulton-Barrett in 1810–15. The anonymous architect of this interesting house (perhaps the owner) placed a large ogee-profile dome of glass on his central block and small bulbous domes above corner columns. Sold by Moulton-Barrett in 1831, the house was demolished in 1867. The stable-block, with seven 16-foot high minarets, survives. For illus. see *Diary of Elizabeth Barrett Browning*, eds. P. Kelley and R. Hudson (Athens, Ohio, 1969) and the *Barretts at Hope End*, ed. E. Berridge (1974): also Conner (1979), 125–7.

77 Robert Kerr, *The English Gentleman's House* (1864), sees the conservatory as a normal part of the plan. See John Hix, *The Glass House* (1974), 87.

78 Conner (1979), discusses and illustrates these buildings and the Daniell sources, 138, 139.

79 In his *Remarks on Hothouses* (1817) Loudon makes it clear that he considered the pointed dome, possessing what he calls the 'acuminated apex', better for plants than the semi-circular shape because condensation would not form to the same extent.

80 See Hix (1974), fig. 111. Added popularity will have been given to the glass ogee-dome by its use above the fountain in the Royal Colosseum, Regent's Park, London, by Decimus Burton, c.1825. This was a much-visited building, and in any case a lithograph of the fountain was issued by Ackermann in 1829.

81 Illus. in Hix (1974), fig. 25. For a near-contemporary comment, see John Timbs, *Curiosities of London* (1855), 36. See also R. P. Ross Williamson, 'The Last Act at the Pantheon', *AR* LXXXII (1937), 7–10.

82 Many Mughal tent-hangings of the seventeenth and eighteenth centuries survive in Western collections and were shown in the 'Indian Heritage' exhibition (1982) at the

Victoria and Albert Museum: see cat. For a rare survival see *ibid.*, 84, Tipu Sultan's tent (roof and a wall) acquired by the second Lord Clive and his collector-wife, and now at Powis Castle. This is of cotton printed, painted and dyed.

83 Nathaniel Whittock, *Decorative Painter's and Glazier's Guide* (1827).

84 Conner (1979), pl. 123. The German prince Pückler-Muskau saw 'Moorish houses executed with taste' at Virginia Water in 1827. *Tour in England* . . ., Zürich 1940, 176.

85 This survived into the 1930s but was rebuilt to a different design after a fire. Regent's Park in the 1830s provided at least one other prominent reference to the Islamic style: the observatory in Arab taste built in the grounds of South Villa in 1836 by George Bishop (1785–1861), the owner. The dome and instruments for this were taken to Twickenham by his son to be installed in his observatory there.

86 For Porter's oriental decorations at his house, Vine Cottage, Fulham, see Rudolph Ackermann's *Repository of Arts*, series I, iii (1810), 393.

87 Moore, *Poetical Works*, ed. W. M. Rossetti (nd), 161.

88 See John Morley, *The Making of the Royal Pavilion, Brighton: Designs and Drawings* (1984).

89 Maria Edgeworth, *(Castle Rackrent and) The Absentee*, ch. II (edn 1895, 101–2).

90 Richard Brown, *The Rudiments of Drawing Cabinet and Upholstery Furniture* (1822).

91 F. D. Klingender, *Art and the Industrial Revolution* (1968, 1947), 124 and pls. 69, 80. Klingender cites the 'Moorish Arch' which John Foster (1786–1846) designed in 1830 for the Liverpool terminus of the Liverpool and Manchester Railway, and compares the view of it by S. G. Hughes after T. T. Bury with Mayer's view of the Gate of Grand Cairo, pl. xxv of his *Views in Egypt* (1801). Hughes's print was contained in *Coloured Views of the Liverpool and Manchester Railway*, published in 1831.

92 The lighthouse form has interesting similarities to the minaret, but only in the case of an unusual example like Girdleness – straightsidedly tapering, and with a second gallery (originally housing a second light) lower down the tower – is the similarity at all close: and there the vertical corbelling brings to mind Romanesque rather than Islamic style. It is worth noting, nevertheless, the possibility of links between the minaret form and the Pharos of Alexandria (283–247 BC), one of the Wonders of the Ancient World. Was this the architectural inspiration for the Muslim minaret? Douglas B. Hague and Rosemary Christie in *Lighthouses: their architecture, history and archaeology* (1975), 9, suggesting that it might have been, point to the root of the Arabic word for minaret, *manara*, which means 'a place where fire burns'. At the time of the survey by the Arab Ibn al Shaikh (1132–1207) of Málaga, there was a small mosque on top, instead, presumably, of a light. The ruins of the Pharos were still to be seen in the mid fourteenth century. The Roman lighthouse of La Coruña, Spain ('The Tower of Hercules') was provided with a slow ramp, echoing Moorish towers, in the reconstruction of 1791: see Hague and Christie, *ibid.*, 71–2. For illus of Girdleness, see *ibid.*, fig. 36.

4 AFTER 1820: THE PAINTERS' VISION

1 *The Eclectic Review* was soon saying that Byron's poetry about Greece and the Levant was 'the best possible substitute for the actual sight of the scenes themselves' (XIV, ns, Nov. 1820, 301), quoted by Wallace Cable Brown, 'Byron and English Interest in the Near East', *Studies in Philology* XXXIV (1937), 58. In 1812–18 *Childe Harold* appeared with its famous passage beginning 'Oh! that the Desert were my dwelling-place': see Tidrick (1981), ch. 2.

2 Delacroix's interest in the Muslim world, like that of Byron, was stimulated before he actually visited it. A sketchbook for 1824–6 (Louvre) shows that he copied figures from *Costumes Turcs de la Cour de la Ville de Constantinople en 1720* (Bibliothèque Nationale, Paris). See Lee Johnson, 'Towards Delacroix's Oriental Sources', *Burl Mag.* cxx (March 1978) 144f. For his remarks on Persian carpets see ch. 5, n. 30.

3 On *Kubla Khan* and its visual sources, see Allan Grant, *A Preface to Coleridge* (1972), 128f.; Geoffrey Grigson, 'Kubla Khan in Wales, Hafod and the Devil's Bridge', *Cornhill Magazine* 970 (Spring 1947), 275f. On Hafod see Elisabeth Inglis Jones, *Peacocks in Paradise* (1960). The house, remodelled for Colonel Thomas Johnes by John Nash in 1794, received a 'flattened Mughal cap': see John Piper, *Buildings and Prospects* (1948), 36. On Yuan Ming Yuan see Conner (1979) and 'China and the Landscape Garden', *Art History* II (1979), 433–4.

4 Most notably by John Livingston Lowes, *The Road to Xanadu, a study in the ways of the imagination* (1927).

5 The Middle Eastern travels of Burton and Doughty, together with those of Gifford Palgrave and Wilfrid Scawen Blunt, who with his artist wife Lady Anne recorded the life of the area in the late 1870s, are extensively treated in Tidrick (1981).

6 Richard Burton, foreword to his edition of the *Arabian Nights*, vol. 1, vii–viii.

7 Egyptian monuments were thoroughly surveyed by Napoleon's command and published as *Description de l'Egypte* (1809–28) in nine volumes of text and 10 of plates together with an atlas. Ancient Egyptian hieroglyphics were untranslated until Champollion deciphered them in 1822. The explorer Belzoni's exhibition of Egyptian antiquities in Piccadilly (1821–22) was a popular success.

8 Coste's work was to be useful to illustrators, among whom William Harvey (1796–1866) became prominent and something of an 'Islamic' specialist. He used Coste's original drawings to help him provide illustrations to Edward Lane's translation of the *Arabian Nights* (1841 ed.). See Darby (1983), 80–81 (illus.). Coste was later (1840–1) a member of a French expedition to Iran and collaborated with the painter E. Flandin in influential publications on Persian architecture, *Voyages en Perse* (1851–67). These were used by Owen Jones. Though still attractive for their illustrations Coste's volumes were soon superseded in matters of accuracy by the work of scholars such as Max von Berchem, the Swiss epigrapher.

9 Henry Salt (1780–1827) was in India with Viscount Valentia in 1802–6, and carried out the illustrations to Valentia's *Travels into India* etc. (1809). He also produced *Twenty-four Views of St Helena and Egypt* (1809). He became British Consul-General in Egypt from 1815.

10 Sarah Searight (1979) discusses the routes to India, 151f.

11 For Hay, millionaire, admirer of Belzoni (n. 7) and taskmaster, and for details of his expeditions, see Selwyn Tillett, *Egypt Itself, the Career of Robert Hay Esquire, of Linplum and Nunrow* (1984).

12 James Justinian Morier (1780?–1849) is an extremely interesting figure. Brought up in Constantinople where his father was British Consul, he was in Persia in 1809 (attached to Sir Harcourt Jones's embassy), and from 1810 to 1815 (attached to Sir Gore Ouseley's embassy). He came to know Persian life intimately and filled the novel *Hajji Baba*, the account of the adventures of a likeable rogue from Isfahān, with remarkably readable detail based on observation. This book has been seen as representative of a new age which demanded the sharpness of observed facts in contrast to the old generalised escapism of Thomas Moore's *Lalla Rookh* (1817): see J. E. Heseltine, 'The Royame of Perse', in *The Legacy of Persia*, ed. A. J. Arberry (1953), 384–5. Morier was a competent master of the conventions of landscape composition as is shown by the 25 engravings, made from his drawings, in his *Journey through Persia, Armenia and Asia Minor to Constantinople* (1812). His *Second Journey*, along the same route and also illustrated, appeared in 1818.

13 In Lewis's case, especially: he distinguishes, as Briony Llewellyn (1985) observes, numerous races and types: Bedouin, Egyptians, Turks, Copts, Circassians, Georgians and Abyssinians, also many Nubians, of both sexes, e.g. in the watercolours *Prince Hassan and his servant* (Fine Art Society, 1978), *An Arab Scribe, Cairo* (private coll., see fig. 73), and in his bazaar scenes, such as the oil *The Bezestein Bazaar of El Khan Khalil, Cairo*, 1872; here especially the cosmopolitan Cairo scene is richly conveyed. About 1830 the Scottish painter William Allan had studied the physical and social differences between Turk, Arab and Negro on his visit to Constantinople: his picture *The Slave Market, Constantinople* (1838) records this.

14 Scott, *Ivanhoe*, ch. X. See Henderson, *ibid.*, 191–2.

15 Esteem for the Moors grew despite the ambivalence of Shakespeare's Othello, tragic hero and simultaneously 'abuser of the world'. Although the Moors of Morocco and Spain had figured in the iconography of European art, their political role had been less conspicuous than that of the Turks. It is significant that Said's *Orientalism* (1978) does not discuss them. In the early nineteenth century they were, however, being re-appraised. The introduction to J. G. Lockhart's widely read translation of *Ancient Spanish Ballads* (1823, 1841) extols the benefits of the Moors to Spanish cultural life, and the ballads depict them as worthy enemies of Spanish national heroes. In fact Owen

Jones did five title-pages together with borders and vignettes for the 1841 edition of this work, drawing the architecture behind Henry Warren's figures in the 'Murder of the Master of St Jago'. Another illustrator of the *Ballads* was William Harvey, see n. 8.

16 Morocco had had trade treaties with many European countries in the mid eighteenth century, including England in 1760 and France in 1767. In 1765 Muhammad III founded the town of Mogador, with French and English planning assistance, as the main centre of foreign trade in the south. The country retained its character very strongly, however, through to 1912 when General Lyautey, Resident-General of the French Protectorate which then took over, played a prominent part in conserving the old Moorish capitals of Rabat, Marrakesh, Fez and Mehnes.

17 Letter to Thomas Phillips, 14 Feb. 1828. A. Cunningham, *Life of Sir David Wilkie* III (1843), 503. In fact it was not wholly unexplored. As we saw (p. 270, n. 93) Muntz had been active there in the mid eighteenth century. Travel books on Spain had included Henry Swinburne, *Travels through Spain in the Years 1775–1776* (1779), Richard Twiss, *Travels through Portugal and Spain in 1772 and 1773* (1775); and Sir John Carr, *Descriptive Travels in the Southern and Eastern Parts of Spain and the Balearic Isles in the Year 1809* (1811). James Cavanah Murphy (1760–1814) produced *The Arabian Antiquities of Spain* based on his travels of 1802–09: published posthumously in 1815, it contains 110 plates by Murphy with descriptions by T. Hartwell Horne. The British Architectural Library (Drawings Collection), London, has an early proof of pl. xxxvii contained (sheet 41) in an album of drawings by Murphy of grotesque panels from a Spanish Renaissance church (see n. 18). As a country where extreme forms of European styles were to be seen (Spanish Gothic, Spanish Baroque) and which had produced highly individualistic artists of first rank (such as Velázquez and most recently Goya) Spain was to become a place of pilgrimage for the Romantics. Much useful information on the 'opening-up' of Spanish painting to Europe is to be found in Francis Haskell, *Rediscoveries in Art* (1976), 77f.

18 J. C. Murphy's *Plans, Elevations, Sections and Views of the Church of Batalha* of 1795 (he had gone to Portugal to measure it in 1788) illustrates three examples of Moorish arches in plate I: two come from the Alhambra, Granada. The album of drawings in the RIBA (see n. 17) contains a letter from the donor, John Newman, Fellow of the RIBA, dated 24 April 1850, which alludes to 'James Murphy, the author of the Alhambra', with a reference to the *Arabian Antiquities of Spain* of 1815. So Murphy, it appears, was still remembered for his work on the Alhambra: as well he might (despite Owen Jones's greater efforts) because the *Antiquities* illustrates views of its courts and interiors as well as details of stucco and tiles, pavements and ceilings. Even so, Murphy was inaccurate beside Jones, and was seen to be by Richard Ford, Matthew Digby Wyatt and others.

19 Chateaubriand had visited Spain on his way back from the Near East in 1807.

20 Girault showed views of Tunis and Granada at the Paris Salon of 1836. His *Monuments Arabes et Moresques de Cordoue, Séville et Granade* (1836–9) was followed by *Choix d'Ornaments Moresques de L'Alhambra* (1842). These are handsome books but their colours, lithographically printed, can sometimes be garish and ill-adjusted to one another (the yellow being too heavy for the blue). Interest in the Alhambra and the parallel experiments in the fields of colour and colour-printing at the period nevertheless surely complemented each other, as Michael Darby suggests, *Owen Jones and the Eastern Ideal* (1974), I.55. Girault's works were well known in Britain. He published *Monuments Arabes d'Egypte, de Syrie et d'Asie Mineure* between 1846 and 1855.

21 Irving's *Alhambra* was much revised in 1857 and went through many editions in English and Spanish. A convenient one is that of 1896, with illustrations by the American Joseph Pennell.

22 See *Richard Ford in Spain*, exh. cat., Wildenstein (London 1974), pl. 1b. On the drawings see the essay by Brinsley Ford in the same catalogue, 31f. See also Sir William Stirling of Kier, *ibid.*, obituary notice of Ford in *The Times*, 4 Sept. 1858.

23 After three weeks at Granada in 1833, Roberts moved on to Málaga and, through the friendship of the British consul there, to Gibraltar, and then to Tangier. He had carried out 206 finished drawings, mainly coloured. He then had a long stay in Seville painting the Giralda and other subjects before returning to England. There he illustrated four issues of Jennings's *Landscape Annual*, the volumes for Granada (1835), Andalusia (1836), Biscay (1837) and Spain and Morocco (1838), using his own drawings except for

some instances in the case of the last. His *Picturesque Sketches in Spain* appeared in 1837. Over the same years he read widely on the East. See Helen Guiterman, *David Roberts R.A. 1796–1864* (1981), 6, and Katharine Sim's full biography with the same title (1984), chs. 6, 7 and 8.

24 James Ballantine, *David Roberts R.A.* (1866), 50; Sim, *ibid.*, 74–5.

25 The *Alhambra* series consists of 26 lithographs. See Abbey (1956), cat. 148. Lewis drew all the plates (though no. 18 is unsigned). Some are actually lithographed by him also: the others are by J. D. Harding, R. J. Lane, and W. Gauci. Lewis's *Sketches of Spain and Spanish Character*, 24 plates, appeared in 1836, see Abbey (1956), cat. 149. These were mainly of figures and town and country scenes, but no. 17, '*Jewish Woman of Gibraltar in a festa dress*', includes Moorish architecture and no. 19 the Mosque at Córdoba.

26 For Jones, see Darby (1974) and his exh. cat. *The Islamic Perspective* (1983). Jones's portrait by Henry Wyndham Phillips, against a background of Moorish ornament, is in the RIBA, London.

27 For detailed discussion of the complex bibliographical problems associated with Jones's *Alhambra*, see Darby (1983), 46. There were 162 subscription copies. An auction in 1854 offered a further 64 large paper, 101 colombier and 42 folio copies. Jones had quantities of letterpress on his hands at his death (bought by Quaritch who issued a reprint using the original stones etc. in 1877). The original edn sold at £36 10s (large paper). Cost and bulk clearly limited sales: cf. p. 217.

28 Sicily was becoming particularly prominent from the 1820s as a centre for the study of polychromy in architecture. Hittorff and Semper were both there; Hittorff had worked in company with Ludwig Zanth, later (1837) to design the polychromatic Moorish Villa Wilhelma for the King of Württemberg. The major texts on polychromy refer to Greek sculpture (Quatremère de Quincy's *Jupiter Olympien*, 1814–15) and Greek architecture (Hittorff 1827, Semper 1834, Kugler 1835). Hittorff's controversial work on the Temple of Empedocles at Selinunte, Sicily – claiming (to the consternation of neo-classicists) that the Greeks covered their buildings with colour – usefully lists (French edn 1851, 823f.) the technical papers that had been prepared by this date, by Chevreul, Faraday, Landerer, Humphry Davy and others. This interesting subject is charted in David van Zanten, *Architectural Polychromy of the 1830s* (1977), especially 120f.

29 Darby (1974), I, 40 also calls attention to Sir David Brewster (1781–1868), who had engaged in a number of experiments with light between 1800 and 1820, had written about the primary colours which were so much to concern Jones, and had rediscovered the kaleidoscope.

30 'An Attempt to define the Principles which should regulate the Employment of Colour in the Decorative Arts', in *Lectures on the Results of the Great Exhibition of 1851 delivered to the Society of Arts, Manufactures and Commerce*, series II (1853), 255f. The arguments and 'propositions' adduced here are taken up again in his *Grammar of Ornament* (1856).

31 This lecture is fully discussed, together with its background, by Darby (1974), I, 274f. For a detailed description of the colours used in the Crystal Palace, see Van Zanten (1977), 240–1. Jones's ideas on the primaries as well as his references to Field's theories were reproduced in the chapter 'Moresque Ornament' in the *Grammar of Ornament*, 72, where the practices described are connected with the Moors.

32 Darby (1974), I, 28.

33 Darby (1974), I, 291.

34 *Athenaeum*, 4 August 1838, 556. The *Builder*, 2 December 1854, notes the book's 'very liberal and catholic ideas upon the subject of the union of form and colour which are fast finding favour in the minds of the public generally and in which the successful employment of the profession will most probably be concentrated for the remainder of the century'. For an example of an architect's use of Jones's colour theory in relation to Islamic style cf. G. R. Crickmay's Dorset County Museum, see *Arch. Rev.* CLVI (1974), 167 (illus.) and figure 98, p. 165 above.

35 César Daly, *Revue générale de l'Architecture* v (1844), 97–105, 529–38; VI (1845), 1, 7–14, 49–52. Daly especially valued the book for the way in which it 'allied' science and art.

36 The Victoria and Albert Museum has 10 volumes of Jones's designs for wallpapers together with examples of woven textile designs by him. See Darby (1983), 88–91 (illus.).

37 Reprod. in Darby (1983), 85.

38 Ruskin's *Works*, eds. E. T. Cook and A. Wedderburn, IX (1903), 243. The Alhambra itself is seen here as in general 'beautiful in disposition' but 'base in ornamentation'. See also p. 469 (Appendix 22): here Ruskin records the decoration of the Alhambra as late Spanish work, uncharacteristic of 'Arab' work. For an example of Moorish detail on a shop-front of the time see N. Whittock, *On the Construction and Decoration of the Shop-fronts of London* (n.d. but probably c.1840), pl. 17.

39 E.g. by John Steegman, *Victorian Taste: a Study of the Arts and Architecture from 1830 to 1870* (edn 1970), 305.

40 See his words quoted in *Works* XVI (1905), 307: they were omitted from the final text of Lecture II, 'The Unity of Art' in *The Two Paths* (1859), but Ruskin's low estimate of the quality of the ornament of the Alhambra does appear there, p. 311. For him such ornament caters merely for fancy and pleasure, and lacks the 'real, deep and intense' qualities of true ornamental art based on the scientific study of nature. Lying behind Ruskin's view is a distinction between on the one hand the study of nature and concern for human life, and on the other refined pleasure in art and indifference to human life (which he connects with the Arabs and Indians). Though in *Stones of Venice* (I, i, xxvi) Ruskin is not without appreciation of the 'exquisite refinement' of Arab architecture, his theory of European Gothic lastingly coloured his view of Islam. The contrast developed in his social theory, between the wholeness of the artisan's life (as Ruskin saw it) in the European Middle Ages and the fragmentation of labour under the modern factory system, confirmed his Eurocentric attitudes.

41 Ruskin, *The Seven Lamps of Architecture* (1849), 'The Lamp of Beauty'.

42 Jones's own words in his lecture on colour to the Society of Arts, 1853, 268 (see n. 30 above).

43 Carpets were hung from the aisle roofs, as contemporary views make clear (e.g. the oil by Henry C. Selous of *The Opening of the Great Exhibition* (VAM). There were also awnings in certain places, presenting a vaguely bazaar-like appearance, which was greatly intensified in the Turkish section with its impressive display of rugs (the colour print by Walter Goodall of the Turkish Court shows one of these awnings). The splendidly clear contemporary wood-engravings of the interior make the absence of photographs all the more tantalising. The colour-prints of George Baxter provide evidence that is valuable, though variable in terms of clarity. The official record of views was by the Dickinson brothers, 2 vol., 1854 (originals at Windsor Castle).

44 *Builder*, xxxii (1874), 383.

45 The continuing association of the Alhambra and Moorish style with landscape is suggested in the contemporary description of the saloon at Eaton Hall, Chester, as being 'recently richly decorated in the Alhambresque style, by Mr John Morris of this City (Chester), each panel being most beautifully painted with Moorish scenery': see *Stranger's Guide Book to Chester and Eaton Hall* (1857), 118. The *Guide* also describes the ante-dining room and ante-drawing room as being in a similar style (118–19). These decorations were presumably replaced during the partial rebuilding and remodelling of Eaton Hall by Alfred Waterhouse in 1870–3. John Morris, house and ornamental painter, is listed at 81 Foregate Street, Chester, in the *Post Office Directory of Cheshire* (1857). I am grateful to Annette M. Kennett, City Archivist, Chester, for this information.

46 He was jostled and even on occasion bombarded; he charitably wondered if a Turk sketching in Cheapside would have come away so lightly. Cf. Sim (1984), 152.

47 Though Lewis did not see Constantinople until 1840, he had drawn Turks in Venice during his European tour of 1827 (see sketchbook in Fitzwilliam Museum, Cambridge). In 1828 he showed a picture, *Interior of the Habitation allotted to the Turks in Venice*, at the British Institution (no. 72). No other oriental works by him were exhibited until 1833, when Moorish subjects began to appear. See Michael Lewis, *John Frederick Lewis RA 1805–1876* (1978), 51. In 1837 Lewis published lithographs of Constantinople after drawings by Coke Smyth.

48 W. M. Thackeray, 'Notes of a Journey from Cornhill to Grand Cairo', 1846, in Smith, Elder edn of Thackeray's *Works* VII (1894), 697f. After a long description of Lewis's house with its wooden lattices, courtyard and audience-chamber 'about forty feet long, and eighteen or twenty high', Thackeray gives an account of his dinner with Lewis, a figure of 'Bey-like appearance', handsomely dressed in Turkish fashion. Lewis's

Cairo house was close to the Darb-al-Asfar: see Briony Llewellyn in Parker and Sabin, *A Practical Guide to Islamic Monuments in Cairo* (1974), 55. I am grateful to Major-General Michael Lewis for this reference. Miss Llewellyn is now certain that the house is no longer standing.

49 Lewis (1978), 24. Other useful material on Lewis is found in Richard Green's catalogue to the Lewis exhibition at the Laing Art Gallery (Newcastle-upon-Tyne 1971); Kenneth P. Bendiner, *The Portrayal of the Middle East in British Painting 1835–1860* (Columbia Univ. 1979); Briony Llewellyn, 'The Islamic Inspiration, John Frederick Lewis: Painter of Islamic Egypt' (1985).

50 Recorded by J. L. Roget, *History of the Old Water-Colour Society* II (1891), 144, n. 1.

51 Bendiner (1979), 209–10. *The Times* 1 May 1850, 8; Théophile Gautier, *Les Beaux Arts en Europe* (1855), 93.

52 Lord Castlereagh's *Journey to Damascus through Egypt, Nubia, Arabia Petraea, Palestine and Syria* (2 vols, 1847).

53 If Ruskin's analysis highlights the effect of this encounter on the European, the Arab remains the real hero of the *Frank Encampment*. The combination of primitive integrity and civilised acceptance that Lewis shows in him recalls Chateaubriand's impressions of the Arab (ch. 3, n. 12). Kathryn Tidrick's discussion of the relationship in the nineteenth century between English gentleman-visitors to Arabia and the acquiescent but proud Bedouin (1981), 208f., stresses the factor of 'shared values'. She also cites the theory of the psychiatrist O. Mannoni, who sees the English gentleman in Arabia as a kind of Prospero-figure 'exerting a magical sway' (Tidrick's words, p. 216) over the inhabitants, but also requiring the reassurance of their acceptance. Whatever the accuracy of this view, and notwithstanding Thackeray's description of Lewis's bey-like lifestyle in Egypt, the *Encampment* clearly marks Lewis's appreciation of qualities in the Arab that were far from the old stereotypes (it is noticeable that the time-honoured languor is in fact here given to Castlereagh).

54 Three Watteau subjects, one of them a *fête champêtre* (Louvre), figure among Lewis's 'copies' of old masters in the Royal Scottish Academy, Edinburgh.

55 W. Holman Hunt, *Pre-Raphaelitism* I (1905), 270. See also Lewis (1978), 29.

56 Müller's scope as an artist is best seen from the large collection of his work at the City Art Gallery, Bristol: the Eastern scenes are a small part only, though very important in terms of merit.

57 For Dadd's Eastern journey, see Patricia Allderidge, *The Late Richard Dadd 1817–1886*, exh. cat., Tate Gallery (London, 1974), 18f.

58 For Dillon, see obituaries in the *Athenaeum*, May 1909, 567 and the *Art Journal*, July 1909, 223, and Llewellyn (1984).

59 Crace's watercolours of Cairo are in the British Architectural Library, London.

60 For Goodall, see N. G. Slarke, *Frederick Goodall, R.A.*, Oundle 1981.

61 M. Phipps-Jackson, 'Cairo in London', *Art Journal* 1883, 71f. See also Roget (1891), II, 351.

62 For Leighton's 'Eastern' works, see R. and L. Ormond, *Lord Leighton* (New Haven and London 1975), 98; *Study: at a Reading Desk* (cat. 240) is illus. there, pl. 137. See also Mary Anne Stevens (ed.), *The Orientalists*, exh. cat., RA (1984), 201–2 (illus. of *Old Damascus: Jews' Quarter*, 201) and pl. 88 (col. illus. of *Grand Mosque*). The Ashmolean Museum, Oxford, has a study for *Old Damascus*.

63 See Abbey (1956), cat. 272 (*Egypt and Nubia*) and 385 (*Holy Land . . .*). Roberts's spacious drawings represent the peak of his achievement. Those for Jerusalem and Syria were bought by Lord Francis Egerton. Each printed folio work contained 121 lithographs (hand-coloured or tinted from blocks) and text illustrations, all by Haghe. A shorter edn with 30 plates was published in Brussels in 1843. A quarto edn (241 illus., 6 vols. in 3), appeared in 1855–6 (Abbey (1956), cat. 388). See also K. Bendiner, 'David Roberts in the Near East: social and religious themes', *AH*, vol. 6, no. 1 (1983), 67–81, which discusses the impact of what *The Times* (16 Feb. 1842) called 'these illustrations of a sacred history', and presents the evidence for Roberts and his commentator Brockedon's interest, as shown in *Egypt and Nubia*, in the theory of historical links between Muslim architecture and Western Gothic.

64 For nearly eight years Allom was articled to the architect Francis Goodwin. He comes to be one of the most lively architectural draughtsmen of his day.

65 Carne was in the Roman Orient in 1830. For an anecdote of his encounter with English visitors dressed *à la turque* at Baalbek, see Rose Macaulay, *Pleasure of Ruins* (1953), 81. See also Abbey (1956), cat. 377.

66 See A. Cunningham, *Life of Sir David Wilkie* III (1843), 415.

67 Holman Hunt, with his strong Christian belief and the bent of his imagination towards European art (seeking artistic regeneration, as a Pre-Raphaelite, in the early Italian painters), cannot be regarded as an artist who responded deeply to Islamic inspiration; but it was part of the authenticity he desired that he should design frames to go with the Palestinian subjects of his pictures, which might include Islamic elements: see Mary Bennett, *Bulletin of the Walker Art Gallery, Liverpool* XIII (1968), 56–64. Hunt also studied Owen Jones's Alhambra Court at the Crystal Palace, Sydenham, for the architectural detail of the *Finding of the Saviour in the Temple* (oil, 1854–5, 1956–60, Birmingham Museum and Art Gallery): see Judith Bronkhurst in *The Pre-Raphaelites*, exh. cat. Tate Gallery (1984), 158. Hunt's interest in Muslim custom is shown in his *Street-scene in Cairo: The Lantern-maker's Courtship* (oil, 1854–6, 1860–1, Birmingham Museum and Art Gallery), *ibid.*, 161. Hunt also painted *The Golden Prime of Haroun al Raschid* (watercolour on vellum, 1866, 1891, National Museum of Wales, Cardiff), based on an illustration by him to Tennyson's 'Recollections of the Arabian Nights', in Moxon edn 1857. This has a view of an Islamic city ('Bagdat') in the background. Photographs of interiors of Hunt's house Draycott Lodge, Fulham, in 1893 show a number of Persian rugs and, in the drawing-room, a pierced brass lantern probably from Damascus. He also possessed Persian lustre ceramics as well as the predictable low Cairene tables. See Diana Holman-Hunt, 'The Holman-Hunt Collection, A Personal Recollection', in *Pre-Raphaelite Papers*, ed. Leslie Parris (Tate Gallery 1984), 206–25, illus.

68 The part played by architecture in this process is referred to in ch. 5, p. 169 and n. 13; also Appendix 1.

69 For Frith (who later ran a photographic business in Reigate, Surrey), see *Egypt and the Holy Land in Historic Photographs: 77 views by Francis Frith*, intro. Julia van Haaften (New York 1980). The Palestine Exploration Fund was active in promoting photographic surveys (1872–5, 1877–9; publication 1881–5); see also L. Vaczek and G. Buckland, *Travellers in Ancient Lands, A Portrait of the Middle East 1839–1919* (New York 1981); and next note. The French were also active. Maxime du Camp (1822–94) made 200 paper negatives of the Near East in the late 1840s (pub. Blanquart-Evrard as *Egypte, Nubie, Palestine et Syrie*, 1852). Félix Bonfils (1831–85) was in Beirut in 1867 and had photography studios both there and at Alais (France): Le Maison Bonfils published *Souvenirs d'Orient* in 1877–8. For examples of photographs of Mughal subjects, see Ray Desmond, *Victorian India in Focus* HMSO 1982 (based on the collections in the India Office Library and Records, London).

70 The Prince's journeys were chronicled by William Howard Russell in *Diary in the East* (1869), and (on Nepal and India) in *The Prince of Wales's Tours* (1877). Francis Bedford (1816–94), a member of the Prince's entourage on the Near Eastern journey of 1862, made a photographic record of it.

71 For Smith and Prinsep, see W. G. Archer, 'Benares through the Eyes of British Artists', *Apollo* XCII (1970), 96f.

72 For an excellent detailed survey, see R. Lightbown's essays 'India Illustrated' and 'India Viewed' in Archer and Lightbown (1982), 74f. and 111f.

73 For F. C. Lewis's Indian subjects, see Archer and Lightbown, *ibid.*, 107, 133, 150–1 (illus.).

74 B. Taylor, *A Visit to India, China and Japan* (1859), 67. Taylor, a great admirer of the Alhambra, is referring here to 'Moorish art in Spain', but clearly has the fortress at Granada in mind.

75 T. Twining, *Travels in India a Hundred Years Ago* (1893), 191–92. Marianne Postans, *Western India in 1838* (1839), 275. W. H. Sleeman, *Rambles*, edn 1893, I, 377–8. Bayard Taylor devotes a whole chapter in his book on India and the Far East (see n. 74 above) to the Taj (66–72). For Fergusson see his *History of Indian and Eastern Architecture* (1876), 1891 ed., 595. See also D. Carroll, *The Taj Mahal* (New York 1972) and J. Keay, *India Discovered* (1981).

76 Sleeman invokes the name of a Frenchman, Austin of Bordeaux, mentioned by Tavernier, and identifies him with the person of Ustad Isa mentioned as designer of the

Taj in the contemporary (seventeenth century) Mughal sources. Vincent Smith (*History of Fine Art in India and Ceylon*, 1911) claimed that a Venetian jeweller, Geronimo Veroneo, designed the Taj. This was effectively countered by E. B. Havell, see p. 205. On the influence of European herbals see R. W. Skelton, 'A Decorative Motif in Mughal Art', *Aspects of Indian Art*, ed. P. Pal, Leiden (1972), 147f.

77 Edward Lear, *Indian Journal*, 16 February 1874. The original is in the Houghton Library, Harvard University, but an edited version was published by Ray Murphy in 1953. See also Vivien Noakes, *Edward Lear, The Life of a Wanderer* (1968), 265, which quotes Lear's irresistible description of his stay in Delhi making 'Delhineations of the Delhicate architecture as is all impressed on my mind, as inDelhibly as the Delhiterious quality of the water of that city'.

78 Brabazon (1821–1906) probably made his Taj drawing about 1875, a year after Lear's visit.

79 The converse view of this was Aldous Huxley's in *Jesting Pilate* (1926): he found in the Taj 'a deficiency of fancy, a poverty of imagination'.

80 Richard Altick, *The Shows of London* (Cambridge, Mass. and London 1978), 207.

81 For much detail on the panorama as a social phenomenon see Altick (1978). For the art-historical background see my essay in *The Panoramic Image*, exh. cat. John Hansard Gallery, University of Southampton (1981), 7f.

82 Altick (1978), 182.

5 AFTER 1850: THE DESIGN REFORMERS

1 Mary Bennett, *William Holman Hunt*, exh. cat. Walker Art Gallery, Liverpool (1969), 39.

2 Two are reproduced in R. Altick (1978), 497.

3 Benjamin W. Richardson, *Thomas Sopwith* (1891), 82. Sopwith (1803–79) visited Egypt in 1856, travelling from Alexandria to Cairo by the first 'Mussulman Railway'.

4 See *Journal of Horticulture and Cottage Gardener* (July 1867). The exterior is illustrated in the *Builder* XXIV (1866), 833 (description 885, interior view 887).

5 Macfarlane's cast-iron Durbar hall, with Islamic cusped arches, was exported to India: see the firm's catalogue, *Illustrated Examples of Macfarlane's Architectural Ironwork*, n.d. (*c*.1912), copy in RIBA, London; also E. Graeme Robertson and Joan Robertson, *Cast Iron Decoration, A World Survey* (1977), fig. 478.

6 The continuing use of the onion dome in British greenhouse design is shown in the Winter Garden, Llandudno, 1875, illus. S. Koppelkamm, *Winter Gardens and Glasshouses in the Nineteenth Century* (1981), 45.

7 For the Jones design, see M. Darby (1983), 87, illus., p. 86. For the Paxton design, see H. R. Hitchcock, *Early Victorian Architecture* (2 vols, New Haven, 1954), I, 552 and II, fig. XVI 20. For the dome of Khan-i Khanan's tomb, see Percy Brown, *Indian Architecture (Islamic Period)* (Bombay 1956, edn 1975), pl. LV.

8 Imre Kiralfy, born in Budapest in 1849, was singer, conjuror and engineer before turning to the organisation of fêtes and exhibitions. He built Earl's Court in 1897, and devised fanciful Islamic architecture of the most ambitious kind, in plaster, for the White City exhibition. Contemporary colour postcard views published by Valentine and Sons give an excellent idea of this: two illus. in M. Darby (1983), 136. A considerable archive of Kiralfy material exists in the Museum of London. I am indebted to Colin Sorensen of the Museum for information.

9 Illus. Altick (1978), 156.

10 Ram Raj, *Essay on the Architecture of the Hindus* (1834). Jones (1856), 82, cites Ram Raj. See also Mitter (1977), 180f.

11 Jones (1856), 3. James William Wild is an important figure. In 1841 he designed the polychrome brick church of Christ Church, Streatham, which was much praised: some critics accused it of looking Saracenic, though in fact it was more Lombardic with Gothic and Islamic elements (horseshoe arches; Owen Jones provided interior decoration with Islamic star-patterns). In 1842 Wild was commissioned to design the Anglican church in Alexandria. The Turkish Viceroy suggested Islamic detailing, but lack of funds eventually stopped the scheme. In 1878 Wild became Curator of the Soane Museum, where he designed an Islamic ante-room about 1889 (surviving). Among his papers in the Museum there is a drawing for the detail of this room, showing an

Alhambra-style band pattern forming a star. There is also a tracing of Owen Jones's memorial plaque given in 1874 by Jones's sisters Catherine and Hannah. For the documentary value of Wild's Cairo drawings (presented to the Victoria and Albert Museum by his daughter Elizabeth in 1938), see n. 81 below.

12 Charles Félix Marie Texier published *Description de l'Asie Mineure* in 1839–49 (3 vols.), based on his travels between 1833 and 1837, and *Description de l'Arménie, la Perse et la Mésopotamie* in 1842–52 (2 vols.), based on an expedition made between 1839 and 1841.

13 The part played by the Jews in the process of familiarising Europe with Islamic architectural forms must also be mentioned here, though it is not central to our purpose and is therefore further discussed in Appendix 1. Jerusalem was the obvious focus of missionary efforts by Europeans to convert the Jews to Christianity. These, however, seem to have been largely unsuccessful, and far more significant as a spiritual force was the concern felt for Jerusalem and Palestine in general by the international Jewish community in Europe. The Damascus Affair of 1840, in which certain Jews were accused of ritual murder, and the persecution of East European Jews in later years, led to an urgent Zionism which sought to draw attention to Palestine as the true home of the Jews. Whatever the influence of European anti-Zionism, the interesting fact remains of the choice, by Jews disenchanted with Europe, of Islamic dome and minaret-forms in a sequence of important synagogues that were built across Europe and America. Indeed, despite the inherent unlikelihood of it, there seems to be a possibility that such forms took on the force of symbol for Jews, whereby they could express their sense of pride in their country of origin. England has little part in this process, but there were Islamic elements in the design of the Central Synagogue, London (1870), and in many examples in the United States: cf. pp. 236, 252–3.

14 Fergusson, *A History of Architecture in All Countries*, ed. R. Phené Spiers (1893), vol. II, 520. Fergusson's faith in the exclusive pre-eminence of European medieval architecture had also, it is worth noting, been 'first shaken' when he studied Mughal Agra and Delhi (*ibid.*, vol. I, xx).

15 Gottfried Semper, *Wissenschaft, Industrie und Kunst* (Brunswick 1852): Eng. trans. quoted E. G. Holt, ed., *The Art of All Nations 1850–73* (Princeton 1982), 69.

16 Jones (1856), 77. See also his article 'Gleanings from the Great Exhibition of 1851', *Journal of Design and Manufactures* (28 June 1851), 89–93.

17 See Henry-Russell Hitchcock, 'Brunel and Paddington', *AR*, CIX (1951), 240–6; and the same writer's *Early Victorian Architecture* (1954), I, 558–62, II, figs. XVI 34–9 and *Architecture Nineteenth and Twentieth Centuries* (1958), 127 and pl. 65.

18 See Gombrich (1979), 139, 191: the 'Paisley' pattern, here alluded to, is a familiar example of these properties.

19 Plate 224 in J. B. Waring, *Masterpieces of Industrial Art and Sculpture in the International Exhibition 1862* (1863). See Darby (1983), 87 and illus., 88. The Alhambra was still a name to conjure with in 1862: Waring also illustrates the 'Alhambra Table Fountain', the silver-gilt table-centre (having a domed central feature with arabesque inlays) made 10 years previously for the Prince Consort by Robert Garrard to the design of Edward Lorenzo Percy 'under the direction' of the Prince, and still in the Royal Collection. It had been shown in 1853 at the Dublin Exhibition as well as in the London 1862 Exhibition; see col. illus. in Hermione Hobhouse, *Prince Albert, His Life and Work* (1983), pl. X.

20 In *An Architect's Note Book in Spain* (1872), 143, Wyatt writes of the Alhambra in words which recall Owen Jones and praises the further light thrown on 'Arabian work' in the illustrations by E. Prisse d'Avennes, eventually to appear in the latter's *L'Art Arabe* (Paris 1877).

21 Steegman, *Victorian Taste* (edn 1970), 307. See *Barchester Towers*, ch. 9 (Penguin edn 1982, 63).

22 Gombrich (1979), 53.

23 William Morris, in *Works*, ed. May Morris (1910–15), XXII, 93.

24 The oriental carpet collection at South Kensington was begun in 1876 with seven nineteenth-century pieces (three Persian, four Turcoman). Eight further contemporary ones came from Shāh Nasiruddin of Persia a year later. Important examples from Khotan arrived in 1883, and the two celebrated sixteenth-century Persians – the so-called 'Chelsea' carpet and the Ardabil carpet – in 1890 and 1893 respectively. By

1900 the Museum possessed 60 pre-1700 oriental carpets and about 180 later ones. Cf. Sylvester (1972), 5; also Donald King in *Hali* II (1979), 302–3.

25 *The Letters of William Morris to his Family and Friends*, ed. Philip Henderson (1950), 90;.

26 Morris, 'The History of Pattern-Designing', lecture, 1882, in *Works* XXII, 216.

27 Quoted by J. W. Mackail, *The Life of William Morris* (1899), II, 4–5.

28 Cited in Oliver Fairclough and Emmeline Leary, *Textiles by William Morris and Morris & Co. 1861–1940* (1981), 53.

29 Sir William Perkin's synthesis of mauveine, which revolutionised the old carpet dyes, dates from 1856. Morris came to see a certain decadence in Persian carpets made after 1650 (lecture 'Textile Fabrics', 1884, *Works* XXII, 289). Though he recognised that beautiful modern examples were still made, he was in no doubt about the ill-effects of Western influence on the arts of India, including calico-printing and carpets: in the lecture 'The Art of the People', 1879, delivered in Birmingham Town Hall, he accused the English of destroying these arts in the interests of commerce, and attacked the conditions which had led to native carpet-weavers making their own work conform to inferior standards of the Raj: ironically the true standards could now only be seen in museums (*Works* XXII, 36).

30 Morris valued Persian carpets for their harmonies of colour (as well as their qualities as craft objects which were the result of a full understanding of what a material could do). He was not alone in this. Delacroix records (*Journal*, 26 Sept. 1847) an Algerian craftsman who cut leather and cloth and derived his designs from the study of flowers, and concludes that it was probably prolonged study of nature which enabled such men to achieve their understanding of colour harmonies. One of the most interesting underlying developments of the later nineteenth century, however, is the way in which the colours and configurations of Persian carpets came to be seen by European painters as superior to Western paintings themselves. According to Maxime du Camp's *Souvenirs littéraires* (1882), 290, Delacroix remarked that 'the most beautiful pictures I have seen are certain Persian carpets', probably meaning, as David Sylvester suggested (1972, 6), that in these carpets he saw full colour 'atonomy'. Sargent echoed his view (see ch. 6, p. 227), as did Sir Charles Holmes, on examining the Milan Hunting Carpet in the London Exhibition of January 1931: 'more art has gone into a great carpet like this than into any picture that was ever painted' (quoted Arthur U. Pope, *A Survey of Persian Art*, edn 1964–5, vol. I, 2). It is probable, as Sylvester suggests, that such allusions were already a common usage among artists by the 1880s; Gauguin was another well-known admirer. In Britain the Arts and Crafts movement stressed pattern and colour-harmony, not colour-autonomy, and the craft rather than the 'fine art' aspect of these carpets; but it is surely probable that the big universal exhibitions and dealers' galleries, with their displays of vertically hung carpets (see ch. 4, n. 43 above) will have contributed much to the experience of them as pictorial objects. The collecting of Persian carpets by such shape and colour-sensitive figures as Edward W. Godwin, the designer, and J. McNeill Whistler (who had introduced a Sind rug into his painting *La Princesse du Pays de la Porcelaine* 1864) must here be noted. Sargent, having studied about 40 rugs at Widener's, writes in 1917 that he has 'found out a sort of principle governing the distribution of the various motives. When you get mine hung up would you have it photographed . . . I am curious to compare it with some drawings I did at Mr Widener's' (letter to Fox, in Isabella Stewart Gardner Museum, Boston, Mass.: see ch. 6, n. 40).

31 Ahead of workers in other fields of Islamic art, students of carpets were beginning to work out these historical perspectives, particularly in Germany. The first book on oriental carpets, Julius Lessing, *Altorientalische Teppiche nach Bildern und Originalen des XV–XVI Jahrhunderts* (Eng. trans. 1879), was concerned to make designs available to the carpet industry. Early landmarks were A. Riegl, 'Ältere Teppiche aus dem Besitz des Allerhöchsten Kaiserhauses' (*Jahrbuch der Kunsthistorischen Sammlungen*, Vienna XIII, 1892, 267f.), and W. von Bode, 'Ein altpersischer Teppich im Besitz der Kgl. Museen zu Berlin' (*Jahrbuch der preussischen Kunstsammlungen* XIII, 1892, 43f., 108f.). In Britain, M. W. Conway, 'The Lesson of a Persian Carpet', *Art J.* (1891), 371f., is noteworthy. Outstanding carpet exhibitions took place at Vienna (1891), Munich (1910), New York (1910) and Philadelphia (1919), their catalogues revealing the fruit of increasing specialism. See Erdmann (1970), 34.

32 Sylvester (1972), 9. In Robinson's carpet books the large colour plates were from his sister's watercolour drawings. Robinson as collector, dealer and Fellow of the Society of Antiquaries is variously bound up with the fortunes of Islamic art in Britain. The Fremlin carpet (now VAM) was bought by him. A good idea of his activity may be had from the catalogue of the collection of J. R. Preece CMG, exhibited at the Vincent Robinson Galleries at 34, Wigmore Street, London in May 1913. Preece was British Consul-general at Isfahān; he despatched oriental items to his brother Sir William Preece KCB for over 40 years. These were housed at the latter's Gothic Lodge, Wimbledon. The catalogue lists a version (in fact probably a nineteenth-century copy) of the famous lustreware 'Alhambra Vases' which had been in Robinson's own collection from 1880: he had then acquired it on the advice of Purdon Clarke of the South Kensington Museum. From 1910 to 1913 it had belonged to Alfred Brown. Robinson also supplied American collectors, e.g. George W. Vanderbilt with oriental carpets for his home at Biltmore, Asheville, N. Carolina: see *Hali* III (1980), 305.

33 It is useful to chart the steps in this progress in chronological detail. The 1862 exhibition (with its catalogue introduced by J. C. Robinson) gave a useful airing to problems of what was and what was not Persian. Fifty-one ceramic objects were allocated to Persia. The French consul at Rhodes pointed out ceramic objects from that island to which the name 'Rhodian' was applied in the catalogue. Iznik was still unrecognised for what it was. Augustus (later Sir Augustus) Wollaston Franks (1826–97), on the staff of the British Museum since 1851, is claimed to have isolated further Turkish-inscribed pieces under the label 'Rhodian'. 'Damascus' became the designation for a sub-group of Turkish ware produced from 1530, and 'Rhodian' from 1550 or 1560 (both are still useful as period-names for what has now become established as Iznik).

In 1865 the naturalist Frederick du Cane Godman FRS (1834–1919) began half a century's collecting of Islamic ceramics. In 1868 a pioneer of the study of Islamic ceramic body-material, C. Drury E. Fortnum (1820–99), gave a lecture to the Society of Antiquaries (published in *Archaeologia*, vol. XLII) on a mosque lamp dated 1549 from the Dome of the Rock, Jerusalem (the lamp is now regarded as Iznik and is in the BM). In 1873 Fortnum compiled the first of the South Kensington Museum catalogues, on the ceramics, entitled *Maiolica, Hispano-Moresque, Persian, Damascus and Rhodian Wares*. In 1875 Robert (later Sir Robert) Murdoch-Smith, formerly Director of the Persian Telegraph Department, bought for South Kensington the collection of Jules Richard, who had worked in Persia for years as tutor to the Shāh's children; this *coup* brought to London 62 chests of Persian artefacts including a wealth of ceramic types. In the following year Murdoch-Smith produced a hand-book on the acquisitions (enlarged in 1885): cf. Jennifer Scarce, 'Travels with Telegraph and Tiles in Persia: from the private papers of Major-General Sir Robert Murdoch-Smith', *AARP* (1973). In the late seventies Purdon Clarke was scouring Syria on behalf of South Kensington. In 1878 the collector John Henderson bequeathed a quantity of outstandingly fine Islamic material, notably Turkish ceramics, to the BM. The BFAC exh. in 1885 of 'Persian and Arab Art' was a landmark, containing as it did the Iznik mosque-lamp dated 1549 noted above (item 527); the Iznik jug with English silver mounts of 1597–8 cited above (Fig. 23) (item 546); and a Persian lustred star-tile dated 1217 (A. Higgins Coll., item 147). In 1887 Franks gave his Islamic items, including numerous tiles, to the BM (he continued to donate items in later years). In 1891 Henry Wallis brought out Part I of a catalogue of the Godman Collection, on thirteenth-century lustre vases: three years later he produced a volume on a particularly important and little-studied aspect of the subject, thirteenth-century lustre wall-tiles. Wallis, a collector-dealer, was himself to benefit South Kensington: he sold fifteenth-century tiles obtained in Cairo to the collections in 1898. See John Carswell, 'Some Fifteenth Century Hexagonal Tiles from the Near East', *VAM Yearbook* III (1972), 59–75. Wallis was interested in the debt of European ceramics to the East through Italian maiolica, and published *The Oriental Influence on the Ceramic Art of the Italian Renaissance* in 1899. The new century saw the publication of the *Godman Collection of Oriental and Spanish pottery and glass 1865–1900* (1901): the collection of 600 pieces was ultimately to reach the BM in 1983. Finally we must note the arrival in 1910 at South Kensington (by then VAM) of the remarkable resources of George Salting, with their wealth of Persian, Turkish and Hispano-Moresque ceramics.

Hispano-Moresque pottery was also the subject of much attention. Nineteenth-

century interest in it in Britain may be traceable to mid century excavations of medieval pottery in London: although the precise nature of the discoveries is often obscure. At the BM Augustus Wollaston Franks contributed medieval pieces to the Museum collections as well as using his position of influence to encourage and guide collectors. These included Godman (see Fig. 17), the Earl Spencer, Salting and Wallis. The first major study of the ware as such appears to have been A. van de Put's *Hispano-Moresque Ware of the XV Century* (Art Workers' Quarterly 1904). In 1903 Charles Freer bought his 'Alhambra' vase (see Fig. 19, p. 37 above) on the London market (Charles Davis sale). On American developments see ch. 6, n. 44.

34 De Morgan's lecture is printed in *JRSA* XL (1892), 756–64. See also Reginald Blunt, *The Wonderful Village* (1918). For de Morgan's work see W. Gaunt and M. D. E. Clayton-Stamm, *William de Morgan* (1971); R. Pinkham, *Cat. of Pottery of William de Morgan* (VAM 1973); Jon Catleugh, *William de Morgan Tiles*, 1983. This last contains sections on nineteenth-century tiles by Elizabeth Aslin; on de Morgan's own tiles, including his price-lists, by Jon Catleugh; and on his technique by Alan Caiger-Smith.

35 Catleugh (1983), section on 'Islam-inspired designs', 71–9 (useful illus.). There are many tile designs among de Morgan's drawings in the VAM, given by his wife. De Morgan turned from buying Staffordshire tiles to making his own in order to experiment with a body which had dried (and therefore shrunk) naturally from the wet, rather than to continue to use one which was pressed or compacted and in his view less resistant to outside agents. See Reginald Blunt (1918). For de Morgan's claims concerning the suitability of his tiles for external use see Catleugh, *ibid.*, 124. His experimentation is a symptom of his wish to have total understanding of his material, in the spirit of Morris and, as he believed, of the early Persian potters.

36 The French potter Joseph-Théodore Deck (1823–91) attracted attention (including that of de Morgan) in England through his researches in the sixties into glazes and colours: in 1862 he exhibited Iznik-style plates in the London Exhibition. He was art director at Sèvres from 1887 until his death. Another development in France which was useful for potters seeking Islamic motifs on both sides of the Channel was the publication by Adalbert de Beaumont and Eugène Victor Collinot of the *Recueil de dessins pour l'Art et l'Industrie* (1859). This led to a series of lithographically illustrated books entitled *Encyclopédie des Arts Décoratifs de l'Orient* (Paris 1871–83). The big French tile-manufacturing firm of H. Boulenger & Cie of Choisy-le-Roi (c.1860 onwards) were by the nineties producing Persian designs in which the colour areas were outlined by slip: their schemes included wall-designs (illus. E. Aslin in Catleugh 1983, where these tiles are further discussed, 29). The slip technique was employed in England also, e.g. by Lewis F. Day (1845–1910), whose Persian lustre tiles were executed by J. C. Edwards of Ruabon. Day also produced tiles for Maw and Pilkington, and designed Iznik-style pottery.

37 Anthea Callen, *Women in the Arts and Crafts Movement 1870–1914* (1979): on Minna Crawley, 74; on Louisa Davies, 62–3 (both with illus.). Desmond Eyles, *Royal Doulton 1815–1965* (1965), reporting that this 'Persian ware' was being made by the factory in the mid 1880s, records that Doulton ware was sometimes sent to de Morgan's Cheyne Row factory to be fired; also noted Pinkham (1973), 14.

38 Susan Wilkin, 'Burmantofts Faience', *LAC* 84 (1979), 15–20.

39 On Maw, see Michael Messenger, 'Tile Designs of Maw and Co'., *CL* CLXIV (1978), 28–9. On Pilkington, Anthony J. Cross, *Pilkington's Royal Lancastrian Pottery and Tiles* (1975). The title 'Royal Lancastrian' was conferred by George V in 1913. The First World War and the economic depression that followed were serious setbacks to production, but Islamic influence is still present in the 'Clifton Junction' vase of 1930 (VAM).

40 See 'Minton 1798–1910', exh. cat. VAM (1976): also E. Aslin, in Catleugh (1983), 25f. In the 1860s Mintons perfected a turquoise ('celeste') blue enamel and showed pottery in 'Persian' (Iznik) colours at the Paris Exhibition in 1867. By the London Exhibition of 1871 they could also manage the elusive red of the Iznik repertoire.

41 J. Mordaunt Crook, *William Burges and The High Victorian Dream* (1981), 265, 398.

42 See *Christopher Dresser*, exh. cat. by Richard Dennis and John Jesse (Fine Art Society 1972), and *Christopher Dresser 1834–1904*, Camden Arts Centre and Dorman Museum, Middlesbrough (1980, contribs. by Michael Collins, Stuart Durant, Paul Atterbury).

43 Quoted from the first of Dresser's 23 articles in *The Technical Educator* (1870–72), on

'Principles of Design' (vol. I, 90). These articles formed the text of Dresser's book *Principles of Decorative Design* (1873).

44 Dresser, *ibid.*, article xviii (vol. III, 248f.).

45 Alison Adburgham, *Liberty's, A Biography of a Shop* (1975), provides many details of this fascinating venture: of Liberty himself (pictured at a window of the Alhambra); of Grey Bentley of the Contracts Department; and 'Mr. Wyburd', who was said to be able to draw wooden arches in Moorish style 'blindfold'. A page from Liberty's 'Handbook of Sketches', showing the type of Arab smoking-room furnished by the firm, is reproduced (p. 46).

46 The 7th Earl of Aberdeen took 27 Grosvenor Square in 1886–8: his architect was J. T. Wimperis. See *Survey of London* XXXIX (1977), part I, 151, fig. 24a (plan of house).

47 Pauline Agius, *British Furniture 1880–1915* (1978), 53–4 (illus.). Moorish style continues to be one strand in the eclectic mix of furniture styles in the last 40 years of the century, and design commentators reflect its presence, not always approvingly. Robert W. Edis, FSA, FRIBA, in a Cantor lecture (RSA, 1890) criticised the oriental taste, especially that for Indian and Japanese forms in art ('nothing can be worse than art at second hand'), but his book *Decoration and Furniture of Town Houses* (1881) gives space to designs which show the conflations of classical, oriental and naturalistic ornament that were being produced. J. Moyr Smith's *Interior Decoration* (1887) reflects the interest in Damascus niches and even stalactite vaulting (*Ornamental Interiors, Ancient and Modern* 1887, 142). See R. Smith, 'Furniture of the Eclectic Decades', *Antiques* 76 (1959), 52. Moorish horseshoe arch forms are detectable in the sumptuously eclectic decoration of bookcases designed *c.*1862 by Charles Foster Hayward (1831–1905) for the collector John Jones: three of these entered the VAM in 1882; see Simon Jervis, 'Gothic at No. 95, Piccadilly: New Light on the Taste of John Jones', *Apollo* XCV (1972), 206f. (illus.).

48 Bakers' activities are fully documented in *From East to West, Textiles from G. P. and J. Baker*, exh. cat., VAM (1984), published when the present chapter was in typescript.

49 Mark Girouard, *Life in the English Country House, A Social and Architectural History* (1978), 295.

50 J. Hawthorne, *Shapes that Pass* (1928), 138.

51 See *Survey of London* XXXVI (1973), 136f.; L. and R. Ormond, *Lord Leighton* (New Haven 1975), 98f.; G. Stamp and C. Amery, *Victorian Building of London* (1980), 95.

52 Isobel Spencer, *Walter Crane* (1975), 118. The Arab Hall reminds us that the detailed sorting-out of the sequences of Islamic styles was as yet in the future: it was largely to be undertaken after 1900.

53 Mrs Haweis, *Beautiful Houses* (1882), 7 and 2; *Vernon Lee's Letters*, ed. I. Cooper-Willis (1937), 123.

54 Crook, see n. 41 above, 260–79; Mark Girouard, *The Victorian Country House* (rev. edn 1979), 273–90.

55 'Architectural Experiences at Constantinople', *Builder* XVI (1858), 88–90, 104–8. See especially 108: also *Building News* IV (1858), 163–7 (illus.).

56 This would presumably have been too much like fancy dress, which he abhorred. The links between costume and architecture in Burges's mind are shown in his volume of *Architectural Drawings* (1870), which includes examples of medieval European costume: see Crook, *ibid.*, 57.

57 See illus. of Turkish lamp in *Building News* IV (1858), 164.

58 Henry Gally Knight, *Saracenic and Norman Remains to illustrate the Normans in Sicily* (1838, 1840), ii.

59 E.g. 'Note sur les Etoffes anciennes fabriquées en Sicile', *Memoires de la Société Académique du Dep. de l'Oise* III (Beauvais 1857), 266.

60 Article by Burges on 'The Japanese Court' in *Gentleman's Magazine* CCXIII (1862).

61 The words are those of *Building News* XI (1864), 871.

62 See Clive Aslet, *The Last Country Houses* (1982), 62. On the Diwan-i-Kass, see Brown, n. 7 above, 104.

63 We noted Digby Wyatt's Arab billiard room of 1864 above (p. 173). An earlier example was at Breadsall Priory, Derbyshire, remodelled by Robert Scrivener of Hamley for Francis Morley, a hosier, from 1861. Besides Newhouse Park, the architectural photographer Harry Lemere also recorded the fine example of the smoking-room at Coombe Wood, Norbiton (1898). This had modern versions of prayer-rugs hung

around the walls and an Indian print fabric in the ceiling, which thus gave the appearance of a tent. The fireplace had Persian tiles. Lemere's work is now mainly in the National Monument Record, London. The Coombe Wood smoking-room is reproduced in Nicholas Cooper, *The Opulent Eye* (1977), pl. 99.

64 Illus. Darby (1983), 135. Another Arab room, at Rolleston Hall, Staffs., was by S. J. Waring and Sons (demolished 1926): see *CL* CLVI (1974), 1599.

65 There is little light on the genesis of this scheme: correspondence between Sykes and his architect Brierley in the Sykes papers, Brynmore-Jones Library, University of Kingston-upon-Hull, discusses only technical points of building. There is no surviving reference in this archive to the reputed designer, the Armenian D. Ohanessian. See also Roger Adelson, *Mark Sykes, Portrait of an Amateur* (1975), 131, 151–3.

66 See *Building News* VI (1860), 62.

67 For Brodrick's Baths, see J. Physick and M. Darby, *Marble Halls: Drawings and Models for Victorian Secular Buildings* (VAM, 1973), 134, no. 86. For Somers Clarke's Jermyn Street Baths, see *Building News* IX (1862), 11–12. Burnet's Edinburgh Baths still exist, though some features are now missing: see illus. in *Architect's Journal* (27 June 1923, original façade and interior) I am grateful to David Walker for information. Burnet sometimes used the minaret form, e.g. on the roof at Charing Cross Mansions, Sauchiehall Street, Glasgow, 1891: see A. Gomme and D. Walker, *The Architecture of Glasgow* (1968), pl. 181.

68 For Ambler, see Derek Linstrum, *West Yorkshire Architects and Architecture* (1978): St Paul's House is illustrated on p. 245. See also *Building News* XXXVI (1879), 62, illus. 64.

69 Architects who pursued the Byzantine interest included W. R. Lethaby (1857–1931) and Harold Swainson (1868–94). Both went together to Constantinople (Swainson continued with Somers Clarke to Egypt where he died at Luxor). The book by Lethaby and Swainson, *The Church of Sancta Sophia*, was published in 1894.

70 *Omar Khayyam*, first published in the West by Edward Fitzgerald in 1859, 'gave the Occident an impression of Persian poetry and the Persian outlook which can never be effaced': Arthur Arberry, 'Persian Literature' in T. Cuyler Young (ed.), *Near Eastern Culture and Society, A Symposium on the Meeting of East and West* (Princeton, New Jersey 1951), 73. On the reception of the Rubáiyát in the English-speaking West, see J. D. Yohannan, *Persian Poetry in England and America* (New York 1977), 161ff.

71 Later given by Burne-Jones to Frances Graham (now coll. Earl of Oxford and Asquith). Burne-Jones, who wished to translate Hafiz, wrote that Islam in Persia is all 'gladness of heart and scorn of low ideals of Allah, and love of freedom and delight in beauty ... and brave sayings about life and a little impertinence and mockery', *Memorials of Edward Burne-Jones* (2 vols., 1904), II, 135, quoted by Yohannan, *ibid.*, 192. The interest in fantasy which links Burne-Jones, Rossetti, Burges and James Thomson, who wrote *City of Dreadful Night* (1874) and had oriental tastes also, is noticed by Crook (see n. 41), 34, 275. Thomson considered the Rubáiyát a 'masterpiece of energy and beauty', see William D. Schaefer, *James Thomson (B.V.): Beyond the City*, Berkeley and Los Angeles (1965), 137.

72 Charles Ricketts and Charles Shannon, artists whose collection reflected many aspects of European and non-European art at this time, possessed Islamic items at least by the early 1900s: see J. Darracott, *The World of Charles Ricketts* (1980), 140. In particular they had Persian drawings, later selling them to pay for Shannon's medical expenses, *ibid.*, 138, 139 (illus.). E. B. Havell and William Rothenstein (the latter a member of the circle of Ricketts and Shannon) were collecting Mughal miniatures in 1910 and 1911, see M. Archer and T. Falk, *Indian Miniatures in the India Office Library* (1981), 32. It is worth noting also that Ricketts and Shannon possessed the sketch for J. F. Lewis's *The Siesta* (now Fitzwilliam Museum, Cambridge).

73 Crane's sense of the relationship to room-shape which an oriental carpet can create is a further interesting indication of the unique range of ideas that these rugs offered to the progressive designers of the late Victorian period and beyond. C. L. Eastlake, at pains to uphold irregularity rather than machine perfection, had illustrated the *variations* in the carpet-borders, within the same carpet, but had also (*Hints* 108–9) pleaded for carpets to be left as uncut rectangles in a room, with floor showing round them. In his designs for rooms in the Khedive's Palace in Egypt Owen Jones, working from a more mathematically-concerned standpoint than either Eastlake or Crane, had introduced

an 'independent multiple', determined by the proportions of each saloon, for all the carpet-designs, as well as mural and ceiling decorations: see *Builder* XXXII (1874), 385.

74 Crane's discussion of carpets and Persian gardens in *The Bases of Design* opens up interesting lines of speculation concerning possible links between Persian carpet design and the actual garden effects which were being achieved in these same years by Edwin Lutyens and Gertrude Jekyll, e.g. at Hestercombe, Somerset (1905–6). Here a walled and terraced garden, with straight iris rills, is sunk within the sweeping lines of Taunton Dean in a way which recalls Persian 'paradises': compare Veronica Hitchcock, 'Paradises on Earth: the Gardens of Shiraz, Iran', *CL* CLXIII (1978), 70f., which refers to Hestercombe. The idea of the intimate walled landscaped garden with water and flowers as ingredients as a place to go into, much as one entered a room, is certainly alive for Crane in these early years of the century, and is distinct from the eighteenth-century Western approach to the landscaped garden as a place that afforded extended 'views', and also from the English 'Picturesque' convention which emphasised irregularity of contour and the linking of man-made effects to surrounding landscape by means of it. The disfavour with which adherents of traditional Western landscaped 'views' could regard Persian gardens, so firmly enclosed from the outside world and lacking 'views' of this kind, is indicated by Lord Curzon writing of the Persian garden: '. . . Admitting of no view but a vista, the surrounding plots being a jungle of bushes and shrubs . . . Sometimes these gardens rise in terraces to a pavilion at the summit, whose reflection in the pool below is regarded as a triumph of landscape gardening . . . Such beauty as arises from shade and the purling of water, is all that the Persian requires' (*Persia and the Persian Question*, 2 vols., 1892, vol. II, 503). The degree to which awareness of Persian gardens helped to produce the Lutyens/Jekyll solution with its straight paths, water channels and enclosing walls, must remain a matter for speculation. The architect's daughter, Mary, recalls no mention of Persian gardens by her father; Jane Brown (author of the garden section of the Lutyens Exhibition, Hayward Gallery, London 1981, and of the book *Gardens of a Golden Afternoon* (1981) – on Jekyll and her partnership with Lutyens) considers any ideas on the subject would have come from the former, not the latter: and is inclined to attribute the main influence on Hestercombe to the Italian garden of the Villa Lante, Bagnaia. It is of some interest nevertheless that Gertrude Jekyll, who had studied with Hercules Brabazon Brabazon, knew the Moorish gardens of Spain such as the Generalife, and had collected oriental embroideries (the basis of her collection is in the VAM). For Gertrude Jekyll's encounter with Islamic art in North Africa during her visit of 1873, see Francis Jekyll, *Gertrude Jekyll, A Memoir* (1934), 97. I am grateful to Mary Lutyens (Mrs Links) and Jane Brown for help on these points. Lutyens's Mughal garden at New Delhi, done later in life, was of course suggested by its location (compare Appendix 1).

75 Lethaby, 'Medieval Architecture', in G. C. Crump and E. F. Jacob, *The Legacy of the Middle Ages* (1926), 63.

76 Adburgham, see n. 45 above, 60.

77 For Birdwood see Mitter (1977), 236f.

78 Clarke edited the book *Oriental Carpets* (1892), an English edition of a guide to the collection at the Kaiserliches Königliches Oesterreichisches Handelsmuseum, Vienna. He also published (with T. H. Lewis) an article 'Persian Architecture and Construction', *RIBA Journal* (1880–1), 161–75, and 'The examples of Mughal art in the India Museum', *RIBA Journal*, Series II, vol. IV (1888), 122–33.

79 See A. Topsfield, 'Ketelaar's Embassy and the Farangi Theme in the Art of Udaipur', *OA* XXX (1984–5), 350. This article (*farangi* denotes Frank, i.e. European) discusses two large Mughal court paintings, in gouache on cloth, which came to the VAM from the India Office in 1880.

80 See A. Somers Cocks, *The Victoria and Albert Museum, The Making of the Collection* (1980), 112f.

81 Lane-Poole's book sheds light on interesting episodes in the formation of the Islamic collections at the South Kensington Museum. He describes (95–6) how he took casts in 1883 of every ornament of the Wekala or Khan (lodging house) of Qa'it Ba'i on the south side of the el-Azhar mosque complex (one of the more difficult Muslim places for Europeans in Cairo to penetrate), and brought back paper squeezes, fortified with gypsum, from which casts were made and exhibited in the Museum. He also tells

(115–16) how carved wood panels in the Museum were related to the pulpit of Sultan Lāgīn (AD 1296), formerly in the Mosque of Ibn Tūlūn, Cairo, using drawings made about 1845 (when the pulpit had been intact and in situ) by James Wild. The value of Wild's many drawings, in this and other endeavours at South Kensington, is amply reflected in Lane-Poole's account.

82 For Havell's work on behalf of Hindu art see W. G. Archer, *India and Modern Art* (1959), Mitter (1977), 270f., also John Keay, *India Discovered* (1981), 135f., 165f., 215f.

83 Quoted by Keay, *ibid.*, 215. George Forster (d. 1792) was a civil servant of the East India Company at Madras who in 1782 journeyed from Calcutta to England via Russia: his account was published as *A Journey from Bengal to England* (2 vols., 1798).

84 In 1901 the Rylands acquired the Persian examples from the Bibliotheca Lindesiana of the 25th Earl of Crawford (1812–80).

85 Dulac painted a caricature portrait of the orientalist Sir Edward Denison Ross (1871–1940) as an Eastern potentate and in the style of a Persian miniature (gouache, watercolour and gold paint, 1916, coll. A Denison Ross, sold Christie's, 18 July 1975).

86 See *Maxwell Armfield 1881–1972*, exh. cat., Southampton Art Gallery (1978), item 28. Armfield had trained under the influential Birmingham artist Joseph Southall (1861–1944), who sometimes painted Arabian Nights subjects (coll. Birmingham Art Gallery).

87 Agnes McKay, *Arthur Melville, Scottish Impressionist* (1951), 125 (15) pl. 7.

88 Rodney Brangwyn, *Brangwyn* (1978), 189. This episode appears to have taken place soon after Brangwyn settled in Ditchley in 1918.

89 Mary Lutyens, *Edwin Lutyens* (1980), 142.

90 *Ibid.*, 260.

91 J. Carswell, *Kütahya Tiles and Pottery from the Armenian Cathedral of St James, Jerusalem* (Oxford 1972), vol. 2, 39; A. Crawford, *C. R. Ashbee, Architect, Designer and Romantic Socialist* (New Haven, Yale University Press 1985), 173.

6 THE AMERICAN STORY

1 Oliver W. Larkin, *Art and Life in America* (1949), 17.

2 Estate of Mrs Hibbins of Massachusetts, *Probate Records of Suffolk County*, Mass., III, 73 (Suffolk County, Mass. U.S.A.) See Irwin and Brett (1970), 25.

3 Ann Pollard Rowe, 'Crewel-embroidered Bed Hangings in Old and New England', *Boston Museum of Fine Arts Bulletin* LXXI, no. 365 (1973), 109–11.

4 Florence M. Montgomery, *Printed Textiles: English and American Cottons and Linens 1700–1850* (1970), 96. This work has much valuable information.

5 Carl Bridenbaugh, *The Colonial Craftsman* (New York and London 1950), 79.

6 E.g. nos. 74 and 75, pl. xxxiii, in Edwin A. Barber, *Spanish Maiolica in the Collection of the Hispanic Society of America* (New York 1915). In the sixteenth century, Seville (suburb of Triana) possessed the monopoly of the American trade, which proved lively: see Alice W. Frothingham, *Lustreware of Spain* (New York 1951), 272. Cf. n. 44.

7 Edwin A. Barber, *Tulip Ware of the Pennsylvania German Potters* (Philadelphia 1903), 83, 93 and figs. 20, 34.

8 An example painted in red, yellow and white is illustrated in *American Art 1750–1800: Towards Independence* (Yale University Art Gallery and Victoria and Albert Museum, 1976), pl. 118.

9 See John Bivins Jr, *The Moravian Potters in North Carolina* (Chapel Hill, University of North Carolina Press 1972). For Islamic echoes see the bowl with radiating lines in brown and green slip, attrib. to the Moravian potter Rudolf Christ (illus. Bivins, pl. 229).

10 John Wilmerding, *American Art* (Pelican History of Art, 1976), 29.

11 S. B. Sherrill, 'Oriental Carpets in seventeenth and eighteenth-century America', *Antiques* CIX, 155. See also Helen von Rosenstiel, *American Rugs and Carpets from the Seventeenth Century to Modern Times* (1978). For Benjamin Franklin's Turkey carpet see his *Papers*, ed. L. W. Labaree, XIII (1969), 233.

12 Colin Sheaf, 'America and the China Trade 1770–1870', *TrOCS* XLVI (1981–2), 29–40.

13 Conner (1979), pl. 135.

14 Neil Harris discusses this point in his essay 'The Making of an American Culture 1750–1800' in *American Art 1750–1800*, 31. It is also worth noting that neo-classical taste

in America, as in Europe, encompassed an interest in the exotic wallpapers of Dufour. Four sets of Dufour's *Voyages du Capitaine Cook* and 12 sets of his *Les Français en Egypte* went to America: see D. Watkin, 'Some Dufour Wallpapers', *Apollo* LXXXV (1967), 432.

15 Edn 1860, 329: quoted by Conner (1979), 173.

16 Gerald S. Bernstein, *In Pursuit of the Exotic* (1968), 92. Clay Lancaster, 'Indian Influence in the American Architecture of the Nineteenth Century', *Marg*, VI, no. 2 (1953), 6–21, cites a number of Muslim references in 'Picturesque' cottage architecture as relayed by Robert Lugar and by Richard Brown, *Domestic Architecture* (1841) etc.

17 Conner (1979), pl. 136.

18 Though he considered Iranistan, P. T. Barnum's elaborately oriental mansion (1846–8) 'unsuited to our life or climate' (*Architecture of Country Houses*, edn 1853, 27).

19 I am indebted to James Ryan, of Olana, for this reference.

20 Illustrated in Clay Lancaster, 'Oriental Forms in American Architecture 1800–1870', *Art Bull.* XXIX (1947), 183f., fig. 5 (reprod. from Goss, *Cincinnati*, Chicago–Cincinnati, 1912, facing p. 362).

21 'Prince's Palace', *Atkinson's Casket* 9 (1831), 409; see Bernstein (1968), 92.

22 T. S. Fay, 'The Alhambra of Washington Irving', *New York Mirror*, 23 June 1832, 311.

23 See Bernstein (1968), 32.

24 Victor W. von Hagen, 'Mr. Catherwood's Panorama', *Magazine of Art* 40 (1947), 145.

25 Rena M. Coen, 'Cole, Coleridge and Kubla Khan', *AH* III (1980), 218–28. Cole's drawing reproduced there (fig. 35) is in the Art Institute, Detroit, Michigan. For a literary parallel see Poe's *Domain of Arnheim* (1847) in which a traveller is imagined in a Cole-like paradise landscape with oriental trees and exotic birds, 'and upspringing confusedly from amid all, a mass of semi-Gothic, semi-Saracenic architecture, sustaining itself as if by a miracle in mid-air; glittering in the red sunlight with a hundred oriels, minarets and pinnacles...' Poe's wide-ranging use of Middle Eastern themes in his stories and poems has been seen as part of an imaginative search for 'thoughts and moods and designs that impart an eternal and universal quality' (see William Goldhurst, 'Edgar Allen and the East', *Aramco World Magazine*, Mar.–Apr. 1983, 25–29. Cole seems to have been attracted in a similar way.

26 Barnum had seen the Pavilion. Its design was in any case available in Nash's *Royal Pavilion at Brighton* (1827) and E. W. Brayley, *Illustrations of Her Majesty's Palace at Brighton* (London 1838).

27 Conner (1979), 178, reports that Dr Haller Nutt had visited Egypt. Bernstein (1968), 38, notes the interesting if inconclusive mention of a 'Mr Nutt' among the subscribers to Owen Jones's *Alhambra* volumes.

28 See Orson S. Fowler, *A Home for All* (1848, seven printings in the 1850s), and Walter Creese, 'Fowler and the Domestic Octagon', *Art Bull.* XXVIII (1946), 89f.

29 For the octagonal house see also Clay Lancaster, 'Some Octagonal Forms in Southern Architecture', *Art Bull.* XXVIII (1946), 103f.

30 Samuel Colt (1814–62) would make a rewarding character-study in any investigation into the links between a certain type of male assertiveness and a liking for 'unconventional', i.e. Muslim, art in the nineteenth century. An extremely active, adventurous spirit, he visited Calcutta in 1830 at the age of 16, and Europe and Turkey in 1849. On his return from Constantinople he received from the Sultan a diamond-studded and enamelled gold snuff-box. See Henry Barnard, *Armsmear, The Home of Samuel Colt* (New York 1866), 307. Colt bought the Armoury site in 1852 and built his house on the same plot simultaneously. This was of Italianate design but the extensive conservatory on its south side had two oriental domes and minarets at the angles: see illustration in Barnard, p. 75.

31 A later English travel book which had an American edition was Edward Roe, *The Country of the Moors* (London 1877): see Bernstein (1968), 22–3.

32 Many of Gleyre's oriental drawings are reproduced in colour in *The Orientalists*, exh. cat., Royal Academy, London 1984.

33 Vaux had a very consultative role: of 300 architectural drawings for Olana all but 20 or so are in Church's hand. See David C. Huntington, *The Landscapes of Frederic Edwin Church, Vision of an American Era* (New York 1966), 117f. For Olana see also Vincent Scully, 'Palace of the Past: Frederic Church's Olana at Hudson, New York', *Progressive Architecture* XLVI (1965), 184–9.

34 L. L. Noble, *The Life and Works of Thomas Cole* (1853), ed. E. S. Vessell, Cambridge, Mass. (1964), 148.

35 Weeks's picture *L'Heure de la Prière dans La Mosque de la Perle, Agra* is illustrated in *Eastern Encounters*, exh. cat., Fine Art Society, London (1978), 56.

36 Charles Merrill Mount, *John Singer Sargent* (1957), 107.

37 *Ibid.*, 62.

38 For list see *ibid.*, 342.

39 *Ibid.*, 245–6; list, 358.

40 The list of Sargent's works in William Howe Downes, *John S. Sargent, his Life and Work* (1926), includes (p. 331) a 'Study done from a Persian carpet', 54 × 10 in., formerly coll. Lancelot Hugh Smith and sold Christie's July, 1925. The present whereabouts of this appear to be unknown. It is not clear when Sargent painted it, but it may have been referred to in Sargent's letter to Mrs Gardner of 18 August, 1894. I am grateful to Richard Ormond for information which guided me to these letters, and to the Director of the Isabella Stewart Gardner Museum, Boston, for permission to print extracts from them. See also M. Carter, *Isabella Stewart Gardner and Fenway Court*, Boston (1925), 145.

41 See T. Westcott, *Centennial Portfolio* (1876), 3. Bernstein (1968), 114, has further detail on the Islamic buildings at the Centennial. The Parvis cabinet was illustrated in *Masterpieces of the Centennial*, vol. II and is reproduced in Diane Chalmers Johnson, *American Art Nouveau* (New York 1979); pl. 20. Parvis also showed 'Arabian' cabinets in the Paris Exhibitions of 1867 and 1878.

42 Cf. Mario Amaya, *Art Nouveau* (1966), 35. Tiffany's firm, Associated Artists, opened in New York in 1879. Bing opened shops in Paris in the later 70s, and his Maison de l'Art Nouveau in 1895.

43 Information kindly conveyed by Kevin Stayton, Brooklyn Museum of Art, which has much documentation on the room.

44 Richard Ettinghausen, 'Art and Archaeology' in *Near Eastern Culture and Society*, ed. T. Cuyler Young (Princeton, N.J. 1951), 39. The collecting of Archer M. Huntington, founder of the Hispanic Society of America, New York, is also worth noting. He presented important Hispano-Moresque lustrewares to the Society, acquired by him in 1904–8 from sales of collections in Paris and London, which are named with dates in Frothingham (1951), ix. See also Alice W. Frothingham, 'Formed of Earth and Fire', *Apollo* XCV (1972), 272–82 (on the genesis of the Hispanic Society's ceramic collection). Oriental carpets and other textiles were also being acquired by American collectors. The collection of Charles T. Yerkes was formed by 1910 (see J. K. Mumford, *The Yerkes Collection of Oriental Carpets*, New York 1910): examples are in MMA; Los Angeles, etc. Of the 50 pieces in W. R. Valentiner's carpet exhibition in New York in 1910, 40 were privately owned and most went to public museums. Collectors (and benefiting museums) included C. F. Williams (Philadelphia); John D. McIlhenny (Philadelphia); W. A. Clark (Corcoran, Washington); P. A. B. Widener (NG Washington); Benjamin Altman (MMA). The large James F. Ballard Collection went mainly to the MMA and the Museum at St Louis. See J. Breck and F. Morris, *The James F. Ballard Collection of Oriental Rugs* (New York 1923); M. S. Dimand, *The Ballard Collection of Oriental Rugs in the City Art Museum of St Louis* (1935). For painting see E. Grube, *Muslim Miniature Paintings from the XIII to XIX Century from Collections in the United States and Canada* (Venice 1962).

45 Gillian Naylor, *The Arts and Crafts Movement* (1971), 103.

46 'Already by the early 1880s "Morris chintzes" were a household word in both England and the United States': see Peter Floud, 'English Chintz: The Influence of William Morris', *CIBA Review* 2 (1961).

47 See David Howard Dickason, *The Daring Young Men: The Story of The American Pre-Raphaelites* (Indiana Univ. Press, 1953, 1970 re-issue), 182–7.

48 *The Arts and Crafts Movement in America 1876–1916*, exh. cat., ed. R. Judson Clark (Princeton University 1972), 9.

49 Walter Crane, *The English Revival in Decorative Art, William Morris to Whistler* (1911), 54.

50 Morris distinguished, for instance, between 'necessary workaday furniture', which must be kept 'simple to the last degree', and 'state furniture', which is to be made 'as elegant and elaborate as we can with carving or inlaying or painting' (*Collected Works* XXII (1914), 261). Under the influence of this, Voysey, Gimson and Ambrose Heal went

on to make furniture in which carving and inlay played a key part: cf. Naylor (1971), 107.

51 The vase was discussed and illustrated in E. A. Barber, *The Pottery and Porcelain of the United States* (1893), 281–83. See Princeton (Judson Clark, 1972), 122.

52 For Cook see Dickason (1953), 87f.

53 For Moore see Robert Koch's introduction to Samuel Bing: *Artistic America, Tiffany Glass, and Art Nouveau* (1970), 3.

54 Joseph Purtell, *The Tiffany Touch* (New York 1971), 116.

55 The Veterans' Room, not in Sheldon's book, is illustrated in Bing (1970), pl. 39. For Tiffany interiors from Sheldon's *Artistic Houses*, notably his Library for Samuel Colman and the salon for George Kemp, see Johnson (1979), figs. 28, 29.

56 Illustrated in Johnson (1979), fig. 104. The set was presented at Christmas 1879 to Henry Kiddle by the Teachers of the Public Schools of the City of New York.

57 See *Nineteenth-century America: Furniture and other Decorative Arts*, exh. cat., Metropolitan Museum of Art (New York 1970), xxvi. For Lockwood de Forest (1850–1932) see Anne Suydern Lewis, *Lockwood de Forest, Painter, Importer, Decorator*, Heckscher Museum, Huntington (New York 1975). For the Indian decoration in his New York house (East 10th St) see illus. and discussion in Raymond Head, *The Indian Style* (1986), 107f.

58 Though the peacock occurs in Islamic textile art at least by the twelfth century it is not specially Islamic in origin or use. In its Indian and Burmese varieties the peacock plays a part in Chinese art, notably in Tang metal work, on enamelled Ming porcelain and in Qing dynasty silk embroideries. A more specifically Islamic association was the Peacock throne of the Mughal Emperor Shah Jahān, completed in 1635, which became well-known in Europe through descriptions by Tavernier, Bernier and others. The bird was an obviously 'exotic' motif, and became popular in the West in the later nineteenth century. In Britain Rossetti (who kept peacocks in his garden at Tudor House) and the aesthetes of the 1880s encouraged it. Japanese influence perhaps purveyed it more than anything: E. W. Godwin had adapted the motif from a Japanese crest in his work at Dromore Castle in the 1860s and designed a Peacock wallpaper in 1873 (hand-printed by Jeffery and Co.). The bird made a spectacular appearance in Whistler's famous 'Peacock Room' (1876) in Princes Gate, London, for F. R. Leyland (now Freer Gallery, Washington). The peacock feather, with its iridescent eye, also exerted a great fascination: in America Tiffany exhibited a brooch, set with the Brunswick yellow diamond, at the Philadelphia Centennial in 1876, and the feather became a popular motif in 'Art' pottery on both sides of the Atlantic: with, for example, de Morgan and Burmantofts in Britain and Charles Schmidt, working for the Rookwood Pottery, Cincinnati, in America.

59 Bernstein (1968), 131.

60 Among designers who were interested in lustre Sicard is outstanding, though his shapes rarely suggest anything specifically Islamic, and he is too close to Art Nouveau to qualify for more than a footnote here. Having worked in France with Clement Massier he arrived in America in 1901 and began an association with the Weller Pottery, Zanesville, Ohio, producing metallic lustrewares until 1907, when he returned to France. He died in 1923. His work is in the Metropolitan Museum and the Smithsonian, and extensively in the Art Center Museum, Zanesville. See Paul Evans, *Art Pottery of the United States* (New York 1974), 325, 329 and col. pl. 7.

61 For Lee, see B. St J. Ravenel, *Architects of Charleston*, Charleston 1945.

62 The sea-changes undergone by the Moorish horseshoe arch in the mid to late nineteenth century make an interesting subject for study. As part of a circle enclosing a circular window it not only occurs in Lee's Bank but also, interestingly, in the architecture of another Muslim tradition, that of Turkey, in the 1880s. In Istanbul the Sirkeci Station (1888) has arcades composed of it. The architect here was Jasmond, a graduate of the Ecole des Beaux Arts, and his design takes its place among a group of Moorish-style buildings erected in Turkey, notably at Izmir, late in the century. Western eclecticism appears to have been the main catalyst of this process. See Godfrey Goodwin, 'Turkish Architecture, 1840–1940' in *AARP* XI (1977), 9.

63 For Mould see D. van Zanten, 'Jacob Wrey Mould: Echoes of Owen Jones and the High Victorian Styles in New York 1853–1865', *JSocAH* (USA) XXVIII (1969), 41–57, and Darby, exh. cat. (1983), 82.

64 See F. Webster Smith, *A Design and Prospectus for a National Gallery of History and Art at Washington* (1891). It is evident that these galleries of architectural styles – though never realised – exercised Webster Smith's mind for many years. In 1900 the U.S. government published Smith's *Petition* to realise the scheme (Senate Document no. 209, from the First Session of the 56th Congress), and it seems likely that he did have the proposal discussed by Congress. The *Petition* contained a 'Descriptive Handbook of the Halls of the Ancients'. A large architect's drawing gives a birds' eye view of the whole complex: the third courtyard from the front on the right clearly indicated arcading of the Alhambra and a free-standing Taj Mahal. The estimated cost of 10 million dollars for the whole scheme presumably defeated it. I am grateful for information and help given by Larry Baume, Curator of Research Collections at the Columbia Historical Society, Washington, D.C.

65 Russell Sturgis, *History of Architecture* (New York 1909), II, 245. Sturgis was also a collector of various forms of Oriental, including Islamic, art: see W. G. Constable, *Art Collecting in the United States of America* (1964), 84.

66 *The Israelite* on 6 May, 1864 (before completion of the building) describes it as Byzantine in style, later likening it, however, to the Alhambra. See Rahel Wischnitzer-Bernstein, *Synagogue Architecture in The United States* (Jewish Publication Soc. of America 1955), 70.

67 Wischnitzer-Bernstein (1955), 75–6, fig. 44. Many other examples of American Moorish-style synagogues are illustrated there, 70–83.

68 Terra-cotta decorations in the Zion Temple, Chicago, 1884–5, and the theatre interior of his Chicago Auditorium Building, 1886–88.

69 Nikolaus Pevsner, *Pioneers of Modern Design* (edn 1960), 97.

70 Peter Collins, *Changing Ideals in Modern Architecture 1750–1950* (1965), 115. In fact Collins connects Sullivan specifically with 'Ruskinism'. This seems exaggerated, if the term implies Ruskin's doctrine that 'ornamentation is the principal part of architecture': compare Pevsner (1960), 19.

71 Wischnitzer-Bernstein (1955), 78 and figs. 47–8.

72 For discussion and illustrations of this and other buildings mentioned here see Johnson (1979) and particularly Bernstein (1968). Hunt also designed the Scroll and Key Society Clubhouse, Yale University, New Haven, Conn. (1969), with banded masonry and stilted arches that recall Moorish effects: for this and the Tweedy Store see Paul R. Baker, *Richard Morris Hunt* (Cambridge Mass. and London 1980), 190–2 and 214–16 (illus.).

73 Albert Bush-Brown, *Louis Sullivan* (1961), pl. 1. For illustrations and comparison of this with the Hispano-Moorish formulations of Antonio Gaudì see Johnson (1979), 152, 154.

74 Willard Connely, *Louis Sullivan as he lived: the Shaping of American Architecture* (New York 1960), 45.

75 The link between Islamic style and buildings for exhibitions and entertainments induced the critic A. D. F. Hamlin to see it as 'trivial, playful and gay', ideally suited to 'open-air theaters or cafe restaurants in the park.' See his article 'The Battle of Styles', *Architectural Record* I (1892), 409–10, and Bernstein (1968), 151.

76 Connely (1960), 153.

77 Banister Fletcher, 'American Architecture through English Spectacles', *Engineering Magazine* (7 June 1894), 321.

78 Dimitri Tselos, 'The Chicago Fair and the Myth of the "Lost Cause"', *JSocAH* (USA), XXVI (1967), 259f. The Marrakesh Gate is there reproduced from J. de la Nezière, *Monuments Mauresques du Maroc* (Paris 1922–4).

79 Nos. 1–4, 7, 8, 10, 12, 13 and 17–20.

80 Narciso G. Menocal, *Architecture as Nature: The Transcendentalist Idea of Louis Sullivan* (Madison, Wisconsin, University of Wisconsin Press, 1981), 36.

81 Connely (1960), pl. 37.

82 Bernstein (1968), 5.

CONCLUSION

1 Nikolaus Pevsner, *Some Architectural Writers of the Nineteenth Century* (Oxford 1972), 165.
2 Charles L. Eastlake, *Hints*, 106.
3 Said (1978), 118, 120.

4 Eugene Delacroix, letter to J. B. Pierret, from Tangier, 29 February 1832: see Lorenz Eitner, *Neoclassicism and Romanticism 1750–1850* (Sources and Documents in the History of Art), vol. II (1970), 115.

5 Delacroix, *Journal*, Saturday, 7 April [1849]: see Eitner, *ibid.*, 109.

6 Linda Nochlin, *Realism* (1971), 23.

7 *Taine's Notes on England*, trans. Edward Hyams (1957), 242.

8 Jean Cassou, in *The Sources of Modern Art* (1962), 11f.

Bibliography

This includes two divisions of books and articles which throw light on aspects of the regard paid to Islamic art by artists and writers of Britain and America. 'Primary sources' lists publications of the period 1500–1920. 'Secondary sources' contains modern critical works. A third section lists periodicals. The place of publication is London unless otherwise noted.

In the preparation of the book, a number of published works specifically concerned with Islamic art as such have also proved invaluable as background. First among these must come the writings of K. A. C. Creswell, *Early Muslim Architecture* (Oxford 1932–40) and, particularly, his *Bibliography of the Architecture, Arts and Crafts of Islam* (Cairo and Oxford 1961). The riches of Arthur Upham Pope's book *A Survey of Persian Art from prehistoric times to the present* (6 vols., edn 1964–5) must also be mentioned.

In addition I have found the following of great use:
Arts Council of Great Britain, *The Arts of Islam*, exh. cat., Hayward Gallery, 1976; Arthur J. Arberry (ed.), *The Legacy of Persia*, Oxford 1953; Esin Atil, *Ceramics from the World of Islam*, exh. cat., Freer Gallery of Art, Washington, D.C. 1973; Colnaghi, *Persian and Mughal Art*, exh. cat., ed. B. W. Robinson, 1976; Keith Critchlow, *Islamic Pattern: an Analytical and Cosmological Approach*, 1976; Kurt Erdmann, *Seven Hundred Years of Oriental Carpets* (tr. Beattie and Herzog), Berkeley, Calif., and London 1970; Richard Ettinghausen, *Arab Painting*, 1962; Oleg Grabar, *The Alhambra*, Cambridge, Mass., Harvard University Press 1978; Basil Gray, 'Islamic Art and Architecture' in *A History of Art*, ed. L. Gowing, 1983; Ernst Grube, *The World of Islam*, New York and Toronto 1966; Arthur Lane, *Early Islamic Pottery: Mesopotamia, Egypt and Persia*, 1947, and *Later Islamic Pottery, Persia, Syria, Egypt, Turkey*, 1957, 2nd edn 1971; Michael Levey, *The World of Ottoman Art*, 1975; George Michell (ed.), *Architecture of the Islamic World, its History and Social Meaning*, 1978; D. Talbot Rice, *Islamic Art*, 1965, 1975; Oliver Watson, *Persian Lustreware*, 1985.

Michael (J. M.) Rogers, *Islamic Art 1500–1700*, exh. cat., BM 1983, came out when much of this book was in typescript; but its discussion of the influence of European art on Islamic countries provides very useful material on this hitherto little-studied aspect of East–West artistic relations. Similarly, Jessica Rawson, *Chinese Ornament: The Lotus and the Dragon*, BM 1984, is valuable for its examination of the influence of Chinese motifs on Islamic design. Norah Titley, *Persian Miniature Painting*, British Library 1983, explores Persian influence in Turkey and India.

I PRIMARY SOURCES

Adams, Maurice, *Artists' Homes*, 1883.
Aikin, Edmund, *Designs for Villas and other Rural Buildings*, 1808, r.p. 1835.
Annesley, G. (Lord Valentia), *Voyages and Travels to India, Ceylon, the Red Sea, Abyssinia and Egypt in 1802–1806*, 3 vols., 1809.
Arrowsmith, James, *Paperhanger's and Upholsterer's Guide*, n.d., c. 1850.
Asiatick Researches, 20 vols., Asiatic Society of Bengal, Calcutta 1788–1839.
Ballantine, James, *The Life of David Roberts, R.A.*, 1866.
Barnum, Phineas Taylor, *The Autobiography of P. T. Barnum*, 1855.
Beckford, William, *Vathek*, 1786–7.

Life at Fonthill 1807–1822, With Interludes in Paris and London, from the Correspondence of William Beckford, tr. and ed. Boyd Alexander, 1957.

Bernier, François, *Histoire de la Dernière Révolution des Etats du Grand Mogol*, 2 vols., Paris 1670.

Travels in the Moghul Empire, tr. Archibald Constable, 1891.

Bing, Samuel (ed. Koch, R.), *Artistic America, Tiffany Glass, and Art Nouveau*, New York 1970.

Birdwood, (Sir) George C. M., *The Industrial Arts of India*, 1880.

Blagdon, Francis, *A Brief History of Ancient and Modern India*, 1808.

Boullaye-le-Gouz, François de la, *Voyages et Observations*, Paris 1653.

Bourgoin, Jules, *Les Arts Arabes*, Paris 1873.

Brayley, Edward (ed.), *Nash's Illustrations of Her Majesty's Palace at Brighton*, 2nd ptg 1838.

Brown, Richard, *Domestic Architecture*, 1841.

Browning, Elizabeth Barrett, *The Barrets of Hope End: the Early Diary of Elizabeth Barrett Browning*, 1974.

Bruyn, Cornelis de, *Travels in Muscovy, Persia and Part of the East Indies*, 1737 (orig. edn Amsterdam 1711).

Burke, Edmund, *A Philosophical Inquiry into the Origin of our Ideas of the Sublime and Beautiful*, 1757.

Byron, George Gordon Noel (Lord Byron), *Works of Lord Byron*, 13 vols., J. Murray 1898–1905.

Carne, John, *Letters from the East*, 1826, 1830.

Syria, the Holy Land, Asia Minor etc, 3 vols., 1836–8.

Carstensen, G. J. B., and Gildemeister, C., *The New York Crystal Palace*, New York 1854.

Castlereagh, Lord, *A Journey to Damascus, through Egypt, Nubia, Arabia Petraea, Palestine and Syria*, 1841–2.

Chambers, (Sir) William, *Plans, Elevations, Sections and Perspective Views of the Gardens and Buildings at Kew in Surrey* etc., 1763.

Chandler, Richard, *Ionian Antiquities*, 1769.

Chardin, (Sir) John, *Travels in Persia*, 1686.

Sir John Chardin's Travels in Persia, intro. by Sir Percy Sykes, preface by N. M. Penzer, 1927.

Chateaubriand, François René de, *Travels in Greece, Palestine, Egypt and Barbary*, 1812 (Eng. tr. by Frederic Shobert of *Itinéraire de Paris à Jerusalem*, Paris 1811).

Christie, Archibald H., *Traditional Methods of Pattern Designing*, Oxford 1910, 2nd revised ed. 1929; reprinted by Dover Publications, New York, as *Pattern Design*, 1969.

Cockerell, Charles R., *Travels in Southern Europe and the Levant 1810–1817. The Journal of C. R. Cockerell, R.A.*, ed. S. P. Cockerell, 1903.

Cook, Clarence, *The House Beautiful*, 1878.

Coste, Pascal-Xavier, *Architecture Arabe ou Monuments du Kaire*, Paris 1837–9.

Monuments Modernes de la Perse, Paris 1867.

Mémoires d'un Artiste, Notes et Souvenirs de Voyages, Paris 1878.

Crane, Walter, *The Bases of Design*, 1898.

Line and Form, 1900.

Daniell, Thomas and William, *Oriental Scenery*, 6 parts, 1795–1808.

A Picturesque Voyage to India by the Way of China, 1810.

Daulier des Landes, André, *Les Beautés de la Perse*, Paris 1673.

Denon, Dominique Vivant, *Voyage dans la Basse et la Haute Egypte*, Paris 1802.

Downing, Andrew Jackson, *A Treatise on the Theory and Practice of Landscape Gardening*, New York and London 1844.

Cottage Residences, New York and London 1842.

The Architecture of Country Houses, New York and London 1850.

Duckett, William Alexander, *La Turquie Pittoresque: Histoire, Moeurs, Description*. Pref. by T. Gautier, Paris 1855.

Eastlake, Charles Locke, *Hints on Household Taste in Furniture, Upholstery and other Details*, 1868, rev. and enl. 4th edn 1878: reprint Dover 1969 (orig. publ. in *The Queen*, 1865–6, as by 'Jack Easel').

Evelyn, John, 'An Account of Architects and Architecture', prefaced to *Parallel of the*

Ancient Architecture with the Modern, 1707 (2nd edn of tr. of Fréart de Chambray, *Parallèle de l'Architecture antique et de la moderne*, Paris 1650).

The Diary of John Evelyn, ed. E. S. de Beer, 6 vols., Oxford 1955.

Fergusson, James, *The History of Indian and Eastern Architecture*, 1876.

Fischer von Erlach, Johann Bernhard, *A Plan of Civil and Historical Architecture*, 1730. (Eng. trans. by Thomas Lediard of *Entwurff einer historischen Architektur*, Vienna 1721).

Ford, Richard, *A Handbook for Travellers in Spain and Readers at Home*, 1845 (9 eds until 1898).

Fryer, John, *A New Account of East India and Persia, being Nine Years' Travels 1672–1681*, 1698.

Geminus, Thomas, *Morysse and Damaschin renewed and encreased, very profitable for Gold-smythes and Embroderars*, 1548 (only complete copy in Landesmuseum, Munster).

Girault de Prangey, see Prangey.

The Godman Collection of Oriental and Spanish Pottery and Glass, 1865–1900, 1901.

Goodall, Frederick, *The Reminiscences of Frederick Goodall, R.A.*, 1902.

(Greaves, John), *A Description of the Grand Signour's Seraglio*, 1650, 1653 (latter ascr. to Greaves; now known that text was by Ottaviano Bon before 1622).

Grelot, Guillaume-Joseph, *A Late Voyage to Constantinople*, 1683 (Eng trans. by John Phillips of *Relation d'un Voyage de Constantinople*, Paris 1680).

Guer, Jean-Antoine, *Moeurs et Usages des Turcs*, 2 vols., Paris 1747.

Hakluyt, Richard, *Principall Navigations, Voiages, and Discoveries of the English Nation*, 3 vols 1598–1600, edn Glasgow, 12 vols., 1903–5.

Havell, Ernest B., *Indian Sculpture and Painting*, 1908.

Handbook to Agra and the Taj, 2nd edn 1912.

Haweis, Mrs, *Beautiful Houses*, 1882.

Hay, Robert, *Illustrations of Cairo*, 1840.

Hendley, T. H., *Damascening on Steel or iron, as practised in India*, 1892.

Herbert, (Sir) Thomas, *Travels in Persia*, 1634, ed. Sir William Foster, 1928.

Hobhouse, J. C., *A Journey through Albania and other Provinces of Turkey in Europe and Asia, to Constantinople*, 1809–10.

Hodges, William, *Select Views in India, drawn on the spot in the years 1780, 1781, 1782, and 1783*, nd, plates pub. 1785–8.

A Dissertation on the Prototypes of Architecture, Hindoo, Moorish and Gothic, 1787.

Travels in India during the years 1780, 1781, 1782 and 1783, 1793.

Hope, Thomas, *Household Furniture and Interior Design*, 1807, r.p. 1970.

Hugo, Victor, *Les Orientales*, Paris 1829.

Hunt, William Holman, *Pre-Raphaelitism and the Pre-Raphaelite Brotherhood*, 2 vols., 1905.

Irving, Washington, *Legends of The Alhambra*, 2 vols., 1832.

Jefferys, Thomas, *A Collection of the Dresses of different Nations, antient and modern . . .* , 1757 etc.

Jones, Owen, *Plans, Elevations, Sections and Details of the Alhambra*, 2 vols., 1842, 1845.

'An Attempt to define the Principles which should regulate the Employment of Colour in the Decorative Arts', in *Lectures on the Results of the Great Exhibition of 1851, delivered to the Society of Arts, Manufactures and Commerce*, Series II, 1853, 255f.

The Grammar of Ornament, 1856.

Kinglake, A. W., *Eothen*, 1844.

Lane, Edward William, *An Account of the Manners and Customs of the Modern Egyptians*, 2 vols., 1836, 3rd edn 1842.

Lane-Poole, Stanley, *The Art of the Saracens in Egypt*, 1886.

Le Hay, Jacques, *Recueil de Cent Estampes représentant différantes Nations du Levant*, 1713.

Lewis, John Frederick, *Sketches and Drawings of the Alhambra made during a Residence in Granada, in the years 1833–34*, 1835.

Sketches of Spain and Spanish Character, made during his Tour in that Country, in the years 1833–34, 1836.

Illustrations of Constantinople, made . . . in the years 1835–36. Arranged and drawn on stone from the original sketches of Coke Smyth, by John F. Lewis, 1837.

Lockhart, J. G. (trans.), *Ancient Spanish Ballads*, 1823 (1841 edn).

Loudon, John Claudius, *An Encyclopaedia of Gardening*, 1822 (1828 edn).

Lugar, Robert, *Architectural Sketches for Cottages, Rural Dwellings and Villas in the Grecian, Gothic and Fancy Styles*, 1805; r.p. 1815, 1823.

Mayer, Luigi, *Views in Egypt*, 1801.
 Views in the Ottoman Empire, 1803.
 Views in Palestine, 1804.
 (A combined edition of these books came out in 1804.)
Monconys, Balthasar, *Voyages de M. de Monconys*, 3 vols., Lyons 1665.
Montagu, (Lady) Mary Wortley, *Complete Letters*, ed. Robert Halsband, Oxford 1965.
Moore, Thomas, *Lalla Rookh*, 1817.
 Paradise and the Peri (Lalla Rookh), edn 1860 (illus. Henry Warren, Owen Jones).
Morier, James Justinian, *The Adventures of Hajji Baba of Ispahan*, 1824.
Morris, William, *The Collected Works*, ed. May Morris, 24 vols., 1910–15.
Motraye, Aubry de la, *Travels through Europe, Asia and into parts of Africa* etc., 1723–4.
Mundy, Peter, *Travels in Asia*, Hakluyt Society, series II, 1914.
Murdoch-Smith, Sir Robert, *The Handbook of Persian Art*, 1876, 3rd edn *c.* 1885.
Murphy, James Cavanah, *The Arabian Antiquities of Spain*, 1815.
Murray, John (pub.), *A Handbook for Travellers in Egypt*, 1847 (by J. G. Wilkinson; orig. pub. as *Modern Egypt and Thebes*, 1843).
Nash, John, *Views of the Royal Pavilion at Brighton*, 1826 (pub. 1827).
Norden, Frederick Lewis, *Travels through Egypt and Nubia*, London 1757 (Paris 1755).
Ogilby, John, *Asia, the first part . . .* , 1673.
Ouseley, (Sir) William, *Travels in Various Countries of the East*, 2 vols., 1819.
Pardoe, Julia M., *The Beauties of the Bosphorus*, 1838.
Pococke, Richard, *A Description of the East*, vol. I, 1743; II, 1745.
Porter, (Sir) Robert Ker, *Travels in Georgia, Persia, Armenia, Ancient Babylonia* etc., 2 vols., 1821.
Postans, Marianne, *Cutch, or Random Sketches, taken during a residence in one of the northern provinces of Western India*, 1839.
Prangey, Philibert Joseph Girault de, *Monuments Arabes et Moresques de Cordoue, Séville et Granade*, Paris 1836–9.
 Essai sur l'Architecture des Arabes et des Mors en Espagne, en Sicile et en Barbarie, Paris 1841.
 Choix d'Ornements Moresques de l'Alhambra, Paris 1842.
 Monuments Arabes d'Egypte, de Syrie et d'Asie Mineure, Paris 1846–55.
Prinsep, Valentine Cameron, *Imperial India, An Artist's Journals*, 1879.
Prisse d'Avennes, Achille Constant Théodore Emile, *L'Art Arabe d'après les Monuments du Kaire*, Paris 1877. Eng. edn Paris and London 1983.
Put, A. van de, *Hispano-Moresque Ware of the XV Century*, 1904.
Ram Raj (Ram Raz), *Essay on the Architecture of the Hindus*, 1843.
The Repository of Arts, *Literature, Commerce, Manufacturers, Fashions and Politics*, 1st series, 14 vols., 1809–15.
Repton, Humphry, *Enquiry into the Changes of Taste in Landscape Gardening and Architecture*, 1806.
 Designs for the Pavillon [sic] *at Brighton*, 1808.
Roberts, David, *The Holy Land, Syria, Idumea, Arabia, Egypt and Nubia*, vol. I, 1842; II, 1843; III, 1849.
 Egypt and Nubia, vol. I, 1846; II, 1849; III, 1849.
Robinson, John C., *Catalogue of the Loan Exhibition, 1862*, 1863.
Robinson, Vincent, *Eastern Carpets, Twelve Early Examples*, 1882. 2nd series 1893.
Roe, (Sir) Thomas, *The Embassy of Sir Thomas Roe to India 1615–19*, ed. Sir William Foster, 1926.
Ruskin, John, *Works*, eds. E. T. Cook and A. Wedderburn, 39 vols., 1903–12.
Sandys, George, *A Relation of a Journey begun An. Dom. 1610, Four Bookes*, 1615.
Scott, (Sir) Walter, *Ivanhoe*, 1819.
 The Talisman, 1825.
Sheldon, George, *Artistic Houses*, 1882–4.
Solly, N. Neal, *A Memoir of the Life of W. J. Müller*, 1875.
Spiers, Richard Phené, *A Series of 36 Views of Ancient and Modern Egypt*, 1887.
 Architecture East and West, 1905.
Spofford (formerly Prescott), Mrs Harriet, *Art Decoration applied to Furniture*, New York 1878.
Stebbing, E., *The Holy Carpet of the Mosque of Ardebil*, 1892–3.

Stirling, Mrs A. M. W., *William De Morgan and his Wife*, 1922.
Stuart, James, and Revett, Nicholas, *The Antiquities of Athens*, vol. I (of IV), 1762.
Tavernier, Jean-Baptiste, *Collections of Travels . . . being the Travels of Monsieur Tavernier, Bernier and other great men*, 2 vols., 1684 (with trans. by J. Phillips and E. Everard of *Six Voyages en Turquie, en Perse et aux Indes*, 2 pts., Paris 1676).
Texier, Charles Félix Marie, *Description de l'Asie Mineure*, 3 vols., Paris 1839–49.
 Description de l'Arménie, la Perse et la Mésopotamie, 2 vols., Paris 1842–52.
Thackeray, William Makepeace, *Notes of a Journey from Cornhill to Grand Cairo*, 1846.
Thevenot, Jean de, *The Travels of M. Thevenot into the Indies*, 1687; trans. by A. Lovell of *Voyages de Jean Thevenot*, Paris 1684.
Tod, James, *Annals and Antiquities of Rajasthan*, 1829–32.
Twining, Thomas, *Travels in India a hundred years ago*, 1893.
Two Letters on the Industrial Arts of India, 1879.
Valentia, Lord, see Annesley.
Vaux, Calvert, *Villas and Cottages*, New York 1857.
Vergil, Polydore, *The Works of the Famous Antiquary, Polydore Virgil*, 1663 (trans. of *De Inventoribus Rerum*, 1499).
Warren, C. (ed.), *Picturesque Palestine, Sinai and Egypt*, 4 vols., c. 1877–85 (illus. Roberts, Goodall *et al.*).
Weeks, Edwin Lord, *From the Black Sea through Persia and India*, New York 1895, London 1896.
Wilkie, David, *Sir David Wilkie's Sketches in Turkey, Syria and Egypt 1840–1, drawn on stone by Joseph Nash*, 1843.
 Spain, Italy and the East, 1847.
Wren, (Sir) Christopher, *Parentalia*, ed. C. Wren, 1750.

II SECONDARY SOURCES

* denotes books etc., on intellectual or literary background;
† denotes books with substantial bibliography on Islamic matters.

Abbey, John Roland, *Travel in Aquatint and Lithography 1770–1860*, 2 vols., 1956.
Adburgham, Alison, *Liberty's, A Biography of a Shop*, 1975.
Agius, Pauline, *British Furniture 1880–1915* (Antique Collectors' Club), 1978.
Ahmed, L., *Edward W. Lane, A Study of his Life and Work and of British Ideas of the Middle East in the Nineteenth Century*, 1978.
†Alazard, Jean, *L'Orient et la Peinture française au XIXᵉ Siècle, d'Eugène Delacroix à Auguste Renoir*, Paris 1930.
*Alexander, Boyd, *England's Wealthiest Son, A study of William Beckford*, 1962.
*Allen, B. Sprague, *Tides in English Taste*, 2 vols., Cambridge, Mass. 1937.
Anderson, Susan H., 'Hand made Carpets in the British Isles: Migration of a Tradition', *Hali* III 1980, 196–206.
Apollo XCII, August 1970, Issue devoted to Britain and India: articles by W. G. Archer, Mildred Archer, Michael Archer and Nicholas Cooper, q.v.
Archer, Michael, 'Indian Themes in English Pottery', *Apollo* XCII, 1970, 114–23.
Archer, Mildred, *Tippoo's Tiger*, 1959.
 Indian Architecture and the British, RIBA 1968.
 India and British Portraiture, 1770–1825, 1979.
 Early Views of India: The Picturesque Journeys of Thomas and William Daniell 1786–1794, The Complete Aquatints, 1980.
 and Lightbown, Ronald, *India Observed*. See London, Victoria and Albert Museum.
Archer, W. G., *India and Modern Art*, 1959.
 'Benares through the Eyes of British Artists', *Apollo* XCII, 1970, 96–103.
Arts Council of Great Britain, *Islamic Carpets from the Collection of Joseph V. McMullan*, exh. cat., 1972. See under Sylvester, David.
 The Eastern Carpet in the Western World from the 15th to the 17th Century, exh. cat., by Donald King and David Sylvester, 1983.
Aslin, Elizabeth, *Nineteenth Century English Furniture*, 1962.
 'Tiles in the Nineteenth Century'. See Catleugh, Jon.

Baker, Patricia, 'William Morris and his Interest in the Orient', in *William Morris and Kelmscott* (Design Council) 1981, 67–71.

Beattie, May, 'Antique Rugs at Hardwick Hall', *Oriental Art* v, 1959, 52–61.

'Britain and the Oriental Carpet', *Leeds Arts Calendar* LV, 1964, 4–15.

Beer, E. S. de, 'King Charles II's own Fashion: An Episode in Anglo-French Relations 1666–70', *Jrnl Warburg Institute* II, 1938, 105–15.

†Bendiner, Kenneth, *The Portrayal of the Middle East in British Painting 1835–1860*, Ph.D. thesis, University of Columbia, New York, 1979, publ. University Microfilms International 1981.

'David Roberts in the Near East: Social and Religious Themes', *Art History* VI, 1983, 67–81.

Berko, P. and V., *Peinture Orientaliste*, Brussels 1982.

Bernstein, Gerald Steven, *In Pursuit of the Exotic: Islamic Forms in Nineteenth Century American Architecture*, unpubl. Ph.D. thesis, University of Pennsylvania 1968.

Betjeman, Sir John, 'Sezincote, Moreton-in-Marsh, Gloucestershire', *Architectural Review* LXIX, 1931, 161–6.

Bezombes, Roger, *L'Exotisme dans l'Art et la Pensée*, Paris 1953.

Blunt, Wilfrid, *Splendours of Islam*, 1976.

Blutman, Sandra, 'Hope End, Herefordshire', *Country Life* CXLIII, 1968, 715–17.

Boppe, Auguste, *Les Peintres du Bosphore au dix-huitième Siècle*, Paris 1911.

Braun, Edmund Wilhelm, 'Die Vorbilde einiger "Türkischer" Darstellungen im deutschen Kunstgewerbe des XVIII Jahrhunderts', *Jahrbuch der Königlichen Preussischen Kunstsammlungen* XXIX; Berlin 1908, 252–63.

Brighton, Museum, *The Inspiration of Egypt, its Influence on British Artists, Travellers and Designers, 1700–1900*, exh. cat. ed. Patrick Conner, 1983.

Brockman, H. A. N., *The Caliph of Fonthill*, 1956.

Bugler, Caroline, '"Innocents Abroad": Nineteenth-century Artists and Travellers in the Near East and North Africa', in *The Orientalists*, exh. cat., Royal Academy, London 1984, 27–31.

Byam Shaw, J., 'Gentile Bellini and Constantinople', *Apollo* CXX, 1984, 56–8.

Caiger-Smith, Alan, *Tin-glaze Pottery*, 1973.

Lustre Pottery, Techniques, Tradition and Innovation in Islam and the Western World, 1985.

'De Morgan's Technique'. See Catleugh, Jon.

Carswell, John, 'East and West, A Study in Aesthetic Contrast (Part I), Sir Thomas Herbert and his Travel Writings', *Art and Archaeological Research Papers* II, December 1972.

Kütahya Tiles and Pottery from the Armenian Cathedral of St James, Jerusalem, 2 vols., Oxford 1972.

Blue and White: Chinese Porcelain and its Impact on the Western World. Chicago 1985.

Catleugh, Jon, *William de Morgan Tiles*, 1983.

Charleston, Robert J., 'The Import of Western Glass into Turkey', *Connoisseur* CLXII, 1966, 18–26.

(ed.), *World Ceramics, An Illustrated History*, 1968.

*Chew, Samuel C., *The Crescent and the Rose*, New York 1974 (1937).

*Clayton, Peter, *The Rediscovery of Egypt*, 1982.

Coen, Rena M., 'Cole, Coleridge and Kubla Khan', *Art History* III, 1980, 218–28.

Conner, Patrick, *Oriental Architecture in the West*, 1979.

See Brighton.

'The Mosque through European Eyes', *Apollo* July 1984, 44–49 (on Searight Coll.)

Cooper, Nicholas, 'Indian Architecture in England 1780–1830', *Apollo* XCII, 1970, 124–33.

The Opulent Eye, Late Victorian and Edwardian Taste in Interior Design, 1976.

Coysh, A. W., and Henrywood, R. K., *The Dictionary of Blue and White Printed Pottery 1780–88*, 1982.

Crawford, Alan, *C. R. Ashbee, Architect, Designer and Romantic Socialist*, New Haven, Yale University Press 1985.

Croft-Murray, Edward, *Decorative Painting in England*, vol. I, 1962; vol. II, 1970.

Crook, J. Mordaunt, *William Burges and the High Victorian Dream*, 1981.

*Daniel, Norman, *The Arabs and Medieval Europe*, 1975.

Heroes and Saracens, Edinburgh 1984.

Darby, Michael, *Owen Jones and the Eastern Ideal*, unpub. Ph.D. thesis, University of Reading 1974.

 The Islamic Perspective, exh. cat., World of Islam Festival Trust 1983.

Desmond, R., *The India Museum 1801–1879*, 1982.

Dinkel, John, *The Royal Pavilion, Brighton*, 1983.

*Dudley, Edward, and Novak, Maximilian E. (eds.), *The Wild Man Within, An Image in Western Thought from the Renaissance to Romanticism*, Pittsburgh, University of Pittsburgh Press 1972.

Dugat, Gustave, *Histoire des Orientalistes de l'Europe, Du XII^e au XIX^e Siècle*, 2 vols., Paris 1868–70.

Ettinghausen, Richard, 'Islamic Art and Archaeology' in Young, T. Cuyler, *Near Eastern Culture and Society, A Symposium on the Meeting of East and West*, Princeton N.J., Princeton University Press 1951.

 'Near-Eastern Book Covers and their Influence on European Bindings', *Ars Orientalis* III, 1959, 113–31.

Fairclough, Oliver and Leary, Emmeline, *Textiles by William Morris and Morris & Co. 1861–1940*, 1981.

Ferber, Stanley, *Islam and the Medieval West*, exh. cat., New York, State University of New York at Binghampton 1975.

Ferrier, R. W., 'Charles I and the Antiquities of Persia: The Mission of Nicholas Wilford', *Iran* VIII, 1970, 51–6.

 'The First English Guide Book to Persia: A Description of the Persian Monarchy', *Iran* XV, 1977, 75–88.

Ford, Brinsley, 'Richard Ford as a Draughtsman' in *Richard Ford in Spain*, exh. cat., Wildenstein, London 1974.

Foster, Sir William, 'British Artists in India, 1760–1820', *Jrnl Walpole Society* XIX, 1931, 1–88.

Frankl, Paul, *The Gothic, Literary Sources and Interpretations through Eight Centuries*, Princeton N.J., Princeton University Press 1960.

Frothingham, Alice, *Lustreware of Spain*, New York 1951.

Fry, Roger, 'Review of Four Books on Oriental Art, *Quarterly Review* CCXII, no. 422, Jan. 1910, 225.

*Gail, Marcia, *Persia and the Victorians*, 1951.

Gaunt, William and Clayton-Stamm, M. E. D., *William de Morgan*, 1971.

Girouard, Mark, 'Cardiff Castle', *Country Life* CXXIX, 1961, 760–3, 822–5, 886–9.

Gombrich, Ernst H., *The Sense of Order, A Study in the Psychology of Decorative Art*, 1979.

Grube, Ernst, *Muslim Miniature Paintings from the XIII to XIX Century from Collections in the United States and Canada*, exh. cat. Venice 1962 (also in Italian).

Guiterman, H. and Llewellyn, B., *David Roberts*, 1986.

Handley-Read, Charles, 'Aladdin's Palace in Kensington', *Country Life* CXXIX, 1966, 600–4.

Harris, John, 'Exoticism at Kew', *Apollo* LXXXV, 1963, 103–8.

*Hazard, Paul, *La Crise de la Conscience Européenne 1680–1715*, Paris 1935; Eng. trans. *The European Mind 1680–1715* by J. Lewis May, 1953.

Head, Raymond, *The Indian Style*, 1986.

Heseltine, J. E., '"The Royame of Perse",' in *The Legacy of Persia*, ed. A. J. Arberry, Oxford 1953, 359–87.

Heywood, C. J., 'Sir Paul Rycaut, a seventeenth-century observer of the Ottoman State'. See under Shaw, Ezel Kural and Heywood, C. J.

Hix, John, *The Glass House*, 1974.

Honour, Hugh, *Chinoiserie, The Vision of Cathay*, 1961.

 Romanticism, 1978.

Huggins, P. J., 'Excavations at Sewardstone Street, Waltham Abbey, Essex, 1966', *Post-Medieval Archaeology* III, 1969, 47–99.

Hughes, Peter, *Eighteenth-century France and the East*, Wallace Collection Monographs, 1981.

Hurst, J. G., 'Spanish Pottery imported into Medieval Britain', *Medieval Archaeology* XXI, 1977, 68–105.

Impey, Oliver, *Chinoiserie*, Oxford 1977.

Irwin, Robert, 'The Orient and the West from Bonaparte to T. E. Lawrence', in *The Orientalists*, exh. cat., Royal Academy, London 1984, 24–6.

Jairazbhoy, R. A., *Oriental Influences in Western Art*, Bombay, New York 1965, London 1966.

Jarry, Madeleine, *Chinoiserie, Chinese Influence on European Decorative Art, 17th and 18th Centuries*, New York and London 1981 (orig. Fribourg 1981).

Johnson, Diane Chalmers, *American Art Nouveau*, New York 1979.

*Jourda, Pierre, *L'Exotisme dans la littérature française depuis Chateaubriand*, 2 vols., Paris 1956 (1938).

†Jullian, Phillippe, *The Orientalists, European Painters of Eastern Scenes*, Oxford 1977 (trans. of *Les Orientalistes*, Fribourg 1977).

Klingender, Francis D., *Art and the Industrial Revolution*, 1968 (1947).

*Kopf, David, *British Orientalism and the Bengal Renaissance*, Berkeley and Los Angeles, University of California Press 1969.

Koppelkamm, Stefan, *Wintergardens and Glasshouses in the Nineteenth Century*, 1981.

Kurz, Otto, *European Clocks and Watches in the Near East*, 1975.
 The Decorative Arts of Europe and the Islamic East, 1977.

Lach, D. F., *Asia in the Making of Europe*, II, i, 'The Visual Arts', Chicago 1970.

Lancaster, Clay, 'Indian Influence on the American Architecture of the Nineteenth Century', *Marg* VI, no. 2, 1953, 6–21.
 'Oriental Forms in American Architecture 1800–1870', *Art Bulletin* XXIX, 1947, 183–93.

Lancaster, Osbert, 'The Glamorous East', *Architectural Review* LXXIX, 1936, 101.

Lane, Arthur, *English Porcelain Figures of the Eighteenth Century*, 1961.

Lewis, Anne Suydern, *Lockwood de Forest, Painter, Importer, Decorator*, Hecksher Museum, Huntington, New York 1975.

*Lewis, Bernard, *The Middle East and the West*, 1964.
* *The Muslim Discovery of Europe*, 1982.

Lewis, Michael (J. M. H.), *John Frederick Lewis RA, 1805–1876*, Leigh-on-Sea 1978.

Lightbown, R. W., 'Oriental Art and the Orient in Late Renaissance and Baroque Italy', *Jrnl Warburg and Courtauld Institutes* XXXII, 1969, 228–79.

Lipski, Louis L., *Dated English Delftware: Tin-glazed Earthenware, 1600–1800*, 1984.

Llewellyn, Briony, 'The Victorian Vision of Egypt', in exh. cat. *The Inspiration of Egypt*, ed. Patrick Conner, Brighton Museum and Art Gallery 1983, 115–44.
 'Frank Dillon and Victorian Pictures of old Cairo Houses', *Ur* 3, 1984, 2–10.
 'The Islamic Inspiration, John Frederick Lewis: Painter of Islamic Egypt', in *Influences in Victorian Art and Architecture*, ed. Sarah Macready and F. H. Thompson. Occasional paper (New Series) VII, The Society of Antiquaries of London 1985, 121–38.

Lockhart, L., 'Persia as seen by the West', in *The Legacy of Persia* (ed. A. J. Arberry), Oxford 1953, 318–58.

London, Fine Art Society Ltd., *North African Traveller, Casablanca to Cairo*, exh. cat. 1974.
 Eastern Encounters, Orientalist Painters of the Nineteenth Century, exh. cat. 1978.
 Travellers beyond the Grand Tour, exh. cat. 1980.

London, Royal Academy of Arts, *The Orientalists*, exh. cat., ed. Mary Anne Stevens, 1984. See under Bugler, C., Irwin, R., Stevens, M. A., and Warner, M.

London, Victoria and Albert Museum, *The Indian Heritage, Court Life and Arts under Mughal Rule*, exh. cat., ed. Robert Skelton, 1982.
 India Observed, India as viewed by British Artists 1760–1860, exh. cat. by Mildred Archer and Ronald Lightbown, 1982.
 From East to West, Textiles from G. P. and J. Baker, exh. cat. 1984.
 Rococo, Art and Design in Hogarth's England, exh. cat., ed. Michael Snodin 1984.

Maass, John, *The Gingerbread Age, A View of Victorian America*, New York 1957.

Mackay, Agnes E., *Arthur Melville, RWS, ARSA, Scottish Impressionist*, Leigh-on-Sea 1951.

*Mansfield, Peter, *The British in Egypt*, 1971.

Marly, Diana de, 'King Charles II's own Fashion: The Theatrical Origins of the English Vest', *Jrnl Warburg and Courtauld Institutes* XXXVII, 1974, 378–82.

Menocal, Narciso G., *Architecture as Nature: The Transcendentalist Idea of Louis Sullivan*, Wisconsin, University of Wisconsin Press 1981.

Miles, Hamish, 'Wilkie and Washington Irving in Spain', *Scottish Art Review* XII, no. 1, 1969, 21–5, 28.

Milner, J. D., 'Tilly Kettle, 1735–1786', *Jrnl Walpole Society* XV, 1927, 47–103.

Mitter, Partha, *Much Maligned Monsters, A History of European Reactions to Indian Art*, Oxford 1977.

Morley, John, *The Making of the Royal Pavilion, Brighton: Designs and Drawings*, 1984.

Moynihan, Elizabeth B., *Paradise as a Garden in Persia and Mughal India*, 1981.

Murphy, Veronica, 'The European Vogue', in exh. cat. *The Indian Heritage*. See under London, Victoria and Albert Museum.

Musgrave, Clifford, *Royal Pavilion, An Episode in the Romantic*, 2nd edn 1959 (1951).

Naderzad, B., 'Louis XIV, La Boullaye et L'Exotisme Persan', *Gaz. des Beaux-arts* LXXIX, 1972, 29–38.

*Nasir, Sari J., *The Arabs and the English*, 1976.

Naylor, Gillian, *The Arts and Crafts Movement*, 1971.

Newcastle-upon-Tyne, England, Laing Art Gallery, *J. F. Lewis, R.A.*, exh. cat. by Richard Green, 1971.

New York, Metropolitan Museum of Art, *Nineteenth Century America, Furniture and other Decorative Arts*, exh. cat. 1970.

Nochlin, Linda, 'The Imaginary Orient', *Art in America*, May 1983, 119–31, 187–91.

Ormond, Richard, *John Singer Sargent, Paintings, Drawings, Watercolours*, New York 1970.
Léonée and Richard, *Lord Leighton*, New Haven 1975.

Ottawa, National Gallery of Canada, chapter by Clive Wainwright on 'The Exotic' in *High Victorian Design*, exh. cat., ed. Simon Jervis, Victoria and Albert Museum 1974.

Pace, Claire, 'Gavin Hamilton's *Wood and Dawkins discovering Palmyra*: the dilettante as hero', *Art History* IV, 1981, 271–90.

Pau, Dunkirk and Douai, Musées des Beaux-Arts, *Les Orientalistes de 1850 à 1914*, exh. cat. 1983.

Penzer, N. M., *The Harem*, 1965 (1936).

Petsopoulos, Yanni (ed.), *Tulips, Arabesques and Turbans*, 1982.

Pinkham, Roger, *Catalogue of Pottery of William de Morgan*, Victoria and Albert Museum 1973.

Princeton University, Art Museum, *The Arts and Crafts Movement in America 1876–1916*, exh. cat., ed. R. Judson Clark (exhibition organised by the Art Museum, Princeton University and the Art Institute of Chicago), 1972.

Raby, Julian, *Venice, Dürer and the Oriental Mode*, 1982.

Ribeiro, Aileen, 'Turquerie: Turkish Dress and English Fashion in the Eighteenth Century', *Connoisseur* CCI, 1979, 16–23.

Robinson, Basil W., 'Persian Miniature Painting from Collections in the British Isles', exh. cat., Victoria and Albert Museum 1967. See also *Victoria and Albert Museum Bulletin* III, no. 3, July 1967, 104–10.

Rogers, Michael, 'The Godman Bequest of Islamic Pottery', *Apollo*, July 1984, 24–31.

Romaya, Valerie, *Nineteenth-century British Artists in the Middle East*, unpub. M.Phil. thesis, University of Nottingham 1977.

Rosenstiel, Helen von, *American Rugs and Carpets from the Seventeenth Century to Modern Times*, 1978.

Rosenthal, Donald A., *Orientalism, The Near East in French Painting 1800–1880*, Rochester, New York, Memorial Art Gallery of the University of Rochester, 1982.

*Rouillard, Clarence D., *The Turk in French History, Thought and Literature 1520–1660*, Paris n.d. (foreword dated 1938).

Rykwert, Joseph, *The First Moderns, Architects of the Eighteenth Century*, Cambridge, Mass. 1980.

*Said, Edward W., *Orientalism*, New York 1978.

St Clair, Alexandrine N., *The Image of the Turk in Europe*, 1973 (part of exh. *The Art of Imperial Turkey and its European Echoes*, Metropolitan Museum of Art, New York 1973).

Scarce, Jennifer, 'Travels with Telegraph and Tiles in Persia: from the private papers of Major-General Sir Robert Murdoch-Smith', *Art and Archaeology Research Papers*, 1973.

Schafer, Edward H., *The Golden Peaches of Samarkand*, Berkeley and Los Angeles, University of California Press 1963.

*Schwab, Raymond, *The Oriental Renaissance*, New York 1984 (Fr. text Paris 1950).

Schwoebel, Robert, *The Shadow of the Crescent: The Renaissance Image of the Turk*, Nieuwkoop 1967.

Searight, Sarah, *The British in The Middle East*, revised edn 1979 (1969).

Sharar, A. H., *Lucknow: the Last Phase of an Oriental Culture*, 1975.

Shaw, Ezel Kural, 'The Double Veil: Travellers' Views of the Ottoman Empire, Sixteenth to

Eighteenth Centuries', in Shaw, E. K. and Heywood, C. J., *English and Continental Views of the Ottoman Empire 1500–1800*, University of California Press 1972.

Shellim, Maurice, *India and the Daniells*, 1979.

Sherrill, S. B., 'Oriental Carpets in Seventeenth and Eighteenth Century America', *Antiques* CIX (Jan. 1976), 155.

Sim, Katharine, *David Roberts RA, 1796–1864*, 1984.

Sims, Eleanor, 'The Setting and the Pictures' (Persian seventeenth-century oil paintings) in *Persian and Mughal Art*, exh. cat. Colnaghi 1976, 223–32.

Skelton, R. and F., *Arts of Bengal*, 1979.

*Smith, Byron Porter, *Islam in English Literature*, Beirut 1939.

Smith, Jerome Irvine, 'An Eighteenth-century Turkish Delight', *Connoisseur* CLVI, 214–19.

Soustiel, Jean and Thornton, Lynne, 'L'Influence des Miniatures Orientales sur les Peintres Français au Début du XXᵉ Siècle', *Art et Curiosité*, Paris 1974.

*Southern, R. W., *Western Views of Islam in the Middle Ages*, Cambridge, Mass. 1962.

Stevens, Mary Anne, 'Western Art and its Encounter with the Islamic World 1798–1914', in *The Orientalists*, exh. cat., ed. Mary Anne Stevens, Royal Academy, London 1984, 15–23.

Stevens, Sir Roger, 'Robert Sherley: The Unanswered Questions', *Iran* XVII, 1979, 115–25.

Stokes, Hugh, 'John Frederick Lewis, RA (1805–1876)', *Walker's Quarterly*, no. 28, 1929.

Stroud, Dorothy, *Humphry Repton*, 1962.

'The Novelty of the Guildhall Façade', *Country Life* CXXXV, 1964, 770–71.

Stuebe, Isobel C., *The Life and Works of William Hodges*, New York and London 1979.

'William Hodges and Warren Hastings, a Study in Eighteenth-century Patronage', *Burlington Magazine* CXV, 1973, 659–66.

Sutton, Denys, 'Don Ricardo: a Witty Hispanophile', in *Richard Ford in Spain*, exh. cat., Wildenstein, London 1974.

Sutton, Thomas, *The Daniells, Artists and Travellers*, 1954.

Sylvester, David, 'On Western Attitudes to Eastern Carpets', in *Islamic Carpets from the Collection of Joseph V. McMullan*, exh. cat., Arts Council 1972.

Tarapor, M., 'John Lockwood Kipling and British Art Education in India', *Victorian Studies* XXIV, n. 1, 1980.

†Thornton, Lynne, *Les Orientalistes: Peintres Voyageurs 1828–1908*, Paris 1983.

Tidrick, Kathryn, *Heart-Beguiling Araby*, Cambridge 1981.

Topsfield, Andrew, 'Ketelaar's Embassy and the Farangi Theme in the Art of Udaipur', *Oriental Art* XXXI, 1985, 350–67.

Tregaskis, Hugh, *Beyond the Grand Tour, The Levant Lunatics*, 1979.

Tselos, Dimitri, 'The Chicago Fair and the Myth of the "Lost Cause"', *Journal of the Society of Architectural Historians* XXVI, Philadelphia 1967, 259–68.

Vaudoyer, Jean-Louis, 'L'Orientalisme en Europe au XVIIIᵉ Siècle', *Gazette des Beaux Arts* VI, 1911, 89–101.

Verrier, Michelle, *The Orientalists*, New York and London 1979.

Vollmer, John, Keall, E. J., and Nagai-Berthrong, E., *Silk Roads, China Ships*, Royal Ontario Museum, Toronto, Ontario 1983.

Wainwright, Clive, see under Ottawa.

Ward-Jackson, Peter, 'Some Main Streams and Tributaries in European Ornament 1500–1750: 2, The Arabesque', *Victoria and Albert Museum Bulletin* III, 1967, 90–103.

Warner, Malcolm, 'The Question of Faith: Orientalism, Christianity and Islam', in *The Orientalists*, exh. cat., Royal Academy, London 1984, 32–39.

Watkin, David, 'Some Dufour Wallpapers: a neoclassical venture into the Picturesque', *Apollo* LXXXV (1967), 432–5.

Thomas Hope 1769–1831 and the Neo-Classical Idea, 1968.

*Watt, W. Montgomery, *Islam and the West: the Making of an Image*, Edinburgh, Edinburgh University Press 1960.

The Influence of Islam on Medieval Europe, Edinburgh, Edinburgh University Press 1972.

Weber, S. H., *Voyages and Travels in the Near East in the Nineteenth Century*, Princeton 1952.

Webster, Mary, *Johan Zoffany*, exh. cat., Arts Council of Great Britain 1976.

Weinhardt, Carl J., 'The Indian Taste', *Bull. New York Metropolitan Museum of Art* XVI (1957–8), 208–16.

Willan, T. S., 'English Trade with the Levant in the Sixteenth Century', *English Historical Review* LXX, 1955, 399–410.

Wischnitzer-Bernstein, Rahel, *Synagogue Design of the United States*, Jewish Publication Society of America 1955.

Architecture of the European Synagogue, Philadelphia 1964.

Young, T. Cuyler (ed.), *Near Eastern Culture and Society, A symposium on the Meeting of East and West*, Princeton N.J., Princeton University Press 1951.

Zanten, D. T. van., 'J. W. Mould, Echoes of Owen Jones and the High Victorian Styles in New York, 1853–65', *Journal of the Society of Architectural Historians* XXVIII, Philadelphia 1969, 41–57.

III PERIODICALS

Art and Archaeology Research Publications

Apollo (1925–)

Architectural Review (1896–)

Ars Islamica

Ars Orientalis (Ann Arbor, Michigan)

Art Bulletin

Art Journal (*Art-Union Monthly Journal*, 1849–1912)

Athenaeum (1828–1921)

Builder (1843–1966)

Building News (1855–1926)

Bulletin of the Victoria and Albert Museum

Burlington Magazine (1903–)

Connoisseur (1901–)

Country Life (1897–)

Gazette des Beaux-Arts (1859–)

Hali

Iran, Journal of the British Institute of Persian Studies

Islamic Quarterly

Journal of the Courtauld and Warburg Institutes (formerly *Journal of the Warburg Institute*, 1937–8)

Journal of Indian Art and Industry (1884–1916)

Journal of the Royal Institute of British Architects (3rd series, 1893–)

Journal of the Society of Architectural Historians, London

Journal of the Society of Architectural Historians, Philadelphia

Journal of the Society for Iranian Studies

Journal of the Walpole Society

Leeds Arts Calendar (Leeds)

Marg (Bombay)

Oriental Art

Proceedings of the Society of Antiquaries

Studio (1893–)

Transactions of the English Ceramic circle

Transactions of the Oriental Ceramic Society

Index